Praise for *To Defend the Revo*

D0486479

Rebecca Gordon-Nesbitt is an internationally esteemed
curator of contemporary art and a committed
commentator upon cultural policy, and, in this unique
work, she turns her attention to the cultural policy of the
Cuban Revolution.

Although there exist academic studies of Cuban art
since the Revolution, there has been little examination
of the policy underlying this practice. As such, this book
is of inestimable value not only to those Cubans and
exiled Cubans (in the US and elsewhere), interested in
the policies which have shaped the representation of
their cultural identity, and to students of Cuban culture
more generally, but also to cultural policy-makers
in Europe, North America, Africa, Asia and Latin
America.

At a time when Cuba is undergoing a period
of political transition and economic reform which
anticipates significant cultural transformation, this work
is both timely and necessary to situate, contextualize
and inform contemporary debates on future Cuban
cultural policy, in particular, and the ways in which
local and national cultural strategies address issues of
globalization and neoliberalism more generally.
**– Ross Birrell, co-director of the film *Guantanamera* and
founding editor of *Art & Research*, Glasgow School of Art.**

Rebecca Gordon-Nesbitt has written a tremendous
book, one that allows us to imagine what culture might
look like in a free society – a society in which art and
culture are not dictated by a market and can be
developed and expressed freely, limited only by the
imagination. This opening of the imagination as to
what is possible is achieved through a detailed cultural
and political description of the early years of the Cuban
Revolution. Gordon-Nesbitt finds a wonderful balance
between expressing the unencumbered prioritization
of cultural expression in Cuba and the various
challenges that this process faced.
**– Marina Sitrin, author of *They Can't Represent Us! Reinventing
Democracy from Greece to Occupy.***

Che Guevara believed that art was the highest form of revolution. And Fidel Castro, searching for the appropriate rank to confer upon Guevara at the public wake following his death, called him Artist. *To Defend the Revolution Is to Defend Culture* is a brilliant and comprehensive study of the Cuban Revolution's struggle to counteract neoliberalism's commodity-oriented degradation of culture with a strategy that recognizes art as an integral part of life, honors the creative mind, and has promoted an ongoing conversation between artist and public that has moved far beyond the borders of the small Caribbean island. It is a struggle that has had its extraordinary highs and painful lows, and Gordon-Nesbitt documents its complex history. This is a must read for everyone interested in Cuba, art, and culture. And it is long overdue.
– Margaret Randall, author of *Che on My Mind* and *Haydée Santamaría, Cuban Revolutionary: She Led by Transgression.*

There is, I am sure, a great deal to be learned from the Cuban experience. And I couldn't agree more with Rebecca Gordon-Nesbitt about the threat to culture under the neoliberal assault on the general population.
– Noam Chomsky, Institute Professor of Linguistics (Emeritus), Massachusetts Institute of Technology.

For all the obvious reasons, there is very little useful scholarship on the achievements of socialism past, present and to come. This valuable study of emergent cultural structures in the Cuban Revolution fills a real gap and reminds us of one of that revolution's many (and mostly ignored) successes. Cuba is still in existence; maybe it actually has some lessons for us, in our current social distress.
– Fredric Jameson, author of *Postmodernism; or, The Cultural Logic of Late Capitalism.*

 Writing on cultural policy has completely forgotten the socialist and communist regimes of the 20th century – or preserves them as historical memories only. The end of the Soviet Union and the gradual erosion of any explicit social values from the Chinese regime has left us with an impoverished set of cultural policy goals, in which city branding, innovation systems and tourism dollars reign supreme. That there could be another conception of artistic practice and cultural policy; that this could be socialist and not be about tractors and propaganda; that this might persist as a living tradition – all this remains hidden from view. Rebecca Gordon-Nesbitt's new book makes an enormous contribution to the process of retrieving buried histories and opening new futures for cultural policy at a time when the value of culture is utterly debased and obscured.
– Justin O'Connor, Professor of Communications and Cultural Economy, Monash University, Melbourne, Australia.

 Rebecca Gordon-Nesbitt is to be congratulated on having had the courage and tenacity to explore this largely uncharted territory and thereby to have given fresh impetus to the debate on cultural policy in Cuba. With a specific focus on the visual arts, her study is as timely as it is enlightening at this particular historical juncture. This is not only because Cuba is undergoing significant transformations but also because her detailed study of cultural policy under socialism provides much food for thought for all those interested in broader questions of policy-making and provision. This certainly contributes significantly to our understanding of the current neoliberalisation of the cultural domain in the West.
– Chin-tao Wu, author of *Privatising Culture: Corporate Art Intervention since the 1980s*.

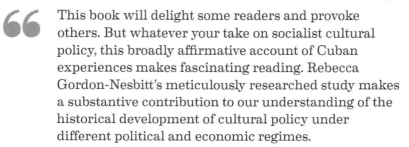

This book will delight some readers and provoke others. But whatever your take on socialist cultural policy, this broadly affirmative account of Cuban experiences makes fascinating reading. Rebecca Gordon-Nesbitt's meticulously researched study makes a substantive contribution to our understanding of the historical development of cultural policy under different political and economic regimes.
– **Oliver Bennett, editor of the *International Journal of Cultural Policy*.**

This study is thoroughly researched and commendably detailed, excelling especially in its methodical approach to tracing the formation and evolution of cultural policy in Cuba from 1959 to 1976. It is likely to prove of considerable use to others working on, and interested in, the relationship between art and politics, not only in Cuba but also beyond the Cuban case.
– **Antoni Kapcia, Professor of Latin American History, University of Nottingham, author of *Literary culture in Cuba: Revolution, nation-building and the book*.**

Understanding the uniquely Cuban approach to the support of one of the world's most celebrated, diverse cultures is essential to a thorough understanding of the Revolution. With meticulous research and insightful analysis, Rebecca Gordon-Nesbitt documents the policies, programs and, most importantly, the philosophy behind the active cultivation of vibrant and authentic arts and culture by and for the people. Revolutionary women, like Haydée Santamaría and Celia Sánchez, played a particularly important role in the arts and culture movement, and this book gives voice to their invaluable contributions.
– **Betsy MacLean, editor of *Haydée Santamaría: Rebel Lives*.**

To Defend the Revolution Is to Defend Culture

The Cultural Policy of the Cuban Revolution

Rebecca Gordon-Nesbitt

ISBN: 978-1-62963-104-2

Library of Congress Control Number: 2015930872

Cover by John Yates/Stealworks
Interior design by briandesign
Index by Chris Dodge
Editing and proofreading by 100% Proof and Gregory Nipper

10 9 8 7 6 5 4 3 2 1

PM Press
PO Box 23912
Oakland, CA 94623
www.pmpress.org

Printed in the USA by the Employee Owners of Thomson-Shore in Dexter, Michigan.
www.thomsonshore.com

For Haydée Santamaría

Contents

Acknowledgements

In a study spanning four years and two continents, it is inevitable that many people contributed along the way. At the University of Strathclyde in Glasgow, David Miller and Colm Breathnach deserve recognition for their endurance and healthy scepticism, while I remain hugely grateful to Colin Clark for encouraging this work from inception to conclusion. On the rare occasions I looked up from these pages, cultural and culinary events instigated by my colleagues were both welcome and instructive.

Although it may not be immediately obvious from the findings outlined here, Mike Gonzalez, former Professor of Latin American Studies at the University of Glasgow, was influential to this study, unleashing an adolescent petulance that determined me to disprove him on certain counts and introducing me to Antoni Kapcia, Professor of Latin American History at the University of Nottingham, one of the few people who took the time to read the research underlying this book and pass on some vital amendments. When it came to practicalities, I was pleased to receive a contribution towards my first flight to Havana from the Society for Latin American Studies, administered by Adrian Pearce. Also in London, Stephen Wilkinson at the International Centre for the Study of Cuba provided a foretaste of what was to come, offering bibliographical advice and putting me in contact with Laura Monteagudo at the University of Havana who, together with Damarys Valdes, shed light on the intricate process of visa application. Behind the scenes, Ross Birrell, David Harding and Euan Sutherland tried in vain to help me secure funding from Creative Scotland to finalise this massive research endeavour, while Fernando Brugman at UNESCO provided advice on the ground in Havana (capably aided by Gilda Betancourt Roa).

In Havana, Jorge and Teresa Fariñas made an apartment at the back of their colonial-style Vedado house feel like home, helping to secure much-needed supplies and conspiring, together with our Norwegian neighbours,

Gaute and Margot, to keep the dominoes, rum and cigars flowing into the night. Much laughter was provided at the University of Havana, not least by Alison and Paddy, while Marta Vega and Ivis Peraza Oliva spent an inordinate amount of time, both during and after class, patiently attempting to teach me their language. I am grateful to fellow researcher Maria Inigo Clavo for putting me in touch with Arien González Crespo, directora of the library at Casa de las Américas, who would introduce me to various people and ideas. Also at the Casa library, my thanks are due to Ángel Abreu, Eloisa Suárez, Rosa Marina González, Yanet and Jamila for making me feel so welcome, and to Adriana Urrea, a colleague from Columbia, who paved the way for me to contact Ambrosio Fornet and Zaida Capote Cruz. The contributions of Adelaida de Juan and Graziella Pogolotti, who gave their time to this study so graciously by consenting to be interviewed, will be evident throughout.

Thanks are also due to librarians in the Biblioteca Nacional José Martí – particularly Michel, Nury, Iandra and Esperanza – who guided me through the dusty file cards and snatched moments to reassure me, and to Mayra Garcia, Lourdes M. Quijano and Alain Talavera at UNEAC for making available a then-unpublished manuscript of a book about the various congresses to have taken place around the artists' union. At the Office of Historical Affairs of the Council of State, the highly articulate Armando Gómez went out of his way to help me with this research, even kindly checking the wording of my interview with Graziella Pogolotti to save me from linguistic embarrassment. Perhaps the nicest day in Cuba was spent with Ernesto Fundora, Alejandro de la Torre and Rolando Almirante when Ernesto – a professor at the Instituto Superior de Arte (Higher Art Institute, ISA) – extended an invitation to hear a lecture he was giving on the playwright Virgilio Piñera, in advance of a foray around the terra cotta landscape of the National Art Schools.

Back in the UK, various learned people took time to contribute to this research, and I am particularly grateful to Arnold Wesker for sending a copy of his reflections on the 1968 Cultural Congress and to Benedict Read for pointing the way to an issue of the ICA Bulletin containing his late father's speech to the same congress, which was efficiently sourced by Jennifer Reeves at the National Art Library. While the quest for Cedric Belfrage's 1961 speech to the First National Congress of Writers and Artists, led by his son, Nicolas, and Peter Filado, ultimately proved fruitless, it provides an excuse for returning to Havana to revisit the conference publication from which I failed to copy it. Thanks are also due to Osmi Cocozza for beginning the transcription of the Pogolotti interview and to Elena Sola-Simon for finishing it. Later in the process, Chris Miller eloquently translated the foreword from Spanish into English, while Paloma Atencia-Linares helped in the other direction with a couple of formal e-mails. Returning to London to check a final reference, I prevailed upon the willingness of the librarian at Iniva to postpone her lunch

and help. On the other side of the Atlantic, Rosa F. Monteleone, at New York University's Elmer Holmes Bobst Library, kindly reserved the official publication of the 1968 congress for me until I was able to consult it.

I am also greatly indebted to those who, at times unwittingly, provided the focused periods of time necessary to the vast process of translating documents and implementing notes into an increasingly unwieldy document, including Doreen Jakob and Bas van Heur, organisers of a panel at the annual conference of the Association of American Geographers in Seattle in April 2011. Special thanks are due to Lisa Rosendahl, Renée Padt, Jonatan Habib Engqvist and Suzi Ersahin for facilitating a precious three-week residency at IASPIS (May–June 2011) to undertake the final thrust of translations, and to friends in Stockholm and Fränsta for ensuring that time spent in Sweden had its lighter moments. During this stay, I was humbled by those who responded so positively and incisively to my first tentative presentation of this research at IASPIS, especially Milena Placentile with her thoughtful reflections. Others who have shown a level of interest and confidence in my research that I hope will not be misplaced include Viccy Coltman, Angela Dimitrakaki and Kirsten Lloyd at the University of Edinburgh, Clive Parkinson and Langley Brown at Manchester Metropolitan University (plus Brian Chapman at Lime) and Justin O'Connor at Monash University in Melbourne, together with all those distinguished intellectuals who have endorsed this publication and Silvia Federici, who indirectly encouraged these efforts. Historically, the same must be said of Marianne Möller and Klaus Jung and, more recently, of Arno van Roosmalen and the team at Stroom Den Haag.

Every study of this kind inevitably relies on the tangible and intangible support of family and friends. When I first left for Cuba, my father stayed up to an unearthly hour to cook a farewell meal en route to the airport, and he extended the rural tranquillity of my childhood home during crucial writing phases thereafter. My mother sent me cuttings about Cuba from the capitalist press which galvanised my thoughts. At the same time, the extended McCallum and Menter clans were on hand with their humour and informed curiosity, while the manifest generosity of Hilary and Adrian, on my side of the Atlantic, and of Nick, Kelly, Mary and Neil on the other, provided much-needed respite from an often-tortuous process. Enquiries about the progress of this research from friends are too numerous to mention but all of them greatly appreciated, particularly when their eyes didn't glaze over during my response. Among these, Oran Wishart warrants a special mention for recommending *Castro's Cuba, Cuba's Fidel*, while Tim Savage stands out for his empathy in relation to the challenge of time spent in unfamiliar locations. Also on the subject of friendship, heartfelt thanks are due to the self-ironically titled Ladies' Cultural Circle, of which I form an enthusiastic part, which long ago deviated from its high-minded aims to concentrate on navigating life's

challenges in a spirit of female solidarity. Equal and opposite, much respect and admiration are owed to Jacob Lovatt for providing the soundtrack to these deliberations.

My ultimate thanks are reserved for those without whom this publication simply would not have been possible. Contrary to the myth of meritocracy, it is disproportionately difficult for women to publish their work in the capitalist world, and I am grateful to several men for helping to overcome this bias. Anthony Davies has been a loyal friend for much of my adult life, and it was he who urged Iain Boal to recommend my work to Ramsey Kanaan at PM Press, who unflinchingly ensured that the book you hold in your hand – in printed or electronic form – came into the world unscathed. In this endeavour, the editorial insight of Gregory Nipper and the vision and patience of Brian Layng and John Yates have proven invaluable to the body and face of this publication, abetted by the unsung heroes and heroines at 100% Proof. It cannot go unremarked that all of these interactions – with people who consistently demonstrate that the political is personal – have been overwhelmingly pleasant and supportive.

Having met only briefly in Havana, I was delighted and honoured that Jorge Fornet consented to write the foreword to this book. His unique knowledge and lived experience of Cuban cultural policy adds a dimension that would otherwise have been lacking. In pictorial terms, I am immensely grateful to Roberto Fernández Retamar, Silvia Gil and Ana Cecilia Ruiz for facilitating access to archival photographs from Casa de las Américas which provide a visual route into the history being reconstructed here. When it came to distilling the keywords of this work into an index, Chris Dodge seemed to inhabit the content to such an extent that his categorisation extrapolated new connections. Thanks are also due to Camille Barbagallo, Stephanie Pasvankias and Steven Stothard at PM Press for helping to disseminate news of this publication far and wide.

Approaching the finishing line, I had the good fortune of being introduced to Tony Ryan, a Cuba aficionado in the US, who not only generously conveyed his enthusiasm about this text but also backed it up with several book recommendations (and editions) and digital introductions to Sara Cooper, Juanamaria Cordones-Cook, Nancy Morejón and Margaret Randall (the latter of whom not only contributed an endorsement but also shared some precious reminiscences about Haydée Santamaría).

And finally, I have tears in my eyes as I think of the unwavering support offered by my compañero, Kyle McCallum, who accompanied me on this literal and metaphorical journey. The Cuban national anthem at Pedro Marrero Stadium plays for you.

LIST OF ILLUSTRATIONS

COLOUR INSERT 1

COLOUR INSERT 2

Asger Jorn mural in a stairwell at the Office of Historical Affairs of the Council of State (painted during the Cultural Congress of Havana, January 1968).

Asger Jorn mural at the Office of Historical Affairs of the Council of State (on pillar), with Raúl Martínez painting and photograph of Celia Sánchez Manduley in the background.

Publicity material from the 1972 Meeting of Latin American Plastic Artists, designed by Umberto Peña.

Plastic arts bulletin produced as a result of the 1972 Meeting of Latin American Plastic Artists, designed by Umberto Peña.

Alfredo Plank, Ignacio Colombres, Carlos Sessano, Juan Manuel Sánchez, Nani Capurro, *Che* (collective series), oil on canvas, 1968.

Schoolgirls' dancing lesson, 2009.

Wall painting in Santa Clara, citing the US as the greatest terrorist.

Wall painting in Havana, reading 'More united and combative defending socialism'.

Vultures hovering over the Habana Libre [Free Havana] hotel.

The shelves of a minimarket in Havana (selling goods in convertible currency), depleted as a result of the economic sanctions imposed upon Cuba by the US since 1960.

Karl Marx Theatre, Havana, venue for the inauguration of the International Festival of New Latin American Film, 2009.

Unless otherwise stated in the relevant caption, all images are courtesy of the author.

KEY TO INSTITUTIONS AND ABBREVIATIONS

Casa de las Américas	House of the Americas
Casas de Cultura	Houses of Culture
Comité Estatal de Estadísticas	State Committee of Statistics
Centro Nacional de Aficionados	National Centre of Amateur Artists
Centro Provincial de Aficionados	Provincial Centre of Amateur Artists
Confederación de Trabajadores Cubanos (CTC)	Cuban Workers' Confederation
Consejo Nacional de Cultura (CNC)	National Council of Culture
Consejo Provincial de Cultura (CPC)	Provincial Council of Culture
Escuelas Nacionales de Arte (ENA)	National Schools of Art
Federación Estudantil Universitarios (FEU)	University Students' Federation
Fuerzas Armadas Revolucionarias (FAR)	Revolutionary Armed Forces
Instituto Cubano de Artes e Industrias Cinematográficas (ICAIC)	Cuban Institute of Cinematic Arts and Industries
Instituto Cubano del Libro	Cuban Book Institute
Instituto Nacional de Reforma Agraria (INRA)	National Institute for Agrarian Reform
Ministerio de Cultura (MINCULT)	Ministry of Culture
Ministerio de Educación (MINED)	Ministry of Education
Ministerio del Interior (MININT)	Ministry of the Interior
Ministerio de Relaciones Exteriores (MINREX)	Ministry of Foreign Relations
Partido Comunista de Cuba (PCC)	Cuban Communist Party
Partido Socialista Popular (PSP)	Popular Socialist Party
Unidad Militar para Ayuda a la Producción (UMAP)	Military Units to Aid Production
Unión Nacional de Escritores y Artistas de Cuba (UNEAC)	National Union of Cuban Writers and Artists

Foreword

Jorge Fornet

In 1960, little more than a year after the triumph of the Cuban Revolution, C. Wright Mills's book, *Listen, Yankee: The Revolution in Cuba*, appeared. It opened the floodgates; since then – outside Cuba – dozens of books have been written about the Revolution as one of the most influential political events of the second half of the twentieth century. Journalists and academics, ranging across the entire political spectrum, have attempted to grasp a phenomenon that transcends Cuba's narrow borders. Most of these approaches prioritise the first decade of the revolutionary process. And they often attempt to comprehend the whole through one of its parts – the cultural domain – in which the Revolution discovered an exceptional space for self-realisation.

Why this repeated return to an epoch now apparently remote? Especially when there is so much to say about the Cuba of the last twenty years and still more about the scenarios of its future? Archaeology is not the principal motive for this recurrent journeying into the past. Closed it may seem, but that era remains a zone of high controversy. Its study and interpretation speak to us not only of the Revolution's protagonists and their positions, the ideas that they defended and their possible relevance today; it also tells us something about ourselves. In other words, such accounts amount to a reflection on the present and our place therein, which inevitably has implications for the future.

Among the many questions generated, over time, by any revolution, one of the most persistent is whether or not it was worthwhile. Did its achievements compensate for so much sacrifice and discomfort, the destinies irrevocably altered, the many lives broken? In answering these questions, the legitimacy of the Cuban Revolution is widely acknowledged. It is often said to have been valid in its starting points but distorted by multifarious motives and interests. And, not uncommonly, such reinterpretations invite us to identify the point at which this turn for the worse occurred. As might be expected,

the location of that point varies with the attitude of the historian. Moreover, the very act of posing these questions is usually a way of challenging the Revolution's legitimacy, since they seem to begin with negative presumptions.

Rebecca Gordon-Nesbitt's *To Defend the Revolution Is to Defend Culture: The Cultural Policy of the Cuban Revolution* is also a journey into the past, but one that avoids the trap posed by such questions. The book moves forward on two planes, simultaneously recounting and interrogating history. In its pages, we witness the Revolution's achievements and gain an understanding of their most profound causes. And thus we see how a new cultural policy was elaborated in Cuba – one that reflected a vision of the world unprecedented in the Western hemisphere; we see how the institutions that made this possible were forged, and encounter the disputes generated by this radically new situation. I refer not only to the confrontations between revolutionary intellectuals and the so-called class enemies (given that the Marxist notion of class struggle, understood as the motor of history, then occupied a central place) but also to those between groups within the revolutionary tendency, which assumed various stances – some of them very divisive – as to how culture should be understood and implemented in the Revolution. It is no surprise that, during the foundational years, above all the first half of the 1960s, polemics raged about precisely these questions. And, although this volume details the process of dogmatisation that affected the cultural domain – and the resulting tensions (doubtlessly representative of deeper-seated political positions) – it avoids pronouncing anathemas and repeating clichéd condemnations.

Gordon-Nesbitt's research has been assiduous. She has rummaged through forgotten publications, explored the most recent bibliographies and interviewed some of the participants in this history along with the scholars who studied it. Even if this had not resulted in an acute analysis and a fresh look at a historical moment so often reviewed, it would still be of considerable value on account of the information it makes available and the voices which meet up and converse in the pages that follow. Her book is unusual in that its focus extends as far as 1976 and thus generates a different kind of interpretation, miles away from the sombre image on which histories of the first ten or twelve years of the Revolution customarily conclude. Moreover, I should like to emphasise Gordon-Nesbitt's courage. Her interrogation of received ideas, her fearlessness in adopting her own perspective and her unprejudiced use of the 'unfashionable "M" word' (Marxism) exemplify this. Averse to simplification, she foregrounds the complexity of a process full of concealed pitfalls.

We should remember that the Cuban Revolution and the cultural policy that it promoted, during the era being considered here, took place in the midst of the Cold War. In this context, the entire Revolution may be thought of as unexpected and anomalous. In the midst of a conflict with clearly delimited exclusion zones, one could hardly have predicted what occurred in Cuba.

What is more, the Cuban process helped to transform the global agenda. From 1959 onwards, the Cold War could no longer be considered simply as a confrontation between the great powers; new protagonists, new subjects, came into being. Appeals from Havana were made to the peoples of Asia, Africa and Latin America, and the theme of decolonisation – the struggle against imperialism and its diverse means of domination – became central. 'The great mass of humanity has said *enough* and has begun its march' was one of the most fundamental proclamations heard from Cuba. In this context, it is easy to see why the decolonisation of culture was such a priority within Cuban cultural policy. It was no inconsiderable task in a country whose cultural dependency on the United States was terrifying. Hollywood dominated the cinema screen, and fascination with the American lifestyle was widespread. To construct a new culture on these foundations was a sizeable challenge; it could only be imagined as part of the radical transformation of Cuban society in the context of the decolonisation of what was then known as the Third World.

What does culture mean, and how can culture for the people be fomented? Attempts to answer these questions necessarily gave rise to intense scrutiny and multiple conflicts. They involved tasks such as teaching the illiterate masses to read, stimulating and diffusing versions of popular and traditional culture and enabling the greatest possible number of people to encounter avant-garde literature and art. A classic documentary of 1967, mentioned by Gordon-Nesbitt – Octavio Cortázar's *Por primera vez* [For the First Time] – films the arrival of cinema in a remote village of the Sierra Maestra, whose inhabitants stood astonished in front of the first cine projection of their lives. Significantly enough, the film chosen for this initiatory rite was Charlie Chaplin's *Modern Times*, and the only scene from the film to appear in the documentary was one in which the machine intended to automate workers' mealtimes breaks down during an ordeal to which Chaplin's character is subjected. This is greeted with hilarity by the audience, who thus gained access to the modernity represented in the film but from quite a different perspective than the (proto-)modernity Chaplin criticised in his film. In *Modern Times*, Taylorist modernity attempts to sacrifice workers' leisure-time, while the spectators in the Sierra Maestra took their place in modernity precisely through the leisure that made enjoyment of a film projection possible. The Serrano peasants, experiencing cinema for the first time, become a kind of model of the new spectator that the Revolution aspired to create. Not only do they have access to a world that was previously alien and inaccessible to them but they also 'understand', appropriate and incorporate it into their own lives.

Earlier Cuban cinema had taken as a theme the way in which the popular classes negotiated their assimilation into an alien world with which they had only recently become acquainted. A scene in Tomás Gutiérrez Alea's 1962 film, *Las Doce Sillas* [Twelve Chairs], accords a humorous glance to a

cultural episode at once bizarre and symbolic. The recently founded Imprenta Nacional de Cuba [Cuban National Printing Press] had published a popular edition of 100,000 copies of its first title, *Don Quixote*. In the film, a newspaper vendor vaunts the appearance of Cervantes's novel as if it were a rag from the gutter press. The terms used by the salesman imply a rather peculiar use of classical literature and emphasise the tension between massive access to culture and the means through which that is achieved.

These and other examples formed part of the process of imagining and constructing a culture that was, as Gordon-Nesbitt rightly indicates, at once anti-elitist and anti-dogmatic. As one can easily imagine, this was a path strewn with controversy. In the construction of a popular culture, there is a high risk of anti-intellectualism. The rejection of elite culture – understood as high-prestige culture exclusively intended to satisfy the demands of a small and sophisticated group – often leads to the rejection or demonisation of creators capable of generating, and consumers capable of enjoying, that art, whereas what is required is to overcome barriers and broaden the production and enjoyment of the various forms of cultural expression.

In an essay entitled 'On Raskolnikov's Landing', the Italian writer Claudio Magris argued that writers cannot be representatives of anything because, when, motivated by a sense of moral responsibility, they take up other themes, their creative adventure comes to an end. In his view, the contradiction can be dramatic; writers have the same duties as any other citizen and 'are responsible to their family, country, freedom, justice and everything else'; they may even be asked to renounce their art in order to take up something higher. But, for Magris, prestige won by the pen does not confer any special authority in the exercise of moral duties, and when writers place their pen at the service of a cause, they should know that, by doing so, they renounce their creative status. Seemingly impeccable, this argument becomes questionable when the very notion of culture (and literature) acquires new meanings as the Revolution aspires to eliminate the dichotomy between the status of writer and citizen. Indeed, many of the most notable Latin American writers of the 1960s felt the need to participate in the *res publica* as a specific corollary of their status as writers.

I should like to highlight the dedication of this book to Haydée Santamaría. That exceptional woman was connected with the Cuban Revolution from the outset. She took part in actions related to the assault on the Moncada Barracks, where her brother, Abel (second-in-command of the attack), and her fiancé were brutally murdered; she was captured, worked in the Sierra Maestra insurrection and supported the armed revolution from exile. After the triumph of January 1959, she was placed in charge of Casa de las Américas, a cultural institution emblematic of the Cuban Revolution, and contributed mightily to making it one of the intellectual centres of the continent – a place

for meeting and discussion for all those who supported Cuba. Despite her limited education, Haydée was a respected interlocutor for renowned writers and artists, who recognised her intelligence, sensitivity and historical and political authority. But she never overcame the pain of her many losses and, in a final tragedy in July 1980, she took her own life. The dedication of this volume to her is a restorative act of justice.

In *To Defend the Revolution Is to Defend Culture*, Rebecca Gordon-Nesbitt reinterprets a cardinal moment of the (cultural) history of the Cuban Revolution; she speaks of a project replete with achievements, frustrations, dreams and nightmares. By so doing, she invites us to imagine a different future and to take part in the struggle to attain it.

Cuba as an Antidote to Neoliberalism

The neoliberal project, which set out to secure the conditions for capital accumulation and restore the power of economic elites, has been gaining ground for more than three decades.[1] This sustained, ideologically motivated campaign – which implies a withdrawal of the state in favour of market forces – has had a detrimental effect upon the cultural field. Art has become synonymous with commerce, and its role within society has been systematically eroded.

The starting point for this book was an understanding of the shortcomings of neoliberalism, combined with an inkling that the revolutionary government in Cuba followed a trajectory distinct from, and explicitly critical of, capitalist globalisation and its ideological justification.[2] When this presumed hegemonic resistance was carried over into a study of cultural policy, it was done so in the hope that the 1959 Cuban Revolution enabled the subsidy, production and distribution of culture to be rethought from first principles. This initial optimism led to a detailed study, spanning more than four years and involving extended periods of fieldwork in Havana. During this time, it became clear that this unique island in the Caribbean Sea provides fertile ground on which to discover much-needed clues about forms of relations between culture, state and society that differ substantially from those developed under capitalism.

In its totality, the experiment carried out in Cuba from 1959 onwards represents the most ambitious rethinking of cultural provision and participation from a Marxian perspective in the twentieth century. Yet, when compared to the volume of analysis that exists around similar developments in the fields of health and education, surprisingly little consideration has been given to the ways in which culture has been foregrounded in Cuba. It is this gap between the manifest significance of culture to the Revolution and the knowledge that exists beyond Cuban shores which this book attempts to fill. In the process,

this study seeks to cast new light on the cultural field of Cuba, about which what little is known in the capitalist world has often been tainted by ideologically motivated campaigns.

NOTES

1 For a consideration of the way in which this has occurred, see David Harvey, *A Brief History of Neoliberalism* (Oxford: Oxford University Press, 2005).

2 Professor Emeritus of the London School of Economics, Leslie Sklair, undertakes an elucidation of generic, capitalist and alternative forms of globalisation in 'The Emancipatory Potential of Generic Globalization', *Globalizations*, 6, no. 4, December 2009, and Antonio Carmona Báez looks at Cuba as an alternative form of globalisation in *State Resistance to Globalisation in Cuba* (London: Pluto Press, 2004).

Conceptualising Cultural Policy in Cuba

 Culture brings freedom.

– José Martí y Pérez.

Whether conducted at a local, national or regional level, any study of cultural policy must take account of two basic factors. In the first place, the precise relationship between culture and the state must be considered, with an emphasis on the role that cultural producers are expected to play within society. At the same time, the socio-economic framework that has been created to support culture needs to be assessed, particularly whether cultural production and dissemination is provided for wholly or partially by the state and, if partially, which other mechanisms are expected to be relied upon by artists and cultural institutions. These factors are interdependent inasmuch as a proportional relationship tends to exist between the perceived social role of culture and the extent to which it is supported by the state. In turn, these determinants influence discussions that are central to the cultural field, such as those around the relationships between aesthetics and ideology, form and content, autonomy and engagement.

Cultural Policy under Capitalism

If we broadly consider the cultural policy of Western Europe and the US in relation to the first of the two main factors outlined above – the relationship between culture, state and society – we find that the emergence of a private market for art during the eighteenth century ultimately led to the exemption of artists from playing a social role. As the economy of art moved away from the whims of individual patrons towards a system in which artworks were made in advance of finding buyers, 'the artistic genius isolated himself or herself from the masses and from the market; and art isolated itself in

this first phase from society'.[1] But rather than representing a total separation, the newly autonomous art of the late eighteenth and early nineteenth centuries maintained the prerogative to 'reflect critically upon society'.[2] In the years leading up to the French Revolution of 1848, creative intellectuals formed alliances across political, social and economic divides, to participate in concerted action which reached its denouement in the Paris Commune of 1871. Sixteen years earlier, one of the artists involved in the Commune, Gustave Courbet, had published a *Realist Manifesto* as the catalogue for a self-organised exhibition.[3]

At the start of the nineteenth century, G.W.F. Hegel had afforded art a significant role in his philosophy of spirit, within the subcategory of absolute spirit (alongside, but subordinate to, religion and philosophy). For him, art – conceived as literature, poetry and, to some extent, painting and sculpture but not music – could portray the human spirit in sensual form (considered inferior to the pictorial depiction of religion and the conceptual thought of philosophy). As the human spirit was considered the highest manifestation of the absolute, Hegel argued, art not only revealed God but also colluded in His self-actualisation, rendering art a phase of the Absolute Idea. The epitome of this way of working was to be found in Greek art, which perfectly reconciled form and content in a way that the Romantics had not been able to repeat under Christianity. Grounded in Hegelian idealism, Courbet's *Realist Manifesto* rejected the subjectivism of the Romantic era to embrace a new artistic objectivity that reconciled form and content.

In Hegel's schema, absolute spirit was categorically distinct from subjective spirit (corresponding to individual psychology) and objective spirit (composed of 'morality, social and economic institutions, the state and political history').[4] This meant that the sensual medium, art, was doomed to remain segregated from matters of politics and the state. It is hardly surprising, then, that, after the rout of the Commune, the attempt to reconcile art and politics was superseded by an evacuation of political content from art. This gave rise to an 'art for art's sake' that Walter Benjamin would later bemoan as the cult of 'negative theology in the form of the idea of "pure" art, which [...] denied any social function'.[5] In chapter three, we shall consider the ways in which discussions around Marxian aesthetics have historically tended to prioritise realism over abstraction and to deem formal experimentation escapist. As will be seen, attempts to prescribe and proscribe particular aesthetic tropes were strongly resisted by creative practitioners in revolutionary Cuba, stimulating a lively debate around both realism and idealism.

Significantly, the eighteenth-century shift to a market economy for art coincided with the inception of aesthetic theory, which saw Immanuel Kant positing aesthetics as a realm of enquiry distinct from both practical reason (moral judgement) and understanding (scientific knowledge), to form

a necessary, if problematic, bridge between the two.[6] Terry Eagleton has convincingly argued that the imposition of theory onto a potentially liberating, sensual experience formed part of a deliberate attempt to engender the social cohesion vital to capitalist societies grounded in consensus and economic individualism. By contrast, he determines that, 'if the aesthetic is a dangerous, ambiguous affair, it is because [...] there is something in the body which can revolt against the power which inscribes it.'[7] As we shall see, the emancipatory connotations of aesthetic engagement were embedded into Cuban conceptions of culture from the outset.

As an antidote to the aloofness of Kantian aesthetics, the Italian art critic Mario de Micheli – whose work on the European artistic vanguards of the twentieth century was published in Cuba in the 1960s – cites Hegel's invocation that artistic work should be created with the people in mind, becoming representative of the epoch in a widely comprehensible way.[8] In the context of this discussion, it is interesting to distinguish de Micheli's use of the term 'vanguard' (which was enthusiastically taken up in Cuba) from that of 'avant-garde' (which emerged in capitalist Europe). While notions of the vanguard retained their militaristic, socio-political roots, the avant-garde rejected bourgeois cultural tradition from the relative safety of the aesthetic terrain.[9] In considering early twentieth-century Western Europe, the German literary critic Peter Bürger distinguishes an historical avant-garde, the explicit aim of which was a retreat from nineteenth-century aestheticism in favour of the elision of art and social life. This project was exemplified by Dada and surrealism, in which 'real life' objects were brought into the gallery, thereby exposing the institution of art as a prelude to its destruction. For Bürger, the second part of this project failed, serving only to reassert the autonomy of art within bourgeois society – 'its (relative) independence in the face of demands that it be socially useful'.[10] In much the same way, the appearance of a neo-avant-garde in the US from the late 1960s ultimately did little to narrow the gap between art and society.[11]

Turning to a consideration of the second main determinant of cultural policy – the socio-economic framework provided by the state – we find that, in the UK, the late capitalist era coincided with the introduction of the ideas of the economist John Maynard Keynes into the cultural field, most directly through his 1942 appointment as chairman of the Council for the Encouragement of Music and the Arts (CEMA). Under Keynes's jurisdiction, CEMA would become the Arts Council of Great Britain (ACGB), with a remit for providing state support for the arts *alongside the marketplace and at arm's length from government*.[12] Top-down and paternalistic, the governing council and specialist committees of the national funding body were largely devoid of artists, thus robbing creative practitioners of any structural impact upon their fate.

This way of working continued until Margaret Thatcher came to power in 1979. A few months before the general election, Thatcher promised the Chairman of the Arts Council that her government would continue to support the arts; but, once elected, she cut spending in all areas of public policy, including the cultural field (reducing arts expenditure by £3 million out of a total £63 million). While the right wing of her Conservative Party called for the total abolition of ACGB, the government understood that this move would encounter resistance and decided instead to implement its policies *through* the existing organisation, eradicating the arm's length principle by appointing politically aligned chairmen to reshape the council.[13]

Consistent with her belief that funding gaps should not be solely plugged by the state, Thatcher appointed Norman St John-Stevas as Arts Minister, who argued that the private sector must be looked to for new sources of cultural funding. A campaign was launched, aimed at doubling the 1979 figure for private arts sponsorship of £3–4 million, and St John-Stevas established a fourteen-member sponsorship committee which included corporate executives and offered tax relief to businesses supporting the arts. A special grant was made to the Association for Business Sponsorship of the Arts, which was responsible for brokering deals between corporate sponsors and cultural institutions, and a tirade was launched against the 'welfare state mentality' that the government perceived to exist among arts organisations. Throughout the 1980s, ACGB was prevailed upon to outline new business ideas and compelled to advocate private support (specifically business sponsorship) to its core-funded organisations. Museums were exposed to market forces and businessmen were appointed to their boards, in a bid to make them more enterprising. This 'harnessing of the power of corporate capital into what had hitherto, at least in Britain, been an almost exclusively public domain' meant that arts organisations found themselves competing with each other to attract sponsorship.[14]

Multinational companies began to involve themselves in the sponsorship of exhibitions and in giving awards to artists. During this time, the corporate approach to sponsoring the arts moved from the passive provision of solicited donations to the proactive deployment of funds as part of a targeted public relations strategy, marking a shift from a 'something for nothing' attitude to a climate of 'something for something'.[15] This became part of a two-pronged attack which either made a connection between the brand and exhibition – exemplified by the distribution of a drinks manufacturer's product at a private view – or aimed to improve the corporate image, which proved especially useful for companies whose brands (alcohol, tobacco, oil or armaments) were in need of burnishing in the public eye. In addition, sponsors came to expect lavish receptions at which they could entertain their guests, providing them with a seemingly apolitical space in which politicians could be met and lobbied.

While a similar history may be traced in relation to the National Endowment for the Arts and the Reagan administration from 1980 onwards, the association between culture and commerce dates back further in the US. In 1976, Hans Haacke was invited to exhibit at the Museum of Modern Art (MoMA) in New York, and conducted some prescient research into the relationship between art and business as evinced by the museum's trustees. David Rockefeller – a banker from a wealthy and influential dynasty, whose brother, Nelson, was Governor of New York State and would go on to become Vice President under Gerald Ford – was chairman of the board of trustees at MoMA, and Haacke quotes him as saying that:

> From an economic standpoint, [corporate] involvement in the arts can mean direct and tangible benefits.
>
> It can provide a company with extensive publicity and advertising, a brighter public reputation, and an improved corporate image.
>
> It can build better customer relations, a readier acceptance of company products, and a superior appraisal of their quality.
>
> Promotion of the arts can improve the morale of employees and help attract qualified personnel.[16]

Having promoted corporate intervention into the arts at the museum level during the Conservative era (1979–97), the UK government under the Labour Party (1997–2007) prompted the devolved arts councils in England, Northern Ireland, Scotland and Wales to turn their attention to other ways of supplementing state support of artists. In the first place, the private market for art had been growing in parallel with finance capitalism since the stock market crash of 1987, leaving the US accounting for around half the global market and the UK for around a quarter. During the New Labour era, this burgeoning market was bolstered by the arts councils – through direct measures including the subsidy of commercial galleries and the introduction of interest-free loans for art collectors – thereby eroding the notion of public sector funding bodies operating alongside the marketplace.[17] In 2004, Arts Council England commissioned a report from private consultants, entitled *Taste Buds: How to Cultivate the Art Market*, which unequivocally placed the flourishing private market at the centre of the art system and examined how it could be better exploited, identifying 6.1 million potential collectors of contemporary art.[18] In the process, all the elements of what had traditionally been regarded as the public sphere – from art school and artist-led activity to non-commercial gallery – were rendered subordinate to the market.

A year earlier, the French sociologist Pierre Bourdieu had observed with regret that 'what is currently happening to the universes of artistic production throughout the developed world is entirely novel and truly without precedent: the hard won independence of cultural production and circulation is being

The Art Eco-System Model

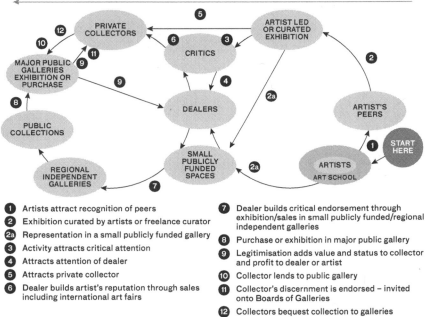

1. Artists attract recognition of peers
2. Exhibition curated by artists or freelance curator
2a. Representation in a small publicly funded gallery
3. Activity attracts critical attention
4. Attracts attention of dealer
5. Attracts private collector
6. Dealer builds artist's reputation through sales including international art fairs
7. Dealer builds critical endorsement through exhibition/sales in small publicly funded/regional independent galleries
8. Purchase or exhibition in major public gallery
9. Legitimisation adds value and status to collector and profit to dealer or artist
10. Collector lends to public gallery
11. Collector's discernment is endorsed – invited onto Boards of Galleries
12. Collectors bequest collection to galleries

Diagram, featured in Morris Hargreaves McIntyre, *Taste Buds: How to Cultivate the Art Market* (London: Arts Council England, 2004), showing the central position of the market in the cultural field under capitalism.

threatened, in its very principle, by the intrusion of commercial logic at every stage'.[19] As a consequence, those working in the highly professionalised and individualistic contemporary cultural field in the capitalist world face a situation in which it can be argued that 'The international art market is the sole mechanism for conferring value onto art'.[20] The potency of the market and the competitiveness it engenders mean that many artistic investigations are driven by financial considerations. This implies 'the total subordination of work contents to profit motives, and a fading of the critical potencies of works in favour of a training in consumer attitudes'.[21] Indeed, the general trend since 1979 has been that 'aesthetics has triumphed over ethics as a prime focus of social and intellectual concern',[22] leading to a relentless pursuit of formal innovation at the expense of political content.[23] As might be expected, this departure is celebrated by conservative critics for whom 'the ending of modernism did not happen too soon [because] the art world of the seventies was filled with artists [...] putting art at the service of this or that personal or political goal'.[24]

At the same time, recent US and European policy has tended to value culture according to its perceived contribution to economic recovery, spearheaded by what the US urban studies theorist Richard Florida calls the

'creative class'. This doctrine conceives 'the highest order of creative work as producing new forms or designs that are readily transferable and widely useful – such as designing a product that can be widely made, sold and used; coming up with a theorem or strategy that can be applied in many cases; or composing music that can be performed again and again',[25] which discriminates against the one-off productions of artists. In much the same way, the creative industries – which are increasingly being prioritised for state funding throughout the European Union – are defined as 'those industries which have their origin in individual creativity, skill and talent and which have a potential for wealth and job creation through the generation and exploitation of intellectual property'.[26] The creative industries are typically taken to include advertising, architecture, computer games, crafts, design, fashion, film and video, music, performing arts, publishing, software, TV and radio. The only point at which art has typically been mentioned within this rhetoric is in relation to its commercial market (where it is aligned with antiques).

In May 2010, in his first major speech as UK Prime Minister, David Cameron identified a key part of recovery from the 2007–8 economic crisis to reside in support for knowledge-based industries, including the creative industries.[27] Five months later, Arts Council England was informed that its subsidy would be cut by £100 million in 2014, which led 206 cultural organisations to be dropped from the national funding portfolio. At the same time, arts organisations have been compelled to think of themselves as social centres and argue their worth in terms of increased participation (rather than passive spectatorship).[28] In April 2013, the then UK Secretary of State for Culture, Media and Sport, Maria Miller, gave a speech to arts and cultural leaders which again placed culture centre stage in the return to economic growth. Against the backdrop of funding cuts, this presumed that 'the public funding distributed by the Arts Council should effectively act as seed funding, or venture capital: giving confidence to others to invest in the creativity and innovation of our cultural organisations'.[29] Such investment, she foresaw, would be drawn from the commercial or philanthropic sectors.

There is a paradox at the heart of recent cultural policy in the capitalist world. On the one hand, the mass-reproducible by-products of culture are heralded as the economic saviours of an unequal society; on the other hand, prioritisation of the creative industries has been accompanied by systematic state disinvestment in the arts and culture. Considering the impact of the creative industries on the artist as early as 1980, the United Nations Educational, Scientific and Cultural Organization (UNESCO) specified that 'art should be considered neither as a consumer good nor as an investment',[30] which suggests that we need new arguments about the value of art. In 2012, the UK's Arts and Humanities Research Council – the main funder of academic research in the field – instigated a three-year funding stream under

the banner of the Cultural Value Project. Due to report in 2015, this aims to articulate the potential value of culture to individuals and society:

> Its starting premise has been that we need to begin by looking at the actual experience of culture and the arts rather than the ancillary effects of this experience. It is understood that the cultural itself will give coherence to the framework as a whole. The value begins there, with something fundamental and irreducible, and all the other components in the framework might be seen, to a greater or lesser extent, to cascade from it. In giving priority to the cultural experience itself, the Cultural Value Project takes the lead in developing a rigorous approach to what many see as the most important aspect of art and culture.[31]

That the capitalist world has only just begun to probe the 'actual experience of culture and the arts' is astonishing when we consider that Cuba has been prioritising this way of working for more than half a century.

In summary, then, the capitalist era witnessed the introduction of a private market for art which initially promised to liberate artists from the bespoke requirements of their patrons, paving the way for socially critical works. Yet this emphasis on political content was quickly displaced by an abiding concern with the formal properties of art. In turn, this consolidated the commodity character of artworks and exempted artists from playing a social role. And, while the introduction of state funding had originally been intended to militate against the subsumption of art to commercial (and governmental) interests, the neoliberal doctrine which has defined socio-economic relations over recent decades has seen a recession of the state from the funding arena in favour of private enterprise and instrumental approaches.[32] As an antidote, many artists and cultural commentators advocate a return to the autonomous status of art, which would have the effect of reinforcing the gulf between art and society.

The Cuban Revolution Dawns

Far from being a remote phenomenon, capitalism was being avidly pursued in Cuba in the 1950s, which was further corrupted by gangsterism and the leaching of profits ninety miles to the north. The neocolonial relationship between the US and Cuba, which had been in place since 1898, had given rise to US ownership of the sugar industry, oil refineries and utilities, and preferential tariffs being offered to those US capitalists willing to provide Cubans with their essential goods. In order to maintain this imbalance, General Fulgencio Batista Zalvídar – who seized control of the island through a military coup in March 1952, having earlier served as its elected President – killed thousands of Cuban citizens with US support. And, while there are those who claim a relatively healthy pre-revolutionary situation,[33] Fidel Castro Ruz – who would

lead the Revolution and serve as Prime Minister of Cuba from 1959 to 1976 and President from 1976 to 2008 – has countered that this 'false image of prosperity, which was really the prosperity of one small class, is the image which the United States still tries to present of Cuba before the Revolution. They try to hide the true image of that epoch, the image of terrible economic and social conditions in which the vast majority of the country lived'.[34]

While indices like life expectancy and the number of doctors per capita were remarkably high before 1959 – leading Cuba to be ranked third in Latin America and eleventh in the world (above Britain, France, Holland and Japan) – these statistics were biased towards urban areas. The growing population and its dependence on the monocultural sugar trade led to rising unemployment and dramatic differences between urban and rural populations and between Havana and the rest of the country, with a private system of health care existing for those who could afford it.[35] A similar pattern emerges from a consideration of education. According to a 1953 census conducted across Latin America, 76.4 percent of the population of pre-revolutionary Cuba could read and write – a figure that was exceeded by only three other countries in Latin America. But, whereas only 7.5 percent of people in Havana were illiterate, an estimated 43 percent of the rural population could not read or write and 44 percent had never attended school.[36] These socio-economic contradictions would eventually provide the impetus for the majority of the population to support a radical solution which shaped itself to the unique circumstances of the island. A little analysis of the period will help us to understand the events that followed, paying particular attention to the fractious relationship between Cuba and the US and between the various tendencies that came together to form a revolutionary government.

In 1933–4, an insurgency had been mounted by the Stalinist-inflected Cuban Communist Party (PCC) against the military dictatorship of Gerardo Machado (former director of General Electric in Cuba), which had overseen the arrest, murder and deportation of union and labour leaders. This uprising was swiftly crushed by Batista, abetted by his allies in the US, who helped to install him as Machado's successor. By the time of the 1938 election, the PCC had joined forces with Batista and, the following year, the Cuban Workers' Confederation (CTC) was created under PCC control, voting against strike action and helping to keep Batista in power. In the early 1940s, two PCC leaders – Carlos Rafael Rodríguez and Juan Marinello, both of whom will recur in this narrative – were invited into Batista's cabinet.

By the 1950s, the Communist International (COMINTERN) had withdrawn its support from insurrection in the region, meaning that communism no longer represented a revolutionary option in Latin America. Added to this, famine and repression in the Soviet Union and McCarthyism in the US did little to convince the Cuban intelligentsia that international Marxism would

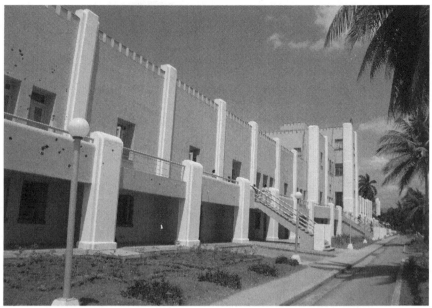

Moncada Barracks, peppered with gunshots following the assault of 26 July 1953.

better their situation. Admitting to being politically illiterate when he entered university, Fidel describes how, before he had studied any Marxist or Leninist material, he was a 'utopian Communist [which] is someone whose ideas don't have any basis in science or history, but who sees that things are very bad, who sees poverty, injustice, inequality, an insuperable contradiction between society and true development.'[17] And, while Marxist texts were consulted by some of the revolutionary leadership in advance of the attack on two of Batista's army barracks (at Moncada and Bayamo) on 26 July 1953 – which sparked the Revolution and gave the insurgent movement its name – they did not call themselves Marxist-Leninists. The daring barracks attacks were orchestrated with the intention of overthrowing the government rather than making a socialist revolution. When this action ended in devastating failure, Fidel and those 71 of his 132 comrades who had not been killed during or after the assault were tried and imprisoned on the Isle of Pines.

In May 1955, having served twenty-two months of their fifteen-year sentences, Fidel and his brother, Raúl, were released by the recently restored Batista. Two months later, they sought exile in Mexico, where they were introduced to Ernesto 'Che' Guevara de la Serna, an Argentinian with pronounced Marxist leanings, who immediately signed up as the physician of the nascent Revolution, becoming the first *comandante* of the Rebel Army two years later. According to the British Cubanist Richard Gott, 'Guevara provided Castro with broader horizons, a wider reading list, an insight into other revolutionary experiments and considerable first-hand knowledge of

 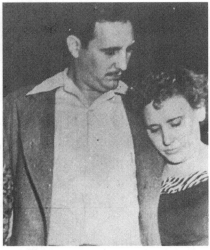

Ernesto Guevara, photographed by his father in Argentina, 1951.

Haydée Santamaría with Fidel Castro upon his release from prison, 1955. Courtesy of the Archive of Casa de las Américas.

Latin America. Castro gave Guevara a ready-made political cause, for which he had long been searching, as well as the benefit of his own brief experience in charge of an armed revolutionary movement'.[38] Also joining the Castro brothers during this phase of their adventure was Camilo Cienfuegos Gorriarán. Having received his early political grounding from family and friends, Camilo developed an affinity for Marxism through others in the 26 July Movement (which he joined in August 1956) and would prove himself Che's equal in battle.

While in Mexico, Fidel and his troops began to undertake training with a veteran of the Spanish Civil War. In November 1956, a total of eighty-two men boarded the diminutive *Granma* motor cruiser and set sail for the southeastern tip of Cuba. Running aground in early December, they missed the urban uprising that had been organised to distract the authorities in Santiago de Cuba (on 30 November 1956), which served instead as advance warning of their arrival. On 3 December, twenty-one members of the expedition were captured at Alegría del Pío, with the same number falling in combat from 5 to 16 December. Between 16 and 27 December, the remaining men regrouped in the Sierra Maestra mountains. The number of survivors from the *Granma* expedition is usually given as a biblical twelve, but the actual figure is twenty-one.[39] This small band of men set up guerrilla *foci*, designed to defeat Batista's troops in rural terrain, in an audacious campaign lasting just over two years.[40] At this time, the Communist Party – renamed the Popular Socialist Party (PSP)[41] – remained vehemently opposed to armed struggle until less than three months before victory.

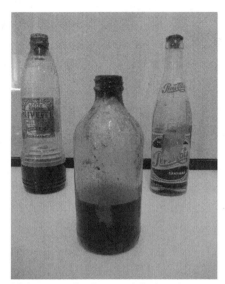

Molotov cocktails, used during the insurrection, on display at the Moncada Barracks.

In September 1958, Che and Camilo led columns from the Sierra Maestra into the interior of the island, culminating in a decisive action by the former at Santa Clara. When Batista was finally forced to flee the country for the Dominican Republic on New Year's Eve, 1958, Fidel urged the continuation of revolutionary action to overcome the military junta that had been installed. On 2 January 1959, Che and Camilo marched into Havana, followed by Fidel a week later, and the victorious guerrillas embarked upon a comprehensive campaign of nationalisation and redistribution which constitutes the second phase of the Revolution. Even then, many among the leadership remained sceptical about communism, and, in May 1959, Fidel would assert in the 26 July Movement's daily newspaper, *Revolución*, that 'capitalism starves people to death, [while] Communism [...] resolves the economic problem, but suppresses the liberties which are so dear to man'.[42] Moreover, the leaders were keen to emphasise that it had not been the old economic order per se that made the Revolution, nor was it a 'fight between peasants and landowners, or between wage workers and capitalists – either Cuban or Yankee; nor was it a direct nationalist battle between Cubans and any foreigners';[43] rather, young intellectuals had led an insurrection, abetted by the local peasantry, which had attracted widespread popular support. Departing from orthodox models, the revolutionary leaders felt that they:

> [...] did not belong to the old left intelligentsia – the older men who had gone through Communism and been disillusioned with Stalinism and with the purges and the trials and the 35 years of all that – we've had one enormous advantage as revolutionaries. We've not gone through all that terribly destructive process; we are revolutionaries of the post-Stalin era; we've never had any 'God That Failed.' We just don't belong to that lineage. We don't have all that cynicism and futility about what we're doing, and about what we feel must be done. [...] We are new men. That is why we are so original and spontaneous and so unafraid to do what must be done in Cuba. There really are no ex-radicals among us. We are new radicals. We really are, we think, a new left in the world.[44]

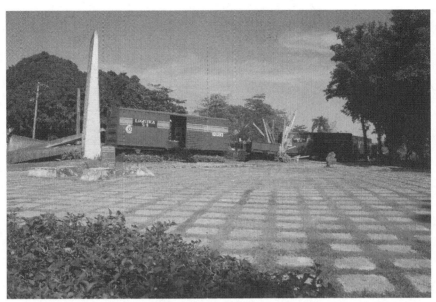

A train is derailed in Santa Clara following a decisive action by Ernesto 'Che' Guevara in 1958.

In the summer of 1960, the esteemed US sociologist, C. Wright Mills, visited Cuba, to be told by Fidel that his 1956 book, *The Power Elite*, had been bedside reading for many of the *guerrilleros* in the Sierra Maestra. The two men spent three and a half days together, devoting an average of eighteen hours a day to discussions, and Mills met several other key figures – including Osvaldo Dorticós Torrado, Che Guevara, Armando Hart Dávalos and Carlos Franqui – all of whom are integral to this study. Formulating his findings as an address to citizens of the US, entitled *Listen, Yankee*, Mills determined three main factors that would increase the political power of the PSP: anti-communist rhetoric being used by the US against Cuba; the revolutionary government persecuting the party; and, most seriously, the US making serious economic difficulties for Cuba or encouraging the organisation of counterrevolutionaries abroad in the name of anti-communism. History has shown that the US played its part most effectively. And, while there are those who claim that, rather than being a direct response to US hostility, it was the agency of the revolutionary leaders, while the Soviet Union was in the ascendant, which led to avoidable confrontations with the US,[45] the trigger for the Revolution's public conversion to Marxism was a specific act of US aggression.

On 15 April 1961, an air raid targeted Havana airport as a prelude to the invasion of Playa Girón (known to the English-speaking world as the Bay of Pigs) by CIA-sponsored paramilitary forces. The following day, at the funeral for those killed, Fidel would make explicit what he later claimed was 'already a fact'[46] – that the Revolution was grounded in socialism. And, although he

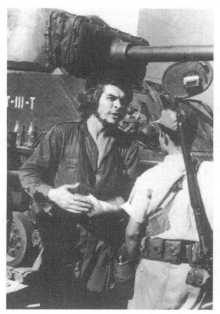

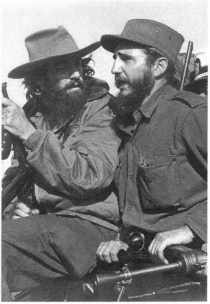

Che Guevara in Santa Clara, December 1958.

Camilo Cienfuegos and Fidel Castro, photographed by Luis Korda in Havana, January 1959.

has since been suspected of taking the short step from the realisation that his enemies were resistant to social change to the 'conviction that his program had been socialist from the beginning',[47] ten months earlier, on 28 July 1960, Che had said 'if you ask me whether this Revolution before your eyes is a communist Revolution, we would come say that this Revolution will be Marxist because it discovered, through its methods, paths which point to Marx'.[48] That same summer, the voice of Cuba had speculated that 'It was the U.S. pressure, it was the U.S. propaganda, it was what the U.S. has failed to do in connection with our revolution that has forced us, finally, to see that maybe we do *belong* in the Soviet political alliance'.[49] On 2 September 1960, the First Declaration of Havana defended the sovereignty and right to self-determination of the Cuban people and acknowledged the help offered by the Soviet Union in case of pro-imperialist attack, thus expressing 'without naming itself, the socialist character of the Revolution'.[50] Within Cuba, it is still widely perceived that 'The aggressive reaction of the United States precipitated the socialist character of a revolution that did not begin that way',[51] with the Bay of Pigs invasion prompting Cuba to approach the Soviet Union for help. On 16 April 1961, Fidel made it plain that 'What the imperialists cannot forgive us is that we are making a socialist revolution under their very noses',[52] and even the leadership's harshest critics were compelled to admit that the Revolution's conversion to Marxism had occurred through the struggle against US imperialism.[53]

Given that Marx had never envisaged a revolution taking place in a country lacking heavy industry or a class-conscious proletariat and the revolutionary leaders prioritised the contribution of peasants and students, Cuba's later reliance on canonical Marxist-Leninist texts may seem misplaced. But the second post-revolutionary President of the Republic, Dr. Osvaldo Dorticós Torrado – a former young communist and Minister of Justice in the first revolutionary government – would dismiss this perspective as orthodox, pointing out that 'Marx had fixed the final goal and explained the nature of the future society; the rest was simply a matter of discovering the right means. And the more appropriate the means the more quickly the ends would be attained'.[54]

Lenin had earlier explained that 'the only scientific distinction between socialism and communism is that the first term implies the initial stage of the new society, arising out of capitalism, while the second implies the next and higher stage'.[55] And, while Che Guevara argued 'for the desirability and possibility of achieving communism in Cuba without passing through the "necessary" stages of late capitalism and socialism'[56] and there are those who maintain that Cuba has found neither the means nor ends to either socialism or communism,[57] socialism was actively pursued until 1963,[58] followed by a sustained push towards communism during the remainder of the 1960s and throughout the 1970s before a reversion to the rhetoric of socialism.[59] Rafael Hernández, editor of the prominent Cuban magazine, *Temas* [Themes], concludes that 'the revolution was not a change of regime or the rise of a communist party to government, but a fundamental social transformation; it was and continues to be a process with deep social roots, as characterized by Marx and as can be found in the Cuban revolutionary tradition'.[60]

In light of the above, the volume of studies about Cuban culture that neglect, or negate, considerations of Marxism is astonishing, often leading to substitutions of the unfashionable 'M' word with euphemisms like 'modernity' or with antithetical concepts such as 'postmodernism'.[61] With regard to the latter, several commentators have pointed out that postmodernism – as it played out in the capitalist world – implied a rejection of the Enlightenment aims that had underwritten modernism, which presumed 'the accumulation of knowledge generated by many individuals working freely and creatively for the pursuit of human emancipation and the enrichment of daily life'.[62] As we shall see, postmodernism's renunciation of these emancipatory aims makes it inimical to the cultural approaches that have consistently been applied in Cuba. Moreover, it may be seen that artworks made on the island have never been derivative of those produced under the 'cultural logic of late capitalism',[63] nor privy to its scepticism; if it shares the visual eclecticism of postmodernism, this is because 'Cuban art continues to be both the product of the belief in and a tool for striving for the betterment of society, and it uses any means available'.[64]

Returning to Cuban disaffection with communist parties,[65] the Polish-born French journalist K.S. Karol, who conducted research in Cuba in the 1960s, details how, in the preceding decade:

> The PSP remained a party of the poor, highly disciplined, devoted, and often persecuted. And then someone else made the revolution in its place, and in so doing cast doubt on all its theories, tactics, and on its very *raison d'etre*. A party born for revolution and convinced that it had a monopoly in this field was suddenly forced to stand by almost idly while socialism triumphed all around. [...] Fidel did not blame them for their conduct during the anti-Batista struggle, simply because he had reached the conclusion that, at that stage, the Communist Party was no longer capable of making a revolution. If it had given the order for an insurrection against Batista, no one would have listened. This was due not only to the anti-Communist atmosphere prevalent on the entire American continent during the '50s, but also to memories of the tortuous history of the PSP. Fidel thus blamed historical circumstances rather than the men. But his judgment nevertheless implied a crushing political indictment, because what stronger condemnation is there of a Communist Party than the claim that it was honest, morally irreproachable, but had ceased to be a force capable of guiding or even influencing the course of events?[66]

When the option of joining revolutionary institutions became available, whatever rebellion might have been implied in joining the party during Batista's time evaporated.

Following Cuba's entry into the Soviet ambit, the position of the party shifted. Soviet support was made conditional on the rehabilitation of the PSP under the leadership of Aníbal Escalante Dellundé.[67] With membership estimated between 6,000 and 17,000,[68] the PSP was perceived as disciplined, organised, responsive to hierarchical structures and in possession of allies in Eastern Europe, all of which made it valuable to the Revolution. In July 1961, the 26 July Movement merged with both the PSP and the Revolutionary Student Directorate (led by Faure Chomón Mediavilla) to form the Integrated Revolutionary Organisations (ORI), with Aníbal Escalante as Organising Secretary. Of the twenty-five leaders of the National Directorate of the ORI announced by Escalante on 9 March 1962, fourteen were from the 26 July Movement, ten from the PSP and only one from the Revolutionary Directorate (its leader, Faure Chomón), a disparity which caused ructions within the fragile alliance.

During this early stage of building socialism, there was a heavy reliance on 'those who were not affected by either doubt or vacillation, on those who, by reason of their long-time militancy, offered absolute assurance concerning

their firmness'.[69] This meant that the orthodox communists of the PSP were momentarily permitted to dominate in the political sphere, and it is said that:

> [...] everybody in Havana knew that the old PSP formed the backbone of the ORI, that Aníbal Escalante was in charge of organization, his brother César of propaganda, Carlos Rafael Rodríguez of economic matters, Edith García Buchacha [sic] of culture – and that they were all Communist leaders of the old school. People even had the impression that Fidel Castro and his supporters from the Sierra were willing to play second fiddle to this old guard.[70]

Among the initial leadership of the ORI, those most relevant to this study include Fidel, Che, Dorticós, Armando Hart and Haydée Santamaría (from the 26 July Movement) and Carlos Rafael Rodríguez and Blas Roca (from the PSP). Edith García Buchaca is also integral to this story, and we will hear more about her position shortly.

As will become obvious, the two decades following the triumph of the Revolution, during which cultural policy was formulated, were characterised by a transitional political situation. Fidel has retrospectively detailed how the prestige of the Soviet Union combined with various 'idealistic mistakes', made by the revolutionary government in the first few years, to create a political 'culture favourable to the appearance and application in Cuba of the methods for the construction of socialism that were being applied in the Soviet Union and other socialist countries'.[71] As the rhetoric of socialism and communism was pursued, organisational forms inherited from the Soviet Union were toyed with, accepted and eventually rejected on the grounds that they were making 'ever greater use of the categories and mechanisms of capitalism [...] the poison that was killing socialism'.[72] In the short term, revised leadership of the ORI was announced on 22 March 1962, with Blas Roca as the PSP's only representative.

As might be expected in such a volatile atmosphere, several disparate approaches to culture vied for supremacy. Karol's account, written from an anti-communist perspective, describes how, when confronted with a plethora of Cuban cultural products that might embarrass visitors from the Eastern Bloc, 'the Communists asked for a free hand to bring some sort of order into this cultural and ideological jungle. [...] The cultural leaders, foremost among them Mrs. García Buchacha [sic], would have liked but were unable to supply their country with socialist culture imported from Russia in ready-made, easy-to-digest form'.[73] This orthodox approach to culture, and the consequences arising from it, will be interrogated in due course.

Interim President of the National Union of Cuban Writers and Artists (UNEAC) Graziella Pogolotti offers a more nuanced explanation that, 'as in every process of this type, there were distinct tendencies within the Revolution

[...] within the intellectual realm was an area which came from an orthodox Marxist tradition and another very important tradition which came from the left, in some cases Marxist, but which understood what Stalinism had meant for art and literature'.[74] With this in mind, the polemics of the period under consideration will be probed extensively throughout, providing an insight into the main points of contention between rival camps. In considering such a heterogeneous policy landscape, this book draws upon a range of sources, cross-referencing government documents with the perspectives of practition-ers, allowing the gap between rhetoric and reality to be assessed. Spanning conceptions of culture in capitalist and socialist societies and their respective implications for expressive freedom and the role of intellectuals, these discus-sions remain hugely pertinent today.

The Centrality of Culture to the Revolution

While Marx had regarded creative activity as an end in itself – rather than a utilitarian means – this did not imply that art and literature were gratuitous. Even before the revolutionary government in Cuba officially adopted socialism, a socially consequential role for art and literature had been firmly embraced. In November 1960, the country's artists and writers issued a manifesto align-ing them with the Revolution and its people, which is included as Appendix A and will be discussed in chapter four. Acknowledgement of the relationship between art and social life is consistent throughout the rhetoric of the revo-lutionary government during the period covered by this study, with the first formal interpretation of the government's position on culture stating that 'In socialist society, it is logical to aspire for writers and artists to have intimate contact with life'.[75] In a reversal of the experience of the historical avant-garde, Cuban practitioners have largely left aesthetic regimes unchanged, integrat-ing vernacular elements into the canon rather than challenging the Western (capitalist) aesthetic mainstream.[76] But, by maintaining the aim of breaking down the barriers between artists and the people (long ago dropped by the European and US avant-gardes), the Cuban experiment has realised itself in the most ambitious reconciliation of art and society to have taken place to date. The ethos underlying this development and the precise steps through which it was achieved will be dealt in greater depth with as this story progresses.

Just as Antonio Gramsci describes culture as a 'basic concept of socialism, because it integrates and makes concrete the vague concept of freedom',[77] so Pogolotti observes that, when the socialist character of the Revolution was affirmed, this implied that the role of culture would be revalorised.[78] While capitalism has consistently been regarded as alienating art from both its crea-tors and the society in which it is made – thereby diminishing its potential contribution to the betterment of humanity and the achievement of social justice – the revolutionary government continues to argue that socialism

recognises the true value of art and literature. Cultural works, past and present, were embraced as part of the shared patrimony, while material stability was offered to artists at the same time as their social role was vindicated. And so it was that, against a backdrop of major socio-economic upheaval at home and hostility being orchestrated abroad, the revolutionary government made its commitment to culture.

In relation to the two primary determinants of cultural policy and by contrast to the capitalist model sketched above, we can say that the social role of culture was acknowledged by the state and provided for accordingly. At the first congress of the rejuvenated PCC in 1975, it was observed that 'The Party, beginning in its historical work of constructing a socialist society, highly values the singular importance of the development of the artistic culture of our country'.[79] Within a few months of revolutionary victory, two pioneering cultural institutions – the Cuban Institute of Cinematographic Arts and Industries (ICAIC) and Casa de las Américas [House of the Americas] – would be founded by influential figures with close connections to the leadership, and remain hugely important fifty years on. In the next chapter, an analysis of these and other cultural institutions will be undertaken, through a consideration of governmental and legislative documents and an examination of their personnel and *modi operandi*.

A Uniquely Cuban Approach to Culture

Previous attempts to distinguish the Cuban ideological variant from that developed in the Soviet Union have had recourse to the notion of 'Martían Marxism', which Che Guevara is credited with having introduced into the constitution.[80] This implies a Marxism tempered by the insistence of the nineteenth-century Cuban poet and revolutionary José Martí on resistance to US imperialism being mounted across 'Our America' – a phrase that would become shorthand for continent-wide resistance to imperialism.[81] Yet, while the ideas of Martí indisputably influenced the broader ideology of the Cuban Revolution from Moncada onwards and the reconciliation of Martí and Marx would come to be regarded as alien to the dogmatism that had led to the installation of socialist realism in Europe, post-revolutionary cultural policy documents refer not to Martían Marxism but to Marxist humanism.

The humanistic roots of Marx's philosophy find their clearest articulation in the Economic and Philosophic Manuscripts of 1844, first published in English in 1959, and interested readers are referred to the original source. These manuscripts demonstrate that 'the very aim of Marx is to liberate man from the pressure of economic needs, so that he can be fully human. [...] Marx is primarily concerned with the emancipation of man as an individual, the overcoming of alienation, the restoration of his capacity to relate himself fully to man and to nature'.[82]

The revolutionary objective of total human emancipation is further elaborated by Marx and Engels in *The German Ideology* of 1846. This argues that political emancipation must be accompanied by its social equivalent and that both of these abstract concepts must be underwritten by a detailed understanding of humanity.[83] For Marx and Engels, one of the key considerations in advancing emancipation was consciousness. Determined by material conditions and social relations, consciousness was taken to be grounded in the sensual awareness of one's surroundings, transcending the instinctive to become a rational social product. And, while heightened consciousness alone would not bring about revolution, it would enable an appraisal of current conditions to be made in advance of trying to better them.

When contemplating the humanistic character of Cuban Marxism, the work of Argentinian writer and politician Aníbal Ponce is of particular relevance. In 1935, Ponce undertook a detailed study of the humanism that had arisen in the capitalist world, finding it to be centred on a 'conception of man in whom individuality implies absolute autonomy [...] detached from any social stratum, category or class' and concluding that class society made the idea of universal culture impossible.[84] Analysing individual and social consciousness from a dialectical materialist perspective, Ponce found unity to exist between humanity and the natural and social world. Within this formulation, he proposed that culture could be understood as a form of social consciousness that encompassed individual consciousness. For him, the Russian Revolution had paved the way for the emergence of a proletarian humanism, as a 'consequence of the revolutionary process and the concomitant appearance of the new man'.[85] Later, we shall see that Ponce's distinction between bourgeois and socialist humanism would be reiterated at the first congress of the PCC, and his thinking around consciousness and the new man would reinforce Che's ideas, conferring a particular responsibility onto cultural producers in the process.

In 1958, Raya Dunayevskaya published *Marxism and Freedom*, which sought to excavate the humanism intrinsic to Marx. As Herbert Marcuse explained in his preface, freedom presumes an 'existence without toil, poverty, injustice, and anxiety' – which is simultaneously enabled and repressed within advanced capitalist society, necessitating revolutionary seizure of the means of production with human freedom as its ultimate aim.[86] As we have seen, the stage of industrialisation envisaged by Marx as a precursor to revolution had not been reached in Cuba, meaning that the technical means for achieving freedom needed to be built at the same time as its philosophical underpinnings. For Dunayevskaya, Marxist humanism as a theory of liberation was the 'only genuine ground from which to oppose Communist totalitarianism'.[87] In the absence of a counter-model, she absolutely equated communism with totalitarianism and the 'theory and practice

of enslavement',[88] inadvertently excluding her compelling work from Cuban considerations.

It would fall to the Spanish-born Mexican Marxist aesthetician Adolfo Sánchez Vázquez (whose lectures on aesthetics would be influential upon Cuban intellectuals in the 1960s) to broach the logical gap between Marxist humanism and cultural production, by arguing that 'artistic creation and aesthetic gratification presupposed, in Marx's eyes, the specifically human appropriation of things and of human nature that is to prevail in a communist society, a society that will mark humanity's leap from the realm of necessity into that of true freedom'.[89] In this formulation, both (passive) appreciation of and (active) engagement in creative practice would be vital to building a better world foreshadowed by human desire. As will be seen throughout this study, the harnessing of creative work to the project of building a new society implicated culture within the broader terrain of ideological struggle, investing it with a social significance found wanting in the capitalist world.[90]

Above all, then, this book seeks to isolate the main tenets of Marxist-humanist cultural policy as it evolved in Cuba from 1959 onwards. That said, this is not an attempt to reinvent the wheel, and precedents for the discussions outlined here will be mentioned throughout, from early Soviet experiments in cultural policy to discussions around aesthetics in 1930s Germany and the germ of cultural democratisation that manifested itself in Poland from the late-1940s to the mid-1950s.

A Subject for the Object

In considering the ways in which culture was conceived in Cuba, we find that, during the insurrectionary years, culture remained synonymous with education. So, for example, the defence speech Fidel made at the trial for his part in the 1953 Moncada attacks made reference to education.[91] Similarly, the seventh clause of fifteen in the first manifesto issued by the 26 July Movement, while the Castro brothers were exiled in Mexico, pointed to the essential 'Extension of culture, preceded by reform of all methods of teaching, to the furthest corner of the country in such a way that every Cuban has the possibility of developing their mental and physical aptitudes'.[92]

Having coordinated a guerrilla campaign in the densely forested terrain of the Sierra Maestra for more than two years, the triumphant revolutionaries turned their attention to ironing out the inequalities that persisted in rural areas. The broader rationale for this is to be found in Lenin's assertion that 'in order to abolish classes completely, it is not enough to overthrow the exploiters, the landlords and capitalists, not enough to abolish *their* rights of ownership of the means of production, it is necessary to abolish the distinction between town and country, as well as the distinction between manual workers and brain workers'.[93]

The 1961 literacy campaign saw 250,000 urbanites going into the countryside to teach illiterate members of the population to read.

Fidel asserts that Che 'wanted his first action as a military commander to be putting in place his literacy programme and teaching all combatants'.[94] From April 1959, the National Institute for Agrarian Reform (INRA) began a modest programme of literacy work under Che's command. In October 1960, preparations were made to extend this programme nationally. On the understanding that writing and related activities would be a first step in reducing inequality to a minimum, the Cuban government launched an ambitious strategy. On 22 September 1960, Fidel announced at the United Nations General Assembly that the Revolution would eradicate illiteracy within a year.[95]

During 1961, which became known as Year of Education, a census was conducted which, by the end of August, had identified 985,000 illiterates. The universities were closed, and some 250,000 urbanites (among them 100,000 students), armed with politicised teaching manuals, oil lamps and oversized pencils, were sent out into the countryside to teach the peasant population to read. A specially designed flag was hoisted in villages to signal the eradication of illiteracy, which, within one year, dropped to just 3.7 percent. To put this in context, the *Skills for Life* survey – commissioned by the UK Department for Education and Skills in 2001 – found that 5.2 million (8.8 percent) adults of working age had lower than basic (G grade GCSE) literacy, which was found to correlate closely with their earning potential.[96] Similarly, in 2009, the US Education Department published the findings of its *National Assessment of Adult Literacy*, which showed that one in seven US adults (14.3 percent) could not read anything more complicated than a children's book.[97] At the time of writing, Cuba is cited as having the second highest literacy rate in the world, with the UK and US falling forty-fourth and forty-fifth respectively.[98]

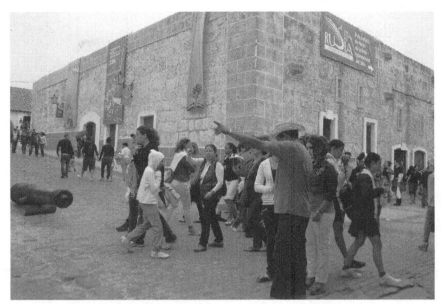

The international book festival, which tours the island annually, is a testament to high levels of literary in Cuba.

In a pamphlet published by UNESCO at the end of the 1970s, it was claimed that the Revolution had kept its promise in 'an extraordinary feat on the part of the Cuban people who, in but one year, succeeded in eradicating an evil considered as insuperable in more developed countries'.[99] And, while it may be argued that only basic literacy was mastered and just as easily forgotten, with some refusing to participate in this costly and occasionally dangerous campaign,[100] at local and international levels the literacy campaign came to define the energy and experimentalism of the Revolution, massively transforming rural areas and providing a revolutionary role for teenagers who had been too young to participate in the armed struggle.

The momentum of the literacy campaign was continued into education more broadly, and grants were made available to students wishing to train as teachers. Initially prioritising those who had worked within the literacy brigades, the first 40,300 grants were made; by the first semester of 1961, this had risen to 50,000 and, by the start of courses in 1974–5, to 542,000.[101] A school for student teachers was set up at Minas del Frio in the Sierra Maestra, training young people from every province who would disseminate their skills throughout the mountainous region around the school and beyond.

The programme for training new teachers inevitably stimulated an increase in the number of children entering primary education, with 717,000 alumni in 1958–9 multiplying to 8 million entrants in 1967–8. The same picture is seen at secondary and tertiary levels, along with the intention of increasing not only the quantity but also the quality of educational opportunity

Moncada Barracks, converted into a school following the triumph of the Revolution.

for revolutionary students. Such a pronounced commitment to education found its way into the balance sheets of the revolutionary government, and so, whereas Batista had invested 79.4 MMP [million pesos] in education in 1957–8, this had jumped to 260.4 MMP by 1965 and to 741.5 MMP by 1974. At the same time, the school curriculum was changed to reflect the aims of the new society, with individualism being discouraged in favour of cooperation.

A century before the Cuban Revolution, Marx had implicated art in the production of social life, explaining that, just like any other product, the art object 'creates a public that has artistic taste and is able to enjoy beauty',[102] which meant that artistic productivity 'produces not only an object for the subject, but also a subject for the object'.[103] While raised educational levels played a part in uniting rural and urban populations, they also signalled the emergence of an audience capable of enjoying cultural production and playing an active part in the creation of artistic and literary works. In 1971, the First National Congress on Education and Culture (discussed in chapter seven) would attest in relation to mass education that 'the literacy campaign, the nationalisation of teaching and the means of mass communication, the plans for grants and the creation of cultural institutions were essential premises of this transformation. From this followed in the people the eagerness for books, theatrical works, films, art'.[104] In this way, burgeoning literacy may be regarded as the foundation stone of the discussions in these pages, priming a population for informed participation in culture.

At the end of the 1960s, the respected Uruguayan novelist, poet and journalist Mario Benedetti, who had been visiting Cuba since 1966, observed that:

> Education on so massive a scale [...] has created a craving for culture that cannot always be met by the present Cuban artists and intellectuals, and this is easy to understand: a culture is not improvised in a decade. Of course, there is always someone who demands great creations, legitimate masterpieces on the topics to which the revolution gives rise every day, and that, without doubt, is a demand that has not been fully met to date.[105]

By then, the revolutionary government had become alert to growing cultural demand. At the First National Congress of Writers and Artists in August 1961 (discussed in chapter four), President Dorticós told his audience that 'In the first years of a Socialist Revolution, most of the attention is absorbed by emergencies and the fundamental priorities of the work of a Revolutionary Government. Evidently, it would be a luxury to discuss literature and art had we not first discussed production in our country'.[106] Once sovereignty had been established on solid economic foundations, it became not only possible but also necessary to consider culture.

By the time of the 1961 congress, building work had begun on an ambitious complex of five national art schools, which, it was estimated, would provide professional training for an initial 600 alumni. Beyond this professional milieu, the same anti-elitist ethos that permeated the broader educational field found its way into cultural education, and one of the most important implications of Cuban cultural policy after 1 January 1959 is that 'the Revolution took culture "to the people" in a process of conscious democratisation'.[107] Similar in scope to the literacy campaign, a programme was implemented to train tens of thousands of new art teachers which, in turn, led to the creation of up to a million amateur artists in a population of around seven million. This tendency of the revolutionary government towards widening access to, and involvement in, culture will be explored in more detail in chapter five.

By the time of the Cultural Congress of Havana in 1968 (discussed in chapter six), Dorticós proclaimed 'the need for literature and art in a revolution – above all in a revolution', which led the government to invest in culture before more direct industrial measures were taken.[108] By the end of the 1970s, it could be said that:

> All this fruitful concern for the advancement of culture took tangible shape in a country devoting the bulk of its resources to a gigantic task of economic and social development, while beset by all kinds of aggression and blockade. Nothing can better testify to the importance which

the people, the State and the Communist Party of Cuba attach to art and literature as instruments of the advancement of society and of the inalienable rights of man.[109]

As these statements imply, culture was not prioritised at the expense of economic and social development; rather, material recovery was bound up with the cultural progress of the nation.

Marx had consistently incited a departure from considerations of material wealth and poverty – which typify political economy under capitalism – in favour of human richness and spiritual nourishment. In June 1961, Fidel asserted that:

> [...] just as we want a better life for the people in the material sphere, so do we want a better life for the people in a spiritual and cultural sense. And just as the Revolution is concerned with the development of the conditions and forces that will permit the people to satisfy all their material needs, so do we also want to create the conditions that will permit the people to satisfy all their cultural needs.[110]

While this understanding of culture as an integral part of fostering the new spirit of society will be explored in greater depth in chapter three and beyond, it was immediately clear that the definition of culture would have to be broadened in the society under construction. Supplanting purely educational understandings, culture came to be defined as both 'all the creation of a human community' and 'literature, the arts and thinking', with a tendency to prioritise the latter over the former.[111] The notion of culture as artistic creation overflowed into conceptions of culture as part of a conscious process of construction which had human growth as its ultimate purpose.

The Cultural Gains of the Revolution

As in the case of health and education, the pre-revolutionary picture must be borne in mind when considering the cultural gains of the Revolution. Nicola Miller at University College London argues that there is every reason to believe that the triumphant guerrillas acknowledged the 'importance of culture to the legitimacy of the revolutionary government' because:

> When the *comandantes* came to power, culture had long been embedded in Cuban concepts of what it is to be fully a human being and a citizen. [...] the revolutionaries themselves grew up in the context of this tradition, and their own political views had been shaped by it. Thus the revolutionary government did not so much try to found a wholly new culture as seek to connect the radical elements of Cuba's existing cultural traditions to the revolutionary project of cultural decolonisation.[112]

As Miller points out, the comparatively enlightened constitution of 1940, produced under Batista's first presidency,[113] included a fifth section split between family and culture. While the emphasis of the latter subsection is on education, culture is cited as a 'fundamental interest of the state' alongside the assertion that 'scientific research, artistic expression and the publication of their results are free'.[114] In February 1959, the Fundamental Law of the Republic, which would serve as the Cuban constitution for almost two decades, reiterated this wording exactly.[115]

Yet, despite acknowledgement having been made of the strategic importance of culture before the Revolution, conditions for its production and dissemination had generally been regressive. Armando Hart – who would serve as the first post-revolutionary Minister of Education and then Culture – has charted the ways in which the annexation of Cuba to the US in the twentieth century had retarded the cultural development of the island, subordinating culture to the parasitic interests of a neocolonial bourgeoisie and preventing the evolution of a culture with profoundly Cuban roots.[116] The first issue of the influential journal *Nuestro Tiempo* [Our Time] to be published after the triumph of the Revolution voiced the frustration of a generation, describing how Batista's henchmen had not only engaged in acts of physical repression but also deprived people of the right to think or to express their thoughts through the known means of distribution.[117] Similarly, Ambrosio Fornet – a writer whose work is central to this study – has reflected on the pre-revolutionary Era of Contempt, in which 'to write, paint or read poetry were suspicious acts that ought to be executed in the strictest secrecy'.[118] The cultural climate of the 1950s was perceived as stultifying, and 'most of the artists, lacking all social and economic support, lived on the fringe of society or were accepted only for the entertainment of minorities. Hundreds of talents were frustrated in this hostile environment. What was encouraged was sensationalism, glib entertainment and escapism in art'.[119] This situation forced many prolific artists and writers into voluntary or political exile in Europe and Latin America.[120]

Lisandro Otero – a novelist who would occupy key administrative positions in the revolutionary landscape – documented the Cuban cultural field of the 1950s, describing how 'Economic insecurity, subservience to the tastes of the ruling class, the commercialization of art, the scanty possibilities of getting to the top, and the intervention of unworthy political consideration were characteristic of the milieu in which art in Cuba had to be pursued, with great difficulty, before the advent of the Revolutionary Government'.[121] And, in an autobiographical statement to the 1968 Cultural Congress of Havana, another writer, Onelio Jorge Cardoso, would describe how:

> [...] life and work in the pre-Revolutionary years were marked by frustration and humiliation. Publication was accorded to the privileged few

who were sycophantic and dishonest and who were aspiring for political favours. The writer who was poor and without connections was lost. He was alone. He was unheard. The Revolution has changed the situation radically. The intellectual now has a free voice and the people know what he is saying, and they in turn are given the opportunity to hear him.[122]

In much the same way, the novelist and playwright Eduardo Manet described how, in former times, taking the decision to become an artist implied living at the margins of society, publishing books with one's own money or struggling to gather together enough funds to stage a theatrical performance. For him, the worst consequence of this state of affairs was the feeling of uselessness that it conferred upon creative practitioners.[123] Fidel's official photographer, Alberto Korda – who captured the iconic image of Che that has been reproduced exponentially the world over – is taken to be exemplary of the sense of responsibility that was assumed by creative practitioners after the Revolution: 'Like many another middle-class Cuban, Korda had been a happy-go-lucky hedonist whom the victorious revolution struck with moral lightning. It bestowed upon him perhaps its greatest gift – a sense of identity and direction, of counting for something. His perspective changed completely. For the first time in his life, he says, he became concerned about other people'.[124] In interview in 2010, Pogolotti movingly explained how, before 1959, it would bring disgrace upon a family if one of its members decided to become an artist, because it was regarded as dedicating oneself to something senseless and useless;[125] by contrast, many parents now inspire their children to become artists – a vocation that is highly respected in contemporary Cuba.

Charting the Trajectory of Cuban Cultural Policy

When charting the trajectory of Cuban cultural policy, mid-1961 is generally taken to signal the beginnings of its official elucidation, by virtue of a landmark speech Fidel delivered in June of that year, but the events leading up to this point have not been sufficiently considered. An important juncture from the early years is a little-discussed meeting that took place between artists and writers in October 1960. This resulted in the aforementioned manifesto being issued, which would provide the basis of the First National Congress of Writers and Artists in August 1961. In the course of analysing such developments in chapter four, it has proven essential to delve deeper into the 1950s to find the precedents for these discussions.

As may already be apparent, the process of devising and implementing revolutionary cultural policy was not without its paradoxes, and the various waves through which it passed will be assessed in their appropriate historical and geopolitical context. The generally accepted lineage is that the 'first

discordant note sounded with the closing down of the weekly cultural supplement *Lunes de Revolución* [November 1961], its first major schism came with the Padilla case [1968–71], and the process of officially imposed "cultural parameters" that ushered in a period of profound dogma following the 1971 Congress of Education and Culture'.[126] In chapters four to seven, this calendar of ostensibly opaque or unrelated events, and the claims associated with them, will be unravelled through a chronological discussion of the various congresses and confluences that occurred in the 1960s and '70s. In national terms, the congresses convened in 1961 and 1971 stand out as milestones within this early period, while the Cultural Congress of Havana (January 1968) extended local and regional discussions into an international arena. Interweaving these high-profile events, informal convergences – of artists, writers, governmental figures and cultural functionaries – played a necessary part in defining the trajectory of domestic cultural policy, and will be discussed at some length.

It is universally recognised that a shadow fell over Cuban creativity in the wake of the 1971 congress. In 1987, Fornet condemned the period between 1971 and 1976 as the *quinquenio gris* [five grey years], later accepting that those castigated during this era may prefer the term *decenio negro* [black decade].[127] For Desiderio Navarro – editor of the journal *Criterios*, which emerged in 1972 to counteract the repressive forces of the period by offering an alternative to Soviet-derived approaches – the immediate acceptance by the government of the euphemistic phrase 'five grey years' underplays the fifteen years between 1968 and 1983 that may be attributed to this dark period.[128] With this in mind, the events giving rise to the *quinquenio gris* over an elongated period will be explored at the relevant moment.

Two things are notable about the five years identified by Fornet and acknowledged by the revolutionary government. The first is that they coincided with a shift in the way in which culture was administered, specifically through a change of leadership at the National Council of Culture (CNC) – a body established in January 1961, under Edith García Buchaca, to interpret and implement the cultural policy of the revolutionary government – at the same time as this state organisation was reorganised to confer maximum power upon its president. In chapter seven, it will be necessary to draw out this connection in order to establish the source of the dogma that emerged during this era. The second noteworthy point is that contemporaneous discourse among artists and writers, often centred on more open-minded cultural institutions, offered some resistance to the prevailing strictures. Important in this regard is a series of meetings between Latin American plastic artists that took place at Casa de las Américas during the 1970s, and chapter seven will also include an attempt to locate the grey areas within the grey years. As for the official end point of the grey years, it is well documented that, in the wake of the first

PCC congress in December 1975 – which presaged the opening of the Ministry of Culture (MINCULT) the following year (fully operational from 1977) – state control of culture was loosened. As such, this book covers developments up to the second half of the 1970s in order to encompass this period.

While there are as many versions of pre- and post-revolutionary history as there are writers on the subject, it has been necessary to ground this study in a handful of relatively unassailable historical facts. Mindful of the impossibility of considering cultural developments in a vacuum, a range of resonant events is laid out in the timeline which forms Appendix B. It is hoped that this will guide the reader through territory that may not be immediately familiar.

It has already been seen that the Cuban leadership has long acknowledged the importance of culture.[129] Among others, Fidel has often expressed the view that humankind's happiness is the ultimate revolutionary aspiration, and that culture should be considered one of the means of achieving this. Publicly preferring sport to art, the figurehead of the Revolution has demarcated the limits of his knowledge in the field of culture to assert, on behalf of the revolutionary government, that 'We don't suppose that all the political leaders should have an encyclopedic knowledge and be in a position to speak the last word on matters of culture and of art. I would not consider myself sufficiently skilled to make decisions in that realm without professional advice from really qualified people in whose sound and revolutionary judgment I could trust'.[130] Just who those qualified people might be is established in the chapters that follow, through close scrutiny of published memoirs and transcripts of discussions staged in response to a constantly changing situation.

It quickly becomes clear that various individuals – guerrillas turned institutional figures, practising writers and artists – helped to shape emerging policies on culture. Significantly, however, the Soviet concept of the *commissar* – or high-ranking bureaucrat – is irrelevant to the Cuban cultural field. In fact, the only time we see this appellation appearing in the literature is in relation to those responsible for the repressive tendencies that befell culture in the 1970s, which will be discussed in chapter seven.[131] In elucidating the various interests at play, this study makes firm distinctions not only between the 26 July Movement and the PSP but also between individual members of both organisations. Referring extensively to documents held in Havana, light will be shed upon the personal dynamics which brought about the most significant discursive shifts.

In the process, detailed consideration will be given not only to the ways in which the revolutionary government consolidated its position on culture but also to the ways in which the cultural communities envisaged and enacted their contribution. An analysis will be undertaken of the shifting role that was adopted by, and assigned to, artists and writers in shaping individual and

collective identity as part of a constructively critical process at the vanguard of revolutionary society. Departing from popular top-down conceptions of Cuban policy formation, this account reinstates a role for artists and other creative intellectuals in thwarting dogmatism and refocusing the main points of the debate.

A Focus on the Plastic Arts

Just as the social, political and economic backdrop against which cultural policy is formed is integral to its understanding, the cultural modes emerging from said policy speak volumes about the direction in which culture is travelling. It has been shown, for example, that film 'offered an unparalleled opportunity for cultural revolution',[132] and that drama was initially identified as a 'preferred form for developing cultural awareness and latent talent, stimulating a boom in local amateur performance' by taking 'revolutionary theatre outside Havana to the peasantry, copying early Soviet efforts in the use of culture as an instrument of revolutionary change'.[133] Writing thirty-five years after the triumph of the Revolution, the artist and German-born citizen of Uruguay Luis Camnitzer would describe how, 'in pragmatic terms, art provides Cuba with an internationally perceivable image. The Cuban government support of the arts addresses this factor with an interest in ensuring that Cuban artists excel in their trade on the international scene, very much as with Cuban athletes'.[134] This refers to the *artes plásticas*[135] – or plastic arts – which, with an initial emphasis on painting, 'proved most capable of fusing the outward gaze and endogenous expression'.[136] In the mid-1960s, the US photographer Lee Lockwood, who spent considerable time in Cuba, would describe how:

> Perhaps the liveliest of all Cuban arts is painting [...] painters feel free to experiment with new styles and unpopular ideas. Raúl Martínez paints critical canvases in pop style utilizing multiple images of Fidel and Che; Antonia Eiríz' giant expressionist canvases evoke a tortured world akin to that of Francis Bacon; Amélia Peláez and René Portocarrero are older non-objective painters whose work is known internationally but who still live and work in Cuba. So far, Cuba has not attempted to coerce her artists to produce only such art as can serve as propaganda for the Revolution.[137]

Similarly, within Cuba, it is noted that 'A visible modification of the Cuban landscape was produced at street level and everyday life, associated with the role of art and its forms of exhibition and relation with the public'.[138] As we shall see, this involved a revalidation of the utility of art and the proactive engagement of spectators in public places, including those beyond the museums.

That said, Antoni Kapcia reminds us that, 'in tracing any community's cultural history, we should not focus principally, or at all, on the products of a culture (since that inevitably privileges forms that have been recorded and accorded prestige by those who control or dominate the means of communication and dissemination) but, rather, on the individual processes of creation and on the collective sites and communities for creation, authority-bestowing and change'.[139] As such, except to acknowledge some general trends in artistic practice in relation to the Revolution, this study will not dwell on individual artworks or oeuvres. Yet, while Cuban film,[140] music[141] and literature[142] have all received genre-specific treatment, the relationship of art to the policies developed to support it has been less evident.[143] In an attempt to redress the balance, primacy will be given to data pertaining to visual forms. This fits with Fornet's observations about his position in relation to literature as 'the only field that I know through my own experience'.[144]

A Note on Style by Way of Conclusion

As has perhaps already become evident, Fidel will be identified by his first name, in recognition of the way he is referred to by the people of Cuba while serving to distinguish him from the other historically important Castro, his brother, Raúl. The same informal approach will be applied to Che (thus avoiding confusion with the unrelated Alfredo) Guevara and to Haydée Santamaría (who emerges as a key cultural figure), and is in no way intended to imply irreverence. It is also worth noting that two surnames are used in Latin America – father's first, then mother's – but that one of these is often dropped (usually the latter). Thus, where relevant, people's full names will be given the first time they are mentioned then the less formal nomenclature will be adopted. Other central personnel will be contextualised in the body text, while those who are mentioned in passing will have their credentials outlined in a footnote to aid identification. Beyond this and the attribution of direct and indirect quotations, explanatory notes will be kept to a minimum. However, as the majority of this research was conducted under the auspices of a doctorate at the University of Strathclyde, with the source of every assertion meticulously referenced (except the chapter on the Cultural Congress of Havana of 1968, which was excised due to lack of space), those wishing to refer to the material from which this story is constructed should be able to access the original thesis, a copy of which is also held as part of the Hennessy Collection at the University of Nottingham.

Somewhat surprisingly, many of the texts commenting on the Cuban situation use US English, which will be retained here only for direct quotations, being bracketed by UK/international English on either side. A handful of linguistic anachronisms persist in texts cited from the period, notably the use of 'man', to mean humanity; 'the masses' used interchangeably with 'the

people'; and 'Third World' to refer to underdeveloped countries (the appropriateness of which was already being questioned by the time of the Cultural Congress of Havana in 1968, which took underdevelopment as its main theme). Also on the subject of language, this research has been conducted for the benefit of those who do not necessarily read Castilian (as the Spanish language tends to be known in Latin America), which means that indigenous terms are given in English translation throughout. The only exceptions to this general rule are proper names – of organisations, such as Nuestro Tiempo and Casa de las Américas, and newspapers and journals, such as *Granma*[145] and *Revolución y Cultura* [Revolution and Culture] – which are retained in their original in the body text with any necessary explanation being given. And finally, while the Revolution may not be televised, it will be capitalised, when appearing as a noun. This serves to indicate its significance, which is common among those commentators sympathetic to the political, social and cultural transformations it signalled. But, rather than being simply a 'bland confession of partisanship',[146] this research attempts to objectively examine diverse standpoints and historical evidence in a bid to understand the ways in which culture may be re-imagined as both anti-elitist and anti-dogmatic.

NOTES

1 Jochen Shulte-Sasse, 'Foreword: Theory of Modernism Versus Theory of the Avant-Garde', P. Bürger, *Theory of the Avant-Garde* (Minneapolis: University of Minnesota Press, 1984 [1974]), p. x.

2 Shulte-Sasse, 'Foreword', p. xi. See also Larry Shiner, *The Invention of Art: A Cultural History* (Chicago and London: The University of Chicago Press, 2001).

3 Gustave Courbet, *Realist Manifesto*, 1855.

4 See Michael Inwood, 'Introduction', *Georg Wilhelm Friedrich Hegel: Introductory Lectures on Aesthetics* (London: Penguin Books, 2004 [1886]), with the specific quotation appearing on p. xiii.

5 Walter Benjamin, 'The Work of Art in the Age of Mechanical Reproduction', C. Harrison and P. Wood (eds.), *Art in Theory 1900–1990: An Anthology of Changing Ideas* (Oxford: Blackwell, 1992 [1936]), p. 514.

6 See Immanuel Kant, *The Critique of Judgement* (Oxford: Oxford University Press, 1790).

7 Terry Eagleton, *The Ideology of the Aesthetic* (Oxford: Basil Blackwell, 1990), p. 28. Pierre Bourdieu had earlier defined this branch of philosophy, which relies on individual taste, as a lever with which the privileged exert their dominance in *Distinction: A Social Critique of the Judgement of Taste,* (London: Routledge, 1984).

8 Mario de Micheli, *Las Vanguardias Artísticas del Siglo XX* [The Artistic Vanguards of the Twentieth Century] (Havana: Ediciones UNIÓN, 1967).

9 See Susan Buck-Morss, *The Origin of Negative Dialectics* (Hassocks: The Harvester Press, 1977), p. 32.

10 Bürger, *Theory of the Avant-Garde*, p. 24.

11 See Hal Foster, *The Return of the Real: The Avant-Garde at the End of the Twentieth Century* (Cambridge, MA: MIT Press, 1996).

12 See Richard Witts, *Artist Unknown: An Alternative History of the Arts Council* (London: Warner Books, 1998).

13 The ardent Conservative Sir William Rees-Mogg was appointed in 1982 and the property developer, Lord Peter Palumbo, in 1989. Fast-forwarding to the twenty-first century, we find that the Conservative-dominated coalition government, which came to power in 2010, unceremoniously declined to renew the tenure of Arts Council chair, Dame Liz Forgan, and that neoliberal think tank, the Institute of Economic Affairs, has recommended the closure of the UK government's Department for Culture, Media and Sport.

14 This consideration of the corporate invasion of the cultural field is taken from Chin-tao Wu, *Privatising Culture: Corporate Art Intervention Since the 1980s* (London: Verso, 2002), with the specific quotation found on p. 47.

15 For a consideration of this shift in attitude, see Anthony Davies and Simon Ford, 'Art Capital', *Art Monthly*, 1998; 'Art Futures', *Art Monthly*, 1999; and 'Culture Clubs', *Mute*, 2000.

16 Hans Haacke, *Framing and Being Framed: 7 Works 1970–75* (New York: New York University Press, 1976).

17 See Rebecca Gordon-Nesbitt, 'Don't Look Back in Anger', M. Lind (ed.), *Cultural Policy in 2015* (Stockholm and Vienna: International Artists Studio Program in Sweden [IASPIS] and European Institute of Progressive Cultural Policy [EIPCP], 2006).

18 Morris Hargreaves McIntyre, *Taste Buds: How to Cultivate the Art Market* (London: Arts Council England, 2004).

19 Pierre Bourdieu, *Firing Back: Against the Tyranny of the Market* (London: Verso, 2003), p. 67.

20 Iain Robertson, *Understanding International Art Markets and Management* (London and New York: Routledge, 2005), p. 13.

21 Bürger, *Theory of the Avant-Garde*, p. 30.

22 David Harvey, *The Condition of Postmodernity: An Enquiry into the Origins of Cultural Change* (Oxford: Blackwell, 1980), p. 328.

23 See Ian Burn, 'The Art Market: Affluence and Degradation', *Artforum*, April 1975, p. 35.

24 Arthur Danto, *After the End of Art: Contemporary Art and the Pale of History* (Princeton, NJ: Princeton University Press, 1997), p. 15.

25 Richard Florida, *The Rise of the Creative Class* (Cambridge, MA: Basic Books, 2002), p. 69.

26 Department for Culture, Media and Sport (DCMS), *Creative Industries Mapping Document*, November 1998. Tellingly, when this definition was reiterated in 2010, 'intellectual property' had become 'economic property' (Department for Culture, Media and Sport, *Creative Industries Economic Estimates (Experimental Statistics)*, Full Statistical Release, 9 December 2010).

27 See David Cameron, 'Transforming the British Economy: Coalition Strategy for Economic Growth', 28 May 2010, available at: https://www.gov.uk/government/speeches/transforming-the-british-economy-coalition-strategy-for-economic-growth.

28 See John Knell and Matthew Taylor, *Arts Funding, Austerity and the Big Society: Remaking the Case for the Arts* (London: RSA, 2011). For a response to this expectation from within the cultural sector, see the work of Common Practice London, including Rebecca Gordon-Nesbitt, *Value, Measure, Sustainability: Ideas towards the Future of the Small-Scale Visual Arts Sector* (London: Common Practice, December 2010), available at: http://www.commonpractice.org.uk/wp-content/uploads/2014/11/Common-Practice_Value_Measure_Sustainability.pdf.

29 Maria Miller, 'Testing Times: Fighting Culture's Corner in an Age of Austerity', 24 April 2013, available at: https://www.gov.uk/government/speeches/testing-times-fighting-cultures-corner-in-an-age-of-austerity

30 UNESCO, Recommendation Concerning the Status of the Artist, 27 October 1980.

31 This statement appears within the two funding calls that have been made in relation to this programme.

32 Other ways in which private interests have intruded into the cultural field include: the ring-fencing of public funds, through agendas such as social inclusion, aimed at increasing participation in the labour market (see Cultural Policy Collective, *Beyond Social Inclusion: Towards Social Democracy*, 2004), and the use of culture to encourage relocation, stimulate property development, increase tourism and kick-start failing economies (see Rebecca Gordon-Nesbitt, 'Misguided Loyalties', *Conflict, Community Culture: A critical Analysis of Culture-Led Regeneration*, 2013), available at: http://shiftyparadigms.org/misguided_loyalties.htm

33 See, for example, Susan Eva Eckstein, *Back from the Future: Cuba under Castro* (Princeton, NJ: Princeton University Press, 1994).

34 Cited in Lee Lockwood, *Castro's Cuba, Cuba's Fidel: An American Journalist's Inside Look at Today's Cuba in Text and Pictures* (Boulder, CO: Westview Press, 1990 [1967]), p. 90.

35 See Richard Gott, *Cuba: A New History* (New Haven, CT: Yale University Press, 2004).

36 See Richard Fagen, *The Transformation of Political Culture in Cuba* (Stanford, CA: Stanford University Press, 1969).

37 Fidel Castro Ruz and Ignacio Ramonet, *My Life* (London: Penguin Books, 2008 [2006]), pp. 99–100.

38 Gott, *Cuba*, p. 152.

39 Figures relating to the *Granma* landing are taken from an exhibit at the Museum of Clandestine Struggle in Santiago de Cuba, which shows the fate of each of the eighty-two men involved.

40 See Ernesto Guevara, *Guerrilla Warfare* (Lincoln: University of Nebraska Press, 1998 [1961]).

41 Partido Socialista Popular, led by Blas Roca Calderío.

42 Cited in C. Ian Lumsden, 'The Ideology of the Revolution', R.E. Bonachea and N.P. Valdés (eds.), *Cuba in Revolution* (Garden City, NY: Doubleday & Company, 1972 [1969]), pp. 541–2. Antoni Kapcia, *Leadership in the Cuban Revolution: The Unseen Story* (London: Zed Books, 2014) refers to these words being spoken by Raúl Roa García at the United Nations, shortly after his appointment as Foreign Minister the following month.

43 C. Wright Mills, *Listen, Yankee: The Revolution in Cuba* (New York: Ballantine Books, 1960), p. 46.

44 Mills, *Listen, Yankee*, p. 43.

45 See Samuel Farber, *The Origins of the Cuban Revolution Reconsidered* (Chapel Hill: University of North Carolina Press, 2006).

46 Fidel Castro Ruz, *Fidel Castro Denounces Sectarianism* (Havana: Ministry of Foreign Relations, 1962), p. 15.

47 K.S. Karol, *Guerrillas in Power: The Course of the Cuban Revolution* (London: Jonathan Cape, 1971 [1970]), p. 158.

48 Cited in Mills, *Listen, Yankee*, p. 112.

49 Mills, *Listen, Yankee*, p. 152; italics in original.

50 Roberto Fernández Retamar, 'Hacia una Intelectualidad Revolucionaria en Cuba' [Towards a Revolutionary Intelligentsia in Cuba], *Cuba Defendida* [Cuba Defended] (Havana: Editorial Letras Cubanas, 2004 [1966]), p. 278.

51 Roberto Fernández Retamar, 'The Enormity of Cuba', *Boundary* 2, 23, no. 3, Autumn 1996, p. 174.

52 Cited in Kapcia, *Leadership in the Cuban Revolution*, p. 65.

53 See PCC Central Committee, *Information from the Central Committee of the Communist Party of Cuba on Microfaction Activity* (Havana: Instituto Cubano del Libro, 1968).

54 Cited in Karol, *Guerrillas in Power*, p. 360.

55 Vladimir Lenin, *On Socialist Culture and Ideology* (Moscow: Foreign Languages Publishing House, 1960 [1909]), p. 21.

56 Kapcia, *Leadership in the Cuban Revolution*, p. 118.

57 Eckstein, *Back from the Future*, claims that neither communism nor socialism has been achieved in Cuba.

58 See Carlos Rafael Rodríguez, *Cuba en el Tránsito al Socialismo, 1959–1963; Lenin y la Cuestión Colonial* [Cuba in the Transition to Socialism, 1959–63: Lenin and the Colonial Question] (Mexico City: Siglo Veintiuno, 1978 [1966]).

59 Puerto Rican academic and activist Antonio Carmona Báez defines the current Cuban system as a form of bureaucratic state capitalism and an alternative form of globalisation in *State Resistance to Globalisation in Cuba* (London: Pluto Press, 2004), while the Cuban researcher and critic, Desiderio Navarro, isolates four ideological tropes existing simultaneously – barracks communism, democratic socialism, state capitalism and neoliberal capitalism – the first three of which have been united in their opposition to both US annexation and the demands typically enforced by the barracks model in 'Introducción al Ciclo "La Política Cultural del Periodo Revolucionario: Memoria y Reflexion"' [Introduction to the Series 'The Cultural Policy of the Revolutionary Period: Memory and Reflection'], 30 January 2007.

60 Rafael Hernández, *Looking at Cuba: Essays on Culture and Civil Society* (Gainesville: University Press of Florida, 2003), p. 29.

61 On the former, see Nicola Miller, 'A Revolutionary Modernity: The Cultural Policy of the Cuban Revolution', *Journal of Latin American Studies*, 40, Special Issue 04 (Cuba: 50 Years of Revolution), 2008, pp. 675–96; on the latter, see Catherine Davies, 'Surviving (on) the Soup of Signs: Postmodernism, Politics, and Culture in Cuba', *Latin American Perspectives*, 27, no. 113, 2000, pp. 103–21.

62 Harvey, *The Condition of Postmodernity*, p. 12.

63 Fredric Jameson, *Postmodernism, or, The Cultural Logic of Late Capitalism* (Durham, NC: Duke University Press, 1990).

64 Luis Camnitzer, *New Art of Cuba* (Austin: University of Texas Press, 1994), p. 312.

65 The Cuban case is taken as evidence of broader disaffection in Roger Garaudy, *The Turning Point of Socialism* (London: Fontana Books, 1970 [1969]).

66 Karol, *Guerrillas in Power*, pp. 58–9.

67 Former editor of the party newspaper, *Hoy* [Today].

68 The first figure is given in Antoni Kapcia, *Cuba in Revolution: A History Since the Fifties* (London: Reaktion Books, 2008); the second, cited in Mills, *Listen, Yankee*, relies on the calculations of a CIA deputy at the end of 1959.

69 PCC Central Committee, *Information from the Central Committee of the Communist Party of Cuba on Microfaction Activity*, pp. 128–9.

70 Karol, *Guerrillas in Power*, p. 234.

71 Fidel Castro Ruz, excerpt from an interview with Tomás Borge, reproduced in *Che: A Memoir by Fidel Castro* (Melbourne: Ocean Press, 1994), p. 160.

72 Castro Ruz, *Che*, p. 161.

73 Karol, *Guerrillas in Power*, p. 237.

74 Graziella Pogolotti, interview with the author, Havana, 9 March 2010.

75 Consejo Nacional de Cultura, *Anteproyecto del Plan de Cultura de 1963* [Draft of the 1963 Cultural Plan] (Havana: Consejo Nacional de Cultura, 1963).

76 For a consideration of this, see Camnitzer, *New Art of Cuba*.

77 Antonio Gramsci, 'Philanthropy, Good Will and Organization', *Selections from Cultural Writings* (Cambridge, MA: Harvard University Press, 1991 [1917]), p. 25.

78 Graziella Pogolotti, *Polémicas Culturales De Los 60* [Cultural Polemics of the 1960s] (Havana: Instituto Cubano del Libro, 2006).

79 Comité Central del Partido Comunista de Cuba (PCC), *Tesis y Resoluciones Primer Congreso Del Partido Comunista De Cuba* [Thesis and Resolutions of the First Congress of the PCC] (Havana: Comité Central del PCC, 1976), p. 501.

80 Clive W. Kronenberg, 'Che and the Pre-Eminence of Culture in Revolutionary Cuba: The Pursuit of a Spontaneous, Inseparable Integrity', *Cultural Politics*, 7, no. 2, 2011, pp. 189–218.

81 José Martí, 'Our America', P.S. Foner (ed.), *Our America by José Martí: Writings on Latin America and the Struggle for Cuban Independence* (New York and London: Monthly Review Press, 1977), pp. 84–94.

82 Erich Fromm, *Marx's Concept of Man* (New York: Continuum, 1988 [1961]), p. 5. This title contains a translation of the philosophical elements of the manuscripts.

83 Karl Marx and Friedrich Engels, *The German Ideology* (London: Lawrence and Wishart, 1970).

84 Emilio Troise, *Aníbal Ponce: Introducción al Estudio de Sus Obras Fundamentales* [Aníbal Ponce: Introduction to the Study of His Fundamental Works] (Buenos Aires: Ediciones Sílaba, 1969), p. 227.

85 Troise, *Aníbal Ponce*, p. 283.

86 Herbert Marcuse, 'Preface', R. Dunayevskaya, *Marxism and Freedom: From 1776 until Today* (London: Pluto Press, 1975 [1958]), p. 12.

87 Raya Dunayevskaya, 'Introduction to the Second Edition', R. Dunayevskaya, *Marxism and Freedom*, p. 18.

88 Raya Dunayevskaya, 'Introduction to the First Edition', R. Dunayevskaya, *Marxism and Freedom*, p. 21.

89 Adolfo Sánchez Vásquez, *Art and Society: Essays in Marxist Aesthetics* (London: Merlin Press, 1973), p. 10.

90 See Terry Eagleton taking issue with Raymond Williams's definition of culture on the basis of its negation of ideology in *Criticism and Ideology* (London: New Left Books, 1975).

91 Fidel Castro Ruz, 'History Will Absolve Me', Havana, 1953, F. Castro Ruz and R. Debray, *On Trial* (London: Lorrimer, 1968 [1953]), pp. 9–108; also available at: Marxists.org/history/cuba/archive/castro/1953/10/16.htm.

92 Fidel Castro Ruz, 'Manifiesto No. 1 del 26 de Julio al Pueblo de Cuba' [Manifesto No. 1 from the 26 July Movement to the People of Cuba], Mexico, 8 August 1955.

93 Lenin, *On Socialist Culture and Ideology*, p. 23, italics in original.

94 Castro and Ramonet, *My Life*, p. 202.

95 Fidel Castro Ruz, 'The Problem of Cuba and Its Revolutionary Policy', Speech to the United Nations General Assembly, 26 September 1960, available at: Marxists.org/history/cuba/archive/castro/1960/09/26.htm

96 Department for Education and Skills, *Skills for Life: A National Needs and Impact Survey of Literacy, Numeracy and ICT Skills*, October 2003.

97 US Department of Education, *National Assessment of Adult Literacy*, 2009.

98 Figures taken from the United Nations Development Programme.

99 Jaime Sarusky and Gerardo Mosquera, *The Cultural Policy of Cuba* (Paris: UNESCO, 1979), p. 13.

100 The campaign became the target of counterrevolutionaries, and rumours abounded that teenage brigadiers were being killed.

101 Figures, in this and next paragraph, taken from Ministerio de Educación (MINED), *Algunos Datos sobre la Educación en Cuba* [Some Data on Education in Cuba] (Havana: Ministerio de Educación, 1975).

102 Karl Marx, *Grundrisse: Foundations of the Critique of Political Economy* (London: Penguin Books, 1973 [1857–61]), pp. xci–xcii.

103 Ibid., p. xcii. David Craven reminds us that Marx's precise phraseology was used by Gutiérrez Alea as the epigraph of a 1982 book, in *Art and Revolution in Latin America 1910–1990* (New Haven, CT, and London: Yale University Press, 2002).

104 Joaquín G. Santana, *Política Cultural de la Revolución Cubana: Documentos* [Cultural Policy of the Cuban Revolution: Documents], (Havana: Editorial De Ciencias Sociales, 1977).

105 Mario Benedetti, 'Present Status of Cuban Culture' [1969], Bonachea and Valdés, p. 501.

106 Ministry of Foreign Relations, *The Revolution and Cultural Problems in Cuba* (Havana: Ministry of Foreign Relations, 1962), p. 75.

107 Antoni Kapcia, *Havana: The Making of Cuban Culture* (Oxford and New York: Berg, 2005), p. 22.

108 Instituto Cubano del Libro, *Cultural Congress of Havana: Meeting of Intellectuals from All the World on Problems of Asia, Africa and Latin America* (Havana: Instituto Cubano del Libro, 1968), unpaginated.

109 Sarusky and Mosquera, *The Cultural Policy of Cuba*, p. 19.

110 Fidel Castro Ruz, 'Palabras a los Intelectuales' [Words to the Intellectuals] (Havana: Ministry of Foreign Relations, 1962 [1961]), p. 19. This sentiment would be reiterated, as the country emerged from the grey years, in Sarusky and Mosquera, *The Cultural Policy of Cuba*.

111 Fernández Retamar, 'Hacia una Intelectualidad Revolucionaria en Cuba', p. 266.

112 Miller, 'A Revolutionary Modernity', pp. 675 and 685.

113 During his elected presidency from 1940 to 1944, Batista established a constitutional democracy which he viciously eradicated after seizing power in 1952.

114 Hortensia Pichardo, 'Constitución de la República de Cuba' [Constitution of the Republic of Cuba], *Documentos para la Historia de Cuba*, IV: Part 2, Editorial de Ciencias Sociales, La Habana, 1940, p. 340.

115 Manuel Urrutia y Lleó, *Ley Fundamental de la Republica* [Fundamental Law of the Republic], 1959.

116 Juan Sanchez, 'Interview with Armando Hart Dávalos', *Bohemia*, 20 October 1989.

117 This sentiment was expressed in a contribution by Mariano Sánchez Roca, a lawyer and journalist from Madrid, who had been exiled in Cuba during the Spanish Civil War. See R.L. Hernández Otero (ed.), *Sociedad Cultural Nuestro Tiempo: Resistencia y Acción* [Nuestro Tiempo Cultural Society: Resistance and Action] (Havana: Editorial Letras Cubanas, 2002).

118 Ambrosio Fornet, 'La Década Prodigiosa: Un Testimonio Personal' [The Prodigious Decade: A Personal Testimony], S. Maldonado (ed.), *Mirar a los 60: Antología de una Década* [Looking at the 60s: Anthology of a Decade] (Havana: Museo Nacional de Bellas Artes, 2004), p. 11.

119 Sarusky and Mosquera, *The Cultural Policy of Cuba*, pp. 12–3.

120 Exile was voluntary in the case of Alejo Carpentier, Virgilio Piñera, Jaime Sarusky, Roberto Fernández Retamar and others, and political in the case of PSP activists such as Nicolás Guillén and José Antonio Portuondo.

121 Lisandro Otero, *Cultural Policy in Cuba* (Paris: UNESCO, 1972), p. 23.

122 Cited in Andrew Salkey, *Havana Journal* (London: Penguin Books, 1971), p. 111.

123 Unión de Escritores y Artistas de Cuba (UNEAC), J.A. Baragaño (ed.), *Memorias del Primer Congreso Nacional de Escritores y Artistas de Cuba* [Proceedings of the National Congress of Writers and Artists of Cuba] (Havana: Ediciones UNIÓN, 1961).

124 Lockwood, *Castro's Cuba, Cuba's Fidel*, p. 2.

125 Pogolotti, interview with the author, 2010.

126 Leonardo Padura Fuentes, 'Living and Creating in Cuba: Risks and Challenges', J.M. Kirk and L. Padura Fuentes (eds.), *Culture and the Cuban Revolution: Conversations in Havana* (Gainesville: University Press of Florida, 2001), p. 178.

127 Ambrosio Fornet, 'El Quinquenio Gris: Revisitando el Término' [The Five Grey Years: Revisiting the Term], *Narrar la Nación: Ensayos en Blanco y Negro* [Narrating the Nation: Essays in White and Black] (La Habana: Editorial Letras Cubanas, 2009 [2007]).

128 Desiderio Navarro, 'In Medias Res Publicas' [In the Midst of the Public Sphere], *La Gaceta de Cuba*, no. 3, June 2001, pp. 40–5.

129 For a consideration of the different layers of influence constituting the leadership, see Kapcia, *Leadership in the Cuban Revolution*.

130 Lockwood, *Castro's Cuba, Cuba's Fidel*, p. 111.

131 This term appears in a report issued on 24 January 2007, entitled 'Restringen Entrada a Conferencia sobre el "Quinquenio Gris" en la Casa de las Américas' [Entry to the Conference on the 'Five Grey Years' at Casa de las Américas Restricted].

132 Kapcia, *Havana*, p. 142.

133 Ibid.

134 Camnitzer, *New Art of Cuba*, p. 136.

135 In the late 1970s, in an educational context, the plastic arts were defined as engraving, painting, sculpture, with consideration being given 'to the possible inclusion of town planning, interior design, furniture design, toy design and stage design in the plastic-arts section' (Sarusky and Mosquera, *The Cultural Policy of Cuba*, p. 39).

136 Kapcia, *Havana*, p. 100.

137 Lockwood, *Castro's Cuba, Cuba's Fidel*, p. 136.

138 Jorge Fornet, *El 71: Anatomía de una Crisis* [In '71: Anatomy of a Crisis] (Havana: Editorial Letras Cubanas, 2013), p. 77.

139 Kapcia, *Havana*, p. 17.

140 See Michael Chanan, *Cuban Cinema* (Minneapolis: University of Minnesota Press, 2003).

141 See Robin D. Moore, *Music and Revolution: Cultural Change in Socialist Cuba* (Berkeley: University of California Press, 2006).

142 See Antoni Kapcia and Par Kumaraswami, *Literary Culture in Cuba: Revolution, Nation-Building and the Book* (Manchester: Manchester University Press, 2012).

143 A notable exception to this has been Camnitzer, although his 1994 study was centred on the 1980s and only dealt with policy in passing.

144 Fornet, 'El Quinquenio Gris', p. 382.

145 Named after the boat on which Fidel and his comrades set sail from Mexico to Cuba to start the insurrection, this daily newspaper formed as a merger of the PSP's *Noticias de Hoy* and the 26 July Movement's *Revolución* (in 1965) and took as its subtitle *Órgano Oficial del Comité Central del Partido Comunista de Cuba* [Official Organ of the Central Committee of the Cuban Communist Party].

146 Alvin W. Gouldner, 'The Sociologist as Partisan: Sociology and the Welfare State', *The American Sociologist*, 3, no. 2, May 1968, p. 112.

Revolutionary Rebuilding

 We know that for any culturally impoverished country like Cuba this problem of establishing cultural institutions is a terribly important and perilous effort. We'd like to say too that we don't think anybody in the world has really solved the problem of establishing the best chances for art and literature and culture in general.

– the voice of Cuba, mediated by C. Wright Mills, 1960.

When the Revolution triumphed, it inherited a fully formed mass communication system, consisting of several television and radio stations, which broadcast to the majority of Cuban homes. Commenting on Fidel's regular and extended television appearances – the purposes of which ranged from rebutting rumours to stimulating revolutionary consciousness – Mills noted his 'antibureaucratic personality and way of going about things, of getting things done, without red tape and without delay and in a thoroughly practical and immediate way'.[1] To the increasingly radicalised leadership, bureaucracy and institutionalisation were regarded as a vehicle for orthodoxy and an impediment to the flux necessary to create an entirely new society.[2] An allergy to bureaucratism remains consistent throughout the rhetoric and campaigns of the revolutionary government, informing Tomás Gutiérrez Alea's satirical 1966 film, *The Death of a Bureaucrat*, which made a contribution to popular debates and the decentralisation process of the 1970s. At the Cultural Congress of Havana in 1968, one of the commissions agreed that 'Bureaucracy is consubstantial to the society of exploitation of man by man, and represents a reminiscence of the old structure in the new society, which plans the complete formation of man. That is why bureaucracy is gradually disappearing, is being abolished, not only by placing man in productive, scientific and cultural activities, but by means of the very development of

the society that is organized to fully meet the growing spiritual and material needs of man'.[3]

Acknowledging their need for culture to be so great that they could not afford to waste talent and resources, the Cubans turned their attention to creating cultural institutions in a thoroughly practical and immediate way. In considering the specifics of institutionalisation, Mills's extended paraphrase of the Cuban voice mused that, 'On the one hand, there's your capitalist way of doing it. [...] If it will sell, then it will be produced [...] But there's no real plan, no real establishment of cultural effort – except the commercial'.[4] Clearly, then, an alternative to the commercial model would be needed in the new society. And, while one US scholar suggests that 'Some officials wanted to emulate the Soviet commissar Anatoly Lunacharsky in creating didactic cultural and educational institutions',[5] the revolutionaries generally understood the Soviet method to involve 'state or party control of all cultural activity, directly or indirectly', concluding that 'Perhaps that's all right in science and technology [...] but we don't think it has resulted in much good poetry'.[6] Those involved in the rethinking process elaborated upon the nature of cultural institutions appropriate to a revolutionary situation:

> We're starting out with all the disorder we've inherited, and with what amounts to No Culture in Cuba. To bring about real cultural and intellectual establishments is one of our biggest and most difficult tasks. Of course, it's linked [...] with our need for administrators and technicians in Cuba. But we want so much more than that. We want poetry as well as physics. And we know you can't plan for poets as you can for engineers. You can only plan and construct cultural institutions, and then hope that poets, as well as engineers, will grow in them and do great work'.[7]

It was obvious, then, that an entirely novel cultural infrastructure would be needed in revolutionary Cuba which was neither commercial nor centrally planned.

As will be seen in this chapter, the seeds were sown for a robust cultural infrastructure, with the Cuban Institute of Cinematographic Arts and Industries (ICAIC) and Casa de las Américas (respectively founded in March and April 1959) standing as prominent examples of this early period and inspiring confidence in the protagonism of intellectuals in transforming society. Another significant step in the institutionalisation process was the creation, in January 1961, of the National Council of Culture (CNC). This organisation – which operated at varying levels of autonomy from the state during the course of its development – was responsible for interpreting and implementing the cultural policy of the revolutionary government in ways that will be analysed throughout this book. As we have seen, creative intellectuals took the lead in organising themselves and, in August 1961, this led to

the formation of the National Union of Cuban Writers and Artists (UNEAC). These key cultural institutions and others will be introduced in the following pages. In the process, the tensions between politico-cultural functionaries, cultural directors and creative practitioners will be made manifest. In order to properly understand the changes that came about after 1959, it is first necessary to consider the pre-revolutionary situation.

Nuestro Tiempo Cultural Society

The Batista era gave rise to several new cultural institutions, paralleled by an increase in private patronage and prizes, but these tended to cater only to the privileged élites. During Batista's second (unelected) presidency from March 1952, the main agency for promoting culture was the National Institute of Culture (INC). The majority of Cuba's creative intellectuals suspected that, despite attempts to create an illusion of cultural neutrality, the INC served as a nexus for US recruitment of their less scrupulous colleagues. As we saw in the previous chapter, the cultural climate of the 1950s caused many artists and writers to seek refuge outside Cuba. Those cultural practitioners remaining on the island who refused to comply with the prevailing regime took steps to resist official culture and develop a more egalitarian language of their own.

In the early 1950s, a group of young composers – including Juan Blanco, Harold Gramatges and Nico Rodríguez – came together to discuss ways of bypassing Batista's institutions and taking their music directly to the people. This initial nucleus swiftly made links with painters, poets and playwrights equally unable to express themselves through the existing channels. Among the founders were Carlos Franqui and Guillermo Cabrera Infante, whose names will recur during the early part of this story. Among the members was one Marcos Armando Rodríguez, a communist student who would surrender to Batista the four surviving members of an attack on the presidential palace, mounted by the Revolutionary Directorate in March 1957, thereby condemning them to a brutal death.

In February 1951, a new cultural society was inscribed into the provincial government of Havana under the presidency of Gramatges. The society became known as Nuestro Tiempo [Our Time], taking its name from the fact that it 'dealt with current art, our art in that moment'.[8] Its first event, an exhibition of paintings by Fidelio Ponce – the first time that many Cubans had seen the work of this important figure from recent history – opened on 18 February 1951, the second anniversary of the artist's death. But Gramatges traces the real inauguration of Nuestro Tiempo to 9pm on 10 March of the same year and the inauguration by Raúl Roa García[9] of an exhibition by twenty Cuban artists, including the most renowned contemporary painters, accompanied by a programme of singing and a theatrical work by Strindberg.[10] For the following nine years, Nuestro Tiempo would organise an average of

five or six cultural activities per month as a counterpart to the government's programme, quickly achieving recognition for the seriousness of its work.

A manifesto soon followed, acknowledging the creativity inherent in humanity and announcing the intention of this young generation to preserve and disseminate the best cultural products. Traces of Martí's thinking around the united continent of Our America are in evidence, with the society's aesthetic being defined as 'that of an American art, free from political and religious prejudices'. The twenty-eight signatories to the manifesto would become key figures of the post-revolutionary period, including the aforementioned film-maker Tomás 'Titón' Gutiérrez Alea and the writers Lisandro Otero and Roberto Fernández Retamar. Also among the signatories were Guillermo Cabrera Infante and his brother, Sabá. Recapping the society's founding aim – of bringing the people to art, bringing the people closer to the aesthetic and cultural concerns of the time, precisely when contemporaneous realities demanded rapid cultural maturity – this impassioned statement concluded: 'We are the voice of a new generation which arises in a moment at which violence, desperation and death appear to be the only solutions'.[11]

The society's biographer, Ricardo Luis Hernández Otero, finds the ethos of Nuestro Tiempo to be nationalist (without being chauvinist), universalist, anti-cosmopolitanist and anti-imperialist (not only in the field of culture),[12] all of which would become watchwords for revolutionary cultural action. While ideas around universalism and anti-imperialism will be unpicked later, it may be noted here that cosmopolitanism became linked to chauvinistic bourgeois nationalism, with Fidel later asserting that 'Chauvinism is the bane of sincere internationalism, and without internationalism there is no salvation for humanity'.[13] Beyond this, the cultural society initially lacked a specific ideological orientation, and this absence of political and aesthetic extremism was regarded, by some, as one of its strengths.

In April 1954, Nuestro Tiempo began publishing an eponymous bimonthly magazine, edited by Gramatges and administered by Blanco. The first issue contained the society's succinct manifesto and featured on its front cover a drawing by the artist Wifredo Lam, who famously combined European cubism and surrealism with Cuba's African roots. The editorial board included Gutiérrez Alea and his fellow film-makers Julio García Espinosa and Alfredo Guevara Valdés. These three would collaborate with Blanco, José 'Pepe' Massip and several others under the auspices of Nuestro Tiempo, to produce a neo-realist short film, called El Mégano (named after a popular cinema), which was screened at the University of Havana on 9 January 1955 and subsequently banned by Batista's regime.[14] Also involved in the editorial board of Nuestro Tiempo was the esteemed writer and PSP stalwart Mirta Aguirre, who would emerge as a controversial protagonist in post-revolutionary polemics. The film critic Mario Rodríguez Alemán would later note that 'to write

for this publication was to commit oneself and commitment was to define oneself against Batista and his henchmen, against North American imperialism, in favour of the cause of oppressed peoples and the countries with popular democracies'.[15] Organising itself by art form, the filmic branch of the society began publishing *Cuadernos de Cultura Cinematográfica* [Notebooks on Cinematographic Culture].

In addition to occupying a politically precarious position, the society's financial situation was far from secure, which, on occasion, saw the electrical supply being cut off. Its subsistence depended upon the efforts of a team of activists, the majority of whom were young communists, who organised touring productions and occasional raffles of artwork. After six months of activity, the group addressed a memorandum to the Minister of Education, detailing its achievements and articulating a desire to move from being a purely artistic society to becoming a national cultural movement. The members solicited an official grant as a stimulus for all those working in the diverse field of art, but their request fell on deaf ears and only much later did the society receive a meagre contribution from Havana municipality, until which time its core members became practised in the art of generating advertising revenue via the magazine.

Looking back on Nuestro Tiempo more than two decades after its foundation, Gramatges describes how:

> [...] some of the members of the new institution had close links with intellectual personalities from the Communist Party. In the foreground was Nicolás Guillén, for very obvious reasons: Nicolás Guillén is, for us musicians, another composer, because his poetry is all music. We also had a great link with Mirta Aguirre. For people of my generation, she was an admirable person, full of wisdom, a person with whom one spoke for half an hour and covered all that which had to do with the world of creation and the world of philosophy. Equally, we depended on Carlos Rafael Rodríguez, on José Antonio Portuondo and many other communist intellectuals.[16]

As this story progresses, we shall see how the communist cultural figures mentioned here influenced revolutionary culture. Nicolás Guillén Batista would become the Cuban national poet, in recognition of his creative work, and prove himself an outspoken participant of various early convergences of artists and writers. Mirta Aguirre would come to occupy a key role in the National Council of Culture (CNC), sparking a polemic through her writing that would animate the country's creative practitioners in 1963–4. Visiting the Sierra Maestra in February 1958 to negotiate with Fidel on behalf of the PSP, Carlos Rafael Rodríguez would be the first party member to join the 26 July Movement, going on to fight in the closing stages of the insurrection

and occupy various posts in the revolutionary government, including Deputy Minister of Culture and Vice President of the Republic. José Antonio Portuondo, a writer born in Santiago de Cuba, would become Vice President of the National Union of Cuban Writers and Artists (UNEAC), initially advocating self-reflexive, revolutionary praxis to his contemporaries. To Nuestro Tiempo's founding President, it seemed logical that those responsible for the ideological questions of the PSP would be interested in those young people using their creative efforts to denounce contemporaneous reality through their cultural work.

The centenary of the birth of José Martí (28 January 1953) would prove decisive for the society, providing a moment at which the bitter struggle against Batista's dictatorship could declare itself publicly. To commemorate the occasion, an artistic biennial had been proposed for Havana, organised by Franco's government in Spain using Cuban centennial funding. Across genres, the most highly renowned artists of the day came together to sign a manifesto denouncing the exhibition.[17] As a riposte, they proposed an International Martían Exhibition of Art, which quickly became known as the anti-biennial. The official biennial had been organised for the sumptuous galleries of the National Museum of Fine Arts, while the anti-biennial opted to use the Lyceum, a lively cultural centre. Having both been planned to open on 28 January, inauguration of the former was changed to 18 May, and the protesting artists were able to claim that silence and darkness had dominated the official venue on the centenary, while the success of its rival had repercussions as far away as Santiago de Cuba and Camagüey, attracting the solidarity of many continental intellectuals and exiled Spaniards. The night before the new opening date of the official biennial, the University Students' Federation (FEU)[18] organised the First University Festival of Art, which included forty-two artists and inspired many ancillary events. At the time, FEU Director of Culture Luis de la Cuesta described his collaborators as those 'who know that art and dictatorship are as contradictory as democracy and tyranny'.[19]

The group of young intellectuals that had united around the idea of a committed culture – which was both aesthetic and political and included all the artistic tendencies of the era – continued to define itself in opposition to Batista's cultural policy. During this time, armed rebellion, clandestine struggle and popular mobilisation were on the rise, and members of Nuestro Tiempo would contribute to the growing insurrection, with some giving their lives at Moncada. The July 1953 attacks prompted the PSP to form a Commission for Intellectual Work, led by Aguirre, Rafael and Juan Marinello,[20] with Aguirre the most closely involved. This resulted in a deeper synergy between the party and Nuestro Tiempo, with the directorate of the society being restructured around a Central Bureau of party activists and film-makers taking prominent public roles, including García Espinosa, Guevara, Gutiérrez Alea and Massip

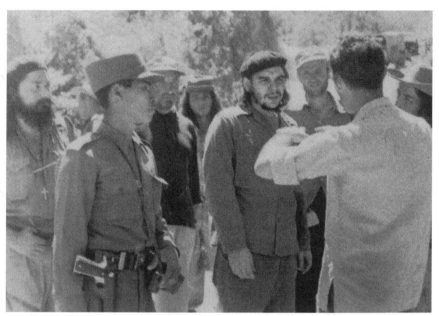

Tomás Gutiérrez Alea meets Che Guevara in the Sierra Maestra.

alongside the communist proto-documentarist, Santiago Álvarez. In this way, party and society became synonymous, and Nuestro Tiempo took as its headquarters the unoccupied office of the party-run Mil Diez [1010] radio station. The PSP and Socialist Youth[21] began helping to orient the group into becoming a cutting-edge revolutionary cultural vehicle which transcended purely aesthetic work, with the society operating as both a genuine cultural organisation and a political group.

According to a retrospective account by the Spanish cinematographer Nestór Almendros, this alignment of Nuestro Tiempo with the PSP caused a split within the filmic ranks of the society. In 1948–9, the Cinema Club of Havana – founded by Germán Puig and Ricardo Vigón – had brought together Gutiérrez Alea and Guillermo Cabrera Infante, among others, to discuss cinematic classics. Under the auspices of the Nuestro Tiempo film department, this would become the Cuban Cinemateque. Following the PSP 'infiltration' of Nuestro Tiempo, Almendros, Cabrera Infante, Puig and Vigón broke away from the Marxist cinema club (and the Catholic variant that had formed elsewhere) to establish their own cinematic discussion group, unencumbered by ideology or religion.[22] As we shall see, these rivalries would persist long after the triumph of the Revolution.

At the end of 1953, both the Commission for Intellectual Work and Nuestro Tiempo moved to the upper floor of a building at the corner of streets 23 and 4, close to the University of Havana, where a Permanent Gallery of Plastic Arts was opened with the intention of exhibiting all the greats of

Cuban art. In a message of support dating from that time, the pedagogue Rosario Novoa, who would establish the History of Art department at the university, attested that 'To open an art gallery in Havana is still a risky business, but the animated enthusiasts of the Nuestro Tiempo Society have rushed to do so with the purpose of contributing to the creation of an indispensable atmosphere for the suitable appreciation of Cuban artistic production'.[23] Centred on Havana, its example would radiate into the interior of the country, giving rise to similar institutions, including the Plastic Arts Gallery[24] in Santiago de Cuba and the New Time Group[25] in Camagüey, with their respective magazines, *Galería* and *Tiempo Nuevo*.

In the January 1956 issue of *Nuestro Tiempo*, Cuba's leading plastic artists again enacted their refusal, this time around the Eighth Salon of Painting, Sculpture and Ceramics, convened by the INC. While the INC was accused of violating universities, torturing students and ransacking libraries,[26] the national salon was rejected on the grounds that it distorted public perception – by exhibiting some of the country's more politically ambiguous artworks – which paved the way for an anti-salon in 1957. In their combined declaration, Cuban artists also implicated the state in the broader dissemination of their work (both within and beyond national territory) and in providing an economy that would liberate them from the functions of the market and from earning their subsistence through means other than art. This, they argued, would permit them to maintain their artistic dignity and freedom of aesthetic expression, but not at the cost of the creative development of the population – aims which would remain central after the Revolution.

Such visible acts of protest placed the society in danger, and Gramatges tells of their monitoring by the Military Intelligence Service (SIM)[27] and the Office for the Repression of Communist Activities (BRAC),[28] together with the imprisonment and interrogation of the society's leaders, which caused them to appear on a blacklist at the visa department and limited their travel possibilities.[29] Massip recalls that agents from BRAC once burst into his house in the early hours of the morning and confiscated *War and Peace* among other 'suspect' volumes.[30] Yet, despite regular denouncements of the society, as a hotbed of communist infiltration, authored by vociferous supporters of US imperialism, it was very difficult to prove that Nuestro Tiempo was led by the PSP; added to this, the prestige of the society impeded any Batistiano intentions to shut it down, which would have constituted an intellectual scandal. In another act of defiance, on 15 March 1958, the society signed a statement, authored by the Collective of Cuban Institutions, which demanded the immediate renunciation of power by the dictator.[31]

At the same time, Nuestro Tiempo aligned itself with the Revolution, making recommendations for the advancement of cultural policy which will be considered in chapter four. In the January–February 1959 issue of

its journal, published as jubilation swept the island, the society launched a retrospective tirade against the tyranny, arguing that it would be impossible to estimate the length of time by which culture had been arrested in its development. Equally incalculable was the agony of those writers, artists and film-makers who had been prevented from making their work and those who had been tortured, imprisoned, exiled or killed. At the same time, Gramatges declared that Nuestro Tiempo had fulfilled its destiny, but, as a great ideological struggle was being waged that would inevitably continue to have an impact on the cultural sector, its journal would be published for a further year.[32] After that, as we shall see, the society's most distinguished members would come to occupy leading roles within revolutionary society.

Cuban Institute of Cinematographic Arts and Industries (ICAIC)

Despite having the relevant equipment, studios and artists and there being an enthusiastic cinema-going audience, the Cuban film industry was practically non-existent before the Revolution. The majority of films that were produced were perceived as market-driven, artistically vulgar and ethically questionable by virtue of their tendency to reduce the island to its erotico-tropical elements. The industry itself was a source of corruption, and the January 1956 issue of *Nuestro Tiempo* raised concerns about the Bank for Fomenting National Industry and Agriculture (BANFIAC), a North American entity which had committed $750,000 to making three feature films but had only disbursed $30,000 as the fund was run on an investment basis, offering credit to those projects guaranteeing returns.

As we have seen, a group of aspiring film-makers coalesced around Nuestro Tiempo. A conference, hosted by the society on 17 June 1954, provoked a treatise from Gutiérrez Alea on the realities of film-making in Cuba. In this, he outlined the shared objective of those assembled to create a cinematic industry, on firm bases, which had the capacity to become an important source of work and wealth and a vehicle of national expression. In this endeavour, he argued, the support of the viewing public would be crucial, necessitating high-quality productions. Expressing admiration for the Italian film industry in general and the neorealist attitude in particular, Gutiérrez Alea predicted that, by directing their attention towards everyday life and promoting sincerity over artifice, Cuban film-makers could discover their own language and profoundly local subject matter, isolating a 'Cuban means of expression with universal value, the source of which has to be the reality of our people'.[33] Hampering them in this effort would be the fact that the Cuban market did not generate enough revenue to cover the cost of making films, which forced external markets to be sought. In order to overcome this situation, it was predicted that other branches of national culture would need to be embraced, including the realist strain in literature.

During the insurrection, Gutiérrez Alea would visit the Sierra Maestra, where he engaged in animated conversation with Che Guevara. The immediate consequence of this proximity was that Nuestro Tiempo was revivified with Che's support; a subsequent effect was that it would provide the firm basis for a new Cuban film industry. Within two weeks of Batista's exodus, Che set up a school in the San Carlos de La Cabaña fortress in Havana harbour, which had been used as a prison under the previous regime. Che's aide and Rebel Army captain Armando Acosta was appointed as leader of this new school, supported by three Nuestro Tiempo film-makers – Santiago Álvarez, Julio García Espinosa and José Massip.

Alfredo Guevara Valdés in 1970.
Courtesy of the Archive of Casa de las Américas.

The Rebel Army also established a Cultural Directorate, led by Camilo Cienfuegos within the Ministry of Education (MINED). Camilo had begun studying Fine Art at the conservative San Alejandro Academy in 1949, but financial necessity had forced him to take up work in a clothes shop, ironically called Art. When weapons were laid down, Che, Vilma Espín[34] and others came together to draw up an Agrarian Reform Law, which divided all estates over 1,000 acres into smaller plots to be distributed among landless Cubans. While this relatively moderate law would provoke communist accusations, demands for compensation and covert retaliation from the US,[35] Camilo oversaw production of a documentary film, entitled *Esta Tierra Nuestra* [This Land of Ours], directed by Gutiérrez Alea and García Espinosa, which explained agrarian reform to a domestic audience, initiating an informative series entitled 'The Revolution in Progress'. As part of the same series, in relation to the Urban Reform Law – which saw domestic rents being halved in a bid to stimulate redistribution – Camilo commissioned García Espinosa to make a short documentary called *La Vivienda* [Housing]. Tragically early in the revolutionary process, on 28 October 1959, a night flight carrying Camilo back to Havana disappeared over the sea, leaving others to continue his work in the cultural field.

The film-maker and former Nuestro Tiempo member Alfredo Guevara (to whom Fidel's 2006 autobiography is dedicated) had been asked to work on drafting the Agrarian Reform Law. Having met Fidel at university in 1945 when they were both nineteen years old, Guevara had spent the years after

graduation (between 1949 and 1951) in Paris, Prague and Rome, where he developed his love of cinema. Returning from Europe in the early 1950s, he had joined the PSP and was entrusted by the leader of the Young Communist League (UJC) with selling the party newspaper, *Noticias de Hoy* [Today's News, universally abbreviated to *Hoy*], on the streets of Havana. Taking part in the training that preceded the Moncada attacks, Guevara became frustrated with the PSP's focus on the mass movement at the expense of armed struggle, which combined with other factors to prompt his resignation from the party. Meeting up with Fidel in Mexico, he joined the 26 July Movement and returned home to participate in the urban resistance, which saw him being detained and tortured by Batista's officials.[36]

After the triumph of the Revolution, Fidel told Guevara that he would not be able to fulfil his vocation within cinema; however, the commander-in-chief eventually relented and asked his friend to inscribe the incipient film industry into law. Guevara seized the opportunity, assembling a small advisory group around him which included militant film-makers such as García Espinosa and Gutiérrez Alea.[37] On 20 March 1959, just eleven weeks after victory, the Cuban Institute of Cinematographic Arts and Industries (ICAIC) came into being through Law 169. This early legislation recognised film as the most powerful and suggestive of the creative media and the most direct vehicle for promoting education and popularising ideas. Subsequent rhetoric, formulated by the revolutionary government and its organs once the pursuit of socialism had been made explicit, would acknowledge Lenin's evocation of film as the revolutionary art form *par excellence*.

Echoing Marx's conception of art creating a subject for the object, the law creating ICAIC acknowledged cinema to be 'an instrument of opinion and of the formation of individual and collective consciousness, capable of contributing to the creation of a more profound and clearer revolutionary spirit and to sustaining its creative breath'.[38] It is here, in the first piece of revolutionary legislation to refer to ideo-cultural activity, that we encounter the humanism which would underwrite revolutionary approaches to culture. The creation of ICAIC presumed that, liberated from servitude, cinema would 'contribute all its resources to the development and enrichment of the new humanism inspiring the Revolution'.[39] Cinema was explicitly acknowledged as an art form and, consistent with the noblest conceptions of art, it was stated that the film industry should contribute to eradicating ignorance, clarifying problems, formulating solutions and representing the great conflicts of humanity through dramatic means. The two main objectives of ICAIC became: to enrich the Cuban cultural field (by developing a new medium of artistic expression, consistent with cultural tradition and in an atmosphere of free creation); and to form a more knowledgeable, demanding, critical, and hence revolutionary, public.

Echoing Gutiérrez Alea's earlier thoughts, it was recognised that an entirely new apparatus would be needed for the production and dissemination of film. In addition to this, it was envisaged that the re-education of popular taste would demand creatively beneficial collaborations – between economists and film directors, educators, psychologists and sociologists, artists from all disciplines, teaching specialists, the *comandantes* and specialist departments of the armed forces and the police. Also prefacing Law 169 was a reiteration of the well-defined characteristics of the country – its music, dance, customs and locations – together with the expectation that, when captured on film, Cuban life would inevitably appeal to publics from all latitudes, giving rise to a permanent and progressive source of foreign income while popularising the island and encouraging tourism (without recourse to the gambling and prostitution that had typified the neocolonial era).

Initially occupying the fifth floor of the Atlantic building in Havana, ICAIC was created as an autonomous organism with its own juridical identity, and the level of control that was devolved to the institute is noteworthy. It was charged with signing agreements with all relevant national and international institutions and overseeing all aspects of cinematic production, from the financing of films (in collaboration with banks which would soon be nationalised under the direction of Che Guevara) to the development of studios and the distribution of creative output. ICAIC also assumed responsibility for all pedagogical activities pertaining to film, from convening conferences and congresses to running cinema clubs. In 1960, it established a magazine, *Cine Cubano*, to tackle Cuban cinema, art and contemporaneous culture from an informative and wide-ranging theoretical perspective. At the same time, the ICAIC library provided a forum for internal debates that often found their way into the pages of the journal. The film institute also established a publishing arm, ICAIC Editions, for the production and dissemination of book-length cinematic studies, generally, but not exclusively, written from a Marxist perspective. In the mid-1960s, the Cuban Cinemateque and a related publication were created, with the aim of increasing knowledge of cinematic culture among the people, through the acquisition and conservation of films of technical, artistic, historical and social merit alongside the corresponding documentation. At the same time, a centre for cultural training was set up (which used exhibition halls and study centres in the capital and provinces) alongside a centre for cinematic studies (which ran training courses for laboratory technicians, sound engineers and projectionists, developing the capacity to produce colour films on the island).

Law 169 also ordained that ICAIC would be led and administered by a President-Director, appointed by the Prime Minister of the Republic and ratified by the Council of Ministers. The incumbent to this post would have control over the executive character of the institute and all aspects of its

administration, overseeing the activities of a managing council, the three members of which the President-Director could appoint and remove at will. Alfredo Guevara, who had written ICAIC into existence, was personally proposed for this role by Fidel, and agreed to serve for an initial three years, with the intention of making films thereafter; in the event, this task would continue until his retirement in 2000, with a hiatus from 1980 to 1991 when he took up work for UNESCO in the wake of a controversy around Humberto Solás's film *Cecilia*. During a career spanning half a century, Guevara became something of a cultural ambassador for Cuba, which continued through his association with the annual International Festival of New Latin American Film until his death in 2013. His thoughtful rhetoric is peppered with an acknowledgement of mutability – of the constant change that constitutes both humanity and revolution – and a critical self-awareness of the revolutionary project with which he was involved.

As we have seen, the films of the early post-revolutionary era were commissioned by the Cultural Directorate and largely concerned with illustrating social transformations, which segued into considerations of literacy, racial discrimination and the Bay of Pigs invasion. From June 1959, ICAIC began commissioning films, the first of which was the eighteen-minute *Sexto aniversario*, by García Espinosa, which documented the arrival in Havana of half a million farmers to commemorate the sixth anniversary of Moncada. Rather than having the luxury of several years to plan, study and train, film-makers had to begin work immediately. Nonetheless, ICAIC's productions – including a weekly newsreel – have been described as 'the most striking cultural creations of the Revolution',[40] and the institute itself quickly became accepted as a 'prestigious forum, gathering film-makers and others who gravitated naturally towards ICAIC's more directed radicalism'.[41] As well as nurturing young directors and commissioning new productions, the burgeoning film industry would soon provoke experiments in distribution that were consistent with its revolutionary objective of forming new audiences capable of appreciating works of art.

In 1960, ICAIC created the Department of Cinematographic Dissemination, with the aim of engaging thousands of new spectators in the most dispersed parts of the island, and all the relevant distribution mechanisms were nationalised in mid-1961. As part of the literacy campaign, the price of a cinema ticket was reduced by twenty cents (which represented a quarter or a fifth of the former price, depending on which seats were chosen) for two years, in a bid to cultivate a new public. Towards the end of 1965, construction began on fourteen new cinemas throughout the island, which was accompanied by the rapid renovation of four existing cinemas (left in a deplorable condition by the outgoing cultural leaders) and the maintenance and repair of a further seventeen. As early as April 1962, thirty-two lorries

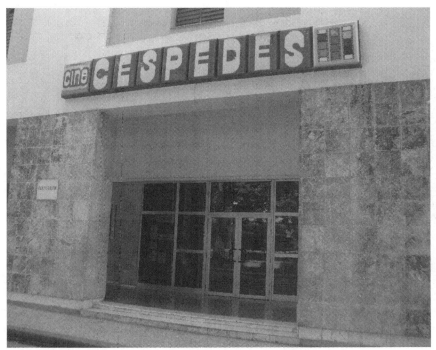

Cespedes Cinema in Bayamo, named after Carlos Manuel de Céspedes del Castillo, who made the declaration of Cuban independence in 1868.

were designated travelling cinemas, and UJC projectionists began travelling for twenty-five days every month around regions which otherwise lacked the means of cinematic diffusion. These young projectionists would spend hours screening didactic documentaries, particularly in agricultural areas where large numbers of voluntary workers were concentrated, before returning to their point of departure to maintain, repair and renew the film stock.

Serving a population of just over seven million, Cuba could soon boast a total of 616 cinemas housing 16mm projection facilities – 480 of which were stationary, 112 pulled by lorry, twenty-two drawn by animals and two carried by boat around the coast – as part of the concerted effort to dissolve discrepancies between rural and urban areas which formed one of the overarching priorities of the Revolution. And, while film had been understood as an accessible medium, the results surpassed all expectations, with *The Adventures of Juan Quin Quin* – a 1967 comedy by García Espinosa, based on a young man's involvement in revolutionary struggle – being watched by around a million people. The mobile cinema programme extended to narrative and international productions and, in a scene captured in an eight-minute film by Octavio Cortázar called *Por primera vez*, 'children and adults alike were doubled up in laughter in front of an improvised screen, seeing Chaplin act for the first time'.[42]

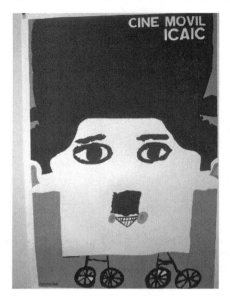

A poster, produced by ICAIC, to publicise mobile cinemas disseminating films such as those by Charlie Chaplin.

By 1970, the network of mobile cinemas had facilitated more than 363,000 screenings for forty million spectators. By the end of the decade, this figure had increased to more than 1.5 million screenings watched by around 200 million spectators.[43] Through its commissioned content and democratising efforts, Cuban cinema was able to consider itself a protagonist in the revolutionary process, seeking a lively inter-relationship between itself and its spectators that would inspire the continent. Cinemas continue to be run by ICAIC, subsidised by the state throughout the island, and the egalitarianism underlying Cuba's approach to cinematic production and distribution is reflected in the fact that, at the time of writing, admission to any cinema costs two pesos, which is equivalent to the price of an egg.

By contrast to the successes of local commissioning, ICAIC's strategy for importing foreign films met with a mixed response. A self-reflexive letter from the institute's directors to the 26 July Movement newspaper, *Revolución*, in December 1963, referred to the country's recent emergence from two years of terrible cinematic tedium. This period coincided with a very public dispute around whether films by Buñuel, Fellini and Pasolini were appropriate for Cuban audiences, requiring Guevara to take a stand against the respected PSP leader and columnist, Blas Roca Calderío, which will be considered in depth in chapter five. Harvard Latin Americanist Jorge I. Domínguez would later note that 'Between forty-three and fifty-seven Soviet films were shown every year in Cuba from 1961 through 1964, accounting for a fifth to a quarter of all films shown'. This was accompanied by the observation that, 'When it came to popular entertainment, politically suitable films had a hard time'[44] in an environment in which quality remained paramount. And, although the influx of films from the Eastern Bloc had abated by 1968, the main protagonist of Edmundo Desnoes's *Inconsolable Memories* – a novella reflecting on a society undergoing acculturation, which would form the screenplay of Gutiérrez Alea's film *Memories of Underdevelopment* – notes that he 'suffered through two films from the "friendly countries," which is what the "satellite nations" of just a few years ago are called now. [...] I can't swallow another one of those

pictures. They depress me terribly; they smell so old, like the mothballs in my Aunt Angelina's closet'.[45]

Nowadays, ICAIC programmes a wide range of content from all over the world, including the US, which is screened to rapturous audiences from bootlegged DVDs. As the rest of the world labours under the commercial model of the 'culture industry' so derided by Adorno and Horkheimer,[46] the wider significance of this approach cannot be overstated. Bypassing the profit motive, ICAIC is able to provide universal access to the world's best contemporary films, including its own productions.

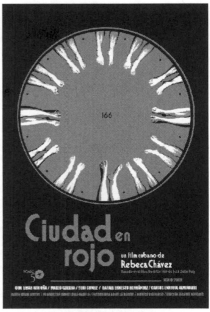

A poster, produced by ICAIC, to publicise the 2009 film, *Ciudad en rojo* [City in Red] by Rebeca Chávez.

Another area in which ICAIC continues to exert its revolutionary authority is in fostering a new genre of public art through the film posters it has commissioned from artists and graphic designers since 1960. Aesthetically and politically, these roughly A2 sheets challenge the hegemony of Hollywood and its high-earning starlets, their block colour and screen-printed texture immediately distinguishing them from their mass-produced equivalents. Combining artistic tropes – most memorably, the collage technique of Raúl Martínez – they bypass all mention of individual actors to encapsulate the content of the films they advertise in punchy visual aphorisms. Consistent with the principle and practice of universal access, the posters refute the idea of the cinema-goer as consumer, treating viewers instead as 'consciously interdependent subjects, whose free choices are continually replete with serious implications for humanity in general'.[47] Many of the posters have found their way into high-profile exhibitions at Pabellón Cuba in 1966, the First National Poster Salon in 1969 and the National Museum of Fine Arts in 1979. To this day, film posters are made using the same technique and style, and international visitors are able to purchase these iconic multiples for $10–15 from a discreet shop near ICAIC's headquarters.

One final area of innovation pioneered by the cinematic institute has been in the field of music, providing a forum for the development of new Cuban song and a refuge for experimental electroacoustic sound – particularly Leo Brouwer's Grupo Experimentación Sonora [Sonic Experimentation Group] – at times when the cultural landscape lost its flavour. In a letter to Desiderio Navarro in January 2007, Enrique Colina – who directed the TV

Cubana programme *24 per Second* for thirty-two years – described the cultural policy cultivated by ICAIC as the most open, tolerant and anti-dogmatic, fostering conceptual profundity and artistic expression within the coordinates imposed by censors. Above all, Colina wrote, the film institute signalled resistance to the errors of intolerance, and we shall see how important this approach would be during the more dogmatic moments to come. By contrast, Almendros notes that, by handing to control of cinematic production to the Marxist element of the Nuestro Tiempo film department, the revolutionary government completely excluded the founders of the Cinema Club of Havana. In chapter four, we shall see how this latter group spectacularly took matters into their own hands.

Casa de las Américas

For two full years following revolutionary triumph, the major official entity to promote culture was the Cultural Directorate of MINED, overseen by a young lawyer, Armando Hart Dávalos, in his role as Minister of Education. Hart had joined the 26 July Movement while Fidel was imprisoned on the Isle of Pines and played a crucial part in the urban underground. In 1956, he met and married Haydée Santamaría Cuadrado, a *guerrillera* eight years his senior, who will be fully introduced shortly. Arrested many times and staging a daring escape from a court hearing in Havana, Hart was eventually captured coming down from the mountains in 1958 and imprisoned until 1 January 1959.

One of only a handful of members of the urban underground to form part of the inner core of the Revolution, being entrusted with a pivotal educational role, Hart oversaw the 'seminal 1961 literacy campaign, the nationalisation of all schools, the major and contentious university reform, and the creation of experimental schools'.[48] Described as 'Cuba's renowned Marxist-humanist philosopher and cultural strategist',[49] Hart has consistently expressed the view that art and politics are neither synonymous nor separable, which has led him to firmly locate culture within its social context, interwoven with the problems and successes of society. This perspective has informed the policies he developed in relation to Cuban culture, which he regards as being uniquely shaped by historical processes and informed by 'political, patriotic and revolutionary principles'.[50] Prominent within the political hierarchy, Hart has been a key figure of the revolutionary era, proving himself as someone to whom creative intellectuals could appeal for support at crucial moments. As we shall see, this was particularly evident when he became a member of the Central Committee of the PCC upon its formation in 1965 and when he was appointed to the top post at the Ministry of Culture established in 1976.

It is said that Che Guevara first mooted the idea of creating a cultural organisation that would allow Cuba to bypass the blockades which would inevitably be imposed upon the country. In a 1977 interview with the writer

Jaime Sarusky, Haydée Santamaría described how, in 1959, the incoming administration took one look at an organisation called the Panamerican Colombista Society and realised that it was corrupt. Working at MINED immediately after revolutionary victory, Haydée discussed with her husband, the Minister, the idea that she take over responsibility for this institution and explore the possibilities for how it could be run.

Haydée had been among a small number of prominent female revolutionaries who had taken part in the occupation of the military hospital at Moncada during the 1953 assault, having been part of the four-person

Armando Hart Dávalos.

group that planned the barracks attacks and hosted most of the meetings in her Havana flat. It was after this failed action that her brother, Abel, and her fiancé, Boris Luis Santa Coloma, died under torture. This prosaic statement gives us a clue about the essence of a woman who would be central to revolutionary culture. Shedding light on the atrocities perpetrated by Batista's men in retaliation for Moncada, Fidel would describe at his trial how:

> Frustrated by the valour of the men, they tried to break the spirit of our women. With a bleeding eye in their hands, a sergeant and several other men went to the cell where our comrades Melba Hernández and Haydée Santamaría were held. Addressing the latter, and showing her the eye, they said: 'This eye belonged to your brother. If you will not tell us what he refused to say, we will tear out the other.' She, who loved her valiant brother above all things, replied full of dignity: 'If you tore out an eye and he did not speak, much less will I.' Later they came back and burned their arms with lit cigarettes until at last, filled with spite, they told the young Haydée Santamaría: 'You no longer have a fiancé because we have killed him too.' But still imperturbable, she answered: 'He is not dead, because to die for one's country is to live forever.' Never had the heroism and the dignity of Cuban womanhood reached such heights.[51]

Imprisoned until February 1954 for her part in the aborted coup, Haydée – who had never finished senior school – voraciously indulged her passion for reading, revisiting the complete works of José Martí. Upon her release, she was entrusted with the clandestine circulation of the nascent 26 July

Monument to Abel Santamaría, Santiago de Cuba.

Movement's manifesto, *Message to the Suffering Cuba*, closely followed by the dissemination of tens of thousands of copies of Fidel's Moncada defence speech, which had become known as 'History Will Absolve Me' on account of its concluding sentiment. When the Castro brothers were released from prison in May 1955 and left for Mexico to plan the next stage of the insurrection two months later, Haydée went underground in Havana under the *nom de guerre* of María, during which time she made contact with many of the young intellectuals who would later serve as her bridge to the world of culture.

When the next stage of the Revolution began, with the return of Fidel and his troops aboard the *Granma*, it fell to Haydée and her comrades to organise the uprising intended to distract authorities in Santiago de Cuba. She would go on to play a key part in the movement's leadership and the urban resistance, venturing into the Sierra only sporadically. Her early married life was particularly hazardous, with herself and Hart equally wanted by the

Haydée Santamaría Cuadrado. Courtesy of the Archive of Casa de las Américas.

police, meaning that they were only able to meet up fleetingly between missions, in the mountains or transient safe houses of Santiago. When Hart was imprisoned, Haydée was sent to Miami to carry out tasks beneficial to the Revolution, including fund-raising and arms trafficking, before returning to Cuba on 2 January 1959.

Three months later, Haydée would occupy the building described by Lisandro Otero as a small baroque castle reminiscent of an Etruscan tomb.[52] Having arranged for its tasteful redecoration, she began to consult artists and writers, whose proposals gave rise to a gallery, conference centre and journal under the rubric of Casa de las Américas [House of the Americas].[53] Established on 28 April 1959 (more than two years before Cuba was officially declared a socialist state), the original remit of Casa was to sustain a free cultural centre for adults, specifically aimed at the working class. It was also charged with maintaining a library specialising in American affairs. And, perhaps most importantly, it was made responsible for promoting the development of cultural exchanges, by working with organisations dedicated to nurturing relationships across the continent and disseminating details of the Revolution. Initially envisaged as a pan-American house of culture and a meeting place for the radical artists and intellectuals whose work it actively promoted, Casa quickly became the revolutionary centre of Latin American culture and remains a nexus for cultural visitors to the island.

Undertaking doctoral research into Casa de las Américas at Yale, Judith Weiss describes its director as 'an intellectually neutral, modest person. [...] The impressions of Haydée relayed by her acquaintances stressed her

kindness, her simple character, and her interest in giving every artist and writer a chance; there is no doubt that she is above all an intelligent, fair-minded administrator'.[54] While benign, this description seems to discount Haydée from the same tenacity in the field of culture that she had shown on the battlefield. By contrast, in Cuba, her centrality is continually reinforced. Otero alludes to the strange intensity of this intransigent, impassioned woman and refers to her combative disposition in times of peace, while her latter-day colleague Roberto Fernández Retamar describes her as 'a guerrilla fighter twenty-four hours a night'.[55] In an attempt to redress the balance in the literature of the English-speaking world, Betsy Maclean edited a collection of personal testimonies by and about the Casa director for an Australian publisher, articulating how, 'With her internationalist vision in tow, Haydée transformed herself from *guerrillera* to cultural emissary, choosing to wield art and culture as powerful weapons for social change'.[56] There is much evidence that Haydée applied her radical sensibility to the work she carried out with the wide variety of Latin American artists and writers she came to regard as kindred spirits.[57] The 2010 edition of the international book festival which annually tours the island carried a book of letters to Haydée – known as Yeyé to her friends – giving a clearer idea about the esteem in which she continues to be held by cultural practitioners and compañeros across the continent; from Nicolás Guillén to Gabriel García Márquez, Che Guevara to Eduardo Galeano, these missives convey an atmosphere of amity and solidarity.[58]

Although she turned down several posts within the revolutionary government, Haydée was one of only twenty-five members of the National Directorate of the ORI, and her proximity to the centre of power is attested to by the fact that buildings at Casa de las Américas are named after key revolutionary figures. So, for example, the book library, inaugurated on 7 September 1959, is dedicated to José Antonio Echeverría, a leading member of the 26 July Movement who, in 1955, resuscitated the Revolutionary Directorate (established by students in the 1930s), going on to orchestrate the aforementioned attack on Batista's presidential palace on 13 March 1957 and dying in a subsequent shoot-out. Becoming a member of the Central Committee of the PCC in 1965, Haydée was in a position to be very effective culturally, and was aware of the reciprocal relationship she had with her team, offering leadership and political influence in return for aesthetic advice. As we shall see, Haydée's revolutionary prestige would ensure the survival of her institution during difficult times. Under her directorship, Casa would intervene in local political affairs when the situation called for it, discussing any serious discrepancies among its constituents but never joining in the international hostility that was increasingly directed at the Revolution.

From October 1960, the US enacted economic sanctions against Cuba, which would be fortified over the following fifteen months into an almost total

Exterior view of Casa de las Américas. Courtesy of the Archive of Casa de las Américas.

blockade of the island. At a meeting of the Organization of American States (OAS) in Uruguay in January 1962, the US pressured the other member states into voting for Cuba's expulsion – a move that was only resisted by Mexico. As diplomatic relations were severed between Cuba and the rest of the continent, the island found itself increasingly isolated, with its sympathisers becoming targets of persecution. Nevertheless, the hope was maintained that this attitude did not extend to the 180 million people of Latin America, who were connected through a history of anti-imperialist struggle. Accordingly, Haydée identified 'what she believed was the one crack in the ideological blockade being built around her island – culture'.[59] At the same time, it was felt that cultural exchanges might play a part in the recovery of national identities and resources across Latin America in the broader fight for economic independence and political sovereignty, thus extending the possibility of continental revolution sparked by the example of Cuba. As we shall see, the anti-imperialist intellectual current evinced at Casa would come to represent one of the main poles around which culture was defined, successfully engaging revolutionary artists and writers and their respective communities.

For the sake of balance, it is worth noting that Guillermo Cabrera Infante – whose name has already been mentioned in connection with Nuestro Tiempo and will be writ large over chapter four – is unique in his criticism of Haydée. Typically writing of women as possessions of the men who form his main narrative, Cabrera Infante details how, for a short time,

Poster featuring the cover image of José Soler Puig's historical novel, *Bertillón 166*, winner of the 1960 Casa de las Américas Prize. Courtesy of the Archive of Casa de las Américas.

he served as a 'representative to the minister of Education, Armando Hart in the Cultural Directorate, but serious differences [developed] with Hart and, above all, with his woman, Haydée Santamaría'.[60] Aggrieved by the Revolution's communist embrace, his reflections are tainted by a sense of snide superiority as he notes that 'Casa de las Américas was just a toy with which compañera Yeyé would entertain her revolutionary leisure',[61] while 'No-one in Cuba was worse equipped to deal with the immediate [...] problems of culture. Compared to her, everyone was professionals of the highest order'.[62]

A centre for conferences, courses and seminars, Casa became a house of dialogue and, as a testament to this, many of the most important disputes of the period covered by this study (and beyond) have had their origins in this discursive place. In relation to the plastic arts, Casa houses a gallery which hosts temporary exhibitions and showcases a permanent collection of several thousand Latin American artworks, including those commissioned *in situ* from artists spending time in Cuba. The annual Exhibition of Havana, organised by Casa throughout the 1960s, was deemed the most important plastic arts event in Latin America, while the thriving poster art movement was initially centred on Casa, which oversaw the continent-wide dissemination of posters produced by Cuban institutions and organised a competition for printmakers.

Among those offering early practical support at Casa were Marcia Leiseca and Katia Álvarez, the latter of whom would have the idea of an annual literary prize for works written in Castilian. This was initially known as the Hispanoamerican Literary Competition, changing its name in 1965 to the snappier Casa de las Américas Prize. Initially centred on essays, plays, poetry, novels and stories and offering publication and $1,000 (now $3,000) to winners in each of these categories, the prize quickly became the most prestigious on the continent. In part, this was due to Casa's refusal to impose any theme, style or political position, with quality being the only decisive factor. This reputation would see an increasing number of manuscripts flowing into Cuba and intellectuals flouting the blockade to sit on the jury. Yet, while the

Cover of *Casa de las Américas* journal.

Argentinian scholar Claudia Gilman cites Casa as an exemplary institution that attempted to ensure an open space, free from party doctrine, in which unlimited aesthetic experimentation could be undertaken, she notes that the first three Casa prizes for fiction, between 1960 and 1962, were awarded to works 'with positive heroes, which satisfied the demands of ideological health but doubtless were not what the majority of artists hoped would be encouraged as an artistic programme'.[63] This refers to José Soler Puig's epic, historical novel about the clandestine struggle against Batista, entitled *Bertillón 166*; Bay of Pigs correspondent Dora Alonso and her novel about the pre-revolutionary past; and Daura Olema's story of a bourgeois girl who underwent a conversion during the Revolution to become one of the young teachers in the literacy campaign. But, as a testament to the enduring appeal of revolutionary themes (and bearing in mind the liberty that was granted to Casa, especially during its early years), it is necessary to note here that *Bertillón 166* provided the screenplay for the stylish 2009 film *Ciudad en Rojo* [City in Red] directed by Rebeca Chávez and produced by ICAIC.

By the early 1960s, Casa was running an active programme of cultural extension which included the dissemination of: 1,000 copies of a weekly bulletin, synthesising what was deemed to be the most important news in Cuba; monthly dispatches of social and artistic material; books to cultural institutions and student, cultural and workers' groups with an affinity to Cuba; and daily replies to those soliciting information about the local cultural scene. Publishing remains one of the main strands of Casa's activity. In addition to

Haydée Santamaría Cuadrado, Mariano Rodríguez Álvarez and Roberto Fernández Retamar. Courtesy of the Archive of Casa de las Américas.

the prize-winning works published every year,[64] another notable achievement in this area has been the bimonthly journal *Casa de las Américas*, the first issue of which was edited by the writer Antón Arrufat and printed in an edition of 2,000 for May–June 1960.

Directorship of Casa conferred responsibility for its journal upon Haydée, a role she initially oversaw before delegating the task to an editorial council and then to Roberto Fernández Retamar. A promising young poet who had undertaken a doctoral study of modern Cuban poetry and won the 1952 National Prize for Literature, Retamar co-founded a journal called *Nueva Revista Cubana* [New Cuban Magazine] in the year of revolutionary victory. He then took up a diplomatic post in Paris – where he met the legendary Latin American poets, Octavio Paz and Pablo Neruda – and spent time with writers in Genoa before travelling to Prague to teach twentieth-century Hispanoamerican poetry. Returning to Havana in 1961, he would become Secretary of the National Union of Cuban Writers and Artists (UNEAC), to be discussed shortly, founding its in-house magazine, *Unión*, the following year, which he co-edited with the respected novelist Alejo Carpentier until 1964. His association with Casa de las Américas was resumed in the early 1960s, through his contributions to its publications and his service on the jury of its literary prize. When the editor's post of the prestigious journal was vacated in March 1965, it was suggested that this astute cultural spokesperson apply. And so, since issue thirty, (May–June 1965), with one brief pause in 1986, resuming with issue 184, Retamar has served as editor of *Casa de las Américas*,

Roberto Fernández Retamar. Courtesy of the Archive of Casa de las Américas.

to become 'the visible face of Cuban literary culture and author of some of the key texts of the period'.[65]

In 1959, Retamar described how the continent's diversity was underwritten by a 'spiritual unity that is realised at the frontiers of paper and ink'.[66] Casa would serve to extrapolate this unity, and Haydée would locate the journal as a key weapon in attaining communication across Latin America, being both a literary and political vehicle through which 'the continent's writers expressed themselves and explained what was happening from their points of view'.[67] Weiss observes that the change in editorship coincided with a continent-wide politicisation, whereby 'Arrufat's literary bimonthly was to become Retamar's ideological bimonthly if it wanted to survive as a congruous part of international policy'.[68] Having been quick to familiarise himself with Marxist-Leninist tenets, Retamar would articulate the position that 'The Revolution is not a thing already made, which we can accept or reject, but a process whose course is not exact but, at the same time, we are immersed in. In some way, as humble as we are, we contribute to modifying this process; in some way, we are the Revolution'.[69] Consistent with broader institutional policy, *Casa* demonstrated an unflinching commitment to political and creative freedom and urged regional unity in the face of US aggression. At the same time, the highest standards of quality would be maintained, with the journal becoming central to the Latin American literary boom of the 1960s and continuing to occupy a visible place among the continent's periodicals.

Over the course of Retamar's editorship, the journal has encompassed a range of themes to reflect the main political, social and artistic problems of

Latin America at any given moment. Among the many examples of key arti-
cles cited by Retamar are considerations of the various independence struggles
and literary developments of the region; among the special issues he high-
lights are those dedicated to structuralism, aesthetics and semiotics, those
relating to Marxism and postmodernism and those considering the activities
of the institution.[70] In parallel to its textual impact, the journal – with cutting-
edge graphics, by Umberto Peña, which came to be associated with Retamar's
editorship – has consistently represented the plastic arts of the continent in
an international context, reproducing works from Rivera to Picasso.

Early during Retamar's editorship, a collaborative committee was set
up which included Mario Benedetti, Edmundo Desnoes, Ambrosio Fornet,
Lisandro Otero and Graziella Pogolotti alongside Roque Dalton,[71] René
Depestre[72] and Mario Vargas Llosa.[73] This committee met on three occasions,
in 1967, 1969 and (in reconfigured form) 1971, and put out important declara-
tions. In spring 1969, the committee concluded that it would be necessary
for revolutionary intellectuals to participate in direct action. As we shall see,
this decision was taken at the threshold of an era of stifled creativity which
caused Casa to modify its *modus operandi* in order to avoid confrontations with
cultural functionaries. While this will be expanded upon later, it is necessary
to mention here that Casa has remained one of the most anti-dogmatic of
the revolutionary institutions. Most importantly, it provided a vital forum
during the grey years from which the continent's artists could consider their
revolutionary role.

Having worked closely with Haydée, Retamar likens her to Don Quixote,
describing how 'She spent her life building things, attacking the air with her
broadsword, attacking windmills and iron mills as well, suffering on others'
behalf, freeing galley-slaves. Until her pain grew too much for her (the eternal
pain her horrible executioners [*sic*] caused her after the Moncada attack), her
mind grew darkened, and she took her own life'.[74] Haydée Santamaría died by
her own hand on 28 July 1980. In a retrospective tribute to her, Juan Almeida[75]
asserts that 'As revolutionaries, we cannot agree on principle with suicide. The
life of a revolutionary belongs to his or her cause and people and should be
devoted to serving them to the last ounce of energy and the last second of exist-
ence. But we cannot coldly judge comrade Haydée. That would not be just'.[76]
Retamar also offers a comment on the taboo subject of revolutionary suicide,
expanding on the cause of her eventual death as the horrors of Moncada: 'From
the shadows that were initially cast in 1953 emerged the hand that murdered
her in 1980. Was it her own? Or was it not rather one of those bestial hands that
castrated fiancés or pulled out the eyes of brothers, alive, and sowed in a valiant,
pure, strong and fragile girl a seed that later sullied her reason?'.[77] US writer and
activist Margaret Randall recasts such attempts to exonerate Haydée, urging
the Revolution to honour her suicide as a tragic but acceptable act.[78]

After Haydée's untimely death, the painter and Vice President of Casa Mariano Rodríguez Álvarez assumed presidency for six years until his retirement in 1986, when he was succeeded by Retamar, who remains in post to date. Prior to this, Retamar, a Martí scholar, had served as director of the Centre for Studies of Martí, which he had established in 1977. In 1959, Retamar had asserted a need to distinguish Martí's conceptions of Our America from the superficial variant being invoked by feuding politicians. In the revolutionary poet's seminal 1891 text, Retamar finds a celebration of the blood and heroism of native Latin America and a rejection of the genocide perpetrated by Europeans, who equated colonisation with oppression in the name of civilisation. For him, any consideration of political unity should be based on genuine solidarity between peoples, while acknowledging the plurality that existed throughout the region. Between 7 and 20 June 1971, Retamar penned a 'defiant challenge to neocolonial ideology',[79] entitled 'Caliban', after Shakespeare's character in *The Tempest*, whose name – a rough anagram of cannibal – is derived from the Carib Indians who originally occupied Latin America.

While Shakespeare can be shown to have read a translation of Montaigne's 'On Cannibals' of 1580 – which portrays the native American in a noble light – Retamar argues that the English playwright chose the pragmatic option, in an increasingly bourgeois world, of depicting the islander encountered by the shipwrecked Prospero as an ignoble savage deserving of domination. Retamar's response bemoans the approach deployed by Prospero, who 'invaded the islands, killed our ancestors, enslaved Caliban, and taught him his language to make himself understood'.[80] Charting the racism underlying colonial literature, Retamar outlines the two responses available to the Latin American intellectual: to 'choose between serving Prospero [...] at which he is apparently unusually adept but for whom he is nothing more than a timorous slave, or allying himself with Caliban in his struggle for true freedom'.[81]

As Martí in general and Our America in particular continue to inform the anti-imperialist ethos of Cuban cultural policy, as exemplified by Casa, it is worthwhile consulting the original text. Arguing that the day was imminent when Latin America would be called upon to face 'The scorn of our formidable neighbour who does not know us',[82] Martí firmly urges continental unity. In this effort, he offers a few words that are specifically relevant to culture, beginning with a consideration of the power of ideas to suggest that 'Barricades of ideas are worth more than barricades of stone. [...] A powerful idea, waved before the world at the proper time, can stop a squadron of ironclad ships'.[83] Urging that the (Hegelian) Absolute Idea should take relative forms, Martí's thinking is significant in relation to intellectual practice within the Revolution, which, as we shall see, would find itself at odds with the anti-idealism of the more ardent materialists. At the same time, Martí cautions

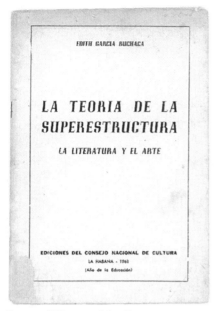

EDITH GARCÍA BUCHACA

LA TEORIA DE LA
SUPERESTRUCTURA

LA LITERATURA Y EL ARTE

EDICIONES DEL CONSEJO NACIONAL DE CULTURA
LA HABANA - 1961
(Año de la Educación)

Cover of *Theory of the Superstructure* by Edith García Buchaca.

against the inauthentic polemicist, 'The presumptuous man [who] feels that the earth was made to serve as his pedestal because he happens to have a facile pen or colourful speech'.[84] Nonetheless, he argues that creativity holds the key to salvation, providing the impetus and vision according to which authentic new Latin American societies would be formed. And, in direct contrast with Haydée's reminder to jurors that the Casa prize was a literary one, which should be awarded to the best work irrespective of its political impeccability, Martí contends that 'The prize in literary contests should not go for the best ode, but for the best study of political factors of one's country',[85] ultimately subordinating culture to contextual imperatives. We shall see how such conflicting approaches to culture and politics would continue to play out over the decades.

National Council of Culture (CNC)

As mentioned above, the main agency for promoting culture during Batista's dictatorship was the National Institute of Culture (INC), a repressive organisation that politically committed artists were destined to avoid. A 1976 publication by the Ministry of Foreign Relations (MINREX) describes how the initial popular, anti-imperialist phase of the Revolution was followed by the beginnings of socialist construction, characterised by the perfection of a new education system and an act of 'extraordinary meaning and transcendence'[86] – the creation of the National Council of Culture (CNC). Spawned as an organ of MINED by Law 926 of 4 January 1961, the council would begin operation under a president, vice president, secretary and five members, each designated by the President of the Republic and meeting twice a year with the directors of its various departments.[87]

For the following fifteen years, all tasks of an artistic and literary nature would be delegated to the CNC. In its first incarnation, the council was overseen by Edith García Buchaca, who was mentioned briefly in the previous chapter, and we gain a great deal of insight from her pamphlet *The Theory of the Superstructure: Literature and Art*, which was published as one of the first gestures of the CNC in 1961. In this, she concedes art and literature to be

social phenomena – arising in specific communities and serving as a means of human communication – while confining culture to the superstructure. In his preface to *Foundations of the Critique of Political Economy* (known as the *Grundrisse*), Marx situated the aesthetic terrain among the ideological forms determining consciousness (alongside law, politics, religion and philosophy).[88] While a narrow reading of this formulation permits cultural production and intellectual engagement to be considered part of the superstructure, Marx was explicit that the ideological superstructure is inextricably linked to the economic conditions of production. Moreover, he argued that transformations in the economic base, which may be predicted scientifically, inevitably bring about less predictable changes in the superstructure. This implies that, when the economic structure of society changes – as it did in Cuba throughout the 1960s – so, too, do social, political and intellectual life.

García Buchaca adopts an orthodox – if paradoxical – reading of Marx's inconclusive application of the theory of base and superstructure to cultural matters. On the one hand, by treating culture as a frozen and dislocated entity (as part of the superstructure with no connection to the economic base), she segregates the arts and literature from the historical processes constituting the Revolution. On the other hand, she regards culture as being entirely determined by the economic context in which it is produced and consumed, permitting her to dismiss all art produced under capitalism and to attribute specific expectations to the art produced under socialism. In considering these two – usually opposing – positions, Macdonald Daly notes that 'both views share idealist assumptions which are anathema to Marxism, and it is therefore unlikely that Marx, though himself a passionate *literatus*, would have espoused either'.[89] This left García Buchaca in the irreconcilable position of denuding culture of any social value while simultaneously fearing the influence it might have. A decade after her pamphlet was written, Raymond Williams would dismiss the formula of base and superstructure for 'its rigid, abstract and static character'[90] and for its centrality in utilitarian, and hence bourgeois, thought. In prioritising humanist over orthodox interpretations of Marxism, the Cuban experiment echoes Williams's fear that 'the proposition of base and superstructure, with its figurative element, with its suggestion of a fixed and definite spatial relationship, constitutes, at least in certain hands, a very specialized and at times unacceptable version'[91] of culture compared to more socially derived readings. After much trial and (acknowledged) error, this is the position at which the revolutionary government would arrive.

Analysing the composition of the CNC, Robin Moore, who has conducted research into Cuban music, observes that:

> As opposed to other areas of government, members of Castro's 26th of July movement did not figure prominently in the CNC. [The 26 July members]

chose to take charge of military, economic, and financial sectors, leaving what were perceived as less vital interests such as culture to 'old-guard' Communist leaders. When the revolution triumphed, the PSP [...] was one of the few viable political groups from the past with a national infrastructure and a codified ideology. Castro took advantage of this by affiliating himself with its members. Among other things, he charged it with the formulation of a cultural agenda.[92]

García Buchaca was supported in her work by the aforementioned PSP militant, Mirta Aguirre, as Director of Theatre and Dance. In an autobiographical conversation conducted in 2007, Alfredo Guevara remembers García Buchaca and Aguirre as talented and cultured, while self-admittedly exaggerating that they were more Stalinist than Stalin. Reading their writing, one is reminded of a word that Desnoes introduces us to in his novella – *'sarampionado*: measled; a person intoxicated with too much Marxist-Leninist theory, a dogmatic revolutionary'.[93] Railing against 'sectarianism' in 1962, Fidel would assert that 'dialectics teaches us that what in a given moment is a correct method, later on may be incorrect. [...] Anything else is dogmatism'.[94] By the same token, between 1965 and 1966, Che took the *Manual of Political Economy*, published by the Soviet Union's Academy of Sciences to task, arguing that 'scholasticism [...] has held back the development of Marxist philosophy'.[95] Before long, we shall see how the dogmatic, scholastic contagion perpetuated by *sarampionados* at the CNC swept through the cultural ranks of the 1960s and '70s.

García Buchaca and Aguirre were joined by Vincentina Antuña, a poet and university professor, associated with the Orthodox Party (favoured by the leftist intelligentsia, including Fidel, before the Revolution), who transferred over from the Cultural Directorate of MINED to become Director of Culture at the CNC. García Buchaca's second husband, Joaquin Ordoquí,[96] was also involved, and Moore also lists Marinello and Carlos Rafael as having been influential in the CNC during its early years, while noting that the contribution of PSP militants overshadowed that of more moderate influences, such as the writers Alejo Carpentier and José Lezama Lima.

While the majority of cultural producers may initially have identified with the CNC's aim to 'work on the recovery of [their] traditions and the dignifying of artistic and literary work',[97] within a few months of its creation, tension between the council and the country's intellectuals was already evident. In a June 1961 address to intellectuals, Fidel probed fears that the CNC sought to inhibit creative expression, concluding that 'our comrades in the National Council of Culture are as concerned as all of you about bringing about the best conditions for the creative endeavours of artists and intellectuals. It is the duty of the Revolution and the Revolutionary Government to see that there is a highly qualified organization that can be relied upon to stimulate,

encourage, develop, and guide, yes, guide, that creative spirit'.[98] But his faith in those to whom he had delegated responsibility would soon prove unfounded. Explicitly exempting Antuña, Carpentier and Lezama Lima,[99] Otero would retrospectively assert that personnel at the early CNC had used the council as a device for implementing their theories of socialism in relation to culture.[100] In considering how this was achieved, Guevara notes that García Buchaca was culpable for the emergence of 'cultural Councillors, cultural *attachés*' – intermediaries who drove a wedge between intellectuals and the Revolution.[101]

Defining its own raison d'être in the wake of Fidel's vote of confidence, the CNC would describe, in a 1962 report, how the revolutionary process made necessary the existence of an organisation that would orient and lead the cultural activities being planned by official organisations in response to the cultural policy that was being traced according to the objectives and character of the Revolution. This hints at the centrality and inviolability of an organisation charged with creating the conditions suited to the development of an art and literature that would form an integral part of the new social reality. While the precise policy and ideology arising from the CNC and its suitability to culture will be discussed throughout this book, it is useful to map its overall ethos here.

In the beginning, the council concerned itself with ironing out some of the organisational anarchy that existed in the administration of cultural affairs, in a bid to integrate national, provincial and municipal activities. By the last trimester of 1961, assemblies had taken place in each of the six provinces,[102] with full delegations from every municipality representing mass organisations and participating in determining budgets.[103] By the end of 1962, the CNC had crafted a Preliminary Plan that would define policy for the following year. This was predicated on the proximity of culture and politics under socialism, with cultural activities being harnessed to the most urgent aims of the revolutionary government in any given period, which, it was anticipated, might include defence, production and political development. In the early years, policy was based on the cultural necessities of the people, and a call was made to mass organisations to mobilise the strengths of each locality in order to stimulate the interest of workers, farmers and students in cultural activities. At the same time, attention was paid to the training of professional artists and their teachers.[104]

The idea of a national salon (discredited under the INC) was reinvigorated, with the objective of attracting the participation of all artists in the Republic, alternating each year between painting/sculpture and printmaking. This would provide an occasion for the state to buy works of art, as recommended by jurors, in a bid to expand museum collections.[105] A Directorate of Plastic Arts was created within the CNC, which was largely centred on the reorganisation of existing museums and the creation of new ones (to be

considered shortly). This would run alongside departments dealing with exhibitions organised outside museums and galleries and those centred on professional and amateur education. While a reorganised Casa de las Américas was taken under the CNC umbrella, ICAIC retained its juridical autonomy; nonetheless, the film institute's activities were reported on by the council within the broader ambit of revolutionary cultural policy, and ICAIC representatives participated in meetings at which CNC policy was decided. Pogolotti retrospectively finds that subordination under this hierarchical organisation ended the possibility of these well-defined institutions determining their own cultural policy. For her, this bringing-together of diverse entities under one official arm promoted dialogue between distinct intellectual families and made latent discrepancies visible.[106]

In July 1963, it was decided that, as the central cultural planning organisation, the CNC needed autonomy from the state, which led to its being detached from MINED and taken directly under the Council of Ministers.[107] The following year, García Buchaca and Ordoqui found themselves embroiled in the public trial of the aforementioned Nuestro Tiempo member Marcos Armando Rodríguez. As key PSP members who had offered protection to Rodríguez after he confessed his Batistiano betrayal to them, García Buchaca and Ordoqui were placed under house arrest in December 1964 (until 1973). While not denying their involvement, Karol alleges that 'they apparently played some minor part in this unfortunate affair and were made to pay for it, but in such a way that this crime could not be laid at the door of the party they once led'.[108] García Buchaca was replaced at the CNC by the diplomat and journalist Carlos Lechuga, and the psychiatrist Dr. Eduardo Muzio was brought in to work alongside Otero, with Harold Gramatges as an advisor. In 1966, the process of taking the council back under the auspices of MINED was initiated, which concluded in April 1967.[109]

In 1971, the CNC would again be transformed, when Lieutenant Luis Pavón Tamayo – second-in-command of the Political Directorate of the Revolutionary Armed Forces (FAR) and editor of *Verde Olivo* [Olive Green], the army magazine founded by Che – was appointed as President. Coinciding with a new phase of autonomy, the council was reorganised, with the President achieving near omniscience, representing the CNC within the Popular Council of Education, Culture and Sport and all international organisations (including UNESCO), dictating all directives, resolutions, instructions and circulars relating to cultural policy, general organisation of the CNC, the nomination of leadership personnel and more besides. With his newly acquired power, Pavón oversaw the purging from cultural institutions of anyone suspected of ideological diversionism, and the following five years would witness a bleak and treacherous period for cultural policy, characterised by dogmatism and mediocrity, which will be discussed at length as this account continues.

In March 1974, the CNC was restored as a central organisation under the Vice Minister for Education, Culture and Science, governed and administered by a president and one or more vice presidents, who could be designated and removed by the President of the Republic and Prime Minister upon the recommendation of the Minister. With this, the CNC began a new stage of institutional development.[110] At the first congress of the PCC in December 1975, material reinforcement of the council was announced as part of a generalised need to strengthen cultural institutions in their ideological aspects as much as in their artistic and technical elements.[111] In the event, what transpired was the dissolution of the council on 31 November 1976 and its replacement with the Ministry of Culture (MINCULT). And, while a retrospective consideration of the CNC, undertaken by MINREX in the same year, concluded that the council had remained loyal to its primary objective – of being the instrument of orientation and leadership, in coordination with other state and mass organisations, in relation to the tasks of the party and government in attaining a culture for the masses and by the masses – considerable damage to creative development was caused during this period and will be considered towards the end of this study.

The Ministry of Culture (MINCULT)

In 1976, as part of a major restructuring process in which the rejuvenated PCC took centre stage, a National Assembly was set up and the Council of Ministers established a new Ministry of Culture. Created under Law 1323[112] and ministered to by Armando Hart, MINCULT became the 'lead agency for implementing and monitoring the cultural policy, art and literature of the state and government'.[113] Complementing the activities of regional organisations, the ministry was intended to oversee culture at a national level, focusing on 'guidance, technique and methodology',[114] fostering cultural development and administering policy in relation to artistic education. While the ministry was born during a phase in which Cuba was close to the Soviet Union, it created 'greater tolerance' by establishing an 'accountable single set of policies for people to pursue and execute' and engendered a less dogmatic outlook than that perpetuated by the CNC.[115] As such, it is necessary to note its existence as a unifying cultural institution here, paving the way for a consideration of its significance within the chronological analysis of policy that follows.

National Union of Cuban Writers and Artists (UNEAC)

From the scant information that exists in English scholarship, it is possible to discern that the National Union of Cuban Writers and Artists (UNEAC) was founded as a direct consequence of the First National Congress of Writers and Artists held in August 1961. With leading writers at its head, the union was organised over different creative disciplines, with members grouped

according to the art form in which they worked. Par Kumaraswami finds that the 'new association would allow both the CNC to be more effective and, importantly, for this sector to manage its own creative practices, as long as these fell broadly within the definition of revolution'.[116] In order to understand more about the genesis of UNEAC, we must turn to sources originating in Cuba.

As early as the 1930s, a group of Cuban artists and writers had made a proposal for an association with similar ends. Presided over by leftist intellectuals, including Guillén, the intended organisation was to have been a way of defending the work of its members without being regarded as a union. The group met several times, but the initiative was never finalised. While the August 1961 congress, at which UNEAC was founded, will be thoroughly interrogated at the appropriate moment, it is useful to outline the structure and aims of the union within this consideration of the main cultural institutions of the Revolution. Interim UNEAC President Graziella Pogolotti describes how, in the early 1960s, nobody thought it a bad idea to have an organisation in which artists could come together in a way that would give them a voice and allow them to pursue their own projects.[117] After much congressional debate, it was agreed that UNEAC should be inscribed into law as an autonomous organisation that would group together writers and artists interested in contributing, through their work, to the success of the Cuban Revolution.

At its formative congress, the union's statutes were drafted by adapting experiments attempted in other countries to the specific circumstances of Cuba. Reading out the provisional statutes at the end of the congress, Retamar would point to UNEAC as an organisation of the Revolution, a tool through which artists and writers, united through the particularities of their vocation, could participate in the realisation of the Revolution. As such, the union eschewed passive, beautifying approaches and strict adhesion to any particular tendency, with quality and variety being understood as paramount. On this latter point, Retamar was emphatic; the union would not tolerate, and much less sponsor, any narrow-mindedness which sought to delimit the rich plurality of forms and tendencies that existed within Cuba. Criteria for admission to the union would be identification with the Revolution and the participation in literary/artistic activities that demonstrated high technical capacity, quality and originality. When the statutes were concretised, they coupled the social usefulness of artists and writers to the betterment of their material conditions.

More specifically, the founding aims of the organisation were: to favour the creation of literary and artistic works; to promote beneficial conditions for the intellectual work of its members; to link the works of writers and artists to the great tasks of the Cuban Revolution, reflecting that encounter in said works; to organise free discussions on the problems of literary and artistic

creation; to stimulate new tendencies; to enhance the study of traditions and to define national Cuban characteristics, examined in a critical manner; to fortify links with the literature and art of the fraternal nations of Latin America; to increase cultural relations with all the countries of the world, especially those with socialist experience; to favour the growth of literary and artistic talents, orienting their forces and contributing to the distribution of their works.

The union was created with a sixty-strong national committee, which included the most influential protagonists from all disciplines (with twelve plastic artists among them). From this was drawn a thirteen-member executive committee, with Guillén as President, the writers Carpentier, Lezama Lima, Portuondo and Guillermo Cabrera Infante and the ballerina Alicia Alonso as Vice Presidents and the thirty-one-year-old Retamar as Secretary. Also on the secretariat, Otero and José Álvarez Baragaño were both twenty-nine, and the average age of the membership was similarly low. Mirroring the structure of Nuestro Tiempo, members were grouped into sections representing literature, plastic arts, music, theatre, ballet and dance, with a section for cinema, radio and television being included later and each section being responsible for deciding on its individual membership. In turn, these sections were subdivided into different genres, enabling relevant activities to be organised. Voting on the national committee and presidency would take place every three years, and, by the second half of the 1970s, the organisational structure was composed of one president and eight vice presidents (representing the different disciplines), a coordinating secretary, a secretary of cultural activities, a secretary of public relations and an administrative secretary, with five provincial affiliates having the same number of secretaries.

The Cuban state assigned the union a budget and determined resources to enable the development of its work; members also paid a nominal subscription of two pesos per month. The union was given a colonial-style former family house near the University of Havana, the rooms of which were converted into offices, meeting rooms and a library, surrounded by outhouses in which workshops and galleries were created. In the early years, the union contained shops from which it was possible to acquire artists' materials, books and magazines and, while these were gradually lost to office space, the café, established in the lush tropical gardens, became a vibrant meeting place.

Interestingly, at the founding congress, Fidel distinguished UNEAC – which was oriented towards creative ends – from workers' unions (or syndicates), on the basis that UNEAC would represent the efforts of many who were not members of a syndicate. In this, he drew a rather unflattering parallel between UNEAC members and housewives who were members of neither syndicate nor party but might play an active part in the Committees for the Defence of the Revolution, which had been set up to mobilise the population

in times of crisis. By this rationale, UNEAC was initially conceived of as a non-partisan organisation. By the time of the first PCC congress in 1975, it was being considered alongside the National Union of Arts and Spectacles and the Union of Press and Freedom, with cooperation being encouraged between these workers' organisations in the task of elevating the cultural level of the people in a defence against cultural imperialism.

Two months prior to the foundation of UNEAC, during a debacle around the avant-gardist cultural publication *Lunes de Revolución* (discussed in chapter four), Fidel had expressed the wish that writers and artists had a magazine that was accessible to all in their cohort; rather than putting resources into the hands of a particular group, he argued, these resources should be mobilised through a union. On 15 April 1962, this desire was realised with the foundation, by the union, of not one but two journals – *La Gaceta de Cuba* [The Cuban Gazette][118] and *Unión*. Both were overseen by Guillén on the proviso that the reactionary and counterrevolutionary would be excluded; the former initially received editorial input from Otero, the latter from Carpentier and Retamar. Published six times a year in an edition of 5,000, the 64-page *Gaceta* passed through several distinct phases, reflecting on the most vivid happenings in Cuban culture throughout the 1960s, becoming a more theoretical space in the 1970s and, from the late 1980s and early 1990s onwards, serving as a place for the exchange of ideas which began to include the Cuban diaspora in Spain, the US and beyond. As we shall see, in 1963–4, *Gaceta* would provide a vital platform from which film-makers and their allies could defend a pluralistic notion of culture.

Initiated at the same time, *Unión* had a different responsibility to its members as a forum in which 'cultural policies were outlined, defended and expressed'.[119] Led by prominent figures from Cuban culture and published four times a year in an edition of 2,000, the magazine was more international in its focus. As well as publishing authors and artists from Cuba, it dedicated a good number of its pages to essays and works of fiction from foreign writers and organised monographic issues around writers from Europe (including the Eastern Bloc) and Vietnam. In 1981, the *Revista de Literatura Cubana* [Magazine of Cuban Literature] would be added to the union's publishing repertoire.

In addition to this, a literary prize was established by UNEAC, which formed the national counterpart to Casa's continental honours. In 1966, this was supplemented by the David prize for novelists, aimed at young writers, which took its name from the *nom de guerre* of the urban underground leader, Frank País. The plastic arts section of the union ran an annual salon and published an artistic bulletin which discussed pertinent issues and introduced new materials and techniques to artists. Through the Hermanos Saíz Association,[120] UNEAC would channel its creative concerns to a young audience, sharing venues and resources with the CNC; at the end of April 1974,

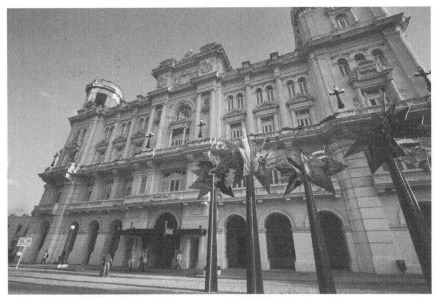

Exterior view of the Museum of Fine Arts (national section).

a plastic arts branch of the expanded organisation was initiated with 92 members, swelling to 160 within two years.

For more than half a century, UNEAC has worked towards its aims by organising projects in parallel with those orchestrated by governmental institutions. Yet, in 1969, Fornet noted that the creation of UNEAC had led to a paradoxical situation in which all writers and intellectuals were subsumed within an organisation that gave them private ownership of high culture in the midst of a Revolution that did not believe in private property. The second half of the 1960s proved particularly testing for the union, when Guillermo Cabrera Infante was ejected and an international jury's decision to award the UNEAC poetry prize to Heberto Padilla was called into question. For a period, this conspired with its ageing membership and complicated admissions process (requiring two nominations and a lengthy waiting time) to prevent the union from refreshing itself, giving it the air of an elite organisation. Nonetheless, UNEAC remained a major driving force in representing the interests of its members, and, from the official perspective at the end of the 1970s, its main achievement was regarded as having been 'to unite creative artists in pursuit of a fundamental objective: to produce work of artistic quality and to build up a revolutionary society'.[121]

At the UNEAC congress in 1988, Fidel, Armando Hart and Carlos Rafael all 'stressed the need for youth' within the union, while warning against 'the evils of dogmatic approaches' and reinforcing the 'importance of freedom in form and content'.[122] On being asked by Abel Prieto Jiménez, who had replaced Hart as Minister of Culture,[123] to reflect on UNEAC thirty-five years after its

Centre for the Development of Plastic Arts.

formation, Retamar referred back to the pronouncements that were made during the founding congress, to find an expression of love for the new-born Revolution with its essential desire for justice. Taking account of the early years of struggle and contradiction, of enthusiasm, creation, diversity and youth, he regretted that this intensity had not been possible to sustain. Yet, in the rejuvenated UNEAC of the 1990s, he found that the fire of the early years, instigated by Guillén and his compañeros, had not been extinguished. In conversation in 2010, the art historian, critic and wife of Retamar, Adelaida de Juan, attested that membership of UNEAC remained a stamp

Wifredo Lam Contemporary Art Centre.

of professionalism, with artists and writers being assessed every five years, compelling them to keep proving themselves by producing exhibitions and books.[124]

Museums and Galleries

A retrospective inventory of pre-revolutionary cultural institutions, drawn up by Otero in 1972 and published in English by UNESCO, finds that, before the Revolution, there had been six museums, centred on Havana, the most important of which was the palatial National Museum of Fine Arts, which was in slightly better condition than the others, although much of the building was being used for storage. The first revolutionary gesture towards museums, enacted through Law 110 of 27 February 1959, brought about a swift reform of the National Museum's board of trustees and, in October of the same year, an exceptional grant was made for its restoration.

In 1961, the CNC was made responsible for preserving and operating museums, and a National Museums Commission was formed under the Plastic Arts Directorate (alluded to above). This necessitated the creation of a team capable of managing permanent collections and touring them to the museums and galleries that were being constructed in the provinces. The revolutionary government had recovered and restored various collections amassed by the former elite, including furniture and weapons, and the CNC set about ensuring that they would be exhibited around the island. In painting, more than 350 works were restored by the national museum, in

advance of an exhibition in November 1962, while a further 500 works of art in diverse media were restored for future exhibitions. In 1963, a Commission of Museums and Monuments was set up, making a further ten museums and four galleries operational. By 1964, five more museums had been created in other key places, hosting permanent exhibitions of painting, sculpture and printmaking. These enabled the Cuban people to become familiar with the country's artists while serving as a platform for artworks that had been purchased by the state. During a second stage, eleven new museums were built, making a total of thirty new cultural centres by 1972, with many of the museums aimed at restoring the lost traditions of Cuban folk art.

While fourteen exhibitions had been staged in 1962, 100 were planned for 1963 and, by 1965, 1,800 exhibitions of Cuban and foreign artists were being toured around the island. By the time MINCULT was established 'In 1976, Cuban museums were visited by 1.5 million people, which is a very high figure, if it is borne in mind that Cuba is a developing country and that the people were formerly not accustomed to visiting museums'.[125] By 1979, fifty-eight museums were in operation in twelve of the fourteen provinces,[126] six of which were art museums. Resolution 38/81 of 1981 ordained the creation of ten basic cultural institutions in each of the 169 municipalities, working together with the local groupings of Popular Power, which provoked an unprecedented growth in cultural organisations.

A similar pattern is evident in the gallery infrastructure. In 1962, large galleries were created in each of the six provincial capitals as part of a plan to foster the conditions necessary for the development of painters and sculptors throughout the island, which paved the way for exhibitions touring between thirteen galleries and numerous exhibition halls. From a situation in 1961 in which artists had to compete to exhibit in the few state- or privately-run institutions, a network of twenty-five galleries was set up, twenty of which still existed by 1972; between 1963 and 1975, these galleries attracted 900,000 visitors to see a range of provincial, national, international and touring exhibitions organised by the CNC. According to official figures, the 1960s saw a massive upsurge in attendance at cultural events, with nearly two million exhibitions being staged, of which 1,852,304 were urban and 107,114 were rural. By 1991, the plastic arts could boast a total of 117 galleries, attracting around 500,000 visitors per year. Beyond the conventional infrastructure, the CNC also toured exhibitions to workplaces, such as trade unions, military units and student organisations.

Casas de Cultura

Since the emergence of a Cuban working class in the middle of the nineteenth century, the Casas de Cultura [Houses of Culture] had played an important role as a meeting place, operating alongside workers' clubs throughout the

Casa de Cultura, Trinidad de Cuba.

country and making a significant contribution to raising political conscious-
ness. While priority was given to the development of museums and galleries
under the CNC, the Casas remained active in organising cultural activities,
with 131 exhibitions being programmed in such venues for 1964.

The opening of the Ministry of Culture caused a significant change within
the institutional landscape, via the creation of a national system of Casas de
Cultura, to cope with the growing demand for cultural participation brought
about by rising educational levels.[127] The first function outlined for this new
network of organisations was 'To favour the development of activities of a
patriotic character which contribute to the political and ideological formation
of [the Cuban] people'.[128] The founding structure of these new model organi-
sations was inherently hierarchical, with a director being appointed as the
ultimate authority in each Casa, overseeing departments of artistic technique,
activities and administration, and a directorate holding collective responsibil-
ity for a board of directors, a users' committee and governing and technical
councils. At the same time, coordination of the Casas, in conjunction with
the mass political organisations including Popular Power, gave the local com-
munity a high degree of control over its cultural landscape, and Casa users
were urged to maintain a collective attitude and to adhere to the requisites of
socialist ownership. Collaboration was encouraged between the Casas and all
the other cultural organisations within and beyond a given locality, including
museums, libraries, cinemas, galleries, theatres and universities.

The overall aim of the Casa network became to stimulate and develop the creative propensity, ability and taste of the population, and Jaime Sarusky and Gerardo Mosquera, Cuban cultural commentators based at the Ministry of Culture, described how the object of an initial fifty Casas was 'to bring the people into direct contact with art, to disseminate culture, to raise the educational level of the population and to provide it with opportunities for leisure and recreation'.[129] As such, the role of the Casas became 'to acquaint the masses with the different forms of artistic expression, so that people [would] in this way learn to appreciate works of art and have the opportunity to pursue their own artistic interests'.[130] Significantly, as will be seen, the Casas would become the headquarters of the burgeoning movement of *aficionados* [amateur artists]. As a counterpoint to this, an explicit link was made between the Casas and the professional artists and writers within local communities – who were said to be contributing to this 'valuable cultural work and throw[ing] themselves wholeheartedly into the search for genuinely Cuban artistic values'.[131] Any conflict this implies will be dealt with in due course.

Educational Institutions

No consideration of revolutionary cultural institutions would be complete without addressing the changes undergone within art education. Having been modelled after European *conservatoires*, Cuban art schools were slower to develop during the years of Spanish colonisation than those for theatre, music or literature. A boost for painting would be provided in 1819, when the Frenchman Jean Baptiste Vermay set up the San Alejandro School of Art (where Camilo Cienfuegos, Wifredo Lam and others studied). Teaching in this former convent adhered to the presumption, rife in Europe at the time, that artistic skills could be taught and that exact likeness, or mimesis, was paramount. Avant-garde movements in the first third of the twentieth century, which suggested otherwise, had little impact in Cuba and, while some reforms were made in the teaching of architecture, little changed in the mainstream art schools in advance of the Revolution.

This grounding in the French bourgeois tradition inevitably created certain paradoxes within the revolutionary milieu. But, even earlier, the conservatism of San Alejandro had given rise to several alternatives, including non-academic exhibition spaces and open-air schools in rural areas. In 1936, these departures came to fruition in the Free Plastic Arts Studio, set up by the artist Eduardo Abela, which offered free tuition, materials and technical assistance to 80 of an initial 200 applicants, using surplus Ministry of Education funding and Abela's personal resources. Modernist tendencies found their way into a discursive programme which consolidated the politicised and avowedly Cuban *vanguardia* movement. The Free Studio culminated

in a landmark salon-style exhibition in 1937, and, although the experiment lasted a little over a year, it continues to be referred to as a model.

During the dictatorship, Batista's Minister of Education announced plans to reform teaching at San Alejandro and contemplated building a new plastic arts school; after the Revolution, San Alejandro attempted to reinvent itself but could not lose its academic connotations. In 1961, Fidel and Che were enjoying a game of golf at a requisitioned country club in Cubanacán, on the outskirts of Havana, discussing ways in which the momentum of the literacy campaign could be extended into the promotion of cultural activities. Surrounded by rolling hills on all sides, they decided to use this unique site as a centre for creative education, and the National Art Schools (ENA) were born. The revolutionary government quickly formed a board of schools to draw up a programme that would provide for the education of artists across the disciplines of music, plastic arts, drama, ballet and modern/folkloric dance.

While the Revolution had seen the exodus of many established architects, several political exiles had returned to contribute to revolutionary culture. Among them was Ricardo Porro, who had worked in the Civic Resistance Movement against Batista, offering a safe house to Hart and Rafael. Exiled to Venezuela in 1958, he had been urged to come back to Cuba by Camilo's brother, the Minister of Construction, Osmani Cienfuegos. In January 1961, it would be Osmani's first wife, Selma Díaz, who would arrive uninvited at a party at Porro's house, bringing the news that Fidel would like him to convert the country club into an art school within two months. Accepting this impossible challenge, Porro was appointed lead architect of the national schools, alongside Vittorio Garatti and Roberto Gottardi, two Italian architects Porro had met in Venezuela. Together, they implemented an organic design that was specifically tailored to each art form, with the cupolas of the School of Plastic Arts evoking the female form and the School of Music snaking like a treble clef through the grass.

At the August 1961 congress during which UNEAC was formed, Fidel alluded to the fact that ENA was already under construction and that it would start functioning the following year with capacity for 3,000 students. It was imagined that 'All the teachers in the country will learn how to recognize which child has special talent, and will recommend which child should be given a scholarship'.[132] While the buildings were being completed, the abandoned houses of the haute bourgeoisie served as convenient lodgings for students from all over the country. Beginning its activities in February 1962, the School of Plastic Arts accepted 30 new students in 1963, distributed across sculpture (7), printmaking (5) and painting (18), taking the total number of art students up to 71 out of a total 600 students across the five schools. As it was always intended that ENA would train professional artists, rather than being a national school for the masses, 600 was considered a not inconsiderable

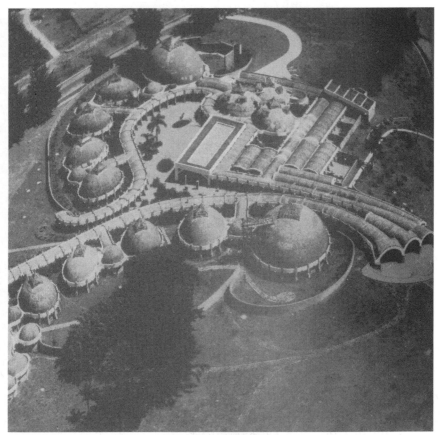

A bird's eye view of the National School of Plastic Arts.

number of artists within a population of 7 million, and it was anticipated that the cost of the schools would be offset against the results that would be obtained. At the start of the twenty-first century, John M. Kirk and Leonardo Padura Fuentes published a series of interviews with established cultural practitioners, many hailing from poor and/or rural backgrounds and retaining links with their specific roots and with the Cuban people; the majority of those interviewed attributed their professional trajectory to the education they had received.[133]

The existence of ENA encouraged the involvement of an older generation of artists which had previously lacked any inclination towards curricular matters, including Raúl Martínez and Antonia Eiríz. Combining the approaches of Abela's Free Studio and the Bauhaus, teaching was centred on figuration while full freedom of expression was retained. The duration of courses depended on the discipline, with piano, dance and ballet requiring eight years of study and plastic arts tending to need six. Producing graduates from 1967, ENA quickly became a focal point for visiting artists and, when

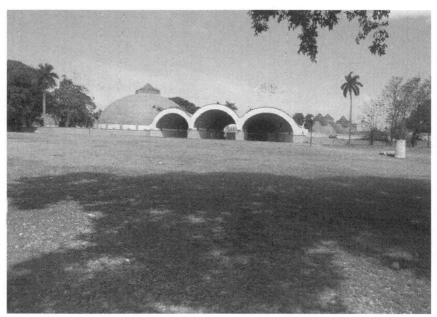

National School of Plastic Arts.

Lam brought the Paris Salon to Havana in July of that year, accompanied by many of the exhibiting artists, ENA students acted as guides. Offering scholarships to promising students not cnly in Cuba but also the tricontinental area of Africa, Asia and Latin America, ENA became a symbol of high-quality artistic education, and it continues to train artists from all over the world.

The five national schools were soon accompanied by their provincial and municipal equivalents, offering teaching in all branches of the arts. In relation to the plastic arts, two types of schools were established. Elementary schools were centred on two years of professional training in painting, sculpture and theory, following the completion of basic secondary education. By contrast, intermediate level school-workshops, operational from 1962, were tailored to those with a vocation for studying art, who had previously been prevented from doing so on account of their age, work or life conditions. Schools would be open for applications once a year, which would be widely advertised in the press. By the mid-1960s, eight such centres were in operation with 1,240 students and 93 staff for the 1964–5 academic year; by 1991, forty-nine centres existed around the country (twenty-six elementary, twenty-two intermediate level and one superior).

Technique remained a defining factor, with training centred on drawing from primary school onwards and specialisation in media required at the age of fifteen. Study plans included painting, sculpture and printmaking alongside ceramics and industrial design, and timetables were adjusted to suit those working at the same time as studying, with some students boarding and

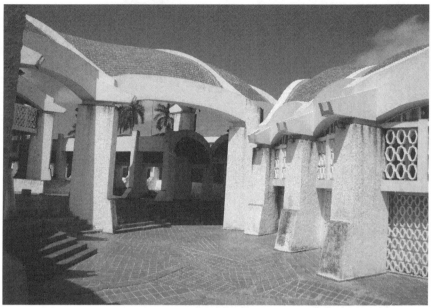

National School of Dance, built in the grounds of a requisitioned country club in Cubanacán, on the outskirts of Havana.

others attending during the day, depending on the proximity of their home to the nearest school. Students could be promoted to the National School of Plastic Arts from either elementary or intermediate level schools or by passing a vocational exam.

From its inception until the formation of MINCULT in 1976, ENA was jointly directed by the CNC and MINED, and, in 1962, the CNC described ENA as 'one of the most important initiatives of the Revolutionary Government in the field of culture'.[134] However, in a 1999 publication for Princeton Architectural Press, John Loomis argues that the missile crisis of October 1962 redirected workers away from the project and construction began to stagnate. Despite students being accepted from 1962, he asserts that the schools were inaugurated in an incomplete state on 26 July 1965 and were neglected thereafter 'not merely [as] the result of redirected national priorities necessitated by economic concerns. In the increasingly doctrinaire political environment, the schools became subject to a series of ideologically framed attacks that resulted in their repudiation'.[135] Ascribing this hiatus to anti-US sentiment and growing Soviet influence, Loomis gives the impression that the schools were abandoned for political reasons. Similarly, the documentary, *Unfinished Spaces*, by Alysa Nahmias and Ben Murray, two young film-makers from the US, follows Loomis's line in portraying the schools as the death of a dream.[136] Yet, while the schools of music and ballet remain incomplete, in part due to the prohibitive cost of bringing the necessary brick and terracotta from Italy,

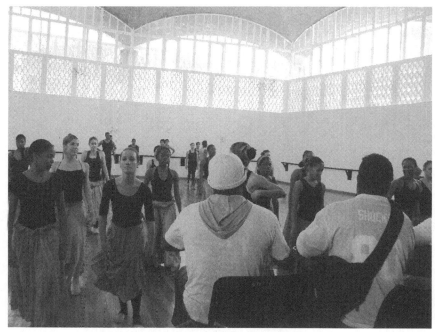

A lesson in progress at the National School of Dance.

the drama school had to be evacuated when water from the river running through the country club forced its way through the skylights of the stunning subterranean rehearsal rooms. To this day, mildew on the russet walls of its amphitheatres is evidence of rising water levels and prosaic reasons for ceasing to use this part of the school. Meanwhile, the schools of modern dance and plastic arts remain fully functional, standing as testament to the architects' sensitivity to acoustics and light.

Much later than Loomis suggests, the schools were eventually affected, like other institutions, by international and ideological pressures, which had an impact on teaching. In 1974, attempts were made to standardise the curriculum throughout the country, which was changed to reflect Soviet approaches. In 1976, this retrenchment was bypassed through the creation, under MINCULT, of the Higher Art Institute (ISA) based at ENA. This school of advanced study 'made it possible to broaden [ENA's] sphere of activity and, with the support of the Soviet Union, to meet some of Cuba's own requirements'.[137]

Benefiting from a staff to student ratio of one to seven, ISA continues to provide training up to doctoral level in all art forms including the plastic arts. Acceptance requires a university entrance exam and a professional quality test. Students are regarded as professionals from the moment they begin their studies, and they are expected to play an active part in the art scene, including taking part in exhibitions. Within the curriculum, there is no prescription of

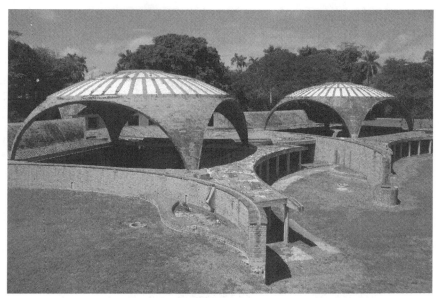

Exterior view of the National School of Theatre.

the content of artworks. 'Instead, there is a stress on logical thinking, articulation of ideas, objective evaluation, the development of a system of aesthetic concepts and criteria to guide the search for, and adoption of, a personal language, and on stimulating imagination and creative talent using a maximum diversity of expressive means'.[138] This highly exceptional method was quick to yield experimental, internationally oriented Cuban art, and it is noted that:

> The education system has been a guarantee for highly trained generations of artists who are able to defend and argue their creative positions convincingly. The ISA itself has been a training ground for conceptual thought and for arguing what you do. It has proved to be a highly useful exercise that is now paying dividends across the world, where many of us are left speechless before the barrage of polished rhetoric that spills out such glittering results.[139]

The success of ISA may be attributed to its encouragement of independent thought, as advocated by the Venezuelan Simón Rodríguez, tutor and mentor of Simón Bolívar, the founder of the first union of independent nations in Latin America, in whose name the Bolivarian Revolution is currently being fought.

Continuing in the pioneering tradition of revolutionary pedagogy, graduates from ISA are invited to contribute to the education of future artists, thus feeding back into the system while securing themselves a livelihood and playing a productive part in society. Luis Camnitzer emphasises the importance of this feedback loop, finding freedom of expression to be perpetuated

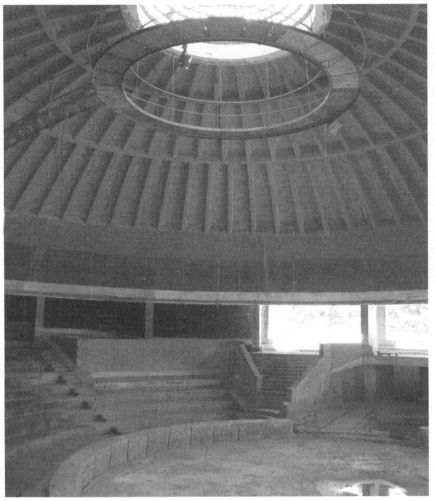

Inside the National School of Theatre.

during the long immersion of students in this environment. Alongside the education of professional artists, ENA and ISA continue to play an expanded role in the cultural education of society and, by 1991, offered 265 week-long courses to workers which are taken up throughout the year.

An Institutional Overview

In 1970, K.S. Karol urged the creation of social institutions in Cuba on the basis that 'The innovation all Cubans so fervently desire is the complete reorganization, from top to bottom, of their social system, a reorganization that will give workers a greater say over their lives and will no longer leave them at the mercy of the errors of remote planners, however well-intentioned'.[140] As we have seen, the process of creating institutions appropriate to the new

society had been necessarily slow. The cultural field provides an exception to this tardy process, with the revolutionary government acknowledging the importance of institutions to the dual process of acculturating its own people and developing international cultural links.

From the considerations of this chapter, it seems clear that the creation of cultural institutions was of paramount importance in the immediate post-revolutionary period. Even before the vital Agrarian Reform Law had been drafted and its consequences documented on film, one of its authors was deployed in developing a cinematic industry out of the abandoned resources of the old regime and the wealth of national talent. Through the international system for the production of distribution of film that arose around ICAIC, home-grown directors would be supported in orchestrating documentary and narrative adventures that utilised contemporary cinematic language. Of an equally high quality, the exhibitions, publications and conferences initiated by Casa de las Américas during the period of this study would be central to creating and disseminating an image of the Cuban Revolution throughout Latin America and beyond. At the same time, the transnational friendships of its personnel would amply prove the ability of culture to overcome the ideological blockade to which the island had been subjected. While all the revolutionary cultural institutions deployed a hierarchical structure, the level of ownership among creative communities is noteworthy, and, for a time at least, this relieved them from the 'errors of remote planners'.

While ICAIC and Casa made advances at the forefronts of their respective fields, the abiding legacy of the CNC is its efforts in extending the cultural infrastructure into multifarious museums and galleries throughout the island and in broadening cultural activities beyond the confines of this infrastructure. This dissemination continued through the work of MINCULT and the decentralisation of the 1990s, and the profound consequences of this programme in bridging the gap between art and the people will continue to be addressed.

In 1991, MINCULT issued a pamphlet entitled *Some Data on Current Cultural Development*,[141] which outlined how Cuban culture had passed through three distinct stages in the revolutionary period. The first of these saw the creation of key institutions, like ICAIC, Casa de las Américas and the CNC, alongside the strengthening of existing institutions in other disciplines. This early phase was acknowledged by MINCULT to have encompassed an era during which certain dogmatic restrictions were imposed onto creative expression (yet to be explored in depth). The second phase, during the 1980s, was characterised by the growth of community institutions throughout the country, notably the Casas de Cultura, which offered access to diverse expressions of culture to the whole population. The third phase was embarked upon as the European socialist bloc crumbled.

Having relied for two decades on the alternative economic system of the Council for Mutual Economic Assistance,[142] the collapse of the Soviet Union, combined with the hardening of the US embargo, caused serious problems for Cuba's decentralised economy. Thus, the Special Period in Times of Peace was implemented,[143] which wrought dramatic changes to the material base of culture, diminishing supplies of equipment (which formerly came mainly from the

Alfredo Guevara, Roberto Fernández Retamar and Lisandro Otero.

Eastern Bloc) and hard currency (through cultural exports undertaken by MINCULT). An estimated $4 million in income from the capitalist world was lost during this period. In 1990, the total budget assigned to culture was 138.7 billion pesos, a reduction of 10.5 billion. This had a profound effect on cultural institutions; so, for example, the estimated income of ICAIC in 1991 was $2.04 million but, by October, it had only earned $1.35 million.

The Special Period brought about the conversion of national and provincial directorates into less centralised networks of specialist local institutions, which was perceived to strengthen the links between the processes of creation and dissemination and between artists, writers and the population.[144] In this way, the smallest communities were urged to develop their own material bases for culture, and institutions were faced with three options – to remain totally or partially state-financed or to become self-financing. In 1991, economic difficulties saw the amount of students accepted to ISA fall by a half, and erstwhile tutor Kevin Power highlighted how 'the dark shadows cast by the [Special Period] have involved a massive gnawing away at the educational budgets and the gradual exodus of many of the best teachers. The ISA, however diminished, partially resists and has somehow developed its own strategies of survival.'[145] In many ways, the Special Period exposed the earlier successes of the Revolution, by revealing the continued necessity of cultural institutions.

In 2010, the Cuban sociologist Mayra Espina Prieto noted the 'absence of a real vocation of service by public institutions, and the lack of popular democratic control over them and of systematic, transparent and reliable information about their operations and their actual impacts, their inefficiency and their irregular dealings.'[146] From the account given above, it seems clear that this generalisation cannot be convincingly applied to cultural institutions in Cuba, where vocational level is unsurpassed in Latin America, continuing to generate cultural works of exceptionally high quality. One reason for this has

to be the involvement of creative practitioners in some of the key institutions, notably the former film-maker Alfredo Guevara at ICAIC, the poet Roberto Fernández Retamar at Casa and those creative intellectuals who advised on the creation and operations of these two organisations. Marginalised until then, artists and writers came to occupy social space, through their involvement in recently founded polycentric institutions, and Pogolotti describes how significant it was that the nascent film industry, the magazines and publishing houses, the museums and galleries and the centres dedicated to national and international art and the promotion of culture fell into the hands of intellectuals.[147] This agency has been evident since pre-revolutionary times and forms a continuum from Nuestro Tiempo and its precedents to UNEAC, fulfilling a commitment to the Revolution that will continue to be analysed. The involvement of artists and writers in the inception and operation of cultural institutions also marks an important distinction from the late capitalist countries in which practitioners have been excised from decision-making in their respective fields.

Various commentators have observed Fidel's willingness to delegate the implementation of cultural policy to members of the PSP, some perceiving this as evidence of his disinterest in culture.[148] His actions in the field would have seemed logical at the time, however, given the party's early fomentation of cultural activism around Nuestro Tiempo. Adding complexion to this debate, Guevara notes that there were two wings within the PSP, with the older group following the lines of the Communist International, which was more or less Stalinist. This makes it necessary to distinguish the initial approaches of, for example, Carlos Rafael and communist intellectuals like Nicolás Guillén from the *sarampionados* who were permitted to thrive at the CNC such as García Buchaca, Aguirre and, later, Pavón.

In turn, these orthodox voices must be distinguished from their Marxist-humanist counterparts, who would occupy equally responsible positions in the cultural field. Adelaida de Juan alludes to 'people that had belonged, or that believed or that continued the line of the old communist party in Cuba, that were very close to the Soviet journey, whereas the real government sources – that came not from that party but from the 26 July [Movement] – did not have that close ideological following of the Soviet Union and we kept on with our own history and our own historical values'.[149] In this regard, Haydée Santamaría emerges as a crucial figure, as does her husband, Armando Hart, who would oversee the euphoric first two years of cultural rebuilding from his position in MINED and signal cultural salvation as the country emerged from the grey years. Before considering the specific ways in which these pivotal figures influenced the development of Marxist-humanist cultural policy, let us turn out attention to the broader ideology underpinning revolutionary approaches to culture.

NOTES

1 C. Wright Mills, *Listen, Yankee: The Revolution in Cuba* (New York: Ballantine Books, 1960), p. 123.

2 For a consideration of this, see Antoni Kapcia, *Leadership in the Cuban Revolution: The Unseen Story* (London: Zed Books, 2014).

3 Instituto Cubano del Libro, *Cultural Congress of Havana: Meeting of Intellectuals from All the World on Problems of Asia, Africa and Latin America* (Havana: Instituto Cubano del Libro, 1968), unpaginated.

4 Mills, *Listen, Yankee*, p. 142.

5 Linda S. Howe, *Transgression and Conformity: Cuban Writers and Artists After the Revolution.* (Madison: University of Wisconsin Press, 2004), p. 4.

6 Mills, *Listen, Yankee*, p. 142.

7 Ibid., pp. 140–1.

8 Harold Gramatges [1974], 'La Sociedad Cultural Nuestro Tiempo' [The Nuestro Tiempo Cultural Society], R.L. Hernández Otero, (ed.), *Sociedad Cultural Nuestro Tiempo: Resistencia y Acción* [Nuestro Tiempo Cultural Society: Resistance and Action] (Havana: Editorial Letras Cubanas, 2002), p. 283.

9 Head of the Cultural Directorate under Batista, this Marxist university lecturer would become Foreign Minister in the revolutionary government.

10 The exhibition included Servando Cabrera Moreno, Wifredo Lam, Raúl Martínez, René Portocarrero, Amelia Peláez and eight sculptors including Rita Longa. The singing programme for a mixed choir was conducted by Edmundo López, while the Strindberg play was directed by Francisco Morín.

11 Hernández Otero, *Sociedad Cultural Nuestro Tiempo*, p. 286.

12 Ibid.

13 Fidel Castro Ruz with Ignacio Ramonet, *My Life*, trans. Andrew Hurley (London: Penguin Books, 2008 [2006]), p. 89.

14 *El Mégano* is available to watch at: https://www.youtube.com/watch?v=bzBsw58uorI

15 Hernández Otero, *Sociedad Cultural Nuestro Tiempo*, p. 319.

16 Gramatges, 'La Sociedad Cultural Nuestro Tiempo', pp. 283–4.

17 Signatories to the manifesto included Amelia Peláez, René Portocarrero, Mariano Rodríguez Álvarez, Raúl Martínez, Fayad Jamís and Marcello Pogolotti among many others.

18 Federación Estudiantil Universitaria.

19 Hernández Otero, *Sociedad Cultural Nuestro Tiempo*, p. 255.

20 Active during the 1933 Revolution, Marinello was founding President of the PCC and part of Batista's cabinet, participating in presidential elections as a PSP candidate in 1948. In 1962, he was made Rector of the University of Havana and, when the PCC was reformed in 1965, he became a member of its central committee.

21 Juventud Socialista.

22 'Cine y Cultura en Cuba: Entrevista a Nestór Almendros', *Linden Lane Magazine*, 5, no. 3, July–September 1986, reproduced in W. Luis (ed.), *Lunes de Revolución: Literatura y Cultura en los Primeros Años de la Revolución Cubana* [*Lunes de Revolución*: Literature and Culture in the Early Years of the Cuban Revolution] (Madrid: Editorial Verbum, 2003).

23 Hernández Otero, *Sociedad Cultural Nuestro Tiempo*, p. 225.

24 Galería de Artes Plásticas.

25 Grupo Tiempo Nuevo.

26 Mirta Aguirre, '¿Instituto Nacional... y de Cultura?' [National Institute... and of Culture?], *Cuadernos Marxistas* [Marxist Notebooks], 1, no. 1, July 1956, pp. x–xiv.

27 Servicio de Inteligencia Militar.

28 Buró de Represión de Actividades Comunistas.

29 Gramatges, 'La Sociedad Cultural Nuestro Tiempo'.

30 José Massip, 'Cincuenta Años de Nuestro Tiempo' [Fifty Years of Nuestro Tiempo], Hernández Otero, *Sociedad Cultural Nuestro Tiempo*.

31 This collective statement to the people of Cuba on behalf of religious, fraternal, professional, civic and cultural organisations is available at: Autentico.org/0a09039.php

32 Humberto Rodríguez Manso (ed.), *45 Años Después: Memorias de los Congresos de la UNEAC* [Forty-five Years Later: Proceedings of the UNEAC Congresses] (unpublished manuscript referenced by the author in 2010).

33 Tomás Gutiérrez Alea [1954], 'Realidades del Cine en Cuba' [Realities of Film in Cuba], Hernández Otero, *Sociedad Cultural Nuestro Tiempo*, p. 177.

34 Vilma Espin was one of the central *guerrilleras*, serving as a driver to Frank País (who organised the urban revolutionary movement) and communicating messages from País to the 26 July Movement (with which País's movement merged after Fidel's release from prison). She would marry Raúl Castro in January 1959.

35 For a succinct account of the murky relationship between Cuba and the US, see Aviva Chomsky, 'Relations with the United States', *A History of the Cuban Revolution* (Hoboken, NJ: Wiley-Blackwell, 2010).

36 Much of this account is taken from Alfredo Guevara in interview with Leadro Estupiñán Zalvidar, 'El Peor Enemigo de La Revolución Es La Ignorancia' [The Worst Enemy of the Revolution Is Ignorance], *Revista Caliban*, May 2007.

37 Also involved were Humberto Ramos, José Massip and Guillermo Cabrera Infante.

38 José Bell, Delia Luisa López and Tania Caram, *Documentos de la Revolución Cubana 1959* [Documents of the 1959 Cuban Revolution] (Havana: Editorial de Ciencias Sociales, 2008), p. 151.

39 Bell, López and Caram, *Documentos de la Revolución Cubana 1959*, p. 152.

40 Richard Gott, *Cuba: A New History* (New Haven, CT: Yale University Press, 2004), pp. 246–7.

41 Antoni Kapcia, *Havana: The Making of Cuban Culture* (Oxford and New York: Berg, 2005), p. 132.

42 Ambrosio Fornet, 'La Década Prodigiosa: Un Testimonio Personal' [The Prodigious Decade: A Personal Testimony], S. Maldonado (ed.), *Mirar a los 60: Antología de una Década* [Looking at the 60s: Anthology of a Decade] (Havana: Museo Nacional de Bellas Artes, 2004), p. 9. *Por primera vez* is available to watch at: https://www.youtube.com/watch?v=gKf4maMqbVo.

43 Jaime Sarusky and Gerardo Mosquera, *The Cultural Policy of Cuba* (Paris: UNESCO, 1979), p. 17.

44 Jorge I. Domínguez, *Cuba: Order and Revolution* (Cambridge, MA, and London: Harvard University Press, 1978), p. 414.

45 Edmundo Desnoes, *Memories of Underdevelopment* (Middlesex: Penguin Books, 1971 [1968]), p. 31.

46 Theodor Adorno and Max Horkheimer, 'The Culture Industry: Enlightenment as Mass Deception', *Dialectic of Enlightenment* (Stanford, CA: Stanford University Press, 2002), pp. 94–136.

47 David Craven, 'The Visual Arts Since the Cuban Revolution', *Third Text*, 6, no. 20, 1992, p. 82.

48 Kapcia, *Leadership in the Cuban Revolution*, p. 92.

49 Clive W. Kronenberg, 'Che and the Pre-Eminence of Culture in Revolutionary Cuba: The Pursuit of a Spontaneous, Inseparable Integrity', *Cultural Politics*, 7, no. 2, 2011, p. 190.

50 Juan Sanchez, 'Interview with Armando Hart Dávalos', *Bohemia*, 20 October 1989, p. 9.

51 Fidel Castro Ruz, 'History Will Absolve Me', Havana, 1953, F. Castro Ruz and R. Debray, *On Trial* (London: Lorrimer, 1968 [1953]), pp. 9–108; also available at: Marxists.org/history/cuba/archive/castro/1953/10/16.htm

52 Lisandro Otero, *Llover sobre Mojado: Una Reflexión Personal sobre la Historia* [To Rain on the Wet: A Personal Reflection on History] (Havana: Editorial Letras Cubanas, 1997).

53 Law 299 saw the creation of Casa under the auspices of the Ministry of Education (MINED). Overseen for a period by the CNC, Casa was transferred into the jurisdiction of its successor, the Ministry of Culture (MINCULT), on 15 August 1978.

54 Judith A. Weiss, *Casa de las Américas: An Intellectual Review in the Cuban Revolution* (Chapel Hill, NC: Estudios de Hispanófila, 1977), pp. 41–2.

55 Jaime Sarusky, 'From the 200th, with Love, in a Leopard: Interview with Roberto Fernández Retamar', *The Black Scholar*, Autumn 2005 [1995], p. 36.

56 Betsy Maclean (ed.), *Haydée Santamaría* (Sydney: Ocean Press, 2003), p. 6.

57 See Mario Benedetti, 'The Presence and Absence of Haydée Santamaría' and Haydée Santamaría and Jaime Sarusky, 'Casa Is Our America, Our Culture, Our Revolution', B. Maclean (ed.), *Haydée Santamaría* (Sydney: Ocean Press, 2003).

58 See Silvia Gil, Ana Cecilia Ruiz Lim and Chiki Salsamendi (eds.), *Destino Haydée* (Havana: Casa de las Américas, 2009).

59 Maclean, *Haydée Santamaría*, p. 6.

60 'Statement from Guillermo Cabrera Infante' [1987], Luis, *Lunes de Revolución*, p. 137.

61 Ibid., p. 148.

62 Ibid.

63 Claudia Gilman, *Entre la Pluma y el Fusil: Debates y Dilemas del Escritor Revolucionario en América Latina* [Between the Quill and the Rifle: Debates and Dilemmas of the Revolutionary Writer in Latin America] (Buenos Aires: Siglo Veintiuno, 2003), pp. 193–4.

64 The five prize-winning books have consistently been guaranteed publication alongside a further ten achieving special mention by the respective juries. By the early 1960s, Casa was publishing twenty-four literary titles per year alongside six annual factual books, based on the countries of Latin America, which included photographs and maps.

65 Gilman, *Entre la Pluma y el Fusil*, p. 85.

66 Roberto Fernández Retamar, '¿Va a Enseñarse la Historia de la América Nuestra?' [You're Going to Teach Us the History of Our America?], *Cuba Defendida* [Cuba Defended] (Havana: Editorial Letras Cubanas, 2004 [1959]), p. 48.

67 Santamaría and Sarusky, 'Casa Is Our America, Our Culture, Our Revolution', p. 61.

68 Weiss, *Casa de las Américas*, p. 82.

69 Roberto Fernández Retamar, 'Hacia una Intelectualidad Revolucionaria en Cuba' [Towards a Revolutionary Intelligentsia in Cuba] (1966), *Cuba Defendida*, p. 288.

70 Roberto Fernández Retamar, 'Sobre la Revista *Casa de las Américas*' [On the *Casa de las Américas* Journal], *Casa de las Américas*, 2009.

71 A Salvadoran poet and journalist who sought sanctuary at Casa in 1961 and undertook revolutionary training in Cuba.

72 An 'exiled Haitian poet, living in Havana and contributing meaningfully and unobtrusively to the Revolution' (Andrew Salkey, *Havana Journal* [London: Penguin Books, 1971], p. 152.)

73 A Peruvian-Spanish writer who would turn against the Revolution in 1971, going on to win a Nobel Prize for Literature in 2010.

74 Fernández Retamar, 'Sobre la Revista *Casa de las Américas*', unpaginated.

75 Co-founder of the 26 July Movement, Moncada combatant, internee of the Isle of Pines prison, PCC political bureau member and Vice President of the Council of State.

76 Juan Almeida, 'In the Face of Haydée's Death', Maclean, *Haydée Santamaría*, p. 88.

77 Ibid., p. 84.

78 Margaret Randall, *Haydée Santamaría: She Led by Transgression* (Durham, NC: Duke University Press, 2015).

79 Ambrosio Fornet, 'El Quinquenio Gris: Revistando El Término' [The Five Grey Years: Revisiting the Term], *Narrar La Nación: Ensayos en Blanco y Negro* [Narrating the Nation: Essays in White and Black] (Havana: Editorial Letras Cubanas, 2009 [2007]), p. 393.

80 Roberto Fernández Retamar, 'Caliban', *Caliban and Other Essays* (Minneapolis: University of Minnesota Press, 1989 [1971]), p. 14.

81 Fernández Retamar, 'Caliban', p. 39.

82 José Martí, 'Our America', P.S. Foner (ed.), *Our America by José Martí: Writings on Latin America and the Struggle for Cuban Independence* (New York and London: Monthly Review Press, 1977 [1891]), p. 93.

83 Ibid., p. 84.

84 Ibid., p. 86.

85 Ibid., p. 88.

86 Ministerio de Relaciones Exteriores (MINREX), *Suplemento/Sumario: La Función Cultural-Educacional del Estado Socialista Cubano* [Supplement: The Cultural-Educational Function of the Cuban Socialist State], (Havana: Dirección de Prensa, Información y Relaciones Culturales, 1976), p. 10.

87 Under Law 1026, enacted on 8 May 1963, the Editorial Consejo Nacional de Cultura was established as the publishing arm of the CNC.

88 For a translation of the relevant passage, see L. Baxandall and S. Morawski (eds.), *Karl Marx and Frederick Engels on Literature and Art* (Nottingham: Critical, Cultural and Communications Press, 2006), p. 67.

89 Macdonald Daly, 'A Short History of Marxist Aesthetics', Baxandall and Morawski, *Karl Marx and Frederick Engels on Literature and Art*, p. iv.

90 Raymond Williams, 'Literature and Sociology', *Culture and Materialism* (London and New York: Verso, 2005 [1971]), p. 20.

91 Raymond Williams, 'Base and Superstructure in Marxist Cultural Theory', *Culture and Materialism* (London and New York: Verso, 2005 [1973]), p. 35.

92 Robin Moore, *Music and Revolution: Cultural Change in Socialist Cuba* (Berkeley: University of California Press, 2006), p. 83.

93 Desnoes, *Memories of Underdevelopment*, p. 62.

94 Fidel Castro Ruz, *Fidel Castro Denounces Sectarianism* (Havana: Ministry of Foreign Relations, 1962), p. 16.

95 Ernesto Guevara, 'El Socialismo y el Hombre en Cuba' [Socialism and Man in Cuba], originally published under the title 'From Algiers', *Marcha*, 12 March 1965, unpaginated.

96 A leader of the PSP (since 1927) during the time the party was accused by Batista of carrying out the Moncada assault; apparently, the party strenuously denied the charge and Ordoqui 'distinguished himself above all the rest by the intemperance of his vituperations'. K.S. Karol, *Guerrillas in Power: The Course of the Cuban Revolution* (London: Jonathan Cape, 1971 [1970]), p. 139.

97 Nicola Miller, 'A Revolutionary Modernity: The Cultural Policy of the Cuban Revolution', *Journal of Latin American Studies*, 40, Special Issue 04 (Cuba: 50 Years of Revolution), 2008, p. 686.

98 Fidel Castro Ruz, 'Palabras a los Intelectuales' [Words to the Intellectuals] (Havana: Ministry of Foreign Relations, 1962 [1961]), p. 21.

99 Author of *Paradiso*, a novel replete with homosexual content.

100 Otero, *Llover sobre Mojado*.

101 Guevara and Estupiñán Zalvidar, 'El Peor Enemigo de La Revolución Es La Ignorancia'.

102 Until 1976, these were Pinar del Río, La Habana, Matanzas, Las Villas, Camagüey and Oriente.

103 MINREX, *La Función Cultural-Educacional del Estado Socialista Cubano*.

104 Consejo Nacional de Cultura, *Anteproyecto del Plan de Cultura de 1963* [Draft of the 1963 Cultural Plan] (Havana: Consejo Nacional de Cultura, 1963).

105 Consejo Nacional de Cultura, *Política Cultural de Cuba* [Cultural Policy of Cuba] (Havana: Consejo Nacional de Cultura, 1970).

106 Graziella Pogolotti, *Polémicas Culturales de los 60* [Cultural Polemics of the 1960s] (Havana: Instituto Cubano del Libro, 2006).

107 Under Law 1117 of 18 July 1963 (Asesora Jurídica Nacional, 1980).

108 Karol, *Guerrillas in Power*, p. 286.

109 On 27 April 1967, the CNC was ascribed to MINED under law 1202.

110 On 8 March 1974, Law 1266 re-established the CNC as a central organisation.

111 Comité Central del Partido Comunista de Cuba (PCC), *Tesis y Resoluciones Primer Congreso del Partido Comunista de Cuba* [Thesis and Resolutions of the First Congress of the PCC] (Havana: Comité Central del PCC, 1976).

112 This law of 30 November 1976 related more generally to state administration. On 4 August 1977, the Ministry was entrusted with the protection of cultural patrimony (under law 1).

113 Mercedes Garrudo Marañón and Armando Hart Dávalos, *Resolución no. 8/78: Resolución Que Crea el Sistema Nacional de Casas de Cultura* [Resolution no. 8/78: Resolution Creating the National System of Casas de Cultura] (Havana: Ministerio de Cultura, 1978).

114 Sarusky and Mosquera, *The Cultural Policy of Cuba*, p. 23.

115 Kapcia, *Leadership in the Cuban Revolution*, p. 11.

116 Par Kumaraswami, 'Cultural Policy and Cultural Politics in Revolutionary Cuba: Re-reading the Palabras a los Intelectuales (Words to the Intellectuals)', *Bulletin of Latin American Research*, 28, no. 4, 2009, p. 535.

117 In interview with the author, Havana, 9 March 2010.

118 The journal took its name from *La Gaceta del Caribe*, a radical monthly magazine associated with the PSP, which was published from March to December 1944 with Guillén, Portuondo, Aguirre, Ángel Augier and Félix Pita Rodríguez on its editorial board.

119 Kapcia *Havana*, p. 134.

120 Named after the brothers Luis Rodolfo and Sergio Enrique Saíz Montes de Oca, members of the Revolutionary Directorate who had joined the 26 July Movement and were killed by Batista in August 1957 while preparing birthday celebrations for Fidel.

121 Sarusky and Mosquera, *The Cultural Policy of Cuba*, p. 33.

122 Cited in Luis Camnitzer, *New Art of Cuba* (Austin: University of Texas Press, 1994), p. xxviii.

123 Prieto held this post from 1997 to 2011, standing down when the Political Bureau of the PCC was streamlined at its 2011 congress. Former President of UNEAC and a writer himself, Prieto had played an important role in defending Cuban intellectuals from PSP accusations. From the late 1990s, he advocated the creation of controlled spaces for critical debate.

124 Adelaida de Juan, interview with the author, Havana, 3 March 2010.

125 Ministerio de Cultura (MINCULT), *Directorio: Instituciones Culturales* [Directory: Cultural Institutions] (Havana: Ministerio de Cultura, 1983), p. 26.

126 In 1976, fourteen provinces were created from the original six.

127 Under Resolution 8 of 24 January 1978, the national system of Casas de Cultura was linked to the Ministry of Culture, the Directorate of Cultural Orientation and Extension and the Directorate of Amateur Artists.

128 Armando Hart Dávalos, *Resolución no. 32/78: Resolución Que Reglamenta las Actividades en las Casas de Cultura* [Resolution no. 32/78: Resolution That Legislates the Activities of the Casas de Cultura] (Havana: Ministerio de Cultura, 1979), p. 2.

129 Sarusky and Mosquera, *The Cultural Policy of Cuba*, p. 25.

130 Ibid., p. 26.

131 Ibid.

132 Fidel Castro Ruz, 'Palabras a los Intelectuales', p. 34.

133 John M. Kirk and Leonardo Padura Fuentes, *Culture and the Cuban Revolution: Conversations in Havana* (Gainesville: University Press of Florida, 2001).

134 Consejo Nacional de Cultura, *Anteproyecto del Plan de Cultura de 1963*, p. 16.

135 John Loomis, *Revolution of Forms: Cuba's Forgotten Art Schools* (New York: Princeton Architectural Press, 1999), p. 111.

136 Alysa Nahmias and Ben Murray, *Unfinished Spaces*, 2001.

137 Sarusky and Mosquera, *The Cultural Policy of Cuba*, p. 14.

138 Camnitzer, *New Art of Cuba*, p. 170.

139 Kevin Power, 'Cuba: One Story after Another', K. Power and P. Perez (eds.), *While Cuba Waits: Art from the Nineties* (Santa Monica, CA: Smart Art Press, 1999), p. 24.

140 Karol, *Guerrillas in Power*, p. 549.

141 Ministerio de Cultura (MINCULT), *Algunos Datos sobre la Gestion Cultural Actual* [Some Data on Current Cultural Development] (Havana: Ministerio de Cultura, 1991).

142 CMEA, also known as COMECON, had been established in 1949 as a political response to the 1947 Marshall Plan and an economic counterpart to the Organisation for European Economic Cooperation (OEEC); Cuba signed up in 1972.

143 Carmona Báez (*State Resistance to Globalisation in Cuba*) describes how, during the Special Period, previously inconceivable measures were introduced, including foreign direct investment (up to 100 percent after 1995), the legalisation of citizens' use of hard currency (dollars) to buy imported products and the formalisation of self-employment.

144 According to the 1991 MINCULT publication (*Algunos Datos sobre la Gestion Cultural Actual*), this saw the existing central institutions – ICAIC, the institutes of books and music and the national councils of visual arts and scenery – supplemented in 1989 by a National Centre of Aficionados and Casas de Cultura, the Grand Theatre in Havana and the National Centre of Art Schools. In 1990, this saw the creation of provincial centres corresponding to the national institutions. A study, conducted in October 1991, demonstrated the possibility of reducing staff at a national level and increasing them at a provincial level. Between July 1990 and June 1991, the cultural field lost a total of 1,878 workers.

145 Power, 'Cuba', p. 31.

146 Mayra Espina Prieto, 'Looking at Cuba Today: Four Assumptions and Six Intertwined Problems', *Socialism and Democracy*, 24, no. 1, March 2010, p. 101.

147 Pogolotti, *Polémicas Culturales de los 60*.

148 Carlos Franqui, *Family Portrait with Fidel* (London: Jonathan Cape, 1983).

149 De Juan, interview with the author.

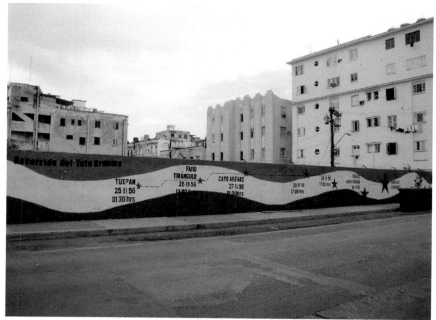

Mural in Havana showing the route of the *Granma* motor cruiser from Mexico to Cuba, November 1956.

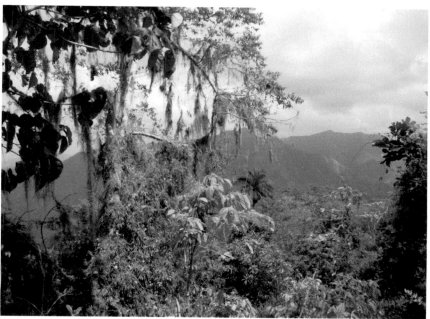

The densely forested, mountainous terrain of the Sierra Maestra provides the backdrop to the rural insurrection.

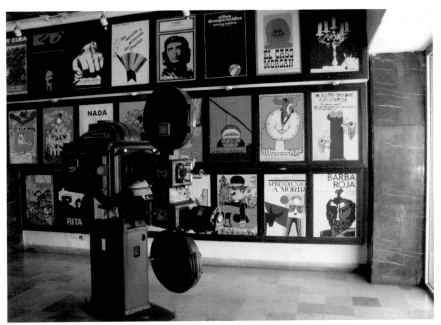

Silk-screened film posters at ICAIC.

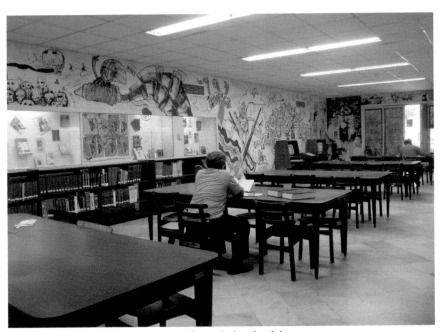

José Antonio Echevarría library at Casa de las Américas.

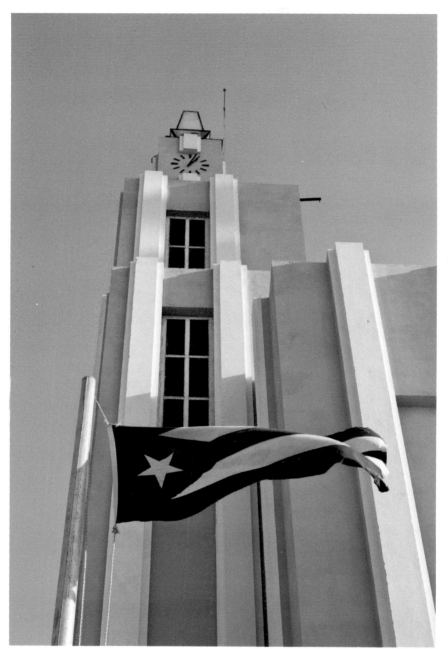

Exterior view of Casa de las Américas. Courtesy of the Archive of Casa de las Américas.

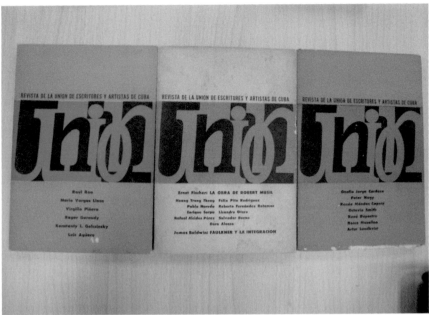

Covers of *Unión* magazine published by UNEAC.

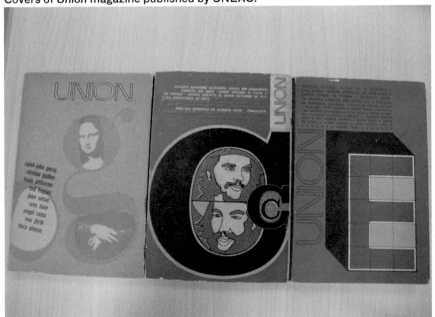

Commemorative publication produced for the First National Congress of Writers and Artists, 1961, which includes the slogan 'To Defend the Revolution Is to Defend Culture'.

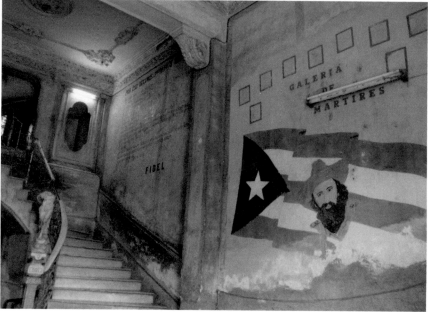

Paladar used as a set for Tomás Gutiérrez Alea's 1994 film, *Fresa y Chocolate* [Strawberry and Chocolate].

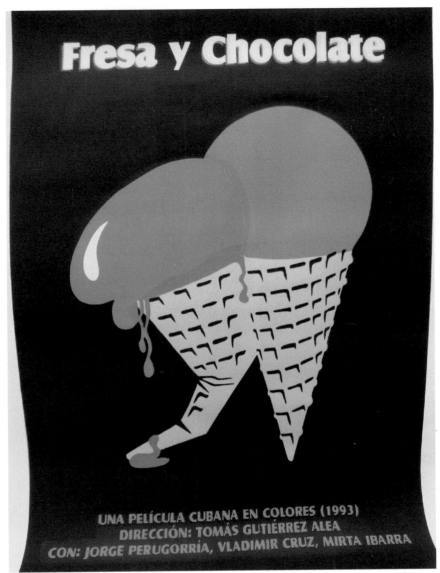

Poster for *Fresa y Chocolate*.

Copelia ice cream parlour, used as a set for *Fresa y Chocolate*.

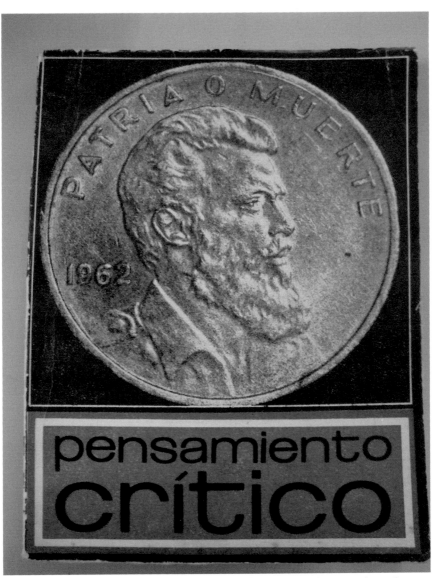

Cover of *Pensamiento Crítico* [Critical Thought], established in 1967, featuring a coin with the revolutionary slogan 'patria o muerte' [homeland or death].

The Emancipatory Potential of Culture under Socialism

 Just as we want a better life for the people in the material sphere, so do we want a better life for the people in a spiritual and cultural sense.

– Fidel Castro, June 1961

In order to articulate a new culture for Cuba, explicitly predicated on Marxist principles from April 1961, it was first necessary to scrutinise the conditions for cultural production that existed under capitalism. Marx had stated that 'capitalist production is hostile to certain aspects of intellectual production, such as art and poetry'.[1] At the Soviet Writers' Congress in 1934, the poet Maxim Gorky had discerned a combination of critical realism and revolutionary romanticism among a handful of bourgeois European (and Russian) writers, who had 'torn themselves away from the suffocating atmosphere in which they lived'[2] to create works of technical merit which 'explain the process of the bourgeoisie's development and decay' by elucidating 'its life, traditions and deeds in a critical light'.[3] At the same event, however, the chief ideologue of the Soviet Union, Andrey Zhdanov had observed that 'The present state of bourgeois literature is such that it is no longer able to create great works of art', as a consequence of 'The decadence and disintegration of bourgeois literature, resulting from the decay of the capitalist system'.[4]

In Cuba, it was consistently recognised that progressive and democratic cultural elements could be discerned within capitalist society, but it was widely understood that this tendency would not be allowed to prevail under a system that discriminated against the production of humanistic works. In documents issued during its first year of activity, the CNC and its provincial corollary (the CPC) empathised with artists operating under capitalism,

finding that their lack of positive ideals often led them to justify the infamies of the bourgeois world by portraying them as inherent in human existence. More generally, the art produced as part of capitalist culture was dismissed as a moribund reflection of bourgeois thought, capable of exerting an undesirable ideological influence. In a 1965 letter to Carlos Quijano, editor of the Montevideo-based *Marcha* [Progress] magazine, Che Guevara – whose reconciliation of theory and practice led him to be regarded as exemplary – wrote that, 'In the field of culture, capitalism has given all that it had to give, and nothing remains but the stench of a corpse – today's decadence in art'.[5]

In *The German Ideology*, Marx and Engels had given specific attention to the position of the artist within capitalist society. While confining their remarks to the Renaissance era (and thus ignoring the private market for art that had since emerged), they concluded that artists were inextricably linked to their socio-economic surroundings – to previous technical advances in art and to the division of labour both locally and internationally, which, in turn, dictated demand for their work. In a more accusatory way, in the aforementioned letter, which became known as 'Socialism and Man in Cuba', Che implicated artists in capitalist societies as part of the scaffolding around the law of value. In turn, he observed that 'The superstructure imposes a kind of art in which the artist must be educated. Rebels are subdued by the machine, and only exceptional talents may create their own work. The rest become shamefaced hirelings or are crushed'.[6] By the time of the first PCC congress a decade later, it would be asserted that the hostility of capitalism towards art and literature was evident in its subordination of artworks to the laws of supply and demand and to the interests of the dominant class, which succeeded in depriving the wider population of fully enjoying culture while spreading products that ideologically disarmed the masses.

As we have seen, the revolutionary government in Cuba inherited a capitalist system of cultural production, and attention was soon turned to reversing the effects of centuries of colonial and neocolonial rule. But this did not imply the wholesale replacement of capitalist with socialist culture, and another key tenet in Marxian thinking is relevant here, concerning our relationship to historical art. In the *Grundrisse*, Marx found that the artefacts of Greek culture continued to provide aesthetic pleasure long after their production. As vestiges of the 'historical childhood of humanity', this made them worthy of preservation.[7] Outlining the consequence of this approach to the revolutionary movement, Lenin would later claim that 'Marxism has won its world-historic significance as the ideology of the revolutionary proletariat because, far from rejecting the most valuable achievements of the bourgeois epoch, Marxism, on the contrary, has assimilated and reshaped the more valuable elements accumulated in the course of more than two thousand years of development of human thought and culture'.[8]

In Cuba, the vast majority of gov-
ernment figures and creative practi-
tioners agreed on the need to preserve
cultural works from the previous era.
Throughout 1961, Nicolás Guillén
refuted the indiscriminate rejection
of bourgeois culture, arguing that
the task of artists and writers lay in
rescuing the culture that had been
abandoned by the bourgeoisie and,
rather than confining its enjoyment
to a small minority, reclaiming it on
behalf of the Cuban people. In August
of that year, this would form the
first objective of the First National

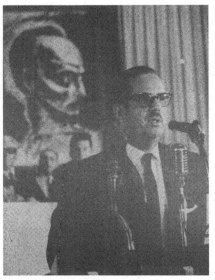

Congress of Writers and Artists, and,
in his opening speech to the congress,
President Dorticós urged the assem-
bled writers and artists to salvage the

President Dorticós inaugurating the
First National Congress of Writers and
Artists, 18 August 1961.

positive aspects of historical culture, in order to preserve the fertile achieve-
ments of outstanding minds. At the same event, Guillén would insist that:

> It is a grave error to deny the important part played by the bourgeoisie in
> the birth and development of socialist culture. Ambitious as our forces
> may be, despite everything the Revolution may be able to do – and it
> can do much – it would be impossible to endow Cuba with a proletar-
> ian culture, as if by prescription, without taking into consideration the
> former culture in its most developed and progressive forms.[9]

Juan Blanco would later invoke those revolutionary artists who appreci-
ated and respected their artistic predecessors, including Picasso and Klee,
Stravinsky and Mayakovsky.[10] And, while the act of rescue may have predomi-
nated over other concerns for a time, decades later, having retired from his
post as Minister of Culture, Armando Hart would continue to remind younger
artists to ground their work in history and tradition, on the basis that neither
Marx nor Lenin had dogmatically refuted previous cultures.

While agreement on the need to preserve historical artworks formed
the overwhelming consensus in 1960s Cuba, a handful of orthodox voices
were less forgiving about the cultural artefacts of the previous era. When the
CNC drew up its first formal policy document, it would dedicate a section to
cultural inheritance, affirming that, 'for Marxists, the cultural past, assimi-
lated by the development of humanity over the years, constitutes an active
and influential element [...] of the cultural life of society'.[11] Conceding that art

contained elements of the absolute, enabling it to be enjoyed centuries after its creation, the first President of the CNC, Edith García Buchaca, considered that only the purest essence of cultural heritage should be preserved for the sake of continuity. Moreover, she prescribed that a new form of art should arise in classless society, which would contain values relative to its historical moment. Throughout the remainder of this book, the consequences of this prescription, and the strategies mounted against it, will be thoroughly interrogated.

Already we have a hint of the ideological complexities involved in forging a new culture from the ruins of the old. In this chapter, we shall see how culture was conceived as an essential part of society and released from commercial constraints, leaving artists free to perform their revolutionary duty. We shall also see how culture was mobilised as a tool of class struggle and how the emancipatory aims assigned to it found their way into discussions on aesthetics and prompted questions about freedom of expression.

Art as a Form of Social Production

By now, it should be clear that culture was placed at the heart of evolving society by the revolutionary government, with the cultural and spiritual development of the people being inextricably linked to the material development of the country. Let us begin with an analysis of the economic implications of this sea change before moving to consider the social responsibility it conferred upon the island's cultural producers.

Before 1959, Cuban artists were almost entirely dependent upon the whims of businessmen who commissioned work through private negotiations. After 1959, as the capitalist class fled the island, this patronage system largely disappeared. Rather than being replaced by a commercial exchange system, as had happened in Europe and the US, the market was rejected as part of a broader plan to eliminate money.[12] In 1842, Marx had written that 'A writer must of course earn a living to exist and be able to write, but he must in no sense exist and write so as to earn a living'.[13] To this end, it was decided that creative practitioners should have a fixed income equal to that of other workers. At the 1961 congress, the CNC Director of Culture, Vincentina Antuña, alluded to numerous grants being awarded to young artists and writers.[14] At the same event, Roberto Fernández Retamar announced the creation of a Literary and Artistic Fund as an integral part of the newly formed UNEAC. Cautioning that this should not be envisaged as a total solution to the material problems facing artists and writers, he commended the recent trend of paying writers and articulated a hope that this would bring about a commitment to the profession of arts and letters. Consistent with a desire to overcome idealism, which represented an advanced stage in the separation of humanity from its material foundations, Retamar also uttered the wish that intellectual work

would shortly be considered akin to manual work. In another presentation to the congress, the Cuban Workers' Confederation (CTC) echoed the aspiration that intellectual and manual labourers be united into one class. By the end of the decade, plastic artists were being paid a salary, and the cost of their materials was covered under a mutual agreement between the artist and the state. Consistent with pre-revolutionary demands, cultural producers were declared free from economic insecurity, allowing them to pursue their art without having to rely on sales or earn a living from work other than their creative practice. As a result, Ambrosio Fornet reminisces that intellectuals 'were able to create with total autonomy thanks to autonomous institutions and a type of patronage – state subsidy – free from the demands of bureaucracy like that of servitude to the market'.[15]

As we have seen, most professional artists in Cuba pass through at least six years of higher education. In return, many artists repaid the state through their work as teachers within art schools or as designers of mass-produced books and periodicals. Armed with a comprehensive grounding in their field, artists graduating from ENA during the 1960s and '70s had a 'guaranteed place in society and [were] able to devote themselves to creative activities without any concerns or difficulties'.[16] Artworks shed their commodity character to become either a part of the national collection (with the state acting as both sponsor and collector) or a means of dissemination (a prime example of which is the silk-screen posters produced by Casa de las Américas and ICAIC). Combined with the institutional restructuring described in the previous chapter, this served to redefine the relations of cultural production.

In 1961, the process of guaranteeing artists and writers a decent income brought about reorganisation of the Copyrights Institute, which would eventually see a decision being taken to revise copyright laws. Prior to the Revolution, laws governing intellectual property – drawn up on 10 January 1879 and amended in the 1930s – had covered scientific, literary, artistic, dramatic and musical works. On 29 April 1967, while inaugurating projects by female scholarship students at Guane, in Pinar del Río province, Fidel contemplated the intellectual property rights which had historically prevented the people from accessing useful information. Considering that the country's cultural development could be accelerated by reprinting works from around the world – from North American technical manuals to universal works of literature – he proclaimed the abolition of copyright. At the same time, he renounced Cuba's right to any intellectual property accrued within its borders, on the understanding that provision would be made for those who relied for their survival on royalties from creative work. In October of the same year, this theme would be taken up at the preparatory seminar for the Cultural Congress of Havana. Convinced of the national and international significance of this stance, the artists and writers present at the seminar willingly

renounced the commercial rights to their work, in return for social recognition and the value inherent in the creative act. A resolution was issued on the subject of artists' rights, signalling Cuba's intention to elevate its cultural condition by accessing the world's knowledge.

At a stroke, the floodgates were open to the liberal reproduction of classic works of literature, sociology, anthropology and economics, which were freely disseminated around the island in Castilian editions of multiple thousands under the collective title of Revolutionary Publications. At the same time, the renunciation of copyright on Cuban works reinforced the material reliance of writers upon the state. It has been observed, however, that 'the importance of such a change can be easily overestimated abroad, where royalties are an essential part of the writer's incentive system. In Cuba, even after the new publishing structures eliminated the need (and later even the opportunity) for self-financed editions, royalties did not represent a significant income for most authors'.[17]

At the 1971 congress, it was reiterated that 'The Revolution frees art and literature from the inflexible mechanisms of supply and demand that rule over bourgeois society. Art and literature will cease to be merchandise, and all possibilities will be offered for aesthetic expression and experimentation in its most diverse manifestations'.[18] And, while decisions about the kind of work granted support would be politicised in the wake of this congress, the receipt of support did not, in itself, imply the imposition of any particular criteria. By the time of the first congress of the PCC in 1975 – which rejected dogmatic approaches to cultural decision-making – reference was being made to the system of intellectual and artistic remuneration in place which aimed to maximise human and material resources. At this congress, it was also asserted that the Revolution had eradicated the conditions of penury and humiliation in which art had been maintained – a sentiment that was repeated four years later, in a report to UNESCO which described Cuba as the only country in Latin America to accept art as a form of social production.

Conceiving art as a form of social production not only implied freedom from material constraints on the part of artists; it also entailed a contribution to the process of forging a new society. As creativity was acknowledged to play an essential part in the struggle for dignity, politicised intellectuals of the epoch came to regard their intervention in public affairs as not only a possibility but also an obligation. Yet it would take time for this unprecedented reconciliation to be realised. Before the Revolution, the majority of contemporary artists had been too discouraged and politically detached to play a major role in the insurrection. And, while Cuban intellectuals contributed to the momentum of the urban movement – writing and distributing clandestine newspapers and collecting money that would be sent to insurgents in the Sierra Maestra – the 26 July Movement had little structural influence

over the intelligentsia at the moment of revolutionary victory and counted no militant artists among its ranks. This meant that while, for the political vanguard, the Revolution began with Moncada in 1953, the intellectual vanguard was shocked to find itself lagging behind both its political counterpart and its Russian precedent.

By contrast, Che was knowledgeable about matters of art and culture to the point of preoccupation. In 1965, he expressed a Zhdanovian impatience with the slow revolutionary development of intellectuals, provoking a response that will be discussed in due course. Notwithstanding any perceived delays, the vanguard role attributed by Lenin to the party and its intellectuals manifested itself in Cuba, and a shared commitment to change established a necessary link between political and artistic vanguards. In this regard, Picasso was taken as an exemplar of artistic, political and human evolution. On the Latin American continent, the poets César Vallejo and Pablo Neruda were singled out for praise, while, in Eastern Europe, the constructivists Mayakovsky, Eisenstein and Meyerhold were mentioned for their ability to both depict the October Revolution and withstand Stalin's persecution – with the former being identified as the 'first poet of the Soviet era [who] represents an example of an artist from the vanguard, the aesthetic order, in service of the revolution'.[19]

In November 1963, the film-maker Julio García Espinosa added some provisos to the debate around art as a form of social production, advising that the concept of productivity in art could not be applied mechanically, lest artists be judged for the quantity of works produced in a given period, which would fail to either recognise the quality of their work or take account of less productive artists. The quantitative path, he warned, could easily lead to opportunism and mediocrity rather than the increased spiritual wealth through which the Revolution sought to eradicate exploitation. Similarly, he feared that productivity might come to be measured in terms of the popularity of artworks, which would negate experimental work that might not find public favour.[20]

More generally, it was recognised that popular enjoyment of art should not be confined to vulgar forms; rather, the population of Cuba 'which has developed its Revolution at the cost of immeasurable sacrifices, has the right to true art'.[21] In this regard, Dorticós would consistently argue that artists and writers had a duty to elevate the cultural level of society. Inaugurating the 1961 congress, he urged delegates to take artistic and literary weapons of the highest quality to the people. And, as art and literature were the product of societies, this implied that great artistic quality would only be possible if artists and writers understood the society in which they lived. Alfredo Guevara would later paraphrase his sentiment that, in the midst of a revolution, it was necessary to engender in young creators an understanding of the

importance of studying Marxism not as a political act but as an artistic one.[22] Accordingly, the curriculum at the Higher Art Institute (ISA) would involve an analysis of socio-economic structures from a proletarian perspective. In 1967, Dorticós would reiterate his earlier formulation, emphasising that the responsibility of creative intellectuals lay in their dissemination of the values of art and culture to the people, together with the capacity to interpret those values, which meant that the quality of creative expressions must remain undiminished while the intellectual level of the people rose to meet them.

There are several precedents for discussions around the quality of artistic production and the necessity of its alignment with the people. Writing in a 1926 publication for the Left Front in Art (LEF) – a vanguardist association of formalists and futurists in the Soviet Union – just before experimentalism was snuffed out, Mayakovsky insisted that 'a poet must be in the middle of things and events. A knowledge of theoretical economics, a knowledge of the realities of everyday life, an immersion in the scientific study of history are for the poet, in the very fundamentals of his work, more important than scholarly textbooks by idealist professors who worship the past'.[23] At the 1934 Soviet Writers' Congress, Zhdanov took Stalin's evocation of writers as 'engineers of the human soul' to mean that Soviet writers should 'remould the mentality of their readers'.[24] In turn, this implied 'knowing life so as to be able to depict it truthfully in works of art, not to depict it in a dead, scholastic way, not simply as "objective reality," but to depict reality in its revolutionary development'.[25] In 1963, the CNC would repeat this sentiment virtually verbatim, to insist that artists and writers should be 'capable of representing in their work not only objective reality but also reality in its revolutionary development, helping it in its important task of transforming old ways of thinking and lapsed ideas, educating workers in the spirit of socialism'.[26] However, Zhdanov's comments signalled the end of a period of extraordinary creativity in the Soviet Union and, as we shall see in subsequent chapters, their reiteration in Cuba threatened to do the same.

On 2 May 1969, six male writers from the collaborative committee of *Casa de las Américas* journal – Dalton, Depestre, Desnoes, Fornet, Retamar and Carlos María Gutiérrez[27] – met in the painting studio of Mariano Rodríguez Álvarez (Vice President of Casa, generally referred to by his first name) to discuss the impact of the first decade of the Revolution in the field of culture and politics, specifically whether it was possible to be an intellectual without being revolutionary. The ensuing debate – which was published by *Casa* and, much later, by Editorial Siglo XXI in Mexico – demonstrated both the extent to which creative intellectuals considered themselves integrated into the Revolution and the conviction that their former separation from the Cuban people had been overcome.[28] Fornet would later reflect upon how 'the Revolution – the real possibility to change life – appeared to us as a political expression of the artistic

aspirations of the vanguard',[29] and, in later chapters, we shall see how this mutual flowering mutated down the years. During the 1969 discussion, Dalton asserted that elimination of the remunerable character of creative work – through the eradication of copyright and nationalisation of the publishing industry – compelled the personal–social responsibility of each creator. Rather than autonomous creative colonies forming (as had happened in other socialist countries), he observed that Cuban writers and artists had immersed themselves in the social life of the island.[30]

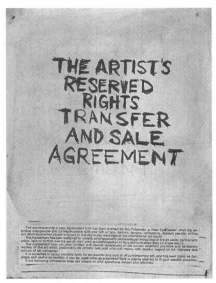

The Artist's Reserved Rights Transfer and Sale Agreement, 1971.

In 1975, in recognition of the need to adequately reward creators for the fruits of their labours, the PCC reinstated intellectual property rights. Accordingly, Law 14,[31] ratified at the National Assembly of Popular Power in 1977, made provision for the moral recognition and juridical protection of copyright on the basis that this would stimulate the development of artistic, literary and scientific creation; it also detailed the remuneration of intellectual work according to guidelines drawn up by MINCULT in dialogue with the social agencies representing cultural producers. According to this law, the author's right to be recognised as the creator of a particular work would last for twenty-five years beyond their natural life, or, in the case of works by unknown authors, twenty-five years after first publication. Where the descendants of the author were still resident in Cuba, these rights would pass to them; where copyright passed to those outside the country, these works may be declared the patrimony of the state by the Council of Ministers.

Significantly, Law 14 also prescribed that, following the sale of any work of art, ownership alone would pass to the purchaser, with the author retaining copyright. This contradicts standard practice in the capitalist world, particularly the US (with the exception of California), which has historically deprived artists of rights to their work after its sale. In a bid to overcome this, in 1971, art agent Seth Siegelaub and New York City lawyer Robert Projansky drew up the Artist's Reserved Rights Transfer and Sale Agreement, a 'model contract, reserving certain rights to the artists, such as entitlement to fifteen per cent of subsequent sales, and the right to borrow the work for exhibitions at certain intervals and to veto loans to exhibitions in which the artist did not want it to be shown'.[32] In Europe, the nineteenth-century French concept of *droit de*

suite gives artists rights over their work as it passes through the hands of successive owners. On 27 September 2001, the European Union attempted to have directive 2001/84/EC accepted across the union, giving artists continued rights over their work in the event of its resale; in the UK, this has been manifested as the Artist's Resale Right, conferring a share of royalties when artwork changes hands for more than €1,000.

Consistent with the democratising aims of revolutionary cultural policy, the reinstatement of intellectual property rights in Cuba was made subordinate to the social need for disseminating cultural works as widely as possible. This means that, where any work is considered necessary for scientific, technical or educational development or professional improvement, a license can be granted for its reproduction and distribution, without acrimony about money. Extracts of cultural products may be used without the consent of the author, either with or without remuneration, providing that the author is recognised as the originator of the work. And, while the introduction of an art market in Cuba, after the period encompassed by this study, starkly illustrates the inequities that result from such a system, the conception of art as a form of social production, and of the artist as an integral member of society, endures.

Culture as a Tool of Class Struggle

Polish aesthetician Stefan Morawski has noted that Marx and Engels repeatedly observe that 'an artist's stated or implicit values were equivalent to aspects of the ideology of a social class. These connections were founded on explicit evidence in a work of art – never on mere reference to a writer's or artist's class of origin, which would have been reductive'.[33] In founding Russian Marxism, Georgi Plekhanov perpetuated thinking around the 'class equivalence' of artworks, which found its way into Lenin's ideas about the inextricable relationship between creative production and class struggle.

In 1961, the Provincial Council of Culture (CPC) in Cuba declared that 'Artistic creation cannot remain at the margins of class struggle, outside politics, for the simple reason that all writers or artists – whether they want to or not – express and bring together in their work the interests of one or other of the classes'.[34] Adherence to the position that cultural work could not remain detached from class struggle became more vehement after the 1971 congress, the final declaration for which asserted that 'Culture, like education, is not, nor can it be, either impartial or apolitical. It is a social and historical phenomenon conditioned by the needs of social classes and their struggles and interests throughout time. Apolitical thought is nothing more than a shameful and reactionary point of view regarding cultural concepts and expression'.[35] This corresponds with the LEF position that 'you must smash to smithereens the myth of an apolitical art'.[36] In turn, Cuban creative intellectuals acknowledged

that 'To write is to direct oneself to someone, to exert influence; the carrier of words is also a carrier of a determined ideological content, of a determined vision of the world, of a determined class position'.[37]

Morawski argues that ideas around the class equivalence of art may be interpreted in two ways. On the one hand, 'In the more deterministic sense, this notion means that the expression of a work of art will conform to the ideology of a particular class, as imposed upon and mediated by the artist'.[38] In the wake of the 1934 Soviet Writers' Congress, the foremost magazine of literary criticism reported that many speeches had been made by the 'old intelligentsia',[39] at the same time as Zhdanov urged Soviet writers to 'Be in the front ranks of those who are fighting for a classless socialist society'.[40] As we shall see, many among the CNC regarded artists trained before the Revolution to be eternally wedded to a reactionary class position which was at odds with the council's aspiration for Cuba's 'creators and critics to operate as the first ranks of combatants for a classless society'.[41] On the other hand, Morawski argues that 'A more comprehensive interpretation will find that the class conditioning of artistic values primarily occurs – or at least most profoundly occurs – where epochal class conflicts are depicted with lucidity and deft control by artists who have an exceptional awareness of the tale they would tell'.[42] Rather than simply projecting ideology in a tendentious way, this relies on the extent to which each depicted situation is dynamic and typical of its historical moment. And, while this approach may tend towards realism, primacy is given to originality in the artistic-cognitive and stylistic dimensions. In this matter, Marx and Engels distinguished between the artist's ideology – or world view – and both artistic cognition and universal human value, the latter of which was awarded priority, clearly corresponding with a humanistic approach.

Considering humanistic readings of Marxian theory, Peter Hudis and Kevin Anderson note that 'For Marx the subjective struggle of the workers is capable of attaining a liberatory, human self-determination by experiencing the dialectic of absolute negativity'.[43] Since Marx, attempts have been made to expand upon the emancipatory connotations of Hegel's theory of absolute negativity, in a bid to re-imagine a revolutionary future without recourse to totalitarianism. The original theory implies a two-stage process in which, first of all, existing reality is negated, followed by a second stage in which first-order negation is negated, paving the way for positive humanism. Through the negation of the negation, the abstract becomes concrete, as happens, for example, in the transition from rejecting private property to creating new social relations. In the mid-twentieth century, Raya Dunayevskaya worked with C.L.R. James (who visited Cuba in 1968) to find in absolute negativity the basis for a philosophy of human emancipation and 'the quest by masses of people, not simply to negate existing economic and political structures, but to create *totally new human relations* as well'.[44]

In his influential series of lectures, Adolfo Sánchez Vázquez elaborated on the humanistic attributes of Marxism in relation to culture, to deride the kind of dogmatic thinking that prohibits paths to 'the curious dialectic of the negation of the negation, to an affirmation of man's creative power, which is precisely the negation of a decadent outlook in life'.[45] In this, he deemed art to have a function in both exposing the previous failings of society and helping to repair them:

> Because of its class origin, its ideological character, art is an expression of the social division or gash in humanity; but because of its ability to extend a bridge between people across time and social divisions, art manifests a vocation for universality, and in a certain way prefigures that universal human destiny which will only be effectively realized in a new society, with the abolition of the material and ideological particularisms of social classes.[46]

In this multi-facetted statement, the Marxist aesthetician equates art with ideology by virtue of its class origins while invoking the power of art to transcend class and time by focusing on universal human values. Grounded in Aristotle's advocacy of poetry as a means through which to universalise specifics, this confers upon art the role of prefiguring a better society.

In regard to what Sánchez Vásquez called art's 'vocation to universality', a further highly instructive point to be taken from *The German Ideology* is Marx and Engels's rejection of the Romantic conception of creative activity being confined to unique individuals working within constrained disciplines:

> The exclusive concentration of artistic talent in particular individuals, and its suppression in the broad mass which is bound up with this, is a consequence of division of labour. If, even in certain social conditions, everyone was an excellent painter, that would not at all exclude the possibility of each of them being also an original painter [...]. In any case, with a communist organisation of society, there disappears the subordination of the artist to local and national narrowness, which arises entirely from division of labour, and also the subordination of the artist to some definite art, thanks to which he is exclusively a painter, sculptor, etc., the very name of his activity adequately expressing the narrowness of his professional development and his dependence on division of labour. In a communist society there are no painters but at most people who engage in painting among other activities.[47]

We see here that individualism and specialisation, both typical of the cultural field under capitalism, are attributed to hierarchical forms of social organisation and taken to rely upon the suppression of artistic talent in the broader populace. By contrast, in a society in which hierarchies are being broken down,

it is envisaged that everyone's latent creativity will be encouraged, giving free rein to creative excellence, which in no way precludes original ideas from being expressed.

Shortly after the Russian Revolution, following Lenin and Alexander Bogdanov's work on proletarian culture, Antonio Gramsci elaborated an anti-elitist conception of culture, to argue that:

> [...] one must understand the impetus by which workers feel drawn to the contemplation of art, to the creation of art, how deeply they feel offended in their humanity because the slavery of wages and work cuts them off from a world that integrates man's life, which makes it worth living. The struggle of the Russian communists to multiply schools, theatres and opera houses, to make galleries accessible to the crowds, the fact that villages and factories which distinguish themselves in the sector of production are awarded with aesthetic and cultural entertainments, show that, once in power, the proletariat tends to establish the reign of beauty and grace, to elevate the dignity and freedom of those who create beauty.[48]

In outlining the conditions for culture in a revolutionary situation, Gramsci predicted that 'Bourgeois careerism will be shattered and there will be a poetry, a novel, a theatre, a moral code, a language, a painting and a music' of revolution.[49] Without precisely describing these new art forms, he understood that their emergence would entail destroying 'spiritual hierarchies, prejudices, idols and ossified traditions [...] not being afraid of innovations and audacities, not being afraid of monsters, not believing that the world will collapse if a worker makes grammatical mistakes, if a poem limps, if a picture resembles a hoarding or if young men sneer at academic and feeble-minded senility'.[50] As we shall see, this precedent for democratising culture would find easy accommodation with Cuban aims. And, while Cuban conceptions of the proletariat initially tended towards the peasantry, rather than the industrial working class, it was assumed that the production of cultural works was the prerogative of all. In this way, culture was reinforced as a vital factor in the desired shift to classless society.

In considering the universal right to creativity, Gramsci proposed that, as everyone is capable of engaging in intellectual labour, the category of 'intellectual' does not rely on some intrinsic property of mental activity; rather, the capitalist system of social relations encourages this kind of work from selected people who are complicit with the status quo. In this schema, 'The traditional and vulgarised type of intellectual is given by the man of letters, the philosopher, the artist',[51] whereas in fact 'Every social group, coming into existence [...] creates together with itself, organically, one or more strata of intellectuals which give it homogeneity and an awareness of its own function not only in the economic but also in the social and political fields'.[52] It

is commonly presumed that this refers to a clear-cut division between two categories of intellectual – traditional and organic – based on their ethos and class of origin. In relation to Cuba, Judith Weiss draws a line between those 'organic intellectuals who engage in tasks serving the perpetuation of the present system, and those true intellectuals – thinkers, artists, and writers who choose exile or active opposition to the system'.[53] This description of the choices available to intellectuals appears to turn on its head Gramsci's indictment of those *traditional* intellectuals favoured by, and perpetuating, an elitist regime while exonerating those (perhaps equally traditional) intellectuals who choose to leave or resist.

Nicola Miller advises caution in relation to the transposition of Marxian interpretations of European capitalist society onto a Latin American context. Conceding that a 'series of translated excerpts from the *Prison Notebooks* was published in Buenos Aires from 1958 to 1962',[54] she maintains that Gramsci's work on intellectuals in relation to class and the state 'was not widely known in Spanish America until the 1970s'.[55] But this generalisation does not apply to Cuba, and, later in this chapter, we shall see that, in 1962, Fornet would appeal to Gramsci's invocation of Benedetto Croce in the *Prison Notebooks*. Gramsci's thinking also visibly influenced other intellectuals on the island, notably Retamar, and the former's ideas around the social function of intellectuals were taken as the explicit starting point for the Cultural Congress of Havana in 1968.

In considering the position of intellectuals across the continent, Miller paraphrases Gramsci's understanding of organic intellectuals as 'those who were ready to acknowledge their class position' as compared to their traditional counterparts who were not.[56] Parenthetically, but not irrelevantly, her interpretation attributes powers of acknowledgement and denial to the two categories of intellectual which appear to be absent in Gramsci's original. And, although Miller's description of the position of traditional intellectuals roughly corresponds with conditions under capitalism, as Gramsci intended, it cannot be convincingly applied to revolutionary Cuba.

Recognising geographical specificity at the end of the first half of the twentieth century, Gramsci would observe that the industrial underdevelopment that prevailed in Latin America meant that the category of traditional intellectual was insignificant and largely confined to the clerical and military class and the landowners of the *latifundia*. While the role of the church was less important in Cuba, we have seen that, with the full support of Batista's army, the *latifundists* held considerable sway over cultural life alongside indigenous and foreign investors. Consistent with Gramsci's demography, the soubriquet 'traditional' cannot be applied with conviction to the majority of mid-twentieth-century Cuban intellectuals mentioned in this book, as they took a stand against Batista's dictatorship and neither sought nor

received the patronage of the ruling class. Indeed, as we have seen, a number of intellectuals maintained some kind of praxis under Batista, but this was carried out in a self-financed and often samizdat fashion and risked punitive measures. At the 1961 congress, Guillén would assert that Cuban intellectuals had never formed a distinct social class; rather, they were part of the exploited class under capitalism, and had only unwittingly propagated the system that oppressed them.[57]

Nonetheless, Weiss maintains that:

> The responsibility of the intellectual is, first and foremost, to liberate himself from the colonized bourgeois mentality, in other words, to betray the class to which he presently belongs, before he can participate actively in the planning of the new order. The concept of 'class betrayal' is valid in the case of the intellectuals even though they do not constitute a distinct social class, because they do have a class interest: that of the class that, as planners and thinkers, they are historically bound to serve.[58]

This fits with the orthodox position, in evidence in Cuba, which presumed that pre-revolutionary intellectuals were inextricably bound to bourgeois modes of thought. If the superstructure (to which the CNC persisted in consigning the cultural field) remained in the hands of the class that the revolutionary situation aimed to eradicate, this inevitably implied a conflict. But the majority of the leading revolutionaries are well known to have come from a middle-class background and aspired to ensure that all Cubans had access to the benefits – land, housing, employment, education, culture – of which many had historically been deprived. At the time of the insurrection, writers were considered to be intellectuals, but artists, scientists and politicians less so. As a more inclusive definition of intellectual activity prevailed and training was extended to those organic intellectuals (primarily from peasant backgrounds) who would come to make up a sizeable proportion of the intelligentsia in Cuba, Retamar would find evidence in *The Communist Manifesto* of traditional intellectuals detaching themselves from their class of origin in order to align themselves with the oppressed,[59] with 'traditional' territory willingly being conceded to those developing their mental capacities anew.[60]

Above all, Gramsci's thinking in this area may be regarded as an attempt to expose the selective processes through which traditional intellectuals are favoured *within class society* at the expense of the latent mental labour operating at all levels of society. From this, the revolutionary idea emerges that the intellectual capacity of the huge breadth of organic intellectuals needs to be encouraged. If, as seems clear, Gramsci's intention was to encourage a wholesale reappraisal of the mechanisms through which intellectual activity is made available to the people, his evocations were enthusiastically taken up in Cuba, with education becoming accessible to all strata of society at the same

time as attempts were made to erode those strata. Arguably, then, Gramsci's distinction between traditional and organic intellectuals reaches its natural limit when the social relations underlying it are disrupted. Let us turn now to a consideration of the ways in which the freedom of culture from mercantile constraints, and its reconfiguration as the legitimate right of the people, permitted more spiritual aims to be pursued.

Culture as a Means of Enhancing Spiritual Growth

In considering the mechanisms of the Russian Revolution, the Ukrainian scholar Zenovia Sochor isolates two basic prerequisites for revolutionary success – de-legitimation of the existing regime and the emergence of a competing ideology. Opinion has historically been divided over the specifics of the second process – its timing (before, during or after the seizure of power), its trigger (whether ideological shifts would occur as a natural consequence of the changing socio-economic structure or would need to be implemented extrinsically) and its tenets (whether the new ideology should be based on ideology per se or on class consciousness).

Whereas Marx had every faith in the ability of the proletariat to overcome false consciousness at the moment of revolutionary rupture, Lenin did not believe that this would happen spontaneously, which caused him to advocate the intervention of the party vanguard including its intellectuals. In the Soviet context, Sochor observes that:

> Among the problems facing revolutionary leaders, one of the most diffi-
> cult is how to transform the attitudes, beliefs and customs inherited from
> the old society that hinder the creation of a new society. Clearly, there is
> no automatic change when power is seized; the population at large may
> have altered its expectations but not its familiar habits in work and social
> behavior. Yet without cultural transformation, the building of socialism
> may remain an evasive goal. Even when the political opposition has been
> subdued and economic development has at least been launched, the
> cultural sphere is not easily changed. Revolution and culture are pitted
> against each other.[61]

While Sochor's definition of culture errs towards 'all the creation of a human community', referring as it does to mores and modes of behaviour, the Cuban leadership understood the need to engender a broad shift in culture, including 'literature, the arts and thinking', as an integral part of societal transformation. In this, Fidel was said to be counting 'on two factors: success by a superhuman effort on the economic front, and the creation, in record time, of a popular consciousness capable of sloughing off old habits, of combining Communist with unorthodox ideas'.[62] Considering the consciousness-raising impetus in Cuba, Karol notes that:

Fidel knew that he could not give the moon to those who asked for it, nor even satisfy their much more real needs here and now. All he wanted was to make them conscious of these needs, and to persuade them to join him in seeking a fair solution. Fidel and his small group of *barbudos* [bearded men] thus set themselves a task after the Revolution which Lenin had long ago assigned to the Communist Party in order to make the revolution: to infuse the masses with class consciousness from without.[63]

Having seized power after a prolonged guerrilla campaign – during which revolutionary consciousness had developed in the Sierra Maestra – the 26 July Movement and their associates were faced with the task of stimulating revolutionary consciousness among the people at large. As Fidel said, 'building socialism and communism is not just a matter of producing and distributing wealth but is also a matter of education and consciousness'.[64]

Central to ideas around expanding consciousness would be elaboration of the new revolutionary subject or 'new man'. Gramsci had speculated upon this concept during his internment (1929–35), taking Lenin's original to be shorthand for new social relations. In considering the gendered aspect of this terminology, Gramsci predicted that a new ideology, superstructure and literature would not occur spontaneously – as through asexual reproduction in females – rather, these new social relations would require the 'male' element of history and revolutionary activity to fertilise them.

For Che Guevara – who prioritised subjective conditions over objective ones – the new man was a subject motivated by moral imperatives more than the promise of fiscal reward. Apparently, the 'central question' at the 1934 Soviet Writers' Congress was 'how to portray the new man in works of art'.[65] Che's thinking on this was informed by Ernst Fischer's book *The Necessity of Art: A Marxist Approach*. This book, first published in the same year as the triumph of the Revolution, speculated on the role of art as a social experience, which fits with Gramsci's understanding of the new man as new social relations: 'Evidently man wants to be more than just himself. He wants to be a *whole* man. He is not satisfied with being a separate individual; [...] He wants to refer to something more than "I", something outside himself and yet essential to himself'.[66] Building on these ideas, the Cuban archetype would be encouraged to achieve full, un-alienated consciousness through holistic participation in society and culture.

Che consistently argued that increased acculturation would be the key to both economic growth and human realisation, and, in 1965, he insisted that:

It is still necessary to deepen conscious participation, individual and collective, in all the structures of management and production, and to

link this to the idea of the need for technical and ideological education, so that the individual will realise that these processes are closely inter-dependent and their advancement is parallel. In this way, the individual will reach total consciousness as a social being, which is equivalent to the full realisation as a human creature, once the chains of alienation are broken. This will be translated concretely into the re-conquering of one's true nature, through liberated labour and the expression of one's own human condition through culture and art.[67]

This took as its basis the idea that revolutionary consciousness would grow out of a direct involvement in the building of society, combined with educa-tion, and that this would give rise to a new human subject with full access to the means of self-expression. In this sense, culture was regarded neither as a tool of development, or 'civilisation', nor as a means of moral education. Rather, it became the goal towards which all of humanity must strive in order to overcome alienation.

At the Cultural Congress of Havana in 1968, the influential British poet and critic Herbert Read would describe how 'Alienation is a problem of industrialization, of dehumanized modes of production. It is a disease of the uncreative mind, of the mind divorced from sensuous contact with primary materials, and the disease is inescapable unless at some stage in production the shaping spirit of the imagination intervenes and guides the process of production into forms pleasing to the senses'.[68] At the same congress, the London-based Trinidadian writer Andrew Salkey was informed by his guide, a medical student, that 'Alienation's dead and forgotten in our society now'.[69] A few years later, the 1971 congress grounded the history of humanity in revolutionary struggle, prophesying that man would become master of his own destiny, free from alienation.[70]

As will be discussed at length in chapter six, the integral growth of man would form the second of five themes at the 1968 congress. As a prelude to discussions, the British playwright Arnold Wesker would observe that:

In Cuba they talk only about what Che Guevara called the 'new man' who will be for them, simply, the man whose personal and social incentives will be moral rather than material. Man will work not because his pay will increase but because his fullfilment [sic] as a human being is complete in knowing the degree to which he has contributed to the well being of his society; and this fullfilment will affect his personal relationships with his neighbour, making them richer; it will affect his need and capacity for education and the enjoyment of art, making them natural and inevitable [...] [The Cubans] are actually looking at the acquisitive and competitive nature of man as we have believed it must always be and saying: he is

like this only from centuries of conditioning and we are now going to completely change that conditioning.'[71]

Prefacing days of deliberation, Dorticós emphasised the role of artists and writers in helping to develop the personality of the new revolutionary man to which the country aspired, engaging intellectuals in priming the people to meet their revolutionary duty. In his closing speech to the congress, Fidel would assert that the development of consciousness, of social and cultural development, would be a prerequisite for economic and industrial development.

At the end of the 1960s, the Canadian writer C. Ian Lumsden would note that 'Every domestic policy implemented by the Castro regime is ideologically linked to the creation of this new socialist consciousness'.[72] Lumsden observed that the Revolution was attempting 'to build a new generation of socialists that will identify itself with the plight of the underdeveloped world in general, and which will commit itself to a long and arduous revolutionary struggle as the only means of freeing the underdeveloped world from its present dependency upon the developed world'.[73] By the time of the 1971 congress, the full formation of man - through the development of all the capacities which society is able to promote in him - was being hailed as imperative, with education being advocated through participation in all manifestations of art and literature. And, at the first PCC congress in 1975, it was categorically stated that 'Cultural level profoundly influences man, helping to determine conduct and having repercussions in forms of speech and customs. A high cultural level is absolutely necessary for our youth, especially in creating an unblemished love of our socialist cause'.[74] In this way, it was maintained that culture 'would prepare the ideological terrain for the transformation of society'.[75]

Just as changing consciousness was thought to pave the way to revolutionary society, the full development of human subjectivity was perceived to be an urgent task in and of itself. In an era in which basic needs could be met, and in strict contradistinction to societies in which production for profit and consumption for consumption's sake predominated, this presumed the rediscovery of the human imagination and 'the full expansion of what is specifically human in man, his aptitude for creation'.[76] Mayra Espina Prieto argues that socialism 'should be seen as an emancipatory process, as a change and reconstruction of economic, political, social, and cultural relations with the intention of eliminating alienation by means of social inclusion and decentralisation of power'.[77] In this, she attributes to culture a role in satisfying some of humankind's basic needs and creating values that distinguish worker from consumer, citizen from client, real person from instrumental one.

We have already seen that the socialist declaration of 1961 caused Fidel to be explicit about the need to improve people's lives not only in the material sense but also in their spiritual aspect. He would later elaborate that 'The

Revolution is not made for the sake of revolution itself; it is made in order to create the best conditions for the development of the material and spiritual activities of the human being. That is, revolutions are only made with the postulate of creating a happier man'.[78] In his closing speech to the 1961 congress, Fidel affirmed that, like any other workers, artists and writers would have to create wealth, which, in their case, would be measured in terms of the infinite happiness their work produced.

In considering the instrumental nature of this task, Fidel would elaborate, with ample historical justification:

> I don't think there has ever existed a society in which all the manifestations of culture have not been at the service of some cause or concept. Our duty is to see that the whole is at the service of the kind of man we wish to create. [...] I believe that the content of any artistic work of any kind – *its very quality for its own sake, without its necessarily having to carry a message* – can give rise to a beneficial and noble feeling in the human being.[79]

These combined statements perfectly illustrate the Marxist-humanist attitude to culture. Central to this is the idea that the Revolution would bring about positive changes in the evolution of humanity, and that contact with culture would help pave the way for this transformation. In emphasising the inherent properties of artworks, Fidel successfully exempted them from the didactic aims being enforced in orthodox circles (to be discussed in more detail below). At the same time, he veered close to a Kantian (and, hence, idealistic) understanding of the enjoyment of artistic engagement and the contribution this experience could make to physical and mental wellbeing. Yet, while the pleasure principle underlying aesthetic encounters was closely linked to individualistic experience under bourgeois regimes, the enjoyment of art in Cuba was made available to all as part of the collective project of creating a happier individual and social consciousness.

An untitled pamphlet, issued by the CTC in 1984, develops the category of work to include not only active participation in material production but also the involvement of workers in the construction of a new society, enhancing the spiritual development of the people through the full expression of their artistic and literary capabilities. The extent to which retrospective transformation was, and is, possible remains a moot point. What seems indisputable is that, during the period under consideration, the creation of new social relations, through the combined agency of Cuban men and women engaged in culture, remained uppermost in the minds of the revolutionary leaders and the country's intellectuals.

By the end of the 1970s, it was agreed that 'Only in a society free of exploitation, whose fundamental objectives are to satisfy the ever-growing

material and spiritual needs of the human being and to develop a new form of social relations, can culture attain its finest flowering and raise human life itself to aesthetic levels'.[80] In examining the relationship between emancipation and the elevation of human life to aesthetic levels, it was further argued that:

> The future of Cuban culture is determined not merely by advances in specifically cultural fields but also by the parallel economic and social development and the building of a socialist society. The march towards communism is in itself a movement towards the reign of culture, towards the conversion of every aspect of human life into an aesthetic experience. The premises of this evolution are: (a) the elimination of the class struggle and an all-round approach to education and culture thanks to which all human beings can become recipients and creators of art; (b) the dissemination of general education and artistic education; (c) the constant growth of artistic output and aesthetic needs; and (d) the emergence of aesthetic behaviour as a higher form of relationship between man and nature, between the individual and society.[81]

We have already seen how the backdrop to this discussion was the wholesale rethinking of economic and social structures, within which culture was harnessed to the elimination of class struggle. While the implications of an all-round approach to education and culture will be dealt with more thoroughly in chapter five, let us turn now to a consideration of the ways in which aesthetic experience and behaviour has been understood in Cuba and beyond.

The Revolution and Aesthetics

Prior to the Cuban Revolution, one of the most fruitful periods of aesthetic experimentation in film, poetry, music, theatre and art had been witnessed in the Soviet Union either side of the 1917 revolutions. In 1969, John Berger noted the evolution of a 'movement in the Russian visual arts which, for its creativity, confidence, engagement in life and synthesizing power, has so far remained unique in the history of modern art'.[82] This produced a burst of experimentation from Malevich to Lissitsky and an affirmation of the social role of artists from Kandinsky to Tatlin.

Well into the 1920s, 'artists served the State on their own initiative in a context of maximum freedom'.[83] As the 1930s loomed, persistent inequalities in the Soviet project and the ravages of unrelenting industrialisation, compounded by a lack of artistic unity, permitted reaction to set in. In 1932, all artistic organisations were dissolved and an organising committee set up in advance of a National Congress of Soviet Writers, scheduled to run for two weeks from 17 August 1934. In May of that year, in his role as secretary of the Central Committee, Zhdanov was appointed to chair the organising committee.

At the eventual congress, Zhdanov would make the opening speech (heavily edited by Stalin), and, while the enormous attention he received around this event meant that 'In the mind of the Soviet public and of foreign observers, he remained associated ever after with culture',[84] his biographer reminds us that this connection is often overstated. Nonetheless, Zhdanov used his speech to consecrate 'socialism realism', a term coined by Gorky to distinguish it from the critical realism he had discerned within bourgeois literature. In the process of engineering souls, the method of socialist realism presupposed, for Zhdanov, the rejection of reactionary Romanticism and the embrace of revolutionary romanticism, firmly rooted in real-life materialism, depicting heroes and offering glimpses of the future by harnessing the full range of 'genres, styles, forms and methods of literary creation'.[85]

A decade earlier, Trotsky had expressed support for realistic art in its widest definition; he had also written that, 'as far as the political use of art is concerned, [...] the actual development of art, and its struggle for new forms, are not part of the party's tasks, nor is it its concern'.[86] By contrast, advocacy of socialist realism:

> [...] heralded an attack on most literary experiments and the suppression of any genuine creativity and inspiration. A typical Socialist Realist work depicts supposedly true-to-life protagonists in wooden language, positive people's heroes inspired and guided by the Communist party, who always triumph over reactionary or counterrevolutionary opponents and class enemies. [...] Its didactic aim is to raise the masses to enlightenment and civilization, selfless sacrifice, and loyalty to the party and state.[87]

Initially confined to literature, Stalin would later extrapolate the thinking behind socialist realism to become 'obsessed with all forms of art by the mid-1930s. [He] saw "formalism," which was how most surviving experimentation – from symbolism to cubism to futurism – in the plastic arts, literature, or theatre was now labelled, could be construed as criticism of his rigorously ordered socialist society'.[88]

Following the 1934 congress, '180 of the total of 597 delegates were persecuted in the Great Terror, including one-third of the Union bosses elected at the Congress'.[89] Zhdanov would manipulate the blood purges of 1937–8 to his own advantage to become head of the agitation and propaganda (agitprop) section, dipping out of cultural administration until he became a film censor in August 1940. Thereupon, he chastised those perceived to be indulging in formal experimentation or critique of the Soviet model, and enforced the faithful adherence of artists from all disciplines to socialist realism (which was never precisely defined) – a campaign that became more ferocious after 1945. It was not until the Third Congress of Soviet Writers in 1959 that subordination to socialist realism began to unravel.

A 1959 text by Berger, written in defence of persecuted Russian artists – which led him to be treated with suspicion when he visited Moscow – shows that this impasse was far from over by the time the Cuban Revolution triumphed.[90] Cubans were as aware of this history as they were of the artistic and literary productions being circulated by the USSR outside its own territory, and Pogolotti reflects broader understanding when she describes how the dawn of the October Revolution had coincided with the expansion of thought in Russia, giving rise to new manifestations in visual art, poetry, architecture and cinema and leading to a revolutionary convergence of art and politics.[91] Similarly, Cubans largely agreed that, after this initial blossoming, the dramatic circumstances of the economy of war caused the experimental adventure of art to be cancelled in favour of propagandistic immediacy.

Within the European Marxist camp, developments in the Soviet Union generated a prolonged debate around the relationship between aesthetics and socialism. This began in the 1930s, centred on the non-realistic tendency united under the banner of German Expressionism, and endured well into the 1960s. The Hungarian aesthetician György Lukács followed the Zhdanovian line to dismiss the subjectivism and faux criticality of abstract works and advocate socialist realism in its narrowest definition. In 1965, a Cultural Theory Panel overseen by the Central Committee of the Hungarian Socialist Workers' Party would dismiss their countryman for providing theoretical support to revisionists and dogmatists alike, thus blocking the way to the healthy development of aesthetic theory.[92]

In the meantime, two lines of attack were mounted against orthodox interpretations of aesthetic theory, the first of which attempted a defence of abstraction. In 1934, the German philosopher Ernst Bloch found the merit of such artwork to lie in the fact that it flouted academic conventions to direct 'attention to human beings and their substances, in their quest for the most authentic expression possible'.[93] In the UK, this discussion was taken up by Herbert Read, who proclaimed abstract artists of every persuasion 'the true revolutionary artists, whom every Communist should learn to respect and encourage'.[94] In Latin America during the same period, Aníbal Ponce considered such a retreat into art for art's sake to be self-isolating in its attempt to deny the artist's socio-historical context. But, while acknowledging Communist Party understanding that, in order to create an artistic literature destined for the masses, it would be necessary to break with the aristocratic condition, he resisted any attempt to define an aesthetic trope appropriate to revolutionary situations.[95]

The second line of argument against socialist realism was centred on a consideration of the broader possibilities opened up by adopting realism as a method. Berger's 1959 treatise in support of Soviet artists persecuted under the banner of 'formalism' would make a crucial distinction between realism

and naturalism. The former tendency, Berger argued, had the capacity to embrace the innovations of the modernist era, notably acknowledgement of the subjective nature of art, which could pave the way for a genuinely materialist art by revealing layers of truth that were blocked within capitalist societies. By contrast, the latter tendency – which Berger termed 'socialist naturalism' – required artists to stage, 'according to the demands of purely theoretical dogma, an artificial or hypothetical event; then paint it with maximum naturalism, so that it appears to have been taken from life. Thus naturalism becomes a kind of alibi for the unnatural and the false'.[96] Added to this, Berger argued that there was no evidence that naturalism was accessible to, or embraced by, the masses or effective as an educative tool. Despite the support of Stalin's apparatchiks for 'artists in smocks working in their studios on propaganda oil paintings which were put into gilt frames so as to be recognized as *objets d'art* and then dispatched to a semi-literate peasantry',[97] popular taste remained fixated on nineteenth-century precedents. And, while improved access to art – through exhibitions, publications, changes to the curriculum and the establishment of amateur painting groups – meant that the Soviet people became aware of the part that art could play in their lives, it remained 'defined in the popular mind as a social privilege',[98] alienating the people from the process of art and foreclosing the possibility of creative self-consciousness. As will already be obvious, this provides an antithesis to the Marxist-humanist approaches pioneered in Cuba.

At the same time, other attempts were made to address Lukács's oversight, by reconsidering the relationship between objective reality and the subjective position of the artist. In 1963, Roger Garaudy, a French philosopher and member of the Central Committee of the French Communist Party, published his *D'un Réalisme sans Rivages* [For a Borderless Realism]. This sought to formulate a humanistic variant of socialist realism, based on socialist partisanship instead of party dominance. In the Soviet Union and its satellites, it was greeted as an unacceptable example of Western revisionism and led to his dismissal from the party. During an interview in Budapest in 1967, Garaudy would clarify that his understanding of realism was not centred on the extent to which artworks offered a precise reflection of objective reality. Rather, 'The criterion of realism is whether the work reflects adequately the relationship of man to reality'.[99] This conceived art as an exercise in both perception and transformation (of the world and its inhabitants), which could be applied to all creative manifestations. In 1964, Garaudy's thoughts were translated into Castilian by a member of the Communist Party of Argentina and would prove particularly useful to those pursuing alternatives to aesthetic orthodoxy in Cuba.

Ernst Fischer – whose influence on Che Guevara has already been mentioned – also refuted the misapplication of the term 'socialist realism' to

propagandistic idealisations and the rigid equation of aesthetic value with naturalism. Moreover, he rejected the idea that any aesthetic theory could be applied in advance of artworks being made. As an antidote, he proffered the term 'socialist art', which 'clearly refers to an attitude – not a style – and emphasizes the socialist outlook, not the realist method'.[100] Fischer envisaged that this umbrella term could be applied to all those artists and writers 'adopting the historical viewpoint of the working class, and accepting socialist society, with all its contradictory developments, as a matter of principle'.[101] This, he argued, would allow creative intellectuals to anticipate the future without being blinded by it, while assisting in the transition to socialism without losing their critical edge. In the relationship between an artwork and its viewer, Fischer's 1959 thesis permitted an 'element of entertainment and satisfaction which consists precisely in the fact that the onlooker does *not* identify himself with what is represented but *gains distance* from it, overcomes the direct power of reality through its deliberate representation, and finds, in art, that happy freedom of which the burdens of everyday life deprive him'.[102] This implied that the 'tension and dialectical contradiction' between reality and its representation was harnessed by artists through a 'highly conscious, rational process at the end of which the work emerges as mastered reality – not at all a state of intoxicated inspiration'.[103] To this end, it was imagined that art would provide enlightenment for, and stimulate the actions of, 'a class destined to change the world'.[104]

The aforementioned Hungarian panel would dismiss both Garaudy and Fischer as revisionists who extended 'the concept of realism to the point where it deprives the category as such of any aesthetic meaning, and makes the struggle against bourgeois decadence theoretically impossible'.[105] While maintaining the orthodox view of art as a medium for expressing the victory of socialism under the direction of the party – rather than as a means of expression in itself – the panel nonetheless conceded that socialist realism was not always inimical to humanism, in the sense that art could represent the desires and efforts of the masses. Perhaps the most appropriate riposte to the Marxist-realist debate is that of Morawski, who notes that 'The word "realism" does not appear in any text by Marx';[106] rather, it was Engels who popularised the idea that art in general – and realism in particular – had a part to play in the construction of socialism, while remaining clear that art should not be judged solely by its effectiveness in this matter. As we have seen, both Marx and Engels exempted art and literature from being explicitly ideological and dissociated the ideology of an artwork from that of its producer.

Another European approach to aesthetics was centred on the cognitive nature of art. In the 1930s, Bertolt Brecht conceived of aesthetics as a distinct form of knowledge about the world that could lead to transformation of the latter, which coincides with the Enlightenment hope that increased insight

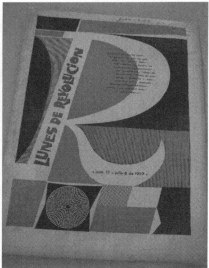

Covers of *Lunes de Revolución*.

would bring about positive change. Three decades later, Marcuse would posit art as a cognitive faculty with a truth of its own, to argue that 'the aesthetic dimension is a potential dimension of reality and not only of art as contrasted with reality'.[107] While upholding the segregation of art from material production, Marcuse nonetheless advocated art (aligned with science) as a technique for building, or guiding, society, in a way that is reminiscent of the Cuban process. At the same time, he acknowledged the capacity of art to provide gratification, which could contribute to either the sublimation of reality's horrors or the negation of that sublimation, asserting itself in the humanistic aim of the negation of the negation.

The fraught question of aesthetics is no less complicated in Cuba. Just as had happened in Europe during the inter-war years, two distinct camps formed, according to whether they believed in an art for art's sake or a more committed form of artistic activity. In the first camp, 'united in the belief that the 1933 revolution had been betrayed, the generation that reached maturity in the early 1930s rejected politics in favour of a retreat into aestheticism'.[108] By contrast, the more politically oriented National Group of Art Action was born into the political vacuum that predated the formation of revolutionary parties on the continent; 'their political position was somewhere between "proto-communist" and indeterminately radical, meaning an intellectual rejection of Positivism, a cultural embrace of the European avant-garde, and the popularisation of all art, seeing itself as the [...] "crucible of the Cuban avant-garde"'.[109] At the same time, a group that assembled around the avant-garde journal *Revista de Avance* – including Alejo Carpentier and Juan Marinello – would go on to play a part in the insurrection.

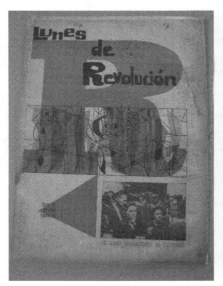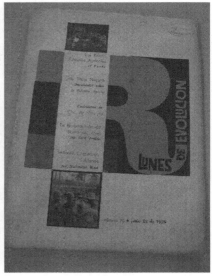

By the time of Batista's second presidency, a kind of 'cosmopolitan formalism' prevailed, and the dialectic between formal experimentation and political commitment persisted. During the insurrectionary years of the 1950s, there was a significant indigenous contingent of abstract expressionist painters, centred on a group called Los Once [The Eleven] which had been closely associated with the anti-biennial discussed in the previous chapter. In the immediate post-revolutionary period, those Cuban artists actively participating in a reform of the aesthetic vocabulary were encouraged in the hope that it would be possible to correct the historical error of Marxist-Leninist vanguards, which, in rejecting modern art, had reinforced the segregation between artistic and political vanguards. This end of the rhetorical spectrum was provided by *Lunes* [Monday], a cultural supplement published at the start of every week (and on occasional days in between) by the 26 July Movement newspaper, *Revolución*.

Lunes de Revolución was conceived by Carlos Franqui, a self-educated film aficionado from a peasant family who founded the periodicals *Mella* [named after the founder of the PCC, Julio Antonio Mella McPartland] and *Nueva Generación* [New Generation] in the 1940s. Joining the nascent insurrection in 1954, he formed part of the 26 July Movement's National Committee the following year, seeking exile in Costa Rica in 1956 before returning the year after that. Heading for the Sierra Maestra, he assumed responsibility for running *Revolución* and the broadcasting service, Radio Rebelde – the two main vehicles through which the guerrillas were able to communicate with the Cuban people. Following his late-1960s exile, Franqui would reminisce about how, in response to Fidel's perceived disinterest in culture, he had

appointed himself a 'cultural guerrilla fighter',[110] using *Lunes* as his main weapon. A total of 131 issues were produced between 23 March 1959 and 6 November 1961, during which time the periodical quadrupled in size from an initial twelve pages and increased its distribution from 100,000 to 250,000 copies, making it the most-read supplement in Latin America. Edited by two writers – Guillermo Cabrera Infante (who has already been mentioned in connection with Nuestro Tiempo and UNEAC and devised the name for the supplement) and Pablo Armando Fernández – *Lunes* brought together a disparate group – including José Baragaño, Edmundo Desnoes, Nicolás Guillén, José Lezama Lima, Lisandro Otero, Heberto Padilla, Virgilio Piñera and Roberto Fernández Retamar – which would otherwise have been riven by internal conflict. Memorably designed by four different artistic directors, including Raúl Martínez, the cultural supplement wore its aesthetic credentials on its sleeve as it aligned itself with the Revolution and perpetuated a modernist rupture with the past. Having fostered connections with the heirs of the European avant-garde, the editors of *Lunes* advocated maximum expressive freedom in an apparent attempt to bring the best universal art to the people of Cuba:

> Our thesis was that we had to break down the barriers that separated elite culture from mass culture. We wanted to bring the highest quality of culture to hundreds of thousands of readers. We were motivated by a motto we got directly from Jose Marti: 'Culture brings freedom.' So we published huge editions with pictures and texts by Marx, Borges, Sartre, Neruda, Faulkner, Lezama Lima, Martí, Breton, Picasso, Miró, Virginia Woolf, Trotsky, Bernanos, and Brecht. We also published protest issues on cultural colonialism in Puerto Rico, Latin America, and Asia.[111]

In a retrospective analysis of *Lunes*, Ariel González probes the seemingly irreconcilable predicament of advocating both intellectual commitment and absolute creative freedom. For him, this approach implied belonging to a professional group of partial subjects, acting as the spokespeople of humanist and universal conscience, in which the doctrine of 'commitment' – to use Sartre's term – secured for intellectuals their participation in politics without abandoning their own field. While notions of commitment contained the potential to resolve the Marxist paradox of art in its semi-autonomous position (by bringing creative practice close to the political, social and economic elements of society), González argues that contemporaneous realities required a political response. By contrast, he concludes that the abiding approach of *Lunes* was an ideo-aesthetic one which couched moral responses in politicised language, emphasising the freedom of intellectuals and leaving commitment to be determined by their individual consciences.[112] It is easy to understand how this position would find itself at odds with a revolutionary process in which cultural producers were being urged to play an active part in the generation

of autochthonous works which demonstrated a thoroughgoing understanding of the process of societal change. In a message of support to the first anniversary edition of *Lunes*, Fidel positioned the people of Cuba as the missing link between the Revolution and culture, and Che Guevara discerned an intellectualism in the supplement which, at times, placed it beyond Cuban reality. In the next chapter, the full consequences of this position will be explored.

As we have seen, when the 26 July Movement merged with the PSP and the Revolutionary Directorate to form the ORI in July 1961, party leaders were entrusted with vital roles and the cultural field was no exception, quickly becoming a battleground on which internecine struggles would be played out. Retamar describes how, in the first half of the 1960s, socialism was often perceived as having frozen into a monolith which inhibited politics, pluralism and thought, turning Marxism from an orthodoxy without windows into a heterodoxy without sense.[113] In the process of its reinvention in Cuba, socialism would need adequate aesthetics and corresponding ethics. 'However, for numerous writers and artists of the left, not only in Cuba but all over the world, a phantom was abreast: that of a monstrous deformation incarnate in socialist realism, which caused incalculable damage in countries called socialist'.[114] Claudia Gilman asserts that the majority of Cuban artists, taking part in a totally unprecedented revolutionary process, were especially sensitive to the trauma of Stalinism and were the most insistent in repudiating official Soviet art; with every medium at their disposal, they proclaimed the necessity of revising the Marxist theory of aesthetics, condemning the anti-dialectical approach of official Marxist aesthetics, specifically that of Zdhanovism.[115]

At the 1934 Soviet Writers' Congress, Zhdanov had embraced tendentiousness as the ostensible opposite of apolitical literature in the face of class struggle. At the 1961 First National Congress of Writers and Artists (which forms the closest Cuban parallel to the Soviet congress, given that the creation of a union of writers and artists was its stated aim), Guillén, found that 'everything [...] which constitutes life in these dramatic days, and which belongs to our struggle for liberty, must be experienced by us and expressed in print, stone, music, color'.[116] But, he cautioned, this must be done without subscribing to the didacticism or tendentiousness of socialist realism, which he described as 'those aggressive paintings and sculptures in which men with unpleasant faces appear with their fists raised, their lips tightly drawn, their eyes fiery, presumably due to their anger, even when the eyes are made of stone'.[117]

Condemnation of socialist realism by Cuban artists and writers is consistent throughout the decades, primarily on account of its unrealistic heroes, simplistic Manichaeism and absence of critique. Moreover, David Craven encapsulates the understanding of many Cuban intellectuals in his observation that 'The privileging of a Eurocentric style such as "socialist realism"

would ultimately lead to another form of cultural domination'.[118] Despite these protestations, Rolando Bonachea and Nelson Valdés locate 1961-2 as the period during which 'the regime tried to impose socialist realism'.[119] While these attempts persisted well into the mid-1960s, to re-emerge in full force at the end of the decade, they were not at the instigation of the regime per se. Fornet argues that the CNC managed to convince young writers that 'socialist realism was the aesthetic of the Revolution, an aesthetic that dare not speak its name, among other things because it was never officially adopted in any instance by the Party or the government'.[120]

In 1961, Edith García Buchaca's *Theory of the Superstructure* unequivocally rejected idealistic interpretations – found lurking in aesthetic theory from Plato to Hegel via Kant – which permitted art to be evaluated on the basis of a subjective response to its formal properties. Invoking the age-old polemic between those who believed that art should not have a social function and those who maintained that it could contribute to the betterment of humanity, García Buchaca exclusively harnessed art to the project of transforming social reality, accelerating the disintegration of the capitalist world and easing the transition to socialism. Invoking Mao, she urged political criteria to displace aesthetic ones, arguing that artists who destroyed the values of previous society without understanding them politically could only ever reflect on internal life, reinforcing individualism and blocking true understanding of social life. In turn, those dissociating the form of artistic production from its content, proclaiming autonomy and advocating abstraction would confine art to the domain of 'pure' intelligentsia. This kind of minority art, she argued, aligned itself with depravity, 'preoccupied with describing the reactions and psychological abnormalities of drug addicts, homosexuals, prostitutes and the mentally ill'.[121] In much the same way, the following year, the Soviet President, Nikita Khrushchev, would violently dismiss abstract art during a visit to an exhibition, wondering loudly whether the artists were paedophiles.

Alfredo Guevara has detailed a meeting with García Buchaca in May 1963, which provides evidence of the attitude infecting the CNC. She reportedly spoke to him about a recent trip to Santiago de Cuba, during which she had seen an exhibition by two abstract painters, claiming that opinions given in the comments book were very unfavourable. Many agreed, she said, that state money should not be spent on a type of art that did not express the Revolution.[122] At the time, Guevara dismissed this ethos as the 'Marxism of fear', asserting that 'What we are is Marxists, and for that reason we don't accept dogmatic distortions [...] that static, copyist, routine Marxism which desperately seeks formulae to synthesise solutions that should be applied to the most tormenting problems'.[123]

In chapter five, we shall see that, in 1963-4, a significant debate was generated between film-makers and functionaries around the merits of certain

artistic forms and the extent to which aesthetic production was thought capable of shaping society. This came at a time when an exact reproduction of reality (mimesis) was expected of artists by senior CNC personnel, and Fornet argues that, although the Aristotelian conception of 'Mimesis can be a good defensive tactic [...] it was lamentable that it was adopted as a trope at the moments in which the Revolution initiated the greatest process of cultural decolonisation remembered in the history of Cuba'.[124] Expectations that political messages would transmit itself themselves the minimum of ambiguity found their way into creative output in Cuba, with 'educative' art forms such as political novels and literature for children and adolescents being prioritised and aesthetic criteria being imposed. Culture was harnessed to the project of moral education, which has been claimed as one of its social roles since Aristotle first explored the cathartic function of tragedy.[125] Considering the didactic function of art at a critics' forum, held in the national library in 1962, Fornet would appeal to Gramsci's invocation of Croce on the limited educative potential of art to conclude that, 'In the first instance, that which art *teaches* us is to sharpen the senses; that which art *educates* is our sensibility' – in other words, art shows us how to think, rather than telling us what to think.[126]

As had happened in the Soviet Union, formal experimentation was demonised, which diminished the possibility for risk-taking, delimited the potential for creative participation and critical thinking and gave free rein to 'prolific mediocrity'.[127] But scepticism towards aesthetic experimentation was not confined to the CNC *sarampionados*, and even Marinello – the trusted old communist associated with Nuestro Tiempo, whose conversations with abstract artists had been circulated clandestinely under Batista and re-edited for revolutionary times – retained reservations about abstraction.[128] Similarly, Roberto Fandiño – a Cuban film-maker, theatre director and scenographer who died in Miami in 2009 – attempted to establish links between non-figurative expression and the cultural policy of the overthrown regime in an article in one of the final issues of *Nuestro Tiempo* that would be rapidly counteracted.[129] Nonetheless, prominent exhibitions of abstract art were mounted throughout the 1960s – including Los Once's 'Abstract Expressionism' and re-stagings of the Paris Salon (by José Llanusa Gobel, Alfredo Guevara and Carlos Franqui) – and were met with acclaim. At the same time, the revolutionary government upheld the right to aesthetic experimentation; aptly conveying the mood of the times, Craven reminds us that, 'In the early 1960s, when Eastern Bloc leaders were continuing to denounce modernist art, Fidel Castro declared instead: "Our enemies are capitalists and imperialists, not abstract art."'.[30]

From 1962, *Casa de las Américas* stimulated a discussion of aesthetic questions in professional circles, based on the new lectures of Adolfo Sánchez Vásquez. He argued that 'Everything in our times that does not fit into a

narrow rubric of realism – futurism, cubism, expressionism, surrealism, etc. – is here lumped under the rubric of formalism. This sectarian and dogmatic position is indefensible, for it narrows the sphere of art, ignoring its specific nature in order to apply exclusively ideological criteria to it'.[131] Exploring the main tenets that had historically underwritten considerations of aesthetics – art, society, class, ideology, form, content, autonomy, beauty, reality and reflection – Sánchez Vásquez reasserted that the simple equation of art with ideology had been proscribed by Marx and Engels. Instead, he proposed that a humanistic understanding of Marxism would inevitably encompass aesthetics:

> [This] requires an understanding of Marxism as a philosophy of praxis; more precisely of a praxis which aims to transform human reality radically (on a concrete historical level, to transform capitalist society) so as to establish a society in which humanity can give free rein to its essential powers, frustrated, denied, postponed, and emasculated for so long. This understanding of Marxism as the true humanism, as the radical transformation of humanity on all planes, fulfills Marx's aspiration. Aesthetics cannot be alien to this humanist Marxism, since [...] it is an essential dimension of human existence.[132]

In Argentina in 1965, Luis Felipe Noé postulated a theory of anti-aesthetics which presumed art to be in an intimate relationship with its surrounding reality, not in the sense of reflecting existing reality but projecting what it might become; in the process, he argued, art must refute any laws that sought to constrain it and maintain a condition of absolute freedom. In much the same way, Sánchez Vásquez posited art as a cognitive form distinct from both scientific knowledge and the mechanical reproduction of existing reality – one which creates a new reality and, in doing so, provides insights into the human condition. While this approach might be considered realist, he argued, it should not become distorted to make representation an end in itself. In the process, he dismissed the elevation of relative to absolute truths, reinforcing an anti-dogmatic approach.

Despite the articulate arguments mounted against socialist realism, ideas from the 1934 Soviet congress persisted in orthodox circles, including Stalin's conception of writers as 'engineers of the human soul'. By the CNC and its outposts, it was deemed that 'Literature and art do not limit themselves to reflecting the life of the people but model the human soul',[133] thus consolidating the cultural field as a nexus for action. It would take Che Guevara to resolve the debate. Having asserted in 1961 that 'Every revolution, like it or not, inevitably has its share of Stalinism, simply because every revolution faces capitalist encirclement', while concluding that 'conditions for Stalinist developments do not exist in Cuba; that phenomenon simply cannot

be repeated here',[134] Che railed against the rigid prescriptions of Soviet-style socialist realism which sought:

> [...] an art that would be understood by everyone, the kind of 'art' that functionaries understand. True artistic values were disregarded, and the problem of general culture was reduced to taking some things from the socialist present and some from the dead (and, hence, not dangerous) past. Thus, socialist realism arose upon the foundations of the past century. But the realistic art of the nineteenth century is also a class art, more purely capitalist than this decadent art of the twentieth century which reveals the anguish of alienated people. Why, then, try to find the only valid prescription for art in the frozen forms of socialist realism? [...] Let us not attempt, from the pontifical throne of realism-at-all-cost, to condemn all the art forms that have evolved since the first half of the nineteenth century for we would then fall into the Proudhonian mistake of returning to the past, of putting a straitjacket on the artistic expression of the person who is being born and who is in the process of making himself.[135]

Inevitably, the defenders of creative freedom took these words – definitively decoupling Cuban artists and writers from the errors of socialist realism and its nineteenth-century antecedents – to be of extraordinary importance. This attitude was embraced to great effect, perhaps most spectacularly by the Danish Situationist Asger Jorn, who took time away from the ruminations of the 1968 Cultural Congress of Havana to adorn the walls of the Office of Historical Affairs of the Council of State (a requisitioned bank) with abstract murals, at the instigation of Fidel's closest confidante, Celia Sánchez Manduley.

The following year, the *Casa* collaborative committee reminded their readers that the revolutionary leadership demarcated an ideological line, rather than an aesthetic one. At the threshold to the grey years, Fidel would continue to link aesthetics to the emancipatory and humanistic aims of the Revolution, to state that 'There can be no aesthetic value without human content. There can be no aesthetic value opposed to man. There can be no aesthetic value opposed to justice, opposed to well being, opposed to freedom, opposed to man's happiness'.[136] Beyond this, no prescriptions were made about the forms that were to be used to convey such an ethos. By the time of the 1975 PCC Congress, which signalled the beginning of the end of the grey years, aesthetics were harnessed to the task of representing reality, but through lateral expressions of life rather than absolute mimesis.

Consistent with this hands-off attitude to artistic form, a non-dogmatic, committed approach has been favoured at ENA and ISA, where courses were initially content-oriented, within a Marxist-Leninist framework. As a testament to the primacy of content, aesthetics did not become a separate discipline

within professional art education until 1987 and, rather than attempting an exhaustive history of Marxist aesthetics, teaching remained eclectic. Despite the presence of various Soviet advisers in the schools, especially between 1976 and 1980, Camnitzer asserts that 'Cuban art remained relatively open, even during the most doctrinaire periods and in those times when the West felt that Cuba had a Soviet dependent culture. While some limits were set during the late 1960s and early 1970s [...] these restrictions were not based on a rigid aesthetic credo'.[137] Yet, while aesthetic *prescription* was largely resisted at a professional level, aesthetic *training* has been considered 'an indispensable part of the formation of the personality',[138] featuring on the curriculum from primary school onwards, with a fifth 'aesthetic' year being added to the studies of future teachers.

Although socialist realism never managed to achieve a foothold as an aesthetic trope in Cuba, concerns about its imposition did not disappear completely, and Retamar notes that:

> Dogmatism would predominate one moment and recede, defeated, the next, but it was an evil that lay in wait for the Revolution, supported by comfort and ignorance, because it dispensed with the need to think and furnished apparently easy solutions to intricate problems. Anti-dogmatism, for its part, justified its vigilant presence by the measure to which dogmatism was a threat; but its sympathetic mask could cover for those who prefer to say that they are combating dogmatism who cannot openly say that they are combating the Revolution.[139]

With the benefit of four decades of hindsight, Fornet realises that the 1960s witnessed a blurring of the line between art, pedagogy, propaganda and publicity. More specifically, 'aesthetic disputes formed part of the struggle for cultural power, for the control of certain zones of influence'.[140] Through ignorance, bad faith or cowardice, combined with a lack of true revolutionary spirit, the opposing camps of dogmatism and liberalism succeeded in freezing intellectual debate, and Fornet indicts everyone as culpable. For him, it is deeply regrettable that culture 'had become a battlefield, a symbolic space, in which all types of discrepancies were aired by distinct groups disputing the hegemony'.[141] But, he explains, it was somewhat inevitable that defenders of creative freedom would find themselves in a difficult position, given that revolutionary culture was forged in a climate of violent confrontation, in spaces fortified against the constant threat of terrorism, in which it was not possible to engage in the noble exercise of ideological coexistence.

Freedom of Expression

David Harvey has observed that the founders of neoliberalism wisely chose freedom as one of their central tenets, enabling them to argue that

individualism should be preserved at all cost and any form of collective action or state intervention repelled.[142] In doing so, they tapped into a persistent mode of thought, and, early in its existence, the CPC noted furious attempts by Lenin's detractors to 'demonstrate that those who serve the interests of a particular class and conscientiously maintain particular political lines are incapable of free artistic expression'.[143] In turn, this echoed Gramsci's observation that 'among the so-called intellectuals runs the widely held prejudice that the workers' movement and communism are enemies of beauty and art, and that the friend to art in favour of creation and the disinterested contemplation of beauty is supposedly the present regime of merchants, greedy for wealth and exploitation, who perform their essential activity by barbarously destroying life and beauty'.[144] In a political climate which saw Cuban artists implicated in the building of socialism against the turbulent backdrop outlined above, it was inevitable that freedom of artistic content would be called into question, not only by those operating within Cuba.

In an afterword to his mediated monologue, Mills confessed that his greatest fear for Cuba lay in her cultural development, which he took to include not only art and literature but also education and the mass media. For him, a lack of personnel possessing knowledge of, and a sensibility for, culture ran the risk of combining with the 'menace of counterrevolution and with the fact of a generally uneducated population [which] *could* lead to the easy way out: the absolute control of all means of expression and the laying down of a Line to be followed'.[145] He had found such uncertainties to be palpable at the heart of the Revolution, with the worry being expressed that, if art 'might hurt the revolution [...] maybe we just have to limit artistic expression'.[146] A decade later, Cuban émigrée Lourdes Casal would declare that 'it is obvious that "freedom of expression" does not exist in Cuba', before conceding that 'it is also obvious that, given the scope and variety of the works that have been produced, there has been considerable leeway given to literary words during the first ten years of the Revolution'.[147] In much the same way, between undertaking an undergraduate degree at Harvard and a postgraduate at Yale, Georgina Dopico Black would emphasise that 'outright limitations of intellectual freedom have existed to some degree in Cuba since the earliest days of the Revolution (and, indeed, well before then)',[148] while being compelled to admit that:

> [...] it was not until the institutionalization period of the early seventies that repressive acts were more consistently, if less frequently, applied. The artistic policy that has operated since these years has made it exceedingly clear that certain themes and ideas could not and would not be tolerated by the regime. Official declarations have broadly defined what these themes are. Whereas there have been significant variations over

time in the extent to which this policy has been exercised, the official criteria for what is inadmissible have nonetheless remained relatively stable.[149]

Nowhere does Dopico Black specify what these criteria were or in which official declarations they appeared, and she hesitates to admit that restrictions eased after 1976 and certainly into the late 1980s when her text was written. It is equally unclear to which institutionalisation process she is referring as the relevant cultural institutions had been established in the late 1950s and early 1960s. Her words are clearly at odds with broader governmental rhetoric, which, as we shall continue to see, explicitly avoided prescribing official themes.

While the previous section referred to the freedom of formal experimentation, this section considers freedom of content. Within the Revolution, the influential figures (cultural and otherwise) to whom Mills spoke quickly realised that art could capture the 'human tragedy and glory of the revolution, and the essential humanity of our struggle'.[150] This prompted them to ask, 'Why should not art, through its many different forms of expression, gather all that up for the present and for the future generations? [...] Must not art pay a tribute to the revolution?' In which case, 'we ask ourselves too, must not the revolution, especially our Cuban revolution, pay a tribute to art? [...] We want an absolutely free manifestation of the human spirit. This is our goal. We want a great and absolutely free intelligentsia'.[151] In considering the practicalities of how this might be achieved in the face of internal and external enemies, it was realised that 'it is difficult to see the conditions for an absolutely free culture [...] The less the revolution feels menaced, the more chemically pure will be the liberty of expression in Cuba. When we no longer feel that we must fight to exist, [...] we will be able to think about the freedom of culture and expression'.[152] In this way, a fragile equilibrium was established between the freedom of creative expression and the security of the Revolution which would echo down the years.

Fidel would consistently reinforce the creative freedom that existed within the Revolution while acknowledging the responsibility borne by the producers of revolutionary culture. In the mid-1960s, he foresaw a day when there would be no limitation on the publication of universal literature:

Why? Because I believe in the free man, I believe in the well-educated man, I believe in the man able to think, in the man who acts always out of conviction, without fear of any kind. And I believe that ideas must be able to defend themselves. I am opposed to the blacklists of books, prohibited films and all such things. What is my personal ideal of the kind of people that we wish to have in the future? People sufficiently

cultivated and educated to be capable of making a correct judgment about anything without fear of coming into contact with ideas that could confound or deflect them [who] could read any book or see any film, about any theme, without changing our fundamental beliefs; and if there is in a book a solid argument about something that could be useful, that we are capable of analyzing and evaluating it. [...] If we did not think like that, we would be men with no faith in our own convictions, in our own philosophy.'[153]

This approach would be extended to the 'children now in elementary school and who are going to be the future intellectuals, the future citizens of our country, [who] should not be educated in a dogmatic way, but should develop their capacity to think and to judge for themselves'.[154] In the meantime, concerns about the mutual exclusivity of politicised praxis and free expression persisted. As had happened in the 1930s, a retreat into aestheticism was seen to operate at the expense of revolutionary commitment. In 1965, Che would recount that, as 'Artistic inquiry experienced a new impulse [...] the escapist concept hid itself behind the word "freedom"'.[155] In the next chapter, we shall consider how the insistence of *Lunes* upon absolute expressive freedom would lead to accusations of counterrevolutionary activity at a politically sensitive time. For now, it is interesting to note that, at the 1961 congress, José Baragaño, an existential surrealist writer closely associated with *Lunes*, would assert that the submission of intellectuals to the revolutionary project was more important than aesthetic pursuit of the marvellous, via language and abstractions, as the Revolution itself provided a full transformation of reality. For him, this acknowledgement in no way implied a diminution of quality and, in a reversal of the abiding slogan that gives this book its title, Baragaño would argue that to defend creative work of the highest and clearest quality was to defend the Revolution.[156]

In 1967, Dorticós would assert that, at a time when problems around freedom of literary and artistic expression were again stirring up polemics, this issue had transcended the polemical in Cuba, neither through coercion nor ideological disorientation but through an exceptional conciliation between freedom of expression and the revolutionary duty of writers and artists.[157] Echoing this sentiment at the first graduation ceremony at ENA, the then Minister of Education, José Llanusa,[158] asserted that 'It will be necessary to discuss with those who are concerned about freedom of expression and to ask them to what freedom they are referring. Our revolution defines a line. There is no discussion on esthetic expression, but rather on how art serves the people, their happiness, their cultural development. There is complete freedom to do this'.[159] What this came to mean was that those artists and writers fully immersed in the processes of creating a new society, familiarising

themselves at first hand with the necessities this entailed, were free to communicate these realities through whichever formal means they saw fit.

Even as the grey years took hold, a CNC publication would assert that 'Each creator chooses tendencies, manners and styles according to their need for expression which guarantees a diversity and spontaneity in their manifestations. It is hoped that the responsibility of each artist will lead to an intimate resolution between their freedom of expression and their revolutionary obligations'.[160] Similarly, the 1971 congress was at pains to highlight the commitment to freedom at the heart of 'Socialism [which] creates the objective and subjective conditions that make authentic creative freedom feasible'.[161] Again, this translated into a situation in which 'the State relies on each artist's sense of responsibility for a close reconciliation of his freedom of expression and his revolutionary duty, setting a barrier against the subtle ideological infiltration whose final goal is the destruction of the institutions that guarantee and promote his freedom'.[162]

During his visit to the 1968 cultural congress, Andrew Salkey noted that 'the artist and the intellectual are free in Revolutionary Cuba. [...] The artist is *not* dictated to in any way'.[163] In the ambivalence towards Fidel and the Revolution that Desnoes expressed in *Inconsolable Memories*, he found that 'The literary freedom Edmundo was enjoying was clearly a tribute to the quality of the Revolution'.[164] Interestingly, at the *Casa* round-table the following year, Desnoes would indict himself and his fellow writers for creating the illusion to visiting foreigners that there existed an absolute freedom to express oneself without recognising the demands of a society in revolution. At the same event, Fornet disagreed that the impression of absolute freedom was illusory, arguing that he and his contemporaries had practical freedom, not only of creation and experimentation but also the freedom to exhibit, to publish, to use the means of diffusion that the state made available. Gutiérrez perceived that, from the outside, the eclecticism of styles and diversity of genres that existed was taken to signal unconditional freedom, which distinguished Cuba from the cultural rigidity of other socialist societies. Freedom, Desnoes demurred, did not exist in the abstract but was conditioned by the Revolution; rather than being a capricious freedom that responded to individual desire, it related to contemporaneous reality as embraced by intellectuals. For Gutiérrez, the construction of socialism required ideological solidity and total integration, which might necessitate a certain renunciation of expressive freedom and a subordination to the objectives and methods established by the leadership; in this regard, it seemed that intellectuals accepted that they would sacrifice aesthetic experimentation if it became necessary to do so in the face of mortal urgency.[165] Years later, Otero confessed he had vowed to himself that, if the moment ever came when he was forced to choose between literature and social justice, he would take the latter.[166]

In 2001, a representative sample of Cuban artists and writers were interviewed about their work and the context in which it was made. While all demanded greater faith in their creative work on the part of the government, Afro-Cuban poet Nancy Morejón argued that:

> We are a country that is still under siege and one that has never been alone. We must always remember the hostility to which we have been subjected. [...] I feel that Cuban writers today are demanding things that simply cannot be conceded in a period like this, since we are facing difficulties as critical as the Bay of Pigs invasion or the Missile Crisis. This country has to survive. Moreover, 'freedom' has many facets, and many people think that they have to make demands on the state for their freedom. I think that there are, in fact, several 'freedoms' and not just 'freedom' in absolute terms.[167]

In spite of the discursive process that has taken place in Cuba around the relative nature of expressive freedom, commentators from the capitalist world consistently overestimate the extent to which freedom of expression has been sacrificed. So, for example, Bonachea and Valdés argue that:

> To be an intellectual, the Cubans argue, one must be a revolutionary. And to be a revolutionary one must not be concerned with aesthetic questions, or matters surrounding artistic freedom. The function of the intellectual is to contribute his work toward the development of the Revolution. Literature and art are the arms of combat against all weaknesses and problems that interfere in any way with revolutionary objectives. A revolutionary intellectual provides unconditional support to the men of power and aids them in the mobilization of the masses, in transmitting objectives to them while exalting the accomplished achievements.[168]

By invoking the 'unconditional support to the men of power' ostensibly provided by revolutionary intellectuals, this account mistakenly underplays the role of critique in Cuba. Bürger reminds us that, in the Hegelian Marxist conception of critique, 'Criticism is not regarded as a judgment that harshly sets one's own views against the untruth of ideology, but rather as the *production* of cognitions. Criticism attempts to separate the truth of ideology from its untruth'.[169] In 1961, Fidel asserted that 'when man's ability to think and reason is impaired he is turned from a human being into a domesticated animal'.[170] Reflecting on these words forty years after they were delivered, Retamar would remark that operating within the Revolution had not implied obsequiousness on the part of writers and artists, but 'included critique, from revolutionary perspectives, of those who appraise the conflicts or errors which we have incurred'.[171] At the 1969 *Casa* discussion, Desnoes argued that writers and artists should not be afraid to express their vision of the revolutionary

process, including their doubts – an approach which had led a *Times* reviewer to describe *Inconsolable Memories* as 'Intelligent, intimate and honest, the novel of a man who believes that doubt is not treason in his country'.[172] While the role of intellectuals in criticising the Revolution will be returned to in due course, it is necessary to note here that the issue of creative freedom sheds further light on the orthodox Marxist approach.

In 1961, when a CPC pamphlet pontificated on whether harnessing culture to revolutionary aims would limit artistic freedom, the answer came: 'In some way'. And, not for the last time, this train of thought segued into the idea that 'The principal postulate of socialist realism is that it imposes the necessity of representing reality as it advances'.[173] Yet this kind of rhetoric was the exception that proved the (Marxist-humanist) rule, and, at the 1968 cultural congress Fidel would distinguish the approach of the Cuban Revolution from restrictive interpretations of Marxism that had befallen other parts of the world.

This discussion of expressive freedom prompts us to probe the illusion of absolute freedom being projected from the other side of the ideological fence. In *On the Jewish Question*, Marx observed that, in a society based on private property, people regard each other as the barrier to freedom, which means that the pursuit of individual happiness precludes consideration of the needs and desires of others.[174] As freedom is such a nebulous concept, it is usually defined, in the capitalist world, in opposition to its perceived antithesis, with communism serving as convenient shorthand for totalitarianism. At the Cultural Congress of Havana, President Dorticós made this explicit, arguing that the imperialist countries – especially the United States – 'always proclaimed the need of an effort to defend cultural freedom', whereas 'the countries in the process of socialist or revolutionary construction are always accused of implementing a policy that tends to frustrate that so-called cultural freedom'. For him, the composition of delegates – united only by a concern for the problems of the underdeveloped world – and the platform that had been established for discussions to take place without reaching unanimity was 'the most evident proof that [the congress] constitutes a true exercise of cultural freedom'.[175] Taking part in this event, Wesker noted that Cuba risked demonstrating 'that real communism and free intellectual enquiry are not merely compatible but essential to each other [...] And the United States is frightened because Cuba proves their one excuse for armed intervention in Vietnam is false – namely that the west must protect itself against communism because it denies intellectual and spiritual freedom'.[176]

The 1968 congress also discussed the infiltration of higher education institutes outside Cuba by imperialist ideas and the accusations of subversion levelled at anyone who attempted to challenge them. We are familiar with US claims of academic freedom, freedom of press, etc. But, in his

interrogation of US cultural interventions in Latin America, Christopher Lasch observed that:

> It is a serious mistake to confuse academic freedom with cultural freedom. [US] American intellectuals are not subject to political control, but the very conditions which have brought about this result have at the same time undermined their capacity for independent thought. The American press is free but censors itself. The university is free, but they use their freedom to propagandize for the state. What has led to this curious state of affairs? The very freedom of [US] American intellectuals blinds them to their unfreedom. It leads them to confuse the political interests of intellectuals as an official minority with the progress of intellect. Their freedom from overt political control [...] blinds them to the way in which the 'knowledge industry' has been incorporated into the state and the military-industrial complex. Since the state exerts so little censorship over the cultural enterprises it subsidizes [...] intellectuals do not see that these activities serve the interests of the state, not the interests of intellect. All that they can see is the absence of censorship; that and that alone proves to their satisfaction.[177]

Since these lines were written, implicit political control of the knowledge and cultural industries has heightened throughout the capitalist world. As Harvey observes, 'The advocates of the neoliberal way now occupy positions of considerable influence in education (the universities and many 'think tanks'), in the media, in corporate boardrooms and financial institutions, in key state institutions (treasury departments, the central banks), and also in those international institutions such as the International Monetary Fund (IMF), the World Bank, and the World Trade Organization (WTO) that regulate global finance and trade. Neoliberalism has, in short, become hegemonic as a mode of discourse'.[178] Those who refuse to conform to neoliberal modes of thought are systematically excluded from society's institutions. In the knowledge and cultural industries, this has led to high-profile dismissals and censorship, of which two examples from the US provide a flavour.

In 2005, Chris Gilbert was appointed as a temporary curator at the Berkeley Art Museum, where he initiated a cycle of exhibitions charting the Bolivarian process in Venezuela. In this effort, he consistently faced pressure from the museum's administrators to remove any expressions of revolutionary solidarity from interpretative materials surrounding the exhibitions. When the public relations department moved to neutralise the wording of an information panel, Gilbert resigned, issuing an explanatory statement which exposed the class interests of the museum and its position within the imperialist machine. In the process, he acknowledged that 'of course, revolutionary Venezuela is a symbolic threat to the US government and the capitalist

class that benefits from that government's policies, just as Cuba is a symbolic threat, just as Nicaragua was, and just as is any country that tries to set its house in order in a way that is different from the ideas of Washington and London – which is primarily to say Washington and London's insistence that there is no alternative to capitalism'.[179]

The second example of unfreedom in the capitalist world concerns an exhibition of a very different nature which was due to open in Brooklyn Museum of Art six years earlier. Whereas Gilbert planned to screen videos made within the *barrios* of Caracas, the 'Sensation' exhibition, initiated at the Royal Academy in London, was made up of artworks from the private collection of Margaret Thatcher's ad man, Charles Saatchi, by young British 'artists who [...] unquestioningly acceded to their delegated role as the vanguard of a hyper-real image culture'.[180] With Damien Hirst as their acknowledged ringleader, 'many of these artists generally want nothing more than to work within the status quo, hiding their essential conservatism and nostalgia behind a veneer of up-to-date pop cultural references, a scattering of demotic material and constant assurances that they are the expression of the present'.[181] The month before the exhibition was due to open, the Mayor of New York, Rudolph Giuliani, threatened to withhold financing from the museum unless it cancelled the exhibition. As the *New York Times* observed, this 'grossly distorted the First Amendment, whose very purpose is to insure freedom of speech without intrusion by legally constituted authority'.[182] Che Guevara had earlier observed that, within the capitalist world, 'A school of artistic experimentation is invented, which is said to be the definition of freedom; but this "experimentation" has its limits, imperceptible until there is a clash, that is, until the real problems of individual alienation arise. Meaningless anguish or vulgar amusement thus become convenient safety valves for human anxiety. The idea of using art as a weapon of protest is combated'.[183]

Remarks in Conclusion

Throughout this chapter, we have seen how revolutionary ideas began to crystallise around cultural work. In the first place, we saw that creative practice was embraced by the Revolution and released from the law of value through a system of state bursaries. These subsidies replaced the derided system of private sales and royalties, and intellectuals willingly relinquished their intellectual property rights on the understanding that the island's reserves of universal literature needed to be bolstered at the same time as the artistic and social value of their work was recognised.

It seems beyond doubt that the totalising process which was undertaken in the 1960s and '70s enabled Cuba to depart from mercantile considerations of culture in a way that has consistently been precluded under the capitalist system. As a result, it could soon be claimed that 'Socialism is the first social

regime that emancipates culture from the oppression of money, which means the artist can create not to satisfy the depraved tastes of a handful of gluttons but for the great mass of the people'.[184] Acknowledged as a form of social production, culture was liberated from the uselessness that defines its existence under capitalism. This presumed that artists and writers would contribute to the building of socialist society by gaining the fullest possible understanding of the seismic shifts being undergone around them and communicating them via the most appropriate (but not necessarily the most direct) means.

Whereas Marx had expected false consciousness to be shed spontaneously when capitalism was overturned through mass action, Lenin's vanguardist approach implied that revolutionary consciousness would need to be both stimulated and sustained in the broader populace. In the Cuban case, it seems clear that this process was in its infancy at the moment of revolutionary triumph. Within the Central Committee of the PCC, it was understood that:

> A revolution is an incessant struggle of ideas. Revolutionary ideas arise and develop dialectically. In the beginning, the struggle is more intense, because the vast majority of the masses must be educated politically and it is necessary to struggle against the false 'truths' that have influenced them during all of their lives, to struggle against the ideology that prevailed prior to the revolution. And it is in the day-by-day activity of the revolution that people discover its truth; it is in the carrying forward of the revolution itself that that truth gains in depth and becomes a part of the consciousness [...][185]

The seizure of power by a relatively small fraction of the population gave way to a sustained campaign aimed at endowing the people with the educational and critical tools necessary for achieving class consciousness and inspiring individual and collective effort in overcoming the country's underdeveloped condition. We have seen the unique part which was assigned to culture in this ambitious effort, and the reader is left to decide whether such a large-scale shift in attitude and behaviour was tenable under the circumstances.

In 1966, Régis Debray, a champion of the Revolution, would write, 'Militant is he who in his own intellectual work ideologically combats the class enemy, he, who in his work as an artist, roots out the privilege of beauty from the ruling class'.[186] A heightened awareness of the ideological potency of artistic work developed at the same time as the best cultural works from around the world were salvaged for the people of Cuba. And, while the acculturation of the population was tied up with the material renovation of the country, the revolutionary government's embrace of culture was underwritten by a humanistic understanding of its emancipatory potential. In this regard, it was envisaged that cultural work would contribute to humankind's happiness,

through immediate experience and by pointing the way to a society in which everyone's aesthetic personality could be expressed. Integral to this was an understanding that the Cuban people needed to develop their spiritual lives, via access to culture, enabling them not only to play a productive part in society but also to escape alienation.

We have continued to observe the ways in which the unification of diverse currents under the revolutionary banner exacerbated the persistent dialectic between political commitment and aesthetic experimentation. We have also begun to see how the poles of this debate were hardened by the reluctance of those at the aesthetic vanguard to relinquish their hard-won territory. By contrast, the orthodox Marxists who held sway in the cultural field – notably García Buchaca and her cronies at the CNC – espoused narrow formulae which sought to delimit creative practice by eschewing certain formal paths. This introduced a language of prescription and proscription that was inappropriate to an otherwise highly charged and experimental atmosphere. The Cuban leadership insisted that 'In order to be revolutionaries we must also be dialectical, and Marxism is not a schema that can be imported mechanically'.[187] It is deeply regrettable, therefore, that dogmatists at the CNC were permitted to thrive in the revolutionary cultural climate, and, while we may struggle to take any positives from this state of affairs, the Cuban case seems to prove beyond doubt that socialist realism is far from being the only aesthetic mode applicable to a revolutionary situation.

In a challenging and ever-changing environment, the majority of creative intellectuals working in Cuba accommodated themselves to a revolutionary position, with the full support of the leadership, which combined ideological rigour with formal experimentation while maintaining the quality of their output. In the process, the relative nature of freedom was acknowledged. At the same time, the need for constructive criticism was embraced, with creative intellectuals accepting the uniqueness and fragility of the revolutionary process and aligning their work to supporting, rather than undermining, it. This compels us to delve deeper into the processes through which cultural policy was formulated and to further unravel the contribution of intellectuals to the transformation of social reality.

NOTES

1 Karl Marx, 'Theories of Surplus Value', L. Baxandall and S. Morawski (eds.), *Karl Marx and Frederick Engels on Literature and Art* (Nottingham: Critical, Cultural and Communications Press, 2006 [1861–2]), p. 52.

2 Maxim Gorky, 'Soviet Literature', M. Gorky, K. Radek, N. Bukharin, A. Zhdanov et al, *Soviet Writers' Congress 1934: The Debate on Socialist Realism and Modernism in the Soviet Union* (London: Lawrence & Wishart, 1977), p.41.

3 Ibid., p. 42.

4 Andrey Zhdanov, 'Soviet Literature – The Richest in Ideas, the Most Advanced Literature', *Soviet Writers' Congress 1934*, p. 19.

5 Ernesto Guevara, 'El Socialismo y el Hombre en Cuba' [Socialism and Man in Cuba], *Marcha*, 12 March 1965, unpaginated.

6 Guevara, 'Socialism and Man in Cuba', unpaginated.

7 Karl Marx, *Grundrisse: Foundations of the Critique of Political Economy* (London: Penguin Books, 1973 [1857–61]), p. cxviii.

8 Vladimir Lenin, Speech to the Young Communist League on Proletarian Culture, 8 October 1920 (first published 1926), included in Vladimir Lenin, *On Socialist Culture and Ideology* (Moscow: Foreign Languages Publishing House, 1960), pp. 79–80.

9 Nicolás Guillén, 'Report to the First National Congress of Writers and Artists', *The Revolution and Cultural Problems in Cuba* (Havana: Ministry of Foreign Relations, 1962 [1961]), p. 55.

10 Juan Blanco, 'Los Herederos de Oscurantismo' [The Heirs of Obscurantism], *La Gaceta de Cuba* II, no. 15, 1 April 1963, reproduced in G. Pogolotti (ed.), *Polémicas culturales de los 60* [Cultural Polemics of the 1960s] (Havana: Instituto Cubano del Libro, 2006), pp. 3–8.

11 Consejo Nacional de Cultura, *Anteproyecto del Plan de Cultura de 1963* [Draft of the 1963 Cultural Plan] (Havana: Consejo Nacional de Cultura, 1963), p. 3.

12 In a speech of 13 March 1968, Fidel paved the way for this once communism was reached, pointing to the tens of thousands of scholarship students who had ceased to rely on money.

13 Karl Marx, 'Debating the Freedom of the Press' [1842], Baxandall and Morawski, *Karl Marx and Frederick Engels on Literature and Art*, p. 48.

14 Accounts of the congress are taken from Unión de Escritores y Artistas de Cuba (UNEAC), J.A. Baragaño (ed.), *Memorias del Primer Congreso Nacional de Escritores y Artistas de Cuba* [Proceedings of the National Congress of Writers and Artists of Cuba] (Havana: Ediciones UNIÓN, 1961).

15 Ambrosio Fornet, 'La Década Prodigiosa: Un Testimonio Personal' [The Prodigious Decade: A Personal Testimony], S. Maldonado (ed.), *Mirar a los 60: Antología de una Década* [Looking at the 60s: Anthology of a Decade] (Havana: Museo Nacional de Bellas Artes, 2004), p. 12.

16 Jaime Sarusky and Gerardo Mosquera, *The Cultural Policy of Cuba* (Paris: UNESCO, 1979), p. 40.

17 Lourdes Casal, 'Literature and Society', C. Mesa-Lago (ed.), *Revolutionary Change in Cuba* (Pittsburgh: University of Pittsburgh Press, 1971), p. 457.

18 Instituto Cubano del Libro, *Cuba '71: I Congreso Nacional de Educación y Cultura* [First Congress on Education and Culture] (Havana: Instituto Cubano del Libro/Editorial Ámbito, 1971), unpaginated.

19 Roberto Fernández Retamar, 'Para un Diálogo Inconcluso sobre "El Socialismo y el Hombre en Cuba"' [For an Inconclusive Dialogue on 'Socialism and Man in Cuba'], *Cuba Defendida* [Cuba Defended] (Havana: Editorial Letras Cubanas, 2004 [1965]), p. 183.

20 Julio García Espinosa, 'Galgos y Podencos' [Greyhounds and Hounds], *La Gaceta de Cuba* II, no. 29 (5 November 1963), reproduced in Pogolotti, *Polémicas culturales de los 60*, pp. 86–94.

21 Comité Central del Partido Comunista de Cuba (PCC), *Tesis y Resoluciones Primer Congreso del Partido Comunista de Cuba* [Thesis and Resolutions of the First Congress of the PCC] (Havana: Comité Central del PCC, 1976), p. 487.

22 Alfredo Guevara, *Tiempo de Fundación* (Madrid: Iberautor Promociones Culturales, 2003), pp. 93–4.

23 Vladimir Mayakovsky, *How Are Verses Made?* (London: Cape Editions, 1970 [1926]), pp. 56–7.

24 Zhdanov, 'Soviet Literature', p. 23.

25 Ibid., p. 21.

26 Consejo Nacional de Cultura, *Anteproyecto del Plan de Cultura de 1963*, p. 2.

27 A Uruguayan poet, journalist and occasional novelist, who had been involved in revolutionary activity in Cuba.

28 Roque Dalton et al., 'Diez Años de Revolución: El Intelectual y la Sociedad' [Ten Years of Revolution: the Intellectual and Society], *Casa de las Américas*, 10, no. 56, September–October 1969, pp. 7–48.

29 Ambrosio Fornet, 'El Quinquenio Gris: Revistando el Término' [The Five Grey Years: Revisiting the Term], *Narrar la Nación: Ensayos en Blanco y Negro* [Narrating the Nation: Essays in White and Black] (Havana: Editorial Letras Cubanas, 2009 [2007]), pp. 382–3.

30 Dalton et al., 'Diez Años de Revolución'.

31 Law 14, drawn up by MINCULT and enacted by the Council of Ministers, was intended to cover all branches of creative work and any derivatives of original artworks.

32 Walter Grasskamp, Molly Nesbit and Jon Bird, *Hans Haacke* (London: Phaidon, 2004), p. 56.

33 Stefan Morawski, 'Introduction', Baxandall and Morawski, *Karl Marx and Frederick Engels on Literature and Art*, p. 22.

34 Consejo Provincial de Cultura, *La Cultura para el Pueblo* [Culture for the People] (Havana: Consejo Provincial de Cultura, 1961), p. 3.

35 Instituto Cubano del Libro, *Cuba '71*.

36 Mayakovsky, *How Are Verses Made?*, p. 57.

37 Ambrosio Fornet in Dalton et al., 'Diez Años de Revolución', p. 20.

38 Morawski, 'Introduction', p. 25.

39 'Introduction', *Soviet Writers' Congress 1934*, p. 9.

40 Zhdanov, 'Soviet Literature', p. 24.

41 Consejo Nacional de Cultura, *Anteproyecto del Plan de Cultura de 1963*, p. 2.

42 Morawski, 'Introduction', p. 25.

43 Peter Hudis and Kevin B. Anderson, 'Raya Dunayevskaya's Concept of the Dialectic', *The Power of Negativity: Selected Writings on the Dialectic in Hegel and Marx* (Lanham, MD, and Oxford: Lexington Books, 2002), p. xxii, italics in original.

44 Hudis and Anderson, 'Raya Dunayevskaya's Concept of the Dialectic', p. xxiv; italics in original.

45 Adolfo Sánchez Vásquez, *Art and Society: Essays in Marxist Aesthetics* (London: Merlin Press, 1973 [1965]), p. 28.

46 Sánchez Vásquez, *Art and Society*, pp. 24–5.

47 Karl Marx and Frederick Engels, *The German Ideology*, edited and with an introduction by C.J. Arthur. (London: Lawrence and Wishart, 1970 [1846]), p. 109.

48 Antonio Gramsci, *Selections from Cultural Writings* (Cambridge, MA: Harvard University Press, 1991 [1919]), p. 38.

49 Gramsci, *Selections from Cultural Writings*, pp. 50–1.

50 Ibid., p. 51.

51 Antonio Gramsci, 'The Intellectuals', *Selections from Prison Notebooks* (New York: International Publishers, 1971 [1949]), p. 9.

52 Ibid., p. 5.

53 Judith A. Weiss, '*Casa de las Américas*: An Intellectual Review in the Cuban Revolution' (thesis, Yale University, 1973), p. 29.

54 Nicola Miller, *In the Shadow of the State: Intellectuals and the Quest for National Identity in Twentieth-Century Spanish America*, (London and New York: Verso, 1999), p. 13.

55 Ibid., p. 13.

56 Ibid., p. 19.

57 Guillén, 'Report to the First National Congress of Writers and Artists'.

58 Weiss, '*Casa de las Américas*', p. 11.

59 Roberto Fernández Retamar, 'Caliban', *Caliban and Other Essays* (Minneapolis: University of Minnesota Press, 1989 [1971]).

60 Roberto Fernández Retamar, 'Hacia una Intelectualidad Revolucionaria en Cuba' [Towards a Revolutionary Intelligentsia in Cuba] (1966), *Cuba Defendida*.

61 Zenovia A. Sochor, *Revolution and Culture: The Bogdanov-Lenin Controversy* (Ithaca, NY, and London: Cornell University Press, 1988), p. 3.

62 K.S. Karol, *Guerrillas in Power: The Course of the Cuban Revolution* (London: Jonathan Cape, 1971 [1970]), p. 287.

63 Ibid., p. 453.

64 Fidel Castro, Speech given at ceremony in Pinar del Río to mark the twentieth anniversary of Che Guevara's death, *Che: A Memoir by Fidel Castro* (Melbourne: Ocean Press, 1994 [1989]), p. 147.

65 'Introduction', *Soviet Writers' Congress 1934*, p. 10.

66 Ernst Fischer, *The Necessity of Art: A Marxist Approach* (Middlesex: Penguin Books, 1963 [1959]), p. 8; italics in original.

67 Guevara, 'Socialism and Man in Cuba', unpaginated.

68 Herbert Read, 'The Problems of Internationalism in Art', *The Magazine of the Institute of Contemporary Arts*, 7, 1968, p. 4.

69 Andrew Salkey, *Havana Journal* (London: Penguin Books, 1971), p. 96.

70 Joaquín G. Santana, *Política Cultural de la Revolución Cubana: Documentos* [Cultural Policy of the Cuban Revolution: Documents] (Havana: Editorial de Ciencias Sociales, 1977).

71 Arnold Wesker, 'Aie Cuba! Aie Cuba!', *Envoy*, November 1969, p. 15.

72 C. Ian Lumsden, 'The Ideology of the Revolution', R.E. Bonachea and N.P. Valdés (eds.), *Cuba in Revolution* (Garden City, NY: Doubleday & Company, 1972 [1969]), p. 539.

73 Ibid., p. 540.

74 Comité Central del PCC, *Tesis y Resoluciones Primer Congreso del Partido Comunista de Cuba*, p. 492.

75 Ibid., p. 96.

76 Roger Garaudy, *The Turning Point of Socialism* (London: Fontana Books, 1970 [1969]), p. 39.

77 Mayra Espina Prieto, 'Looking at Cuba Today: Four Assumptions and Six Intertwined Problems', *Socialism and Democracy*, 24, no. 1, 2010, pp. 96–7.

78 Lee Lockwood, *Castro's Cuba, Cuba's Fidel: An American Journalist's Inside Look at Today's Cuba in Text and Pictures* (Boulder, CO: Westview Press, 1990 [1967]), p. 187.

79 Ibid., p. 111, italics added.

80 Sarusky and Mosquera, *The Cultural Policy of Cuba*, p. 20.

81 Ibid., p. 49.

82 John Berger, *Art and Revolution* (London: Writers and Readers Cooperative, 1969), p. 29.

83 Ibid., p. 47.

84 Kees Boterbloem, *The Life and Times of Andrei Zhdanov, 1896–1948* (Montreal and Kingston, London: McGill-Queen's University Press, 2004), p. 116.

85 Zhdanov, 'Soviet Literature', p. 22.

86 Leon Trotsky, 'Literature and Revolution', C. Harrison and P. Wood (eds.), *Art in Theory 1900–1990: An Anthology of Changing Ideas* (Oxford: Blackwell, 1992 [1924]), p. 429.

87 Boterbloem, *The Life and Times of Andrei Zhdanov*, p. 116.

88 Ibid., p. 135.

89 Ibid.

90 John Berger, 'Problems of Socialist Art', first published in *Labour Monthly*, March and April 1961, reprinted in L. Baxandall (ed.), *Radical Perspectives in the Arts* (London: Penguin Books, 1972 [1959]).

91 Graziella Pogolotti, *Polémicas culturales de los 60* [Cultural Polemics of the 1960s] (Havana: Instituto Cubano del Libro, 2006).

92 See Cultural Theory Panel attached to the Central Committee of the Hungarian Socialist Workers' Party, 'Of Socialist Realism', Baxandall, *Radical Perspectives in the Arts*.

93 Ernst Bloch, 'Discussing Expressionism', T. Adorno et al., *Aesthetics and Politics* (London: Verso, 2007 [1934]), p. 23.

94 Herbert Read, 'What Is Revolutionary Art?' [1935], Harrison and Wood, *Art in Theory 1900–1990*, p. 503.

95 Emilio Troise, *Aníbal Ponce: Introducción al Estudio de Sus Obras Fundamentales* [Aníbal Ponce: Introduction to the Study of his Fundamental Works] (Buenos Aires: Ediciones Sílaba, 1969).

96 Berger, *Art and Revolution*, p. 53.

97 Berger, 'Problems of Socialist Art', p. 56.

98 Ibid., p. 61.

99 Baxandall, *Radical Perspectives in the Arts*, p. 206.

100 Fischer, *The Necessity of Art*, p. 107.

101 Ibid., p. 110.

102 Ibid., p. 9, italics in original.

103 Ibid.

104 Ibid., p. 14.

105 Baxandall, *Radical Perspectives in the Arts*, p. 251.

106 Baxandall and Morawski, *Karl Marx and Frederick Engels on Literature and Art*, p. 25.

107 Herbert Marcuse, 'Art in the One-Dimensional Society', *Arts Magazine*, 41, 7, May 1967, originally a lecture at the New York School of Visual Arts (8 March 1967), reprinted in Baxandall, *Radical Perspectives in the Arts*, p. 60.

108 Miller, *In the Shadow of the State*, p. 74.

109 Antoni Kapcia, *Havana: The Making of Cuban Culture* (Oxford and New York: Berg, 2005), p. 77.

110 Carlos Franqui, *Family Portrait with Fidel* (London: Jonathan Cape, 1983), p. 10.

111 Ibid., p. 129.

112 Ariel González, '*Lunes de Revolución* y la Ideostética del Compromiso' [*Lunes de Revolución* and the Ideo-Aesthetics of Commitment], *Temas*, 30, 2002, pp. 83–90.

113 Fernández Retamar, 'Hacia una Intelectualidad Revolucionaria en Cuba'.

114 Roberto Fernández Retamar, 'A Cuarenta Años de "Palabras a los Intelectuales"' [To Forty Years of 'Words to the Intellectuals'] (2001), *Cuba Defendida*, p. 298.

115 Claudia Gilman, *Entre la Pluma y el Fusil: Debates y Dilemas del Escritor Revolucionario en América Latina* [Between the Quill and the Rifle: Debates and Dilemmas of the Revolutionary Writer in Latin America] (Buenos Aires: Siglo Veintiuno, 2003).

116 Guillén, 'Report to the First National Congress of Writers and Artists', p. 59.

117 Ibid.

118 David Craven, 'The Visual Arts Since the Cuban Revolution', *Third Text*, 6, no. 20, 1992, p. 92.

119 Bonachea and Valdés, 'Culture and Revolutionary Ideology: Introduction', *Cuba in Revolution*, p. 497.

120 Ambrosio Fornet, 'El Quinquenio Gris: Revistando el Término' [The Five Grey Years: Revisiting the Term], *Narrar la Nación: Ensayos en Blanco y Negro* [Narrating the Nation: Essays in White and Black] (Havana: Editorial Letras Cubanas, 2009 [2007]), p. 399.

121 Edith García Buchaca, *La Teoría de la Superestructura: La Literatura y el Arte* [Theory of the Superstructure: Literature and Art] (Havana: Consejo Nacional de Cultura, 1961), p. 30.

122 Alfredo Guevara and Leadro Estupiñán Zalvidar, 'El Peor Enemigo de la Revolución Es la Ignorancia' [The Worst Enemy of the Revolution Is Ignorance], *Revista Caliban*, 2007.

123 Alfredo Guevara, 'Aclarando Aclaraciones' [Clarifying Clarifications], Pogolotti, *Polémicas Culturales de los 60*, p. 239.

124 Fornet, 'La Década Prodigiosa', p. 10.
125 For a consideration of the ways in which the presumed value of the arts to society has been postulated down the years, see Eleonora Belfiore and Oliver Bennett, *The Social Impact of the Arts: An Intellectual History* (Basingstoke: Palgrave Macmillan, 2008).
126 Fornet, 'La Década Prodigiosa', p. 12, italics in original.
127 Roberto Fernández Retamar, '1961: Cultura Cubana en Marcha' [1961: Cuban Culture in Progress] (1962), *Cuba Defendida*, pp. 66–73.
128 Pogolotti, *Polémicas culturales de los 60*.
129 R.L. Hernández Otero, (ed.), *Sociedad Cultural Nuestro Tiempo: Resistencia y Acción* [Nuestro Tiempo Cultural Society: Resistance and Action] (Havana: Editorial Letras Cubanas, 2002).
130 Craven, 'The Visual Arts Since the Cuban Revolution', p. 80. Fidel uttered these words in an interview with Claude Julien in February 1963.
131 Sánchez Vásquez, *Art and Society*, p. 35.
132 Ibid., p. 10.
133 Consejo Provincial de Cultura, *La Cultura para el Pueblo*, p. 3.
134 Karol, *Guerrillas in Power*, pp. 47–8.
135 Guevara, 'Socialism and Man in Cuba', unpaginated.
136 Instituto Cubano del Libro, *Cuba '71*, unpaginated.
137 Luis Camnitzer, *New Art of Cuba* (Austin: University of Texas Press, 1994), p. 10.
138 Sarusky and Mosquera, *The Cultural Policy of Cuba*, p. 14.
139 Fernández Retamar, 'Hacia una Intelectualidad Revolucionaria en Cuba', p. 280.
140 Fornet, 'El Quinquenio Gris', p. 386.
141 Fornet, 'La Década Prodigiosa', p. 11.
142 David Harvey, *A Brief History of Neoliberalism* (Oxford: Oxford University Press, 2005).
143 Consejo Provincial de Cultura, *La Cultura para el Pueblo*, p. 3.
144 Gramsci, *Selections from Cultural Writings*, p. 37.
145 C. Wright Mills, *Listen, Yankee: The Revolution in Cuba* (New York: Ballantine Books, 1960), p. 186, italics in original.
146 Ibid., p. 143.
147 Casal, 'Literature and Society', p. 458.
148 Georgina Dopico Black, 'The Limits of Expression: Intellectual Freedom in Postrevolutionary Cuba', *Cuban Studies*, 19, 1989, p. 118.
149 Ibid.
150 Mills, *Listen, Yankee*, p. 143.
151 Ibid.
152 Ibid., p. 144.
153 Cited in Lockwood, *Castro's Cuba, Cuba's Fidel*, p. 112.
154 Ibid., p. 116.
155 Guevara, 'Socialism and Man in Cuba', unpaginated.
156 UNEAC, *Memorias del Primer Congreso Nacional de Escritores y Artistas de Cuba*.
157 José Llanusa Gobel and Osvaldo Dorticós Torrado, *Seminario Preparatorio del Congreso Cultural de la Habana* [Preparatory Seminar of the Cultural Congress of Havana], (Havana: Instituto Cubano del Libro, 1967).
158 In this role, he was also a member of the Central Committee of the PCC. A modest member of the 26 July Movement who returned from the US to Cuba with Haydée on 1 January 1959, José Llanusa was immediately made Mayor of Havana, a post he kept until 1961. Salkey partly dedicates his book to the charismatic minister, described by Karol as 'a former basketball and tennis champion, a man of impressive build [...] one of Fidel's closest collaborators' (*Guerrillas in Power*, p. 382).
159 Cited in Mario Benedetti, 'Present Status of Cuban Culture' [1969], R.E. Bonachea and N.P. Valdés, (eds.), *Cuba in Revolution*, p. 525.

160 Consejo Nacional de Cultura, *Política Cultural de Cuba* [Cultural Policy of Cuba] (Havana: Consejo Nacional de Cultura, 1970).

161 Santana, *Política Cultural de la Revolución Cubana.*

162 Lisandro Otero, *Cultural Policy in Cuba* (Paris: UNESCO 1972), p. 14.

163 Salkey, *Havana Journal*, p. 27, italics in original.

164 Ibid., p. 128.

165 Dalton et al., 'Diez Años de Revolución'.

166 Lisandro Otero, *Llover sobre Mojado: Una Reflexión Personal sobre La Historia* [To Rain on the Wet: A Personal Reflection on History] (Havana: Editorial Letras Cubanas, 1997).

167 John M. Kirk and Leonardo Padura Fuentes, *Culture and the Cuban Revolution: Conversations in Havana* (Gainesville: University Press of Florida, 2001), p. 117.

168 Bonachea and Valdés, *Cuba in Revolution*, pp. 498–9.

169 Peter Bürger, *The Theory of the Avant-Garde* (Minneapolis: University of Minnesota Press, 1984 [1974]), p. 8, italics in original.

170 Fidel Castro Ruz, 'Palabras a los Intelectuales' [Words to the Intellectuals], *The Revolution and Cultural Problems in Cuba* (Havana: Ministry of Foreign Relations, 1962 [1961]), p. 33.

171 Fernández Retamar, 'A Cuarenta Años de "Palabras a los Intelectuales"', p. 301.

172 Edmundo Desnoes, *Memories of Underdevelopment* (Middlesex: Penguin Books, 1971 [1968]), p. 3.

173 Consejo Provincial de Cultura, *La Cultura para el Pueblo*, p. 4.

174 Karl Marx, 'On the Jewish Question', R.C. Tucker (ed.), *The Marx-Engels Reader* (New York: W.W. Norton, 1978 [1844]), 26–52.

175 Instituto Cubano del Libro, *Cultural Congress of Havana: Meeting of Intellectuals from All the World on Problems of Asia, Africa and Latin America* (Havana: Instituto Cubano del Libro, 1968), unpaginated.

176 Wesker, 'Aie Cuba! Aie Cuba!', p. 17.

177 Christopher Lasch, 'The Cultural Cold War: A Short History of the Congress for Cultural Freedom', B.J. Bernstein (ed.), *Towards a New Past: Dissenting Essays in American History* (London: Chatto & Windus, 1970), p. 347.

178 Harvey, *A Brief History of Neoliberalism*, p. 3.

179 For Chris Gilbert's full resignation statement, see: Stretcher.org/features/chris_gilbert_resigns/

180 Howard Slater, 'The Art of Governance: On the Artist Placement Group 1966–1989', *Variant*, 2, no. 11, 2000, p. 23.

181 Julian Stallabrass, *High Art Lite* (London: Verso, 1999), p. 289.

182 'The Mayor as Art Censor', *New York Times*, 24 September 2009.

183 Guevara, 'Socialism and Man in Cuba', unpaginated.

184 Consejo Provincial de Cultura, *La Cultura para el Pueblo* [Culture for the People] (Havana: Consejo Provincial de Cultura, 1961), p. 4.

185 PCC Central Committee, *Information from the Central Committee of the Communist Party of Cuba on Microfaction Activity* (Havana: Instituto Cubano del Libro, 1968), p. 128.

186 Cited in Mario Benedetti, 'Sobre las Relaciones entre el Hombre de Acción y el Intelectual' [On the Relations between the Man of Action and the Intellectual], *Revolución y Cultura*, no. 4, 15 February 1968, p. 29. Debray wrote this in a letter to Enrique de la Osa, which was published in *Bohemia* on 22 July 1966.

187 PCC Central Committee, *Information from the Central Committee of the Communist Party of Cuba on Microfaction Activity*, p. 146.

The Early Cultural Climate

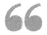 The best cultural policy was that cultural policy didn't exist.

– Ambrosio Fornet, 1969

Having introduced some of the main conceptions of culture in Cuba, let us turn now to the specific policies that were developed in the field as a consequence of the Revolution. We have already seen that the alignment of politics and culture was underscored by uncertainty about the precise direction cultural policy should take. Antoni Kapcia reminds us that it was 'always likely that any cultural policy would either follow the priorities and perspectives of the political vanguard or emerge organically'.[1] If we take the political vanguard to include Fidel, Raúl, Che and Camilo, working alongside Carlos Rafael, Armando Hart, Haydée Santamaría and others, then a more organic evolution might take account of the approaches of some of the pioneering cultural figures we have already encountered, supported by sizeable creative communities. In 1962, Retamar would attest that, rather than being mere passive subjects of rhetoric, writers and artists played an important part at those meetings during which revolutionary management was undertaken.[2] With this in mind, the story presented here inverts the primacy that is generally given to the political vanguard in other areas of Cuban policy-making, to prioritise the contribution made by practitioners to the emergence of cultural policy. Inevitably, this account of the evolution of revolutionary cultural policy pays heed to the period predating its official inscription.

Cultural Discussions as the Revolution Dawns
When the rebel forces disembarked at the south-eastern tip of the island to launch the prolonged final phase of the insurrection, they were too preoccupied with armed struggle to discuss political ideology, let alone cultural policy. Of all the political currents active in Cuba at that time, the PSP

was unique in its development of approaches involving the intelligentsia, through its Commission for Intellectual Work. As we have seen, the PSP-influenced Nuestro Tiempo society speculated on the cultural future of the country throughout the 1950s, developing lines which foreshadowed the cultural policy that would be adopted by the revolutionary government, and Carlos Rafael cites the party's elaboration of policy as one of the main reasons for the synergy between the young communists who formed the nucleus of the society and the young writers and artists who constituted its membership.[3]

When the Batista tyranny collapsed, Nuestro Tiempo issued a salute to the triumphant Revolution. Dated 2 January 1959 and entitled 'Free Culture in Free Cuba', this declaration proposed the consolidation of revolutionary conquests in all aspects of Cuban existence, including culture. Acknowledging the enormous complexity of formulating an artistic and intellectual programme in the country, the society advised the convocation of a great National Congress for Culture and outlined a handful of approaches that would be indispensable in the coming years. Significant in this regard were proposals for: complete reorganisation of the INC at the hands of the most responsible exponents of art, science and letters; close linkage between the highest cultural manifestations and the intensive dissemination of popular education; full respect for the free distribution of thought in all its creative manifestations; moral and material support from the state for the work of artistic and cultural organisations, predicated on strict independence of criteria and action; free international cultural exchange; and forging Cuban culture from the best liberal traditions while battling the cosmopolitanism that could harm its national character.[4] We have already seen how the INC morphed into the CNC and noted the autonomy that was written into the key cultural institutions, which received state support for work grounded in non-chauvinistic nationalism and an international outlook. As will be evident throughout this chapter and beyond, the idea of a great cultural congress was revisited several times, with the development of an authentic Cuban culture remaining paramount and the connection between high culture and popular education becoming inextricable. In this way, Nuestro Tiempo's commitment to prolonging the best of Cuba's past and embarking on work towards the future reaffirms a sense of theoretical and practical continuity either side of 1959.

Alfredo Guevara provides us with a hint about the root cause of cultural tensions when he describes how all the parties entering into the ORI alliance (in July 1961) agreed to dissolve their internal structures, but the PSP failed to disband its commissions, including that for culture.[5] While Fidel, Che and Raúl were aware of this, they were preoccupied with other matters; their failure to act would lead to much turbulence and insecurity in the revolutionary climate.

Words from the Intellectuals (October–November 1960)

As already intimated, Cuban artists and writers were by no means passive bystanders in the process of cultural policy formulation. On 19 November 1960, in the wake of the enactment of urban and agrarian reform laws and the expropriation of US-owned property on the island, creative practitioners published a manifesto called 'Towards a National Culture Serving the Revolution'. In a rare mention of this document in English,[6] the unsigned foreword of a MINREX publication hints at the immediate programme of activity that was outlined by creative practitioners 'conscious of the need to participate' who 'proclaimed their irrevocable commitment to the Revolution and to the people'.[7] Following a brief summary of the manifesto's main points, the trail in the literature available outside Cuba runs cold.

Research undertaken in Havana reveals that the manifesto was drafted during the First National Meeting of Poets and Artists, held in Camagüey between 27 and 30 October 1960, at which creative intellectuals discussed the pressing concern of unifying and coordinating their efforts with those of the revolutionary government. In recognition of the pertinence of the manifesto to this narrative, the full text has been included as Appendix A and its evolution and content are analysed here.

Earlier in October 1960, Rolando Escardó,[8] Nicolás Guillén and other intellectuals decided to convene a meeting of artists and writers from around the country using their own meagre personal funds. A letter, signed by Escardó, was widely disseminated among the leading practitioners of the day, inviting them to the meeting at the end of the month and outlining the parallel programme of cultural activities that would be taking place (including a National Theatre presentation of works by Cuban playwrights and exhibitions of Cuban painting, sculpture and archaeology). This initial letter also detailed the objectives of the forthcoming gathering:

1. To raise funds for 'poetic flights' through the sale of bonds valued at one peso each.
2. To support the Revolution and its laws in the conviction that they contain the principles of liberty, equality and social justice.
3. To demonstrate to the world the solidarity of all artists, writers and intellectuals with all peoples who struggle to achieve their economic, political, social and cultural liberation.
4. To support the Declaration of Havana in all its points.[9]

In relation to the final point, the First Declaration of Havana (2 September 1960) had condemned the imperialistic actions of the US and asserted the right of all the countries of Latin America to national sovereignty. It maintained 'that the spontaneous offer of the Soviet Union to help Cuba if our country is attacked by imperialist military forces cannot be considered an act

of intervention, but rather an open act of solidarity', while refuting 'absolutely that there has existed on the part of the Soviet Union and the People's Republic of China any aim "to make use of the economic, political and social situation in Cuba [...] in order to break continental unity and to engender hemispheric unity"'.[10] Condemning every form of inequality, the Declaration also affirmed 'the duty of workers, peasants, students, intellectuals, Negroes, Indians, youth, women, and the aged to fight for their economic, political and social rights'.[11]

As Escardó was killed in a car accident before the October meeting, it was eventually addressed by Guillén, who would emphasise the meeting's significance to the future of artists and writers within the revolutionary process. Following diverse interventions, the upshot of discussions was the aforementioned manifesto, which begins: 'Cuban intellectuals, writers and artists hereby wish to affirm our public creative responsibility to the Revolution and the people of Cuba, during a period in which the profound sense is that of united struggle to achieve the complete independence of our country'.[12] Inciting artistic unity in developing a national and revolutionary culture, this proposed (in brief):

1. Recovery and development of the Cuban cultural tradition.
2. The preservation and encouragement of folklore, conceived as the spiritual wealth of the Cuban people.
3. Sincere and honest criticism as indispensable to the work of artists and intellectuals.
4. Full identification between creative work and the needs of the advancing Revolution, 'The purpose of which is to bring the people close to the intellectual and the intellectual close to the people, which does not necessarily imply that the artistic quality of our work must thereby suffer'.
5. Exchange, contact and cooperation among Latin American writers, intellectuals and artists, vital for the destiny of our America.
6. Mankind is one. Our national heritage is part of world culture, and world culture contributes to our national aspirations.

In summing up, the manifesto retained the right of artists to express themselves in effective ways of their own choosing, and it summoned 'all Cuban artists, writers and intellectuals to a forthcoming National Congress which unites us in the work of culture, of serving the people and the Revolution'. Three weeks after the meeting, the congress would be formally announced and the manifesto reproduced in the press. The overwhelming sentiment of the meeting – that 'The fate of the revolution depends upon the fate of Cuban culture' – would not be lost, and the concluding phrase of the manifesto would reverberate as a slogan at the eventual congress: 'TO DEFEND THE REVOLUTION IS TO DEFEND CULTURE'.

Among the messages of support the manifesto garnered, President Dorticós acknowledged the passionate commitment of the majority of artists and men of letters to the Revolution, which would necessitate militant action and clarification of the questions most pertinent to Cuban culture. Heralding the forthcoming congress and its resonance on the world stage, he recognised artists and writers as an integral part of the Cuban people and urged them to define their immediate and future roles, with defence of the Revolution and love of the people as their main preoccupation.[13]

In the wake of the Camagüey meeting, an organising committee of thirty-four intellectuals was convened, notably including Mirta Aguirre, Alicia Alonso, Guillermo Cabrera Infante, Alfredo Guevara, Lisandro Otero and Ricardo Porro. Eleven members of the committee formed an executive, which included Guillén, Carpentier and Retamar as President and Vice Presidents respectively. The congress had originally been scheduled for April 1961, and, at a committee meeting on the fourteenth day of that month, Guillén urged that it should happen no later than May or June because it was painful for intellectuals to remain dispersed while other Cubans were dedicated to organising their work within the growing Revolution.[14] The day after the committee meeting, an air raid was launched from Nicaragua which served as a prelude to the CIA-sponsored Bay of Pigs invasion. The day after that, 16 April 1961, at the funeral for those killed, Fidel vocalised the socialist character of the Revolution. For a time, political exigencies would take over as the population was mobilised to overcome the invasion, and plans for the congress were necessarily delayed.

PM and Its Aftermath (May–June 1961)

In May 1961, a thirteen-minute film called *PM (Pasado Meridiano)* was screened on Canal 2 [Channel Two] as part of a weekly half-hour television programme produced by *Lunes de Revolución* – in other words, by Guillermo Cabrera Infante and Carlos Franqui. The short film, by Sabá Cabrera Infante (brother of Guillermo) and the nineteen-year-old Orlando Jiménez Leal, had been finished with a contribution of $500 from Guillermo on behalf of *Lunes*. Shot in black and white on 16mm stock using a hand-held camera, this cinéma vérité-style film depicts what might be thought of as the seedier side of Havana – the drinking, dancing and sex that had hitherto been synonymous with its nightlife.[15] Seeking further distribution while understanding the contentious nature of a film showing the persistence of pre-revolutionary abandon, the *Lunes* team offered *PM* to Cinema Rex, one of the few private film houses in Havana that was not run by ICAIC. Much debate has been generated about what happened next.

In studying contemporaneous documents, a timeline emerges. At the same time as ICAIC was created, a Commission for the Study and Classification

Still from *PM (Pasado Meridiano)*, 1961.

of Films was set up to assess the 'moral, aesthetic, social and political charac-
teristics' of all films screened on the island.[16] On 12 May, *PM* was submitted
to the commission for consideration, and an ordinary session – presided over
by Mario Rodríguez Alemán, director of the Municipal Academy of Dramatic
Art – was convened to study the film. At this meeting, it was decided that *PM*
'offered a partial picture of Havana nightlife which impoverishes, disfigures
and diverts the attitude maintained by the Cuban people against the cunning
attacks of counterrevolutionaries and the dictates of Yankee imperialism'
and that permission for its further distribution should be refused.[17] Alfredo
Guevara was informed of the commission's decision, and *Lunes* immedi-
ately mobilised support for the film, editing a protest document and collect-
ing almost 200 signatures, including those of Lisandro Otero and Roberto
Fernández Retamar.

The statement in which the commission's decision was issued announced
that, to avoid misinterpretation, the film would be screened for the Association
of Artists and Writers, with the film-makers in attendance, at Casa de las
Américas on 31 May, with the intention of either ratifying the original deci-
sion as the democratically correct path or rejecting it as mistaken and sub-
mitting the film to its makers. In a letter to the association the day before
the meeting, ICAIC made mention of the technical qualities of the film but
maintained that it was far from being a 'correct vision' of Cuban existence in
its present revolutionary phase.[18] This missive acknowledged that the decision
to prohibit further distribution – which had been condoned by the highest
authorities of the revolutionary government and distinguished artists and

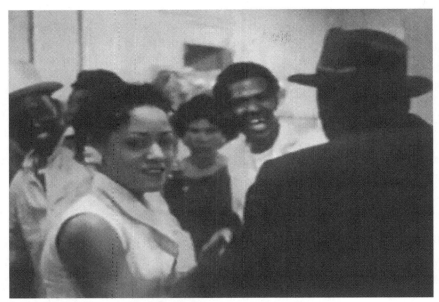

Still from *PM (Pasado Meridiano)*, 1961.

intellectuals – had given rise to fears of a possible attack on creative freedom in the aesthetic terrain. While maintaining the validity of its decision, ICAIC expressed a willingness to immediately reverse it if asked to do so by any of the workers', student, military or mass organisations. The screening and discussion at Casa apparently prompted an overwhelming majority – including those who defended and sympathised with the film – in favour of the commission's original decision that further distribution of the film would be injurious to the people of Cuba, and a statement was made to this effect.[19]

A partisan account of the history and position of *Lunes* implies that this refusal to disseminate *PM* beyond its initial (national) television screening had a dual basis. In the first place, it exhibited latent racism on the part of the authorities, on the basis that the 'festive attitude of afrocubans, demonstrated in the film, could be considered antithetical to that which the white leaders of the Revolution wanted to impose on the rest of the population'.[20] In the second place, it was claimed to have exacerbated an aesthetic rift between the neorealism perpetuated at ICAIC (through films such as *Cuba Baila* by Julio García Espinosa, 1959) and the 'New Wave' sensibilities embraced by *PM*. A renowned exponent of the former tendency, Cesare Zavattini, who had been supportive of the new Cuban film industry since the Nuestro Tiempo days and supervised *Cuba Baila*, was invited to lead a seminar at ICAIC. At the same time, a review of *PM* in the popular magazine, *Bohemia*, by Nestór Almendros – who worked for ICAIC but had loyalties to *Lunes* – championed the New Wave and favourably compared this tendency to its precursor, stimulating an open debate about formalism and art for art's sake. According to either explanation,

the so-called censorship of *PM* is conceived as an attack on *Lunes* as part of an attempt to narrow interpretations of culture as a result of the increased power of the Communist Party within the new governmental system. But, as *Lunes* co-editor Pablo Armando Fernández notes in the same volume, the periodical could always count on absolute official support.[21]

As we saw in chapter two, control of culture had passed from the Cultural Directorate to the PSP-infused National Council of Culture (CNC) in January 1961. Three months later, Fidel's socialist admission served to exacerbate fears among the artistic avant-garde about the undue influence of CNC *sarampionados*. Those on the liberal side feared that delaying general release of *PM* was a 'threat to freedom of expression [...] which insinuated that the ghost of Stalinism had begun to project its ominous shadow over the island'.[22] A precedent for this was to be found in the second part of Leonid Lukov's *The Great Life* of August 1948, which Stalin and Zhdanov condemned for its crude depiction of miners. This parallel was particularly acute for *Lunes*, which had been explicitly critical of the processes used against artists by the state in the Soviet Union from 1929 onwards. The 6 April 1959 issue of *Lunes* had included a manifesto, entitled 'For an Independent Revolutionary Art', signed by André Breton, Diego Rivera and Leon Trotsky in Mexico, speculating that, if the Revolution had to choose a socialist regime for its planning, it should adopt an anarchist regime of individual liberty for creative intellectuals. Also in the pages of *Lunes*, José Baragaño had openly accused the Cultural Directorate of mediocre judgement in curatorial matters. In November 1960, one of the first resolutions that the directorate of ICAIC authorised was prohibition of the public or private screening of 87 foreign films considered to be of inferior technical and artistic quality, the reactionary content of which, it was feared, would distort history and reality.[23]

Daily meetings in Havana wildly speculated about the Stalinist influence on the island, at times bordering on hysteria and concluding that culture would disappear altogether. Fornet contends that, at the time, 'This was an unjustified fear, or at least disproportionate, as was demonstrated later, but it is true that it wasn't far from us – in secret meetings between mediocre writers, known non-partisan opportunists, and cultural bureaucrats who were suddenly established as zealous guardians of the doctrine'.[24] We have already seen how this combination of negative forces resulted in advocacy of didactic, mimetic, 'educative' art. The growing orthodox influence was felt in newspapers, theoretical journals and manuals introducing scholastic Marxism to the island, which translated Soviet theses on culture and national doctrine, committing inevitable simplifications and opening the door to dogmatism. Yet there was more to this conflict than simple factionalism, and it is worth considering the intimate personal dimension alongside the broader political context.

In a letter summarising the *PM* conflict that was addressed to Fidel and Dorticós but never made public, Alfredo Guevara expressed his reservations about the aesthetic line being perpetuated by *Lunes*. In 2007, he went on record to explain that he later realised that this dispute had been an ethical, rather than purely aesthetic, one.[25] For him, the May 1961 confrontation was informed by the *Lunes* group's treatment of paradigmatic cultural figures who had been involved with the pre-revolutionary Orígenes group and its eponymous magazine. When the proto-*Lunes* group broke away from Catholic-inflected Orígenes to form a rival magazine, *Ciclón*, they – particularly Heberto Padilla and José Baragaño – accused the original group – including Carpentier and Lezama Lima – of political apathy, hermeticism, obscurantism and elitism – in other words, of perpetuating tendencies that the Revolution sought to eliminate, thus calling their integrity into doubt. This would later prompt Guevara to brand the personnel of *Lunes* 'intellectual terrorists', and, while apologists of *Lunes* have retrospectively dismissed this attitude towards the Orígenes group as youthful patricide, it created a palpable rift between the old guard and the self-proclaimed avant-garde. Provocatively polarising the debate with the delight of hindsight, Cabrera Infante describes how, with its publishing, television, film and music interests, *Lunes* was virtually omnipotent, whereas ICAIC could not count on many writers or graphic artists.[26]

As we have seen, problems between the personnel of *Lunes* and ICAIC may also be traced to the ideological split within Nuestro Tiempo, which caused Cabrera Infante and Franqui to quit the society in protest at its presumed communist takeover. While Cabrera Infante and Franqui may be commended for their modern and dynamic vision of art, literature and journalism (as evinced in their editorial work), it has been noted that they both had the great disadvantage, in the circumstances, of being dogged anti-communists who were violently opposed to anything emerging from the Soviet Union or the PSP.[27] In October 1959, Alfredo Guevara found it necessary to send a letter to the President of *Bohemia*, defending himself against an anonymous anti-communist campaign which questioned the totalitarianism of ICAIC.[28] The following year, *Lunes* provided modest finances for the production of *PM* on the condition that it would be premiered on the dedicated weekly television programme which the team had recently inaugurated. *PM* was filmed in the run-up to Christmas of 1960 and edited at the Estudios del Río [River Studios], which had not yet been nationalised by ICAIC. The first to see the film outside of the studios had been the editorial committee of *Lunes* and their invited guests from *Revolución*, all of whom apparently declared it a success. Combined with the fact that cinematic distribution was sought which further bypassed ICAIC, the genesis of *PM* was interpreted as an attempt to create a parallel structure which threatened the autonomy and authority of the film

institute. Taking account of the *Lunes* 'position directly confronting communism and its ideas', which was 'opposed to individuals like Alfredo Guevara',[29] it is hardly surprising that Cabrera Infante and Franqui became Guevara's adversaries. In turn, Franqui would frame the *PM* dispute as a direct attack from Fidel, mediated by Alfredo Guevara (explicitly exempting Haydée from responsibility in the process). By contrast, Cabrera Infante points the finger at César Escalante (brother of Aníbal), head of propaganda for the ORI.[30]

Through Guevara's account, we learn that Franqui had been mistreated and expelled by the PSP.[31] Franqui situates the period of his association with the party between the ages of fifteen and twenty-five, during which time he founded the magazine *Mella* (1941–2) and proofread the party newspaper, *Hoy*.[32] He cites the main reason for his conflict with the party as his love of poetry, yet Karol, who maintained a dialogue with Franqui, elaborates that his 'tendency to discuss rather than obey earned him the censure of [*Hoy*'s editor] Aníbal Escalante, and led to his expulsion in 1947'.[33] This serves to explain Franqui's fear of the growing influence of the party and his subsequent actions. In the latter stages of the insurrection, Che noted Franqui's resistance to the presence in the Sierra of the PSP, in the person of Carlos Rafael. Nonetheless, Franqui remained active in Cuba until the Cultural Congress of Havana in January 1968. Later that same year, he would be unmasked as a 'visceral counterrevolutionary' and seek exile in Europe.[34] Guevara ultimately finds that:

> Franqui did not believe in Fidel's talent and ability. Essentially he underestimated it. Carlos Franqui was not predestined by history to be a counterrevolutionary. It was that he believed, or arrived at the conviction that, the PSP submerged Fidel in its positions and he could not accept this. He felt himself superior or more intelligent or capable or more subtle than Fidel. Or more far-sighted. I don't know...[35]

On another personal note, in the mud-slinging that would happen at the end of 1963, to be discussed in the next chapter, Blas Roca, former Secretary General of the pre-revolutionary PCC, would accuse Guevara of having orchestrated the prohibition of *PM*, alleging that, rather than taking personal responsibility for the decision, Guevara invited members of the CNC to watch the film, which led to its suppression and the concomitant uproar.[36] Guevara affirms that, when the meeting was eventually convened at Casa to discuss the fate of *PM*, he was absent and that Mirta Aguirre and her PSP team attended. But he categorically states: 'I did not prohibit the film. That is a lie. They brought the film and submitted it. I refused to play a part in that film, to distribute it through ICAIC. They could have put it wherever they liked'. But options for alternative distribution were limited, and, despite Guevara's protestations of innocence, the film-makers visited his office and called him a fascist. In the event, the commission took advice from the CNC and the

President of the Republic and exercised what Fidel would shortly afterwards refer to as the revolutionary government's indisputable right not to allow the film to be disseminated further.[37]

Looking back on this period, Guevara maintains that it can only be understood through a political analysis which considers how the Revolution had been constituted historically, leading those who had taken an active part in the insurrection to remain on 'combative alert'.[38] Others are keen to emphasise that the screening of *PM* a matter of weeks after the Bay of Pigs invasion prompted questions about the wisdom of its recirculation in a country that well understood the propagandistic value of film and television. (In this regard, it is interesting to note that law 739, passed on 19 February 1960, had prohibited the screening of short films and documentaries made outside Cuba, which hints at heightened sensitivities around this potent medium.) Almost all of Cuba's artists and intellectuals flocked to help repel the US-backed invasion at the Bay of Pigs; some (notably Lisandro Otero and Marcia Leiseca) were mistakenly detained in the subsequent hunt for internal counterrevolutionaries. Cuban researcher Sandra del Valle notes that US military aggression was taken as a pretext for sacrificing a film, which demonstrated an over-excitement that was symptomatic of the tension in which the country was living.[39] Paraphrasing Gutiérrez Alea's perception that ICAIC's objections to *PM* were centred on the partiality of its account of Cubans as marginal and lumpen, Otero asserts that, had the film not been born in a time of confrontation, it would have been forgotten the following week.[40] In conclusion, Retamar argues that 'To exaggerate that incident, as has been done almost always with bad blood, is not appropriate, but neither is it to tone it down'.[41]

Throughout May 1961, nobody could speak about anything else; yet, a cultural congress had been called which threatened to be overshadowed by the debate about artistic freedom. The *Lunes* team petitioned Fidel to host a small, informal discussion (of five or six people); Fidel accepted his role of arbiter and acted to reconcile the differences that had emerged. In a bid to clear the air, a meeting was called at the national library on Friday 16 June 1961. Echoing the account of Franqui (given below), and detaching this denouement from any mention of *PM* to claim that it was the heterodox nature of *Lunes* which had attracted opprobrium, Karol describes how:

> Franqui and his protégés were invited to a discussion at the National Library in Havana. They were told nothing about the purpose of the meeting and they expected a small, friendly gathering to discuss certain minor differences between them and their country's cultural leaders Instead, they found themselves in a large hall, at a meeting attended by almost all the country's intellectuals, great and small. They had to face

a board of inquiry chaired by Mrs. Garcia Buchacha [*sic*] and made up chiefly of PSP leaders; and they were addressed in a manner far more suited to a court of law than an intellectual debate. They were accused of splitting the ranks of the Revolution, a serious crime at a time when unity had become a matter of life and death. They were accused of lacking a proper socialist perspective, of hankering after Western culture, and, more generally, of upholding dubious cultural trends. A terrible indictment, all told.[42]

As no resolution was reached, the group reconvened on two successive Fridays – 23 and 30 June 1961. In fact, neither Franqui nor Cabrera Infante attended the first meeting, but they were persuaded to attend the second, by Rine Leal and Walter Carbonell, to defend themselves against what they now perceived to be a direct attack upon *PM* and *Lunes*. Franqui would later describe from exile how, at the second meeting:

> The library was like a courtroom: above, the presidential tribunal, with Fidel, [Joaquin] Ordoquí, Carlos Rafael Rodríguez, Edith Buchaca, Dorticós, Hart, Alfredo Guevara, and a few comandantes and lawyers; below, the artists and writers. Someone up above suggested I join them, but I said I liked it fine where I was. We were a mixed bag – the *Lunes* team, Lezama Lima, some Catholic writers sympathetic to the revolution, some old, some young.
>
> Alfredo Guevara took the floor: 'I accuse *Lunes* and *Revolución* of trying to split the revolution from within; of being enemies of the Soviet Union; of revisionism; of sowing ideological confusion; of having introduced Polish and Yugoslavian ideas; of having praised Czech and Polish films; of being the spokesmen for existentialism, surrealism, U.S. literature, bourgeois decadence, elitism; of refusing to see the accomplishments of the revolution; of not praising the armed forces.' We were, it seemed, a big internal threat, the Trojan Horse of the counterrevolution. Guevara went on to say that *P.M.*, the film seized and censored by ICAIC [...] and defended by us, was counterrevolutionary, showed decadence instead of the armed forces and their struggle, that Sabá Cabrera [...] and Orlando Jiménez, who made the film, embodied the antirevolutionary ideology of *Lunes* and *Revolución*.[43]

Otero offers a less virulent account of the meetings, describing how the maverick playwright and *Lunes* founder, Virgilio Piñera, began the discussion, professing his fear that the 26 July Movement sought to delimit culture. In this version of events, the *Lunes* associate Baragaño is depicted as an orthodox Marxist, while Heberto Padilla (about whom we shall be hearing more later) is seen to advocate increased acculturation of the population, which

attracted accusations of elitism. Some argued for tolerance of all forms of culture while others objected to the particularities of *PM*. Retamar implicated intellectuals in the revolutionary process, and Otero defended art as a means through which humanity could confront its problems and contradictions, which required the full range of creative expression.[44]

For Del Valle, the national library meetings imposed a kind of sovereignty upon ICAIC.[45] For *Lunes*, the meetings confirmed the totalitarian leanings of ICAIC.[46] Franqui exempted himself from the third meeting and went to Hungary, leaving Cabrera Infante to represent the interests of the supplement. Fidel would assert that, although this discussion had been accelerated by *PM*, it was already in the minds of the government;[47] laying 'his perennial pistol on the table',[48] it would fall to him to conclude discussions.

Words to the Intellectuals (30 June 1961)

Now that Cuba was officially a socialist country, questions had begun to be asked about the future of intellectual life, specifically within the cultural field. Would artists be able to enjoy the same freedom they had in earlier years or, on the contrary, would certain norms be imposed that would narrow artistic expression? It was to questions like these that Fidel addressed himself at the final library meeting.

The MINREX pamphlet which alludes to the November manifesto of the previous year describes how, like so many of the capitalist class who had fled the island, intellectuals representing the official culture of the previous period had turned their backs on the Revolution.[49] Drawing upon indigenous sources, Mills had earlier detailed how, as the Revolution took hold, the 'Cuban intelligentsia as a whole was split. Many intellectuals were with the tyranny; many others, after some education, just wanted to forget Cuba and they left the country'.[50] Che would later assert that 'when the revolution took power there was an exodus of those who had been completely housebroken. The rest – whether they were revolutionaries or not – saw a new road'.[51] Within this latter camp, many of those artists and writers who had initially supported the Revolution had been disconcerted by its rapid momentum into unfamiliar territory, and the library meetings were partly aimed at defining their revolutionary role. Further into the MINREX pamphlet sits a transcript of Fidel's infamous closing speech, which subsequently became known as 'Words to the Intellectuals'.[52]

Lee Lockwood, a US photographer who spent time with Fidel in the mid-1960s, describes the commander-in-chief's tendency to 'unfold his thoughts in long, repetitious, convoluted sentences of baroque syntax whose meaning is carried forward almost as much by the cadence of the phrases as by the connotations of the words'.[53] In this particular soliloquy, Fidel asserted that the ensuing 'economic and social Revolution must inevitably produce a cultural

José Martí National Library, housing a bust of the eponymous revolutionary poet, venue of the meetings in June 1961.

revolution in turn'.[54] Identifying the problem created by *PM* as one of 'freedom for artistic creation' – with a particular emphasis on content rather than form – he addressed the concern that the Revolution might try to stifle, or suffocate, that freedom. The initial tone of this speech, when read more than fifty years after it was delivered, might best be described as indignant, with the leader of the Cuban Revolution reminding his audience: that 'the Revolution defends freedom; that the Revolution has brought the country a very high degree of freedom; that the Revolution cannot by its very nature be an enemy of freedoms; that if some are worried about whether the Revolution is going to stifle their creative spirit, that worry is unnecessary, that worry has no reason to exist'.[55]

Turning his attention to those who might harbour such a fear, Fidel found that the revolutionary artist – for whom a concern for the people is paramount, 'who puts something above even his own creative spirit; [who] puts the Revolution above everything else [with] the most revolutionary artist [being] ready to sacrifice even his own artistic calling for the Revolution'[56] – would not suffer this problem. Rather, Fidel identified his ambivalent subject as that honest artist or writer who was neither revolutionary nor counter-revolutionary, which corresponded with Trotsky's 1924 definition of 'fellow travellers'.[57] In the process, Fidel acknowledged that such non-revolutionary artists had pledged welcome assistance to the Revolution, which, as Trotsky recognised, required enabling all those individual artists and groups who 'have come over to the revolution to grasp correctly the historic meaning of

the Revolution, and to allow them complete freedom of self-determination in the field of art, after putting before them the categorical standard of being for or against the Revolution'.[58]

Commenting on Fidel's 'Words' the year after they were delivered, Retamar would isolate two main groups of artists and writers – the large majority, fervently on the side of the Revolution, who had done nothing but make works in the new spirit, and a minority who had yet to develop the full political consciousness of their contemporaries. For him, this latter group could be further subdivided into those who had been profoundly shaken by the experience of the Revolution and sought high-quality artistic forms with which to express this, and those who were suspicious and opportunistic, stubbornly persisting in their old ways, perhaps in an attempt to demonstrate both their fidelity to certain forms and the expressive freedom they were able to enjoy in a socialist revolution, despite slander to the contrary.[59]

Rooting out the counterrevolutionary and reactionary in 1961, Fidel went on to say that the Revolution should 'act in such a manner that the whole group of artists and intellectuals who are not genuinely revolutionaries can find within the Revolution a place to work and create, a place where their creative spirit, even though they are not revolutionary writers or artists, has the opportunity and freedom to be expressed'.[60] This guaranteed creative freedom to non-partisan artists, as long as they did nothing to jeopardise the paramount survival of the Revolution. In other words, 'within the Revolution, everything; against the Revolution, nothing. Against the Revolution, nothing, because the Revolution has the right to exist, and no one shall oppose the right of the Revolution to exist. Inasmuch as the Revolution understands the interests of the people, inasmuch as the Revolution signifies the interests of the whole nation, no one can justly claim a right in opposition to the Revolution'.[61]

Retamar finds that the fullest freedom of expression was firmly established via Fidel's 'Words'.[62] Similarly, Gemma Del Duca concedes within a University of Miami publication that the central phrase was 'intended to safeguard the Revolution, to protect its right to exist; it was not intended to limit the creative freedom of intellectuals',[63] and Claudia Gilman notes that, although their concerns did not disappear instantaneously, those artists and writers who had feared the imposition of socialist realism seemed relatively calm in the face of these reassurances that the Revolution would leave the criteria of artistic production alone.[64] Bonachea and Valdés find in this the positive result that 'Artists and writers were considered revolutionary not because they wrote didactic works or painted pedagogical murals, but because they supported the Revolution and worked, as private citizens, on its behalf. Hence, a sort of peaceful coexistence bloomed between intellectuals and the state'.[65]

There is an interesting parallel to be drawn between Fidel's policy and the Bolshevik Party's line, expressed by Lenin in 1905. Maintaining full freedom

of expression except in cases where this would bring political or cultural pro-
tagonists into conflict with the party (which would result in their expulsion),
'Lenin justified such a policy because the Party was a "voluntary association"
whose ideological integrity needed to be protected if it was to achieve its
historical aims. Once it had done so and actually become the governing party
in 1917, a little later making itself coterminous with the state, such a policy
applied to art was obviously full of repressive potential'.[66] In certain quarters,
the key phrase of Fidel's speech have been taken as shorthand for an inten-
tion to menace and control dissenting intellectuals.[67] Two decades after it was
made, Franqui would speak of how, with this gesture, Fidel was identifying
the Revolution with his person, to say that it had eyes and ears, which implied
that it 'admitted no critique, admitted no discrepancy, admitted no pluralism'.[68]
Moreover, he would write from exile of 'Fidel's words – ambiguous outside
of Cuba, all too clear inside – "With [sic] the revolution, everything; against
the revolution, nothing." The problem was that the revolution was Fidel and
his personal tastes in art, literature, and politics'.[69] While Fidel's centrality in
dictating cultural matters has already been debunked, the amorphousness of
his central phrase could be bent to the will of cultural functionaries, confer-
ring upon them the freedom to prescribe the kind of artworks they would like
to see being made, in ways that will continue to be explored.

By contrast to Franqui's account, Camnitzer considers that, whereas 'To
Cuba's critics, the statement has represented a succinct recipe for totalitarian-
ism and tyranny', it may be seen that 'Fidel Castro's famous statement in 1961,
"Within the Revolution everything; outside the Revolution, nothing," can be
seen as [...] less ominous than it has generally been portrayed outside of Cuba
by those unsympathetic to the revolutionary process'.[70] In much the same way,
Weiss finds Fidel's formulation to be more consensual than coercive:

> Fidel Castro's famous statement 'dentro de la revolución, todo, fuera
> de la revolución, ningun derecho,' was an inclusive, centripetal state-
> ment which sought the support of intellectuals. This was not necessarily
> prompted by a pressing need for this support, in order to cement the
> Revolution, but he appeared determined to make Cuba a showcase and
> not to risk the criticism of those same intellectuals, both Cuban and
> foreign, who constituted an important lobby of favorable sentiment.[71]

However, both Camnitzer and Weiss are guilty of misquoting Fidel, a common
phenomenon as Kapcia points out:

> Those [...] words have subsequently been taken by critical commentators
> to have established strictures determining control of artistic freedom, or
> at best to have left ambiguity. However, this understanding has arisen
> especially from misquoting *contra* ('against') as *fuera* ('outside') [...], thus

changing the meaning of what Castro was actually saying. For his state-
ment indicated not 'if you are not with us, you are against us' (which the
use of *fuera* would have meant) but the more inclusive 'if you are not
against us, you are with us'. This is not mere semantics, for one charac-
teristic of the Revolution's processes subsequently has, indeed, been its
'argumentalism' [...], its willingness to allow and even encourage internal
debate, within clear parameters and behind metaphorically closed doors,
which has allowed writers, artists and intellectuals to know and even
define the bounds of the acceptable; apart from moments of crisis or of
exaggerated internal tensions, exclusion and a 'hard line' have tended
to be applied only to those publicly going beyond those 'doors' and those
parameters.[72]

As we shall see, this willingness to encourage debate, castigating only those
who came out against the Revolution, is key to understanding Cuba's cultural
milieu.

Kapcia's sometime collaborator, Par Kumaraswami, reprises the various
interpretations of Fidel's monologue, distinguishing it as an example of cul-
tural politics, rather than cultural policy, in the context of the dispute between
the CNC and Cuba's intellectuals. She follows this with an analysis that ranges
further than the central tenets to establish a hierarchical relationship between
politics and culture which placed emphasis on active participation at the
expense of intellectual contemplation. In Fidel's key phrase, she finds 'Castro
pressing intellectuals to commit to a position, within or against, and therefore
to leave behind the middle ground, the terrain of doubt that seemed to be
afflicting many of them'.[73] More damningly, she asserts that, 'as the speech
progressed, the cumulative list of their implied weaknesses became greater:
in contrast to their political counterparts, some artists and intellectuals were
not only fearful, self-centred, destructive and pessimistic, but also impractical
and immature'.[74] From this perceived mockery of intellectuals, Kumaraswami
projects a lineage that would become progressively more adamant – via Che's
'Socialism and Man' of 1965 and the 1971 Congress – to become 'distorted,
intensified and used as a basis for the marginalisation, exclusion and mistreat-
ment of individual writers throughout the *quinquenio gris* [...] and beyond'.[75]
This makes it necessary for us to continue charting the evolution of cultural
policy in order to see how these developments would be played out.

Common to all texts analysing Fidel's speech from a capitalist perspec-
tive is their failure to grasp the connotations of a social revolution for artistic
and intellectual practice. Taking the autonomous intellectual as their implicit
starting point, such analyses consider the politicised role being advocated for
artists as more of a loss than a gain. In the process, they negate the potential
for reconciling art and society that was central to the revolutionary project.

By contrast, Fornet articulates how Fidel's words verified the principles of the Revolution, making it obvious that unlimited perspectives for creative work had been opened up for the vast majority of artistic and literary intellectuals, leading to the possibility of an authentic cultural rebirth at the heart of social transformation; for him, the pending problem facing intellectuals in the 1960s was 'who drew the line between *inside* and *against*'.[76]

Just as there exists uncertainty about the intended meaning of Fidel's 'Words', there is a divergence of opinion about their outcome. Certain commentators project a negative impact, and Karol reflects Franqui's demonisation of the PSP to conclude that:

> [...] the meetings at the National Library ended in compromise. The intel-
> lectuals had won a certain respite, but lost one of their main weapons
> in the cultural field [*Lunes*]. The PSP was content as well, for it had no
> wish to capture *Lunes* or to set up its own cultural and political journal.
> However, it was determined to prevent intellectuals from having any-
> thing to do with politics and ideological questions; in a pinch, they might
> be permitted to paint abstract paintings or write esoteric novels, but no
> more.[77]

In contradistinction to this, Camnitzer finds that the speech had a favourable result, particularly for 'visual arts, policy and practice in Cuba [which] then mostly conformed to the more liberal interpretation of the statement',[78] and Kapcia finds that this mid-1961 clarification of uncertainties permitted a nine-year burst of radicalisation.[79]

Forty-five years after Fidel's speech was delivered, Armando Hart would recall its impact in shaping cultural policy over the next three decades, opening up unexpected paths and providing the political elucidation necessary for Cuban art and literature to reach higher levels, becoming an example in the Americas and beyond.[80] In much the same way, Retamar has retrospectively attempted to reclaim Fidel's commitment to culture from his detractors by considering the Revolution's proven achievements in the educational field, through the democratisation of universities and mass access to high culture.[81] Yet the immediate consequences of the June 1961 meetings were the convocation of a full and stormy congress in August and the cessation of *Lunes* in November of that same year.

The First National Congress of Writers and Artists (18–22 August 1961)

Two months after Fidel delivered his 'Words', the long-awaited First National Congress of Writers and Artists was convened in Havana. As little documentation of this congress is available in the English literature, it is necessary to refer to documents within Cuba, particularly two publications produced by UNEAC

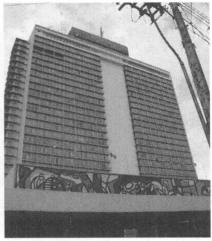

Nicolás Guillén. Courtesy of the Archive of Casa de las Américas.

Habana Libre hotel, venue of the First National Congress of Writers and Artists, with mural by Amelia Peláez.

– one immediately after the congress and one looking back on its history forty-five years later.[82] From these sources, it becomes clear that, as President of the organising committee, Guillén made an extensive tour around the island in June 1961, meeting with artists and writers and taking part in public discussions. Conferences were organised in Santiago de Cuba and Camagüey, in the latter of which cities Guillén was interviewed by a panel of journalists for local television. As a result of his trip, several provincial organising committees were established, with their coordinators joining the national committee. Upon his return to Havana, Guillén expressed his satisfaction with the favourable reaction with which his work for the congress had been met, not only by artists and writers but also by the people at large. To keep information flowing, three bulletins were circulated in May, June and August 1961.

At the aforementioned April meeting of the organising committee, Guillén had pondered the role intellectuals should assume within the Revolution. Entitled 'A Great Task', his speech considered the emergence of the Cuban nation in the nineteenth century and the splendid movement of arts and letters that had emerged in spite of the European influence which had exerted a subtle dictatorship over the Cuban intelligentsia. While the preceding century had ended badly, with US intervention in place from 1898, the Revolution had inspired writers and artists to work and struggle at its side. He concluded that their great task lay in rescuing culture from bourgeois influence for the benefit of the great majority of Cuban people, in which effort the purest values of the nineteenth and twentieth centuries would need to be salvaged. At the same event, Guillén invited the participation, in the forthcoming congress, of all those active in literary and artistic work who had signed up to the November manifesto. Those wishing to take part needed to complete an

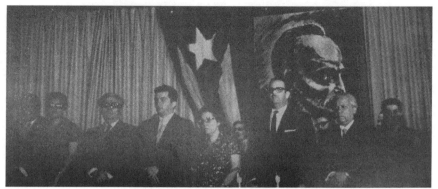

Presidency of the First National Congress of Writers and Artists, August 1961.

application form and return it, by the last day of July, to the national organising committee or one of its provincial equivalents, with accreditation to be collected from the national headquarters on 16 or 17 August.

Also in April, Guillén took the opportunity to outline the organisational framework for the congress, reading out twenty guidelines which had been drawn up to oversee its operation. The full plenary assembly of delegates was cited as the supreme authority of the congress, which would be overseen by an elected presidency of fifteen delegates, presiding over individual sessions on a rotating basis and facilitated by two secretaries in each session. Resolutions approved by each of three main working commissions would be forwarded to the collective presidency for approval by the full plenary assembly, with all accredited delegates having full rights of voice and vote and voting calculated according to simple majority. In the event of disagreement, the collective presidency reserved the right to appeal to the authority of the plenum, giving Cuba's artists and writers ultimate power of self-determination.

The agenda was explicitly 'based on the program set forth in the November Declaration',[83] with the work of the congress split between the following commissions:

1. The creative responsibility of writers and artists to the people of Cuba.
 a) Recovery and development of the Cuban cultural tradition and its integration into universal culture.
 b) Conservation, refinement and advancement of folklore.
 c) Sincere and honest critique as a means of situating the work of writers and artists.
 d) Mutual reconciliation between writers, artists and the people.
 e) Diverse forms of artistic expression.
2. Exchanges, contact and cooperation between Cuban intellectuals and artists and those of Latin America and all the countries of the world, in defence of popular culture, national sovereignty and universal peace.

3. Problems of organising an Association of Cuban Writers and Artists.[84]

In this way, the agenda determined by the country's intellectuals nine months earlier was supplemented by a desire to create an association representing their interests. We have already seen how this would give rise to UNEAC, but the broader discussion that took place at the congress is of interest when considering the formulation of cultural policy.

Before the working sessions began in earnest, Carlos Rafael and José Baragaño made presentations. The former echoed 'Words to the Intellectuals', distinguishing between those artists and writers who had been militantly engaging on behalf of the Revolution and those who maintained a separation between their civic activities and artistic postures, preoccupied with the latter at the expense of their other great responsibility – the task of communicating with the masses – which the Revolution now compelled everyone to address. Alongside abiding considerations of artistic freedom, this reconciliation of creative praxis with the people would form the main theme of the congress. Speaking as a practitioner, Baragaño refuted the Romantic conception of artists and writers as socially useless, to situate their work as the practical and intellectual link between the most profound aspects of life. Now that imperialistic incursions into national territory had been overcome, he urged the destruction of bourgeois thought in the ideological domain, exhorting his colleagues to join the ranks of the Revolution.

In other preliminary submissions, Mariano Rodríguez Álvarez expressed the hope that solutions to cultural problems would be found through the revolutionary union of intellectuals and the people. In considering why Cuban artists and writers had not yet been called to the task of organising themselves, the film-maker José Massip proffered three reasons – firstly, in quantitative terms, intellectuals constituted a small minority; secondly, from a qualitative perspective, they had not yet reached the highest level of historical necessity with respect to national culture; thirdly, intellectuals had fallen behind other sectors in their level of organisation. The congress would provide a serious step towards their incorporation into the powerful revolutionary current, and the writer Eduardo Manet found that this convocation signalled the conversion of an ineffectual and marginal group into a conscious group of citizens, poised to discuss affairs of interest to themselves and the nation.

With the literacy campaign creating millions of new readers and the government producing editions of books in the tens of thousands, the responsibility of writers would thenceforth be to an entire reading public. Lezama Lima argued that, while creative works had previously lacked the power to stimulate or irritate an audience, the Revolution had changed all that, but there were those who were not yet making work that reflected this new situation. For him, the purpose of the congress would be to unite with the people

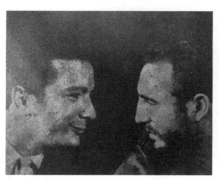

Armando Hart and Fidel Castro at the First National Congress of Writers and Artists, August 1961.

and search for ways in which artists and writers could be useful to the first socialist revolution of the Americas, which, in turn, had provided them with the liberty to follow their chosen path. To this notion of utility, the PSP stalwart Juan Marinello added that it would be misguided to call for any kind of uniformity of aesthetic criteria.

On the evening of 17 August, Armando Hart opened an exhibition of Cuban culture at the National Museum of Fine Arts. The following day, sessions began in the Ambassadors' Suite of the Habana Libre [Free Havana] hotel, a commandeered Hilton which had provided accommodation for the revolutionary government in the months after victory. The contributions of the main speakers are reproduced in full in the congress publications, including a brief opening speech and later extrapolation by Dorticós, lyrical contributions from many of the assembled artists and writers, a report and summing up by Guillén and a closing speech from Fidel. Presidency of the initial session – attended by ministers, members of the diplomatic corps, invited foreigners and Cuban writers and artists – was collectively held by Antuña, Carpentier, Dorticós, Guillén, Hart, Marinello and Retamar. Pablo Armando Fernández announced the official opening of the congress. He was followed by one of the few female speakers, Vincentina Antuña, who made a presentation on behalf of the CNC, outlining the two main directions that had thus far been pursued by the revolutionary government in the field of culture – the development of a national culture and the extension of education and culture to the people.

Paying homage to the Spanish writer Federico García Lorca on the twenty-fifth anniversary of his assassination by fascist hordes in Granada, Guillén was followed by Dorticós, who expressed the revolutionary government's enthusiasm for the congress and the duty that had been embraced by those assembled. As fundamental changes in the economic, political and juridical superstructure had yet to make themselves felt to such a direct and immediate extent in the fields of art and literature, he argued, this made the congress all the more urgent. It would provide an opportunity for all the writers and artists of Cuba to define future attitudes and to outline their individual and collective tasks, reconciling the responsibilities of their office with their duties to the people while forging a creative path that embraced the best of universal culture and national tradition. Having contextualised the revolutionary task of intellectuals, Dorticós commended the congress

themes, providing additional evidence of the autonomy of artists and writers in determining their programme.

As we saw in the introductory chapter, mid-1961 is widely regarded as the moment at which the revolutionary government consolidated its position on culture. Tellingly, in August 1961, Dorticós acknowledged that cultural policy had yet to be formulated, and that the revolutionary government had recently announced it would be addressing itself to this task in a way that would not diminish formal liberty in art:

> Your work is not to be done without the concern and help of the Cuban Revolutionary Government. First of all, we must state that, while you have your duties towards the Revolution and the people, the Revolutionary Government knows what its duties are towards all of you.
>
> It must, first of all, formulate a cultural policy. We cannot escape this duty, it is something we must do.
>
> And when we announce the Revolutionary Government's decision to formulate and implement a cultural policy, let no one be surprised or frightened. Let me make it clear that the Revolutionary Government, in formulating its cultural policy, will not in the least restrain or impair the practice of freedom of form in literature or the arts.[85]

While in other revolutions the development of culture had been postponed and the formulation of cultural policy disdained in literary and artistic circles, Dorticós implicated everyone present in this process, asserting that 'when speaking about formulating a cultural policy we do so realizing that it is a governmental function which must be developed, not away from you, but with yourselves as protagonists, collaborators and executors of that policy'. In this way, he signalled the intention of the revolutionary government to integrate creative intellectuals into the policy-making process, thus distinguishing Cuba from societies in which practitioners are systematically excluded from the decisions affecting them.

Over four intense days, much discussion took place around the various themes of the congress, of which a handful of contributions provide a general flavour. In considering the first theme – recovery of cultural tradition – Guillén undertook an exhaustive analysis of Cuban culture in the period before revolutionary triumph. This was predicated on an understanding that national identity was formed in the nineteenth century, through a fusion of well-defined Spanish and African cultures (which the Mexican writer Alfonso Reyes had likened to the union of hydrogen and oxygen becoming more than the sum of its parts as water). During the same period, colonialism was perceived to have counteracted cultural enrichment, by establishing a cultural monopoly over the philosophical, educational, scientific and aesthetic orders. Access to the most legitimate forms of culture had been blocked as collections

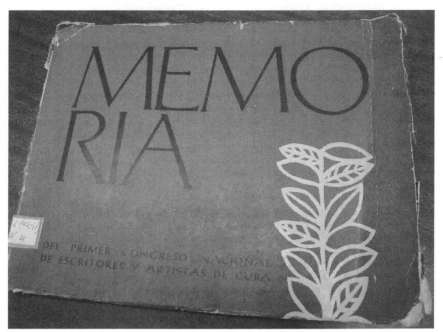

Commemorative publication produced for the First National Congress of Writers and Artists, 1961.

were pillaged and the thinking of distinguished intellectuals distorted to serve imperialistic ends. The resulting diminution of autochthonous culture had led to a mystification of art, bringing about its separation from the people. The triumph of the Revolution had witnessed the revalidation of cultural forms, including the readmission of African tropes and a revival of interest in folklore without recourse to obscurantism and superstition. As such, Guillén urged artists and writers to go forth, united in the battle to create a socialist culture, delivering to the man in the street that which nineteenth-century colonialists had jealously guarded as the exclusive privilege of the dominant class.

Significantly, the congress was also addressed by representatives from diverse workers' organisations. A message from the General Federation of Workers from Oriente (FGTO), reproduced on the same page of the commemorative publication as Dorticós's address, found synergy between the congress and the cultural plans of the CTC, which included the integration of cultural commissions in every union branch and the participation of delegated workers in municipal, provincial and national councils of culture, explicitly affirming the connection between artists, writers and the working class. Later, the CTC would offer fraternal greetings to the congress on behalf of the Cuban proletariat, convinced that the deliberations realised in the various commissions would bring about great advances in the cultural and artistic orders of the Revolution which were eagerly awaited by the people. In

a similar vein, the Association of Rebel Youth asked the assembled writers and artists to contribute their works to the young working masses, prioritising collective effort over personal interest and enabling farmers and students alike to find in their works a vision of the new society that everyone was working to create, using their intellect to light a path to the construction of socialism.

While the notion of critique had consistently featured in the agendas and manifestos of artists and writers since 1959, ideas about the ways in which this would be enacted became more concrete as the 1960s progressed. The 1961 congress provided a useful starting point for discussions about how the work of cultural criticism could be undertaken. Gramsci had earlier prophesied that a new 'type of literary criticism suitable to the philosophy of praxis' would be needed in a revolutionary situation, which 'must fuse the struggle for a new culture (that is, for a new humanism) and criticism of social life, feelings and conceptions of the world with aesthetic or purely artistic criticism, and it must do so with heat and passion, even if it takes the form of sarcasm'.[86]

If there was a false start to cultural criticism in Cuba after 1959, it must be due, in part, to the fact that there was scant critical tradition when the revolutionary government took power, with the bourgeois era having created 'the worst political, artistic and ideological commentators, who exercised a constant influence on tastes and habits'.[87] In the mid-1960s, Fidel would admit that Cuba had 'very few qualified people as yet who could even try to give a Marxist interpretation of the problems of art'.[88] In the process, he acknowledged that 'We have a goal, a program, an objective to fulfill, and that objective essentially controls the activity of the journalists. I would say that it essentially controls the labor of all the intellectual workers'. In this, he elaborated that:

> An enemy of Socialism cannot write in our newspapers – but we don't deny it, and we don't go around proclaiming a hypothetical freedom of the press where it actually doesn't exist, the way [those in the US] do. Furthermore, I admit that our press is deficient in this respect. I don't believe that this lack of criticism is a healthy thing. Rather, criticism is a very useful and positive instrument, and I think that all of us must learn to make use of it.[89]

At the end of the 1960s, Benedetti would observe that, whereas the Mexican Revolution had spawned many great essayists, Cuba had a low output and correspondingly niche audience for critical writing of this kind. Despite exceptions like Fornet and Retamar, 'In Cuba, the few times on which someone establishes his disagreement with any work, the circle is shocked, the archway of the group shivers. It is odd to observe that a country that has turned armed struggle into little less than a gospel should display, nevertheless, in cultural circles a complete lack of being accustomed to critical aggressiveness'.[90]

At the 1961 congress, consideration of 'sincere and honest critique as a means of situating the work of writers and artists' fell to the PSP activist and writer José Antonio Portuondo. He reminded those present that criticism had previously been informed by the system of values and aesthetic criteria (and, hence, conception of reality) of the dominant class. With the triumph of the Revolution, a decision had to be made as to whether these values and criteria, which had now entered into crisis, would be accepted or replaced with new formulations. If the latter path was chosen, Portuondo warned, every care must be taken not to slip into demagoguery or into a condition of only praising those 'great men' who contributed to the creation of socialism.

Having been vocal in his scepticism about the line followed by *Lunes*, Portuondo assigned to critics the duty of making a judgement upon cultural works in a way that assisted artists and writers in their quest to develop expressions of the new historical circumstances. And, while the work of critics would need to be grounded in socialism and Marxism, this did not imply that only Marxists could serve as critics – rather, that critics could not ignore the dominant philosophical currents underlying contemporaneous conceptions of reality. Portuondo also advocated that creative practitioners should engage in a continual process of self-reflexive critique, which did not imply some kind of suicidal tendency or aggression towards the ideas of others. Almost four decades later, Hart would affirm the dialectical potential of critique, as found in Marx (and Hegel before him), dismissing the 'sniper critic' whose every tendency with respect to art and culture is negative, thus denying the dialectical potential of negation. For him, 'In culture, art, intellectual work, absolutely anti-dialectical, abrupt negations, with pretensions to ideological truth, constitute a danger that we should curtail'.[91] Upon assuming director-ship of the CNC, however, García Buchaca had issued the instruction that cultural critics confronting the enemy – that is, the writer or artist in the service of imperialist forces – would have to be devastating in their critique, not only through their arguments but also through the language and forms they used. By contrast, when reflecting on the work of a writer or artist friend, they should use an appropriately friendly tone, rather than an aggressive one.[92]

Discussions of critique inevitably touched upon the critical function of intellectuals. In 'Our America', Martí had argued that 'Nations should live in an atmosphere of self-criticism because criticism is healthy, but always with one heart and one mind'.[93] This distinction was later reinforced by the leader of the Arte Calle [Street Art] group, 'artist Aldito Menéndez [who] summed up the problems [by] saying, "A counterrevolutionary artist criticizes all the problems of the Revolution but does not offer any solutions because he believes that the only possible solution is to change the political system. A revolutionary artist criticizes the problems of the Revolution and tries to offer solutions because he believes in the Revolution"'.[94]

Martí continued that 'Nations should have a pillory for whoever stirs up useless hates, and another for whoever fails to tell them the truth in time'.[95] With regard to the timely telling of truth, this pointed to an important role for intellectuals. In 1960, influential Cubans believed that 'The intellectual searches for truth; all that is artificial the real intellectual is against. The revolution, too, smashes whatever is mere artifice. So it is only, we think, in a revolutionary epoch that intellectuals can do their real work, and it is only by intellectual effort that revolutionaries can be truly successful'.[96] With regard to the stirring up of

Roberto Fernández Retamar reads out the statutes of the National Union of Cuban Writers and Artists (UNEAC) at the First National Congress of Writers and Artists, August 1961.

useless hatred, Benedetti offers a sympathetic account of 'the extraordinary effort involved in taking a small country out of underdevelopment',[97] and the damage that fierce critique entailed to these processes, to conclude that 'it is at least understandable that someone who causes discouragement should not be viewed with sympathy precisely by those who have done everything possible, and everything impossible, to infuse a powerful social spirit, to infect the people with their own revolutionary tenacity'.[98]

As in other capitalist societies, certain artists and writers in pre-revolutionary Cuba had emphasised the power of contestation in their work, mounting considerable opposition to the Batista dictatorship, as described in the case of Nuestro Tiempo. Having been constituted as a stronghold against repressive society, intellectuals had to find a reason to exist in a revolutionary one. At the 1961 congress, to those intellectuals who, for half a century, had formed the Achilles' heel of imperialism by enacting their *dissent*, Carlos Rafael evoked the possibility of *consent*, mildly admonishing those who maintained a position of dissent as a matter of principle rather than as the necessary substrate of all artworks.

In considering the reconciliation of creative practice with the people of Cuba, Guillén identified a need for the refinement of various means of expression in order to facilitate direct contact with the problems society was facing. Portuondo referred to a process that had already begun – of writers and artists visiting factories and cooperatives, to meet people and read poems. Inciting artists and writers to involve themselves in the productive activity of creating magnificent, revolutionary works of art and literature in dialogue with the

people, he argued that the positive effects of this would be two-fold. In the first place, the people would understand that the creator was a person of flesh and blood, susceptible to being advised and guided; in the second place, a true dialogue would be established – an authentic dialectical game between the creator and those with whom they exchanged ideas. When artists and writers went to the people, he insisted, they must do so not as maestros, but to be judged, listening to reactions with genuine humility. In the process, he argued, the creation of things of beauty should not be negated; the Revolution had paved the way for the most extraordinary love poem, biting political satire or profound theological work. In tandem with the proactive engagement of the people, this kind of creative production would give rise to knowledge that could not be gleaned from books.

Carpentier read an introduction to the second main congress theme – regarding exchanges, contact and cooperation between intellectuals and artists from Cuba, Latin America and the rest the world, in defence of popular culture, national sovereignty and universal peace. A resolution was drawn up by the relevant working group, which considered dialogue between nations to provide the basis for universal culture. This assumed that the struggle for independence common to the countries of Latin America was being thwarted by a deliberate strategy orchestrated by the imperialist powers, aimed at eroding cultural linkages. Consistent with the Casa approach, it was decided that, in the face of constant aggression, an increasingly united response would need to be mounted across the continent, stimulating multifarious exchanges in the cultural field.

In discussions surrounding the congress, Pogolotti remembers that 'Words to the Intellectuals' formed something of an obligatory topic, with artistic and literary creativity being discussed alongside the dangers inherent in socialist realism.[99] In outlining the founding aims of UNEAC, Retamar asserted that there would be no place for those who rejected certain aesthetic credos; in order to guarantee this, free discussion would be the only valid means of clarifying intellectual postures and defending creative works. Pogolotti takes it as a sign of the times that events proceeded with much spontaneity and that the statutes of the union were defined by intellectuals rather than government committees; in this regard, she recalls one of the hottest topics being the criteria according to which union members would be selected.[100] Guevara mentions having been involved in the relevant organising committee and being in favour of opening up opportunities to all young artists and writers with talent – an emphasis on quality to which the union would adhere.[101] After messages of support were heard from various distinguished foreign guests, voting on the national committee and directorate of UNEAC took place, which saw Guillén unanimously elected President.[102] Notable among the executive is the name of Guillermo Cabrera Infante, with *Lunes*

collaborator Baragaño on the secretariat, which would suggest that, temporarily at least, differences of opinion were being put aside.

Guillén's final report to the congress was charged with immediacy in the wake of renewed aggression at the Bay of Pigs, which had compelled many of those present to set aside their artistic work and unite in defence of their homeland. Having been embedded in the process of organising the congress and determining its content, Guillén spoke of its historic realisation amid dramatic circumstances. Reminding his colleagues to keep their revolutionary role consistent with the expectations of the Cuban people, he read aloud the resolutions that had been agreed, which were centred on: adoption of the Declaration of Havana; acceptance of the rights and responsibilities of artists and writers to struggle for a better world through their work; pursuit of peace between nations and the full dignity of man; dedication to rescuing the best of Cuban cultural tradition; and consideration of the popular participation that would be essential to the creative task, irrespective of aesthetic position. In this way, the objectives first defined by artists and writers in Camagüey in October 1960 were consolidated.

At the Chaplin Theatre on 22 August 1961, Fidel pronounced his closing speech, expressing great admiration for artists and writers and recognising the fraternal and democratic spirit in which the congress had proceeded, with the full involvement of the Cuban people. For him, this implied a unity of purpose and dedication to the revolutionary cause, with creative intellectuals working for the people in a way that transcended egotism and personal ambition. Acknowledging the artists and writers in attendance to be those who had already shown loyalty to their homeland by staying and joining the fight, he urged them to redouble their efforts in compensating for those who had fled. In the essential task of forging future generations, Fidel implicated all those present in a pedagogical role. Using a metaphor of seeds needing to be sown, the leader of the Cuban Revolution envisaged that, from every artist and writer going into the countryside to disseminate their skills, countless new artists would arise.

In his closing speech, Fidel was at pains to dismiss those who speculated that the congress sought to subdue the aesthetic spirit or coerce creators – those whose insurmountable prejudice led them to distort everything through the lens of chronic pessimism. A year after the event, Retamar would describe how the congress firmly established the adhesion of creators to the revolutionary process and reaffirmed the necessity of Cuban artists working with the fullest political lucidity and formal liberty.[103] Much later, he would reflect that UNEAC, the 'fabulous new institution' arising from the congress, had been founded with the 'sense of unity, the amplitude of aesthetic criteria, the rejection of all dogmatism or sectarianism, and the multi-generational character' advocated by Fidel.[104]

Remarks in Conclusion

This consideration of the period either side of 1959 demonstrates the marked continuity of priorities within the cultural field from Nuestro Tiempo to the First National Congress of Writers and Artists, via the Camagüey meeting and November manifesto. It also sheds light on the proactive stance of the PSP with regard to the development of cultural policy before the Revolution and the problematic persistence of its Commission for Intellectual Work thereafter.

Since the early 1950s, Cuba's creative intellectuals had sought a closer connection with their countrymen and women. It will be remembered that the fourth point of the November 1960 manifesto aimed for full identification between creative work and the needs of the advancing Revolution, the purpose of which was to bring the people close to the intellectual and the intellectual close to the people, without implying that artistic quality must suffer. All the central speeches to the 1961 national congress addressed this theme, which formed the first point in the programme devised by artists and writers. The collection of perspectives assembled above demonstrates the inextricability of these aims and the willingness of all but a minority of creative intellectuals to embrace them. The government, workers' organisations and people at large also echoed this desire. However, this reconciliation of art and the people gives rise to one of the fundamental misunderstandings surrounding Cuban cultural formation from outside the island. Del Duca's account of the cultural dimension of the Revolution, published in Miami in 1972, completely excises the fourth point of the manifesto.[105] By the same token, we have seen that external interpretations of Fidel's 'Words' tend to be sceptical about the assimilation of artists and writers into the Revolution. But it cannot be overstated that the attempts made to narrow the gap between art and the people is one of the most significant and abiding legacies of the Cuban Revolution, and the concrete ways in which this was achieved will continue to be explored.

Throughout the late 1950s and early 1960s, we have seen that the emphasis remained on rescuing and developing national culture, which was re-designated as the patrimony of an entire people and an integral part of universal culture. Consistent with this aim, a new strain developed within revolutionary culture which reflected Cuba's history and traditions, and Sarusky and Mosquera would describe how 'Cuban painters, while operating with a great variety of artistic idioms and kinds of artistic expression, and aware of the latest theories about form, tend to focus attention on the rich veins of the national tradition and to give expression to the new realities'.[106] In this way, artists were implicated in the visual construction of autochthonous culture, through the recovery of lost symbols and the representation of changing reality. Maintaining an international outlook, it was consistently understood

that the most vigorous elements of homegrown culture would transcend national frontiers.

The phase outlined here, spanning the period from the 1950s to 1961, is characterised by a manifest lack of official cultural policy. Dorticós's words to the First National Congress of Writers and Artists categorically prove not only that the revolutionary government had not formulated its policy on culture by August 1961 but also that creative practitioners would be integral to its future development. Of the two possible routes anticipated by Kapcia at the beginning of this chapter, this suggests that, rather than being dictated from on high, an organic approach to the formulation of cultural policy was adopted. Consideration of the various discussions to have taken place during this crucial formative stage reveals the centrality of practitioners in determining the policy that would frame their practice, with Guillén emerging as a red thread through the most important convergences of the era.

This chapter also reminds us of the plurality of currents that were brought together within the Revolution. As we have seen, incipient tensions erupted with dramatic results in the wake of the socialist character of the Revolution being made explicit in the spring of 1961. From the course of events reconstructed above, it is clear, that, rather than this conflict being explicable in simple Manichean terms – of good versus bad, freedom versus Stalinism – it may be understood as the result of a clash between youthful personalities and their disparate histories and beliefs about how culture should be developed within the Revolution. And, while Fidel's 'Words' seem designed to safeguard freedom of aesthetic experimentation and banish the ominous shadow of socialist realism, we shall see that this threat would continue to darken discussions for several years to come.

NOTES

1 Antoni Kapcia, *Havana: The Making of Cuban Culture* (Oxford and New York: Berg, 2005), p. 128.

2 Roberto Fernández Retamar, '1961: Cultura Cubana en Marcha' [1961: Cuban Culture in Progress], *Cuba Defendida* [Cuba Defended] (Havana: Editorial Letras Cubanas, 2004 [1962]), pp. 66–73.

3 Carlos Rafael Rodríguez, 'Discurso en la Celebración de su Trigésimo Aniversario' [Discourse in Celebration of its Thirtieth Anniversary], R.L. Hernández Otero, (ed.), *Sociedad Cultural Nuestro Tiempo: Resistencia y acción* [Nuestro Tiempo Cultural Society: Resistance and Action] (Havana: Editorial Letras Cubanas, 2002), pp. 307–16.

4 Cited in ibid.

5 Alfredo Guevara and Leadro Estupiñán Zaldivar, 'El Peor Enemigo de la Revolución es la Ignorancia' [The Worst Enemy of the Revolution is Ignorance], *Revista Caliban*, 2007.

6 As will become clear in the concluding remarks of this chapter, Del Duca selectively extracts from the manifesto in a text written in English, but nowhere is it cited in full.

7 Ministerio de Relaciones Exteriores (MINREX), *The Revolution and Cultural Problems in Cuba* (Havana: Ministerio de Relaciones Exteriores, 1962), p. 6.

8 A poet and member of the Revolutionary Armed Forces (FAR).

9 This consideration of the First National Meeting of Poets and Artists was taken from a then unpublished manuscript, edited by Humberto Rodríguez Manso for UNEAC, entitled 45 *Años Después: Memorias de los Congresos de la UNEAC* [Forty-five Years Later: Proceedings of the Congress of UNEAC]. The letter to writers and artists is cited on p. 16.

10 See Fidel Castro Ruz, *The Declarations of Havana* (London and New York: Verso, 2008), p. 81.

11 Ibid., p. 84.

12 The manifesto is cited in Rodríguez Manso, 45 *Años Después*, pp. 17–19.

13 Ibid., p. 19.

14 For a consideration of the planning stages of the congress, see Unión de Escritores y Artistas de Cuba (UNEAC), J.A. Baragaño (ed.), *Memorias del Primer Congreso Nacional de Escritores y Artistas de Cuba* [Proceedings of the First National Congress of Writers and Artists of Cuba], (Havana: Ediciones UNIÓN, 1961).

15 To watch the film in two parts, see: Youtube.com/watch?v=Io-8gfWzBa8 and Youtube. com/watch?v=8C8FWGQi4x8&NR=1

16 'ICAIC Accord on the Prohibition of *PM*', W. Luis (ed.), *Lunes de Revolución: Literatura y Cultura en los Primeros Años de la Revolución Cubana* [*Lunes de Revolución*: Literature and Culture in the Early Years of the Cuban Revolution] (Madrid: Editorial Verbum, 2003), p. 223.

17 Ibid.

18 'Communication Sent by ICAIC to the Association of Artists and Writers', 30 May 1961, ibid., p. 224.

19 'Accord Adopted by the Commission for the Study and Classification of Films', 1 June 1961, ibid., p. 225.

20 Ibid., p. 37.

21 '*Lunes de Revolución:* Entrevista a Pablo Armando Fernández' [Interview with Pablo Armando Fernández], ibid., pp. 155–73.

22 Ambrosio Fornet, 'La Década Prodigiosa: Un Testimonio Personal' [The Prodigious Decade: A Personal Testimony], S. Maldonado (ed.), *Mirar a los 60: Antología de una Década* [Looking at the 60s: Anthology of a Decade] (Havana: Museo Nacional de Bellas Artes, 2004), p. 10.

23 Reported in Sandra del Valle, 'Cine y Revolución: La Política Cultural del ICAIC en los Sesenta' [The Cultural Policy of ICAIC in the Sixties], *Perfiles de la Cultura Cubana*, May–December 2002.

24 Fornet, 'La Década Prodigiosa', p. 10.

25 Guevara and Estupiñán Zalvidar, 'El Peor Enemigo de la Revolución es la Ignorancia'.

26 'Statement from Guillermo Cabrera Infante' [1987], Luis, *Lunes de Revolución*, p. 137.

27 Fornet, 'La Década Prodigiosa'.

28 Reported in Del Valle, 'Cine y Revolución'.

29 Cabrera Infante in Luis, *Lunes de Revolución*, p. 47.

30 Ibid.

31 Guevara and Estupiñán Zalvidar, 'El Peor Enemigo de la Revolución es la Ignorancia'.

32 'Literatura y Revolución: Entrevista a Carlos Franqui' [Literature and Revolution: Interview with Carlos Franqui] (1981), Luis, *Lunes de Revolución*.

33 K.S. Karol, *Guerrillas in Power: The Course of the Cuban Revolution* (London: Jonathan Cape, 1971 [1970]), p. 40.

34 Roberto Fernández Retamar, 'A Cuarenta Años de "Palabras a los Intelectuales"' [To Forty Years of 'Words to the Intellectuals'] (2001), *Cuba Defendida*, p. 297.

35 Guevara and Estupiñán Zalvidar, 'El Peor Enemigo de la Revolución es la Ignorancia', unpaginated.

36 Blas Roca Calderío, 'Respuesta a Alfredo Guevara II' [Response to Alfredo Guevara II], *Hoy*, 20 December 1963, reproduced in G. Pogolotti (ed.), *Polémicas culturales de los 60* [Cultural Polemics of the 1960s] (Havana: Instituto Cubano del Libro, 2006), pp. 185–8.

37 Fidel Castro Ruz, 'Palabras a los Intelectuales' [Words to the Intellectuals], *The Revolution and Cultural Problems in Cuba* [1961].

38 Guevara and Estupiñán Zalvidar, 'El Peor Enemigo de la Revolución es la Ignorancia', unpaginated.

39 Del Valle, 'Cine y Revolución'.

40 Lisandro Otero, *Llover sobre Mojado: Una Reflexión Personal sobre La Historia* [To Rain on the Wet: A Personal Reflection on History], (Havana: Editorial Letras Cubanas, 1997).

41 Fernández Retamar, 'A Cuarenta Años de "Palabras a los Intelectuales"', p. 294.

42 Karol, *Guerrillas in Power*, p. 140.

43 Carlos Franqui, *Family Portrait with Fidel* (London: Jonathan Cape, 1983), p. 131.

44 Otero, *Llover sobre Mojado*.

45 Del Valle, 'Cine y Revolución'.

46 Luis, *Lunes de Revolución*.

47 Fernández Retamar, 'A Cuarenta Años de "Palabras a los Intelectuales"'.

48 Guillermo Cabrera Infante, 'The Twisted Tongue of the Poet', *Mea Cuba* (London: Faber and Faber, 1994), p. 40.

49 MINREX, *The Revolution and Cultural Problems in Cuba*.

50 C. Wright Mills, *Listen, Yankee: The Revolution in Cuba* (New York: Ballantine Books, 1960), p. 42.

51 Ernesto Guevara, 'Socialism and Man in Cuba', *Marcha*, 12 March 1965, unpaginated.

52 Castro Ruz, 'Palabras a los Intelectuales'. While Fidel's speech is the only official record of the library meetings, Cabrera Infante claims in *Mea Cuba* that Alfredo Guevara ensured that covert recordings of all the presentations were made.

53 Lee Lockwood, *Castro's Cuba, Cuba's Fidel: An American Journalist's Inside Look at Today's Cuba in Text and Pictures* (Boulder, CO: Westview Press, 1990 [1967]), p. 68.

54 Castro Ruz, 'Palabras a los Intelectuales', p. 10.

55 Ibid., p. 14.

56 Ibid.

57 Leon Trotsky, *Literature and Revolution* (Chicago: Haymarket Books, 2005 [1924]), p. 96.

58 Castro Ruz, 'Palabras a los Intelectuales', p. 33.

59 Fernández Retamar, '1961'.

60 Castro Ruz, 'Palabras a los Intelectuales', p. 18.

61 Ibid.

62 Fernández Retamar, '1961'.

63 Gemma Del Duca, 'Creativity and Revolution: Cultural Dimension of the New Cuba', J. Suchlicki (ed.), *Cuba, Castro and Revolution* (Coral Gables, FL: University of Miami, 1972), p. 96.

64 Claudia Gilman, *Entre la Pluma y el Fusil: Debates y Dilemas del Escritor Revolucionario en América Latina* [Between the Quill and the Rifle: Debates and Dilemmas of the Revolutionary Writer in Latin America] (Buenos Aires: Siglo Veintiuno, 2003).

65 Rolando E. Bonachea and Nelson P. Valdés, 'Culture and Revolutionary Ideology: Introduction', *Cuba in Revolution* (Garden City, NY: Doubleday & Company, 1972), p. 497.

66 Macdonald Daly, 'A Short History of Marxist Aesthetics', L. Baxandall and S. Morawski (eds.), *Karl Marx and Frederick Engels on Literature and Art* (Nottingham: Critical, Cultural and Communications Press, 2006), p. xx.

67 See, for example, Stephanie Schwartz, 'Tania Bruguera: Between Histories', *Oxford Art Journal*, 35, no. 2, 2012, pp. 215–32.

68 Franqui, 'Literatura y Revolución', p. 193.

69 Franqui, *Family Portrait with Fidel*, p. 134.

70 Luis Camnitzer, *New Art of Cuba* (Austin: University of Texas Press, 1994), p. 129.
71 Judith A. Weiss, *Casa de las Americas: An Intellectual Review in the Cuban Revolution* (Chapel Hill, NC: Estudios de Hispanófila, 1977), p. 27.
72 Kapcia, *Havana*, p. 134.
73 Par Kumaraswami, 'Cultural Policy and Cultural Politics in Revolutionary Cuba: Re-reading the Palabras a los Intelectuales (Words to the Intellectuals)', *Bulletin of Latin American Research*, 28, no. 4, 2009, p. 532.
74 Ibid., p. 535.
75 Ibid., p. 538.
76 Fornet, 'La Década Prodigiosa', p. 10, italics in original.
77 Karol, *Guerrillas in Power*, pp. 242–3.
78 Camnitzer, *New Art of Cuba*, p. 130.
79 Kapcia, *Havana*.
80 Rodríguez Manso, *45 Años Después*.
81 Fernández Retamar, 'A Cuarenta Años de "Palabras a los Intelectuales"'.
82 These are: UNEAC, *Memorias del Primer Congreso Nacional de Escritores y Artistas de Cuba* and Rodríguez Manso, *45 Años Después*.
83 MINREX, *The Revolution and Cultural Problems in Cuba*, p. 8.
84 UNEAC, *Memorias del Primer Congreso Nacional de Escritores y Artistas de Cuba*, p. 10.
85 Dorticós's speech is provided in English translation in MINREX, *The Revolution and Cultural Problems in Cuba.*, pp. 68–76; these citations are taken from page 74.
86 Antonio Gramsci, *Selections from Cultural Writings* (Cambridge, MA: Harvard University Press, 1991), p. 95.
87 Consejo Nacional de Cultura, *Política Cultural de Cuba* [Cultural Policy of Cuba] (Havana: Consejo Nacional de Cultura, 1970).
88 Lockwood, *Castro's Cuba, Cuba's Fidel*, p. 111.
89 Ibid., p. 112.
90 Mario Benedetti, 'Present Status of Cuban Culture', Bonachea and Valdés, *Cuba in Revolution*, p. 520.
91 Juan Sanchez, 'Interview with Armando Hart Dávalos', *Bohemia*, 20 October 1989, p. 8.
92 Gilman, *Entre la Pluma y el Fusil*.
93 José Martí, 'Our America', P.S. Foner (ed.), *Our America by José Martí: Writings on Latin America and the Struggle for Cuban Independence* (New York and London: Monthly Review Press, 1977), p. 92.
94 Camnitzer, *New Art of Cuba*, p. 132.
95 Martí, 'Our America', p. 92.
96 Cited in Mills, *Listen, Yankee*, p. 133.
97 Benedetti, 'Present Status of Cuban Culture', p. 524.
98 Ibid., pp. 524–5.
99 Rodríguez Manso, *45 Años Después*.
100 Graziella Pogolotti, interview with the author, Havana, 9 March 2010.
101 Guevara and Estupiñán Zalvidar, 'El Peor Enemigo de la Revolución es la Ignorancia'.
102 The retrospective congress publication lists both the national committee and its executive in full; Guevara took up a position on the first and Retamar on the second.
103 Fernández Retamar, '1961', p. 73.
104 Fernández Retamar, 'A Cuarenta Años de "Palabras a los Intelectuales"', p. 301.
105 Del Duca, 'Creativity and Revolution'.
106 Jaime Sarusky and Gerardo Mosquera, *The Cultural Policy of Cuba* (Paris: UNESCO, 1979), p. 41.

Cultural Policy 1961–7

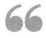

> The rounded personality of the man of tomorrow
> requires more than mere passive spectatorship. For
> their physical and mental balance alike human beings
> need to know and practice one of the arts.

– Che Guevara, 1965

A hint has already been offered about the various interests at play within the cultural arm of the Revolution. Here, we shall look more closely at the ways in which policy was formulated and enacted, from the moment at which the CNC began interpreting the revolutionary government's cultural ideas.

Formulation of Cultural Policy by the CNC 1961–4

In 1961, the CPC published an unassuming four-page pamphlet entitled *Culture for the People*. Extracted from a scholastic manual of Marxism-Leninism issued the previous year, it laid the foundations for mass participation in culture, beginning: 'The socialist regime converts culture into a profoundly democratic instrument, making it the patrimony of the whole society and not one confined to the stratum of intellectuals'.[1] Consistent with Gramsci's conception of organic intellectuals and the Cuban approach to education more broadly, the underlying rationale for this was that 'Thousands and thousands of men of talent are lost in the capitalist world, unable to find a path through the privations and indifference of society'.[2] By contrast, under socialism, it was envisaged that 'persons with creative abilities should develop their gifts and individuality to the full, and [...] the work of writers and artists should contribute to the endeavour of social and personal liberation to which social-ism is committed'.[3] While it may seem surprising that individuality was being encouraged under socialism, Carlos Rafael clarified thinking on this by isolat-ing individuality as the main factor distinguishing artists from other workers. Moreover, like Che before him, Rafael argued that this positive trait must be

freed from the kind of petit-bourgeois individualism which rendered aesthetic pleasure a temporary escape from alienation, in a realm detached from everyday life, neutralising critique and foreclosing the prospect of social change.[4]

Following the charged meetings of spring–summer 1961, the CNC's interpretation of government policy cohered into a ten-point Preliminary Plan by the end of 1962.[5] Grounded in the imposing realities of the country, this aimed:

1. To study and re-evaluate cultural tradition, especially that of the nineteenth century in which Cuban national identity arose.
2. To study and research cultural roots, recognising the Negro contribution to Cuban culture.
3. To divest folkloric expressions of their non-essential elements.
4. To unreservedly acknowledge the talent and creative capacity of Cubans, offering the opportunities necessary to end devaluation of their production.
5. To form, through art schools and seminaries, a new intelligentsia arising from the worker-farmer masses.
6. To promote art and literature consonant with the historical moment in which Cuba exists, through educative practice promoting a greater degree of intimate contact between creators and the people, through coexistence in farms and factories, enabling better reflection through creative work.
7. To afford sciences a corresponding place in cultural activity in the process of improving the conditions of an underdeveloped country.
8. To promote cultural improvement in the great majority of people, intensively developing activities aimed at increasing interest in good art and reading books of literary and scientific value.
9. To erase the inequalities between the cultural life of the capital and the rest of the island, promoting cultural activities in the rural and urban areas of the provinces.
10. To develop the maximum possibilities for cultural exchange with all countries in a way that allows the people of Cuba, its intellectuals and scientists the opportunity to know the cultural expressions and scientific criteria of different schools and continents.

We see that ideas around the vindication of Cuban national culture and folklore – outlined in the November manifesto and explored at the 1961 congress – remain constant, as does the objective of international cultural exchange. Within this, much more detailed consideration is given to the ways in which the 'mutual reconciliation between writers, artists and the people', outlined by artists and writers in August 1961, would be achieved, with specific steps being outlined for raising the cultural level of the population, which saw

creativity entering into the majority of workplaces. It is also noteworthy that the discussion around critique has been displaced by the abiding revolutionary commitment to eradicating differences between rural and urban cultural life. At the same time, science has been incorporated into considerations of culture, as envisaged by the members of Nuestro Tiempo and deemed necessary in a country emerging from underdevelopment.

In chapter three, we saw that, during 1961–2, increasing pressure was mounted against those who wanted to avoid repeating the aesthetic and administrative mistakes of the Soviet Union. Intellectuals who elected not to represent the Revolution directly in their work were presumed to be disinterested in its processes, resulting in a situation that would see 'artists and writers facing absurd prejudices and being marginalised, while mediocrity inhabited abandoned terrain and partly debilitated the creative impulse'.[6] Earlier, Gramsci had observed that:

> When a politician puts pressure on the art of his time to express a particular cultural world, his activity is one of politics, not of artistic criticism. If the cultural world for which one is fighting is a living and necessary fact, its expansiveness will be irresistible and it will find its artists. Yet if, despite pressure, this irreversibility does not appear and is not effective, it means that the world in question was artificial and fictitious, a cardboard lucubration of mediocre men who complain that those of major stature do not agree with them.[7]

It was retrospectively observed by the Central Committee of the PCC that, during this early period, 'certain old militants of the People's Socialist Party and some opportunists [...] without any revolutionary merit whatsoever, had climbed to positions within the party and government'.[8] On 26 March 1962, Fidel publicly reined in the influence of orthodox elements within the PSP by unmaking the 'sectarianism' perceived to exist within the Revolution, which he described as the 'tendency to mistrust everyone who could not claim a long record of revolutionary militancy, who had not been an old Marxist militant'.[9] As a result, Aníbal Escalante – who was perceived to have exploited his position for personal and political gain – and eight of his comrades were temporarily exiled. The ORI mutated into the United Party of the Cuban Socialist Revolution (PURSC), membership of which was reserved for exemplary workers and those who continued to fight for the Revolution, irrespective of their past glories and Marxist credentials. This diminished the orthodox role and sent a clear message to all dogmatic currents within the Revolution that would serve to subdue them for a while.

The missile crisis of October 1962, which revealed Cuba to be little more than a pawn in the game between the two super powers, would have important consequences for the island's relationship with the Soviet Union. Fidel

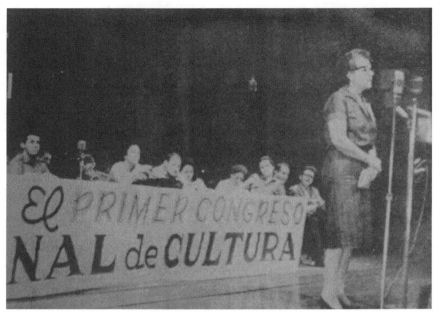

Intervention by Edith García Buchaca at the CNC's First National Congress of Culture, December 1962.

has spoken of how Cuba's subsequent mistrust of Khrushchev 'could never be completely overcome',[10] reaching a low point just before the latter was ousted in October 1964, with Cuban–Soviet relations improving thereafter. In the process, it is argued that Fidel 'had come to the conclusion that he no longer needed ideological go-betweens in his negotiations with Russia. The Communists of the PSP had probably proved a greater disappointment to him than even Khrushchev: at the crucial moment they had supported the views of the Soviet Premier against his own. Fidel felt that he could no longer trust them, and denied most of them any further part in the negotiations with the East'.[11]

On Sunday 25 November 1962, a month after the missile crisis, Edith García Buchaca presented the CNC's Preliminary Plan to a Provincial Assembly of Culture in Havana.[12] She referred to similar assemblies having been effected in the other five provinces, with representatives of official and mass organisations, artists and writers meeting to scrutinise the plan following discussions within every work centre, studio, farm and trench. Out of this process, the definitive remit of the CNC would arise. This emphasised the council's continued reliance on the exemplary efforts of professional writers and artists at a national, provincial and municipal level, compelling their support in disseminating cultural activities to the furthest corners of the island, with the cultural integration of writers, artists, workers and governmental figures being cited as one of the greatest achievements of 1962.

Alongside consideration of the Preliminary Plan, Cuba's mass organisations also spent two months elaborating their own proposals about how cultural development could be accelerated, and, at the CNC-organised First National Congress of Culture,[13] held in Havana in December 1962, each province outlined its programme of work in the cultural field, in parallel with that being undertaken in production and defence. In his introduction to this congress, Dorticós indicated that one of the fundamental tasks of the Revolution was to create a culture for the people based on the principles of Marxist humanism. At the same event, Che found it necessary to defend ICAIC's autonomy 'against PSP criticism, while ICAIC criticised the CNC's "populism" and defended artistic experimentation'.[14] In spite of these simmering tensions, the congress unanimously approved the plans that had been drawn up by the CNC in relation to cultural and educational construction for 1963.

Looking at the Preliminary Plan in greater depth, we find a two-pronged strategy for tackling the gap between art and the people. This proposed that, in order to overcome the unequal access to culture that had been inherited from class society, both the dissemination of the most representative artistic and literary expressions of each era and the direct participation in cultural activities needed to be encouraged. The fundamental objectives of this dual programme were:

1. To incorporate thousands of working men and women into cultural activities, encouraging them to use their free time to improve themselves.

2. To enable the national talents existing within the people to be discovered and the best possibilities offered for developing them to the full.

3. To encourage the transmission of culture, via *aficionados* [amateur artists], to work colleagues, farmers and the general population; to bring cultural shows to the remotest areas which would otherwise feel themselves starved of culture owing to the scarcity of professional and semi-professional groups in the country; to increase the ideological level of the people.

4. To incorporate those vacillating into revolutionary activity, increasing their integration into, and fuller understanding of, the Revolution.

5. To procure a gradual elevation of a popular critical sense in relation to artistic work, bridging the gulf that exists between the cultural levels of the rural and urban areas and between the interior of the country and the most advanced sectors of the capital.

6. To procure, through the activities of *aficionado* groups, the promotion of artistic spectacles, disseminating an interest in music, dance, theatre, literature and the plastic arts.

In this interweaving of appreciation and participation, we find the most explicit inscription into policy of the synergy between culture and ideology, through the expressed desire to increase the ideological level of the people and incorporate vacillators into the Revolution. At the same time, consideration of stimulating a critical sensibility has been reinstated, though significantly this refers to the broad populace.

With regard to cultural appreciation, the CNC implemented a programme of activities, and, in the first half of 1963, almost half the population visited a concert, theatrical performance, museum, exhibition or similar. Like the literacy activists before them, cultural brigadiers took an appreciation of art into the countryside, giving talks and organising conferences to explain works of theatre, dance and music. Massively improved access to creative education, combined with the proliferation of exhibition spaces, served to create a huge public for literary and artistic expressions which had previously been reserved for an urban minority. Ambrosio Fornet describes how the successes of the 1960s found their way 'directly or indirectly into the rugged terrain of ideology. Hundreds of thousands of people were able to read a book for the first time [...] Hundreds of thousands of adolescents attended a painting exhibition for the first time, listened to a recording of symphony music or were present at a performance of ballet or traditional dance'.[15] By 1975, an estimated 67 million visitors attended CNC-supported events. And, while there are those who contend that art audiences remained more sophisticated in urban areas,[16] Pogolotti argues that 'The end result is that there has undoubtedly been an extension of the public for culture, and a great effort has been made to disrupt the monopoly of the City of Havana'.[17]

Turning to a consideration of what Fidel, in his 'Words to the Intellectuals', had called the 'conversion of the people from spectators into creators',[18] we find the recognition that new tools would be needed in order to achieve this transformation. While the establishment of ENA had been instrumental to fostering professional artists, the stimulation of artistic talents in the broader population would demand the training of more specialist teachers. In 1961, building on Che's earlier initiative to educate the peasants of the Rebel Army, the INRA created a School for Art Instructors.

While something of a precedent for this programme exists – in the Proletkult group's instigation of proletarian creative writing studios in the Soviet Union; in the coercive, Soviet-inspired Movement for Communication between City and Countryside, initiated in Poland in 1948; and in the rural mobilisation of artists and writers as part of the Great Leap Forward in China from 1958 – the CNC claimed no experience on which to draw for the selection of alumni and the planning of studies. Following an extensive series of discussions and seminars, various skills deficits were identified and plans systematised – under the CNC's National Directorate of Cultural Extension

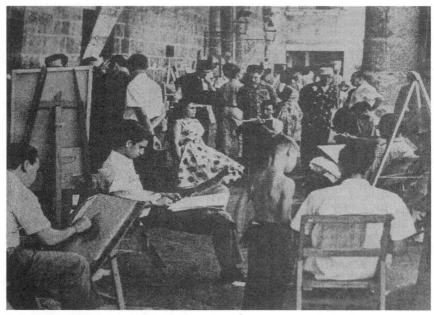

A group of plastic arts *aficionados* [amateurs].

– in a School for Cultural Activists, a boarding establishment at which training costs were covered and students were paid wages for the duration of their courses. This formed the basis of a major initiative to train thousands of art instructors, with a key distinction being that 'An instructor is not formed to be an artist but to detect, orientate, raise awareness of and stimulate activity in diverse sectors of the population.'[19]

Teacher-training courses were open to entrants aged between fifteen and twenty-five, pending completion of the fourth grade of primary school. Instructors were trained in popular music and theatre (from 1961), modern dance (from 1962) and the plastic arts (from 1963), underwritten by general technical knowledge and a study of folklore, with cross-disciplinarity being encouraged. Consistent with primary teaching, dissemination of the plastic arts was centred on the principles of design and on the development of manual dexterity and the juvenile imagination, and the CNC deemed the use of the plastic arts in popular mobilisation to be as important as the campaigns aimed at increasing public health or enhancing productivity.

Instructors were initially selected from people's farms and popular zones to study in the capital, thereafter returning to their places of origin to disseminate the skills they had learnt. By 1963, 1,500 young people had registered as instructors, and those with a vocation for teaching remained in the school. By 1975, forty-seven schools were providing artistic education courses to 5,000 trainee teachers, and, by the end of the decade, a UNESCO report would refer to 40,000 young people being offered scholarships to undertake

a 'two-year training course to enable them to promote the various forms of artistic expression in the previously utterly neglected rural areas'.[20]

As outlined in the Preliminary Plan, these tens of thousands of arts instructors were trained with a view to stimulating groups of *aficionados* throughout the island. Mediated by the CNC and relevant social organisations, this programme encouraged 'the people to channel in large part their artistic vocations and to develop their aesthetic perceptions'.[21] Following Fidel's unmasking of 'sectarianism', CNC literature from this period argued that the concerns of the Revolution could be expressed without recourse to demagogical or sectarian tendencies, with the cultural improvement of the people and the development of a critical spirit being considered inherently revolutionary. At the same time, mass popular aesthetic education was expected to promote the 'transformative action of the masses in essential aspects of social life like family and human relations, an interest in beauty and modification of [...] work and domestic environment'.[22] This meant that the repertoire disseminated to groups of *aficionados* was intended to stimulate the production of works that heightened the best feelings of man without needing to be explicitly political in content.

In the early years, the *aficionado* programme was based in student and work centres, farms, cooperatives and peasant organisations, promoted by the corresponding mass organisations and unions, and, in 'Words to the Intellectuals', Fidel spoke of sending instructors out to 3,000 people's farms and 600 cooperatives. Over the first decade of the scheme's operation, many vocational arts centres were opened, which played an important part in both diffusing cultural products and capturing the artistic talents of the people. Among sixty-three plastic arts centres, various workshops existed in which *aficionados* received the training necessary to make their own artworks. These workshops and social houses were the font of copious production, and exhibitions of artwork generated there toured around the island. UNESCO became a key partner in these educational endeavours, setting up a National Commission on Cuba and making slides, albums and other materials available for the purposes of developing art education in young people and adults. The commission also organised panel discussions, featuring pedagogical experts, and arranged didactic travelling exhibitions, often involving reproductions of famous artworks.

In 1978, the network of Casas de Cultura would become the headquarters of the *aficionados* movement,[23] and, the following year, this effort would be specifically oriented towards the education of workers. While a National Technical Commission evaluated the progress of *aficionados*, as distinct from that of professional artists, the Casas were responsible for collecting data on the various groups. From the vantage point of 1984, official statistics provide an overview of the programme, showing that the number of instructors rose

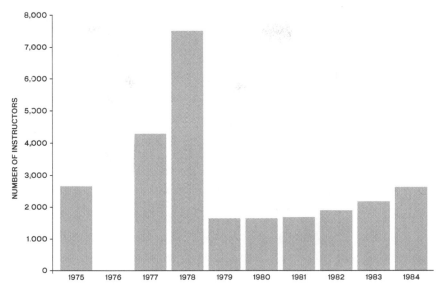

Graph showing the number of arts instructors growing throughout the 1970s before dipping sharply in 1979.

steadily during the first two post-revolutionary decades, tailing off sharply in 1979 before beginning to rise again. The trough in the late 1970s, which coincides with the expansion of the Casa network under MINCULT, was partly compensated for by an increase in the numbers of teaching assistants, which more than doubled in the period 1975–84, dipping only slightly towards the end of the 1970s. Despite fluctuations in the levels of pedagogical personnel, the number of entrants to the *aficionados* programme consistently showed a gradual increase, which was reflected in the number of activities being undertaken.

In 1975, Fidel reprised the work of the CNC in this area, commenting on the massive expansion from 1,164 *aficionado* groups in 1964 to more than 18,000 groups realising 120,000 creative projects a decade later. Sarusky and Mosquera note that 'Through this system [...] large sectors of the population have had the opportunity to receive instruction in the different forms of artistic expression. It has served to enrich the non-material aspects of people's lives and given rise to a movement of amateur artists which has produced many artists of considerable talent'.[24]

In considering this initiative for bringing art to the people, Antoni Kapcia traces its roots to the *PM* affair and the attempts to disarm *Lunes* as a 'self-appointed vanguard':

> Hence, while *Lunes* focused on the cultural *products* of established cultural *producers*, in the *barrios* a real revolution was taking place involving

consumers in the processes of cultural *production*. It was a change with fundamental implications, asking Havana's cultural activists to identify with a different cultural community, the Cuban world they had previously ignored, taken for granted, or perhaps theorised, instead of their natural tendency to identify with a wider global community of cultural producers.[25]

For Kapcia, the later tendency of Casas de Cultura to prioritise amateur creative production over professional practice inevitably created a rift between amateur and professional artists, based on 'an inherent tension in the original concept, whereby the *aficionado*, regardless of talent, could not become an artistic professional without specialist training, having only been coached by *instructores* trained to teach rather than develop their own art. Moreover, *aficionado* resentment of professional counterparts was mirrored by the latter's tendency to look down on the *aficionados*'.[26] While it is apparent that those seeking to become professional artists needed to undertake specialist training – at ENA and its outposts – which exceeded the competencies of arts instructors, the notion of a rift developing between professional and amateur camps will be interrogated here.

It will be remembered that, in his speech to the August 1961 congress, Fidel had urged professional writers and artists to go into the countryside and teach. What transpired was that practitioners were implicated in the process of training arts instructors, and, the following year, Retamar would insist that these instructors could only be trained, directly or indirectly, by those who had already assumed the criteria and attitude of art – that is, by artists.[27] A National Centre for Aficionados and its provincial counterpart would eventually ensure the most effective links between amateur and professional artists. The definition of teachers would come to include both the instructors of *aficionados* and professional art tutors, and fluidity existed between the two types of teacher, with many of the former going on to teach at ENA. At the same time, there is evidence that exceptional amateur artists could ascend to ENA and join the professional ranks, which led to a proportion of *aficionados* entering the field of art as their vocation, and Adelaida de Juan flatly denies the existence of any conflict.[28]

At least initially, the professional community appeared to demonstrate enthusiasm for the potential of the *aficionados* programme, not only in generating new audiences but also in engendering a rigorous culture in which the creation of a vanguard in an underdeveloped country in revolution was more than just a theory. As one of the intellectuals articulating this stance, Retamar celebrated the reduced separation between culture and the people while cautioning against populism.[29] But, visiting Havana in 1968, Arnold Wesker would observe that 'Retamar doesn't confess to, or he's aware [sic] of,

another kind of exploitation of which he is guilty; that of living a satisfactory intellectual and social life – albeit a highly moral, revolutionary and responsible life – while his material goods are being provided by the people who hate having to provide them'.[30] This extends into the statement that 'What Retamar needs, though he could not articulate it, is that the worker will become conscious but not too conscious, that he will assume new dignity but not get too carried away with it, that he will have respect for culture but not imagine he's too cultured, that he'll honour the professors but not actually demand to be one'.[31] This suggests that, instead of eroding the divisions between intellectuals and the people, a hierarchy was maintained – an allegation which merits further exploration.

In relation to the divisions between professional and amateur art-making, we have seen that the distinction between high and popular art was assiduously sustained in an attempt to encourage the former. This raised the issue of qualitative difference between professional and amateur output, which the CNC stressed the need to resolve in its Preliminary Plan. In the early 1960s, there were insufficient instructors to meet demand, and some groups formed spontaneously, which rarely gave rise to creative output of any quality. Even in groups with instructors, it became clear that work would be required before *aficionados* accepted the need to rehearse for weeks before a performance or to develop their technique before mounting exhibitions. On the one hand, *aficionado* groups were continually encouraged to strive for an increase in the quality of their work. On the other hand, as the massive incorporation of the people into cultural participation was being attempted in a culturally impoverished country, it was felt that, if quality were too stringently defined, it would constrain popular enthusiasm. In an attempt to resolve this dilemma, two stages were introduced, with provincial monitoring being carried out. In the first stage, the demands of quality were kept to a minimum; for *aficionados* progressing to the second stage, quality became more of a prerequisite.

Despite the consistent, and commendable, emphasis of the revolutionary government on quality, high standards of creative production were difficult to attain. At the start of the twenty-first century, Nancy Morejón would find quality lacking:

[...] there came a certain point when the idea of massive numbers of people pursuing cultural interests became a priority of the government, often above everything else. They forgot that, in order to appreciate art, people have to have some basic ideas about the need to recover the essence of beauty. It is very true that liberating social sectors as well as progress and social mobility clearly need not be limited to the individual. Just the opposite: They have to reaffirm it. The problem was that often,

closely connected with this emphasis on such a massive approach to culture, there came the accompanying practice of justifying mediocrity, often in the name of a supposed form of equality. As a result, we have often protected mediocre cultural expressions, and I believe that we should be more rigorous.[32]

There is parity here with the literacy campaign, which achieved literacy throughout the island, albeit at a basic level. Extending the literary metaphor into the plastic arts, reading is to the passive reception of art what writing is to its active production. As anyone will know who has learnt a foreign language in later life, it is easier to read and understand than it is to gain the confidence to speak. This suggests that we need to revisit *The German Ideology* and the point that 'If, even in certain social conditions, everyone was an excellent painter, that would not at all exclude the possibility of each of them being also an original painter'. If we take excellence to refer to technical ability, which can be disseminated, and originality to refer to an elusive element which cannot be taught, we might conclude that, while there may be no limit to the number of technically excellent painters that might be formed with the right training, artists with an original perspective on the world will always form a finite group. This vital ingredient corresponds with Carlos Rafael's understanding of individuality with which this chapter began.

Reflecting on Cuban policy-making in the 1960s, C. Ian Lumsden cautions that 'Mass mobilization campaigns are not the same as political participation'.[33] Scrutinising this tendency further, Espina Prieto argues that 'The people (recognized as heterogeneous) who should be the protagonists of the transformation controlling its outcomes and its use of resources, are merely consulted and mobilized'.[34] In the cultural field, the population was not only consulted and mobilised but also participated in its own transformation through cultural engagement, thus departing from other spheres of social change. As such, Craven asserts that 'Far from being mere vanguard accomplishments, then, cultural democracy and the project of socializing art within the Cuban Revolution of 1959 were in fact manifestations of the Cuban populace intervening in history and assuming an active role in national affairs'.[35]

By way of concluding this discussion, it is worth remembering that the original impetus underlying the *aficionado* programme came from Che's insistence on educating all those who had fought in the uprising and his belief that 'the Revolution stood primarily for social justice, for repairing the criminal neglect of the *humildes*, that enormous unemployed and semiliterate mass of yesterday'.[36] By the end of the 1970s, it would be possible to say that: 'on the one side, all possible facilities for artistic creation have been provided; on the other, the masses have been given access to aesthetic enjoyment as an inalienable right attaching to the human condition'.[37] There can be no doubt

that contemporary Cuba has a highly culturally literate population, engendered through active engagement in the processes of making art combined with exposure to the highest quality cultural productions.

Returning to the development of policy by the CNC in the early 1960s, we find that, in the wake of the 1962 congress, the Preliminary Plan was worked up into a general plan that would be enacted by every province and municipality during the following year. At the same time, a pamphlet was published, describing the cultural policy of the revolutionary government, which reiterated the CNC's role of orientating, directing and organising cultural manifestations across art forms. In July 1963, when necessity dictated that the CNC cease being an appendage of MINED, the council assumed responsibility for all activities relating to the plastic arts, including exhibitions and the acquisition and conservation of artworks on the part of the state. In addition to this, it would oversee all levels of artistic teaching, the importation of necessary materials, press briefings, permissions for overseas travel and the organisation of artistic and literary competitions while also appointing their juries. In this way, the CNC achieved a situation of almost total control over every artistic avenue.

The Persistent Polemic around Socialist Aesthetics

The early autonomous period of the CNC coincided with the launch of a staunch polemic that needed to be rebutted by Cuba's creative practitioners. Fornet reminisces that few intellectuals suspected that 'the inheritance of scholastic Marxism was so strongly in our midst, or at least among some intellectuals from the Partido Socialista Popular [PSP]' until 'one of our most brilliant and respected essayists, Mirta Aguirre, wrote in October 1963' a text called 'Notes on Literature and Art'.[38] In this text, published in the journal *Cuba Socialista* [Socialist Cuba], the CNC's Director of Theatre and Dance invoked art as a form of knowledge capable of investigating reality through the reconciliation of concrete creation and abstract thought. As her PSP ally and CNC superior, García Buchaca, had done before her, Aguirre grounded her ideas in the wholesale rejection of idealism. This was predicated on the understanding that, in Marxist-Leninist aesthetics, as in science, the creative act loses all mysterious content to become based in hypothesis. In turn, Aguirre's thesis presumed that the transformation of metaphysics into materialism required two routes to knowledge – science and art, or logical thought and thought acquired through images – both of which were conditioned by objective reality. For her, the conceptual dimension of creative praxis must not be underestimated, conferring upon artists a great responsibility and revolutionary duty. And, whereas to undervalue the beautiful in art

(distinguishing it from science) would be a serious mistake, to limit art to the sensorial – to the element of beauty – would be tantamount to a crime.

In rejecting the purely sensory, Aguirre asserted that abstract art decoupled perception from intellect, and, while this way of working might be useful within the applied arts, abstraction could not be considered the supreme artistic expression of a socialist society. For her, impressionism and surrealism were found to be fundamentally incompatible with dialectical Marxism, and such bourgeois forms of culture (which represented the interests of the overthrown class) should not be allowed to proliferate. Speculating on artistic work appropriate to a revolutionary situation, she categorised images as representations of things – a subjective reflection of the objective world – and considered how best these representations could be made. Rather than striving for a mimetic copy of external reality that would deceive the senses, she argued, the character of realism should be derived from the extent to which it expressed a 'correct' reflection of the real. Reaching the crux of her argument, Aguirre proclaimed that 'Socialist realism which does not undervalue beauty in art, understands it as a vehicle of truth, an element of knowledge and a weapon of transformation of the world'.[39] Combining aesthetics with scientific materialism, she argued, socialist realism obtains an honest and historically concrete representation of reality in its revolutionary development. As we saw in chapter three, this sentiment was derived from Zhdanov's edict to the 1934 congress which had been parroted in the CNC's first interpretation of government policy.

While Aguirre's essay made it abundantly clear that attempts to prescribe aesthetic approaches had not disappeared, this tendency – and its liberal counterpart – had been bubbling under the surface for some time. Six months previously, in an article for the bimonthly UNEAC journal, *La Gaceta de Cuba*, the musician and Nuestro Tiempo co-founder Juan Blanco had reminded his readers of the anti-nationalism and obscurantism that had prevailed under the previous regime.[40] While it had not been possible to counteract this tendency under capitalism, he argued, the Revolution had rescued the dignity of a people, with artists among them. But, while Cuba as a whole would not delimit cultural advances, the regressive forces of imperialism had their heirs, few in number, who used new arguments but made similar points to their forebears in matters of art and culture. Amid the dogmatists of the left and the opportunists of the right, he found attempts to restrict revolutionary cultural policy and a desire to confine artists to a single expressive course – realist or abstract, depending on taste – with the former group appealing to a deformation of Marxism-Leninism in a bid to disorient the people. He urged his colleagues to unmask these enemies of the Revolution wherever they were found and to combat them with increasing force, with the full support of the revolutionary government.

In the same journal issue, Julio García Espinosa alluded to those within the cultural community who insisted on trying to impose pre-existing formulae onto rapidly changing reality, which had emerged as a concern during a recent UNEAC assembly.[41] He discerned that never before had Marxism been closer to a religion, attempting to freeze reality and make an abstraction of the Revolution and its people. In the process of suppressing the chaos of capitalism through socialism, the film-maker warned that dogmatism sought to dominate men rather than encouraging them to be masters of their own destiny. In order to counteract this, it would be necessary to become fully aware of the new reality and, without fear or prejudice, to raise all the questions that this reality dictated, which paved the way for a frank debate around the possible direction of culture.

Three months after his article appeared, García Espinosa would be one of more than 250 signatories to a statement made by a group of film-makers who met in the Department of Artistic Programming at ICAIC on 4, 5 and 6 May 1963 to discuss some of the fundamental problems of cultural policy and aesthetics, particularly the application of debatable, and largely unacceptable, aesthetic principles determined in the Soviet Union. The statement was dated 1 July 1963 and published in *La Gaceta de Cuba* on 3 August of the same year.[42] Its signature initiated a custom of periodically confronting themes of shared interest in relation to the meaning of creative work within society.

Rather than representing a precise consensus, the statement achieved unanimity around certain principles considered essential to the daily preoccupations of artists and intellectuals and of increasing interest to the people of Cuba. It proposed that, in a socialist society, the promotion of culture was the right and responsibility of the party and government. Beyond this, the trajectory of art should be determined through a struggle between aesthetic ideas. To deny that struggle and proclaim peaceful coexistence would be to proclaim an illusion, and the victory of one tendency over another could only be achieved through suppression, by attributing a class character to artistic forms in ways that arbitrarily restricted the necessary conditions of struggle and the development of art. By contrast, the film-makers' statement was predicated on the idea that the formal categories of art do not have an inherently class character; rather, art is a social phenomenon – both a reflection and a form of objective reality – in which the ideological position of its author is not a determinant of quality.

As we have seen, the film-makers' position fits with the understanding of Marx and Engels that the ideology of an artwork is distinct from that of its maker. Before them, Hegel had framed reality as an entity that evolves according to humanity's needs and is represented by artists accordingly. Also of great relevance to this study is his dialectical notion that, rather than having to choose between different philosophical systems, it was possible to

analyse each one and its ostensible opposites and to envisage a holistic system in which all of these tendencies co-existed.[43]

Two months after publication of the statement, three articles appeared. One of these was authored by Alfredo Guevara in *Cine Cubano*, the in-house magazine of ICAIC, and affirmed the difficult, but possible, task of reconciling the ongoing ideological struggle against class enemies and imperialism with the creation of conditions for the fullest freedom of experimentation in all aesthetic manifestations. To Guevara, it seemed apposite that creators would tackle the theoretical and practical problems thrown up by their work and consider, with the greatest seriousness and coherence, theses informing contemporary ideology, discourse and research in relation to diverse ways of elaborating cultural policy (as opposed to the constricted version being adopted by the CNC). But as he acknowledged, such intellectual activity would almost inevitably be perceived as heresy. And, while the directorate of *Cine Cubano* did not share the film-makers' theoretical formulations and maintained reservations about some of their resolutions, the journal subscribed to their conclusions and declared absolute agreement with their underlying intentions. In affirming the validity of dialogue and analysis, the journal not only published the statement but also saluted it as a crucial advance in the movement.[44] Guevara later asserted that these statements were intended to exempt film from being an instrument of education or propaganda and to reinforce its role as art.[45]

On 18 October 1963, García Buchaca entered the debate, proclaiming that the task of government lay not only in promoting culture but also in orientating and leading it (as delegated to the CNC).[46] Echoing her earlier manual, she asserted that, while idealism and materialism may coexist for a while, they would be mutually exclusive if genuine Marxist criteria were adopted. Furthermore, the totalising process of supplanting one ideological expression with another should be reflected in creative work. Capitalism had aesthetic values as surely as it had scientific values, and limitations to creative expression would be an inevitable part of the intense struggle that accompanied the transition from one socio-economic form to another. In considering the film-makers' claim that the *formal* categories of art did not have a class character, she advised that the separation of the form of art from its content was inadmissible for a Marxist. Conceding that major developments in productivity did not always correspond with moments of artistic and literary splendour, García Buchaca nonetheless tied works of art to the general laws of production. Pondering the position of the creator in socialist Cuba, García Buchaca affirmed the responsibility of intellectuals and artists to refuting the alienated society of the past, thus limiting their activity to first-order negation.

In the same month as the contributions of Guevara and García Buchaca appeared, the ensuing polemic provoked the aforementioned treatise from Aguirre. Briefly concurring with the position of her cinematic colleagues, she

conceded that aesthetic contradictions were inevitable on the path to communism and that this recognition would help prevent dogmatism from taking root. But, she was quick to state that there was no possible reconciliation between dialectical materialism and either idealism or religious faith, and aesthetic tendencies could not be tolerated which were grounded in either of these orientations. In the process, Aguirre discerned that certain intellectuals were simultaneously proclaiming their dedication to eradicating the ideological vestiges of the overthrown society while continuing to justify them.

The matter remained unresolved and, in an open letter to Aguirre in the same issue of *Gaceta*, another Cuban film director, Jorge Fraga, traced the century-long search for a Marxist solution to the problems of aesthetics and cultural policy.[47] In particular, he sought to demonstrate the dual existence of bourgeois and socialist cultures in the struggle for Marxist hegemony, and he disputed the idea that the conditions for ideological coexistence could not establish themselves within the current criteria of Marxism. Consistent with the thinking of both Marx and Lenin, this led him to take issue with Aguirre's idea that only selected technical aspects of bourgeois culture should be carried forward. For him, the form and content of bourgeois culture, past and present, ought to be considered a valid part of the cultural inheritance of the proletariat within a dialectical process of acceptance and critique.

The following month, García Espinosa would reassert that the film-makers considered it a mistake to try and diminish or negate the importance of ideological struggle, which formed a vital part of creative activity.[48] In addition to their daily creative work and the taking up of arms whenever the Revolution called for it, ideological struggle between creative intellectuals would be fundamental to the development of critical thought. In his spirited defence of critique, García Espinosa pointed to those self-proclaimed Marxist-Leninists who promoted a formalist current that tried to claim universal truths without elucidating them. A necessary precondition for this was the separation of form and content, and García Espinosa conceded that, in proclaiming that formal categories had no class character, the film-makers had introduced ambiguity into the debate which could have been avoided by first clarifying that form and content are inseparable. Only by struggling against decadence and dogmatism, he argued, could the people be brought closer to artistic problems, in a dialectical relationship that would be integral to the development of art. In the process, he alluded to the fact that, not for the first time, intellectuals had needed to call upon the principal leaders of the Revolution in a bid to ensure that cultural policy was not made behind their backs.

The debate rumbled on, with a public discussion being staged by the Students' Association at the School of Letters, after which the film-makers felt the need to reaffirm their commitment to both their original document and an anti-dogmatic approach. In the rebuttals that followed, they were

variously accused of being part of a 'chapel', which should be rendered ineligible to use the means of dissemination funded by society, and berated (by Juan Flo, Professor of Marxist Aesthetics at the University of Havana) for their bourgeois origins, contra to the proletarian vision of the world that was being formulated. They were charged with separating art from life, in order to take positions around the former, and suspected of embracing cultural heritage in a way that was tantamount to prolonging bourgeois culture rather than contributing to its supersession. On the part of the film-makers, it was argued that consciousness did not evolve at the margins of class struggle but within it, and that, as art spiritually enriched man, it could play a vital part in the struggle for a new socialist culture (and the erasure of idealism) without necessarily having to be Marxist.

In December 1963, the discussion shifted from *Gaceta* into the daily newspaper *Hoy*, the official organ of the party, editorship of which had been taken over from Carlos Rafael by the former PCC leader Francisco Calderío López, under the name of Blas Roca (which he adopted in the 1930s). Within the 'Clarifications' column, a debate was generated around a handful of films from the capitalist world – specifically *La Dolce Vita* (directed by Federico Fellini in 1960) *Accattone* (directed by Pier Paolo Pasolini in 1961), *Alias Gardelito* (directed by Lautaro Murúa in 1961) and *The Exterminating Angel* (directed by Luis Buñuel in 1962) – which were accused of representing corruption and immorality. This made no acknowledgement of an informed critique of the superficiality of *La Dolce Vita*, which had appeared in the October–November 1963 edition of *Cine Cubano*, or of a similar treatment of *Alias Gardelito* included in the following issue. While an initial question, about whether the Cuban people should have access to these 'defeatist' films, was attributed to the well-known television actor Severino Puente and relied on anecdotal evidence from unnamed workers that these films were particularly unsuitable for Cuban youth,[49] future incarnations of the column were taken to be the work of Blas Roca himself. Such questionable productions from the capitalist world, it was argued, prompted a combatively critical attitude from those who were more revolutionaries than artists, more Marxists than anti-dogmatists, more creators than heirs.

British cultural theoretician Macdonald Daly raises a series of questions that might be posed in such circumstances. Where an artwork is 'reactionary, in however subtly tangential and aesthetically pleasing a manner, should Marxist critics thereafter simply wash their hands of it? Or should they embark on a critique of its content while praising its form? In short, how much is Marxist theory willing to separate the aesthetic value of a work of art from its ideological outlook?'.[50]

The outpourings of the Clarifications column prompted a spirited defence, from the directors of ICAIC in *Revolución*, of the properties of film

in enriching discussion and stimulating the imagination, which had a part to play in economic development.[51] In a letter to the same paper – signed by García Espinosa, Gutiérrez Alea, Fraga, Massip and other film-makers from ICAIC's Department of Artistic Programming – a response was made to both Puente and the directors of ICAIC.[52] This argued that art was both a reflection of life and a factor acting upon it. To insinuate, as the editor of the Clarifications column had done, that life was a reflection of art would be to attribute to cinema transformative powers that it could never possess. To advocate the prohibition of films of undeniable value would be to restrict cultural development and relinquish the liberation of cinema screens that had been achieved on 1 January 1959.

The following day, Guevara again entered the fray, responding to the original Clarifications column and exposing the abyss between the understanding of its editor and the meaning of culture sustained by ICAIC.[53] He eloquently advocated to artists the combined role of witness, protagonist, combatant and prophet, arguing that there was nothing more revolutionary than an artist who applied their sensibility, knowledge and imagination not only to themes of immediate concern but also to political agitation and revolutionary propaganda without allowing their work to become propaganda per se. In the process, Guevara expressed concern that, while Blas Roca's editorial did not constitute the cultural policy of the revolutionary government, it would be seen by those responsible for implementing the same, particularly those attending the First National Congress of CNC activists.

This provoked a prolonged textual exchange, with a total of six responses to Guevara being published by Blas Roca and several other interjections being made. Roca's contention was that artists should be more closely linked to the Revolution, not only reflecting daily reality but also making explicit references to revolutionary successes and popular actions. In this, he demonstrated a sycophantic adhesion to the central contentions of 'Words to the Intellectuals' which reveals little understanding of the often fraught processes involved in creative production. Mocking Guevara as the 'champion of free thought', he also asserted that Cuba's artists and intellectuals were neither revolutionary nor socialist in the full sense of either word. On the same day as his second response was published, Antuña responded to Guevara on behalf of the CNC, specifically in relation to the latter's contentions about the CNC congress celebrated the previous year, stating that this had not been confined to the council's activists and that Guevara had participated with his voice and vote alongside the leaders and representatives of state and mass organisations.[54] The reference paper and conclusions had been approved without abstentions by, among others, a hearty delegation from ICAIC; furthermore, Guevara had participated in preliminary meetings at which the ten-point plan (outlined above) had been drawn up and in a meeting with the CNC President and the

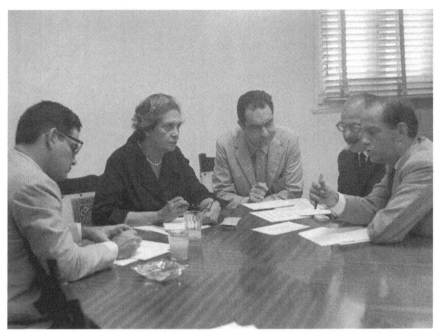

Jury of the 1964 Casa de las Américas Prize: Lisandro Otero, Camila Henríquez Ureña, Italo Calvino, Fernando Benítez, Ángel Rama. Courtesy of the Archive of Casa de las Américas.

Prime Minister during which these points were ratified, and at no time had any discrepancies been raised.

In a final reflection on the spat with Roca that remained unpublished at the time, Guevara commended Fidel's stance of refraining from excommunicating people, engendering a climate of suspicion or prescribing 'artistic formulae', opting instead to create a spirit of communication and clarity about the role of party and government in the field of culture.[55] And, while ICAIC and its leaders studied and accepted his 'Words', rather than applying them mechanically, Cuban intellectuals understood that the party and government would continue to orient the cultural movement rather than anybody else appropriating so delicate a task. However, he warned, it would still be possible for the concrete objectives of the Revolution to be deformed if the field of thought was restricted or Cuba's citizens underestimated. Rejecting the cult of spontaneity as inimical to Marxism, Guevara refuted the idea of holding up mythical workers as a source of knowledge while simultaneously denigrating their ability to understand art. As we shall see, this debate would remain unresolved for a while longer.

At the fifth anniversary of revolutionary victory, Che Guevara showed his support for anti-dogmatic interpretations of culture by sitting next to his namesake. In 1964, CNC policies were put in place for the following five years, which, for the plastic arts, entailed:

1. Continuing dissemination of different expressions of the plastic arts in their national and international manifestations, promoting their free discussion.
2. Guaranteeing the presence of Cuba at significant international events.
3. Increasing the exchange of exhibitions with all countries interested in them.
4. Maintaining the functioning of galleries and museums, realising the necessary work with mass organisations and schools in order that this service bears the necessary fruit.
5. Opening new galleries and museums and readapting others, to bring different museum collections to the public.
6. Continuing the plans of the National Commission of Monuments.

That December, as we have seen, García Buchaca was relieved of her post at the CNC. The following year, the debate around socialist realism would reach a definitive conclusion, and another threat to revolutionary credibility would raise its ugly head.

Socialism and Man in Cuba, March 1965
In chapter three, we saw that, in March 1965, Che Guevara resolved discussions around aesthetics in his landmark text, 'Socialism and Man in Cuba'. This put an end to orthodox attempts to impose socialist realism as the only legitimate revolutionary trope. But the same letter also publicly derided the possibility that the generation of artists and intellectuals formed under the old regime could ever completely achieve a revolutionary consciousness:

> [...] the fault of many of our artists and intellectuals lies in their original sin: they are not true revolutionaries. We can try to graft the elm tree so that it will bear pears, but at the same time we must plant pear trees. New generations will come that will be free of original sin. *The probability that great artists will appear will be greater to the degree that the field of culture and the possibilities for expression are broadened.* Our task is to prevent the current generation, torn asunder by its conflicts, from becoming perverted and from perverting new generations.[56]

In a reply to this missive a few months after its publication, Retamar found solace in Che's reference to *many* intellectuals and artists, which – rather than dismissing an entire generation – implied *others* who were authentic

revolutionaries. Disputing the applicability of the Judeo-Christian concept of original sin to Marxists, he launched a compelling defence:

> Of compañeros who have formed their personal lives with that of the Revolution, and who want to fulfil their destiny; of compañeros who, as militants, were where they were ordered to be when the Bay of Pigs was invaded and the missile crisis occurred; of compañeros who serve not only their artistic work but also other work towards the construction of socialism (when, many times, they could have shut themselves away in their houses to write fiction or to paint); of those compañeros who took part with satisfaction in voluntary labour; of those many compañeros who would be able to live comfortably outside the country but who always prefer to live in their revolutionary homeland; of compañeros whose intellectual and artistic work, through its unshakeable conviction, serves the Revolution, which is sometimes presented by enemies and unenthu-siastic friends as simple repetition of orders but which in reality is experi-ences that they have lived and continue to live deeply; of compañeros who feel pride in serving in the ranks of the Cuban Revolution, which they believe they have the right to call *our* Revolution; of those compañeros, Commander Guevara, able to say of themselves something more than that 'they are not authentically revolutionary'.[57]

In late 1962, while acknowledging that the majority of intellectuals had remained loyal to the Revolution, the CNC had discussed the difficulty for intellectuals, formed in the old society, adjusting to the changes brought about by the advent of the new one. While it seems clear that Che's metaphor about grafting and growing pear trees points to the simultaneous transformation of existing intellectuals and the nurturing of new ones, his words would give credence to the prejudice that artists and writers who had matured before the Revolution presented a problem. As we shall see, the negative side of Che's formulation would gain ground in the latter part of the 1960s, and the aim of placing cultural power in the hands of young, 'uncontaminated' artists would become consistent with the CNC ethos of its darkest days.

In his response to Che, Retamar emphasised the necessity of differen-tiating between the decadent and moribund art produced in the breast of capitalist societies and that which could be considered vanguard – those rebellious works capable of heralding the future. He asserted that the majority of vanguard artists were also at the political vanguard, and that, even those artists whose political development was not yet at the same level as their artistic development rejected the crimes, conventions, codes and hypocrisy of the corrupt capitalist world. The following year, Retamar would build on the specifics of underdeveloped Cuba, giving complexion to the kind of artistic vanguard that could be envisaged:

To make a vanguard art in a country in revolution had already revealed
itself to be complicated enough. One of the misfortunes of this century
has been precisely the separation between the two vanguards, political
and aesthetic, which had demonstrated themselves capable of mutual
fertilisation in the early years of the Russian Revolution [...] The political
vanguard is a minority but by no means minor, being the cutting edge of
a class. The artistic vanguard, in a similar way, if it really is a vanguard,
is not a minority, an ivory tower, a gang [...] but the cutting edge of a
coalition which, sooner or later, is going to embrace the consequences
of that vanguard. [...] However, as we know, those who well understand
the necessity of a political vanguard do not always understand the neces-
sity of an aesthetic vanguard. As a result, there has been a bifurcation
between an official, conventional culture and a real vanguard, but mar-
ginalised, culture. It is our aspiration that what happens in Cuba is not
that which has been happening up till now.[58]

In 1969, Benedetti would observe that, much quicker than in European social-
ist countries, the political and aesthetic vanguards in Cuba had reached a state
in which they could fertilise one another.

Throughout this study, consideration has been given to the extent to
which the different factions striving for supremacy within the Revolution
encouraged dialectical approaches to culture. In 1959, Fischer had speculated
upon the construction of socialism, envisaging that 'The artist's personality
is no longer engaged in a romantic protest against the world that surrounds
him, but the equilibrium between the "I" and the community is never static;
it must be established again and again through contradiction and conflict'.[59] In
his reply to Che's letter, Retamar raised the psychoanalytic subject of conflict
(known in other social disciplines as contradiction), to ask rhetorically, 'Who
will deny that there are contradictions in Cuba? Who will deny that there
are contradictions in us? Contradiction is the motor of historical life as it is
in personal life'.[60] And, while acknowledging that contradiction might have
disastrous consequences, he also outlined the positive sense in which it could
be applied to the vast questions of the Revolution, rather than trying to sup-
press or evade conflict as the devotees of socialist realism had attempted. In
1966, Retamar would observe that:

A theoretical error is committed by whoever converts their opinions
into decisions; this is not only a theoretical error but also possibly an
incorrect measure. With incorrect measures, we run into a problem of
conscience for the revolutionary intellectual; who can truly applaud
while knowing not only that it is an error of *their* revolution but also
when they see that they are dealing with a mistake? [Intellectuals']

support [of the Revolution], if they really want to be useful, cannot be anything other than critical, since critique is 'an exercise of criteria', following the Martían definition. When we have detected such errors in the Revolution, we have discussed them [...] not only in the aesthetic order but also as mistaken ethical conceptions [...]. Such measures were corrected.[61]

Fidel would concur that: 'We made many mistakes, many small mistakes, but no serious errors whose consequences might endure for a long time. That is, whenever we have taken a false step, we have been able to correct it immediately'.[62] More recently, Mayra Espina Prieto has argued for a conception of socialism as a process of continual change, replete with 'advances, reversals, contradictions, conflicts, and ambivalences [in which] the ability to transform and constantly renew itself is key to its economic, social and political policy-making'.[63] For her, it is this inherent state of flux, combined with the risk that 'socialist transformation may also generate its own forms of alienation on a macro and micro scale [which provides] the key to permanent self-criticism and self-correction'.[64]

During a polemic, similar in scale to that of 1963–4, which would erupt in 2007, the Cuban journalist and literary critic Eduardo Heras León would describe the aesthetic of his generation as that of not obscuring anything – of speaking about courage and cowardice, love and hate, heroism and treachery, of the search for the purest form of truth.[65] At the same time, Fornet would advocate 'criticism and self-reflexive criticism [as] the only exercise that is able to liberate us from triumphalism and preserve us from deleterious ideology'.[66] Six years earlier, Desiderio Navarro had observed that, for the majority of revolutionary intellectuals, it was clear that their role in the public sphere should be a critical one. Cuban intellectuals had not considered social critique a threat to socialism but, rather, its oxygen and motor; as such, critique had always been deemed necessary to the survival and health of the revolutionary process. Regrettably, he noted, this had not been the case for the majority of functionaries.

In 2011, the South African scholar Clive W. Kronenberg noted that, 'while Cuban filmmakers consciously set out to incorporate political themes in their work, it is not always to elevate or endorse the revolution per se, but often critically and candidly to evaluate and, at times, deride its limitations'.[67] But, as has been the case with considerations of expressive freedom conducted from outside Cuba, there has been a wilful tendency to underplay and undermine the possibility of critique, with Catherine Davies attempting to demonstrate that 'postmodern expression in Cuba is that which not only challenges Marxist modernity (thus functioning as a neo-avant-garde) but *at the same time* mocks those very challenges, thus parodying the forms that

critiques of Marxism have taken'.[68] With this in mind, it will be necessary to continue the discussion of intellectual critique that runs through these pages.

Crisis Talks between Armando Hart and Intellectuals, October 1965

In the mid-1960s, as was common practice throughout the world at that time,[69] Fidel regarded it as the government's 'duty to take at least minimum measures to the effect that those positions in which one might have a direct influence upon children and young people should not be in the hands of homosexuals, above all in education centres'.[70] While Fidel accepted that sexuality would be no impediment to the profession of revolutionary ideology, he also surmised that homosexuals could never possess the characteristics necessary to be true revolutionaries. As gay men were routinely dismissed from their jobs within education and culture, breaking point came when the directorship of Cuba's most important dramatist, Vicente Revuelta, was terminated at Studio Theatre. Carlos Lechuga, new President of the CNC, informed his Vice President, Lisandro Otero, of the problem, and a meeting was hastily convened at the latter's house, with Desnoes, Fornet, García Espinosa, Gutiérrez Alea, Retamar and others in attendance. Lechuga explained the background to the case, and various solutions were proposed; in the end, it was agreed to try and create a commission to restructure Cuban theatre which would restore Revuelta to his role while ensuring that the government retained its authority.[71]

On 3 October 1965, the governing party was renamed the Cuban Communist Party (PCC), and Armando Hart was made its Secretary. Just over two weeks later, the intellectuals who had convened at Otero's house met with him – together with some new personnel, including Carpentier – to discuss the stronger links that the PCC wished to create with the country's intellectual workers. A series of three small meetings took place, and the intellectuals took the opportunity to air their concerns about problems within the cultural sector, with García Espinosa immediately pointing out that such a dialogue would be difficult while the issue of Revuelta remained unresolved. As previously agreed with Lechuga, Otero proposed the creation of a commission on intellectual work which would kick-start a dynamic cultural policy. Over the course of the three meetings, Hart reasserted the government's anti-dogmatic understanding of Marxism and the aversion of the Revolution to manuals telling people how to think. At the same time, he emphasised the serious responsibility assumed by the Revolutionary Directorate in the ideological and ethical training of youth and its preoccupation with 'deviations of personality'. Otero positions these meetings as a continuation of the discussion begun in the national library in June 1961; although the constituency was much smaller, they served to create an atmosphere of understanding between creative intellectuals and the leadership that would persist for the next few years as dogmatism was forced into remission. The demonisation of homosexuality

was slower to recede, however, and while the forces of dogmatism contin-
ued to accuse the majority of creative intellectuals of remaining outside the
great social process that was underway, homosexual writers and artists were
victimised more than others. Within the CNC, this relied less on political
suspicion and more on a kind of scientific certainty that 'homosexuality was a
contagious disease, a species of leprosy incubated in the breast of class society,
the propagation of which had to be prevented by avoiding contact'.[72]

Military Units to Aid Production (UMAP), November 1965

In his 2006 autobiography, Fidel retrospectively details the three barriers
to entering the military when national service was discussed in 1963 – edu-
cational level, religious belief and sexuality. With regard to the latter, he
argues that the machismo of the time led to 'widespread rejection of the
idea of homosexuals serving in military units [...] but that became a sore
spot, because they were not called upon to make the hard sacrifice [for the
country] and some people used that argument to criticize homosexuals even
more harshly'.[73] In November 1965, Military Units to Aid Production (UMAP)
were set up, and those who were discounted from military service on the
grounds outlined above were recruited. Karol finds that the authorities 'did
not encumber themselves with theoretical explanations or justifications but
simply drafted "guilty" and suspects alike into UMAP [...]. Most of this con-
tingent was made up of intellectuals [...] and the purge at Havana University
[was] specially severe'.[74] The first draftees were treated so brutally that their
commanders were court-martialled and charged with torture.

This period coincided with prevarications over whether to publish
Lezama Lima's novel, *Paradiso*, with its overtly homosexual content. In an
ambiguous text touching on the cultural policy of the post-revolutionary
period, Cuban émigré Carlos Ripoll argues that 'Fidel Castro disregarded
angry protests by Cuban Communists and personally authorized the publica-
tion of *Paradiso*, by José Lezama Lima, a decadent and perverse book in the
eyes of Marxist critics because of its morose descriptions of acts of sodomy'.[75]
In the name of UNEAC and its members, Nicolas Guillén consistently lobbied
for the UMAP to be disbanded. At a meeting of international writers in 1967,
Julio Cortázar and Ángel Rama protested to Fidel about the monstrous per-
secution of homosexuals.[76] Twenty-four hours later, repressive measures
against intellectuals ceased and the UMAP were redeployed as bases for youth
national service. Nonetheless, the presence of the UMAP sits alongside other
instances of gay persecution which have conspired to discredit the Revolution
in the eyes of outside commentators.

It would not be until 1973 that the American Psychiatric Association in
the US removed homosexuality from its manual of mental disorders. In 1977,
the World Health Organization listed homosexuality as a mental illness, a

Copelia ice cream parlour, used as set for *Fresa y Chocolate* [Strawberry and Chocolate].

status which was not revoked until 1990. Visiting Cuba in 1968, the lesbian writer Susan Sherman would later reflect that 'even though the camps were closed, gays in Cuba were closeted, but so was I in the United States – this was before Stonewall and the emergence of the Gay Liberation Front in 1969. I found myself once again confronting an untenable position. While vigorously joining the struggle here in the United States, I was reluctant to join in a public outcry against Cuba – a revolutionary country under constant siege'.[77] Sherman went on to note that 'Official attitudes in Cuba have since changed, sparked in 1985 by the report that homosexuality should not be treated as a pathology, and almost certainly by the influences of the Gay Liberation struggle' in the US and elsewhere.[78]

At the end of the 1960s, Fornet attributed the creation of internal scandals, around issues such as UMAP, to the broader struggle between dogmatists and liberals, during which time it was easier to create a diversion than to seriously address the responsibility of intellectuals in a country in revolution.[79] In 1994, Gutiérrez Alea directed a brilliantly dialectical film, entitled *Fresa y Chocolate* [Strawberry and Chocolate], centred on the Havana branch of the immensely popular Copelia ice cream parlour, which charts the friendship that develops between an artist and a member of the Young Communist League, whose respective sexuality is divulged through their penchants for strawberry and chocolate ice cream. The following year, Retamar would situate Cuban attitudes to homosexuality in their appropriate historical

Bacardi Building, Havana, a legacy of US interests on the island.

context, alluding to 'those who talk about the unacceptable homophobia in Cuba, as if we were still in the times of the UMAP (which we opposed) and not in those of *Strawberry and Chocolate* (which we praised)'.[80]

The Centrality of 1966 to Cultural Discussions

In considering the policy of this period more holistically, 1966 – Year of Solidarity – stands out as the year in which awareness of imperialist penetration became a pressing concern in Latin America. Claudia Gilman repeatedly cites Senator Robert Kennedy's announcement, on US television in May 1966, of the widely held view that the continental revolution was coming, whether

his countrymen liked it or not. This caused the US government to step up its efforts in the region, through brutal repression and military coups alongside various strategies aimed at co-opting intellectuals, including the awarding of grants and the selective loosening of visa restrictions. In a study of covert US-backed action in Cuba, Fabián Escalante notes that 'By 1966, the internal counterrevolution had been decisively defeated through the disappearance of its support bases. Nevertheless, the plots and conspiracies intensified. Thousands of radio hours, written propaganda, rumors and every means of communication – in conjunction with sophisticated mechanisms specifically devised for the assassination – were utilized to stimulate the physical elimination of Fidel Castro'.[81] While the internal counterrevolution may ostensibly have been defeated by 1966, the revolutionary government discovered in this year that the sectarian tendencies, subdued in March 1962, had begun to reassert themselves, through the activities of a microfaction led by Aníbal Escalante, who had returned to Cuba in 1964.[82] It would be another two years before decisive action was required, which will be dealt with at the appropriate moment; for now, attention will be paid to the external threat facing Cuba.

Colombian investigative journalist Hernando Calvo Ospina documents systematic attempts to undermine the revolutionary government from without, describing how – despite a pact being agreed between the superpowers, in the wake of the missile crisis, that the US would not invade Cuba – 'invasion continued to be at the root of US policy. It simply became necessary to make believe that it was the émigrés alone, "orphans" of US help, who sought the "liberation" of their own country'.[83] The influence exerted over Washington by the main émigré group, the Cuban American National Foundation (CANF) – which has manifested itself most egregiously through the embargo-tightening Torricelli-Graham (1992) and Helms-Burton (1996) acts – is common knowledge. Less well known is the fact that the CANF grew out of a terrorist organisation, called Cuban Representation in Exile (RECE), officially founded in Miami in early 1964.[84] In the same year, an FBI memo would describe a plot to assassinate Fidel, orchestrated by the US mafia, financed by the RECE founder and known about by the CIA. The strategic crossovers between RECE and the CIA are uncanny, as are their overlaps in personnel, with both organisations including many key Bay of Pigs mercenaries. Throughout the period of this study, RECE and its precursors mounted counterrevolutionary attacks throughout Latin America and beyond, with the knowledge and approval of the CIA.

In much the same way in the cultural field, the CIA funded the Congress for Cultural Freedom, which established offices in thirty-five different countries, employing dozens of personnel, publishing more than twenty magazines, organising exhibitions and offering grants to artists.[85] From this, the Instituto Latinoamericano de Relaciones Internacionales [Latin American Institute

of International Relations] was created. One of the publications it financed, *Mundo Nuevo* [New World], published in Spanish from Paris, was to prove particularly influential:

> The project was clear: to challenge, from Europe and with a modern look, the hegemony of the revolutionary outlook in Latin American intellectual work. It would be mistaken to contend, and we never suggested, that everyone who published in *Mundo Nuevo* was necessarily hostile to the revolution. On the contrary, the editors' purpose was to create an atmosphere of confusion that would make it difficult to detect the real functions that the review had been assigned.[86]

It was in this forum that the main conflicts surrounding what became known as the 'Padilla case' (to be discussed in chapter seven) were felt in 1968 and again in 1971. While Casa de las Américas kept a suspicious eye on the Inter-American Foundation, which was backed by big business from the US, Retamar (in his capacity as President of Casa) refers us to the Alliance for Progress, which 'plotted an academic version of its demagogic policy [...] Grants proliferated, colloquiums flourished, chairs to study and dissect us sprouted like toadstools after a rainstorm'.[87] Although Latin American plastic artists were favourable to socialism, they were aesthetically close to the US and Europe, which meant that North American attempts to co-opt them were not implausible. Promises of international prestige led to a US dependency among some of the continent's artists that was most evident in international circuits (galleries, museums and itinerant exhibitions) and would ultimately cause a rift with Cuba.

A symptom of the heightened tension this situation created is to be found in an open letter, sent by Cuban intellectuals to a high-profile friend of Cuba, the Chilean communist poet Pablo Neruda, on 25 July 1966 which was published in *Granma* six days later and reprinted in issue 38 of *Casa*. In the midst of the schism among continental intellectuals being precipitated by *Mundo Nuevo*, Neruda had attended the XXXIV Congress of the PEN Club in New York, together with two other Latin American authors – Carlos Fuentes (already collaborating with *Mundo Nuevo* and other magazines of dubious provenance) and Mario Vargas Llosa (who was serving on the collaborative committee of *Casa de las Américas*). Given that Neruda had been active in organising an earlier meeting of the PEN Club behind the Iron Curtain in Dubrovnik and he had recently travelled to Peru to accept a medal from the President, Fernando Belaúnde Terry (whose premiership had been dogged by accusations of humans rights abuses), his participation in New York caused enormous discontent among the Cuban intellectual fraternity, prompting the letter addressed to 'Compañero Pablo'. What mystified the numerous co-signatories to this letter was the granting of Neruda's visa to the US, after twenty

years of refusals, and the erroneous impression it gave that the Cold War was over. It was felt that, if the US granted visas to determined leftists, it did so for one of two reasons – either because they had departed from their beliefs or because their admission was advantageous to the host country. Neruda interpreted this missive as an attack on him personally and on the Chilean Communist Party indirectly, accusing the signatories of ideological weakness and literary envy. Unsurprisingly, *Mundo Nuevo* seized upon Cuba's rift with Neruda, making him one of their own and aggrandising his poetry in the pages of the journal.

CNC brochure, 1966.

It was, perhaps, inevitable, that, in the ensuing climate of ideological warfare, Latin American intellectuals would be called upon to define their position. Just as had happened after the abortive 1933 revolution in Cuba, certain writers – such as Cortázar and Vargas Llosa – retreated into the metaphorical and claimed writing to be an inherently revolutionary act that would inevitably lead to socio-political utopias with writers at the vanguard. In direct opposition to the armchair radicalism of those creative writers exempting themselves from direct action, Cuba was making every effort to integrate intellectuals into the Revolution, and we have already seen that many willingly involved themselves in the material development of the country. Invoking the example of Che, who had demonstrated that intellectuals undergoing revolutionary transformation would be better able to serve the Revolution, Retamar elaborated on the difficulty of undergoing this transformation.[88] In a 1966 essay, he stated that 'It is not enough to verbally adhere to the Revolution to be a revolutionary intellectual. Nor is it enough to realise the actions of a revolutionary, from agricultural work to the defence of the country, although these are conditions *sine qua non*. The intellectual is also obliged to assume a *revolutionary intellectual position*. That is to say, inevitably problematising reality and tackling these problems'.[89] In this way, one of Cuba's leading writers advocated that the task of his contemporaries lay not only in actively building and protecting the new society but also in undertaking self-reflexive praxis leading to the negation of the negation. In the remaining chapters, we shall see how this Marxist-humanist intellectual role manifested itself.

Remarks in Conclusion

One of the most striking aspects of this era of cultural policy formulation is the massive effort that was made to unleash the latent creative potential of an entire populace. In the unique circumstances of Cuba, the Gramscian understanding of organic intellectuals arising from every social class was extrapolated from the proletariat to the peasantry. Instigated by Che and initially implemented by the CNC, the *aficionados* programme continues to offer cultural opportunity throughout society. At the start of the twenty-first century, Fidel would describe how 'We are educating art instructors: there are fifteen teacher-training schools, one in each province, and plans are for 30,000 arts teachers, selected on the basis of their talent, to share their knowledge in educational centres and in communities over the next ten years, because there's a tremendous demand'.[90] This programme has achieved considerable success in eroding differences in cultural level between town and country, and between intellectuals and the people. There can be no doubt that this effort to democratise culture has largely demystified the production of art and made a substantial contribution to cultural literacy in Cuba.

In the early years of this enormous educational effort, professional artists and writers embraced their revolutionary duty by disseminating their skills to instructors who would act as intermediaries between creative intellectuals and the people. While qualitative measures met with varying degrees of success, the revolutionary government nonetheless made provision for the transition of the most gifted amateurs into the professional ranks. The extent to which professional artists, trained before the Revolution, acted as an impediment to those organic intellectuals arising afterwards remains a point of contention. It is possible that there was insufficient willingness on the part of the former to either disseminate their creative skills or relinquish their territory. It seems more likely, however, that the deployment of instructors – as intermediaries between professional and amateur artists – did not create a direct enough relationship for all the ingredients necessary for high-quality artistic activity to be transmitted wholesale. But as we have seen, the main aim of the *aficionados* movement has been to encourage creative activity, with a greater emphasis on process than product as a route to happiness.

In the dispute that erupted between orthodox Marxists and film-makers in 1963, several philosophical points emerge. Following the *PM* debacle discussed in the previous chapter, it should come as no surprise to encounter the cinematic field as a battlefield in which polemics raged about a 'participatory vocation not only concerning the creative universe (the films themselves) but also the theorisation of cinema as a creative process in a revolutionary society'.[91] Crucially, the CNC leadership held the eradication of idealism to be paramount, refuting all possibility for its reconciliation with materialism. Yet it has been noted that, in their rejection of Hegelian idealism, Marx and

Engels had recourse to 'starkly differentiating formulations' which belied their dialectical methods and humanistic beliefs.[92] This exposes García Buchaca and Aguirre as not only more Stalinist than Stalin but also more anti-idealist than Marx and Engels.

Other dimensions of the 1963 polemic perfectly expose the positions of hard-line elements within the PSP, specifically those of García Buchaca, Aguirre and Roca. Central to this was the dual assertion that works of art have an inherently class character and that only selected technical aspects of bourgeois culture should be permitted to form part of socialist society. This directly contradicts both Marx and Lenin on the validity of cultural inheritance which provides clues to the evolution of humanity. If we follow the CNC argument through to its illogical conclusion, we find that it leads to the dismissal of all object-based art on the basis of its exchange value under capitalism. Stopping short of this, orthodox voices would advocate that certain forms of creative expression be curtailed in the transition from capitalism to socialism, singling out abstract art for particular vilification.

In marked contrast to this, Cuban film-makers argued that artistic production thrived in an atmosphere in which disparate aesthetic ideas vied for attention, and any attempt to deny this plurality could only lead to suppression of one form or another. While all parties to the debate ultimately agreed the formal properties of an artwork to be indivisible from its content, the film-makers vehemently resisted formal prescriptions. Crucially, they described art as both a form of objective reality and a factor acting upon it, while delimiting the plausible extent to which life would come to imitate art. As we have seen, this stance was also applicable to cultural works imported from abroad, meaning that, however reactionary European films were taken to be, they were not deemed capable of exacting an adverse influence upon the Cuban people. The counter-argument, mounted by elements within the PSP, exposes the moral guardianship that was assumed on behalf of apocryphal workers. It is noteworthy that this latter position sits in diametric opposition to the idea of engendering a critical spirit in the populace, reflected in Fidel's evocation of 'People sufficiently cultivated and educated [who are] capable of making a correct judgment about anything without fear of coming into contact with ideas that could confound or deflect them [who] could read any book or see any film, about any theme, without changing our fundamental beliefs'.[93]

In a discussion with ENA students, published in the first issue of *Revolución y Cultura* [Revolution and Culture][94] on 1 October 1967, Carlos Rafael would describe the many sectarian errors that had been committed in relation to discussions around form and content over the preceding two decades. Having been vocal about the suppression of culture during the Batista era while championing the power of culture against tyrannies, Rafael confidently offered a range of examples – from Picasso to Pop – to

demonstrate that, while the history of art had been characterised by the separation of artist from society, socialism provided both the possibility and necessity of integrating the creator with the social totality. In this, he was adamant that unilateral dogmatism was not compatible with the development of socialism, which was characterised by multiple interpretations of truth. This meant that socialism was necessarily averse to 'administrative invasion in the sphere of art' – whereby a handful of functionaries judged what should and should not be exhibited – which had created huge catastrophes for art in other socialist countries.[95] The logical consequence of this thinking was that totally free art would represent the profoundest expression of man's desire in the construction of a new world and that the aesthetics of revolutionary times would continue to be formed through diverse currents, across all disciplines, with a vision of the world communicating itself through the work of revolutionary artists.

At the same meeting, Rafael mentioned the creation of a Cultural Commission within the Central Committee of the PCC, which would be consulting cultural organisations, creators, audiences and students and dedicated to constraining over-zealous bureaucrats. This reminds us to take care in distinguishing the perpetuators of dogmatism (and liberalism) from those adhering to more revolutionary interpretations of cultural policy. At the same time, consideration of imperialist attempts to undermine the Revolution, which concludes this chapter, prompts us to remember that external circumstances continued to exert a marked effect upon the internal cultural field. Just eight days after Carlos Rafael's discourse was published, a tragedy hit Cuba that would alter its course irrevocably.

NOTES
1 Consejo Provincial de Cultura (CPC), *La Cultura para el Pueblo* [Culture for the People] (Havana: Consejo Provincial de Cultura, 1961), p. 1.
2 Ibid., p. 2.
3 Jaime Sarusky and Gerardo Mosquera, *The Cultural Policy of Cuba* (Paris: UNESCO, 1979), p. 21.
4 Carlos Rafael Rodríguez, 'Problemas del Arte en la Revolución' [Problems of Art in the Revolution], *Revolución y Cultura*, no. 1, 1 October 1967, pp. 6–32.
5 Unless stated otherwise, consideration of this period of CNC activity is taken from Consejo Nacional de Cultura, *Anteproyecto del Plan de Cultura de 1963* [Draft of the 1963 Cultural Plan] (Havana: Consejo Nacional de Cultura, 1963); Consejo Nacional de Cultura, *Política Cultural del Gobierno Revolucionario y Trabajo de Aficionados* [Cultural Policy of the Revolutionary Government and Work of the Amateurs] (Las Villas: Consejo Nacional de Cultura, 1963); Consejo Nacional de Cultura, *Proyecto-plan para 1964* [Projected Plan for 1964] (Havana: Consejo Nacional de Cultura, 1963); Consejo Nacional de Cultura, *Política Cultural de Cuba* [Cultural Policy of Cuba] (Havana: Consejo Nacional de Cultura, 1970) and Ministerio de Relaciones Exteriores, *Suplemento/Sumario: La Función Cultural-Educacional del Estado Socialista Cubano* [Supplement:

The Cultural-Educaticnal Functicn of the Cuban Socialist State] (Havana: Dirección de Prensa, Información y Relaciones Culturales, 1976).

6 Roberto Fernández Retamar, 'A Cuarenta Años de "Palabras a los Intelectuales"' [To Forty Years of 'Words to the Intellectuals'], *Cuba Defendida* [Cuba Defended] (Havana: Editorial Letras Cubanas, 2004 [2001]), p. 303.

7 Antonio Gramsci, *Selections from Cultural Writings* (Cambridge, MA: Harvard University Press, 1991), p. 109.

8 PCC Central Committee, *Information from the Central Committee of the Communist Party of Cuba on Microfaction Activity* (Havana: Instituto Cubano del Libro, 1968), p. 99.

9 Fidel Castro Ruz, *Fidel Castro Denounces Sectarianism* (Havana: Ministry of Foreign Relations, 1962), p. 12.

10 Lee Lockwood, *Castro's Cuba, Cuba's Fidel: An American Journalist's Inside Look at Today's Cuba in Text and Pictures* (Boulder, CO: Westview Press, 1990 [1967]), p. 226.

11 K.S. Karol, *Guerrillas in Power: The Course of the Cuban Revolution* (London: Jonathan Cape, 1971 [1970]), p. 284.

12 Edith García Buchaca, 'Intervención de Edith García Buchaca' [Intervention of Edith García Buchaca] presented at La Primera Plenaria Provincial de Cultura de La Habana, Payret Theatre, Havana, 25 November 1962.

13 A total of 2,058 delegates participated in the eventual congress. Of these, 1,577 had voting rights and 451 were invited guests from fraternal socialist countries.

14 Antoni Kapcia, *Havana: The Making of Cuban Culture* (Oxford and New York: Berg, 2005), p. 135.

15 Ambrosio Fornet, 'La Década Prodigiosa: Un Testimonio Personal' [The Prodigious Decade: A Personal Testimony], S. Maldonado (ed.), *Mirar a los 60: Antología de una Década* [Looking at the 60s: Anthology of a Decade] (Havana: Museo Nacional de Bellas Artes, 2004), p. 10.

16 Luis Camnitzer, *New Art of Cuba* (Austin: University of Texas Press, 1994).

17 Graziella Pogolotti, interview with the author, Havana, 9 March 2010.

18 Fidel Castro Ruz, 'Palabras a los Intelectuales' [Words to the Intellectuals] (Havana: Ministry of Foreign Relations, 1962 [1961]), p. 32.

19 CNC, *Política Cultural de Cuba*, unpaginated.

20 Sarusky and Mcsquera, *The Cultural Policy cf Cuba*, p. 14.

21 CNC, *Política Cultural de Cuba*, unpaginated.

22 Centro Nacional de Aficionados y Casas de Cultura, *Lineamientos, Funciones Principales y Principios Organizativos Básicos para el Perfeccionamiento y Desarrollo del Trabajo en el Sistema de Casas de Cultura* [Guidelines, Principal Functions and Basic Organisational Principles for Perfecting and Developing the Work of the System of Casas de Cultura] (Havana: Ministerio de Cultura, 1988), p. 1.

23 Article 2(g) of resolution 32/78 describes the function of the Casas in 'carrying out the direction and control of the *aficionados* movement, contributing to the technical and political formation'. Armando Hart Dávalos, *Resolución no. 32/78: Resolución que Reglamenta las Actividades en las Casas de Cultura* [Resolution no. 32/78: Resolution which Legislates for the Activities of the Casas de Cultura] (Havana: Ministerio de Cultura, 1979), p. 3.

24 Sarusky and Mosquera, *The Cultural Policy of Cuba*, p. 14.

25 Kapcia, *Havana*, pp. 135-6, italics in original.

26 Ibid., p. 164.

27 Roberto Fernández Retamar, '1961: Cultura Cubana en Marcha' [1961: Cuban Culture in Progress] (1962), *Cuba Defendida*, pp. 66-73.

28 In interview with the author, Havana, 3 March 2010.

29 Fernández Retamar, '1961'.

30 Arnold Wesker, 'Aie Cuba! Aie Cuba!', *Envoy*, November 1969, p. 20.

31 Ibid., p. 21.

32 John M. Kirk and Leonardo Padura Fuentes, *Culture and the Cuban Revolution: Conversations in Havana* (Gainesville: University Press of Florida, 2001), p. 116.

33 C. Ian Lumsden, 'The Ideology of the Revolution', R.E. Bonachea and N.P. Valdés (eds.), *Cuba in Revolution* (Garden City, NY: Doubleday & Company, 1972 [1969]), p. 542.

34 Mayra Espina Prieto, 'Looking at Cuba Today: Four Assumptions and Six Intertwined Problems', *Socialism and Democracy*, 24, no. 1, March 2010, p. 98.

35 David Craven, *Art and Revolution in Latin America 1910–1990* (New Haven, CT, and London: Yale University Press, 2006), p. 92.

36 Karol, *Guerrillas in Power*, p. 325.

37 Sarusky and Mosquera, *The Cultural Policy of Cuba*, p. 15.

38 Ambrosio Fornet, 'El Quinquenio Gris: Revisitando el Término' [The Five Grey Years: Revisiting the Term], *Narrar la Nación: Ensayos en Blanco y Negro* [Narrating the Nation: Essays in White and Black] (La Habana: Editorial Letras Cubanas, 2009 [2007]), p. 385.

39 Mirta Aguirre, 'Apuntes sobre la Literatura y el Arte' [Notes on Literature and Art], *Cuba Socialista* III, no. 26, October 1963, reproduced in G. Pogolotti (ed.), *Polémicas culturales de los 60* [Cultural Polemics of the 1960s] (Havana: Instituto Cubano del Libro, 2006), p. 53.

40 Juan Blanco, 'Los Herederos de Oscurantismo' [The Heirs of Obscurantism], *La Gaceta de Cuba* II, no. 15, 1 April 1963, ibid, pp. 3–8.

41 Julio García Espinosa, 'Vivir Bajo la Lluvia' [Living in the Rain], *La Gaceta de Cuba* II, no. 15, 1 April 1963, ibid, pp. 9–13.

42 Julio García Espinosa, Nicolás Guillén, Tomás Gutiérrez Alea, Humberto Solás et al., 'Statement by Film-makers', *La Gaceta de Cuba* II, no. 23, 3 August 1963, ibid, pp. 17–22.

43 Georg Wilhelm Friedrich Hegel, *Introductory Lectures on Aesthetics* (London: Penguin Books, 2004 [1886]).

44 Alfredo Guevara, 'Sobre un Debate Entre Cineastas Cubanos' [On a Debate between Cuban Film-makers], *Cine Cubano*, no. 14–15, November 1963, Pogolotti, *Polémicas culturales de los 60*, pp. 23–5.

45 From an unpublished interview cited in Sandra del Valle, 'Cine y Revolución: La Política Cultural del ICAIC en los Sesenta' [The Cultural Policy of ICAIC in the Sixties], *Perfiles de la Cultura Cubana*, May–December 2002.

46 Edith García Buchaca, 'Consideraciones sobre un Manifiesto' [Considerations on a Manifesto], *La Gaceta de Cuba* II, no. 28, 18 October 1963, Pogolotti, *Polémicas culturales de los 60*, pp. 26–34.

47 Jorge Fraga, '¿Cuántas Culturas?' [How Many Cultures? An open letter to Mirta Aguirre], *La Gaceta de Cuba* II, no. 28, 18 October 1963, ibid, pp. 72–85.

48 Julio García Espinosa, 'Galgos y Podencos' [Greyhounds and Hounds], *La Gaceta de Cuba* II, no. 29, 5 November 1963, ibid, pp. 86–94.

49 Severino Puente, 'Preguntas sobre Películas' [Questions on Films], *Hoy*, 12 December 1963, ibid, pp. 145–8.

50 Macdonald Daly, 'A Short History of Marxist Aesthetics', L. Baxandall and S. Morawski (eds.), *Karl Marx and Frederick Engels on Literature and Art* (Nottingham: Critical, Cultural and Communications Press, 2006), p. ix.

51 Directors of ICAIC, '¿Qué Películas Debemos Ver? Las Mejores' [Which Films Should We See? The Best], *Revolución*, 14 December 1963, Pogolotti, *Polémicas culturales de los 60*, pp. 149–51.

52 Julio García Espinosa, Tomás Gutiérrez Alea, Jorge Fraga et al., 'Carta de Severino Puente y de Directores del ICAIC' [Letter from Severino Puente and the Directors of ICAIC], *Revolución*, 17 December 1963, ibid, pp. 152–7.

53 Alfredo Guevara, 'Alfredo Guevara Responde a las Aclaractiones' [Alfredo Guevara Responds to the Clarifications], *Hoy*, 18 December 1963, ibid, pp. 169–74.

54 Vincentina Antuña, 'El Consejo Nacional de Cultura Contesta a Alfredo Guevara' [The CNC Responds to Alfredo Guevara], *Hoy*, 20 December 1963, ibid, pp. 189–94.

55 Alfredo Guevara, 'Declaraciones de Alfredo Guevara' [Declarations of Alfredo Guevara], *Hoy*, 21 December 1963, ibid, pp. 199–2c3.

56 Ernesto Guevara, 'Socialism and Man in Cuba', *Marcha*, 12 March 1965, unpaginated, italics added.

57 Roberto Fernández Retamar, 'Para un Diálogo Inconcluso sobre "El Socialismo y el Hombre en Cuba"' [Fcr an Inconclusive Dialogue on 'Socialism and Man in Cuba'] (1965), *Cuba Defendida*, pp. 187–8, italics in original.

58 Roberto Fernández Retamar, 'Hacia una Intelectualidad Revolucionaria en Cuba' [Towards a Revolutionary Intelligentsia in Cuba] (1966), *Cuba Defendida*, p. 284.

59 Ernst Fischer, *The Necessity of Art: A Marxist Approach* (Middlesex: Penguin Books, 1963 [1959]), p. 112.

60 Fernández Retamar, 'Para un Diálogo Inconcluso', p. 188.

61 Fernández Retamar, 'Hacia una Intelectualidad Revolucionaria en Cuba', pp. 287–8, italics in original.

62 Lockwood, *Castro's Cuba, Cuba's Fidel*, pp. 95–6.

63 Espina Prieto, 'Looking at Cuba Today', p. 96.

64 Ibid., p. 97.

65 Eduardo Heras León, 'El Quinquenio Gris: Testimonio de una Lealtad' [The Five Grey Years: Testimony of a Loyalty], Read by the author at ISA in relation to the cycle of events entitled 'La Política Cultural del Periodo Revolucionario: Memoria y Reflexión' [The Cultural Policy of the Revolutionary Period: Memory and Reflection], 15 May 2007.

66 Fornet, 'El Quinquenio Gris', p. 381.

67 Clive W. Kronenberg, 'Che and the Pre-eminence of Culture in Revolutionary Cuba: The Pursuit of a Spontaneous, Inseparable Integrity', *Cultural Politics*, 7, no. 2, 2011, p. 203.

68 Catherine Davies, 'Surviving (on) the Soup of Signs: Postmodernism, Politics, and Culture in Cuba', *Latin American Perspectives*, 27, no. 113, 2000, p. 105, italics in original.

69 In the UK as recently as 1988, clause 28 of the Local Government Act legislated against 'the teaching in any maintained school of the acceptability of homosexuality as a pre-tended family relationship'. See Legislation.gov.uk/ukpga/1988/9/section/28

70 Lockwood, *Castro's Cuba, Cuba's Fidel*, p. 107.

71 An account of these events is given in Lisandro Otero, *Llover sobre Mojado: Una Reflexión Personal sobre la Historia* [To Rain on the Wet: A Personal Reflection on History] (Havana: Editorial Letras Cubanas, 1997).

72 Fornet, 'El Quinquenio Gris', p. 396.

73 Fidel Castro Ruz and Ignacio Ramonet, *My Life* (London: Penguin Books, 2008 [2006]), pp. 222–3).

74 Karol, *Guerrillas in Power*, p. 395.

75 Carlos Ripoll, 'Writers and Artists in Today's Cuba', *Cuban Communism* (New Brunswick, NJ: Transaction Inc., 1987 [1985]), p. 462.

76 Cortázar, an Argentinian novelist, short story writer and essayist; Rama, an Uruguayan writer and literary critic who served as editor of *Marcha* after Monegal.

77 Susan Sherman, *America's Child: A Woman's Journey through the Radical Sixties* (Willimantic, CT: Curbstone Press, 2007), p. 162.

78 Ibid.

79 Roque Dalton et al., 'Diez Años de Revolución: El Intelectual y la Sociedad' [Ten Years of Revolution: the Intellectual and Society], *Casa de las Américas*, 10, no. 56, Sept–Oct 1969, pp. 7–48.

80 Jaime Sarusky, 'From the 200th, with Love, in a Leopard: Interview with Roberto Fernández Retamar', *The Black Scholar* (Autumn 2005 [1995]), p. 40.

81 Fabián Escalante, *Executive Action: 634 Ways to Kill Fidel Castro* (Melbourne: Ocean Press, 2006), pp. 200–1.

82 For a detailed consideration of this, see PCC Central Committee, *Information from the Central Committee of the Communist Party of Cuba on Microfaction Activity*.

83 Hernando Calvo Ospina, *Bacardi: The Hidden War* (London: Pluto Press, 2001), p. 20.

84 With US knowledge, the son-in-law of significant Bacardi shareholder Enrique Schueg, José 'Pepín' Bosch – who had been Minister of the Treasury when the Cosa Nostra established its 'Empire of Havana' and initially supported the Revolution – decided to organise émigrés, selecting five prominent Cuban exiles to front his plans. RECE was officially disbanded as late as 1988. Until 1964, the CIA-backed Operation Mongoose had been in effect, a covert campaign of sabotage, psychological and biological warfare, overseen by Kennedy's top advisors.

85 See Frances Stonor-Saunders, *Who Paid the Piper? The CIA and the Cultural Cold War* (London: Granta, 1999); Christopher Lasch, 'The Cultural Cold War: A Short History of the Congress for Cultural Freedom', B.J. Bernstein (ed.), *Towards a New Past: Dissenting Essays in American History* (London: Chatto and Windus, 1970), pp. 322–59; and Judith A. Weiss, '*Casa de las Américas*: An Intellectual Review in the Cuban Revolution' (thesis, Yale University, 1973).

86 Roberto Fernández Retamar, 'Caliban Revisited', *Caliban and Other Essays* (Minneapolis: University of Minnesota Press, 1989 [1986]), p. 49.

87 Ibid., p. 48.

88 Roberto Fernández Retamar, 'Algunas Veces el Che: Un Montón de Memorias' [Sometimes Che: A Mountain of Memories] (1965), *Cuba Defendida*, pp. 160–70.

89 Fernández Retamar, 'Hacia una Intelectualidad Revolucionaria en Cuba', p. 276, italics in original.

90 Castro Ruz, 2006, *My Life*, p. 233.

91 Jorge Fornet, 'Hacer la revolución en el cine' [Making the Revolution in Cinema], *El 71: Anatomía de una Crisis* [In '71: Anatomy of a Crisis] (Havana: Editorial Letras Cubanas, 2013), p. 129.

92 Macdonald Daly, 'A Short History of Marxist Aesthetics', p. iv.

93 Lockwood, *Castro's Cuba, Cuba's Fidel*, p. 112.

94 A journal edited by Lisandro Otero, which initially included among its editorial board Blanco, Carpentier, Fornet, Guevara, Guillén, Mariano and Retamar.

95 Rafael Rodríguez, 'Problemas del Arte en la Revolución', p. 30.

The Cultural Congress of Havana (5–12 January 1968)

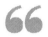 A national culture in underdeveloped countries should take its place at the very heart of the struggle for freedom which these countries are carrying on.

– Frantz Fanon, 1961.

In November 1966, Che Guevara had surreptitiously left Cuba for Bolivia, to open up a new front in the Bolivarian effort to establish a federation of independent Latin American republics. Less than a year later, on 9 October 1967, having been betrayed by a deserter and captured after a prolonged battle, Che was assassinated by young officers of the Bolivian Army, acting under instructions from the national government and Washington. Nine days later, in the midst of uncertainty about the circumstances surrounding the execution, Fidel hosted a rally to honour Che's memory in Havana's Revolutionary Square, describing him an 'artist of revolutionary war'.[1] In considering the poignancy of Che's death, Fidel surmised that 'The artist may die – especially when he is an artist in a field as dangerous as revolutionary struggle – but what will surely never die is the art to which he dedicated his life, the art to which he dedicated his intelligence'.[2] In the process, the leader of the Cuban Revolution made a commitment to ensuring that Che's message would continue to be heard and acted upon across the continent.

The week after Fidel delivered his memorial speech, the Minister of Education, José Llanusa, was called upon to give the opening address at a seminar which had been organised to discuss a putative international cultural congress. In welcoming around a thousand Cuban intellectuals to a seaside resort in the west of Havana, the affable Llanusa expressed his great regret that the seminar precluded the mass participation of the Cuban people, in part because of the great sadness that abounded in the wake of Che's death.[3]

In the immediate aftermath of revolutionary victory, a new beginning for world culture had been anticipated, with Cuba as its vanguard:

> We want to hear [...] a Chinese Communist Party member discussing with a North American Republican Party member the meanings of freedom! Let a Polish economist discuss with a Cuban economist the problems of the collectivization of land. Let a Mexican oil expert discuss the issues of nationalization of oil resources with a Venezuelan expert, employed by Standard Oil of New Jersey. Let a British Labour Party man discuss with a Yugoslav politician – whatever they want to discuss. And put it all on tape. Print it in the newspapers of Cuba. Make books out of it. Make Cuban intellectual life a truly international, truly free forum, for the *entire* range of world opinion, study, art, judgment, feeling.[4]

More specifically, the idea of an international cultural congress can be traced to the Tricontinental Conference, which had been hosted in Havana from 3 to 14 January 1966 with the aim of building links between Africa, Asia and Latin America. At this landmark conference – to which Che sent a letter of support, calling for 'two, three, many Vietnams' – intellectuals conducted a survey which highlighted the urgent task of defining their role within revolutionary society.

One consequence of the Tricontinental Conference was the formation of the Latin American Solidarity Organization (OLAS), which hosted a conference in Havana, chaired by Haydée Santamaría, from 31 July to 10 August 1967. The phrase 'What is the history of Cuba if not the history of Latin America?' was emblazoned in luminous letters behind the OLAS stage, alongside portraits of Bolívar, Martí and Che, the latter of whom was depicted fighting in the front line of a new Bolivarian army. Two central contentions dominated proceedings – that armed struggle was the only way to revolution, and that Cuba should be considered the vanguard of the Latin American revolution – both of which countered the orthodoxy of Moscow.

The death of Che and his comrades in Bolivia caused the armed element of the continental struggle to be postponed. It was assumed, by many Latin American communist party members, that this would lead to a return to orthodoxy on the island, but Cuban-Soviet relations had deteriorated to the extent that speculation about an open rupture was rife. At the same time, US-led counterrevolutionary activities combined with mass emigration and ignorance to engender widespread indifference (verging on hostility) towards the Revolution across the continent. In Cuba, this led to the conclusion that anti-imperialist action was needed on the ideological front, in the underdeveloped world in general and Latin America in particular.

Between the two landmark conferences described above – on 18 January 1967, the birth centennial of Nicaraguan poet Rubén Darío – a group of Latin

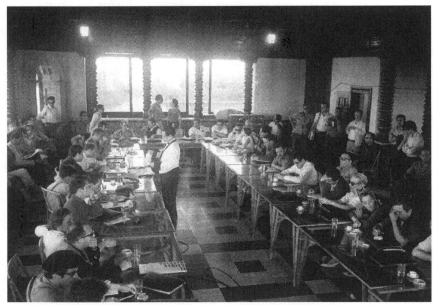

Meeting with Rubén Darío, Casa de las Américas, 18 January 1967, including Mario Benedetti, Margaret Randall, René Depestre, Félix Pita Rodríguez, Juan Bañuelos, José A. Portuondo, Francisco Urondo, Ángel Rama, Heberto Padilla, Ida Vitale, among others. Courtesy of the Archive of Casa de las Américas.

American intellectuals met in Havana to reiterate the necessity of defining their revolutionary role. The following month, the Cuban artists and writers involved took the idea of an international cultural congress to Fidel, who responded enthusiastically while also criticising attitudes assumed in the cultural field by Soviet authorities. The aforementioned preparatory seminar – which ran after 8:30pm every evening between 25 October and 2 November 1967 – refined the topics that would eventually be discussed. This process gave rise to five main themes, which, it was understood, in no way precluded the addition of other topics. The prevailing subjects were:

1. Culture and national independence
2. The integral formation of man
3. The responsibility of the intellectual with respect to the problems of the underdeveloped world
4. Culture and the mass media
5. Problems of artistic creation and of scientific and technical work

Presidency of the preparatory seminar was split between four people, including Haydée, and a president, vice president and secretary were elected to oversee the individual commissions. Each commission was given the autonomy to organise work according to its preferred methodology, which it was understood might involve the formation of sub-committees.

Notable in relation to this study is the participation of Ambrosio Fornet and Roberto Fernández Retamar in discussions around intellectual responsibility under conditions of underdevelopment and that of Alfredo Guevara in the commission pertaining to artistic creation, scientific and technical work. Their involvement, alongside many other creative practitioners, grounded the preparatory seminar, and the eventual congress, in the individuals and institutions at the heart of the Revolution. Yet Lisandro Otero (who served as President of the group on culture and the mass media at the preparatory seminar) alludes to persistent tensions between diverse cultural sectors, which resulted in organisations competing for majority participation of their members.[5] For him, this fierce battle for cultural hegemony exposed the fact that old confrontations had not ceased. With this in mind, the ensuing congress would be noteworthy for its unity – of surrealists, Trotskyists, communists, Catholics, guerrillas and pacifists – which Otero partly attributes to the diversity of its national organising committee.[6] In his closing speech to the congress, Fidel would commend the fact that the intellectuals in attendance had not come as activists from political organisations but as a vanguard nucleus, capable of grasping the nature and severity of the problems facing humanity, thereby aiming a sideswipe at orthodox forces.

We have already seen how Gramscian conceptions of the intellectual were integral to revolutionary thinking. It has also been evident that Nuestro Tiempo advocated the complete reorganisation of culture at the hands of the most responsible exponents of art, science and letters – an approach which was adopted by the CNC during its early years of operation. In the process of addressing the socio-political role of intellectuals, the 1968 congress consolidated the desired convergence of artists and writers, scientists and technicians. During the preparatory seminar, Llanusa explained how Fidel had identified a need to broaden the definition of intellectual to include researchers, technicians and scientists – a move that was enthusiastically embraced by the artists and writers present. Motivation for this redefinition may be found in Llanusa's parallel acknowledgement that revolutionary processes were being retarded by a lack of technical expertise, which might partly be overcome through discussion between the proponents of arts and letters and the scientific-technical community, while engendering greater levels of acculturation in the latter. It was further envisaged that an estimated 400 foreign guests, who would be invited to participate in the January congress, could contribute additional insights to the revolutionary process. In this way, a massive plan (already under way) – to educate agricultural and industrial technicians considered vital to economic and social development – would be complemented by visits to cultural institutions by international writers, artists, researchers, pedagogues, mathematicians and physicists, bringing practical support and building solidarity.

In closing the preparatory seminar, President Dorticós made no secret of the fact that material insufficiencies continued to hamper the Revolution, and he included within the definition of intellectual all those who applied their comprehension to its fundamental objectives. In a ccountry undergoing profound transformation in a bid to pull its people out of underdevelopment, he argued, scientists and technicians deserved to be included in this category, in recognition of the deep interrelations which existed between different types of thinker and the necessity of finding revolutionary solutions to the problems being faced. Accordingly, a

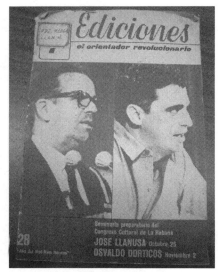

Commemorative publication for the 1967 preparatory seminar of the Cultural Congress of Havana.

concern with the problems of the underdeveloped world and an assumption of responsibility in the face of those problems became the determining criteria for invitation to the congress. In opening the eventual event, Dorticós would reiterate that its uniqueness lay in the fact that it was the 'first gathering of men from all continents, who belong to different professions and who perform their intellectual work either in the field of literature or of art, of science or of technology, in short, men of thought, which means men capable of placing themselves before the contemporary complex of problems [and] making a rigorous critical analysis, with the acuteness of perception that stems from each one's cultural background'.[7]

There are those who argue that the elevation of different social categories to the status of intellectual effectively downgrades artists and writers and undermines their work. So, for example, Weiss asserts that:

> Artists consider themselves a unique breed of intellectual, but this definition was unconditionally rejected after the [1968] Cultural Congress, where a broadened definition gained general acceptance. Political functionaries were intellectuals, cadres were intellectuals; intellectuals were consecrated by a very concrete social function. Artists and writers who wasted their time either chasing after pure ideal forms or attacking one another with dogma and rhetoric could hardly qualify as intellectuals; they continued to exist outside the mainstream, intellectuals in name alone.[8]

While this account accurately prioritises the social role that artists and writers were increasingly expected to play, it erroneously suggests that their impact

President Dorticós opening the Cultural Congress of Havana, 4 January 1968.

was diluted by the expansion of the intellectual category and that this precluded formal experimentation and a discursive approach. In studying Cuban sources, it seems that, rather than implying a devaluation of artists and writers, their inclusion (or consolidation, in the case of writers) into the intellectual pantheon alongside scientists and technicians may be regarded as an acknowledgement of the necessary role that artists and writers could play in shaping revolutionary society alongside thinkers from other fields. This is best illustrated by Llanusa's contention that 'the Revolution knows that intellectuals are those who construct and create the revolutionary process because they are the Revolution, they feel and live with the people and because, for eight and a half years of Revolution, they have suffered, in their own flesh, attacks by enemies of the people'.[9] At the eventual congress, the British physicist G.W. Hutchinson would respond to C.P. Snow's problematisation of the Western separation of science and the humanities into 'two cultures' by reclaiming scientific research as part of the creative imagination.

Towards the end of December 1967, foreign intellectuals and members of the press began to arrive in Havana, to be accommodated at the Habana Libre and Nacional hotels respectively. One of the invited guests, Andrew Salkey, had the foresight to document his experience of the congress in a diary, later published under the title of *Havana Journal*, which provides an invaluable eyewitness account of the times. Salkey describes the discomfort of himself and others in relation to the luxurious hotel life experienced by the delegates, which surpassed that of any Cuban, including the *comandantes*. This was particularly irksome given that fuel rationing was implemented on 2 January 1968. During the first full session, Salkey's travelling companions raised questions about the wisdom of this approach, and 'Irving Teitelbaum of the British delegation proposed that most of all the cars and buses which had been put at the disposal of the delegates should be withdrawn forthwith, and that a much more modest and sensible transportation arrangement should be worked out'.[10]

Estimates of the number of delegates vary, with 440 intellectuals from sixty-six countries being reported in *Granma* on the opening day and 644

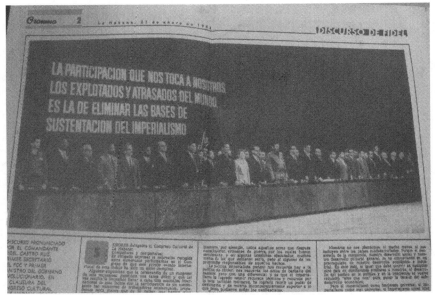

Starting lineup at the Cultural Congress of Havana, January 1968, in front of a slogan implicating the exploited peoples of the world in eliminating the foundations of imperialism.

participants from sixty-seven countries (including Cuba) being retrospectively claimed by the CNC.[11] Attending the event, Arnold Wesker reported that 'It was a massive feat of organisation, a moving manifestation of the kind of universal hope and trust many artists and intellectuals place in Castro and the Cuban revolution and a unique opportunity for some of the century's best minds and talents to meet in private. As such it was a great success'.[12] The inclusion of around 200 Cuban representatives inevitably meant that others were excluded, but an active programme of visits to cultural organisations was orchestrated throughout the period of the congress, while cultural venues around Havana (notably UNEAC) played host to less formal conversations.

Tallying the intellectuals from outside Cuba, Salkey found Europeans to considerably outweigh those from South and Central America, which elsewhere led Benedetti to conclude that the congress could 'be criticized only because of the excessive number of Europeans'.[13] Two prominent exceptions to this were Ernst Fischer and Jean-Paul Sartre, both of whom sent apologies for their absence on the grounds of ill health in letters brimming with admiration and solidarity for the evolving Revolution, with the former evoking the changing character of the working class and burgeoning anti-capitalist movement and the latter expressing a desire to ask the congress how intellectuals from the hateful and harmful culture of Europe could contribute towards an independent culture. Bertrand Russell also sent a note, identifying Cuba 'with the artistic and scientific avant-garde and with the widest and most

adventurous freedom of cultural expression'.[14] The focus on European partici-
pation seems to have been part of a deliberate strategy, aimed at diminishing
the influence of Soviet interpretations of socialism and communism. Karol
reports that the Cubans had bypassed the party machinery when inviting
communist intellectuals, and had taken care to include 'notorious heretics,
ex-Communists, independent Marxists – all of them detested in Moscow.
And yet Moscow could do nothing at all about these scandalous irregularities;
Cuba was still on their official list of friendly countries. And so they sent a
very small delegation, which was just what the Castroists wanted'.[15] For him,
this serves as an indicator of the *froidure* that existed between the established
communist bloc and its potential rival:

> [...] in asking the intellectuals to deal quite openly with the problems
> of the Revolution, the Cubans were inviting them into realms that
> Communist parties had always considered their own preserves. Indeed,
> official Communists had invariably heaped abuse on these petit bour-
> geois hairsplitters and troublemakers as soon as any intellectuals had
> had the audacity to encroach on that preserve. Now, quite suddenly, the
> Cubans, heroic Communists though they were, had asked these same
> intellectuals to share in their most intimate deliberations and to provide
> the answers to their most pressing questions. Nor did the Cubans leave
> it at vague hints, for every time they denounced the failure of revolu-
> tionary movements in capitalist countries, every time that they attacked
> reformism or the spirit of compromise, they put the blame squarely on
> the orthodox Communists, and so exonerated most of those present.[16]

In the midst of a full programme of hospitality, Dorticós inaugurated
the congress at 9:45pm on Thursday 4 January 1968, in the Ambassadors'
Suite of the Habana Libre hotel. From a transcript of this speech, published
in *Granma* the following day and retrospectively translated for the congress
publication, we learn that, in the name of his people and the revolutionary
government, the President of the Republic extended a hand of friendship to
all those intellectuals present and humbly expressed profound gratitude for
their attendance, which he took as a gesture of solidarity in light of the repris-
als they risked from the imperialist powers. (Papers subsequently released
by the FBI show that US intellectuals who considered visiting Cuba for the
congress were placed under investigation.[17])

While Salkey was a little disconcerted by the two long rows making up
the forbidding 'committee face' of the Revolution at the inauguration, he
nonetheless found that:

> The President's address was earnest and forthright. He asked delegates to
> feel free to express themselves and so contribute to Cuba's understanding

of its cultural role in the world. The highlights of his one hour, fifty minutes' address were: (1) the impact of the arts and the sciences on the Revolution, and the Revolution on them; and (2) the making of the New Man whom the social revolution will need for its protection, enhancement and long life in a politically hostile hemisphere.[18]

More specifically, Dorticós reiterated his expectation that the main objective of this unique congress was that of tackling cultural problems in the so-called Third World. The President's speech was infused with a desire for the intellectuals present to engage in a rich and reciprocal exchange of experiences and to undertake rigorous critical analysis in an atmosphere of absolute openness. Reinforcing the fact that no party affiliation had been required from delegates, he explicitly exempted the congress from political, state or indirect limitations.

At the same time, Dorticós envisaged that Cuba's revolutionary departure from the 'distressing, difficult and complex' experience of economic and cultural underdevelopment might prove a useful recent precedent. Without wanting to predetermine debate, he imagined that the *modi operandi* of cultural colonialism might be enumerated, in a bid to better understand the techniques through which ideological penetration succeeded. (The most direct response to this call would be a paper by José Martínez, an editor from Spain, who outlined the ways in which cultural colonisation in Latin America had been intensifying since 1960 – through measures of direct and indirect cultural control.) As an antidote, Dorticós emphasised a pressing need for the intellectual and cultural development of the people (farmers and party leaders alike) – 'protagonist of a revolution and leader of their own destiny' – as a precursor to economic development.

Predicated on Cuba's urgent demand for technical advice, professionalism and intellectual and cultural development, in the face of attempts to block access to the same, Dorticós's speech betrayed a revolutionary impatience for intellectual resources to be dedicated to lifting the country from underdevelopment. Reiterating the broadest conception of intellectual work, the President attributed those present a role not only of analysis and creation but also of action, education and dissemination. This would help to ensure that the fully developed man of the future would be an intellectual in the dual sense – both owning the instruments of culture and engaging 'not merely as a witness or spectator but also as a protagonist in the field of culture'. Tellingly, for the purposes of this study, Dorticós confessed that 'Cuba, which has solved many problems [...] in the economic and in the cultural field [...] has not solved all the questions implied in the problems of the development of culture in the future society – and very especially those referring to questions of art and literature', but the congress would provide an opportunity 'for learning, for lucidity, and for gaining insights'.[19]

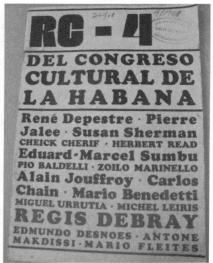

Speech by José Llanusa Gobel at the Cultural Congress of Havana, 5 January 1968.

Special issue of *Revolución y Cultura*, one of three produced to commemorate the Cultural Congress of Havana, February–March 1968.

Later that same evening, delegates received a slip of paper in their hotel rooms, asking them to choose which of the five commissions they would like to attend. Salkey reports that, the following morning, at 11:30 (instead of 9am), 'The stage curtain parted. On the platform: José Llanusa Gobel, the Minister of Education and our official host; José Antonio Portuondo, the critic; Alejo Carpentier, the novelist; René Portocarrero, the painter; and Nicolas Guillén, the poet. During the opening remarks of the Minister of Education, the leader of the South Vietnam delegation [painter Huynh Tu] walked on to the platform and received a standing ovation.'[20] Huynh Tu then read an hour-long report, detailing the cultural fallout from the North American occupation of his country – which had turned Saigon into a gigantic brothel – and the high cost exacted upon Vietnamese artists and writers, and asserting that culture in Vietnam had always been united even when artificially divided by US aggression. The Cuban press reported on the emotional embrace and expression of gratitude Huynh Tu's words elicited from Cu Huy Can, the poet and Vice Minister of Culture of the Democratic Republic of Vietnam, who also declared Vietnam to be one country. This was greeted by a prolonged standing ovation while the flag of the National Liberation Front of Vietnam was presented to the congress.

Aside from this moving intervention, Llanusa talked the plenum through the various modifications to procedure that had been suggested by delegates – which saw overall presidency of the congress being entrusted to Dorticós, Guevara, Guillén, Hart, Llanusa, Rafael, Retamar, Santamaría and others

from the tricontinental area and presidency of the commissions being shared by a rotating group. Following an acknowledgement of solidarity and a plea for open debate, Llanusa expressed a desire to arrive at a final declaration with which everyone could be in agreement – a profoundly anti-imperialist statement that would express support for the people of Vietnam and any other points on which consensus had been reached – giving rise to an historic document that would be issued on behalf of the intellectual movement of the world.

Delegates spent the following week considering very many papers delivered by invited guests, in English, French and Spanish, which were simultaneously translated and transcribed for immediate distribution. In an attempt to convey the flavour of the event, a brief summary of the work of each of the commissions will be made here, reconstructed from the official congress publication, plentiful contemporaneous newspaper coverage and papers selected for publication by the editorial board cf *Revolución y Cultura* over three special issues,[21] alongside translations of selected papers edited by Irwin Silber, first-hand accounts of the first commission from Wesker and of the second commission from the US writer-activist Susan Sherman,[22] together with Salkey's impressions of working within the third commission.

Commission I: Culture and National Independence[23]

The primary question guiding this commission in its work was: 'Is it possible to develop a national culture under colonial or neocolonial domination?' This required consideration of:

1. Colonialism, neocolonialism and national culture.
2. Role of the social classes in the development of national culture.
3. Imperialism and racialism.
4. Cultural development in recently liberated countries.
5. Underdevelopment, development and accelerated development.

We have already begun to see that, when Cuba gained her independence from the neocolonial grip of the US, the island's artists and writers began contributing to the formation of a new internationalist culture with profoundly national roots. The starting point for the first commission at the Cultural Congress of Havana was that US imperialism had never been more aggressive – as manifested in the direct and indirect economic penetration of Latin America and beyond – and the only way to defend human dignity would be through the construction of socialism with fists, words, rifles and cannons. Allied to the process of achieving national sovereignty would be a sustained project of cultural decolonisation.

On the opening day, the Puerto Rican writer Emilio Díaz Varcárcel defined authentic Latin American culture as the total expression of the

continent's peoples. In this, he argued that, while autochthonous culture might serve as protection against absorption by invaders, it was unable to evolve under the prevailing conditions. Maxine Robinson from France would later assert that the imperialistic tendency to destroy national cultures was underwritten by an ideological offensive which sought to subjugate countries, and that these two tendencies conspired to produce an instrumental cultural policy. This implied that a liberation struggle would be necessary, with intellectuals in the front line, to defend a more humane conception of existence than the 'American way of life'. The Angolan literary critic Mario De Andrade argued that armed struggle carried with it certain aesthetic requirements, such as the 'search for a language which, coming from the people, speaks to the people',[24] within which he situated revolution as the poetic act 'par excellence'.

The following day, discussion was centred on the precise relationship between national independence and culture, alongside a detailed consideration of the obstacles imperialism had imposed upon development of the same. On the morning of Sunday 7 January, one of the presidents of this commission, Cu Huy Can, indicated that the fundamental point of departure for that day would be the role of classes and emancipation in developing national culture. Within this session, a presentation was made by the editor of *Socialist Register*, Ralph Miliband (father to David, whose brother, Ed, former leader of the British Labour Party, would be born the following year). Miliband proposed that an 'Appeal of Havana' should be made to all the intellectuals of the world, which would take as its starting point a consideration of the ideological struggle that could liberate humanity. This was unanimously accepted, with the presidency confirming that the idea would be transmitted to the other commissions so that such a document could also take their work into account.

Considering intellectuals within bourgeois society, Nils Castro of Cuba argued that, 'While certain classes become the main suppliers of these intellectual cadres, that does not imply that they remain identified with their class of origin, nor that they become part of the class that they serve'.[25] At the other end of the ideological spectrum, the social critique of bourgeois intellectuals was repressively tolerated, undermining their claim to act as 'critic archangels'.[26] For Castro, exposure of the academically fertilised juvenile imagination to the aims of imperialism presaged the revolutionary potential of a disgruntled intelligentsia.

Pierre Jalée – a retired economist and senior functionary of the French government, who had overseen the financial independence of Morocco – posited economic and cultural underdevelopment as inextricably linked to, and engendered by, imperialist domination. For him, the contradiction between this dependency and a desire for economic and cultural development

René Depestre at the Cultural Congress of Havana, January 1968.

on the part of the peoples of the underdeveloped world was the central paradox of the time, which could only be resolved through revolutionary, anti-imperialist struggle in which intellectual involvement was paramount. This was echoed by René Depestre, in a paper outlining the dubious connotations of negritude that had developed in Haiti, hailed as the 'first Negro republic of modern times'.[27] Depestre also argued that the main aim of the congress was to determine a concrete basis on which to 'carry out common actions for the whole decolonization of diverse cultures of the Third World', which 'forces us *to reconsider the idea itself of the responsibility of intellectuals and, together, define the militant and dynamic forms of solidarity of men of culture of the entire world*'.[28] Such decolonisation was envisaged as a powerful social organism, capable of generating antibodies against the neocolonial epidemic. Finding a collective basis for this decolonisation process would involve determining the social, moral, artistic and political responsibilities of those present. And, just as the decolonisation process must be predicated on true revolution, the development of national culture could only be achieved through a 'radical, violent, dis-alienating rupture with the colonial past'.[29] Also addressing the theme of this commission, Co-president Portuondo argued that culture could venture beyond the peculiarities of a particular country when it contributed to the betterment of society, integrating the most worthwhile elements of universal history into proletarian culture and limiting the dangers of cosmopolitanism and chauvinistic bourgeois nationalism.

In advance of reaching any kind of resolution, various wrangles arose within this commission. Apparently, 'Wesker had been replying robustly to the challenge coming from the United Arab Republic's delegation, in a matter concerning Israel, the United States and the U.A.R.'.[30] One such paper, by

Hussein Fahmy, sketched the history of political Zionism since its foundation in 1897, positioning Israel as a powerful weapon in US attempts to thwart Arab self-determination and peace. Reflecting upon the congress soon afterwards, Wesker remembered the situation as follows:

> [...] despite Castro's independent and imaginative thinking on so many other issues he did not have the courage to face Arab hurt pride and invite delegates from Israel – the only country not called to participate. The logic is totally incomprehensible to me. They invited delegates, most of whom were Jewish anyway, from the United States without fearing to offend the North and South Vietnamese delegates; but Israel, a country whose foundations were built upon communist settlements (kibbutz) hundreds of which still exist and which could have sent delegates able to contribute to the dialogue from a unique experience, were left out for fear of offending the Arabs – most of whom spend their time trying to convince the congress that their greatest enemy was world Zionism and their great danger the Zionist conspiracy. A congress concerned with unfair distribution of the world's wealth snubbing the Jews for defend-ing a tiny land area when the Arabs possess such vast – unused – ter-ritories, immediately rendered the honesty and courage of such a con-gress suspect; though it must be said in favour of the Cuban organisers that they became very bored with the Arab's [sic] persistent attempts to detract from the major issues of the commissions and patiently argued them out of their positions.[31]

This account of Israel's position in Middle East affairs seems at best hope-lessly anachronistic and at worst wilfully naïve. Unsurprisingly, Wesker and the Arab delegation would prove intransigent in their respective positions, causing delays that would have a knock-on effect on the final resolution of the congress as a whole.

The final resolution of this particular commission highlighted the wid-ening inequalities wrought by the imperialist stage of capitalism. It also acknowledged that people were increasingly liberating themselves both from subordination to mercantile interests and alienation from dignity and beauty. This recognised that culture had been distorted by neocolonial vio-lence – as evinced by the ways in which the ideology of negritude had been separated from the revolutionary impetus of the peoples of Africa and the Americas. This prompted the development of autochthonous cultures and international exchanges and predicted that, in the struggle for national liberation, authentic cultural change would be precipitated. In turn, this rendered revolution an avowedly cultural phenomenon, bracing the people to embrace all forms of creative expression in producing a national culture with universal scope.

Commission II: The Integral Formation of Man[32]

The second commission was centred on the formation of the 'new man' – the integral, un-alienated human being – elaborated by Che and invoked in Dorticós's address to 'artists poets and playwrights [who] are also linked with essential immediacy to the development of the personality of the new revolutionary man that we aspire to develop'.[33] Over ten working sessions between 5 and 10 January, it was asked: 'Is it possible to consider the complete transformation of man without a radical social transformation?'. In turn, this necessitated consideration of:

1. The revolutionary process in the formation of man.
2. Science, art, technology and sports in the formation of man.
3. Responsibilities and problems of the youth.
4. The emancipation of women.

David Cooper from England undertook a sociological analysis of the transition from individual to social concerns, which led to accusations of Freudianism. Pop Valeriu from Romania considered the formation of a technical and economic intelligentsia, to advocate cooperation between states – a perspective that was criticised for understating both the accelerated pace of development necessary in the underdeveloped world and the fact that economic cooperation was more likely to serve the colonial powers. The highly accredited Mexican neuro-psychologist Fausto Trejo Fuentes was quoted at length in the daily newspaper *Juventud Rebelde* [Rebel Youth] on Monday 8 January. His paper asserted that intellectuals, artists and men of science were not sufficiently preoccupied with the orientation and development of youth, which might give rise to the same chaos as was evident in the capitalist world, whereby young people were motivated by commercial interests.

More generally, Monday's coverage of the weekend's activities took the contribution of the Chilean surrealist Roberto Matta (father of Gordon Matta-Clark) as exemplary. Against the backdrop of his painting, Matta delivered a brief and vibrant paper, inciting a personal revolution in everyone who had achieved, or was striving for, freedom. Building a new social, cultural, intellectual and artistic world implied that, 'In the field of the imagination, one needs to be as hardened as in the field of battle'.[34] As artists could be distinguished by the intensity of both their lived experience and imagination, and the goal of any fruitful revolutionary process was to stimulate the creative imagination of the people, generating the means for investigating, expressing and resolving problems in the cultural field. In turn, this understood that 'Art is not a luxury; it is a necessity'.[35]

Between 10am and 1pm on the Sunday, the second commission had a lively discussion around a paper by Félix Sautié, a Cuban writer who had been active before the Revolution, going on to serve as editor of *Juventud Rebelde*.

His paper took care to delineate what the term 'new man' concretely expressed – the prioritisation of collective over individual interests; discovery of the intimate satisfaction of participating in social work; the barriers between intellectual and manual work being erased; aesthetic and cultural development being considered equal to physical development. Taking Che as an archetype, Sautié articulated the principle that humanity should be thought of neither as a commodity nor as motivated by blind necessity. Rather, recent experience showed that consciousness was formed holistically, imbued with a deep internationalist and revolutionary sentiment and informed by an inherent compulsion to express the human condition through authentic art and culture. In the responses which were forthcoming from Cuban delegates, care was taken to emphasise that the Revolution did not sacrifice individual, in favour of collective, interest; rather, the fullest realisation of each individual would be achieved through collective revolutionary struggle.

In a contribution selected for publication in the first special issue of *Revolución y Cultura*, Sherman invoked the power of art in educating the new man. Through art, she asserted, we learn something new; our eyes settle on something outside of ourselves, and we learn not only *what* to see but also *how* to see. Through such creative participation, the new man would gain both objective and experiential knowledge of himself. Sherman reports immediately being asked whether she had a ready model for applying her ideas within society, which testifies to the urgency with which Cuba was seeking to implement development. In her 2007 autobiography, she remembers that there were around 200 delegates in this commission, listing Hans Magnus Enszensberger (writer on the consciousness industry) among them. Overall, her impression was that 'Too much was happening. Too many faces, languages, too much information. I knew I would have to wait until I got home to sort it all out. Now I could only try to take it in, record what I was hearing and seeing, feeling and sharing'.[36] The retrospective process of making sense of the congress would lead Sherman to edit a special issue of *IKON* magazine.

In outlining the typical stages of revolutionary processes, the Syrian thinker Antone Makdissi found the threat of counterrevolution lurking in the colonialism that sought to deflect the Cuban Revolution from its objectives. For him, this profoundly anti-cultural tendency was the ultimate metamorphosis of colonialism, as manifested in Zionism and its incarnation in Israel. Alain Jouffroy – a French writer and artist, who would form a writers' union and propose an art strike when protest erupted on the streets of Paris a few months later – asserted that Latin American revolutionaries knew better than anyone that the initial impetus which motivates revolutionary action was never strong enough alone to secure its continuation. This necessitated a continual revision of theory, capable of correcting errors committed in practice, with acknowledged fallibility being a novelty of radical revolutionary thinking.

Similarly, the French film-maker Catherine Winter insisted that intellectuals – men of thought and action – should be freed from the shame of error. Jouffroy affirmed that freedom of thought and mobility of the imagination would be required methods in the new man, as discipline and rigour were in the militant revolutionary.

The final resolution reported that this heterogeneous commission had reached a consensus on a range of issues. In relation to the main question being considered, it was agreed that:

> The formation of the new man in underdeveloped countries cannot be conceived without the previous liberation of the peoples nor without the profound structural changes of economic and social features that such a liberation must implicitly contain. In a class society in which the exploitation of man must prevail, it is not possible to obtain a formation of a complete man because such a regime makes impossible the existence of conditions in which this man can fulfill himself completely.[37]

Such liberation could only be attained through armed struggle, which was not derived from the people or revolutionaries but from the violence of imperialism. Upon seizing power, it was not enough to merely break the existing structures; they must be substituted with those integral to the formation of the new man, with the people taking over the means of production and hurling themselves into revolutionary socialist development. Even before this has been achieved, however, the qualities of the new man were latent within the people, particularly within the vanguard thrown into the struggle from which conditions for the new man arise. The basic prerequisite for the new man was an absolute and equal identification with the people, aligning personal interests with those of society. This required the rejection of individualism, as a vestige of class society, and the embrace of 'that individuality which finds its highest expression in the society in which man is able to participate actively in the varied social creation and in the direction of the entire scientific, educational, artistic, political, and cultural process'. In this way, individuality was again reinforced over individualism.

This was followed by a long exposition of the personal characteristics of the integral man – the patriotic internationalist, free from irrational prejudice, motivated by solidarity with those who struggle for their liberation against despised imperialism:

> The integral man is he who is ideologically, scientifically, technically and culturally qualified to participate in an active and conscientious way in the construction of the new society and in the aesthetic enjoyment derived from art and literary activities and creations; who is always technically prepared to defend the revolution and ready to fight imperialism

as long as it exists; who is able to carry out manual productive work or intellectual activities, indistinctly, both as a social need and as a personal satisfaction; who is physically and mentally able to participate in sports and recreational activities.[38]

Inevitably, it was agreed that 'The best concrete representation of this man is Major Ernesto Che Guevara, who heroically died on Bolivian soil fighting against imperialism', with many of the necessary qualities remaining within reach of those present. In this, it was understood that 'Art and literature, as forms of the social consciousness of the highest human communication, constitute an essential factor for the formation of the integral man.'[39] This was followed by an outline of the resources which should be made available to society by the prevailing forces, culminating in the liberation of women from the domestic servitude endemic within class society.

Commission III: The Responsibility of Intellectuals with Respect to the Problems of the Underdeveloped World[40]

Within the third commission, a question was posed about the responsibility of intellectuals in relation to 'society and the rest of the world'. This was variously posed to intellectuals in developed and underdeveloped countries.

The morning of 6 January began with a message from Prince Norodom Sihanouk, Chief of State of Cambodia, which was read in French by his son, Prince Norodom Ranardih, and reproduced in full in *Granma*. Very brief, 'It contained a statement of aggrieved complaints against [US] American exploitation and aggression, and reaffirmed the determination of the intellectuals of Cambodia to resist American aid and to find the courage to decline all forms of American donations, monetary, cultural and technological, in whatever context they might be offered'.[41]

Following this, the first paper – by Cuban writer and professor Federico Álvarez – overlapped with the territory covered in commission two by considering the new type of man who would need to be born in the underdeveloped world and the role of intellectuals in bringing about this naissance. Perhaps surprisingly, this found that the intellectual's role fundamentally expressed itself in aesthetic, scientific and personal, rather than social, responsibility; nonetheless, Álvarez acknowledged that there would be moments at which the ultimate sacrifice would be demanded, which compelled everyone to join the struggle.

To a silent and bewildered room, C.L.R. James – a writer from Trinidad and Tobago who had travelled from London with Salkey – proposed that 'The function of this Congress is that intellectuals should prepare the way for the abolition of intellectuals as the embodiment of culture'.[42] James would later reiterate this sentiment as the final point in a ten-point self-authored

scenario, which read: 'The function of this Congress is that intellectuals should make way for the abolition of the intellectuals as an embodiment of culture'.[43] It is clear that this statement would have seemed incongruous in a country that was rapidly developing the intellectual capacity of its people in all areas, and Álvarez vehemently disagreed. Much discussion followed, with Julio Cortázar of Argentina dismissing the ivory tower intellectual and Gabriel Celaya of Spain describing the model intellectual as an accessible teacher – making patent what had hitherto been latent – while freely pursuing

C.L.R. James in Havana, 1968. Courtesy of the Archive of Casa de las Américas.

their own high-quality art or science. At the same time, intellectual participation in armed or clandestine struggle or manual labour was determined indispensable for maintaining contact with the people. It was later reported in *Granma* that James had clarified his position by saying that, in order to extend itself to the masses, culture should break with the frameworks that led it to be attributed to individual owners or makers. In this way, he echoed Cuban rejection of bourgeois individualism and redeemed himself in the eyes of his host nation.

In a poignant autobiographical statement, the Cuban short fiction writer Onelio Jorge Cardoso described the vicissitudes suffered by intellectuals before the Revolution, whereby writers would scrape together enough savings to publish a book, sometimes dedicating it to a politician of the day, in the hope of procuring funds to produce another volume that would linger, unread, in the bookshops of Havana. Faced with this situation, writers contemplated four equally unappealing options – to cease publishing and keep their writings in a private drawer; to leave the country; to make deals with unscrupulous politicians; or to become part of the publicity machine. This hinted at the particular losses experienced by the second category of writer – many of whom had recently returned – who 'lost sight in a good measure, of the slow, daily agony of the country, the shared experiences of those days'.[44] Contrasting former times with the present situation, Cardoso argued that 'there has never existed in the history of our country a better time for intellectuals',[45] and, while there was still work to be done in securing the maximum writing time, intellectuals were respected and entrusted with making a contribution to the construction of a fairer way of life for everyone. Alongside

persistent attempts to redefine the category of intellectual, Híber Conteris of Uruguay declared that:

> [...] the intellectual is an interpreter, a radical critic and an unraveller of society and of the world in which he lives with all mankind. [...] He must not be a neutral person. He will begin to atrophy if he relies on any kind of neutrality to see him through his role as an intellectual in a harsh world. He must search for the truth in his particular struggle and endanger his life and existence in doing so. He is a transformer in the times of depression and oppression, and he is obliged to become a critic during the revolutionary period. Even then he must never give up the truthful search for the real revolution for his society. He must be a revolutionary always, even within the established Revolution.[46]

In reiterating the critical intellectual role, Conteris disputed the perceived division between intellectuals of developed and underdeveloped countries, on the basis that the revolutionary credentials of both were paramount. As this called one of the premises of the congress into question, Retamar intervened to define intellectuals as anyone who depended on their creative and mental powers to understand the world around them. This prompted pleas that the duty of intellectuals be precisely defined by the plenary.

During the lunch break, Salkey read the collated papers from the morning session and confessed that he 'felt far from inclined to face the second and final session later in the afternoon. I persuaded myself that a numbing dullness had already been creeping into the reading of the papers in the Commission, and even more so in the replies and the rebuttals from the floor. Still, one's open to blasts of surprise, I told myself'.[47] His forced optimism was rewarded with a furious exchange of opinions, in which José Federico Aguilar, a lawyer from Costa Rica, was cited in the national press as being the most polemical for his advocacy of an end to elitist stereotypes, on the basis that it was insufficient for intellectuals to claim themselves revolutionary or pretend to be so; they must devote themselves to their fellow men and identify themselves with the popular cause. Edelberto Torres of Nicaragua situated Aguilar's position in the utopianism of the previous century, which others opposed to armed struggles that fully identified with the people. Ecuadorean writer Jorge Enrique Adoum acknowledged that – beyond compassionate humanitarianism and patronising reverence for folklore – the intellectuals in attendance were united in their anger at the brutality of imperialism. With the exception of those engaged in armed struggle, the remainder could be divided according to whether they dedicated their creative efforts to analysing man's condition within struggle or whether they believed art should be considered on a higher plane, free from transitory circumstances, while continuing to fulfil their duties as citizens in relation to the world's problems (what the

Mexican economist, Alonso Aguilar, elsewhere referred to as 'The escapist and schizophrenic conception of a mutilated man – half intellectual and half citizen – [which] can only lead to impotence, frustration, and, in the final analysis, serve the existing interests').[48] Recognising his own passivity, Adoum took comfort in the fact that Che Guevara had assigned to Régis Debray the task of explaining the struggle and helping the people to understand the need for liberation, thereby reviving cultural traditions stifled by colonialism and salvaging aesthetic sensibilities. In this, Adoum accepted the individual obligation of contributing to the structural change

Mario Benedetti in Havana, 1967.
Courtesy of the Archive of Casa de las Américas.

of revolution and the professional obligation of helping art to emerge from underdevelopment, which – according to Che's dictum – presupposed both quality and beauty. In 'the humanist socialism of Cuba', he observed, 'the revolution is not a matter of forms but of attitudes'.[49]

Elsewhere, the humanism underlying Marxism was extrapolated by Hungarian writer László Gyurkó, who distinguished between means and ends to note that 'There is nothing more important in the world than man himself and the end of socialism in nothing else but the creation of a freer, more integral, and happier type of man. Marx's philosophical system is fundamentally anthropocentric'.[50] In Marx, Gyurkó found an explanation of the socio-economic causes of alienation as well as the methods to overcome them, with socialisation of the means of production and liberty from poverty geared towards the end of transforming humanity.

Abiding collaborator of Cuba Mario Benedetti made a presentation to the third commission, entitled 'On the Relations between the Man of Action and the Intellectual', outlining how anyone from any walk of life could be compelled to revolutionary action for a variety of reasons, to become what Fidel would call the 'highest form of the human species'.[51] This galvanisation into action had the side effect of making intellectuals seem rather passive by comparison. And, while men of action in the higher ranks of corrupt societies tended to regard intellectuals as contemptible non-conformists, in the revolutionary moment – when men of action united in the struggle for justice – such mutual distrust had to be overcome in order to provide a solid foundation for subsequent transformations. After all, men of action and

revolutionary intellectuals (whatever their aesthetic orientation or medium of expression) shared 'an ideological base, revolutionary ethics and a theory about the Revolution'.[52]

In the wake of the Mexican Revolution, Diego Rivera had posited a role for artists at the vanguard, sometimes as a guerrilla fighter.[53] While, for Benedetti, the categories 'man of action' and 'intellectual' remained largely distinct (except in the unique example of Che), aspects of one would inevitably be found in the other, leading to conflicts that could become fruitful. Evoking Che's 1965 frustration with the slow development of intellectuals, he conceded that 'It is understandable that the man of action may at times grow impatient and that, owing to his dynamic vocation, he may tend to oversimplify the personal qualities of the intellectual or, at worst, to invent a false intellectual, a coarse puppet, who can be more easily ridiculed. What is certainly inadmissible is that the intellectual accepts this simplification'.[54] Rather than becoming mere scribes to men of action, it would be incumbent upon intellectuals to make a dynamic contribution to the process of revolutionary development. Elsewhere, Italian film director Valentino Orsini noted that, while artistic work could not replace its political equivalent, art in bourgeois society had ceased to have any critical or oppositional potential. In response, he compelled intellectuals to 'create works planned as revolutionary opposition to the system', which relied on a 'capacity to single out and to know how to grasp the contradictions of the capitalist system',[55] combined with an awareness of the ideological character of language.

Whereas Celaya had made the vanguardist assertion that 'The intellectual is obliged to raise themselves up to the people and to walk a path in front of them',[56] Benedetti suggested a reciprocal process in which 'the man of action should be a "trail blazer" of the intellectual and vice versa. That is, in the dynamic aspect of the Revolution, the man of action should be the vanguard for the intellectual and, in the sphere of art, of thought, of scientific research, the intellectual should be the vanguard for the man of action'.[57] Echoing his countryman, Conteris, he asserted that the intellectual was 'almost by definition a non-conformist, a critic of his society, a witness with an implacable memory'.[58] Benedetti's speech received a standing ovation and was greeted with almost total agreement, but there were a couple of dissenters. *Granma* reported on this minority opposition, referring to an Italian named Vitale who considered it dangerous to differentiate between the duties of men of action and intellectuals; similarly, César Leante of Cuba argued that there was no need to admit contradictions between them.

The Sunday session began twenty minutes late, with a paper by the Peruvian poet Alejandro Romualdo, who grounded the intellectual's ethical and aesthetic contribution to national independence in their dual identity as both citizen and artist. In this, he argued, the cultural congress formed

the necessary counterpoint to all continental and tricontinental movements which took the *guerrilleros* as their symbol. According to Salkey, the absolute highlight of this session was Fornet's paper, 'The Intellectual in the Revolution'. Beginning with the admission that 'a writer or an artist is not a man of action',[59] Fornet accepted political and artistic responsibility as two sides of the same coin, readily assumed by intellectuals in countries in revolution and now being demanded of others. This not only implied the performance of civic duties, such as teaching and learning how to handle a gun or cut sugar cane, but also positioned intellectuals as intermediaries between their work and the people.

Acknowledging the disorientation felt by intellectuals in the face of revolutionary upheaval, Fornet confessed that, far from being a new man, he had been an old man without his old world to comfort him – at best, the 'man of transition' evoked by Retamar (to be discussed more fully in the next chapter).[60] The first step had been cultural decolonisation – self-definition through negation, accompanied by a rebuttal of worn-out, dogmatic political formulae and a testing of vanguard claims, through a critical process of acceptance and rejection – with the intellectual operating as critical conscience of both himself and society. In the process, intellectuals in revolution claimed the right to universal culture and the conquests of contemporary art, taking an active part in their evolution in order to 'create a new society with new human relations, and an art and thought capable of anticipating and reflecting them'.[61] In an eloquent illustration of the negation of the negation, Fornet described how, initially, 'It was enough to open our eyes widely to discover what we were not, but in order to foresee what we want to be it is necessary to close them now and then and imagine a city of the future, inhabited by men for whom history will have ceased to be a nightmare, and freedom, equality and fraternity mere words'.[62]

In contemplating the difficulty of the task in progress, Fornet turned his attention to the patronising remarks of well-meaning visitors who commended the remarkable Revolution and hoped that nothing would spoil it. An example of this would be Wesker's wish that 'the Cuban revolution could be one hundred percent honest; this tired world looks for it and needs it'.[63] Such sentiments provoked Fornet to say that 'I must confess that this remark, which used to flatter our pride, has lately become irritating. Not only is there a mixture of paternalism and distrust present in the visitors' eagerness to see us preserve the untouched image of an immaculate revolution, but it also transforms us into mere vestals, guardians of an already burning fire, when what we are, actually, is incendiaries, creators of a new fire!'[64]

Following a long debate on methodological questions, commission three reached majority agreement on the creation of a working group, headed by the presidency, which would collate the concrete propositions already made

and submit them to delegates the following day. These proposals would serve as the basis for a General Declaration for the Commission that would be drafted by Fornet.

The Monday session began, thirty-five minutes late, with a plea by Co-president Retamar for clarity and adhesion to time limits so that the commission could get through the remaining papers (which stood at thirty-five and growing) over the following four days. As requested, he summarised the points on which general agreement had been reached to date:

1. The responsibility of the intellectual must be linked inextricably with the social and revolutionary needs of the underdeveloped world;

2. The cultural de-colonization of the entire Third World must be undertaken with far greater resolve;

3. The prospect of the synthesis of multiple cultures, both metropolitan and rural, must be examined with care before it is brought about;

4. The revolutionary writer or artist or intellectual is also a man of action, though it may be sometimes very special 'invisible' action;

5. It is absolutely useless to ask what precedes a revolutionary act, because both armed struggle and intellectual thrust and criticism must work together as a unit;

6. The ultimate success of the Revolution depends on the indivisibility of that unit, which ought to have coalesced during the preparatory stage of the struggle; and

7. It must be a foregone conclusion that the intellectual functions as a critic, before and after the Revolution.[65]

In further analysing the intellectual responsibility, Retamar highlighted the immediate need for illiteracy to be eradicated and asserted that 'imperialist political and cultural penetrations into the underdeveloped country must be resisted and checked permanently'. In order to achieve the latter, he decreed, 'Anti-Bodies must be formed to fight against the "invisible" enemy [...], against imperialistic persuasiveness: Anti-Awards-and-Foundations watch committees ought to be set up: Anti-Metropolitan-and-Foreign-Education complexes should be founded to resist imposed language domination, imported popular entertainment and all the other cultural influences designed to overrun the Third World, with their appeal in books, films, television, advertisements, etc.'[66] This paralleled Lajpat Rai of India's evocation of intellectuals 'for whom leftism has become a lever for personal aggrandisement', who are 'daily succumbing to the vast cultural offensive which the imperialists have mounted against the peoples of the developing countries'.[67] With the experience of Neruda as a cautionary tale, for Rai this compelled all revolutionary intellectuals to expose pseudo-leftists, reaching their own conclusions and

rejecting 'dogmas, even when they are labelled as Marxist [...] theses based not on logic and realities of life but on quotations from manuals, on superfluous analysis'.[68]

After lunch, the British historian Eric Hobsbawm provided an outline aimed at making the question and answer sessions following each paper more constructive and concise by focusing attention on the prevention of ideological penetration. Retamar also delivered a paper, entitled 'Speaking of Responsibility', which asserted that the responsibility of intellectuals in the developed world did not consist solely in realising their intellectual task but extended into a consideration of the utility of their work and its beneficiaries. Implicating intellectuals in armed struggle, in an inversion of the infamous sentiment of playwright and SS officer Hanns Johst, he argued that 'we reject the easy attitude of those who, whenever they hear somebody talking about guns, pull out their culture'.[69] More specifically, Retamar's chosen topic implied responsibility *for something* and *by someone* – in this case, responsibility for underdevelopment on the part of the underdeveloper countries. In support of his argument, Retamar invoked an unnamed North American friend who was explicitly anti-imperialist but implicitly complicit with the system, which presumed that a distinction could be made between conscious individual responsibility and unconscious social responsibility. And, while intellectuals of petit-bourgeois origin might think themselves decoupled from the exploiting class, they needed to accept that a great deal of the wisdom of capitalist countries had been gained through exploitation of the underdeveloped world. Before true dialogue could begin, intellectuals from the capitalist world – with all its fashionable leftism – must acknowledge the connection between the misery of underdevelopment and the gains of Western art and science, which belonged as much to the countries exploited to attain them. In this, he gave due recognition to Jean-Paul Sartre in France, Peter Weiss in Sweden and Noam Chomsky in the US, and predicted that, in the future, 'intellectuals of the left, intellectuals conscious of their responsibility will be the ones, in the underdeveloped countries, who will carry out that restitution in a practical, real manner' – as scientists, linguists and perhaps even thinkers.[70]

In contemplating whether intellectuals from the developed world would ever really know their counterparts in that which they had designated the 'Third World', Jaime Sarusky wondered aloud whether the kind of dialogue sought by Retamar would ever be achieved. In a valuable first step, the congress served as significant proof that those for whom history had been written by others were beginning to emerge from that history, with the Revolution negating the destiny imposed upon Cuba by the US. While noting the lack of rigid specialisation that typified the work of intellectuals in the underdeveloped world, Sarusky simultaneously bemoaned the billions of dollars which

had been invested in the training of unscrupulous researchers and technicians who had been tempted to flee Cuba by the prospect of a more comfortable life. Pondering how this process could be circumvented, he surmised that the answer lay in activating consciousness and in reinvigorating the exhausted concept of solidarity. This would require an authentically revolutionary ethic, a violent break with old modes of thinking and a shared will to create a definitively new world. In the same commission, Gisele Halimi – a lawyer at the Court of Appeals in Paris and a member of the Russell Tribunal, which had demonstrated that the US had committed genocide in Vietnam – implicated culture in imperialist domination. Robbing underdeveloped countries of their language and traditional values, she argued, amounted to cultural genocide, which (according to the objective criteria of international law) might be considered a crime against humanity.

By the Tuesday morning, Salkey reports that, with the exception of the Cubans, South American delegates seemed to be abstaining from discussions with the leader of the Russian delegation. While the general quality of papers tailed off, the concrete measures proposed by Hobsbawm and others led to the formation of a sub-committee on imperialist ideological penetration. This considered a special report on the financial inducements and other opportunities being offered to intellectuals by North American foundations. In this way, Dorticós's initial call, to better understand the mechanisms through which cultural colonisation occurred, was heeded by this commission, and, as we shall continue to see, the strategies that were proposed as a deterrent would form an integral part of Cuba's response to imperialism.

Returning to the Ambassadors' Salon at 9pm on Wednesday 10 January, Salkey imagined that he and his colleagues would be writing and editing the final resolution of commission three and submitting it to the congress presidency for integration into the longer declaration. However, he reports, 'Apparently we were wrong. The resolution had already been written. The reading began at nine-twenty, amidst a rumble of protest about the fact that the resolution had been undemocratically drafted by the Commission Presidency only, and without the courtesy of copies'.[71] Voting was swiftly conducted, with two delegates against, three abstaining and 'a slightly doubting majority' voting in favour. Among the dissenters, the Russians asked Retamar to re-read the resolution, which was seconded by a flurry of other delegates, and Salkey notes that:

> Most of the essential statements in the resolution had been properly culled from the points of general agreement, refined in the discussions and debates on the most important and popular papers read in the Commission during the daily sessions. One or two points had been added by the Presidency to ginger the resolution along, and they were the ones

which had been of concern to a few of the delegates, mainly because of the way they had been described rather than because of the concepts they contained. [...] After the reading, the comments from the floor were spiky and urgent. Semantic tussles broke out with great individual passion. A massive Babel![72]

All suggestions were taken up and the necessary amendments made. By midnight, commissions two, four and five had made their resolutions; commission three would conclude its business at 1:45am.

The eventual resolution for commission three began with an acknowledgement of the 'profound relationship between the problems of the revolution and those of culture' in the tricontinental area, compelling the militant solidarity of cultural protagonists throughout the world. United by anger in the face of inequality, the delegates to this commission positioned culture as 'not only a legitimate goal of the spirit, but also an indispensable weapon in the struggle of our time',[73] acknowledging that every struggle against imperialism and neocolonialism was also a struggle for access to culture. In the process, the resolution resolved the central debate that had unfolded in the working sessions, by arguing that, just as political leaders are often intellectuals, intellectuals are also men of action, usually in specific ways:

> The intellectual can serve the revolutionary struggle on different fronts: the ideological, the political, and the military. Marxism is not a completed whole, a metaphysic: it is a method of knowledge, a science of the revolution. The intellectual discovers its efficiency upon bringing it face to face with reality and with the revolutionary practice, once he integrates himself to the organization and parties that are willing to make the revolution. The intellectual's activity is resolved in different ways: by providing the ideology of the revolutionary classes, by participating in the ideological struggle, by conquering nature – for the benefit of the people – through science and technology, by creating and divulgating artistic and literary works and, if the case were needed, by committing himself to armed struggle.[74]

It was also posited that an intimate relationship existed between the immiseration of the underdeveloped world and the conditions that had engendered the major developments in Western art and science, with the peoples of Asia, Africa and Latin America serving as the human fuel of progress. In rejecting this imbalance, the artists and writers of the so-called Third World 'creatively define their own reality and the struggle of their best combatants', generating a 'revolution in the consciences of the vanguard, who upon launching into political and military action permit that revolution of conscience to extend and deepen within the people', restoring their right to culture.[75] Once this had

been achieved, art and literature would not be luxuries but social necessities, paving the way for new responsibilities:

> In a society in revolution, the intellectual must be a critic of himself as well as a critical conscience of society. Since his aim is contributing to the creation of a new society, with new human relations and a new concept of life, he must, as he advances, measure the distance between the means and the ends, always judging what *is* in the name of what *should* be, and what will be. It is largely his responsibility that a new man appears at the end of the road, finally liberated from his alienation [...][76]

At one with the people and serving as mediator of his work, the intellectual must also contribute to 'disappearance of the concept of the "intellectual" as a member of the cultural elite. A persistent and multiple effort will permit every man in the future to be an integral man, that is, an intellectual also, in the broadest sense of the word'.[77] In this effort, it would be incumbent upon every honest intellectual to avoid co-optation by imperialist powers while joining forces with those intellectuals suffering under imperialist regimes.

Commission IV: Culture and the Mass Media[78]

This commission sought to address the 'function of the mass-media (radio, television, movies, press) in the formation of an authentic national culture'. As such, it took account of the function of the mass media in the process of cultural colonisation and decolonisation as an instrument of education and information in new societies. Throughout the week of the congress, various papers were read on the subject. In contemplating the effects of imperialism in the US, Irwin Silber described how:

> For tens of millions of Americans, the technology of capitalism has become, in fact, a monster which now dominates the very texture of their lives. The victory of this anti-human technology has produced a people frightened by the world, unsure of their own worth, anxiously buying emotional security through the accumulation of material objects. Their own culture has impressed on them that unless their physical appearance and their values match the unreal world of the television commercial and the magazine advertisement, they are incomplete people. The owners and operators of the mass media have mastered the techniques of personality manipulation and motivation. They utilize all the weapons of psychologi-cal warfare – fear, distrust, self-flagellation, guilt – for the purpose of selling their products and making profits. And now the American people have become prisoners in their own land. That they are unaware of their imprisonment or the creeping horror which is engulfing them is itself

part of the process which has dulled their minds and senses to the world they live in.[79]

In short, 'the United States of America, the ultimate triumph of "western ideals," the final "sanctuary of the free world," the core of world imperialism, is a land of deep unhappiness today. [...] And the arts [...] have become terribly sad reflections of a living death and, at the same time, the terrifying overture to imperialism's final funeral hymn'.[80] This sentiment found its equal in the assertion of French writer Catherine Rochefort that Western intellectuals were already so contaminated that they should first admit: 'Do not trust my words, nor anything I have. I am ill. Contagious. The only sanity I have is that I know I am ill. [...] Our disease is the colonization of consciences. We were infected in the course of a protracted psychological war that capitalism waged against the peoples under its rule'.[81]

In considering the tricontinental area, Edmundo Desnoes identified that, just as imperialists pillaged natural and human resources, so too they used communication media to perpetuate values which clashed with the most authentic interests of humanity, with the Mona Lisa smiling ironically over the injustices they perpetuated. While the negative impact of mass media upon the ideological superstructure was growing all the time – generating societies of consumers and fomenting the passivity necessary to situate man within technocratic organisational mechanisms – Desnoes proposed that these same media could be harnessed as a weapon in the war against injustice, adding fuel to the fire of revolution and creating a spark that spread throughout the so-called Third World. On this subject, Le Chan described how the mass media (particularly radio) had been used as a defence against imperialism in Vietnam.

The English writer Roger Smith contemplated the problems facing intellectuals emerging from underdevelopment, keen to demonstrate their creative freedom. Evoking the approach of *Lunes*, he described the perils of seeking validation from the developed countries at the expense of the priorities of their own people. In an acute analysis, he noted that:

> [...] political leaders often have a more profound grasp of ideological realities and tend to be in advance of the creative intellectuals. It is often a case of the intellectuals chasing the revolution. Yet this situation cannot be ignored by the intelligentsia, neither can it be justified in terms of the conventional plea for freedom of self expression. Within a genuine revolution, the old fears of Stalinist repression do not apply. It is not a question of writers and artists being told what to do, but an individual responsibility to the revolution itself which understands that certain

sacrifices are necessary to forge a genuine, popular and national culture. This does not mean a vulgarisation of artistic sensibilities, a crudification of his complexities, but a genuine need to communicate precisely these.[82]

Caiñas Sierra of Cuba responded by mapping the cultural imperialism perpetuated by radio and television before the Revolution, aided by US programmes and their imitations. Smith's demand for high-quality, complex work requiring increasing levels of mental acuity was consistent across the congress, with Eduardo Manet being particularly explicit about the need for sophisticated mass media, representing positions from around the world, in a bid to cultivate a people 'intelligent, lucid, mature and capable of facing the tremendous tasks that a Revolution demands in all fields'.[83]

On Sunday 7 January, Cheick Cherif from the Republic of Guinea expanded upon the ways in which the media could compel mass political awakening, generating a thirst for knowledge and a struggle for destiny. By contrast, deformation of the media by monopoly capitalists reinforced imperialist exploitation and conditioned public opinion in such a way that prevented intellectuals from aligning themselves with liberation struggles and denuded them of any social utility. This supposed that the mass means of communication could, and should, be used as instruments of popular combat, articulating fundamental rights in a bid to end exploitation. *Granma* reported on Cherif's attribution to the media the same importance as armed struggle by virtue of a shared contribution to defensive and offensive activities.

Counterposing the work of the congress with false claims of unity in the cultural field, the Italian cinema critic Pío Baldelli raised the thorny issue of the relationship between political power and the creator (or organiser) of culture. In the intellectual quarters of numerous countries, he noted, this relationship tended to manifest itself in one of two ways – as a separation between politics and culture (in which culture was either exalted or declared incompetent) or as an instrumentalisation of culture by government (in which the former offered itself up as a docile servant of the latter). In certain situations, this relationship had been radically modified, with intellectuals refusing to delegate their fundamental responsibilities and governments beginning to understand that their intervention into culture should be limited to the task of providing its structural and informative bases. As long as the mass media provided disinformation and obfuscated class divisions, Baldelli argued, intellectuals could be useful to the revolutionary cause through their partisan analysis of a given situation and their participation in overturning it, always prioritising action over imagination.

In another contribution from the film world, the Cuban director Santiago Álvarez rejected the pacifying tendency of cinema which had been evident since the early twentieth century. In considering the ideo-cultural penetration

of Hollywood, he invoked film as a potent instrument capable of influencing millions (in an amplification of 1963–4 thinking, which had sought to delimit the transformative power of film in Cuba). In the battle against underdevelopment, Álvarez outlined ways in which cinema could be used to break the vicious circle of ignorance, detailing how, in parallel with the literacy campaign, the creation of a cinematic industry in Cuba had achieved its dual aim of finding new forms for expressing national culture and developing a more critical and revolutionary public through a combination of aesthetic and affective magic.

In summarising its work, this commission positioned the mass media as an instrument of control in the mortal combat between the Third World and imperialism. While these means of communication were not inherently negative, 'A large part of capitalist ideology is dedicated to the inculcation of racial discrimination, egotism, social passivity, and the ideology of servitude, through the mass-media. Such a process tends to create a consensus of general acceptance of the system, a consensus which subordinates the working class and the people in general to the interests of imperialist ideology'. The worldwide explosion of audio-visual media was keenly felt in those countries suffering high illiteracy, aggressively extending the reach of the imperial powers. In this, 'The bourgeois states that feel secure in power utilize a certain so-called freedom of the press to achieve a false equilibrium, to prevent repression from turning into armed violence'.[84] Unable to compete by acquiring media monopolies, people living in underdevelopment must 'strengthen the clandestine press, publishing houses, and radio' and 'increase the number of buildings and walls which overnight appear bearing revolutionary slogans in large letters dripping with paint'. While guerrilla warfare undermined the confidence asserted by the mass media, the 'promiscuity of poverty', which keeps people in close proximity, facilitated mouth-to-mouth communication.[85] And, when liberty from subordination had been achieved, the media had a vital role in educating and uniting the people.

In this regard, revolutionary cultural policy was understood as belonging to a wide public, as both producer and consumer, whose active and critical participation was sought. This relied upon US and European intellectuals not only supporting the Revolution but also being revolutionary, abandoning the paternalism that sought to teach, and the false humility that sought to learn from, the Third World, while joining the struggle against imperialist mass media. By the same token, the duty of intellectuals in underdeveloped countries was to actively participate in the mass media and to study their mechanisms in the universities and art schools of recently liberated countries. Six concrete proposals were made, aimed at reversing the misinformation perpetuated by the mass media, denouncing imperialist wars in the tricontinental area and lifting the blockade of Cuba.

Commission V: Problems of Artistic Creation and of Scientific and Technical Work[86]

This commission sought to identify the problems raised by modern technology in a 'society affected by illiteracy and material backwardness'. It took account of the:

1. Necessity of scientific resources and technical cadres
2. Development of national culture and the problems of formation of scientific, technical and artistic cadres
3. Avant-garde, tradition and underdevelopment
4. The creator and the formation of a public
5. Importance of scientific research, sociological studies and artistic experiences in the formation and development of national culture

Given the breadth of its subject, the fifth commission allowed for the widest-ranging discussion.

Notable among the contributions was that of Adolfo Sánchez Vásquez, on the morning of Saturday 6 January. This noted Marxist aesthetician elaborated ways in which the artistic vanguard in bourgeois society had emerged in opposition to the prevailing aesthetic order and been suppressed, both ideologically and socially, causing it to redouble its aesthetic efforts, stalling at the point at which political protest should begin. This divorce of the aesthetic from the political vanguard – deliberately maintained in both bourgeois society and the Marxist-Leninist camp – meant that artists posed no threat to society, curtailing their revolutionary potential. And, while subservience of the artistic vanguard to its political counterpart tended to mean that 'artistic revolutions cannot change society',[87] this did not imply renouncing revolutions. Rather, it imposed the dual task upon artists of being revolutionary in their art while overcoming political and social conformity, with art and revolution conceived as two inextricable expressions of the creative activity of humanity. In this regard, it was noted that the Cuban experience had precipitated the conditions for ending the dichotomy between artistic and political vanguards. The success of this endeavour relied upon two conditions being met – that art was considered part of the social patrimony, ending the dichotomy between vanguard and mass art, and that the vital problems of art were treated as political problems. In turn, this compelled artists to assume a revolutionary political commitment without making creative activity an appendage of politics and implied that the artistic mission would only be complete when a common language had been found with the revolutionary political vanguard of the people.

In the same session, Jesús Díaz and Juan Valdés Paz of Cuba considered the role of the vanguard in underdeveloped societies, reclaiming it as 'that group which situates itself consciously, scientifically and organisationally

at the front of its people in its struggle for political power and subversion of social structures'.[88] Acknowledging the ideological struggle that was taking place in Cuba under the banner of Marxism, they regretted the emergence of three detrimental 'isms' – populism, ultra-nationalism and traditionalism. These tendencies variously led to the championing of autochthonous cultural forms at the total expense of other cultures, underestimation of the popular potential to develop diverse tastes and a negation of the value of cultural exchange.

The various interventions that followed considered the urgent possibility of forming a union that brought together intellectuals from developed and underdeveloped countries in their shared anti-imperialist struggle. The Sunday session, which involved scientists and medics, dwelt on the health implications of revolutionary situations in underdeveloped countries. The commission, of an estimated 150 participants, then agreed that the next session should be divided into two sub-commissions – respectively exploring the problems of scientific research and technical development and the vanguard in conditions of underdevelopment – of which the second is more pertinent to the narrative being constructed in this book, warranting its further consideration here.

In a paper dealing with 'The Problems of Internationalism in Art', Herbert Read delivered his last public speech before his death five months later. At the cultural congress, he contrasted the political interpretations of internationalism that had been adopted under communism with the monetarist interpretations that had emerged under capitalism, the latter of which had seen art being described as an international commodity, with its dealers having branches throughout the Western world. Dismissing socialist realism, Read made a firm distinction between universality and internationalism, whereby 'Universality is a human quality; internationalism is a political concept. Universality is a question of *depth* – the depth of the artist's vision and sympathy. Internationalism is a question of *width* – of the extent of the audience to which the artist is expected to appeal'.[89] The first part of this formulation chimed with thinking in revolutionary Cuba, which had consistently emphasised the universal quality of art, while the second part implicitly linked internationalism with populism, an approach that had deliberately been resisted in Cuba.

Invoking visual art as a mass medium of communication (through its lack of need for translation), Read condemned the 'art of fragmentation and frustration' being made in the capitalist world – a poor substitute for the art of the past but 'the only kind of art that has any emotional impact on alienated man'.[90] At the same time, he considered it unlikely that entirely new, revolutionary aesthetic forms would be pioneered, which concurred with the situation in Cuba and countered orthodox expectations. This provoked questions

about how grassroots local conditions could be created and sustained. In an echo of Portuondo's paper to the first commission, Read urged artists – those aberrant, atypical individuals, adopting what Salvadorean writer Claribel Alegría elsewhere described as a 'subversively playful position towards life'[91] – to remain connected to the native soil and economic foundations of the society in which they lived, as an antidote to the homogenising tendency of 'rootless internationalism'. As we have seen, the promotion of an authentically national culture had preoccupied Cuban cultural activists since the mid-1950s, and Read would confess that:

> In my optimistic moments, I see a human race with a regenerated sensibility, using its power and vision to create a new art, an art as universal as the art of the past, an art of visual delight and serene form, of human measure and spiritual significance. But before this can happen we must forget the past and reform the present. There can be no great art in the future until we have achieved social unity and social justice, and until a free and joyous activity has replaced the devitalising tyranny of the machine.[92]

Read's paper introduced some linguistic clarity into the call made by Abilio Duarte, a teacher from Portuguese Guinea, in the third commission, for 'A truly internationalist cultural movement',[93] which understood culture as an indispensable weapon in achieving independence and survival. It also consolidated the demand of José Luis Massera, Co-president of the fifth commission, for a class-oriented internationalism which acknowledged the universal characteristics of human culture, assimilating the 'cultural heritage of the past and the present contribution of the cultures from other countries, including the imperial ones [with] sharp criticism, rejecting and combatting all in those cultures which is opposed to the revolutionary ideology'.[94] In turn, this chimed with Italian film-maker Alberto Filippi who asserted that 'only beginning with a historical and class analysis of European culture, can the intellectual of the Third World find his true historical allies', bypassing the 'unnecessary imitation or importation of cultural and artistic forms' in favour of a 'movement of autonomous cultural elaboration that would be at the same time *not only* national or regional but also have a world-wide or continental perspective of revolutionary cultural production'.[95] Like others before him, Massera felt it inadequate to simply decline the offers of advancement made by agents of imperialism, outlining the necessity to 'create the defences, the necessary anti-bodies, so that the assimilation of the cultural contributions from other countries will be accompanied by the rejection of their reactionary ideological connotations'.[96]

In the same sub-commission, the Spanish Marxist philosopher Francisco Fernández-Santos demarcated the artist as a permanent rebel, or

revolutionary, and found that this constituted a vanguard in the philosophical sense, with the objectives of vanguard art being to change man and the world at the same time, using the weapons of imagination and critique. While this might appear to be a retreat into the imagination of the kind dismissed by Baldelli in the fourth commission, Fernández-Santos (like Sánchez Vásquez before him) posited art as an otherworld, a negation of lived reality, alongside a prefiguration of total man, with any implied utopianism being subordinated to historical consciousness.

Giving greater consideration to grassroots cultural development in underdeveloped countries, a group of poets from Cuba decried the dominance of the metropolis and the unidirectional character of the mass media. Invoking a diminution of the gap between artistic vanguard and national reality, they attacked populism and folklorism – the latter a 'sort of outmoded nationalism which advocates a return to the exhausted forms of the art of the people, to avoid possible contamination upon contact with foreign cultures of developed countries'[97] – to advocate an audaciously new and original 'cultured art', founded on history and contemporaneous reality. In a similar way, the French writer and ethnologist Michel Leiris contemplated the kind of art demanded by the Revolution. Clearly, this should not uphold the previous status quo, politically or artistically, but neither should it be of immediate didactic utility. While the Revolution had a need for propaganda, the capacity of the growing audience should not be underestimated and the demands of complex culture should not be mitigated. What would be needed was a revolutionary art that tentatively evolved from its circumstances to point towards the future. In this, the defining characteristics would be originality, experimentation and risk-taking, rather than the technical prowess valorised by capitalist society.

The fifth commission summarised its work according to the two subcommissions into which it had divided. The first of these, authored by scientists and technicians, dwelt on their political role at different stages of the liberation process, facilitating accelerated development and combatting the forces of imperialism. This was the only resolution to mention the Soviet Union and other socialist countries, in recognition of their ongoing contribution towards scientific and technical development. The second sub-commission focused more closely on cultural colonialism, implicating every novel, poem and pamphlet as a valuable form of fortifying national consciousness against domination. But the intellectuals present emphasised that encouragement of national culture could only be undertaken in an international perspective, utilising all available expressive means while bearing in mind the 'contradictory character of the cultural production of societies based on exploitation'. In this effort, literature and art were considered weapons, and intellectuals resisting co-optation could be said to be participating in struggle.

Beyond this, the highest measure of a revolutionary intellectual would be their involvement in armed struggle. But whereas 'Political revolutionaries are by definition intellectual revolutionaries and they are the most prominent section of the social avant-garde', the reverse was not automatically true and intellectuals needed to take steps to become political revolutionaries. Uniting both vanguards, it was argued that 'Education, productive work and, above all, the defence of the revolution, which is the defence of culture, are tasks common to all revolutionaries'.[98]

Building upon these foundations, it was envisaged that development of the shared struggle for decolonisation would rely upon a close understanding of economic, social and ethical problems, in an international context, and the maintenance of a critical awareness in relation to development. Crucially, this would not be a 'question of **formulating** or **contributing to the formulation** of a cultural policy, but of creating the conditions in which artistic creation may develop in full, and consequently bring about gradually- a political fact resulting from the realities and necessities of creation itself'.[99] Alfredo Guevara shared presidency for this commission, and this resolution echoes his earlier aversion to the 'cultural policy' being proclaimed by the CNC. Rather than formulating and implementing a predefined policy, then, it was proposed that the creation of conditions favourable to cultural production should be embedded within said production. In turn, this implied that creative activity, especially in its avant-garde form, could and should experiment and err in conditions of absolute freedom, without waiting for the aesthetic perceptions of the people to be primed. This presupposed that, 'in the arena of art, the battle is done with works of art', thus aiming a further broadside at those who insisted upon grounding culture in populism, ultra-nationalism and tradition. By the parties to this sub-commission, it was anticipated that the radical transformation of social structures would give concrete meaning to the term 'freedom of creation', by creating a 'public which is increasingly capable of sharing with the creator the risks of investigation, audacity, art and thought, which together with society suggest the possibility of a better life which we call "future"'.[100]

Closing the Congress

By the morning of Thursday 11 January, continuing wrangles in commission one caused Fidel's closing speech to be delayed. It would not be until the following morning that the final plenary assembly could meet, at which point Llanusa:

> [...] spoke about the various working tensions of the five Commissions, and smiled when he said that no one expected smooth unanimity; after all, he admitted, still smiling disarmingly, there is always room

for division and controversy, and nothing is ever gained at Congresses without argument and conflict. He made the request that he would personally like to consider the compilation of all five Commission resolutions not so much as a final Congress resolution, but rather as a declaration dealing with the most urgent general points which had arisen out of the week's deliberations. He also expressed the wish of seeing a statement of appeal extracted from the resolution-declaration as a special document, separate in its impact, and which might be called the Appeal of Havana. Such an appeal, he pointed out, would give the resolution-declaration an added importance.[101]

The resolution-declaration was then read by Cu Huy Can. Just a few months after Che fell in his attempt to extend the Bolivarian project, the context for this document remained the fight against imperialism and concomitant underdevelopment. It took the mass gathering of intellectuals, partaking in free and fraternal discussion in the midst of blockade, as renewed proof that to defend the Revolution was to defend culture. In this, culture was situated in the midst of a war being waged in defence of humanity, which was most prevalent in the countries of the underdeveloped world as a consequence of the economic and political domination being bloodily perpetuated by the US. Beyond the obvious suffering caused by economic retardation, oppression in the cultural order had created popular illiteracy, lack of educational opportunity and diminished access to the manifestations of art and science, compounded by deliberate and sustained attempts to displace native cultural values, including language, history and tradition. In order to maintain the status quo, foreign oppressors made it their business to try and corrupt men of culture, and those who refused to become accomplices to exploitation were persecuted for their attempts to articulate the legitimate aspirations of their countries, rendering cultural activity an act of struggle.

A tricontinental impetus was retained in the declaration, with Africa, Asia and Latin America being incited to break their colonial dependencies, using revolutionary violence and armed struggle as necessary. As had been the case in Cuba, it was presumed that, once independence was achieved, national culture would thrive at the same time as valuable elements of cultural tradition were preserved, taking care to avoid a narrow nationalism and imitative universalism. Building on this understanding of the linkages between imperialism and culture, the declaration advocated that the elimination of underdevelopment, imperialism and racism formed the vital motivation of intellectuals – artists and scientists alike – from around the world. In this, the elimination of racism was inextricably linked to the disappearance of imperialism, and solidarity was expressed with the black population of North America.

In acknowledging the congress as an opportunity for intellectuals to examine the duties demanded of them by the contemporary situation in the so-called Third World, the resolution-declaration emphasised responsibility to the struggle for social emancipation and the destruction of imperialism. This presupposed that 'If the defeat of imperialism is the inevitable prerequisite to achieve an authentic culture, the cultural fact – par excellence – in an underdeveloped country is the Revolution. Only through the Revolution can a truly national culture be conceived and it is feasible to fulfil a cultural policy that will give back to the people its legitimate being and render possible the access to scientific progress and to the enjoyment of art'. Furthermore, this document insisted that, to qualify for the soubriquet 'revolutionary', intellectuals must be prepared to fight to the death in achieving the liberation of their homeland and people. And, while literature, art and science were considered weapons in themselves and could be executed with dignity if they resisted being co-opted, the General Declaration of the Cultural Congress asserted that the 'truly revolutionary criterion for the intellectual, in its highest and noblest degree, is his disposition to share the combat duties of the students, the workers, and the peasants, when the circumstances to demand it'.

The permanent linkage, and mutual learning process, between intellectuals and the people was declared to be the basis of cultural progress, with the intellectual becoming a disseminator to, and educator of, the people, without the quality of their creative work and research suffering. In turn, intellectuals in developed countries were also allocated a duty to peoples liberating themselves from imperialism, which would involve aiding them in their scientific, technological and cultural advances. In the process, all honest intellectuals were urged to refuse to cooperate with, or accept invitations or financial help from, the US government and its official organs.

Roughly mapping onto the various commissions, the third clause of the declaration considered the mass media as instruments in the epic struggle between imperialism and the people of the Third World, no longer limited to the superstructure but becoming an integral part of the economic base. While it had been shown that the imperialist powers used communication media to maintain hegemony – perpetuating the cultural colonisation of underdeveloped man in the tricontinental area – these same means could be useful as well as degrading. The huge proliferation of audiovisual media (cinema, radio, television) – which, exacerbated by illiteracy in underdeveloped countries, had surpassed textual information (newspapers, books, magazines) – resulted in a political, rather than technological, problem, with the people ranged against technocracy. This implied that the imperialist bases of the mass media must be undermined, in which effort word-of-mouth communication would be a revolutionary force, keeping the people informed about developments from their own perspective. Once revolutionary control

Appeal of Havana, issued as a result of the Cultural Congress of Havana in 1968.

President Dorticós closing the Cultural Congress of Havana, January 1968.

had been achieved, it was envisaged that the great majority of people would reclaim their right to culture, work and dignity, with the mass media being utilised as a tool of education – dedicating part of their resources to literacy and lectures while affirming national values and promoting revolutionary culture. In turn, the development of revolutionary cultural policy would be underwritten by the idea that the mass media belong to the people, implying responsibility to a new type of producer and consumer previously unexposed to academic education.

The fourth clause of the declaration, mapping onto commission five, referred to the near-total absence of scientists and technicians in liberated countries, which would require a massive training effort, harnessing international advances to accelerate development. This section implicitly described the trajectory followed by Cuba, from increased literacy to free access to school and university education. It also presumed that departure from underdevelopment would compel rapid progress in culture, with artists maintaining permanent contact with the people. In this regard, every novel, poem and pamphlet capable of affecting national consciousness was charged with a specific political value that could lend support to transformation. Through constant technical and artistic improvement, with the full collaboration of intellectuals, it was predicted that new artists would emerge from the popular ranks and a real revolution in culture would be achieved.

The fifth section of the declaration was dedicated to consideration of the new human subject predicted to emerge from anti-imperialist struggles

– liberated from the need to sell his labour, treating work as a vocation and taking a critical view of the past. It was understood that this subjective transformation would not arise spontaneously, but must be triggered within society – through physical work and study, through science and technology, the appreciation of art, participation in sport and the fulfilment of military obligations in defence of the Revolution. In the process, it was anticipated that the egotism which had given rise to individualism in earlier societies would be abolished, enriching true individuality in the process. In permanently leaving enforced capitalism behind, alienated man would be emancipated, evolving in his thinking as the circumstances dictated.

With deep admiration, the congress recognised Vietnam as the greatest contemporaneous example of the incorporation of intellectuals into the liberation struggle, while saluting Che as the supreme example of the revolutionary intellectual, fighting among the oppressed peoples of the earth. By contrast, the congress found that little pride could be taken in the art and science arising from twenty centuries of human intelligence while the majority of humanity still suffered cold and hunger and imperialism used technological developments and artistic techniques to kill and deceive. Convinced that imperialism was extending its military, political, economic and cultural aggression in the underdeveloped world and that the workers of capitalist countries were the object of exploitation by the same system, the intellectuals present proclaimed their militant solidarity with all struggling peoples, most especially those from Vietnam.

After an acknowledged confrontation of ideas, the congress declaration pre-empted an Appeal of Havana – capital of Revolutionary Cuba – to the revolutionary consciences of writers and scientists, artists and professors, workers and students, farmers and the people in general, united by a common interest to join and intensify the anti-imperialist struggle. The intellectuals, assembled in Havana, in whose name the appeal was made, were calling for the denunciation of, and cultural opposition to, imperialism. At the same time, following the heroic example of Che, they were advocating armed struggle, at risk of death if necessary, so that a new and better life would be possible.

When the general declaration had been read, Salkey reports that:

> There were very few comments from the floor. The British delegate Ralph Miliband objected very strongly to the overall flabbiness of the declaration, and suggested that there were more than a few noticeable omissions of fact from the preliminary document which he would like to see restored, and that there were certain emendations and extra additions that should be made before the Congress passed on to the reading of the Appeal of Havana. José Llanusa Gobel accepted Miliband's suggestions and invited him to work on the text with the Congress presidency.[102]

Claudia Gilman puts a more sinister spin on events, describing how, the day before the closing of the conference, a long discussion took place between writers, during which the Appeal of Havana was drawn up and edited by Miliband and Marcel Liebman. According to Gilman, when this document – rather than the resolution-declaration, which included a paragraph referring to the appeal – was read out the following day, 'the authors themselves had difficulty identifying it'.[103] By this account, a paragraph had been added, invoking the example of Che and calling for intellectuals to join the guerrilla war; Miliband protested that the changes had been undertaken without his consent and, some hours later, an extraordinary plenary assembly was convened.

Contrary to this version of events, the main national newspapers of 13 January 1968 documented an admission by Llanusa that the appeal, approved by commission one, had not been read out the previous morning because an unspecified number of delegates had been dissatisfied, feeling that the final draft of the resolution-declaration was missing aspects of the discussion that would make it unintelligible to those intellectuals who had not taken part. Accordingly, the presidency of the congress had met with some of them, to hear their concerns, and responded by convening an additional plenary session. The official congress publication similarly explains that, during the morning session of 12 January, the plenum had approved the general declaration and the principle of issuing an Appeal from Havana, following a prolonged debate in the first commission. Yet certain Cuban delegates had expressed the view that the latter document should have been discussed more thoroughly, and, although the congress had come to an end, the presidency felt that this should happen, in order to maintain the openness that had characterised the congress. As such, an extraordinary plenary assembly was called for 6:30pm on the same day:

> Speaking for the Presidency of the Congress, comrade José Llanusa opened the session and apologized for the inconvenience of this additional Plenary Session, explaining that due to an error the motion submitted had not been discussed and stating that, whatever the importance of the final results of all the work done in the Commissions and in the Plenum ended in the morning, still more important were the methods used, this being a matter of principle for the guest [sic] country. The Assembly applauded the Presidency's decision to reopen the discussion.[104]

Reportage around the additional plenary describes how Llanusa confessed that it had greatly upset the revolutionary government to learn that certain delegates had a bad impression of the methods which had been used in compiling the resolutions. In the process, he reaffirmed his faith in intellectuals and acknowledged that, while inevitable differences of opinion on artistic

and creative questions had arisen during the commissions, these had been centred on questions of style, rather than principle, and been aired in an open, critical environment.

A *Granma* article, dedicated to Llanusa's intervention at the plenary, mentions a change to the declaration's emphasis being offered by Benedetti and paraphrases Miliband's use of the analogy (in relation to the declaration) that children change in character and appearance as they grow. The latter is quoted as saying 'This in no way suggests that I have an objection to the form [the appeal] takes. I believe that the President has read an appeal which constitutes a short summary, an excellent summary, of the appeal prepared by commission one'.[105] He asked only that the entire text produced by commission one, rather than a summary, be used, but this was thought to be too lengthy and it was decided that the majority of points would be retained in the resolution-declaration with the remainder being proposed for publication following the event.

At 7:15pm on 12 January, the revised resolution-declaration was read to the plenary, from which was taken the Appeal from/of Havana. The latter document acknowledged the increasing number of intellectuals in the world and their growing linkages with national liberation movements 'At a time when American imperialism poses a universal threat to the future of culture and to the future of mankind itself'.[106] In response, the intellectuals of seventy countries pledged their solidarity with all those struggling against the imperialism and class oppression endemic to capitalism. In contemplating the means – both brutal and insidious – through which the capitalist economic and social order was maintained, artists, writers, teachers, students and scientists alike were incited to demystify the relevant ideologies and 'attack the structures upon which these rest and the interests they serve'. Such a 'commitment must begin with an unqualified rejection of the policy of cultural subjection of the United States, and this implies the refusal of all invitations, scholarships, employment, and participation in programmes of cultural work and research, where their acceptance could entail collaboration with this policy'.[107] This succinct document was read by Alejo Carpentier and unanimously accepted. In his closing address to the plenary, Llanusa renewed his apologies about the 'haste in which the resolution-declaration had been drafted and thanked the delegates who had intervened to object about the quality of statements in the document'.[108] Salkey describes how:

> [...] in his characteristically shy and unconsciously endearing manner of lowering his voice, smiling uncertainly and looking troubled, he said 'Cuba learns a little more each day. Our friends are here to see to it that Cuba and the Third World make as few mistakes as possible. We are grateful for your help and solidarity.' His address can only be described

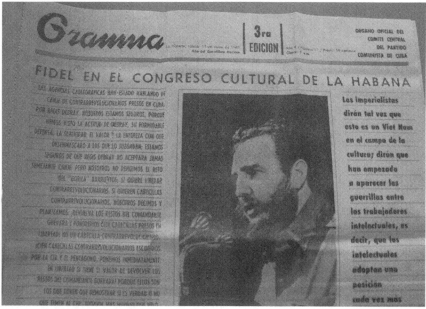

Fidel at the Cultural Congress of Havana, January 1968.

as a triumph of Cuban humility and tri-Continental political good sense. The Congress gave him a standing ovation.[109]

At 9pm on 12 January, Fidel delivered his closing speech in the charged atmosphere of the Chaplin Theatre. Acknowledging that some people had imagined it to be difficult, if not impossible, to hold such a world congress of intellectuals – with a tendency towards individualism being a product of their influences – Fidel proclaimed the event a resounding success. For him, the revolutionary quality of the congress was due, in no small part, to universal awareness of the gravest threats facing humanity and the need for justice. Unequivocally condemning the global penetration of US imperialism – an evil which he likened to European Nazism, albeit on an incomparably greater scale – Fidel undertook a lengthy exposition of the economic consequences of the prevailing system on both Europe and Cuba. In this regard, he noted that European intellectuals had criticised themselves for having a too-distant relationship to the problems of the world. But awareness and mobilisation were on the increase, and intellectuals had often shown greater militancy than the political organisations from which such an approach might reasonably be expected. Distinguishing between words and deeds, Fidel noted that, on the verge of nuclear war during the missile crisis, Europeans who agitated for peace had failed to mobilise in support of Cuba.[110] This recalled Filippi's condemnation of the 'ambiguous pacifist solidarity' of European intellectuals who opposed imperialist incursions in Vietnam without defending the Revolution.

Drawing upon the resolution-declaration, Fidel assumed intellectual workers to be victims of exploitation. He saluted the analysis of imperialism that had been developed at the congress, by intellectuals from developed and under-developed worlds alike. In this, he singled out for special mention a statement formulated by a group of Catholic priests attending the congress, which, despite the different interpretations of the world formulated by Christianity and Marxism, held the latter to be the most appropriate tool for analysing imperialism and revolutionising the masses.

As part of this discussion, it is worth noting that, at the 1942 Yenan Forum, Mao Zedong adopted what he termed a 'proletarian revolutionary utilitarian' approach to art, to assert that:

> Literature and art are subordinate to politics, but in their turn exert a great influence on politics. Revolutionary literature and art are part of the whole revolutionary cause, they are cogs and wheels in it, and though in comparison with certain other and more important parts they may be less significant and less urgent and may occupy a secondary position, nevertheless, they are indispensable cogs and wheels in the whole machine, an indispensable part of the entire revolutionary cause. If we had no literature and art even in the broadest and most ordinary sense, we could not carry on the revolutionary movement and win victory. Failure to recognize this is wrong.[111]

In considering the content of art appropriate to a revolutionary situation, Mao rejected dogma as anti-Marxist and derided works in which political values dominated over artistic ones. He also urged artists and writers to enact reflexive criticism from within the body of the people. Echoing Mao in front of an international audience, Fidel asserted that 'there is nothing more anti-Marxist than dogma, nothing could be more anti-Marxist than the petrification of ideas'. As an antidote to orthodoxy, he argued that 'Marxism needs to develop, break away from a certain rigidity, interpret today's reality from an objective, scientific viewpoint, conduct itself as a revolutionary force and not as a pseudo-revolutionary church'.[112] Wesker describes how 'the left wing artists from 70 different countries, many of whom are weary of left wing dogma, rise to their feet as Castro confirms at last what they've always wanted to believe: that real communism and free intellectual enquiry are not merely compatible but essential to each other'.[113]

While Cubans had no monopoly on revolutionary truth, Fidel continued, they had learnt from their experiences. And he fully expected the imperialists to be concerned about the fact that the congress had taken place, fearing it to be a 'Vietnam in the field of culture', with intellectual workers taking increasingly militant positions. Citing data on widening inequality, he mocked the imperialists' approach to the problems of the world, which

relied on crushing liberation struggles and encouraging birth control – in other words, by reversing population growth rather than sharing access to resources. It was problems like these that the congress had sought to address and, while the cultural questions were by no means resolved, extraordinary advances had been made. To those prestigious delegates who had honoured Cuba with their presence, Fidel expressed his gratitude. In return, he gave an assurance that, in all fields of culture and revolutionary advance, in the construction of a better society and the development of man, the Revolution would not cease in its work and would not betray the confidence and hope with which it had been entrusted.

This summary of the content of Fidel's speech says nothing about the manner in which it was delivered, and Salkey observes that:

> He seemed less expansive and publicly affectionate than I remembered he had been on the other occasions, when we had heard him talking to a majority of the Cuban people. Indeed, the people of Havana were well represented in the very large audience in the theatre, but Fidel's manner and his rhetoric appeared to me not to be aimed at them at all. The attack of his close, cumulative argument, shaped by his legally taut techniques, was being launched at his guests, and at a very definite section of them at that. He was being intentionally selective. [...] He had put aside his charisma and had taken up his intellectual cutlass. [...] I got the impression that he was annoyed with himself for having had to make the statements he had packed into his speech, and dissatisfied with the apathy of the European intellectuals for being the cause of his having had to do so.[114]

For Wesker, 'Castro's speech echoed [the congress's] failure. I still consider him the most dynamic and inspiring political leader alive in the world today, but at this congress he missed his most golden opportunity to revitalise the cream of the world's artists and intellectuals (even though they were not all there they were listening)'.[115] Yet another reading of Fidel's speech is given by Karol as part of a wider attempt to enumerate fissures between Cuba and the Soviet Union. According to this account, in giving primacy to the intellectual vanguard over their political counterparts in historical anti-imperialist struggles, Fidel denigrated the political orthodoxy of the past. In arguing that the congress would be perceived by imperialists as a Vietnam in the field of culture, 'He had taken a new step forward and was plainly asking all militants, and the intellectuals chief among them, to rise up against their calcified leaders. The time for sparing the feelings of these men was gone forever. Fidel did not hide the fact that he was counting on the emergence of a new, Guevarist generation, and that Cuba, like Vietnam, could set them an example. He could not have spelled out more plainly that a new age had dawned in the Communist camp'.[116]

Internal Repercussions

While Cuba's quest for a new form of communism was welcomed within tricontinental and European communities alike, Aníbal Escalante had been agitating around discrepancies with the Soviet model since the end of 1965. Careful to distance himself from any formal organisation, Escalante concentrated on fomenting discontent among orthodox former members of the PSP and their acolytes in Cuba and the socialist bloc. His critique was centred on the petty-bourgeois nature of the revolutionary leadership – manifested in an anti-Soviet current, a leftist adventurism, a Trotskyist line in attempting to export the Revolution and contempt for the working class – which he alone claimed to be capable of curtailing. Aside from Fidel, who was accused of having assumed sole control of policy, those denounced in this way by Escalante included Armando Hart, José Llanusa, Haydée Santamaría and Celia Sánchez, together with long-standing PSP militants such as Blas Roca and Severo Aguirre. For Escalante and his group, exhibitions of abstract art, such as the Paris Salon of 1967–8, were taken as evidence of Cuba's departure from the USSR.

As mentioned in the previous chapter, Escalante's activities came to the attention of the revolutionary government in the middle of 1966. The leadership issued several public and private warnings about the need for unity within the Revolution – including Fidel's closing speech to the OLAS conference – but these served only to fortify the defences and deflections around Escalante. As the last of the foreign delegates left Havana, the Central Committee of the PCC convened a three-day plenary session (24–26 January 1968) to examine the charges ranged against a group of 43 people including Escalante (37 of whom were held in custody). In studying the documents pertaining to this case, it seems clear that Escalante was politically committed to the idea of the Soviet Union as the centre of a world revolution, in which Cuba played a cameo role, and personally aggrieved that he had lost his influence during the rout of orthodox tendencies in 1962, a process in which he regarded himself a scapegoat. During their deliberations on the activities, criminalised under revolutionary law, which had been undertaken by Escalante and his group, the Central Committee took care to establish a clear distinction between these 'resentful, long-time sectarians' of the PSP and the 'clean, selfless, revolutionary and communist conduct of the near totality of men and women who, rising from these same ranks, have maintained in the past and maintain in the present a sincere, loyal and communist position'.[117] It was also made explicit that Escalante's microfaction contained only nine party members, mostly far removed from positions of influence, thus maintaining the integrity of the party. Carlos Rafael (who had been against Escalante's return from exile) addressed the meeting, further distancing the PSP from these isolated activities. In response to charges of

bourgeois, anti-Soviet infiltration of the Revolution, he emphasised that 'it is a matter of whether or not the ideology, not the person is bourgeois' (as evinced by the Bolshevik Party). Moreover, he argued that 'the only true way to show admiration and respect for the Soviet Union is the one we pursue when we criticize whatever we consider to be errors in its policy, when we openly state our differences, when we say, in a fraternal manner, where we consider them to be on the wrong path in international relations and in what way we disagree with those positions'.[118] The microfaction was accused of colluding with pseudo-revolutionaries from Latin American communist parties and coinciding with the views of the CIA, thereby opposing, and potentially destabilising, the Revolution. The nine party members were dishonourably expelled, Escalante received the maximum sentence of fifteen years in prison and the other members of his group received sentences ranging from twelve years imprisonment to two years under house arrest.

Remarks in Conclusion

At the Cultural Congress of Havana in January 1968, Gramsci was taken as the explicit starting point for defining the intellectual function in conjunction with other social relations, and Che was taken as its emblem. Imperialism was cited as the main causal factor in the continued underdevelopment of the tricontinental area, in opposition to which both armed struggle and revolutionary culture were perceived to be central. As we have seen, the process of maintaining progressive intra- and inter-continental links was vital for Cuba, and the 1968 congress is regarded as the third stage (after the Tricontinental and OLAS conferences) in constituting a global front against imperialism. As a prelude to discussions, Dorticós explained that a widespread anti-imperialist consciousness had yet to be achieved, which indicated the subtlety of ideological penetration, specifically in the cultural field.

With ample justification, the Cultural Congress of Havana is generally regarded as a pivotal moment in the history of Cuban cultural development. Looking back from a distance of more than four decades, it seems clear that the congress was as important in fostering international relations as it was in developing domestic cultural policy. The majority of foreign intellectuals who travelled to the revolutionary heartland did so with a sense of optimism and solidarity, where they were rewarded with a warm welcome and a humble request for input. A small minority of delegates harboured concerns about the implications of socialism and communism for evolving society, which arguably led to interventions being made in relation to the seemingly undemocratic process through which the resolution-declaration was initially drafted. Yet others regarded the situation more dialectically, maintaining reservations about the potential that existed for a lack of transparency while succumbing to infectious revolutionary optimism and discerning a genuine alternative to

Soviet forms of communism that implied full artistic freedom. Viewed from any angle, it is undeniable that the cultural congress represents the moment at which Cuba's international prestige reached its zenith.

Interestingly, while European intellectuals had been expected to bring knowledge and support to Havana, some of the opinions they expressed seemed out of step with their Latin American counterparts. So, for example, C.L.R. James's proposal to abolish intellectuals appeared to counter the proliferation of organic intellectuals which continued to inform Cuba's cultural development. At the same time, in formulating his thoughts around internationalism, Herbert Read found inadvertent synergies with thinking that had already been much better elaborated in Cuba. In turn, Arnold Wesker seemed befuddled by notions of the new man. Without having taken part in the relevant commission, he pondered: 'What "new man"? Surely there is and only ever was – man? And its [sic] because we have glimpsed at him, seen hints of him and guessed at his potential that we persist in trying to create societies where his true nature can emerge, can be revealed. Revealing is the operative word. There can be no "new man" only the slow revealing of what man was always intended to be'.[119] As we have seen, this demonstrates a slight misunderstanding of the Gramscian conception of the new man as a synonym for new social relations in which the best characteristics of humanity could thrive.

Throughout this unprecedented convergence of the world's intellectuals, Cuba set the agenda, and Ambrosio Fornet regards as a triumph the fact that the resolution-declaration was 'elaborated from Marxist and Martían positions, [underwritten by] a decolonising thought more linked to Cuban reality and the problems of the Third World than to the Eurocentric ideological currents from both sides of the Atlantic'.[120] Indeed, the five themes that had been drawn up during the preparatory seminar the previous autumn constituted an ideological attack on imperialism, the significance of which had become apparent while the Bolivarian army regrouped. Informed by a manifest desire to emancipate the continent from colonial rule and the underdevelopment this implied, the congress undertook a precise exploration of the mechanisms of imperialist cultural penetration. Better understanding of the ways in which mass means of communication were manipulated to imperialist ends, for example, pointed to other ways in which these media could be made to serve the people of the tricontinental area and stimulate revolutionary processes. By the same token, in the wake of the notorious debacle with Neruda, intellectuals remained on high alert in the face of attempts to co-opt them, and agreed that new defensive and offensive strategies would be needed in the region.

In studying the five congress themes in relation to domestic policy, a remarkable continuity emerges. Consideration of national independence formed a natural starting point as the primary aim in realising the federation of republics that had been fought for by Bolívar and Che. The abiding

preoccupation with creating a new revolutionary subject (and the social relations this implied) formed a necessary second step, with culture being incited to enhance understanding of each rapidly evolving situation. At the same time, individuality was embraced at the heart of the Cuban process, in contradistinction to bourgeois notions of individualism and doctrinaire interpretations of Marxism. Within this, the focus remained on quality and originality and on the critical acceptance and rejection of artworks from the capitalist world. As had been the case since 1960, intellectuals embraced their links to the people without fearing that the quality of their work would suffer. Universalism was explicitly prioritised over internationalism and action over the imagination. These attitudes placed Cuba at the vanguard of revolutionary struggle and firmly acknowledged the position of culture in the process.

Perhaps the most pertinent discussion at the congress was centred on the role of artists and writers in revolutionary situations, which found its way into several of the commissions. The third commission most directly implicated intellectuals in confronting the problems of the underdeveloped world, which formed the overarching theme of the congress. This gave rise to a fruitful discussion about the tasks in which those assembled might involve themselves – ranging from teaching to voluntary labour to clandestine and armed struggle. Francisco Fernández-Santos argued for an intellectual role in the first-order negation of existing society, combined with a prefiguration of the new man, while Pío Baldelli advocated the involvement of intellectuals in both analysing prevailing reality and overturning it, thus summoning a negation of the negation. As against a mummified conception of the perfect revolution, Fornet embraced the forward momentum of the reality that had been activated around him and incited Cuban writers and artists to continue precipitating this incendiary process.

In the course of considering the revolutionary role of creative intellectuals, an awareness of the transformative potential of their productions became heightened in 1968. Having been among the Cuban film-makers who had downplayed the life-altering power of cinema in 1963–4, Santiago Álvarez acknowledged the pervasive effect of the Hollywood machine. More generally, the ideo-cultural power of the mass media was rhetorically acknowledged, and the final congress declaration harnessed cultural artefacts from every discipline to the effort of developing national consciousness.

The handful of outside observers who have commented on the cultural congress since its realisation often linger on a phrase from the final congress resolution, highlighted in *Granma* at the time, declaring that 'for an underdeveloped country the cultural act par excellence is Revolution'.[121] For Gilman, this privileged the revolutionary leader, or *guerrillero*, a side effect of which was the rise of the censor in anti-intellectual cultural circles, which ultimately disqualified creative protagonists from having a voice.[122] But the first thing to

note about this sentiment is its persistence; earlier in the decade, Fidel had affirmed that 'Revolution is an art. And politics is also an art. The most important one, I think',[123] and, just a week before the seminar at which the congress was planned, we have seen that he described Che as an artist of revolutionary war. During the congress, this metaphor would be extended – by Adolfo Sánchez Vázquez, in his description of the Revolution as a creative act, and by Mario De Andrade who identified revolution as the poetic act par excellence.

The second point to make is that, reading contemporaneous coverage of the congress from a multiplicity of sources, there is no sense in which this statement anticipated the subordination of art to political imperatives. Instead, the congress provided a platform from which the dialectic between art and politics could be explored as part of a free and frank debate. This was most memorably dealt with by Mario Benedetti, who advocated a dynamic and mutually beneficial relationship between artistic and political vanguards in which the full critical faculties of both were retained. In the next chapter, we shall explore the successes and failures of this approach.

NOTES

1 Fidel Castro Ruz, speech of 18 October 1967, *Che: A Memoir by Fidel Castro* (Melbourne: Ocean Press, 1994), p. 71.

2 Ibid.

3 References to the preparatory seminar for the Cultural Congress of Havana are to be found in José Llanusa Gobel and Osvaldo Dorticós Torrado, *Seminario Preparatorio del Congreso Cultural de la Habana* [Preparatory Seminar of the Cultural Congress of Havana] (Havana: Instituto Cubano del Libro, 1967).

4 C. Wright Mills, *Listen, Yankee: The Revolution in Cuba* (New York: Ballantine Books, 1960), p. 145, italics in original.

5 Lisandro Otero, *Llover sobre Mojado: Una Reflexión Personal sobre la Historia* [To Rain on the Wet: A Personal Reflection on History] (Havana: Editorial Letras Cubanas, 1997).

6 Among the names that will be familiar from this account, the committee included Juan Blanco and Alfredo Guevara (ICAIC) alongside Carlos Franqui, Vincentina Antuña (CNC), Haydée Santamaría and Roberto Fernández Retamar (Casa de las Américas) and PSP activists such as Nicolás Guillén and José Antonio Portuondo.

7 Unless otherwise stated, references to the format and content of the congress are taken from Instituto Cubano del Libro, *Cultural Congress of Havana: Meeting of Intellectuals from All the World on Problems of Asia, Africa and Latin America* (Havana: Instituto Cubano del Libro, 1968), unpaginated, with typographical corrections made where necessary.

8 Judith A. Weiss, '*Casa de las Américas*: An Intellectual Review in the Cuban Revolution' (thesis, Yale University, 1973), p. 246.

9 Llanusa Gobel and Dorticós Torrado, *Seminario Preparatorio del Congreso Cultural de la Habana*, p. 8.

10 Andrew Salkey, *Havana Journal* (London: Penguin Books, 1971), p. 105.

11 Consejo Nacional de Cultura, *Política Cultural de Cuba* [Cultural Policy of Cuba] (Havana: Consejo Nacional de Cultura, 1970).

12 Arnold Wesker, 'Aie Cuba! Aie Cuba!', *Envoy*, November 1969, p. 18.

13 Mario Benedetti, 'Present Status of Cuban Culture', R.E. Bonachea and N.P. Valdés (eds.), *Cuba in Revolution* (Garden City, NY: Doubleday & Company, 1972 [1969]), p. 513.
14 Cited in Irwin Silber, *Voices of National Liberation: The Revolutionary Ideology of the 'Third World' as Expressed by Intellectuals and Artists at the Cultural Congress of Havana, January 1968* (Brooklyn: Central Book Company, 1970), p. 6.
15 K.S. Karol, *Guerrillas in Power: The Course of the Cuban Revolution* (London: Jonathan Cape, 1971 [1970]), pp. 397–8.
16 Ibid., p. 399.
17 See, for example, the file on Ray Bradbury, who decided against attending, available online.
18 Salkey, *Havana Journal*, p. 92.
19 Osvaldo Dorticós Torrado, 'Inauguration of the Cultural Congress of Havana', 4 January 1968, reproduced in Instituto Cubano del Libro, *Cultural Congress of Havana: Meeting of Intellectuals from All the World on Problems of Asia, Africa and Latin America* (Havana: Instituto Cubano del Libro, 1968), unpaginated.
20 Salkey, *Havana Journal*, p. 100.
21 These were published in quick succession as issues four (15 February), five (29 February) and six (15 March) of 1968.
22 Susan Sherman, *America's Child: A Woman's Journey through the Radical Sixties* (Willimantic, CT: Curbstone Press, 2007).
23 Presidency of this commission was assumed by Cu Huy Can from Vietnam alongside Jorge Serguera (President of the Cuban Institute of Radio and Television), Aimé Césaire (a poet from Martinique), Jesús Silva Herzog (Mexico) and Condetto Nénékhaly-Camara (a poet and playwright from Guinea), with Portuondo and Miguel Cossío acting as clerks, presiding over an estimated 130 delegates from twenty different countries.
24 Silber, *Voices of National Liberation*, p. 121.
25 Ibid., p. 196.
26 Ibid.
27 Ibid., p. 87.
28 Ibid., p. 107, italics in original.
29 Ibid., pp. 109–10.
30 Salkey, *Havana Journal*, p. 200.
31 Wesker, 'Aie Cuba! Aie Cuba!', p. 18.
32 Presidency of this commission was shared by Jaime Crombet (Cuba), Najil Darawche (Syria), Roberto Matta (Chile), with Juan Mier Felbles and José Aguilera Maceiras (Cuba) in supporting roles.
33 Instituto Cubano del Libro, *Cultural Congress of Havana*, unpaginated.
34 'Resumen del Trabajo en las Comisiones' [Work of the Commissions Resumes], *Granma*, 8 January 1968.
35 Silber, *Voices of National Liberation*, p. 124.
36 Sherman, *America's Child*, p. 156.
37 Silber, *Voices of National Liberation*, p. 284.
38 'Final Resolution of Commission II', Instituto Cubano del Libro, *Cultural Congress of Havana*, unpaginated.
39 Ibid.
40 Responsibility for this commission was assumed by Retamar, Seydou Badian Kouyáte (Mali), Julio Cortázar (Argentina) and Abilio Duarte (Guinea), supported by Wilfredo Torres and Fornet (Cuba).
41 Salkey, *Havana Journal*, pp. 109–10.
42 Silber, *Voices of National Liberation*, p. 118.
43 Salkey, *Havana Journal*, p. 117.
44 Silber, *Voices of National Liberation*, p. 69.

45 Ibid.
46 Salkey, *Havana Journal*, pp. 111-2.
47 Silber, *Voices of National Liberation*, p. 114.
48 Ibid., p. 65.
49 Ibid., p. 25.
50 Ibid., p. 117.
51 Fidel Castro, introduction to 1968 edition of Che Guevara's Bolivian diaries, *Che: A Memoir by Fidel Castro* (Melbourne: Ocean Press, 1994), p. 91.
52 Salkey, *Havana Journal*, p. 119.
53 Esteban Palevitch, 'Diego Rivera: El Artista de una Clase' [The Artist of a Class], *Amauta*, no. 5, January 1927, cited in David Craven, *Art and Revolution in Latin America 1910–1990* (New Haven, CT, and London: Yale University Press, 2006).
54 Benedetti, cited in Salkey, *Havana Journal*, p. 126.
55 Silber, *Voices of National Liberation*, p. 125.
56 'Resumen del Trabajo en las Comisiones', p. 5.
57 Mario Benedetti, 'Sobre las Relaciones entre el Hombre de Acción y el Intelectual' [On the Relations between the Man of Action and the Intellectual], *Revolución y Cultura*, no. 4, 15 February 1968, p. 31.
58 Ibid.
59 Silber, *Voices of National Liberation*, p. 211.
60 In the first half of the 1960s, Roberto Fernández Retamar had written a poem, entitled 'Usted Tenía Razón, Tallet: Somos Hombres de Transición' [You Were Right, Tallet: We Are Men of Transition], which may be heard in the author's voice at: Palabravirtual.com.
61 Silber, *Voices of National Liberation*, p. 214.
62 Ibid.
63 Wesker, 'Aie Cuba! Aie Cuba!', p. 21.
64 Ambrosio Fornet, 'El Intelectual en la Revolución' [The Intellectual in the Revolution], *Revolución y Cultura*, no. 5, 29 February 1968, reproduced in *Narrar la Nación: Ensayos en Blanco y Negro* [Narrating the Nation: Essays in White and Black] (Havana: Editorial Letras Cubanas, 2009 [2007]), p. 46.
65 Salkey, *Havana Journal*, pp. 148-9.
66 Ibid., p. 149.
67 Silber, *Voices of National Liberation*, pp. 41-2.
68 Ibid., p. 45.
69 Ibid., p. 178.
70 Ibid., p. 181.
71 Salkey, *Havana Journal*, p. 197.
72 Ibid., p. 199.
73 Instituto Cubano del Libro, *Cultural Congress of Havana*, unpaginated.
74 'Final Resolution of Commission III', ibid.
75 Ibid.
76 Ibid.
77 Ibid.
78 Presidency of this commission was assumed by Otero, Kwame Phomkong (Laos), Kim Youn Seun (Korea) and Tsevegmid Dondogiin (Mongolia), assisted by the painters Alfaro Siqueiros (Mexico) and René Portocarrero (Cuba).
79 Silber, *Voices of National Liberation*, pp. 185-6.
80 Ibid., pp. 187-8.
81 Ibid., p. 199.
82 Ibid., p. 238.
83 Ibid., p. 242.

84 'Final Resolution of Commission IV', Instituto Cubano del Libro, *Cultural Congress of Havana*, unpaginated.

85 Ibid.

86 Responsibility for this commission was assumed by Alfredo Guevara, Mouloud Mammeri (an Algerian writer, poet and anthropologist), Huynh Tu (South Vietnam) and José Luis Massera (an Uruguayan mathematician and industrial engineer), with Jesús Díaz, Adolfo Sánchez Vásquez (Mexico) and Zoilo Marinello (a Cuban oncologist).

87 Silber, *Voices of National Liberation*, p. 130.

88 'Comisión 5: Las Revoluciones Artísticas no Pueden Cambiar la Sociedad' [Artistic Revolutions Cannot Change Society], *Juventud Rebelde*, 6 January 1968, p. 4.

89 Herbert Read, 'The Problems of Internationalism in Art', *The Magazine of the Institute of Contemporary Arts*, no. 7, October 1968, p. 2, italics in original.

90 Ibid., p. 4.

91 Silber, *Voices of National Liberation*, p. 113.

92 Ibid.

93 Ibid., p. 145.

94 Ibid., p. 165.

95 Ibid., p. 171, italics in original.

96 Ibid.

97 Fayad Jamís, Guillermo Rodríguez, Luis Rogelio Nogueras and Miguel A. Sánchez, ibid, p. 169.

98 'Final Resolution of Commission V Sub-Commission II', Instituto Cubano del Libro, *Cultural Congress of Havana*, unpaginated.

99 Ibid. Emphasis in the original.

100 Ibid.

101 Salkey, *Havana Journal*, pp. 215–6.

102 Ibid., p. 217.

103 Claudia Gilman, *Entre la Pluma y el Fusil: Debates y Dilemas del Escritor Revolucionario en América Latina* [Between the Quill and the Rifle: Debates and Dilemmas of the Revolutionary Writer in Latin America] (Buenos Aires: Siglo Veintiuno, 2003), p. 216.

104 Instituto Cubano del Libro, *Cultural Congress of Havana*, unpaginated.

105 José Llanusa Gobel, 'Hay Cuestiones de Método Que Se Convierten en Cuestiones de Principios' [There Are Questions of Method Which Become Questions of Principle], *Granma*, 13 January 1968, p. 1.

106 'Appeal of Havana', Instituto Cubano del Libro, *Cultural Congress of Havana*, unpaginated.

107 Ibid.

108 Salkey, *Havana Journal*, p. 217.

109 Ibid., pp. 217–8.

110 'General Declaration of the Cultural Congress of Havana', Instituto Cubano del Libro, *Cultural Congress of Havana*, unpaginated.

111 Mac Zedong, *Mao Zedong, Selected Works*, Vol. III (Beijing: People's Publishing House, 1991), p. 866.

112 'Speech Given by Major Fidel Castro Ruz, First Secretary of the Communist Party of Cuba and Prime Minister of the Revolutionary Government, at the Closing Session of the Cultural Congress of Havana, 12 January 1968', Instituto Cubano del Libro, *Cultural Congress of Havana*, unpaginated.

113 Wesker, 'Aie Cuba! Aie Cuba!', p. 17.

114 Salkey, *Havana Journal*, p. 220.

115 Wesker, 'Aie Cuba! Aie Cuba!', p. 19.

116 Karol, *Guerrillas in Power*, p. 403.

117 PCC Central Committee, *Information from the Central Committee of the Communist Party of Cuba on Microfaction Activity* (Havana: Instituto Cubano del Libro, 1968), p. 101.

274 | TO DEFEND THE REVOLUTION IS TO DEFEND CULTURE

118 Ibid., p. 116.
119 Wesker, 'Aie Cuba! Aie Cuba!', p. 18.
120 Ambrosio Fornet, 'El Quinquenio Gris: Revisitando el Término' [The Five Grey Years: Revisiting the Term], *Narrar la Nación*, p. 390.
121 'Declaración General del Congreso Cultural de la Habana', *Granma*, 13 January 1968, p. 5.
122 Gilman, *Entre la Pluma y el Fusil*.
123 Lee Lockwood, *Castro's Cuba, Cuba's Fidel: An American Journalist's Inside Look at Today's Cuba in Text and Pictures* (Boulder, CO: Westview Press, 1990 [1967]), p. 187.

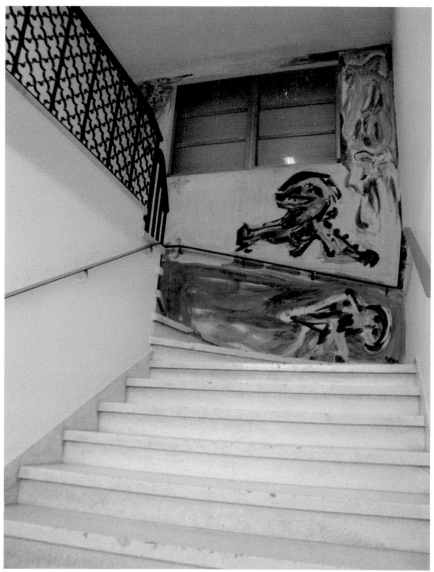

Asger Jorn mural in a stairwell at the Office of Historical Affairs of the Council of State (painted during the Cultural Congress of Havana, January 1968).

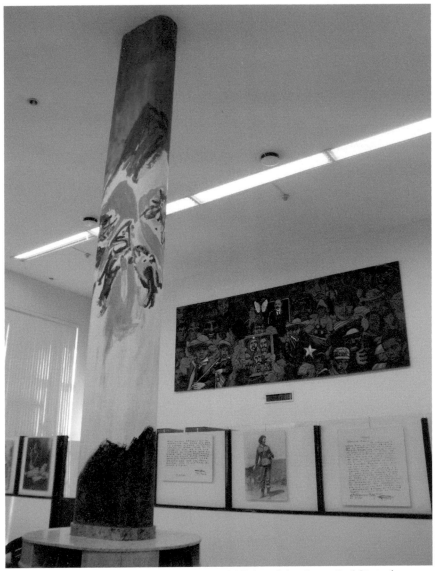

Asger Jorn mural at the Office of Historical Affairs of the Council of State (on pillar), with Raúl Martínez painting and photograph of Celia Sánchez Manduley in the background.

Publicity material from the 1972 Meeting of Latin American Plastic Artists, designed by Umberto Peña.

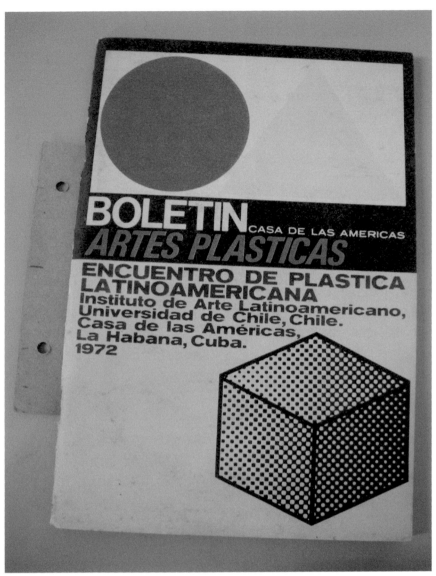

Plastic arts bulletin produced as a result of the 1972 Meeting of Latin American Plastic Artists, designed by Umberto Peña.

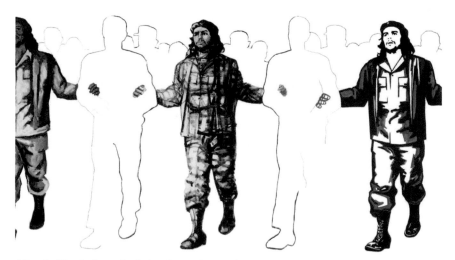

Alfredo Plank, Ignacio Colombres, Carlos Sessano, Juan Manuel Sánchez, Nani
Capurro, *Che* (collective series), oil on canvas, 1968. Courtesy of the Archive of Casa
de las Américas.

Schoolgirls' dancing lesson, 2009.

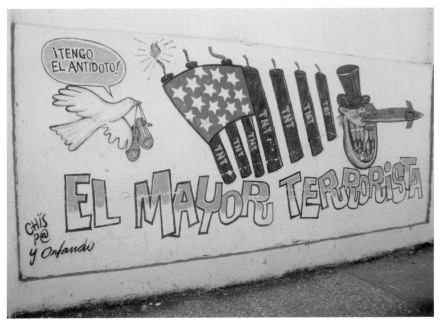

Wall painting in Santa Clara, citing the US as the greatest terrorist.

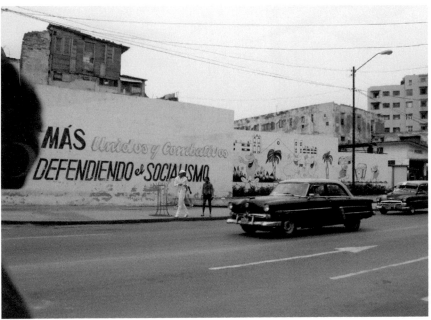

Wall painting in Havana, reading 'More united and combative defending socialism'.

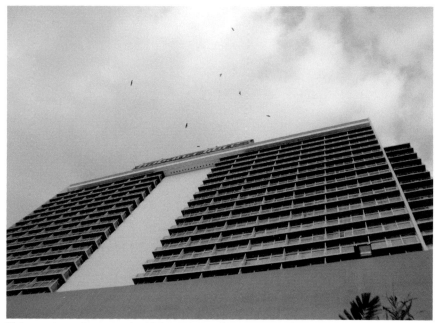

Vultures hovering over the Habana Libre [Free Havana] hotel.

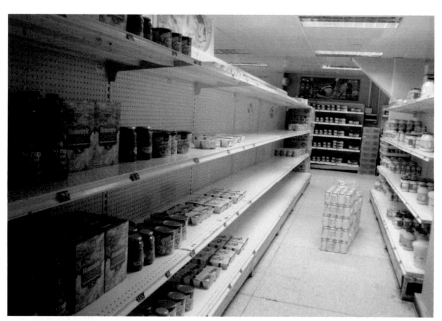

The shelves of a minimarket in Havana (selling goods in convertible currency), depleted as a result of the economic sanctions imposed upon Cuba by the US since 1960.

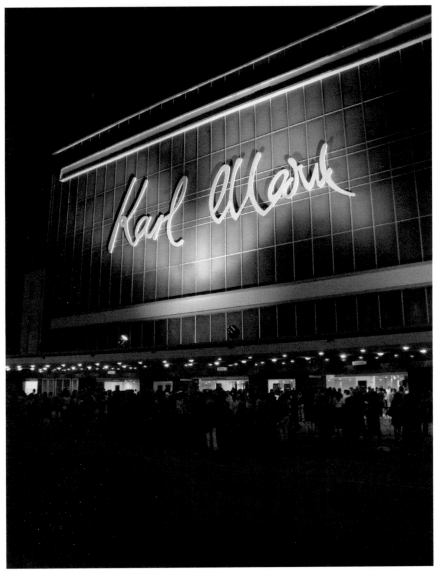

Karl Marx Theatre, Havana, venue for the inauguration of the International Festival of New Latin American Film, 2009.

Cultural Policy of the Revolution 1968–76

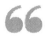 For the world today, America is just the United States; the region we inhabit is a sub-America, a second-class America of nebulous identity. Latin America is the region of open veins.

– Eduardo Galeano, 1971.

Just seven months after the Cultural Congress of Havana, to the surprise of the world (including Cuba), the Soviet Union invaded Czechoslovakia. Since the mid-1960s, Cuba had been explicitly critical of the USSR's pursuit of 'peaceful coexistence' with the capitalist world. Fidel had discerned echoes of these quasi-bourgeois policies in Czechoslovakia, but he was not supportive of aggressive measures. Appearing on television on 23 August 1968, he referred to the military intervention as a violation of legal and international norms which flagrantly violated the sovereignty of Czechoslovakia.[1] Yet he was unable to openly denounce the invasion while remaining part of the international communist movement. Moreover, the frustrated attempts to open a new revolutionary front in Africa and the failure of Che's campaign in Latin America, compounded by frosty relations with China and the rise of Nixon in the US, forced Havana closer to Moscow. Despite the conditional nature of Cuba's support, Russia extended thanks to Cuba, which moderated its position accordingly. Sadly, Fidel's failure to condemn the invasion on the international stage did much to diminish the prestige that Cuba had accumulated at the cultural congress, and it brought about a crisis in leftist movements on both sides of the Atlantic.

Thrust back into the Soviet ideological ambit in the eyes of the world, albeit with fewer illusions and far less material support than in the early 1960s, Cuba was forced to postpone the continental revolutionary project

and focus on domestic issues. In the wake of Che's death, this shift in status and strategy combined with two home-spun moral economic initiatives to lead the country into an exhausting period of 'accumulated tensions'.[2] The first of these domestic projects was the Revolutionary Offensive, launched on 13 March 1968, which sought to nationalise all remaining agricultural smallholdings and private enterprises. The second was a drive to achieve a 10 million tonne sugar harvest in 1970 – to which a large proportion of the country's human and material resources were dedicated – ending in a high-profile failure, for which Fidel assumed personal responsibility. In the same period, a 'dry law' was passed, resulting in the closure of cabarets and dance halls and the disappearance of experimental music from television. As we have consistently witnessed, internal political crises, especially those with an international dimension, had repercussions in the cultural field, and the period under consideration in this chapter was no exception.

The Padilla Case (1968–1971)

In October 1968, Heberto Padilla was unanimously awarded the UNEAC prize for a collection of poetry, entitled *Fuera del Juego* [Out of the Game], while Antón Arrufat received three out of five votes for his dramatic work, *Los Siete Contra Tebas* [Seven Against Thebes]. Written in Moscow, Budapest and Prague, several of the works in Padilla's collection may be taken to reflect disillusionment with Soviet forms of socialism, while the eponymous poem – dedicated to the poet and activist Yannis Ritzos, incarcerated in a Greek prison – unambiguously derided the literary disenfranchisement caused by authoritarianism. Other poems in the collection traversed recognisable Havana streets and riffed upon revolutionary slogans, tainting the doubts that had been dialectically expressed by Desnoes in *Inconsolable Memories* with a sense of bitterness verging on despair. At the same time, Arrufat's reworking of Aeschylus's play dwelt upon the power struggle played out between the two sons of Oedipus. While Arrufat's interpretation was understood as an ambiguous metaphor for the tensions between the Revolution and the bourgeoisie, Padilla's collection was taken to be 'evidently hostile to the Revolution'.[3] And, while the prizes to both Padilla and Arrufat were honoured and their works published and widely distributed, the UNEAC executive inserted a prologue into both books, deeming them unworthy of recognition in a revolutionary country.

Examining the process around the 1968 UNEAC prize more closely, it transpires that one member of the jury – the English translator and critic J.M. Cohen – acted unscrupulously, attempting to influence his juridical colleagues by alluding to his favoured candidate (Padilla) in the press. While this prompted UNEAC President Nicolás Guillén to remind Cohen of his obligations, *Mundo Nuevo* wasted no time in publishing the latter's views as

part of its CIA-fuelled campaign to undermine intellectual commitment to the Cuban Revolution.

Seized upon by the ideological enemies of Cuba abroad, Padilla and Arrufat's works also reignited tussles about the intellectual role at home. From 3 November 1968, a series of weekly articles began to appear in *Verde Olivo*, the magazine of the Revolutionary Armed Forces (FAR). The articles were written under the pseudonym of Leopoldo Ávila, which has since been attributed primarily to the magazine's editor, the poet Lieutenant Luis Pavón Tamayo (and secondarily, or collectively, to José Antonio Portuondo and Félix Pita Rodríguez). That this work was conducted under cover of anonymity was taken as a sign of lack of confidence between the revolutionary leadership and intelligentsia.

Upon being awarded the *Granma* poetry prize two years earlier, Pavón had articulated the relatively moderate view that the revolutionary potential of poets could be measured by the extent to which they absorbed the Revolution into their own lives and communicated it indirectly.[4] Yet, while this implied that creative works could contribute to the building of socialism without necessarily taking the Revolution as their didactic subject matter, Pavón asserted that, if the latter were to be achieved to a high standard, their creators would garner even more admiration.

The first of Ávila's 1968 articles drew attention to the views being expressed by Guillermo Cabrera Infante in the Argentinian magazine *Primera Plana* [Front Page], in which he declared himself to be a staunch enemy of the Revolution. Cabrera Infante had earlier been given temporary permission to leave Cuba, on the pretext of escaping its polemical atmosphere, and he had taken the opportunity to seek exile in Europe, settling in London and joining the ranks of those hostile to the revolutionary government. This compounded the precariousness of Padilla's position. The previous year, he had vociferously championed Cabrera Infante's novel *Tres Tristes Tigres* [variously translated as Three Sad Tigers or Three Trapped Tigers] at the expense of Lisandro Otero's *Pasión del Urbino* [Urbino's Passion], turning literary critique into an attack on Otero in particular and on state security in general, which led Padilla's permission to travel to be withheld.

The next two of Ávila's articles were aggressively dedicated to Padilla and Arrufat, with the former being accused of searching for an excuse to create a scandal against the Revolution. As a result, Voice of America (the external radio station of the US federal government) reported that the writers had been imprisoned, and Associated Press (the US news dissemination agency) deduced that the counterrevolutionary accusations being aimed at Padilla could mean nothing less than the poet's execution by shooting. Inevitably, this caused consternation among European intellectuals and those Latin American contemporaries living among them. In reality, neither author had

been incarcerated; on the contrary, both continued to enjoy their freedom in Cuba, being readily available to foreign interviewers who wished to hear their views. Undiminished, Padilla continued writing (and, in January 1971, he would give a recital at UNEAC of poems from a forthcoming book, bearing the suggestive title *Provocations*). Towards the end of 1968, Padilla addressed a letter to Cabrera Infante (which was published in *Primera Plana* on Christmas Eve), insisting that he intended to continue living and working in Cuba, participating in the construction of a more dignified and just society.

In January 1969, both ICAIC and Casa de las Américas convened meetings to discuss the UNEAC prizewinning works and Ávila's articles. The consensus around the ICAIC seminar was that, in the intellectual vacuum created by the CNC and UNEAC, *Verde Olivo* had been selected as the voice of the Revolution. The three-day meeting of the *Casa* collaborative committee asserted that being revolutionary entailed being critical. Following Martí, this meant that it would be a mistake to affirm sycophantic support of the Revolution if critique were required (although being critical did not necessarily imply being revolutionary). In the wake of the fallout from J.M. Cohen's actions, Haydée informed the judges of that year's Casa de las Américas Prize that, while they had been chosen from the best of the international field, jurors for future incarnations of the prize would all be selected from Latin America.

In opining on the problems of the intellectual world, Ávila's articles touched on the 'depoliticisation' suffered by Cuba's intelligentsia. This was perceived as an attempt to sideline 'old guard' intellectuals and encourage a 'young vanguard'.[5] In chapter five, we saw that, in 1965, Che Guevara indicted many of the intellectuals formed before the Revolution for not being true revolutionaries. The three Cuban members of the pre-revolutionary generation (Edmundo Desnoes, Ambrosio Fornet and Roberto Fernández Retamar) who took part in the *Casa* round-table in May 1969 had done much to advance thinking on this subject. It will be remembered that Retamar had mounted a contemporaneous response to Che's missive, embracing conflict and contradiction as a vital force in the dialectical process of building a fairer society. Mentioned in the previous chapter, Retamar's prose poem, 'Usted Tenía Razón, Tallet: Somos Hombres de Transición' [You Were Right, Tallet: We Are Men of Transition], catalogued the humiliation, defiance, horror and sacrifice upon which the success of the Revolution had depended and conveyed the momentum necessary for its transformative work to continue. Whatever meaning had been intended by Retamar and his predecessor, the activist poet José Zacarías Tallet, the notion of transition became allied, in the minds of certain functionaries, with Che's stigmatisation of pre-revolutionary intellectuals. This was underwritten by the idea that a truly revolutionary intelligentsia – dedicated to ideological struggle and unencumbered by expectations of creative freedom and a critical role – would soon displace these 'men of

transition'. Censuring intellectuals for their timidity in allowing the cultural offensive to come from the magazine of the armed forces rather than *Casa* or *Revolución y Cultura*, Fornet noted at the 1969 meeting that intellectuals were facing not merely a struggle for creative freedom but a fight for survival.[6]

In response to the charges of depoliticisation being levelled at them from the pages of *Verde Olivo*, the film-makers around ICAIC issued a declaration. Noting Ávila's demand for the development of a critique which took ideological level and historical juncture into account, the cineastes assessed the value of this exercise in tackling the roughly defined poles of dogmatism and liberalism. In this endeavour, they identified the task of revolutionaries in ideological struggle to be that of critically analysing the liberal tendency and rejecting dogmatism as part of an authentic revolutionary movement. Jorge Fornet has more recently noted that, while ICAIC might have been considered a predominantly liberal (as opposed to dogmatic) institution, the process of radicalisation initiated in 1968 compelled the majority of national intellectuals and institutions to distance themselves from both positions and opt for a third stance which embraced another paradigm – that of the 'authentically revolutionary' creator.[7]

At the May 1969 *Casa* round-table, Desnoes reasserted critique as the legitimate obligation of Cuban intellectuals, who would be at their most revolutionary when at their most critical. In direct contrast with bourgeois critique – which assumed a distancing from reality – this implicated revolutionary intellectuals in developing a society that would benefit from their critical freedom. In the first place, the power of contestation was invoked against the negative aspects of the human condition inherited from the previous society – specifically spiritual dogma and the alienation of underdevelopment. But, rather than confining themselves to first-order negation and remaining armchair critics of society-in-transformation, the intellectuals assembled in Mariano Rodríguez Álvarez's studio to discuss the first decade of cultural gains affirmed their pursuit of a 'critical literature, capable of expressing the tensions of the epoch and the contradictions of society – a literature that is a form of knowledge, a medium of enriching consciousness, a way of penetrating reality and helping to transform it'.[8]

At the same meeting, Fornet continued the comparison between men of action and intellectuals that Mario Benedetti had initiated at the cultural congress the previous year. While the first group was found to include revolutionary leaders, political cadres and economists, Fornet confessed that 'We were none of those things. We were defenders of form, underdeveloped guardians of the vanguard'.[9] And, while the Revolution was increasingly playing a profound political, moral and psychological role, the Cuban intelligentsia could not claim to be evolving at the ideological pace necessary to relinquish individualism and become organically linked to the people. The parties to the round-table seem agreed that, despite civic and material conditions being in

place to enable an artistic–literary movement which demonstrated the same opposition to capitalism as had been achieved in the political terrain, this had not yet made itself felt in the cultural field, with the exception of documentary film. Depestre argued that, in a revolutionary country, intellectuals should exercise their responsibility on two levels – by undertaking pedagogical duties and by participating in the tasks of the Revolution through their militancy and voluntary work. Beyond this, creators also had an aesthetic responsibility, making valuable works that expressed revolutionary progress *at the level of art*; in this effort, art and politics could both be considered branches of knowledge, but they were not interchangeable.

The dual task of advancing revolutionary consciousness and stimulating the transformation of reality compelled intellectuals to immerse themselves in the most intense social practices – from agricultural work to guerrilla warfare – leading those assembled in May 1969 to reiterate their commitment to armed struggle. Claudia Gilman has more recently observed that, as the balance between art and life tipped in favour of the latter, many writers asked themselves whether they should abandon their writing apparatus and take up arms, or at least postpone their aesthetic enjoyment until such time as the triumphant Revolution had socialised the privilege of culture.[10] According to Gilman's account, the majority of intellectuals lost confidence in their symbolic practices and in all forms of commitment based on their specific professional competences. In the 1969 round-table, she finds evidence of creative intellectuals recognising that their creative work was not being evaluated politically and advocating that their ancillary revolutionary duties be taken into account. But, whereas Gilman argues that intellectuals admitted themselves unworthy of revolutionary credentials, Fornet remained adamant at the time that intellectuals were generally considered revolutionary except by those who 'confused jazz with imperialism and abstract art with the devil'.[11]

This allusion to orthodox currents reminds us of the ongoing battle being waged between liberalism and dogmatism (respectively described by Fornet at the round-table as the stupid son of petit-bourgeois idealism and the ideological offspring of sectarianism). At that time, it was apparently common knowledge that the forces of sectarianism had used state resources to empower themselves before attempting to turn the revolutionary leadership against intellectuals by making the pursuit of diverse creative approaches seem like ideological discrepancies with the Revolution. But it was less well known that these forces had attempted the same process in relation to the cultural policy of the Revolution, and Fornet reflected on the previous decade to observe with regret that 'For many years, we made and supported a policy based on negation, which consisted of avoiding mistakes made in other socialist countries. We avoided mistakes, but that was the end of our successes. For many, that appeared to be enough, but the pitfall of a defensive attitude is

that it doesn't generate an offensive with its own dynamic'.[12] In other words, in confining cultural policy to first-order negation of the Soviet experience, a truly revolutionary approach to culture had not yet been achieved. As such, Fornet discerned a vacuum in cultural life that was reflected in certain sections of the press and caused the most revolutionary intellectuals to absorb themselves in their work, leaving the field clear for dogmatists and liberals.

Jumping ahead by two years, the next phase of the so-called Padilla case was about to flare up. On Saturday 20 March 1971, Padilla was arrested and jailed on charges of counterrevolution relating to a number of activities and the manuscript of his novel, *En Mi Jardín Pastan los Héroes* [Heroes Are Grazing in My Garden].[13] His wife, Belkis Cuza Malé, was also briefly detained before being released the following Monday. A few days after the arrests, Fidel assumed responsibility for this decision and asserted that other intellectuals were implicated. On 5 April, Padilla wrote a letter to the revolutionary government, privately explaining his actions.

Padilla's arrest prompted a letter, addressed to Fidel by fifty-four prominent intellectuals. Authored by Julio Cortázar and the Spanish writer Juan Goytisolo, the letter was signed by Europeans and Latin Americans who had previously been sympathetic to the Revolution – such as Jean-Paul Sartre, Simone de Beauvoir, Italo Calvino and Gabriel García Márquez – and by Cuban émigrés now viscerally against the Revolution, including Carlos Franqui. In this matter, it is argued that quantity was as important as quality, and the polemic became one of names rather than ideas.[14]

The letter, dated 9 April 1971, extrapolated from Padilla's arrest to raise suspicions about the political climate on the island:

> Since the Cuban government up to the present time has yet to supply any information about this arrest, we fear the re-emergence of a sectarian tendency stronger and more dangerous than that which you denounced in March, 1962, and to which Major Che Guevara alluded on several occasions when he denounced the suppression of the right of criticism within the ranks of the revolution.
>
> At this moment – when the installation of a socialist government in Chile and the new situation in Peru and Bolivia help make it possible to break the criminal blockade imposed on Cuba by North American imperialism – the use of repressive measures against intellectuals and writers who have exercised the right of criticism within the revolution can only have deeply negative repercussions among the anti-imperialist forces of the entire world, and most especially of Latin America, for which the Cuban Revolution is a symbol and a banner.[15]

Initially intended as a private missive, the signatories had been assured that it would only be published if a timely reply was not forthcoming. Yet the letter was leaked to *Le Monde* and appeared in print the day after it was written. Thereafter, it 'was copiously circulated by the world's capitalist media, becoming – whatever the intentions of the original signatories might have been – an open accusation against the Cuban Revolution, given the letter's assumption of the use of "repressive methods," and so forth, in Cuba'.[16] Having been vocal about Padilla's persecution at the hands of the security services, Associated Press speculated that he would face execution for his treachery, which seemed to confirm Europe's worst fears. For Jorge Fornet, Padilla's detention hastened a clash between the revolutionary government and the European leftist intelligentsia which had been building up for some time; seen from this angle, Padilla's arrest served to flush out liberal opinion, albeit with the unintended consequence of unleashing a hurricane.[17] On 20 April, in a speech to commemorate the tenth anniversary of the Bay of Pigs invasion, Fidel bemoaned the cultural colonialism that formed part of imperialist dominion and incited the people to resist all manifestations of decadent culture arising in societies full of contradictions.[18]

The First National Congress of Education – and Culture (23–30 April 1971)

On 14 December 1970, a ministerial resolution created a commission to organise an educational congress under MINED. Seven committees were set up to deal with specific issues, using an organisational structure that compensated for the popular participation which had been missed at the 1968 congress. On 12 February 1971, the organising committee of the National Congress of Education issued an announcement that tens of thousands of teachers were meeting in their respective locales to discuss points on the congress programme (which was published in *Granma* the following day, with 54 points grouped into seven broad areas). More than 2,000 preparatory meetings were held around the island, feeding into congresses at the increasingly influential municipal, regional and provincial levels. These meetings culminated in a week-long national congress of 1,781 delegates. Inaugurated at the Radiocentro cinema in Havana, where plenary sessions also took place, eleven working commissions were hosted in the Habana Libre hotel. During this time, an estimated 4,703 of 7,843 of the proposals made during earlier meetings were scrutinised and between 2,500 and 3,000 approved. This was accompanied by a programme of entertainment, organised by ICAIC, which included the screening of a film from the Soviet Union (alongside exhibitions of modern Soviet architecture and photographs commemorating the tenth anniversary of Yuri Gargarin's journey into space). Inaugurating a new school in Matanzas province three days into the congress, Fidel suggested to assembled delegates that culture be

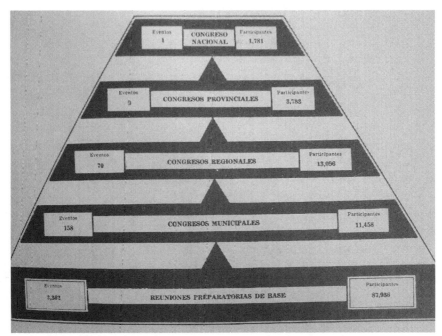

Diagram showing the ways in which preparatory meetings fed into congresses at municipal, regional and provincial levels, culminating in the First National Congress of Education and Culture, 1971.

added to the educational mandate of the congress; this suggestion was immediately adopted and reported on the front page of *Granma* on 27 April 1971. For Jorge Fornet, 'This addition implied a considerable change in the role and purposes of the meeting. It not only meant approving the occasion to speak *also* of culture but to fuse it with (and, to a large extent, subordinate it to) education'.[19]

Consistent with its origins, the broader focus of the congress was educational, with culture being mentioned at the point at which it overlapped with education and the only recommendations of the organising committee relevant to art being:

1. To propose measures strengthening the ideological formation of young artists.
2. To study the forms of neocolonial cultural penetration and to work out a plan of action designed to counteract its negative effects on the national scene.
3. To encourage the genuine and militant cultural expression of Latin America, Asia and Africa, and to assimilate the best of world culture in a discriminating manner.

All three of these objectives – the development of the young artist as a new man, the knowing resistance to imperialist cultural penetration and the

desire to develop legitimate forms of tricontinental culture which drew on the best of universal culture – echo discussions around the 1968 congress, but the surrounding rhetoric was more emphatic.

Just as culture was being added to the congress mandate, on 26 April 1971, Padilla's letter to the revolutionary government was published via Prensa Latina [Latin Press], the Havana-based Latin American news agency. In the early hours of the following day, Padilla was released, just over a month after his initial arrest. By his own account, the poet suggested a private meeting with members of UNEAC, during which he would present a rehearsed self-critique, but Fidel insisted on video recording the event and disseminating a transcript via Prensa Latina. On the evening of 27 April 1971, Padilla presented a prepared 'confession', loosely based on the letter that had been published the previous day.[20]

Reminding his audience that the Revolution would never impose itself on anybody, Padilla expressed his gratitude that the opportunity he had requested to speak had been generously granted to someone who did not deserve to be free on account of the unforgivable mistakes he had made. Comparing himself – so riddled with defects – to his humane and revolutionary comrades in State Security, he noted his estrangement from such friends as Roberto Fernández Retamar, Lisandro Otero, Edmundo Desnoes and Ambrosio Fornet, to find himself aligned with foreign journalists like K.S. Karol (later relishing being described in the foreign press alongside writers he admired). In relation to his work, Padilla regretted having laboured under the guise of a rebellious writer, which had concealed his disaffection with the Revolution, giving rise to a counterrevolution in literature (thereby modestly announcing a new movement with himself at the forefront). Yet, he suggested, many of those present shared his opinions and flaws. In the process of indicting himself, Padilla implicated several other intellectuals from his inner circle, including his long-suffering wife and fellow writers, Pablo Armando Fernández and César López.

Nowadays, it is impossible to read the transcript of Padilla's speech – replete with references to his evident pessimism, enduring shame and ingratitude to Fidel – without perceiving the irony with which it is embellished. Fornet has retrospectively detailed how, as a result of his experiences in Moscow and Prague, Padilla had become an incurable sceptic, troubled by phantasms of Stalinism.[21] Outside Cuba, Eduardo Galeano spoke of his conviction that Padilla's self-critique, offered in the style of the Moscow show trials of the 1930s, was a deliberate attempt to sabotage the Revolution, intended to appeal to the humour of the world's liberals.[22] Padilla later confessed that he had wanted his words to seem like those of an illiterate in which the hand of the police was clearly visible. Accordingly, his parody was swiftly decoded by 'mainly ex-Stalinists who were familiar with the original texts'.[23]

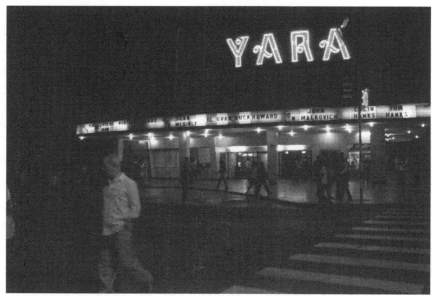

Yara Cinema in Havana, formerly known as Radiocentro, one of the venues of the First National Congress of Education and Culture, April 1971.

By the time of the congress, signs of a rupture between creative intellectuals and the Revolution were perceptible at ICAIC, with prominent filmmakers soliciting permission to spend time gaining experience in Europe (before returning a year or two later). Within commission 6B – dealing with culture and the media of mass communication, presided over by Raúl Roa – the film institute made a representation. Authored by Julio García Espinosa and Manuel Pérez (secretary of the commission), approved by Alfredo Guevara and entitled 'Cinema and Education', this paper outlined the ways in which the film institute had met its objectives and developed policies in an educational context. In the process, cinema was emphasised as a medium of cultural decolonisation in support of free thought. During the subsequent discussion, various doubts were raised about the paper, and a heated debate ensued. Guevara rejected a proposal that the various commissions of the congress should be used to assess the efficacy of cultural organisations, claiming himself responsible for the policies and decisions of ICAIC. When the discussion reached a low point, Fidel entered the room unannounced. He defended the work of ICAIC as responsible, serious and revolutionary, asserted the confidence of the leadership in all that the institute had been doing and signalled his agreement with Guevara's perception that it was the violence of life – rather than that of the cinema – which needed to be counteracted.[24]

Fidel also attended the plenary session on 28 April and the closing event two days later, with his presence interpreted by Jorge Fornet as an implicit means of combating the furore around Padilla while radicalising the Cuban

position. The final congress declaration – read on 30 April by José Ramón Fernández, First Deputy Minister of Education – was intended as a summary of the discussions that had taken place. Evidence of educational themes was uppermost, taking up two of three densely printed broadsheet pages in *Granma* and ranging from a consideration of juvenile delinquency to relations between production centres and community schools. Positing the mass media as powerful ideological tools and paraphrasing Lenin's elucidation of film as the most important art form, the final section of the declaration is dedicated to cultural activity. It opens with the words: 'Development of the artistic and literary activities of our country must be based in the consolidation and promotion of the *aficionados* movement, within the broadest cultural development in the masses, contrary to elite tendencies'.[25] Building upon earlier rhetoric, one of the pull-quotes from the substantial congress publication reads:

> Culture in a collectivist society is an activity of the masses, not an elitist monopoly, the plaything of a few chosen ones or the label of a few misfits. [...] In the heart of the masses true genius is to be found, and not in groups of isolated individuals. The classic culture profit has meant that until now only a few exceptional individuals excell [*sic*]. But this is only a symptom of society's prehistory, not a definitive cultural characteristic.[26]

As before, then, culture was firmly conceived as both the patrimony and activity of the masses – part of a formidable artistic movement which surpassed the role of entertainment and distraction attributed to culture in bourgeois societies. Four years later, the first congress of the PCC would retrospectively describe how teachers, artists and writers had come together in 1971 to ratify a decision to permanently strive for extension of culture to the masses. In this regard, a central point of the earlier congress was taken to be the proclamation that 'aesthetic and cultural education should be an important aspect of all education'.[27]

In considering the position of creative intellectuals in 1971, the final declaration asserted that the Revolution had provided resources and creative freedom unimaginable under capitalism. Looking abroad with sceptical eyes, it was found that – alongside those intellectuals who 'honestly unite with the revolutionary cause, understand its justice and defend it' – certain opportunists were using the Revolution as a springboard from which to garner international prestige, while attempting to impose their ideas and tastes upon Cuba and act as judges of the revolutionary process. Regarded from this angle, it seemed that 'Many of the pseudo-revolutionary writers in Western Europe who masquerade as leftists in reality have positions against socialism; they toy with Marxism but are against socialist countries; they speak of solidarity with liberation struggles but support Israeli aggression and conquests of territories,

sponsored by US imperialism, against the Arab peoples; they have converted leftism into a commodity'.[28] Seemingly aimed at those European intellectuals who had petitioned the revolutionary government over Padilla (and found a small group of like-minded Cubans to perpetuate their ideas), this description also explicitly encompassed those disingenuous Latin American writers who continued to use the continent's underdeveloped peoples as their subject matter while seeking refuge in the decadent capitals of Paris, London, Rome, West Berlin and New York. Thenceforth, their counterrevolutionary contagion would be inadmissible on Cuban shores, which would necessitate a revision of the system for selecting juries and the implementation of a rigorous system for vetting foreign intellectuals in advance of their invitation.

At the same time, the pretensions of bourgeois pseudo-intellectuals, who claimed to act as the critical conscience of society, were vehemently rejected. Instead, this critical role was reserved for the people as a whole, with intellectuals among them, acting from within the struggle rather than from any privileged position on the outside. While this has been taken as an attempt to de-privilege intellectuals, akin to the earlier expansion of the category to include scientists and technicians,[29] it was consistent with the prevailing tendency to democratise the critical role (invoked as early as 1963, albeit by the CNC). It also reinforced the sense of resentment engendered by foreign intellectuals who presumed to judge a revolutionary process in which they played no part. And, in an unfortunate phrase which has repeatedly been picked up on by external commentators, it was declared that the 'cultural media cannot serve to allow the proliferation of false intellectuals who claim to convert snobbery, extravagance, homosexuality and other social aberrations into expressions of revolutionary art, removed from the masses and the spirit of our Revolution'.[30]

Bearing in mind that the letter from foreign intellectuals had been dated 9 April, the congress took place during the week of 23–30 April and Padilla was released on 27 April, to make his faux-Stalinist confession, it is hardly surprising that the declaration evokes a Revolution under threat. Considering the broader geopolitical situation, the fifth clause of the declaration begins: 'We are a blockaded country, constructing socialism in the middle of the imperialist world. The threat of military aggression, of Yankee imperialism, against Cuba is not speculation. Our people struggle to construct socialism on all fronts'.[31] Within this perpetual war, it was claimed that 'Art is an arm of the Revolution. A product of the combative morality of our people. An instrument against the penetration of the enemy'. And, while this has widely been taken as evidence of instrumentalisation specific to the period, the notion of art as a weapon was not a novel one. At the 1961 congress, Retamar had referred to artists taking up arms to defend the Revolution, clarifying that 'these are not arms of gunpowder but of paper, of colour, of rhythm'.[32] At the Festival of Viña

del Mar in Chile in 1967, cinema had been proposed as an arm of the revolution, and we have seen that, at the 1968 congress in Havana, cultural work had been invoked by intellectuals as the ideological corollary of armed struggle.

As sketched in the introductory chapter, the 1971 congress is widely taken to be the moment at which the Cuban cultural field was narrowed and limitations on expressive freedom imposed. Shortly after the congress, Lourdes Casal would describe how:

> Castro's speech during the closing session of the Congress on April 30, 1971, further emphasized the new hard line on cultural affairs: (a) the primacy of political and ideological factors in staffing, universities, mass media, and artistic institutions, (b) the barring of homosexuals from these institutions, (c) tighter controls on literary contests to assure that judges, authors, and topics are truly revolutionary, (d) more control on subjects of publication, giving higher priority to textbooks than to literary works, (e) the elimination of foreign tendencies in cultural affairs in order to wipe out 'cultural imperialism,' and (f) a violent attack against the 'pseudoleftist bourgeois intellectuals' born abroad who had dared to criticize the Revolution on the Padilla issue.[33]

But this list, published in Pittsburgh, exaggerates the congress recommendations and conflates the final declaration with Fidel's speech, which mentions neither homosexuality nor Padilla.[34] Rather, this closing speech, delivered in the theatre of the CTC at 8:30pm on 30 April, paid homage to the 100,000 delegates – from primary teachers to professors – who had infused the congress's thousands of meetings with a spirit of camaraderie and non-conformity, addressing every detail with a critical spirit.

Having surveyed the country's educational situation and the work of the congress in evaluating and developing that work, Fidel turned his attention to the colonialism in the cultural field which had outlived its economic variant. He spoke at length of the failure of the bourgeois media to grasp the very real problems with which Cuba was having to contend in feeding, clothing and educating its children, reminding them that 'our problem is that of underdevelopment and how to overcome the backwardness in which you, our exploiters, imperialists, colonialists, left us'. Condemning those perpetuating the colonial mentality in the cultural field – who had deliberately been excluded from the congress and would be omitted from national juries in the future – he argued that 'to play the role of judge, it is necessary to be a real revolutionary, a real intellectual, a true fighter. In order to win a prize in a national or international competition, one must be a true revolutionary, a real poet'. Expanding upon this, he emphasised that the revolutionary Cuban people would evaluate cultural and artistic work according to the extent to which it contributed to their liberation and happiness. Consistent with the

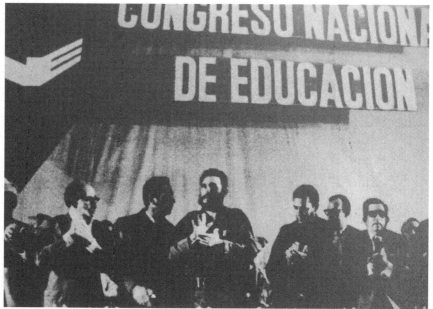

Fidel takes centre stage at the First National Congress of Education and Culture, 1971.

humanistic conceptions of art underwriting the revolutionary process, he asserted that 'There can be no aesthetic value without human content. There can be no aesthetic value opposed to man. There can be no aesthetic value opposed to justice, opposed to well being, opposed to freedom, opposed to man's happiness'.[35]

In a final reflection on bourgeois intellectuals, Fidel aimed his comments at that tiny minority of 'intellectual rats' (which certainly did not include those present, much less all intellectuals) who would sink in the tempestuous sea of history as part of the terminal decline of capitalist Europe. He dismissively referred to a handful of witch doctors, specialising in cultural alchemy, who stood in diametric opposition to those real intellectuals found among teachers, technicians, researchers and the rest of the population. This was underwritten by his abiding belief that the people had the potential to both enjoy culture and engage in its creation, not only as passive recipients but also as active participants. Taking a holistic view of the country's progress, he acknowledged the willingness of Soviet and Swedish delegations to lend their expertise, and looked forward to the day that all of Cuba's educational and cultural work would come to fruition.

While 'Words to the Intellectuals' of 1961 may be read as an attempt to accommodate into the Revolution those artists and writers who did not consider themselves truly revolutionary, this speech, made a decade later, has generally been interpreted outside the country as a more programmatic

step. To take just one example, Ivy League scholar Georgina Dopico Black asserts that, by declaring 'that only true revolutionaries would have a place in the arts',[36] Fidel reneged on his earlier inclusion within the cultural revolution of artists and writers capable of being non-revolutionary without being counterrevolutionary. But this perspective would seem to be negated by the congress's embrace of all those intellectuals who 'honestly unite with the revolutionary cause, understand its justice and defend it' and Fidel's pains to confine his dismissive comments to a tiny minority. The editors of *Casa* would publish a statement fully supporting the congress declarations and the policy arising from it, and, the following month, Retamar would discern that many outside observers attributed the violence in Fidel's speech – 'an attitude that is at the very root of our historical being' – to a 'deformation or to foreign influence'.[37] In this, he argued, they demonstrated their incomprehension, 'ignorance, if not disdain, regarding our concrete realities, past and present'.[38] Rather, for Retamar, a remarkable consistency was demonstrated between this speech and that made a decade earlier, particularly in the primacy given to creative works which made a contribution to humanity.

While the borders of Cuba would remain closed to 'liberal intellectuals' and 'agents of imperialism', this did not imply – as Casal suggests – the elimination of foreign tendencies in cultural affairs, which would have contradicted the internationalist aims of Cuban culture. Nor did it connote the prescription of particular themes. Similarly, the priority given to education in the publishing industry, so that much-needed textbooks would flow to schools, was not necessarily proposed at the expense of literary works, although Fidel had earlier admitted that political factors were at play and 'A book that we did not believe to be of some value wouldn't have a chance of being published'.[39] In the years that followed, cultural works emerging from the newly literate population were embraced as an integral part of humanity, and plans were made to disseminate them using all available media. While this laudable aim continued to distinguish revolutionary approaches from their elitist precedents, the rhetoric surrounding it implied that orthodox currents had triumphed, at least temporarily. Signalling the victory of materialism over idealism and the breakdown of ideological coexistence, it was decreed that 'The revolutionary intellectual has to direct his work to eradicating the vestiges of the old society that persist in the transition period from capitalism to socialism'.[40]

Coverage of the congress in the Cuban media pointed to its educational purpose, with Fidel seen to be heralding a new and superior stage of revolutionary action in the pedagogical field, the sciences and (as something of an afterthought) culture. The Deputy Minister of Education was pictured presiding over the event, and the inception of a National Union of Educational, Cultural and Scientific Workers (representing some 175,000 workers) was announced. In a series of short statements published by *Verde*

Olivo, representatives from each of the creative disciplines were called upon to give their opinion of the congress, all of whom seem to be agreed on the fraternal nature of debates in which a great proportion of those working in education and culture had come together to air their dissatisfactions. *Bohemia* also dedicated the majority of an issue to the final declaration and Fidel's speech from the congress, together with favourable statements from such grandees as Carpentier, Otero and Guillén.

On 6 May, Luis Pavón – the militaristic editor of *Verde Olivo* and suspected (co)author of Leopoldo Ávila's tirades – was appointed President of the CNC, to become the 'representative of the Revolutionary Government in the sphere of culture and, therefore, the supreme authority of the council and of all its integrated units and personnel'.[41] This inaugurated a period in which the armed forces exerted 'visible and sustained' control over the 'cultural life of the country'.[42] In this way, the connection between the cultural leadership and the artistic vanguard was severed, with disastrous results. As this Pavonist interregnum has not been considered in sufficient detail, it seems appropriate to do so here.

The 'Five Grey Years' (1971-6)

Such is the pivotal impact of 1971 that Jorge Fornet has dedicated an entire volume to retrospectively analysing its causes and consequences, with the benefit of insights and freedoms that were lacking at the time.[43] In this year – known as the Year of Productivity – he finds the realisation dawning that artistic and political vanguards would not necessarily be marching together forever (which had been the presumption of those revolutionary intellectuals working in the cultural field until then).

On 12 May 1971, an interview Padilla had granted to the France Press agency, in response to the intellectuals' letter to Fidel, was published in *Le Monde*. Eight days later (and published in the same newspaper the following day), a second letter was sent to Fidel, which read:

> We deem it our duty to communicate to you our shame and anger. The pitiful text of the confession that Heberto Padilla signed can only have been obtained by methods that are the negation of revolutionary legality and justice. The content and form of said confession, with its absurd accusations and delirious statements, as well as the meeting that took place at UNEAC in which Padilla himself and comrades Belkis Cuza, Díaz Martínez, César López and Pablo Armando Fernández submitted to a pitiful charade of self-criticism, recalls the most sordid moments of the Stalinist period, its prefabricated practices and witch-hunts. With the

same vehemence with which we have defended the Cuban Revolution from the outset, because we deemed it exemplary in its respect for human beings in its struggle for liberation, we exhort it to avoid for Cuba the dogmatic obscurantism, the cultural xenophobia and the repressive system that Stalinism imposed in the socialist countries, in which events similar to those taking place in Cuba were flagrant examples. The disregard for human dignity entailed in forcing a man ridiculously to accuse himself of the worst betrayals and the vilest acts does not alarm us because it involves a writer but because any Cuban comrade – a peasant, worker, technician or intellectual – might also be the victim of a similar act of violence or humiliation. We would like the Cuban Revolution once more to become what at one time lead [*sic*] us to consider it a model within socialism.[44]

Authorship of this second letter may be traced to Mario Vargas Llosa, and, although it was signed by sixty-two intellectuals, some of those who had signed the first letter refused to recognise what Cortázar referred to as the contemptible paternalism of the second.

Those foreign intellectuals whose interventions over Padilla were rebuffed now 'had to choose between the right of Cuba to self-management or breaking with the revolution'.[45] Those perpetuating the ideal critical role of the intellectual – notably Vargas Llosa, Carlos Fuentes and Ángel Rama – chose the latter path (with Fuentes later returning to the fold). On 5 May, Vargas Llosa had written to Haydée, resigning his post on the *Casa* collaborative committee, eliciting the reply that it had already been decided months earlier – in a declaration he had signed on 22 January – that the committee would be substituted by a broader list of collaborators. In her reply, which was published in a double issue of *Casa* dedicated to the 1971 congress, Haydée confessed she had been saddened to observe that Vargas Llosa had not hesitated in adding his voice to the choir of the most ferocious enemies of the Cuban Revolution.

Spanning the 1971 iteration of the Padilla case was a less-discussed internal crisis, centred on *Pensamiento Crítico* [Critical Thought], a journal that had been published by the Department of Philosophy at the University of Havana since February 1967, which was committed to armed struggle and considered the 'the most important magazine of social thought extant in Cuba'.[46] In April 1971, an issue dedicated to readings of Marxist thought was impounded at the Instituto Cubano del Libro, again polarising debate. On the one hand, there were those who emphasised the value of intellectual freedom to the building of socialism; on the other hand, there were those who foregrounded the process of cultural decolonisation – a position associated with the government – which regarded the Paris Salon as the ultimate exemplar of cultural colonialism. Both positions superseded discussion of the role of intellectuals within

society. Two months later, having worked towards a particular type of decolonisation – from Soviet ideology – *Pensamiento Crítico* ceased publication.

For Retamar, spring 1971 'was marked by passion, and – on our part – indignation at the paternalism, the rash accusation against Cuba, and even the grotesque "shame" and "anger" of those who, comfortably situated in the "West" with their fears, their guilt, and their prejudices, decided to proclaim themselves judges of the revolution'.[47] The months following the congress and the second letter from foreign intellectuals prompted by Padilla's 'confession' were replete with intellectual positioning, which was widely disseminated through the continent's periodicals. The majority of these missives, including a letter authored by forty-one Cuban writers, sought to distance Cuban intellectuals from their European counterparts. Padilla addressed a response to the signatories of the second letter to Fidel, accusing them of launching poisoned darts against Cuba.

Fornet recalls that 'the situation combined to mark a point of rupture or cooling between the Revolution and numerous European and Latin American intellectuals who until then considered themselves friends and fellow travellers',[48] and Retamar regrets that the ill-fated congress cost them dearly, causing them to lose not only opportunists but also valuable friends. By contrast, many intellectuals, including Benedetti, aligned themselves with the political leadership to make declarations – via Prensa Latina – against the suspect character of those liberal intellectuals who had signed the letters to Fidel. For Pogolotti, the public fracturing of international support for the Revolution created a national crisis which was exacerbated by internal tensions to bring about a redefinition of some of the practical aspects of cultural policy.[49]

As we have seen, the 1971 congress oriented creative production towards the Revolution. It is said that, in the process, 'the leaders hoped to eliminate much of the contemplative, introspective and diffuse individual activity in which intellectuals tended to indulge, and they hoped furthermore to lend a substantive base to the creative sector of the new political culture'.[50] On the other hand, in the wake of the international Padilla scandal, it is argued that the government needed to attract sympathetic intellectual attention from outside the country, becoming 'willing to foster any form of intellectual undertakings that would further certain of their basic aims, such as an open-door policy to attract and maintain the support of western, Soviet socialist, and third world intellectuals'.[51] Among cultural (rather than political) leaders, the former of these tendencies won out, and the period following the congress has been retrospectively (and inadequately) termed *el quinquenio gris* [the five grey years].[52]

The FEU wasted no time in endorsing the cultural policy established during the First National Congress of Education and Culture. At its First

National Congress, staged 22–23 May, the student organisation signalled its intention to develop a powerful cultural movement with full mass participation, which led to cultural festivals involving *aficionados*. In parallel with this, the FEU pledged to fight to the death to overcome negative tendencies from the absence of a critical spirit to hyper-criticality and from elitism to immodesty. Pavón insisted that cultural policy should not be geared towards a handful of geniuses and their exceptional works but should bring the masses in contact with great works of art while facilitating their own creativity. In November 1971, the CNC's prioritisation of youth gave rise to a National Youth Salon of Plastic Arts, followed two years later by a salon for arts teachers. At the same time, television and radio broadcast a spate of programmes arising from the conclusions of the 1971 congress and discrediting 'tendencies based in the false criterion of "absolute freedom"'.[53]

For Antoni Kapcia, 'the radical experimentation of the preceding seven years was abandoned and a series of reforms between 1972 and 1976 set the process on a course of necessary consolidation along more orthodox lines'.[54] During the first few years of the 1970s, a strengthened party apparatus began to exert greater control over cultural organisations. In the case of ICAIC, this led to much closer scrutiny of the films that were produced and screened. On 27 May 1971, in response to defamation of the Revolution, ICAIC published a declaration on behalf of Cuban film-makers in *Cine Cubano* (alongside several papers from the recent congress).[55] The film-makers' declaration clarified that socialism did not imply securing freedom of expression for a small minority; rather, the revolutionary process provided the freedom to effect genuine change. In December 1971, Tomás Gutiérrez Alea wrote a letter to Alfredo Guevara which was presented as a paper at an ICAIC seminar in May 1972, under the title of 'Hora y Momento del Cine Cubano' [Hour and Moment of Cuban Cinema]. In a 'clear reference to the conclusions of the recently finalised congress',[56] he questioned the wisdom of those for whom the solution to Cuba's cultural evolution lay in ostracising older intellectuals (as representatives of the past, of colonised bourgeois culture) in favour of the new culture embodied by *aficionados* and children. For Gutiérrez Alea, the Revolution had entered a phase of definitions more dangerous than those preceding it, which demanded a 'revolutionary cinema that operates directly, efficiently, as an instrument of transforming immediate reality'.[57] Despite such interventions, much of ICAIC's autonomy – which had led to the establishment of film houses and mobile cinemas around the island – passed into the hands of Popular Power, and, although the film institute retained responsibility for training, production and distribution, the relative independence which had protected its cultural policy was disbursed among various administrations and much of its potency was lost.[58] In a letter to Raúl Castro dated 5 March 1973, Alfredo Guevara bemoaned the loss of authority experienced by cultural organisations.

Cuban art historian and curator Gerardo Mosquera writes that, during this time, 'the basic result for culture was the closure of the plural, intense, and quite autonomous scene that had prevailed. No official style was dictated, but a practice of culture as ideological propaganda was imposed, along with a stereotyped nationalism. Under the slogan "Art: An Arm of the Revolution," many of the principal intellectuals were marginalized for "ideological" or "moral" reasons'.[59] While this account of developments within Cuba reads as a fairly moderate reflection, other commentators, notably those based in the US, write with barely constrained glee when discussing the reprisals exacted by the bureaucracy. In a publication for the University of Wisconsin, Linda S. Howe writes that 'after the relative openness and utopian euphoria of the early 1960s, Cuba's cultural vitality atrophied as authorities drew skewed parallels among harvesting sugar cane, fomenting guerrilla warfare, and engendering culture through social volunteerism. Although authorities encouraged a variety of cultural activities, they funded primarily pro-revolutionary literature, documentary films, and graphics'.[60] For Howe, this meant that, 'while artists and writers resisted pressure to conform, experimental or "cosmopolitan" styles were punished, silencing dissenters by dismissing them from their positions or relinquishing their publishing privileges'.[61] Maintaining attention to semantic detail, it is necessary to distinguish between experimentalism and cosmopolitanism, the latter of which had been consistently associated with Western metropolitan centres and derided within the Revolution. In relation to aesthetic experimentation, the Marxist-humanist writings of Ernst Fischer, Roger Garaudy and Adolfo Sánchez Vázquez were ousted in favour of those by the conservative Soviet aesthetician Avner Zis.

Howe's account continues that 'punishment for the slightest ideological dissent or lack of commitment led prudent artists to reach for "revolutionary" metaphors, which lowered standards of artistic judgment. The government's insistence that the proper role of artists was to extend the "revolutionary" political struggle into the realm of culture had lamentable effects on the independence of the art world and on the rich variety of Cuban cultural life'.[62] As usual, we must take care to differentiate between the government's involvement in the field of culture and that of the functionaries appointed to interpret and implement cultural policy. At the end of the 1980s, Dopico Black defined the 'Limits of Expression' in Cuba, outlining how literature 'may be actively promoted, prohibited outright, or marginally tolerated by the official state bureaucracy, depending upon its adherence to prevailing revolutionary norms'.[63] This led her to determine that 'the government's role within the literary arena has directly resulted in the broad promotion of some works of questionable quality, in the outright censorship of some of the country's best literature, and in the institutionalization of an atmosphere of suspicion that in literature assumes the guise of self-censorship'.[64] Antonio Benítez-Rojo – a

writer who remained unpublished during the grey years and lost his job as director of Casa's research centre, later being appointed director of its Centre of Caribbean Studies – responded to Dopico Black's analysis by arguing that:

> [...] the 'limits of expression' are conditioned not only by the content or the form of a literary work, but also by its author's standing with regard to the rigid requirements the Cuban state imposes on its subjects. [...] if a literary work is promoted, prohibited, or tolerated, its treatment is due largely to the degree of esteem its author deserves in the eyes of the state. I could name dozens of writers whose literary works were at some time rejected, impounded, prohibited, partially censored, or criticized in Cuba for purely extraliterary reasons.[65]

One such extra-literary reason was pre-revolutionary history, and we have seen that the sectarian tendency within the PSP/PCC insisted on impeccable Marxist credentials. There is also evidence of intellectuals flagellating themselves for not having wholly having entered into the rebel cause, with Otero, for example, writing candidly about having remained at the margins of legality within the clandestine struggle, which led him to be pursued by an uncomfortable sense of recrimination.[66]

Reflecting upon this dark period in 2001, Desiderio Navarro would describe how the critical role of intellectuals had been diminished, but not because it had been possible to demonstrate the negative effects of certain forms of critique; rather, intellectuals were accused of being hyper-critical, of introducing disorder into public life, offending popular taste and posing a moral danger to revolutionary or Marxist truths. This led to a generalised demonisation of attempts by the intelligentsia to serve as the critical conscience of society and resulted in damning attributes being applied to certain intellectuals. Eduardo Heras León – who was removed from both his professorship at the university and his position on the editorial board of the literary journal, *El Caimán Barbudo* (the weekly supplement of *Juventud Rebelde* which had published Padilla's attack on Otero) and sent to work in a factory far from Havana, but nonetheless remained loyal to Fidel and the Revolution – remembers being trapped in a Kafkaesque situation in which he stood accused of something unspecified, lacking the means to defend himself or provoke a dialogue about it. As evidence of this, Heras cites a report, written for the university (which was itself undergoing scrutiny, particularly its Department of Journalism) by Armando Quesada, Director of Theatre at the CNC, which found the group around *El Caimán Barbudo* to have 'fallen into positions of evident ideological diversionism'.[67]

As before, close scrutiny of the circumstances within Cuba allows us to understand how the harnessing of culture to revolutionary struggle came to be met with punitive consequences for non-compliance. In the first place, as

we have seen, the *quinquenio gris* coincided exactly with Pavón's omnipotent presidency of the CNC. Questions remain about why, having achieved notoriety for his pseudonymous views in the FAR magazine, this former army officer had been appointed to run culture. Years later, an attempt to exonerate Pavón and his cronies on television led the then Minister of Culture, Abel Prieto Jiménez, to argue that some analysis of this period was badly needed.

In the autumn of 2006, while Fidel was convalescing from intestinal surgery and the government otherwise engaged, Quesada was interviewed for the television programme, *Dialogo Abierto* [Open Dialogue]. On 13 December 2006, the former *comandante*, Jorge Serguera – who had eliminated any mention of personalities considered critical of political dogmatism during his tenure as director of the Cuban Institute of Radio and Television (ICRT) from 1966 to 1973 – appeared on *La Differencia* [Difference]. Six days later, he took part in the widely watched programme, *Este Día* [Today]. On 5 January 2007, Pavón himself was interviewed for *Impronta* [Stamp] on Cubavision. Dressed in white, his hands trembling as he spoke with a barely audible voice, Pavón displayed his medals and was shown in photographs alongside revolutionary leaders, with the presenter suggesting that he should be remembered as a committed revolutionary. This triggered a deluge of calls to TV Cubana and a 'small avalanche' of emails as intellectuals who had lived through the Pavonist era condemned his rehabilitation, which seemed to suggest a return to the dark Stalinist past. Among the correspondence that was exchanged, a message of solidarity was sent by Mariela Castro Espin (daughter of Raúl Castro and Vilma Espin) to Reynaldo González, one of those marginalised by Pavón, who had gone on to be awarded the National Prize for Literature.

During this uproar, older Cuban intellectuals warned that the resurrection of these corpses prompted concern and reflection, and they demanded a public apology from the leaders of the ICRT. On 12 January 2007, the ICRT offered a detailed explanation, clarifying that it had not been addressing the policy of the CNC, which was acknowledged to have committed grave errors. UNEAC also issued a statement, via *Granma*, which aimed at reassuring its members, indicating that the anti-dogmatic cultural policy favoured by Fidel and Raúl was irreversible. But the then director of the union, Carlos Martí, made the mistake of trying to dismiss problems around the legacy of the CNC as personal ones. In response, a conference called 'The Five Grey Years: Revisiting the Term' was organised by Ambrosio Fornet at Casa de las Américas for 30 January 2007. This formed part of a series, entitled 'The Cultural Policy of Revolutionary Cuba: Memory and Reflection', organised by the theoretical-cultural centre associated with *Criterios* journal, which had emerged during the grey years in 'an attempt to counteract the intellectual obscurantism that fell over the country'.[68] One of the aims of the discussion series was to ensure that those intellectuals who were too young to remember

the cultural damage that had been caused in the 1970s understood the wider significance of this legacy.

Having initially been planned as a public event, the magnitude of the outcry meant that attendance at the 'Five Grey Years' conference was limited to invited guests from professional organisations – members of UNEAC, art students, representatives from relevant university departments, specialists and staff from the ICRT and cultural institutions. Reflecting on the 'act of suicide' that Pavón's rehabilitation represented, Fornet offered a damning critique of a man whose way of operation was 'not so much the expression of a political tactic as a vision of the world based on suspicion and mediocrity'.[69] He described how those vanguard groups which had, until the late 1960s, predominated in the cultural field came to be regarded as politically untrustworthy:

> That which the publishing houses and magazines published, that which the galleries exhibited, that which the theatres staged, that which was filmed by ICAIC, served to demonstrate who pulled the strings of the 'cultural industry', how far our discourse had become the hegemony, weighed against refusal and the suspicions which, at the same time, were stirred up between some professional ideologues who we usually called the pious Guardians of the Doctrine (headed by a high functionary of the Party who, according to rumours, was the political godfather of Pavón).[70]

Again, we see the struggle for political influence being enacted in the cultural milieu and attempts being made to curtail the ideological role of intellectuals. The presumed 'political godfather' of Pavón was a man named Antonio Pérez Herrero, known as Tony Pérez, who was a member of the Central Committee of the PCC, Vice-Minister for Political Education of the Armed Forces and later head of the Ideology Department of the party under Raúl. In this, Fornet acknowledges that Pavón was neither the primary motor of persecution nor simply the obedient foot soldier of a higher power. Nonetheless, Pavón's anti-intellectualism led him to strip power from those creative intellectuals perceived to be a threat.

With hindsight, Fornet identifies 1971 as the moment at which the 'relative equilibrium that [the Cuban cultural field] had favoured until then' was broken and, with it, 'the consensus on which cultural policy had been based. It was a clear situation of *before* and *after*: from one stage in which all were consulted and all was discussed – although not always to arrive at agreement between the parties' – to a period of 'cultural policy imposed by decree [...] of exclusions and marginalisations, which changed the intellectual field into a bleak terrain (at least for the bearers of the virus of ideological diversionism and for those youths inclined to extravagance, that is to say, aficionados of long hair, the Beatles and tight trousers)'.[71] In the professional creative field,

1971-2 saw certain 'parameters' being applied to 'high risk' sectors of the arts, notably theatre. Those who did not adhere to these parameters and who did not 'qualify as trustworthy – that is to say revolutionaries and heterosexuals – were relocated to other work centres' in agriculture or industry. This led to the imposition of 'neo-Zhdanovist' approach to 'cultural work which took decades to eradicate',[72] preventing artists from exhibiting and writers from publishing and ultimately bringing about the exodus of important cultural figures.

In the cultural policy emerging from the CNC during the early 1970s, we find great emphasis being placed on mass creativity and the nurturing of new generations of creative intellectuals. For the whole of January 1972, for example, a brigade of young writers, painters, musicians, poets and dramatists visited various locations in the Sierra Maestra, developing diverse cultural activities and joining in the community life of this historic region, the dual objective of which was to promote revolutionary sentiment among young artists and enrich their artistic experience. In June of that year, the CNC's Director of Cultural Outreach, Arnoldo Reyes, was interviewed about the *aficionados* movement in *Revolución y Cultura*. He explained that not only did participation in art play an important part in the aesthetic training of man but it also contributed to political, ideological and moral training and the simultaneous development of the intellect. Drawing upon the 1971 congress, he invoked ideo-cultural enrichment as a primary task in strengthening the people against Yankee imperialism. In relation to the plastic arts, Reyes emphasised that knowledge should be geared towards practical results, through the content of the work and the possibility of objective utilisation, thus harnessing art to narrow conceptions of social utility.

In the second week of July 1972, a national meeting of arts instructors was convened at ENA, preceded by meetings at provincial and regional levels, with 198 delegates invited to discuss problems concerning the basic task of developing *aficionados*. The starting point for this meeting was the 1971 congress's embrace of art as an arm of the Revolution and a powerful instrument against enemy penetration and all the deviations of decadent bourgeois culture. Artistic education of the masses was reiterated, on the basis that art was vital to formation of the new man and augmentation of the revolutionary spirit. In addition to plenary sessions – presided over by Reyes – the group split into three commissions, with interventions being made by the leaders of cultural, political and mass organisations, including Pavón and Guevara.

In accordance with the primary resolution of the 1971 congress to massively develop the *aficionados* programme, the first commission – dedicated to the work of instructors – elaborated a new structure to coordinate relations with political and mass organisations, operating across student, worker and peasant fronts. It was determined that instructors would need to have well-defined technical and political qualities to be considered educators. In

light of their influence on the student/worker/peasant body, as dissemina-
tors of Marxist-Leninist ideals, they would have to be disciplined, capable
of maintaining a good moral attitude and radically resistant to ideological
diversionism. Their work was made inseparable from the problematics of the
Revolution, and their training was delegated to FAR and the Ministry of the
Interior (MININT), with the CNC playing a central role.

The second commission at the July 1972 meeting concerned itself with the
training of activist instructors to develop the latent creative potentialities of
the people. This amplified the potency of culture as a weapon in decolonisation,
which compelled every instructor to study their own national roots and the
cultural expressions of the tricontinental area. Those teachers with an artistic
vocation would be selected by official organisations to attend schools, seminars
and courses, and they would be regarded as the vanguard in creating a great
artistic movement. Through the work of heroic youth, it was anticipated that
the divisions between manual and intellectual work would be erased and every
vestige of individualism abolished. At the same time, a decision was taken to
increase the socio-economic content of works so that they directly reflected
reality, which represented a new departure in the prescription of themes. As
a whole, CNC policy from this era took the resolutions of the 1971 congress –
the ideological formation of young artists, the use of culture as an antidote to
neocolonial penetration and the enhancement of culture in the tricontinental
area – in an avowedly orthodox direction, by subordinating the *aficionados* pro-
gramme to army control and instrumentalising artworks to narrow agendas.

Another misdemeanour for which the CNC was responsible during this
period was its reinforcement of the notion, inherited from capitalist society,
that 'the majority of intellectuals and artists – at least those who did not
engage in really lucrative activities – were a kind of "parasites".'[73] In this, the
council took great care to isolate the old guard – including those who were
scarcely forty years old, thinking them already 'contaminated' – from the
young and politically trustworthy. It is here that we see the worst distortion
of Che's invocation that new generations must be nurtured which would be
free from the original sin of not being truly revolutionary.

By 1975, the project spearheaded by Pavón was in its death throes. From
a final directive issued by the CNC that year, we can determine the form into
which cultural policy had congealed.[74] In summarising the most important
achievements of 1974, the report gave priority to the *aficionados*, whose work
was seen to have benefited from the support of professional artists, art schools
and cultural centres. Ideological struggle had become a decisive factor in
artistic manifestations, with artworks expected to contribute to the construc-
tion of socialism while functioning as an expression of solidarity with peoples
struggling for their liberation. In relation to the plastic arts, the emphasis was
on: familiarising provincial communities with the most important work being

made; exchanging cultural knowledge within the socialist camp; incorporat-
ing professional artists into the task of stimulating popular creation; and
developing a youth movement. A national seminar for the plastic arts in 1976
was also mooted.

Within the CNC's 1975 directive, the presence of Soviet advisors was
again explicitly mentioned, along with the novel suggestion that their rec-
ommendations to reform the teaching of art should be adopted. At the same
time, plans were afoot to establish the obligatory study of Marxism-Leninism
among students, professors and art schools leaders. And, alongside a stated
intention to increase the dissemination of artistic activities, the stipulation
was made that artistic groups conform to the *thematic and aesthetic* orienta-
tions of the cultural policy of the Revolution.

Asked about relations between creative intellectuals and the revolution-
ary government during this period, Pogolotti was keen to emphasise that the
application of policy was not uniform but proportional to the extent to which
organisations depended upon the CNC.[75] As such, those institutions with
prestigious leaders – specifically Casa de las Américas, ICAIC and UNEAC –
survived attempts to undermine the cultural field, albeit with significantly
reduced facilities. Retamar claims that, 'somewhat bloodied, *Casa* made it
unbowed through what Ambrosio [Fornet] would baptize [...] the "Grey Five
Years" (1971–1975); it published not a single one of the laudatory pieces of
socialist realism that the Soviet press agencies based in Cuba showered us
with.'[76] More generally, in relation to this period, intellectuals have retroac-
tively indicted themselves and their colleagues for contriving to feign igno-
rance about those responsible and for maintaining a silence which served
to create a semblance of unanimity that detracted from proper considera-
tion of the threat to integrity these policies represented. If one defined this
era according to its malignity, Fornet argues, it would 'have to be seen as a
dangerous and grotesque phenomenon [...] There are acts from this period –
including those of the end of the period – which may be considered crimes of
cultural and patriotic treason'.[77]

Eventually, through various unions and with recourse to the Law of
Work Justice, those persecuted during the grey years appealed to the Supreme
Tribunal. In an unprecedented case, the tribunal ruled that the imposition
of parameters onto the creative arena had been unconstitutional and that
claimants should be compensated. The CNC was forced to pay reparations to
many of the country's creative intellectuals, which ultimately bankrupted it.
In 1979, Pavón was 'retired' for abuses of power.

The Grey Areas within the Grey Years

It is important to note that the controversies outlined above were largely
confined to theatre, film and literature – media having the potential for the

widespread distribution of a message perceived to be counterrevolutionary. Fidel had earlier differentiated between creative media on the basis that 'All manifestations of art have different characteristics. For example, movies are different from painting; [...] It is not the same thing to make a film as it is to paint a picture or write a book'.[78] In 1963, Aguirre had isolated literature as the art form in which ideological content was paramount – because it found the shortest route to conceptualisation, by using words as its expressive instrument – as compared to the sensory stimuli received through music or the plastic arts. This led her to advise caution in relation to authors and playwrights and to urge all artists and intellectuals, but particularly writers, to remain open to being oriented towards 'correct' modes of thought.[79]

In relation to the plastic arts, Carlos Rafael asserted, in 1967, that 'evidently, workers and farmers do not go to [...] exhibitions en masse',[80] and, three decades later, Mosquera would observe that 'the space of the visual arts [is] less controlled and more permissive because it is considered a minor activity'.[81] In considering the various nexi around which policy was constructed during the grey years, it would seem that the relatively elliptical nature of the plastic arts did not find easy accommodation within emerging categories. Nonetheless, levels of artistic dissemination fell away in the first half of the 1970s, with 1970 marking a low point in official statistics issued to account for the professional exhibitions of this era and no data being published between 1971 and 1974. In spite of this diminished output, the caricaturist and critic Antonio Eligio Fernández (working under the name of Tonel) argues that the grey years may be reclaimed as a 'contradictory and dramatic period'.[82] Similarly, Adelaida de Juan suggests that forms of refuge from repression presented themselves, and she points to the Meetings of Latin American Plastic Artists as evidence of such an approach.[83]

In an introduction to the 1968 edition of Che's Bolivian diaries, Fidel referred to the people of Latin America; 'Devastatingly poor in their overwhelming majority and increasing in number to 600 million within 25 years, they have the right to the material things of life, to culture, and to civilization'.[84] In his aforementioned June 1971 text, 'Caliban', Retamar found Cuba to be 'struggling in the front ranks of a family numbering 200 million brothers and sisters' within Latin America, in turn forming 'part of another even larger vanguard, a planetary vanguard – that of socialist countries emerging on every continent'.[85]

In July 1971, in collaboration with the Latin American Art Institute at the University of Chile, Casa de las Américas inaugurated an exhibition of Cuban and Chilean plastic arts, which gave rise to a new idea. The following month, while rigid parameters were being applied to cultural work at home, Casa deployed its characteristically continental outlook to announce that a meeting of Latin American plastic artists would be taking place the following

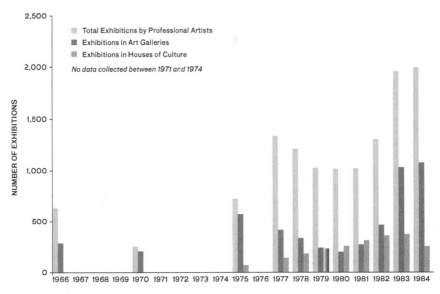

Graph showing the number of exhibitions by professional artists 1966–84.

May. In the event, four such meetings took place at Casa – in 1972, 1973, 1976 and 1979. To prepare the ground, issue 68 of *Casa* (September–October 1971) took up the theme of culture and revolution in Latin America and provided the context for publication of 'Caliban'. In combining resistance with a critical reading of classical texts, this text opened a new path for intellectuals departing from their class of origin to align themselves with the colonised.[86]

Consistent with the objectives arising from the 1971 congress, it was anticipated that the Casa meetings would provide a forum for defining a role that could be assumed by all artists with a revolutionary consciousness. This was predicated on the need to configure an art that would signify a re-encounter of artists with the people – an art that would become the patrimony of all and an intimate expression of Our America. In this way, at a time when the vanguard potential of creative intellectuals was being compromised at home, Casa positioned itself at the forefront of the ideological struggle against imperialism at a continental level.

Co-organised with the Latin American Art Institute, the first meeting included twenty-six artists, critics and art historians from ten Latin American countries, with the Cuban artists, Mariano Rodríguez Álvarez and Lesbia Vent Dumois, acting as President and Secretary on behalf of Casa. In contemporaneous coverage of the event, De Juan described how purely aesthetic discussions were rejected from the outset.[87] Rather, those assembled aimed to establish the function of the artist in Latin America, in terms of their individual and collective creation and the cultural strategies they would pursue.

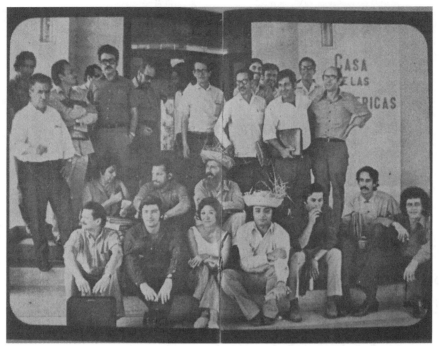

Attendees of the 1972 Meeting of Latin American Plastic Artists on the steps of Casa de las Américas.

It will be remembered that the third commission of the 1968 congress, chaired by Retamar, found that 'Anti-Bodies must be formed to fight against the "invisible" enemy [...], against imperialistic persuasiveness: Anti-Awards-and-Foundations watch committees ought to be set up: Anti-Metropolitan-and-Foreign-Education complexes should be founded to resist imposed language domination, imported popular entertainment and all the other cultural influences designed to overrun the Third World, with their appeal in books, films, television, advertisements, etc'. With this in mind, the first meeting of Latin American artists analysed imperialist cultural strategies and agreed concrete measures for opposing their alienating mechanisms, with a specific session dedicated to consideration of biennials, prizes, competitions and grants.

The meeting culminated in a collective exhibition of artwork, a declaration of solidarity with the Vietnamese struggle, an Appeal to Latin American Plastic Artists (dated 27 May 1972 and signed by all those present) and a series of concrete accords (dated 30 May and read out by Vent Dumois). The appeal, which asked all Latin American artists to join the ideological battle, was based on an understanding that the category 'Latin American art' was a relatively new one, which opened up all kinds of possibilities. Consolidating the 1971 congress declaration, the participants to the appeal proclaimed that Latin

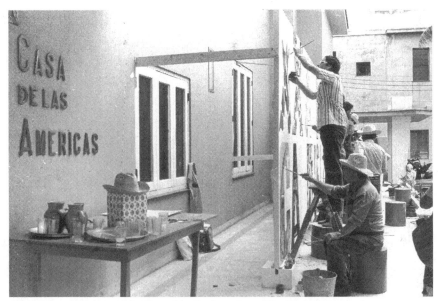

Attendees of the 1972 Meeting of Latin American Plastic Artists create a collective artwork, with Félix Beltrán (on stepladder) and Carmelo González (seated), among others. Courtesy of the Archive of Casa de las Américas.

American artists could neither declare themselves neutral nor isolate their condition as artists from their duty as citizens. As such, the development of revolutionary consciousness was the primary task of the moment, and those involved in drafting the appeal sought ways of inserting themselves into revolutionary struggles taking place across the continent. Liberated from the mechanisms of supply and demand, they asserted, revolutionary art neither suggested a model nor determined a style but implied – as Marx had foreseen – the tendentious character of art in affirming the personality of a people or a culture. In this way, some of the most interesting plastic artists of the region (led by one of Cuba's foremost painters) assumed the revolutionary mantle, situating themselves in the continent's showdown with imperialism – denouncing and dismantling bourgeois ideology where possible, engaging in violent confrontation where necessary. Beyond this, Latin American intellectuals were perceived to have a contribution to make to the recovery of national sovereignty, in advance of implementing a revolutionary cultural programme conducive to the formation of the new man. In its advocacy of second order negation, the appeal – which took up where its 1968 forerunner left off – reads as an attempt to perpetuate the Cuban cultural model in the rest of the continent.

In addition to the appeal, a concrete programme was devised, which included the creation of a continent-wide network of information–coordination centres, with facilities that could be used to support the shared struggle

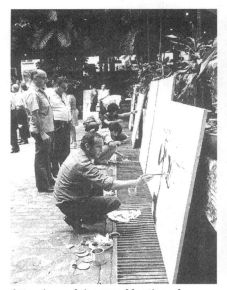

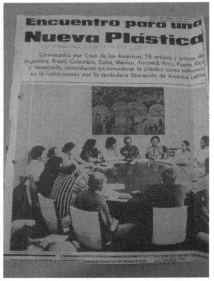

Attendees of the 1973 Meeting of Latin American Plastic Artists create artworks on the patio of the National Museum of Fine Arts, with Ricardo Carpani (in foreground) and Claudio Cedeño (standing), among others. Courtesy of the Archive of Casa de las Américas.

Working meeting at the 1973 Meeting of Latin American Plastic Artists, organised by Casa de las Américas, with Haydée Santamaría and Mariano Rodríguez Álvarez playing a central role.

without losing sight of local specificities. Added to this, diverse exhibitions of new work were proposed, alongside the distribution of reproductions of historical artworks to work centres. Competitions were conceived with the intention of creating images and symbols of revolutionary scope that could be used in the struggle. Articles were proposed that contributed to demystifying the mechanisms through which revolutionary art was neutralised. In addition to this, Casa began publishing an irregular plastic arts bulletin – designed by Umberto Peña, who was responsible for the graphics of *Casa* – the first issue of which documented the meeting and accompanying exhibition.

In October 1973, thirty-seven artists and critics from nine countries convened in Havana, many of whom would overlap with the first meeting. This time, representatives from Chile were notable by their absence, and the event was overshadowed by the recent coup against Salvador Allende. Presided over by Mariano and Gonzalo Rojas (the latter representing the Chilean Government of Popular Unity, the leftist coalition which had seen Allende elected to power), the meeting made a unanimous statement in support of the Chilean people struggling against the fascist military junta and approved a total cultural blockade of Chile for 4 November (the third anniversary of Allende's ascension to government). Alongside other accords, those present

demanded that artworks be donated to a Museum of Solidarity in order to preserve them until power had been returned to popular control in Chile. Delegates also unanimously approved a proposal by the Panamanian delegate, Raúl Rodriguez Porcell, to send a letter to the UN Secretary General, Kurt Waldheim, demanding the safety of all Chilean artists being persecuted, imprisoned and in danger of death. The meeting then proceeded to discuss the ways in which the objectives agreed at the previous meeting had been achieved. In alphabetical order, countries undertook to summarise their activities and analyse the efficacy of art as an anti-imperialist device. Argentinian artists had opposed the repression and torture brought about by the military regime of General Alejandro

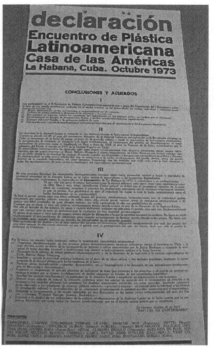

Declaration from the 1973 Meeting of Latin American Plastic Artists.

Lanusse by, among other things, mounting an exhibition called 'America of Che', organising two counter-salons in repudiation of the military dictatorship and disseminating the appeal as widely as possible; Brazilian artists (including émigrés in Paris) were reported to have organised exhibitions and other politico-cultural acts, denouncing the imprisonment and torture of Brazilian revolutionaries; Panamanian artists had signed the Columbus Declaration, addressed to the UN Security Council, which called upon intellectuals to integrate into a broader anti-imperialist front.

Through its discussion of concrete plans, Mariano would differentiate this second meeting from the first, in which it had been necessary to hone a general strategy and tactics. Among the conclusions and accords of the second meeting (dated 20 October 1973 and signed by all those present) were: the intention to organise militant demonstrations of solidarity against fascism in Chile and in defence of political prisoners and victims of torture; the promotion of artistic activity in working class and popular sectors, through the incorporation of visual imagery into daily struggle; the promotion of artistic workshops as a platform for activists; the proliferation of coordination centres beyond the continent's capital cities; the extension of activities into recently independent parts of the Caribbean; and the implication of revolutionary Latin American cultural workers in the common struggle for

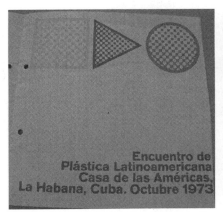

Catalogue for the 1973 Meeting of Latin American Plastic Artists, designed by Umberto Peña.

Catalogue for the 1976 Meeting of Latin American Plastic Artists, designed by Umberto Peña.

liberation. Predictably, *Verde Olivo* emphasised the militant aspect of the artists' programme and implored creators to act upon their agreement, not only confining their activities to galleries but also working at the base of the revolutionary process itself – not just for the people but within the people.

Alongside the meeting, an exhibition of more than 150 works was organised at the National Museum of Fine Arts, and delegates painted diverse works on the museum patio, assisted by Haydée and the Deputy Prime Minister, Belarmino Castilla, before visiting the historic sites of Oriente province. The following year, a bulletin issued by UNESCO's National Commission on Cuba would herald a new function for continental plastic artists – urgent and direct participation in the process of transforming society, in response to the anguish shared by all underdeveloped peoples.[88]

The straitened circumstances of the grey years meant that the next meeting was not organised until 1976 and, even then, participation was much reduced, confined to the Spanish-speaking Antilles of Puerto Rico and the Dominican Republic. Discussion themes were limited to a report on the characteristics of creative work in participating countries, a consideration of US support of two events in the region and the possibility of involving all Caribbean countries at the next meeting, with an exchange of ideas related to painting creeping in. The final declaration sought an end to the mutual ignorance being imposed upon the continent by the US. It also marked greater purpose in reaffirming identity and unity in the struggle against imperialism, most acutely by expressing solidarity with Puerto Rican people fighting for their independence and Panamanians for their canal while continuing to demand freedom for intellectuals, writers and artists in Chile and Uruguay. The final meeting, in 1979, was a return to form, with twenty-nine artists participating from eleven countries. A press release for the event referred to the

series of meetings as 'one of the most fruitful and effective paths for contributing to the permanent defence, diffusion and stimulus of the culture of our peoples'.[89] In this way, the solidarities forged among Latin American plastic artists at Casa in the 1970s enabled the continental revolutionary aspects of previous congress declarations to be realised in a non-dogmatic environment.

Emerging from the Grey Years
While the years following 1971 marked a low point for relations between creative practitioners and the cultural agencies of the state, it is generally agreed that a thawing began to occur from 1976. Two crucial events of the mid-1970s, which facilitated this shift, have already been mentioned in passing and will be elaborated here.

First Congress of the Cuban Communist Party (17–22 December 1975)
After nearly sixteen revolutionary years, in December 1975, the PCC convened the first of six congresses to have been organised to date. Among twenty main themes – ranging from legislative to agricultural matters – a thesis and resolutions were elaborated on artistic and literary culture and included in a dedicated chapter of the retrospective publication, from which all quotations in this section are taken.[90] Further to the detrimental effects of the grey years, the congress provided the governing party with an opportunity to refocus its attitude towards culture. In tacit recognition of the stultification that had occurred, it was stated that PCC policy on artistic culture aimed to establish an atmosphere most conducive to the progress of art and literature, which was reiterated as the legitimate aspiration of the people and the fundamental duty of the political, state and mass institutions.

The party congress represented an important shift in ending the instrumentalisation of culture to dogmatic objectives. Thenceforth, cultural policy would rest upon two fundamental prepositions – firstly, that creative abilities be fully expressed in all their power and uniqueness; secondly, that the work produced by writers and artists would contribute valuable support to the initiation of social and personal liberation that socialism embodied. In this way, culture was recognised as both intrinsically valuable and inherently revolutionary. Continuity with earlier cultural congresses is evident, notably through references to the assimilation of Cuban cultural heritage and the best of universal culture.

In the most direct pronouncement yet, art and literature were harnessed to the socialist humanism at the heart of the Revolution, with a section of the thesis distinguishing this from bourgeois humanism. While the former was seen to exalt solidarity between peoples, encouraging the best and most progressive in man, the latter was regarded as a corruption of the revolutionary

origins of the bourgeoisie – characterised by private ownership, the profit motive and the individualism of a conservative and reactionary class, underpinned by exploitation and the negation of human values. Accordingly, culture was placed centre stage in the 'global ideological confrontation between the humanist culture of socialism and the alienating expression of the culture of capitalism and imperialism', with its role increasing in importance every day, especially in relation to the struggle against attempts by colonial, neocolonial and imperialist exploiters to brutally impose their cultural values upon other countries.

As emancipatory understandings of cultural production were foregrounded, the objectives of socialism and communism were aligned with those of art and literature in achieving this noblest of human aspirations. Based on a renewed understanding that the Revolution had created and reinforced the material and spiritual conditions necessary for the freest artistic creation and conferred social esteem upon its creators, responsibility to the project of human and social transformation was reasserted alongside the right of creative intellectuals to reject any attempt to use art as an instrument adverse to socialism. Following this logic, the most appropriate source for new artistic production was taken to be the 'essence of socialism, the daring and vitality of which is located in the scientific certainty of the perfectibility of man, in an inexorable future of wellbeing and happiness, in revolutionary optimism and in the fraternity and solidarity which result in a highly elevated level of social development'. But, in the process of directing culture towards the overall goal of human emancipation, the prescription of themes was explicitly avoided.

A section of the deliberations on culture was given over to a consideration of literary and artistic critique. Consistent with the occasion, it was presumed that cultural criticism presupposed a profound knowledge not only of Marxism-Leninism but also of the socio-historical processes from which artistic work arose. This posited critique not as a scientific (empirical) process but as a qualitative, contextual one. Within this, artistic work was considered to have increased value if it could demonstrate continuity with previous cultures, affirmation of revolutionary realities and an impulse towards the future aims of socialist society. In a characteristic process of trial and error, itself based on self-reflexive critique, Cuba would emerge from the grey years to embrace the dialectical nature of critique.

The congress would also reaffirm the government's commitment to the *aficionados* movement, demanding 'the support of the most qualified specialists, artists and instructors and a full mobilisation of activists' while insisting on an 'elevation of artistic quality'. Recovering the humanistic rationale for this programme, it was determined that 'Those who participate in artistic activities as *aficionados* will better understand surrounding reality, will

intensify their sensibility for colour, movement, sound, word and image; they will enrich their representation of the world and they will be more capable of interpreting and valuing artistic manifestations'.

At the same time, the party congress advocated full institutional and professional support for cultural workers and (in a return to the consensus of the 1968 congress) the widespread utilisation of mass media in disseminating the work of (professional) artists and writers. As Cuba began its emergence from the grey years, the revolutionary position with respect to aesthetics was that:

> Socialist society requires an art which, through aesthetic enjoyment, contributes to the education of the people. The generalising and educative character of art is of great importance in promoting and contributing to strengthening the new, which emerges from the habits of life and work in socialist society under construction – which does not imply limiting the role of art and literature to a didactic function but recognising great possibilities for the formation and transformation of man.

It is interesting to note here the unambiguous rejection of the didacticism which had dogged the grey years, and an embrace of the approach advocated by Fornet in 1962, whereby 'that which art *teaches* us is to sharpen the senses; that which art *educates* is our sensibility'. This acknowledgement on the part of the PCC formed the theoretical basis for a further comment on the expressive properties of art, which took account of the contemporaneous photorealism being produced by the country's artists to propose that:

> The nexus between socialist art and reality resides in an apprehension of their essences and its aesthetic expression through the most appropriate formal structures. That which is important is not a simple copy of reality but the living quality and dynamic reflections with which Lenin characterised the knowledge conveyed in art, unearthing the intimate truth of objective processes by means of specific aesthetic languages.

In this way, art was finally freed from both didacticism and mimesis and hailed as a way of increasing understanding about the objective world, by uniquely utilising aesthetic forms to interrogate reality.

Ministry of Culture (1976–)

Fornet recounts that never has such a sigh of relief been heard in Cuba as that which accompanied the television broadcast, on the afternoon of 30 November 1976, announcing the creation of a Ministry of Culture to replace the CNC, with Armando Hart as Minister (and Alfredo Guevara as his deputy). For Fornet, Hart's appointment categorically ended the *quinquenio gris*, and the country's relief was due in no small part to the fact that, 'Old or young, militant or non-militant, he did not ask if one liked [...] the Beatles, if one

better appreciated realist or abstract painting, if one preferred strawberry to chocolate or vice versa; he asked only if one was disposed to work'.[91] In other words, compared to his forebears, Hart judged artists and writers less according to whether they had followed an impeccable revolutionary trajectory or possessed great intellectual merits and more according to whether they were committed artists.

In the first full year of MINCULT operation, Hart outlined the task ahead. For him, the first thing that needed to be stated was that, while art and literature were forms through which culture was expressed, culture was much fuller and more profound than that which art and literature expressed. In order for art and literature to develop, the essence of this problem needed to be understood – in other words, the phenomenon of culture and its social content needed to be analysed; in the Cuban case, this entailed an analysis of its popular roots. Craven cites Hart's dual assertion – 'To confuse art and politics is a political mistake. To separate art and politics is another mistake'[92] – to observe that:

> Both positions reaffirm a dialectical approach to art by disallowing the mechanical reduction of art to the old dichotomy that counterposes political or ideological content with aesthetic form. Such a binary view, which implies that art is a passive reproduction or reflection of the 'correct' position, quite naively overlooks the way a visual language actively shapes, forms and even transforms the ideological values and political position it transmits, as part of a dynamic interchange among these interrelated parts.[93]

The inception of the ministry marked an opening in the cultural field that was certainly well received. At the beginning of 1977, Hart had a meeting with members of UNEAC at which he reassured his audience that, 'when government officials with responsibilities in the cultural area misunderstand their mission and feel justified in interfering with the artists' creative work, they lose prestige and influence and become unable to fulfill their duties'.[94] As an antidote to that which had gone before, Hart advocated a 'cultured' politics – which involved communication across society, democratic dialogue, self-reflection and self-analysis – a form of thinking that was not only revolutionary but also autonomous, critical and organic.

When asked, in 1989, in an interview for *Bohemia*, whether the Cuban Revolution had been subject to errors of dogmatism or liberalism in the cultural sphere, Hart was keen to distinguish between generalised errors of this kind, which could not be said to exist within Cuban cultural policy, and those specific instances of dogmatism, which had crept in to create an abyss between intellectual sectors and socialist thinking. While acknowledging the setbacks, pain and sorrow caused during the earlier era, he simultaneously

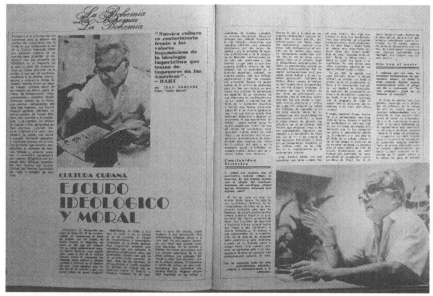

Armando Hart interviewed in *Bohemia* in 1989.

asserted that none of the strategists responsible for these negative tendencies had the influence necessary to cloud the broader cultural work of the Revolution.[95] Seeking an end to institutionalised intolerance, Hart inaugurated a network of organisations better able to cope with the demands of the mid-1970s, some of which were discussed in chapter two. It has been observed that 'Just a few years later [...] these new state structures began to assimilate the need for a more profound change of policy. This was not the result of a new interpretation of the cultural phenomenon per se. Rather, it was demanded by artists themselves, who expressed their feelings clearly in their work'.[96] Hart also encouraged cultural communities to look beyond Cuba for their inspiration, and he participated in the restoration of creative intellectuals who had been persecuted over the preceding years.

Until 1976, the revolutionary government had worked with an amended version of the 1940 Constitution, which stated that 'culture in all of its manifestations constitutes a fundamental interest of the State. Scientific research, artistic expression, and the publication of their results, as well as education, are free, in this regard, without prejudice, from inspection and regulation by the State, as established by law'.[97] The 1976 reorganisation which gave rise to MINCULT coincided with a redrafting of the Constitution which substantially decentralised decision-making and was accepted by the people in a referendum. In the process, a specific article on education and culture was added, containing a clause echoing 'Words to the Intellectuals' which stated that

'artistic creation is free so long as its content is not contrary to the Revolution. Forms of expression in art are free'.[98]

During the second half of the 1970s, cultural policy was more clearly defined in relation to revolutionary aims and the perceived needs of artists and the people. From the vantage point of the late-1980s, Hart would describe the essence of Cuban cultural policy being 'that which is able to develop the fullest freedom in the artistic field, founded on the development of the highest patriotic and revolutionary consciousness and the most elevated political sensibility'.[99] In 1996, just before his resignation, he would reminisce that his ministry had assumed 'responsibility for applying the principles enunciated by Fidel in "Words to the Intellectuals" and for radically banishing the weaknesses and errors which had arisen in the instrumentalisation of that policy'.[100] This would continue to be achieved, he argued, by fostering national culture and by articulating socialist thinking appropriate to the times.

We have seen how, during the *quinquenio gris*, anti-intellectual ideas undermined the role of artists and writers. When the country emerged from the grey years, these tensions did not disappear immediately, and Guevara has reflected on a period in which archetypal, interchangeable functionaries transmitted decisions from the ministry and coordinated activities according to predetermined norms and adopted formulae.[101] Ultimately, Fornet claims that conflicts of opinion were left to flourish, with relations transmuting into mutual respect and an authentic interest in the development of a shared culture. In this way, the atmosphere sought by film-makers in 1963 – allowing multifarious intellectual currents and aesthetic tendencies to thrive alongside each other – would seem to have been achieved.

Remarks in Conclusion

When detailed consideration is given to the factors which brought about the narrowing of creative possibility during this phase of Cuban cultural development, a certain amount of confusion is evident. In the first place, there are anomalies in relation to the timing and broader geopolitical shifts. The time-frame of the grey period is typically taken to encompass the years between 1971 and 1976. But as we have seen, the situation for creative practitioners worsened during the second half of 1968, exacerbated by the international fallout which accompanied Cuba's conditional support of the Soviet invasion of Czechoslovakia in August and compounded by the first phase of the Padilla case in October of the same year. Taking the trajectory outlined in this chapter together with earlier trends, it would seem that the perceived restoration of relations with Moscow emboldened orthodox positions at home.

Jorge Fornet reminds his readers of the curtailed protests in Europe in May 1968 to note that this period emphasised the contrast between rebellion and revolution and exposed European limits in this regard.[102] At the same

time, we have consistently seen that imperialistic attacks upon Cuba and Latin America were stepped up during this era as the clash of civilisations moved from the battlefield to the ideological field. Fuelled by the genuine possibility of a continent-wide revolution, the US launched insidious campaigns aimed at undermining the revolutionary intellectual consensus. In this regard, we find that the autumn of 1968 coincided with a concerted effort on behalf of the CIA-funded journal *Mundo Nuevo* to inflame conflicts around the judging process of that year's UNEAC prize, which had seen Padilla being honoured for his politically ambiguous poetry. At the same time, various critiques of the Revolution began to appear in Europe, providing justification for distanced intellectuals while hardening the governmental response.

In the midst of internal and external tensions, Cuba's creative intellectuals attempted to make sense of their situation, and the round-table discussion involving six of the *Casa* collaborative committees in May 1969 would prove pivotal in this regard. This provided an opportunity to elaborate upon many of the ideas that had been outlined at the 1968 congress and would endure into the 1970s. We have seen that, at the moment of insurrection, the intellectual vanguard had lagged behind its political counterpart. The impatience of the latter with the former had been made palpable by Che Guevara in 1965, and the parties to the 1969 discussion openly admitted their deficiencies in this regard. The cultural congress which had taken place in a climate of international optimism fifteen months earlier had valorised men of action at the same time as it had probed the possibility of intellectuals playing a necessarily creative and critical part in the building of socialism. By the time of the *Casa* round-table, there was less of a sense that intellectual work had any intrinsic revolutionary value, and those assembled argued for their ancillary activities – as voluntary workers, militia men and international cultural ambassadors – to be taken into account when calculating their worth. Yet, while their ideological influence was deliberately undermined, their loyalty to the Revolution meant that the majority of artists and writers would continue to be considered revolutionary by all but the most orthodox forces.

Throughout the deliberations of May 1969, the critical function was upheld on the part of those Latin American intellectuals embedded in revolutionary processes and aiding the transformation of society. At the same time, we have seen that liberal writers at home and abroad asserted a more distanced, 'ideal critical' role. Prominent among them was Mario Vargas Llosa, who took the lead in authoring the second letter to Fidel, going on to align himself with the Cuban émigré community in Europe. In response to the threat posed by the first letter to Fidel, the 1971 educational congress had its remit extended to include culture, providing a platform from which to refute the presumption that a minority of bourgeois pseudo-intellectuals had the right to act as the critical conscience of revolutionary processes. As a

counter-measure, it was reasserted that the critical role should be embraced by all the people of Cuba, with intellectuals among them.

In dismissing the coterie of traditional intellectuals which had judged the Revolution from without, Fidel embraced writers and artists formed within revolutionary society as those most capable of judging that society. In this, he succinctly prioritised the creation of organic intellectuals, which had been an abiding preoccupation since 1953. And, while we have seen that this created problems for intellectuals formed before the Revolution – men of transition who, it was expected, would be replaced by new revolutionary generations – care must be taken to distinguish Fidel's words from the restrictive ways in which they were interpreted by cultural bureaucrats.

To dwell for a moment longer on the emanations of the 1971 congress before considering the fallout that ensued, it is pertinent to note that Nicola Miller denigrates the congress declaration as 'one of the most restrictive government statements on culture (declaring that aesthetic values could not be separated out from ideological content)'.[103] In chapter five, we saw that aesthetic form had been inextricably linked to the content of artworks by all parties to the debate that took place in 1963–4. The departure suggested by Miller is that this content was required to be underwritten by ideological concerns. It is certainly the case that the ideological training of young artists formed one of the starting points for the 1971 congress, to be distorted by orthodox forces in its wake. It is also true that, within the perpetual war with imperialism, the notion of art as an arm of the Revolution was given renewed emphasis in 1971. But, the notion of artists and writers as carriers of ideology had been discussed throughout the 1960s. In considering the specific nature of the ideology that was expected to inform aesthetic production, we find that the 1971 congress emphasised the links between culture and the humanist aims of the Revolution. The primacy given to creative works according to their contribution to human happiness creates several continuities between Fidel's speech to the 1971 congress – which ambivalent commentators prefer to pass off as an oppressive novelty – and those of the decade preceding it. It also seems relevant to reiterate here that attempts to deny the link between art and ideology are symptomatic of a particular perspective in the capitalist world, which became especially heightened during the postmodern era.

Charting broader Cuban policy in the late 1960s, Karol finds that the revolutionary government opted for greater militarisation during this period. That the army magazine, *Verde Olivo*, was permitted to lead debate in the cultural field from late 1968 adds validity to this impression. That an outspoken FAR officer and former editor of *Verde Olivo* became President of the CNC also speaks volumes, and we have witnessed the devastating impact of this appointment. During the early 1970s, in a bastardisation of Che's metaphor of growing new pear trees, the idea of placing cultural power in the hands

of young, 'uncontaminated' artists was actively pursued. A focus was placed on the indoctrination of youth brigades, with the CNC coordinating creative retreats to the sites of military victories. In parallel with this, the training of arts instructors was delegated to FAR, and instructors and their *aficionado* protégés were revered as a new (and, by implication, non-professional) vanguard. By 1972, in an unprecedented departure, the prescription of socio-economic themes had explicitly entered into CNC policy documents pertaining to amateur creative work. Fractured internally and stifled by the repressive climate, the intellectual communities of Latin America failed to respond to the new cultural policy that asserted itself, and Jorge Fornet retrospectively observes that the most acute victim of this lapse was the growth of Cuban culture itself.[104]

According to Karol's account, the Soviet synergies of the late 1960s completely superseded the anti-imperialist project, but it would seem that the Revolution's aversion to US-derived tactics in Latin America was reinforced in 1971 in a way that Karol could not have foreseen when his book was published the previous year. While the anti-imperialist campaign may have been largely postponed in the military arena,[105] it was approached with new vigour in the cultural field. This provided creative intellectuals with a vital vanguard role in the region, exemplified by the Meetings of Latin American Plastic Artists, hosted by Casa de las Américas between 1972 and 1979, which coherently probed the potential of art as an arm of the Revolution. In a more concerted effort than had been made before or attempted since, the participants to these meetings called upon their continental colleagues to join their ranks in furthering the recovery of national sovereignty. In practical terms, revolutionary artists assembled in Havana to open up new Latin American and Caribbean avenues for information-sharing and coordination while devising and deploying cultural antibodies to imperialism. Preventing the focus of their mission from being sidetracked into aestheticism, the participants to these encounters did a great deal to establish the revolutionary function of artists in a bold interpretation of the 1968 congress resolutions.

As we have seen, the trigger for the island's emergence from the grey years was the first PCC congress at the end of 1975. This recognised the inherent power and uniqueness of creative practice and acknowledged that the work undertaken by writers and artists contributed valuable support to the construction of socialism. Representing a significant departure from instrumental understandings of culture, this understood the aesthetic encounter to be an educative experience essential to the formation and transformation of humanity. Thus, the PCC congress simultaneously, and definitively, put an end to the advocacy of 'educative' art, and exempted art from the need to represent objective reality in a naturalistic way. In this way, in the middle of the 1970s, art was explicitly freed from the dual expectations of didacticism

and mimesis and hailed as a way of increasing understanding of the world through the most appropriate formal means. Yet, while this ethos was perpetuated by the Ministry of Culture (fully operational from 1977), it would take several more years before trust between creative intellectuals and state agencies was rebuilt.

In 1977, as critique crept back into the intellectual domain, Haydée would claim on behalf of Casa de las Américas that 'one of our characteristics is that we do not fear controversy. After all, controversy serves to measure our strengths'.[106] In 2001, Desiderio Navarro asserted that the success of post-Soviet socialism would depend upon whether theory and practice could uphold the critical adhesion of intellectuals to the Revolution, whether it would be capable of publicly responding to social critique and whether it could not only tolerate but also propagate such critique according to the principles, ideals and values it claimed as its own.[107] Analysing the role of civil society in building Cuban socialism and culture two years later, Rafael Hernández concluded that Cuban intellectuals are both critical and politically committed, prizing their critical function in a way which is consistent with the values of revolutionary political culture. Considering the role of intellectuals in criticising the Revolution, he argued that, although 'intellectuals are not seen as the privileged depository of the social function of critical consciousness, still culture does constitute a fundamental space for the critical discussion of national problems'.[108] In this, Casa de las Américas, ICAIC, the rejuvenated UNEAC and many alternative spaces continue to provide a vital forum for such discussions.

NOTES

1 Fidel Castro Ruz, 'Comments on Czechoslovak Crisis', Havana Domestic Television and Radio Services, 23 August 1968, available at Lanic.utexas.edu/project/castro/db/1968/19680824.html
2 Ambrosio Fornet, 'El Quinquenio Gris: Revisitando el Término' [The Five Grey Years: Revisiting the Term], *Narrar la Nación: Ensayos en Blanco y Negro* [Narrating the Nation: Essays in White and Black] (Havana: Editorial Letras Cubanas, 2009 [2007]), p. 393.
3 Carlos Rafael Rodríguez, 'Cuba: Ejemplo de América; Informe de la Delegación de Cuba al Congreso de la CEPAL, Intervención del Presidente y Conferencia con la Prensa Mundial', Press Conference presented at the CEPAL, Lima, 17 April, 1969, p. 112.
4 This view was referred to in Mario Benedetti, 'Sobre las Relaciones entre el Hombre de Acción y el Intelectual' [On the Relations between the Man of Action and the Intellectual], *Revolución y Cultura*, no. 4, 15 February 1968.
5 This phrase formed the title of an article by Lisandro Otero, published on the same day as the first of Ávila's articles, and reused decades later, as reported in Jorge Fornet, *El 71: Anatomía de una Crisis* [In '71: Anatomy of a Crisis] (Havana: Editorial Letras Cubanas, 2013).
6 Roque Dalton et al., 'Diez Años de Revolución: El Intelectual y la Sociedad' [Ten Years of Revolution: The Intellectual and Society], *Casa de las Américas*, 10, no. 56, Sept–Oct 1969.
7 Fornet, *El 71*, p. 131.

8 Dalton et al., p. 20.

9 Ibid., p. 17.

10 Claudia Gilman, *Entre la Pluma y el Fusil: Debates y Dilemas del Escritor Revolucionario en América Latina* [Between the Quill and the Rifle: Debates and Dilemmas of the Revolutionary Writer in Latin America] (Buenos Aires: Siglo Veintiuno, 2003).

11 Dalton et al., 'Diez Años de Revolución', p. 18.

12 Ibid., p. 19.

13 A full account of this development – including the preceding arrests of two Francophiles thought to be assisting Padilla to export his manuscripts, as part of a deliberate campaign of confrontation being orchestrated in Europe – is given in Fornet, *El 71*.

14 Discussed in ibid.

15 Originally published in *Le Monde*, 10 April 1971; republished in *The New York Review of Books*, 6 May 1971.

16 Roberto Fernández Retamar, 'Caliban Revisited', *Caliban and Other Essays* (Minneapolis: University of Minnesota Press, 1989 [1986]), p. 50.

17 Fornet, *El 71*.

18 Fidel Castro Ruz, Speech to Commemorate the Bay of Pigs Anniversary, 19 April 1971, available at: Lanic.utexas.edu/project/castro/db/1971/19710420.html

19 Fornet, *El 71*, p. 169; italics in original.

20 A partial transcript of this speech (missing the preamble) is available in Spanish at: Marionoya.com/2011/03/29/padilla-ante-la-union-de-escritores-y-artistas-de-cuba-27-de-abril-de-1971/

21 Fornet, 'El Quinquenio Gris'.

22 Cited in Fornet, *El 71*.

23 Roberto Fernández Retamar, 'The Enormity of Cuba', *Boundary* 2, 23, no. 3, Autumn 1996, p. 180.

24 The account given in this paragraph is taken from Sandra del Valle, 'Cine y Revolución: La Política Cultural del ICAIC en los Sesenta' [The Cultural Policy of ICAIC in the Sixties], *Perfiles de la Cultura Cubana*, May–December 2002.

25 The final congress declaration was reproduced in *Granma* on 1 May 1971; the resolutions pertaining to culture are found on page 4.

26 An unpaginated, hard-backed congress publication, which was published retrospectively, gives a flavour of the collective event rather than reproducing any individual submissions or declarations. See Instituto Cubano del Libro, *Cuba '71: I Congreso Nacional de Educación y Cultura* [First Congress on Education and Culture] (Havana: Instituto Cubano del Libro/Editorial Ámbito, 1971).

27 Comité Central del Partido Comunista de Cuba (PCC), *Tesis y Resoluciones Primer Congreso del Partido Comunista de Cuba* [Thesis and Resolutions of the First Congress of the PCC] (Havana: Comité Central del PCC, 1976), p. 491.

28 Anon., 'El Congreso de Cultura' [The Cultural Congress], *Granma*, 1 May 1971, p. 4.

29 Nicola Miller, *In the Shadow of the State: Intellectuals and the Quest for National Identity in Twentieth-Century Spanish America* (London and New York: Verso, 1999).

30 Anon., 'El Congreso de Cultura' [The Cultural Congress], *Granma*, 1 May 1971, p. 4.

31 Instituto Cubano del Libro, *Cuba '71*, unpaginated.

32 Unión de Escritores y Artistas de Cuba (UNEAC), J.A. Baragaño (ed.), *Memorias del Primer Congreso Nacional de Escritores y Artistas de Cuba* [Proceedings of the National Congress of Writers and Artists of Cuba] (Havana: Ediciones UNIÓN, 1961), p. 67.

33 Lourdes Casal, 'Literature and Society', *Revolutionary Change in Cuba* (Pittsburgh, PA: University of Pittsburgh Press, 1971), p. 462.

34 'Este Congreso Ha Sido el Desarollo Conseguente de una Linea de Masas en la Educacion' [This Congress Has Been the Consistent Development of a Line of Mass Education], *Juventud Rebelde*, 2 May 1971.

35 Instituto Cubano del Libro, *Cuba '71*, unpaginated.

36 Georgina Dopico Black, 'The Limits of Expression: Intellectual Freedom in Postrevolutionary Cuba', *Cuban Studies*, 19, 1989, p. 112.

37 Roberto Fernández Retamar, 'Caliban', *Caliban and Other Essays* (Minneapolis: University of Minnesota Press, 1989 [1971]), p. 40.

38 Ibid.

39 Lee Lockwood, *Castro's Cuba, Cuba's Fidel: An American Journalist's Inside Look at Today's Cuba in Text and Pictures* (Boulder, CO: Westview Press, 1990 [1967]), p. 112.

40 Joaquín G. Santana, *Política Cultural de la Revolución Cubana: Documentos* [Cultural Policy of the Cuban Revolution: Documents] (Havana: Editorial de Ciencias Sociales, 1977).

41 Ministerio de Relaciones Exteriores (MINREX), 'Suplemento/Sumario: La Funcion Cultural-Educacional del Estado Socialista Cubano' [Supplement: The Cultural-Educational Function of the Cuban Socialist State] (Havana: Dirección de Prensa, Información y Relaciones Culturales [Press, Information and Cultural Relations Directorate], 1976), p. 17.

42 Fornet, *El 71*, p. 175.

43 Ibid.

44 Fernández Retamar, 'Caliban Revisited', pp. 51–2.

45 Miller, *In the Shadow of the State*.

46 This account is taken from Fornet, 2013, *El 71*, with the specific quotation appearing on p. 254.

47 Fernández Retamar, 'Caliban Revisited', p. 53.

48 Fornet, 'El Quinquenio Gris', p. 393.

49 Graziella Pogolotti, interview with the author, Havana, 9 March 2010.

50 Judith A. Weiss, *Casa de las Américas: An Intellectual Review in the Cuban Revolution* (Chapel Hill, NC: Estudios de Hispanófila, 1977), p. 31.

51 Ibid.

52 See chapter one for a brief discussion of why this term has been considered inadequate to the severity of reprisals and the extended period over which they were endured.

53 This account is given in Fornet, *El 71*, with the specific quotation appearing on p. 178.

54 Antoni Kapcia, *Havana: The Making of Cuban Culture* (Oxford and New York: Berg, 2005), pp. 122–3.

55 ICAIC, 'Declaración de los Cineastas Cubanos', *Cine Cubano*, 11, no. 69–70, May–July 1971.

56 Fornet, *El 71*, p. 144.

57 Cited in Fornet, *El 71*, pp. 144–5, together with the examples of Gutiérrez Alea's feature-length *Una Pelea Cubana Contra los Demonios* [A Cuban Fight Against Demons] from 1972 and Nicolás Guillén Landrián's 1971 documentary, *Taller de Línea y 18* [Workshop at the Corner of Taller and Línea (two Havana streets)]. This account also mentions the fact that, in September 1997, Gutiérrez Alea wrote to Guevara again, indicating that his earlier letter had been intended as the start of a conversation, based on friendship, and he had been saddened not to receive a reply.

58 See Del Valle, 'Cine y Revolución'.

59 Gerardo Mosquera, Antonio Eligio Fernández and Marilyn Zeitlin (eds.), *Contemporary Art from Cuba: Irony and Survival on the Utopian Island* (New York: Delano Greenidge Editions, 1999), p. 24.

60 Linda S. Howe, *Transgression and Conformity: Cuban Writers and Artists After the Revolution* (Madison: University of Wisconsin Press, 2004), p. 16.

61 Ibid., pp. 16–17.

62 Ibid., pp. 16–18.

63 Dopico Black, 'The Limits of Expression', p. 107.

64 Ibid., p. 109.

65 Antonio Benítez-Rojo, 'Comments on Dopico Black's "The Limits of Expression: Intellectual Freedom in Postrevolutionary Cuba"', *Cuban Studies*, no. 20, 1990, pp. 171–2.
66 Lisandro Otero, *Llover sobre Mojado: Una Reflexión Personal sobre la Historia* [To Rain on the Wet: A Personal Reflection on History] (Havana: Editorial Letras Cubanas, 1997).
67 Eduardo Heras León, 'El Quinquenio Gris: Testimonio de una Lealtad' [The Five Grey Years: Testimony to Loyalty], read by the author at ISA in relation to the cycle of events entitled 'La Política Cultural del Periodo Revolucionario: Memoria y Reflexión' [The Cultural Policy of the Revolutionary Period: Memory and Reflection], 15 May 2007, p. 15.
68 Desiderio Navarro, 'La Política Cultural del Periodo Revolucionario: Memoria y Reflexión' [Introduction to the Series 'The Cultural Policy of the Revolutionary Period: Memory and Reflection'], 30 January 2007.
69 Fornet, 'El Quinquenio Gris', pp. 379–80.
70 Ibid., p. 395.
71 Ibid.
72 Letter from Desiderio Navarro, sent as part of the 2007 polemic.
73 Fornet, 'El Quinquenio Gris', p. 398.
74 Consejo Nacional de Cultura, *Directiva no. 1 del Consejo Nacional de Cultura para el Desarrollo del Trabajo en 1975: Orientaciones Políticas Fundamentales para el Trabajo* [Directive No. 1 of the National Council of Culture for the Development of Work in 1975: Fundamental Political Orientations for Work] (Havana: Consejo Nacional de Cultura, 1975).
75 Pogolotti, interview with the author.
76 Jaime Sarusky, 'From the 200th, with Love, in a Leopard: Interview with Roberto Fernández Retamar', *The Black Scholar*, Autumn 2005 [1995], p. 40.
77 Fornet, 'El Quinquenio Gris', p. 401.
78 Lockwood, *Castro's Cuba, Cuba's Fidel*, p. 112.
79 Mirta Aguirre, 'Apuntes sobre la Literatura y el Arte' [Notes on Literature and Art], *Cuba Socialista* III, no. 26, October 1963.
80 Carlos Rafael Rodríguez, 'Problemas del Arte en la Revolución' [Problems of Art in the Revolution], *Revolución: Letras Artes* (Havana: Letras Cubanas, 1980 [1967]), p. 82.
81 Gerardo Mosquera, 'The Infinite Island: Introduction to New Cuban Art', G. Mosquera, A. Eligio Fernández and M. Zeitlin (eds.), *Contemporary Art from Cuba* (Arizona and New York: Arizona State University and Delano Greenidge Editions, 1999), p. 28.
82 Mosquera, Eligio Fernández and Zeitlin, *Contemporary Art from Cuba*, p. 40.
83 Adelaida de Juan, interview with the author, Havana, 3 March 2010.
84 Fidel Castro, introduction to 1968 edition of Che Guevara's Bolivian diaries, *Che: A Memoir by Fidel Castro* (Melbourne: Ocean Press, 1994), p. 93.
85 Fernández Retamar, 'Caliban', p. 41.
86 Fornet, *El 71*.
87 Adelaida de Juan, Eugenio Darnet, Julio Le Parc, Carlos Granada and José Balmes, 'Puntos de Vista' [Points of View], *Cuba Internacional*, August 1972.
88 'Encuentro de Plástica Latinoamericana' [Meeting of Latin American Plastic Artists], *Boletín de la Comisión Nacional de la UNESCO*, 13, no. 99, February 1974.
89 'Realizará la Casa de las Américas el Encuentro de Plástica Latinoamericana y del Caribe 1979' [1979 Meeting of Latin American and Caribbean Plastic Artists Will Be Realised at Casa de las Américas], Press Release (Havana, undated).
90 Unless otherwise stated, all references in this section are taken from Comité Central del PCC, *Tesis y Resoluciones Primer Congreso del Partido Comunista de Cuba*.
91 Fornet, 'El Quinquenio Gris', p. 401.
92 David Craven, *Art and Revolution in Latin America 1910–1990* (New Haven, CT, and London: Yale University Press, 2002), p. 107.
93 Ibid.

94 Cited in Luis Camnitzer, *New Art of Cuba* (Austin: University of Texas Press, 1994), p. 128.

95 Juan Sanchez, 'Interview with Armando Hart Dávalos', *Bohemia*, 20 October 1989.

96 Leonardo Padura Fuentes, 'Living and Creating in Cuba: Risks and Challenges', J.M. Kirk and L. Padura Fuentes (eds.), *Culture and the Cuban Revolution: Conversations in Havana* (Gainesville: University Press of Florida, 2001), p. 179.

97 José Bell, Delia Luisa López and Tania Caram, *Documentos de la Revolución Cubana 1959* [Documents of the 1959 Cuban Revolution] (Havana: Editorial de Ciencias Sociales, 2008), p. 55. The 1940 Constitution was itself a legacy of the 1933 Cuban Revolution.

98 Departamento de Orientación Revolucionaria del Comité Central del Partido Comunista Cubano, 'Constitución de la República de Cuba' [Constitution of the Republic of Cuba], 1976, clause 39d.

99 Sanchez, 'Interview with Armando Hart Dávalos', p. 8.

100 Cited in Roberto Fernández Retamar, 'A Cuarenta Años de "Palabras a los Intelectuales"' [To Forty Years of 'Words to the Intellectuals'], *Cuba Defendida* [Cuba Defended] (Havana: Editorial Letras Cubanas, 2004 [2001]), p. 304.

101 Alfredo Guevara, *Tiempos de Fundación* (Madrid: Iberoautor Promociones Culturales, 2003).

102 Fornet, *El 71*.

103 Nicola Miller, 'A Revolutionary Modernity: The Cultural Policy of the Cuban Revolution', *Journal of Latin American Studies*, 40, Special Issue 04 (Cuba: 50 Years of Revolution), 2008, p. 687.

104 Fornet, *El 71*.

105 It is noteworthy that 'for most of the 1960s, Cuba became the place where scores of guerrilla groups from throughout the region were trained, funded and armed, all following [Che] Guevara's ideas', the longer-term outcomes of which were that 'not only did many such groups survive, to recover and emerge more successfully (for example the Nicaraguan Sandinistas) or more visibly (in Central America, Colombia and Peru) in the 1970s and 1980s, but also a generation of new leftists were created'. Antoni Kapcia, *Leadership in the Cuban Revolution: The Unseen Story* (London: Zed Books, 2014), pp. 120 and 121.

106 Haydée Santamaría and Jaime Sarusky, 'Casa Is Our America, Our Culture, Our Revolution', B. Maclean (ed.), *Haydée Santamaría* (Sydney: Ocean Press, 2003), p. 61.

107 Desiderio Navarro, 'In Medias Res Publicas' [In the Midst of the Public Sphere], *La Gaceta de Cuba*, no. 3, June 2001, pp. 40–5.

108 Rafael Hernández, *Looking at Cuba: Essays on Culture and Civil Society* (Gainesville: University Press of Florida, 2003), p. 45.

Towards a Marxist-Humanist Cultural Policy

This book began with the hope that the Cuban Revolution enabled the subsidy, production and distribution of culture to be rethought from first principles, providing us with much-needed clues about interactions between culture, state and society which differ substantially from those developed under capitalism. In exploring this proposition, it was first necessary to anticipate, and interrogate, claims that the infrastructure of museums, galleries and cinemas was fit for purpose before the Revolution. It quickly became clear that the scant, and often dilapidated, network of cultural organisations which existed prior to 1959 was beholden to the country's entrepreneurial elite and that the decision to undertake creative work was a risky business that was only tenable through self-financing from other sources. At the same time, as in other areas of social life, there was a persistent division between urban and rural parts of the island (which saw resources concentrated in Havana), and a huge gulf between the cultural access available to a wealthy minority and that which was provided for the rest of the population.

Against this backdrop, a high level of cultural consciousness existed among those who planned and led the insurrection, but it must be restated that no militant artists or writers were among them. Instead, discussions about ways in which the island's cultural situation could be improved were taking place within Nuestro Tiempo – the cultural society born of frustrations around the disconnection between art and the people. Two years into the life of the society, the 1953 assault on the army barracks at Moncada and Bayamo prompted the Popular Socialist Party (PSP) – which would continue to eschew armed struggle for another five years – to heighten its activities in the cultural arena. One of the ways in which the party attempted this was by assuming responsibility for the political orientation of Nuestro Tiempo – a move that was embraced by the majority of its members at the time – providing a cultural platform from which a diverse collection of intellectuals could

consolidate their dissent in the face of dictatorship while articulating their support for the Revolution.

It is to the precedent of Nuestro Tiempo that we must look when seeking to understand why, in January 1961 (three months before the socialist orientation of Revolution was made explicit), the PSP was given responsibility for implementing the cultural policy of the revolutionary government, via the National Council of Culture (CNC). As the only group within the incipient triumvirate of Integrated Revolutionary Organisations to have considered cultural policy before the Revolution, the PSP would have seemed the logical choice. At the same time, we have seen how the failure of the party to dissolve its Commission for Intellectual Work created tensions that would thwart the CNC throughout its existence, compounded by the orthodox views of its leadership and exacerbated whenever Cuban-Soviet relations were strengthened.

It is with a sense of weary inevitability that we reflect upon the dispute which simmered between the two factions identified by Ambrosio Fornet as dogmatists and liberals. We have seen that, although the declaration of the socialist character of the Revolution was little more than a formality – consolidating extant social and anti-imperialist aims – it raised urgent questions about the nature of creative practice that would be permissible in Cuba thenceforward. Cognisant of both the Stalinist roots of the PSP and the catastrophe that had befallen culture in the Soviet Union, liberal cultural protagonists – particularly the group around *Lunes de Revolución*, which was heavily invested in European avant-garde ideas and Sartre's conception of the 'committed intellectual' – attempted to defend freedom of expression at all costs.

We have also seen that concerns about the PSP takeover of culture were not unfounded. Studied in microcosm, the tussle between CNC *sarampionados* and artists, writers and film-makers, which took place throughout the 1960s, provides some useful insights into orthodox interpretations of Marxism in relation to cultural production. Revisiting Mirta Aguirre's treatise on realism, we find that a fundamental conflict centred on whether or not diverse aesthetic forms should be permitted to coexist in the new society. With the benefit of fifty years of hindsight, CNC attempts to render formalist art synonymous with idealist philosophy – as a prelude to the abolition of both – may be regarded as reductive and undialectical. As relations between practitioners and functionaries reached their nadir, the very notion of cultural policy became discredited as a bureaucratic interpretation of governmental attitudes towards culture.

While CNC spokespeople insisted that forms of expression had an inherent class character, a consensus emerged among cultural practitioners that it was they (rather than their artefacts) who were the bearers of ideology. This implied that account must be taken of the social relations surrounding

creative production, and one has only to compare the Pop collages of Raúl Martínez with those of Andy Warhol to see that this is the case. Posing a viable alternative to the mimetic and didactic forms that were increasingly expected of them, Cuba's artists and writers were able to prove beyond doubt that socialist realism was far from being the only aesthetic mode applicable to a revolutionary situation. That the revolutionary government consistently made provision for the full range of creative expression to be pursued represents an artistic and ideological triumph which should not be underestimated.

Those who had fought alongside Fidel would be given pivotal roles once the Revolution triumphed, and we have seen how Che Guevara and Camilo Cienfuegos went on to occupy influential positions, providing the early impetus for the educational and cultural strategies that were pursued. Similarly, the inextricability of Haydée Santamaría with Moncada and of Armando Hart with the Sierra Maestra secured them posts in revolutionary society which would have a significant impact on the cultural field and provide a defence against the most strident instances of dogmatism. Although the CNC would take Casa de las Américas into its jurisdiction and report to the government on the activities of the Cuban Institute of Cinematographic Arts and Industries (ICAIC), it is pertinent that these two pioneering institutions came into being within a few months of revolutionary victory (well before the CNC assumed control of culture). Equally important is the fact that their leadership was assumed by loyal 26 July Movement figures, which would protect both the institutions and the practitioners associated with them during the darkest days of the grey years.

By contrast, it is necessary to mention the conflicts experienced by those among the intelligentsia who felt themselves to have been bystanders to the insurrection. We have seen how Roberto Fernández Retamar and Lisandro Otero took part in covert activity from the relative safety of Havana, which, for the latter at least, created a hangover of recrimination that could never be completely shed. The experience of Cuba demonstrates that all creative intellectuals with a concern for social justice have an active part to play before, during and after revolutionary transformation.

During the heady period of social reconstruction which followed the recovery of national sovereignty in January 1959, the windows of the imagination were thrown open and the impossible became possible. Every novel, film and painting capable of affecting consciousness was charged with political significance, compelling creative practitioners to familiarise themselves with rapidly changing reality. Yet we have seen that varying reaction times between the political and intellectual vanguards provoked frustrations on both sides, reaching a moment of accommodation at the Cultural Congress of Havana in 1968. As roles were more clearly defined and aligned, intellectual work was framed as the ideological corollary to armed struggle. Revolutionary artists

and writers were implicated in the creation of new social relations and posited as a crucial bridge between the political vanguard and the people.

Yet, despite repeated claims being made of mutual fertilisation between political and artistic vanguards, Rafael Hernández would assert, from the vantage point of the early twenty-first century, that an intellectual vanguard had not appeared in Cuba; while intellectuals legitimately participated in often heated ideological discussions, the political vanguard continued to set the terms of the debate in relation to history, imperialism, Latin Americanism and revolutionary culture.[1] This goes some way towards explaining Gerardo Mosquera's observation that artists and critics have 'obviously and fortunately' been excluded from the 'commemorative pantheon of the Revolution'.[2] Distinct reasons are cited for this abiding separation, with Carlos María Gutiérrez positing that the intelligentsia could not enter a political field reserved for the Revolution[3] and Nicola Miller arguing that Cuban intellectuals relinquished their vanguard role when they identified too closely with its political counterpart.[4] A third reason for political and artistic vanguards failing to cross-pollinate is to be found in the deliberate attempts by anti-intellectual currents to keep these two spheres apart. But, while orthodox efforts to prevent intellectuals from influencing the broader ideology of the Revolution appear to have been successful, the same may not be said when we consider the formulation of cultural policy.

During the years immediately before and after revolutionary triumph, the part played by the country's creative practitioners in developing forms of policy appropriate to their praxis is highly significant. We have seen, for example, that, under the auspices of Nuestro Tiempo, the film-maker Tomás Gutiérrez Alea outlined a programme for overhauling the indigenous film industry which provided a valuable template for the pioneering cinematic institute. We have also seen that the country's leading artists and writers converged, in October 1960, to align their work with the aims of the Revolution. The agenda developed at this meeting would find its way into the First National Congress of Writers and Artists in August 1961, in advance of the revolutionary government formalising its policy in the field, thus allowing creative practitioners to determine the parameters of future discussions. We have also witnessed the abiding influence of the former film-maker Alfredo Guevara at ICAIC and the poet Roberto Fernández Retamar at Casa de las Américas alongside the innumerable practitioners that were drawn to these and other institutions.

At the same time, we have seen that Cuban culture was never developed in isolation, both assimilating and informing international developments. Bypassing the regressive tendencies which flourished after the 1971 congress, plastic artists reinforced the continental remit of Casa de las Américas to explore the possible reconciliation of political and artistic vanguards beyond

Cuban shores. While developing new revolutionary aesthetics, the parties to the 1970s discussions transcended symbolism to foster new solidarities and stimulate communication and provocation across Latin America and the Caribbean, opening up a new front in the anti-imperialist struggle.

In interrogating the intellectual role more closely, we have seen how, in pre-revolutionary Cuba, artists and writers tended to assume a critical stance in response to tyranny and injustice. When the Revolution triumphed, creative practitioners were encouraged to set aside their dissent in favour of consent. Maintaining a critical stance, intellectuals understood that it would not be enough to identify past mistakes or question existing reality (first order negation). In accordance with Hegel's theory of absolute negativity, positive, emancipatory visions of the future were taken to rely on achieving a negation of negation. During the early period of this study, this implied a form of critique which exposed contradictions and errors in the revolutionary process, motivated by a desire to solve the problems identified. This was accompanied by an acknowledgement, on the part of the revolutionary government, of the continued need for intellectuals to undertake self-reflexive critique and to cultivate the critical abilities of the people. In this way, the dialectical nature of critique was embraced, in anticipation of a cultivated and educated people capable of forming opinions about a social reality in constant flux.

In the second half of the 1960s, the relatively passive conception of 'committed intellectual' was displaced by more proactive understandings. No longer limited to creative praxis and pedagogy, revolutionary intellectual activity came to imply full engagement in extra-intellectual work vital to society (from voluntary labour to armed combat) and to encompass international cultural diplomacy. And, while certain European and Latin American intellectuals upheld their claims to act as the critical conscience of society, it fell to Cuban artists and writers to adapt their understanding of critique to the Revolution, acknowledging the relative nature of freedom in the process. Regrettably, this paved the way for underhanded attempts to suppress intellectual criticality, orchestrated by orthodox forces, which became particularly vitriolic in the late 1960s and early 1970s.

Cuba does not posit herself as an exemplar, and history teaches us only what we are prepared to learn from it. For those so inclined, this study provides a snapshot of Marxist-humanist approaches to culture as they evolved in contradistinction to Soviet-derived methods. As we have seen, a humanistic reading of Marxism implies a philosophy of praxis directed towards human liberation and social transformation. In revolutionary Cuba, culture was quickly understood to be a vital ingredient in the process of emerging from centuries of colonial and neocolonial rule. This compelled the creation of a

cultured population as a necessary accompaniment to social and economic development. At the same time, aesthetics were identified as an essential dimension of human experience and a route to spiritual fulfilment.

In the introductory chapter, we saw that, in the capitalist world, it is erroneously claimed that 'The international art market is the sole mechanism for conferring value onto art'.[5] If the law of value is abolished – as was attempted in the Cuban cultural field between 1961 and 1976 – the terms of the debate are turned on their head. During this period, creative intellectuals were incited to take their work to the people in an open and dialogical way, with success evaluated according to their contribution to human happiness. As the capitalist world struggles to articulate the individual and social value of culture within increasingly iniquitous societies, the objectives underlying Cuban policy-making provide invaluable insights into more emancipatory understandings.

Marxist-humanist cultural policy, as it has been formulated in Cuba, is underwritten by the Gramscian conviction that those taking up mental labour may emerge from any sector of society. This democratising impulse entails that passive spectatorship of, and active engagement in, creative production are necessary to human fulfilment. In regard to spectatorship, culture was immediately conceived as the patrimony of an entire populace, with cultural works from previous eras acknowledged to provide glimpses of humanity's evolution, making them worthy of preservation.

During the early 1960s, requisitioned artworks and artefacts were catalogued and restored, exhibitions of Cuban and international artists toured around the island and a substantial interpretation programme was orchestrated which paralleled the literacy campaign. This way of working led to advocacy, within the CNC, of an 'educative' art with a didactic message. Intellectuals responded by attempting to promote the idea that art educates by heightening receptivity to the world around us – by encouraging us to think and feel, rather than dictating the content of those thoughts and feelings. In the process, the case was made for art as a unique form of knowledge about the world – embodying social reality, rather than reflecting it – which provided insights into the human condition in ways that could not be judged by the criteria of other disciplines. By the time of the first PCC congress in December 1975, the governing party fully subscribed to the understanding that aesthetic encounters were inherently educational, and revolutionary reality would inevitably communicate itself through the work of Cuba's cultural producers without the need for didacticism or mimesis.

Turning to the conversion of spectators into creators, we find that participation in artistic production has been actively encouraged in a bid to develop individual and social consciousness. This required a complete overhaul of the education system, the construction of new schools and the training of tens

of thousands of arts teachers, representing a political and economic commitment that remains unsurpassed in any other part of the world. The enormous effort required to educate the Cuban people to both appreciate and produce cultural forms cannot be underestimated, and President Osvaldo Dorticós is noteworthy for his consistent refusal to equate mass access to culture with vulgar and unchallenging artworks. At the same time, the *aficionados* programme continues to make artistic opportunities available to all those members of society wishing to take them up. In the process, the ambition to eradicate the gap between art and society – long ago abandoned by European and US avant-gardes – has been realised to a great extent in Cuba.

Notwithstanding the successes outlined above, the distinction between professional and amateur artists has been sustained, and questions remain about the extent to which massively increased access to education and culture has facilitated the emergence of organic intellectuals. While there is ample evidence that many professional artists have emerged from poor and/or rural backgrounds and that scope exists for the transition from amateur to professional ranks, there is an extent to which low expectations around quality in *aficionado* circles inhibit nascent artists from making this leap. One conclusion which may be drawn from this experiment is that, even when the technical elements of creativity are disseminated as fully as is practicable, there is a limit to the number of excellent (or original, to use Marx's phraseology) creative intellectuals that will emerge. However finite in number, Cuba's artists, writers and film-makers continue to produce work of breathtaking originality while undermining the elitism that defines culture under capitalism. If we can take a universal lesson from the Cuban Revolution, it is that removal of the profit motive from the cultural field in no way implies that the quality of creative work will suffer.

NOTES

1 Rafael Hernández, *Looking at Cuba: Essays on Culture and Civil Society* (Gainesville: University Press of Florida, 2003).

2 Gerardo Mosquera, 'The Infinite Island: Introduction to New Cuban Art', G. Mosquera, A. Eligio Fernández and M. Zeitlin (eds.), *Contemporary Art from Cuba: Irony and Survival on the Utopian Island* (New York: Delano Greenidge Editions, 1999), p. 27.

3 Roque Dalton et al., 'Diez Años de Revolución: El Intelectual y la Sociedad [Ten Years of Revolution: the Intellectual and Society]', *Casa de las Américas*, 10, no. 56, September–October 1969, pp. 7–48.

4 Nicola Miller, *In the Shadow of the State: Intellectuals and the Quest for National Identity in Twentieth-Century Spanish America* (London and New York: Verso, 1999).

5 Iain Robertson, *Understanding International Art Markets and Management* (London and New York: Routledge, 2005), p. 13.

Bibliography

26 July Movement. 'Sierra Maestra Manifesto', 12 July 1957. http://www.latinamericanstudies. org/cuban-rebels/manifesto.htm.

Abreu, Pedro. 'Inauguro Dorticós el Congreso Cultural de La Habana: Los pueblos Tienen Que Llevar a Cabo una Revolución para Salir del Subdesarrollo', *El Mundo*, 5 January 1968.

Acanda González, Jorge Luis. 'Introduction', *Looking at Cuba: Essays on Culture and Civil Society* (Gainesville: University Press of Florida, 2003).

Adorno, Theodor, and Max Horkheimer. 'Preface', *Dialectic of Enlightenment* (Stanford: Stanford University Press, 2002 [1944 and 1947]), pp. xiv-xix.

———, 'The Concept of Enlightenment', *Dialectic of Enlightenment*, (Stanford: Stanford University Press, 2002 [1944]), pp. 1-34.

———. 'The Culture Industry: Enlightenment as Mass Deception', *Dialectic of Enlightenment* (Stanford: Stanford University Press, 2002 [1944]), pp. 94-136.

AGA. 'Una Batalla por los Muros' [A Battle for the Walls], *Juventud Rebelde*, 29 May 1972.

———. 'Bloqueo Cultural a la Junta Fascista Aprueba Encuentro de Plástica Latinoamericana' [Meeting of Latin American Plastic Artists Approved Cultural Blockade of the Fascist Junta], *Juventud Rebelde*, 19 October 1973.

'Agasajados por el CNC Delegados al Encuentro de Plástica Latinoamericana' [Delegates of the Meeting of Latin American Plastic Artists Entertained by the CNC]. *Granma: Órgano Oficial del Comité Central del Partido Comunista de Cuba*. 27 May 1972.

Aguirre, Mirta. '¿Instituto Nacional... y de Cultura?' [National Institute... and of Culture?], *Cuadernos Marxistas* [Marxist Notebooks], 1, no. 1, July 1956, pp. x-xiv.

———. 'Apuntes sobre la Literatura y el Arte' [Notes on Literature and Art], *Cuba Socialista* III, no. 26, October 1963, reproduced in G. Pogolotti (ed.), *Polémicas Culturales de los 60* [Cultural Polemics of the 1960s] (Havana: Instituto Cubano del Libro, 2006), pp. 43-71.

Alberro, Alexander. 'Reconsidering Conceptual Art, 1966-1977', *Conceptual Art: A Critical Anthology* (Cambridge, MA: MIT Press, 1999), pp. xvi-xxxvii.

Alegría, Fernando, Noé Jitrik and Juan María Gutiérrez. *Literatura y Praxis En America Latina* (Caracas: Monte Avila, 1974).

Almeida, Juan. 'In the Face of Haydée's Death', B. Maclean (ed.), *Haydée Santamaría* (Sydney: Ocean Press, 2003), pp. 86-9.

Alonso, Alejandro G. 'Un Buen Inicio. Ahora a Continuar la Tarea' [A Good Start. Now to Continue the Task], *Juventud Rebelde*, 29 October 1973.

———. 'Artes Plástica: En el Encuentro Castellanos' [Plastic Arts: In the Spanish-Speaking Meeting], *Juventud Rebelde*, 21 May 1976.

———. 'Música y Teatro en la Exposición Encuentro de Plástica Latinoamericana' [Music and Theatre in the Exhibition for the Meeting of Latin American Plastic Artists], *Bohemia*, 26 June 1979.

Álvarez, Lupe. 'Storytelling in Cuba: The Tale and the Suspicion', *While Cuba Waits: Art from the Nineties* (Santa Monica: Smart Art Press, 1999.

Álvarez Quiñones, Roberto. 'Comienza Hoy el II Encuentro de Plástica Latinoamericana' [Second Meeting of Latin American Plastic Artists Starts Today], *Granma: Órgano Oficial del Comité Central del Partido Comunista de Cuba*, 16 October 1973.

Álvarez, Santiago. 'Medios Masivos de Comunicación: Cine' [Mass Means of Communication: Cinema], *Revolución y Cultura*, no. 5, 29 February 1968, pp. 52-4.

Anon. 'El Camino Trazado por Nuestra Revolución' [The Path Traced by Our Revolution], *La Tarde*, Antena Revolucionaria, 17 December 1963, reproduced in G. Pogolotti (ed.), *Polémicas Culturales de los 60* [Cultural Polemics of the 1960s] (Havana: Instituto Cubano del Libro, 2006), pp. 158-9.

————. '¿Cuáles Son las Mejores Películas?' [Which Are the Best Films?], *Hoy*, Aclaraciones [Clarifications], 18 December 1963, reproduced in G. Pogolotti (ed.), *Polémicas Culturales de los 60* [Cultural Polemics of the 1960s] (Havana: Instituto Cubano del Libro, 2006), pp. 164-8.

————. 'Las Mejores Películas' [The Best Films], *El Mundo*, 19 December 1963, reproduced in G. Pogolotti (ed.), *Polémicas Culturales de los 60* [Cultural Polemics of the 1960s] (Havana: Instituto Cubano del Libro, 2006), pp. 183-4.

————. 'El Arte Puede y Debe Esclarecer la Conciencia del Hombre' [Art Can and Should Clarify the Consciousness of Man], *Bohemia*, 24 December 1963, reproduced in G. Pogolotti (ed.), *Polémicas Culturales de los 60* [Cultural Polemics of the 1960s] (Havana: Instituto Cubano del Libro, 2006), pp. 217-8.

————. 'Respuesta a los Directores Cinemátograficos' [Response the Film Directors], *Hoy*, 26 December 1963, reproduced in G. Pogolotti (ed.), *Polémicas Culturales de los 60* [Cultural Polemics of the 1960s] (Havana: Instituto Cubano del Libro, 2006), pp. 221-4.

————. 'Encuesta: El Papel del Intelectual en Los Movimientos de Liberación Nacional' [Survey: The Role of the Intellectual in National Liberation Movements], *Casa de Las Américas* VI, no. 35, April 1966, pp. 83-99.

————. 'Bibliografia para el Seminario del Congreso Cultural de la Habana' [Literature for the Seminar of the Cultural Congress of Havana], undated [1967].

————. *Reunion de Intelectuales de Todo el Mundo sobre Problemas de Asia, Africa y America Latina: Seminar Preparatorio* [Meeting of World Intellectuals on the Problems of Asia, Africa and Latin America: Preparatory Seminar], Havana, 1967.

————. 'Declaracion del Seminario del Congreso Cultural de La Habana', *Granma: Órgano Oficial del Comité Central del Partido Comunista de Cuba*, 3 November 1967.

————. 'Comenzarán Hoy las Discusiones de las Ponencias del Congreso Cultural de la Habana' [Discussions of the Papers of the Cultural Congress of Havana Start Today], *Granma: Órgano Oficial del Comité Central del Partido Comunista de Cuba*, 6 January 1968.

————. 'Comisión 1: "Para Defender la Dignidad: Los Puños, las Palabras, los Rifles"' [To defend Dignity: Fists, Words and Rifles], *Juventud Rebelde*, 6 January 1968.

————. 'Comisión 2: 'La Cooperación entre Estados de Distintos Regímenes Políticos Sirve para Afianzar el Neocolonialismo' [The Co-operation between States of Distinct Political Regimes Serves to Strengthen Neo-colonialism], *Juventud Rebelde*, 6 January 1968.

————. 'Comisión 3: 'La Incorporación de Nuevos Valores de la Cultura Debe Tener la Condición de una Ósmosis, No de una Invasion' [The Incorporation of New Cultural Values Ought to Have a Condition of Osmosis Not one of Invasion], *Juventud Rebelde*, 6 January 1968.

————. 'Comisión 4: 'La Televisión Sólo Puede Ser Tan Buena como los Creadores que Tenga' [Television Can Only Be as Good as the Creators It Has], *Juventud Rebelde*, 6 January 1968.

————. 'Aprobó la Plenaria Distintas Modificaciones al Reglamento' [The Plenary Approved Various Modifications to the Rules], *Granma: Órgano Oficial del Comité Central Del Partido Comunista de Cuba*, 6 January 1968.

————. 'Comisión 5: 'Las Revoluciones Artísticas No Pueden Cambiar la Sociedad' [Artistic Revolutions Cannot Change Society], *Juventud Rebelde*, 6 January 1968.

————. 'Las Comisiones Trabajan' [The Commissions Work], *Juventud Rebelde*, 8 January 1968.

————. 'Resumen del Trabajo en las Comisiones' [Work of the Commissions Resumes], *Granma: Órgano Oficial del Comité Central del Partido Comunista de Cuba*, 8 January 1968.

————. 'Inauguro Haydée Santamaria Exposicion el Libro en Cuba y la Galería de Arte Contemporaneo' [Haydée Santamaría Inaugurates the Exhibition 'The Book in Cuba' and the Contemporary Art Gallery], *Granma: Órgano Oficial del Comité Central del Partido Comunista de Cuba*, 10 January 1968.

————. 'Las Comisiones: Sesión Vespertina' [The Commissions: Evening Sessions], *Granma: Órgano Oficial del Comité Central del Partido Comunista de Cuba*, 10 January 1968.

————. 'Primer Congreso Mundial de Intelectuales' [First World Congress of Intellectuals], *Bohemia*, 12 January 1968.

————. 'Este Congreso: Un Triunfo frente a los Enemigos, Figó Llanusa' [This Congress: A Triumph in the Face of Enemies, Says Llanusa], *Granma: Órgano Oficial del Comité Central del Partido Comunista de Cuba*, 13 January 1968.

————. 'Declaración General del Congreso Cultural de La Habana', *Granma: Órgano Oficial del Comité Central del Partido Comunista de Cuba*, 13 and 21 January 1968.

————. 'Llamamiento de la Habana' [Appeal of Havana], *Granma: Órgano Oficial del Comité Central del Partido Comunista de Cuba*, 21 January 1968.

————. 'Congreso Cultural de la Habana. Comisión No. 3 "Responsabilidad del Intelectual ante los Problemas del Mundo Subdesarrollado"' [Cultural Congress of Havana. Commission 3 'Responsibility of the Intellectual to the Problems of the Underdeveloped World'], *Casa de las Américas*, VIII, no. 47, April 1968, pp. 101–2.

————. 'Literatura y Revolución (Encuestas)' [Literature and Revolution (Surveys)], *Casa de Las Américas*, IX, no. 51–52, November 1968, p. 119.

————. 'On the First National Congress of Education and Culture', *Casa de las Américas*, no. 65–66, 1971.

————. 'El Congreso de Cultura' [The Cultural Congress], *Granma: Órgano Oficial del Comité Central del Partido Comunista de Cuba*, 1 May 1971.

————. 'Convocan la Casa de las Américas y el Instituto de Arte Latinoamericano de Chile a Encuentro de Plástica Latinoamericana' [Casa and the Institute of Latin American Art of Chile Convene Meeting], *Juventud Rebelde*, 18 August 1971.

————. 'Celebrarán un Encuentro de Plástica Latinoamericana' [Latin American Plastic Artists Will Hold a Meeting], *Juventud Rebelde*, 21 August 1971.

————. 'Encuentro de Plástica Latinoamericana' [Meeting of Latin American Plastic Artists], *Juventud Rebelde*, 16 May 1972.

————. 'Quedara Constituido el Encuentro de Plástica Latinoamericana' [Meeting Will Be Constituted], *Granma: Órgano Oficial del Comité Central Del Partido Comunista de Cuba*, 20 May 1972.

————. 'La Responsabilidad del Artista' [Responsibility of the Artist], *Juventud Rebelde*, 22 May 1972.

————. 'Arriban a Cuba los Pintores Julio le Parc y Sérvulo Esmeraldo' [The Painters Julio Le Parc and Sérvulo Esmeraldo Arrive in Cuba], *Granma: Órgano Oficial del Comité Central del Partido Comunista de Cuba*, 22 May 1972.

————. 'En Cuba Participantes del Encuentro de Plástica Latinoamericana' [Participants of the Meeting of Latin American Plastic Artists in Cuba], *Granma: Órgano Oficial del Comité Central del Partido Comunista de Cuba*, 22 May 1972.

———. 'Constituen Hoy en Casa de las Américas en el Encuentro de Plástica Latinoamericana' [Meeting of Latin American Plastic Artists Convened Today at Casa], *Granma: Órgano Oficial del Comité Central del Partido Comunista de Cuba*, 24 May 1972.

———. 'Iniciado el Encuentro de Plástica Latinoamericana' [Meeting of Latin American Plastic Artists Initiated], *Juventud Rebelde*, 24 May 1972.

———. 'Declaración de Solidaridad con Viet Nam en el Encuentro de Plástica Latinoamericana' [Declaration of Solidarity with Vietnam in the Meeting of Latin American Plastic Artists], *Granma: Órgano Oficial del Comité Central del Partido Comunista de Cuba*, 25 May 1972.

———. 'Constituido en la Casa el Encuentro de Plástica Latinoamericana' [Meeting of Latin American Plastic Artists Convened in Casa], *Granma: Órgano Oficial Del Comité Central Del Partido Comunista de Cuba*, 25 May 1972.

———. 'Acuerdo de la II Sesión de Trabajo del Encuentro de Plástica Latinoamericana' [Accords of the Second Session of Work of the Meeting of Latin American Plastic Artists], *Granma: Órgano Oficial del Comité Central del Partido Comunista de Cuba*, 26 May 1972.

———. 'Continúan las Sesiones del Encuentro de Plástica Latinoamericana' [The Sessions of the Meeting of Latin American Plastic Artists Continue], *Granma: Órgano Oficial Del Comité Central Del Partido Comunista de Cuba*, 27 May 1972.

———. 'Apreuban en el Encuentro de Plástica Latinoamericana Llamamieto a Los Artistas y Criticas de Arte' [An Appeal to Artists and Critics Approved at the Meeting of Latin American Artists], *Granma: Órgano Oficial del Comité Central del Partido Comunista de Cuba*, 29 May 1972.

———. 'Inauguran Exposición sobre la Actual Plástica Latinamericana' [An Exhibition on Current Latin American Plastic Art Inaugurated], *Granma: Órgano Oficial del Comité Central del Partido Comunista de Cuba*, 31 May 1972.

———. 'Primer Encuentro de Plástica Latinoamericana' [First Meeting of Latin American Plastic Artists], *Bohemia*, 9 June 1972.

———. 'Encuentro de Plástica Latinoamericana' [Meeting of Latin American Plastic Artists], *Casa de las Américas*, XIII, no. 73, August 1972, pp. 164–5.

———. 'Encuentro para una Nueva Plástica' [Meeting for a New Plastic Art], *Cuba Internacional*, 1973.

———. 'Chile en el II Encuentro de Plástica Latinoamericana' [Chile in the Second Meeting of Latin American Plastic Artists], *Juventud Rebelde*, 9 October 1973.

———. 'II Encuentro de Plástica Latinoamericana' [Second Meeting of Latin American Plastic Artists], *Bohemia*, 12 October 1973.

———. 'Visitan Delegados a Encuentro de Plástica Latinoamericana la Exposición Imagenes de Cuba' [Delegates of the Meeting of Latin American Plastic Artists Visit the Exhibition Images of Cuba], *Juventud Rebelde*, 14 October 1973.

———. 'Reunense con la Prensa Nacional Delegados al II Encuentro de Plástica Latinoamericana' [Delegates of the Second Meeting of Latin American Plastic Artists Meet the National Press], *Granma: Órgano Oficial del Comité Central del Partido Comunista de Cuba*, 15 October 1973.

———. 'Declaración de Apoyo al Pueblo Chileno en el II Encuentro de Plástica Latinoamericana' [Declaration of Support to Chilean People in Second Meeting of Latin American Plastic Artists], *Juventud Rebelde*, 16 October 1973.

———. 'Solidarizarse con el Pueblo Chilenc el II Encuentro de Plástica Latinoamericana' [Second Meeting of Latin American Plastic Artists Aligns Itself with Chilean People], *Granma: Órgano Oficial del Comité Central del Partido Comunista de Cuba*, 17 October 1973.

———. 'Declaración del II Encuentro de Plástica Latinoamericana' [Declaration of the Second Meeting of Latin American Plastic Artists], *Granma: Órgano Oficial del Comité Central del Partido Comunista de Cuba*, 17 October 1973.

———. 'Emiten Declaración de Apoyo a los Pueblos Arabes Delegados al II Encuentro de Plástica Latinoamericana' [Delgates to the Second Meeting of Latin American Plastic Artists Approve Declaration of Support for Arab Peoples], *Granma: Órgano Oficial del Comité Central del Partido Comunista de Cuba*, 19 October 1973.

———. 'Concluye Hoy el Conclusiones y Acuerdos del II Encuentro de Plástica Latinoamericana' [The Conclusions and Accords of the Second Meeting of Latin American Plastic Artists Conclude Today], *Granma: Órgano Oficial del Comité Central del Partido Comunista de Cuba*, 20 October 1973.

———. 'Dan a Conocer Conclusiones y Acuerdos del II Encuentro de Plástica Latinoamericana' [Getting to Know the Conclusions and Accords of the Meeting of Latin American Plastic Artists], *Juventud Rebelde*, 21 October 1973.

———. 'Conclusiones y Acuerdos' [Conclusions and Accords], *Bohemia*, 26 October 1973.

———. 'Participantes del II Encuentro de Plástica Latinoamericana en el Museo Nacional' [Participants of the Second Meeting of Latin American Plastic Artists in the National Museum], *Granma: Órgano Oficial Del Comité Central Del Partido Comunista de Cuba*, 27 October 1973.

———. 'II Encuentro de Plástica Latinoamericana' [Second Meeting of Latin American Plastic Artists], *Verde Olivo*, 28 October 1973.

———. 'Pintan ante el Publico Delegados de II Encuentro de Plástica Latinoamericana' [Delegates of the Second Meeting of Latin American Plastic Artists Paint in Public], *Granma: Órgano Oficial del Comité Central del Partido Comunista de Cuba*, 29 October 1973.

———. 'Apoyan Artistas Plásticas Latinoamericanas Lucha del Pueblo Chileno' [Latin American Plastic Artists Support the Struggle of the Chilean People], *Romances*, November 1973.

———. 'Encuentro de Plástica Latinoamericana' [Meeting of Latin American Plastic Artists], *Boletín de la Comisión Nacional de la UNESCO*, 13, no. 99, February 1974.

———. 'Comienza el Lunes Encuentro de Plástica Latinoamericana 1976' [The 1976 Meeting of Latin American Plastic Artists Starts on Monday], *Granma: Órgano Oficial del Comité Central del Partido Comunista de Cuba*, 13 May 1976.

———. 'Declaración Final' [Final Declaration], *Juventud Rebelde*, 23 May 1976.

———. 'Declaración Emitada en el Encuentro de Plástica Latinoamericana 1976' [Declaration Issued at the 1976 Meeting of Latin American Plastic Artists], *Granma: Órgano Oficial del Comité Central del Partido Comunista de Cuba*, 24 May 1976.

———. 'Puerto Rico bajo el Imperio y en la Obra Combativa de sus Artes Plásticas: Entrevista a los Pintores Lorenzo Humary y Carlos Irizarry' [Puerto Rico under the Empire and in the Combative Words of Its Plastic Artists: Interviews with Painters...], *Granma: Órgano Oficial del Comité Central del Partido Comunista de Cuba*, 26 May 1976.

———. 'Culmino el Encuentro de Plástica Latinoamericana 1976 con una Conferencia sobre las Artes Plásticas en la Republica Dominicana' [The 1976 Meeting of Latin American Plastic Artists Culminates with a Conference on Plastic Arts in the Dominican Republic], *Granma: Órgano Oficial del Comité Central del Partido Comunista de Cuba*, 26 May 1976.

———. 'Muy Breves' [In Brief], *Juventud Rebelde*, 28 May 1976.

———. 'Un Parte del Arte' [A Part of Art], *Mujeres* [Women], July 1976.

———. 'III Encuentro de Plástica Latinoamericana', *Casa de Las Américas*, XVI, no. 98, October 1976, pp. 160–1.

———. 'Política Cultural de la Revolución Cubana', *Casa de Las Américas,* XVIII, no. 103, August 1977, p. 154.

———. 'Realisará la Casa de las Américas el: Encuentro de Plástica Latinoamericana y del Caribe 1979' [1979 Meeting of Latin American and Caribbean Plastic Artists will be Realised at Casa de las Américas], press release, Havana, undated.

————. 'Declaración Final del IV Encuentro de Plástica Latinoamericana y del Caribe' [Final Declaration of Fourth Meeting of Latin American and Caribbean Plastic Artists], *Granma: Órgano Oficial del Comité Central del Partido Comunista de Cuba*, 29 May 1979.

————. 'Declaraciones' [Declarations], *Casa de las Américas* XX, no. 116, October 1979, pp. 138–40.

————. *Datos Útiles de la Cultura* [Useful Cultural Data] (Havana: Unknown, 1989).

————. *Restringen Entrada a Conferencia Sobre el 'Quinquenio Gris' en la Casa de las Américas* [Entry to the Conference on the 'Quinquenio Gris' at Casa de Las Américas Restricted], undated statement.

Antuña, Vincentina. 'El Consejo Nacional de Cultura Contesta a Alfredo Guevara' [The CNC Responds to Alfredo Guevara], *Hoy*, 20 December 1963, reproduced in G. Pogolotti (ed.), *Polémicas Culturales de los 60* [Cultural Polemics of the 1960s] (Havana: Instituto Cubano del Libro, 2006), pp. 189–94.

Arango, Arturo. 'La Política Cultural del Periodo Revolucionario: Memoria y Reflexion' 'Arturo Arango Responde a Desiderio Navarro' [Arturo Arango Responds to Desiderio Navarro], in relation to the Conference 'El Quinquenio Gris: Revisitando el término' [The Five Grey Years: Revisiting the Term] on 30 January 2007 at Casa de las Americas as part of a cycle of events, offered by distinguished essayist, Ambrosio Fornet, entitled 'La política Cultural del Periodo Revolucionario: Memoria y Reflexion' [The Cultural Policy of the Revolutionary Period: Memory and reflection].

Arato, A., and E. Gebhardt (eds.). *The Essential Frankfurt School Reader* (New York: The Continuum Publishing House, undated).

Arrufat, Antón. 'Letter by Antón Arrufat', January 2007.

Asesoria Juridica Nacional/Banco Nacional de Cuba. *Compilación por Materia de las Leyes y Decretos – Leyes Promulgados desde el 1ro de Enero de 1959 hasta el 30 de Septiembre de 1980* [Compliation of Material of Laws and Decrees – Laws Passed from 1 January 1959 to 30 September 1980] (Havana: Asesoria Juridica Nacional/Banco Nacional de Cuba, 1980).

Baldelli, Pío. 'Mass Media y Revolución' [Mass Media and Revolution], *Revolución y Cultura*, no. 4 (15 February 1968), pp. 49–51.

Barral, Fernando. 'Actitud del Intelectual Revolucionario' [Attitude of the Revolutionary Intellectual], *Revolución y Cultura*, no. 9, 30 April 1968, pp. 3–12.

Baxandall, Lee (ed.). *Marxism and Aesthetics: A Selective Annotated Bibliography* (New York: Humanities Press, 1968).

————. *Radical Perspectives in the Arts* (London: Penguin Books, 1972).

Baxandall, Lee, and Stefan Morawski (eds.). *Karl Marx and Friedrich Engels on Literature and Art* (Nottingham: Critical, Cultural and Communications Press, 2006).

Becker, Howard S. 'Whose Side Are We On?', *Social Problems*, 14, no. 3, Winter 1967, pp. 239–47.

Belfiore, Eleonora, and Oliver Bennett. *The Social Impact of the Arts: An Intellectual History* (Basingstoke: Palgrave Macmillan, 2008).

Bell, José, Delia Luisa López and Tania Caram. *Documentos de la Revolución Cubana 1959* [Documents of the 1959 Cuban Revolution] (Havana: Editorial de Ciencias Sociales, 2008).

Benedetti, Mario. 'Sobre las Relaciones entre el Hombre de Acción y el Intelectual' [On the Relations between the Man of Action and the Intellectual], *Revolución y Cultura*, no. 4, 15 February 1968, pp. 28–31.

————. 'Present Status of Cuban Culture', R.E. Bonachea and N.P. Valdés (eds.), *Cuba in Revolution* (Garden City, NY: Doubleday & Company, 1972), pp. 500–26.

————. 'The Presence and Absence of Haydée Santamaría', B. Maclean (ed.), *Haydée Santamaría* (Sydney: Ocean Press, 2003).

Bengelsdorf, Carollee. *The Problem of Democracy in Cuba: Between Vision and Reality* (New York: Oxford University Press, 1994).

Benítez-Rojo, Antonio. 'Comments on Dopico Black's "The Limits of Expression: Intellectual Freedom in Postrevolutionary Cuba"', *Cuban Studies*, no. 20, 1990, pp. 171–4.

Benjamin, Walter. 'The Work of Art in the Age of Mechanical Reproduction', C. Harrison and P. Wood (eds.), *Art in Theory 1900–1990: An Anthology of Changing Ideas* (Oxford: Blackwell, 1992 [1936]), pp. 512–20.

Benvenuto, Sergio. '¿Cultura Pequeñoburguesa Hay Una Solo?' [There Is Only One Petit-Bourgeois Culture?], *La Gaceta de Cuba*, III, no. 33, 20 March 1964, reproduced in G. Pogolotti (ed.), *Polémicas Culturales de los 60* [Cultural Polemics of the 1960s] (Havana: Instituto Cubano del Libro, 2006), pp. 126–41.

Berger, John. 'Problems of Socialist Art' [1959], first published in *Labour Monthly*, March and April 1961, reprinted in L. Baxandall (ed.), *Radical Perspectives in the Arts* (London: Penguin Books, 1972).

———. *Art and Revolution* (London: Writers and Readers Cooperative, 1969).

Beverley, John, Jose Oviedo and Michael Aronna (eds.). *The Postmodernism Debate in Latin America* (Durham, NC: Duke University Press, 1993).

Blackburn, Robin. 'Prologue to the Cuban Revolution', *New Left Review*, no. 21, 1963, pp. 59–91.

Blanco, Juan. 'Los Herederos de Oscurantismo' [The Heirs of Obscurantism], *La Gaceta de Cuba*, II, no. 15, 1 April 1963, reproduced in G. Pogolotti (ed.), *Polémicas Culturales de los 60* [Cultural Polemics of the 1960s] (Havana: Instituto Cubano del Libro, 2006), pp. 3–8.

Bloch, Ernst. 'Discussing Expressionism', T. Adorno et al., *Aesthetics and Politics* (London: Verso, 2007 [1934]), pp. 16–27.

Boltanski, Luc, and Eve Chiapello. *The New Spirit of Capitalism* (London and New York: Verso, 2005).

Bonachea, Rolando E., and Nelson P. Valdés. *Cuba in Revolution* (Garden City, New York: Doubleday & Company, 1972), pp. 497–9.

Borja, Jordi, and Manuel Castells. *Local and Global: Management of Cities in the Information Age* (London: Earthscan Publications Ltd, 1997).

Boterbloem, Kees. *The Life and Times of Andrei Zhdanov, 1896-1948* (Montreal, Kingston, London & Ithaca: McGill-Queen's University Press, 2004).

Bourdieu, Pierre. *Distinction: A Social Critique of the Judgement of Taste,* (London: Routledge, 1984).

———. 'The Essence of Neoliberalism: Utopia of Endless Exploitation', *Le Monde Diplomatique*, 8 December 1998.

———. *Firing Back: Against the Tyranny of the Market* (London: Verso, 2003).

Brooksbank Jones, Anne, and Ronaldo Munck (eds.). *Cultural Politics in Latin America* (Basingstoke: Palgrave Macmillan, 2000).

Brown, J. 'What Is Workers' Control?', *Workers' Control in Latin America 1930–1979* (Cape Hill: University of North Carolina Press, 1997).

Buck-Morss, Susan. *The Origin of Negative Dialectics* (Hassocks: The Harvester Press, 1977).

Bunck, Julie Marie. *Fidel Castro and the Quest for a Revolutionary Culture in Cuba* (Pennsylvania: Pennsylvania State University Press, 1994).

Buñuel, Luis. *The Exterminating Angel* (film), 1962.

Bürger, Peter. *The Theory of the Avant-Garde* (Minneapolis: University of Minnesota Press, 1984 [1974]).

Burn, Ian. 'The Art Market: Affluence and Degradation', *Artforum*, April 1975, pp. 34–7.

Cabrera Infante, Alberto, and Orlando Jiménez Leal. *PM (Pasado Meridiano)*, 1961.

Cabrera Infante, Guillermo. 'Statement from Guillermo Cabrera Infante', W. Luis (ed.), *Lunes de Revolución: Literatura y Cultura en los Primeros Años de la Revolución Cubana* (Madrid: Editorial Verbum, 2003 [1987]).

———. 'Polemic with a Dead Man', *Mea Cuba* (London: Faber and Faber, 1994), 21–31.

———. 'The Twisted Tongue of the Poet', *Mea Cuba* (London: Faber and Faber, 1994), pp. 36–42.

Calvo Ospina, Hernando. *Bacardi: The Hidden War* (London: Pluto Press, 2001).

Cameron, David. 'Transforming the British Economy: Coalition Strategy for Economic Growth', 28 May 2010. https://www.gov.uk/government/speeches/transforming-the-british-economy-coalition-strategy-for-economic-growth.

Camnitzer, Luis. *New Art of Cuba* (Austin: University of Texas Press, 1994).

Campuzano, Luisa. 'Las Muchachas de La Habana No Tienen Temor de Dios' [The Girls of Havana Have No Fear of God], *Casa de Las Americas*, no. 184, 1 January 2006.

Cancio Isla, Wilfredo. 'Ira Por la Reaparición de Censires Culturales' [Anger at the Reappearance of Cultural Censors], *El Nuevo Herald*, undated.

Caparros, Antonio. 'Responsabilidad Del Intelectual Revolucionario en el Proceso de Liberación de los Paises Dependientes del Imperialismo' [Responsibility of the Revolutionary Intellectual in the Process of Liberating the Countries Dependent on Imperialism], January 1968.

Cardosa Arias, Santiago. 'Efectuaran en la Casa de las Américas el Encuentro de Plástica Latinoamericana 1976' [The 1976 Meeting of Latin American Plastic Artists Will Be Hosted at Casa], *Granma: Órgano Oficial Del Comité Central Del Partido Comunista de Cuba*, 18 May 1976.

―――. 'Abierta en la Casa de las Américas Exposición de Pinturas' [Exhibition of Paintings Opens at Casa], *Granma: Órgano Oficial Del Comité Central Del Partido Comunista de Cuba*, 21 May 1976.

Carmona Báez, Antonio. *State Resistance to Globalisation in Cuba* (London: Pluto Press, 2004).

Carnet Riera, Gonzalo. 'El Contorno Económico de la Cultura Artística' [The Economic Outline of Artistic Culture], *Temas*, no. 17, 1989, pp. 47–72.

Carr, Barry and Steve Ellner. *The Latin American Left: From the Fall of Allende to Perestroika* (London: Latin American Bureau, 1993).

Casal, Lourdes. *El Caso Padilla: Literatura y Revolución en Cuba* [The Padilla Case: Literature and Revolution in Cuba] (Miami: Ediciones Universal, 1971).

―――. 'Literature and Society', *Revolutionary Change in Cuba* (Pennsylvania: University of Pittsburgh Press, 1971).

Castro Ruz, Fidel. 'History Will Absolve Me', F. Castro Ruz and R. Debray, *On Trial* (London: Lorrimer, 1968 [1953]), pp. 9–108.

―――. 'Manifiesto No. 1 Del 26 de Julio al Pueblo de Cuba' [Manifesto No. 1 from the 26 July Movement to the People of Cuba], Manifesto, Mexico, 8 August 1955.

―――. *History Will Absolve Me* (English Version by Oscar Rodríguez Estrada), Havana, 1959.

―――. 'The Problem of Cuba and Its Revolutionary Policy', Speech to the United Nations General Assembly, 26 September 1960, available at: Marxists.org/history/cuba/archive/castro/1960/09/26.htm

―――. 'Speech of 16 April 1961', excerpted at: http://www.themilitant.com/

―――. 'Palabras a los Intelectuales' [Words to the Intellectuals], *The Revolution and Cultural Problems in Cuba* (Havana: Ministry of Foreign Relations, 1962 [1961]).

―――. *The Declarations of Havana* (London and New York: Verso, 2008 [1960 and 1962]).

―――. *Fidel Castro Denounces Sectarianism* (Havana: Ministry of Foreign Relations, 1962).

―――. Speech at Guane, Pinar del Río, 29 April 1967.

―――. Speech of 18 October 1967, *Che: A Memoir by Fidel Castro* (Melbourne: Ocean Press, 1994)

―――. 'Clausura Fidel el Congreso Cultural de la Habana' [Fidel's Closing Speech to the Cultural Congress of Havana], *Granma: Órgano Oficial del Comité Central del Partido Comunista de Cuba*, 13 January 1968.

―――. 'Fidel en el Congreso Cultural de la Habana' [Fidel at the Cultural Congress of Havana], *Granma: Órgano Oficial del Comité Central Del Partido Comunista de Cuba*, 21 January 1968.

——. 'En el Congreso' [At the Congress], *Revolución y Cultura*, no. 6, 15 March 1968, pp. 3–17.
'Speech Given by Major Fidel Castro Ruz, First Secretary of the Communist Party of
Cuba and Prime Minister of the Revolutionary Government, at the Closing Session of
the Cultural Congress of Havana, 12 January 1968', Instituto Cubano del Libro, *Cultural
Congress of Havana: Meeting of Intellectuals from All the World on Problems of Asia, Africa
and Latin America* (Havana: Instituto Cubano del Libro, 1968).

——. 'Comments on Czechoslovak Crisis', Havana Domestic Television and Radio Services,
23 August 1968, available at

——. Speech for the 12th Anniversary of the Attack on the Presidential Palace, Havana,
13 March 1969.

——. Speech to Commemorate the Bay of Pigs Anniversary, 19 April 1971, available at:
Lanic.utexas.edu/project/castro/db/1971/19710420.html

——. 'Este Congreso Ha Sido el Desarollo Conseguente de una Linea de Masas en la
Educación' [This Congress Has Been the Consistent Development of a Line of Mass
Education], *Juventud Rebelde*, 2 May 1971.

——. 'Discurso de Clausura' [Closing Discourse], *Casa de Las Américas*, XI, no. 65–66, June
1971, p. 29.

——. 'En la Clausura del Primer Congreso Nacional de Educación y Cultura' [In Closing the
First National Congress of Education and Culture], *Discursos*, Havana, 1976, pp. 139–60.

——. *La Primera Revolución Socialista en América* [The First Socialist Revolution in America]
(Mexico City: Siglo Veintiuno, 1976).

——. Introduction to 1968 edition of Che Guevara's Bolivian diaries, reproduced in *Che: A
Memoir by Fidel Castro* (Melbourne: Ocean Press, 1994).

——. Speech given at ceremony in Pinar del Río to mark the twentieth anniversary of Che
Guevara's death, *Che: A Memoir by Fidel Castro* (Melbourne: Ocean Press, 1994 [1989]).

——. *Che: A Memoir by Fidel Castro* (Melbourne: Ocean Press, 1994).

——. 'Closer to Haydée Santamaría and the Casa de Las Américas', *Haydée Santamaría*
(Sydney: Ocean Press, 2003).

Castro Ruz, Fidel, and Ernesto Guevara, M.A. Waters (ed.). *To Speak the Truth* (New York:
Pathfinder Press, 1992).

Castro Ruz, Fidel, and Ignacio Ramonet. *My Life* (London: Penguin Books, 2008 [2006]).

Centro Nacional de Aficionados y Casas de Cultura. *Guidelines, Lineamientos, Funciones
Principales y Principios Organizativos Básicos para el Perfeccionamiento y Desarrollo del
Trabajo en el Sistema de Casas de Cultura* [Principal Functions and Basic Organisational
Principles for Perfecting and Developing the Work of the System of Casas de Cultura]
(Havana: Ministerio de Cultura, 1988).

Chanan, Michael. *Cuban Cinema* (Minneapolis: University of Minnesota Press, 2003).

Chaplin, Charlie. *Modern Times* (film), 1936.

Chávez, Rebeca. *Ciudad en Rojo* [City in Red (film)], 2009.

Cherif, Cheick. 'La "Mass-Media"' [The Mass Media], *Revolución y Cultura*, no. 4 15 February
1968, pp. 42–46.

Chomsky, Aviva. *The Cuba Reader: History, Culture, Politics* (Durham, NC: Duke University
Press, 2004).

——. *A History of the Cuban Revolution* (Hoboken, NJ: Wiley-Blackwell, 2010).

Clark, Ian. *Globalization and International Relations Theory* (New York: Oxford University
Press Inc, 1999).

Coates, Barry. 'On Trade', *Anti-Capitalism: A Guide to the Movement* (London: Bookmarks,
2001).

Cocq, Karen, and David A. McDonald. 'Minding the Undertow: Assessing Water "Privatization"
in Cuba', *Antipode* 42, no. 1, 2010, pp. 6–45.

Colina, Enrique. 'Letter to Desiderio Navarro' [by email], January 2007.

Comité Central del Partido Comunista de Cuba (PCC). *Tesis y Resoluciones Primer Congreso del Partido Comunista de Cuba* [Thesis and Resolutions of the First Congress of the PCC] (Havana: Comité Central del Partido Comunista de Cuba, 1976).

Comité Estatal de Estadisticas. 'Anuaria Estadistico de Cuba' [Statistical Yearbook of Cuba] (Havana: Comité Estatal de Estadisticas, 1984).

Confederación de Trabajadores Cubanos (CTC). *Untitled: Pamphlet Presenting Documents, Laws and Resolutions Relating to Education, Culture, Sport and Recreation which Serve as Instruments for Work in Our Sphere* (Havana: CTC Nacional, 1984).

Congreso Nacional de Educación y Cultura Havana 1971. *First National Congress on Education and Culture* (Havana: Permanent Secretariat, Cuban National Commission for UNESCO, 1971).

Consejo Nacional de Cultura. *Anteproyecto del Plan de Cultura de 1963* [Draft of the 1963 Cultural Plan] (Havana: Consejo Nacional de Cultura, 1963).

——. *Proyecto-plan para 1964* (Havana: Consejo Nacional de Cultura, 1963).

——. *Política Cultural del Gobierno Revolucionario y Trabajo de Aficionados* [Cultural Policy of the Revolutionary Government and Work of Aficionados] (Las Villas: Consejo Nacional de Cultura, 1963).

——. *Cultura: Teatro, Artes Plásticas, Arquitectura, Música, Danza, Literatura, Cine* [Culture: Theatre, Plastic Arts, Architecture, Music, Dance, Literature, Film] (Havana: Consejo Nacional de Cultura, 1966).

——. *Resumen Estadístico año 1967* [Statistical Summary 1967] (Havana: Consejo Nacional de Cultura, undated).

——. *Política Cultural de Cuba* [Cultural Policy of Cuba] (Havana: Consejo Nacional de Cultura, 1970).

——. *Reunión Nacional de Instructores de Arte* [National Meeting of Art Instructors] (Havana: Escuela para Instructores de Arte, 1972).

——. *Directiva no. 1 del Consejo Nacional de Cultura para el Desarrollo del Trabajo en 1975: Orientaciones Políticas Fundamentales para el Trabajo* [Directive No. 1 of the National Council of Culture for the Development of Work in 1975: Fundamental Political Orientations for Work] (Havana: Consejo Nacional de Cultura, 1975).

——. *Objetivos para una Exposición* [Objectives for an Exhibition] (Havana: unpublished, undated).

Consejo Provincial de Cultura. *La Cultura para el Pueblo* [Culture for the People] (Havana: Consejo Provincial de Cultura, 1961).

Conte, Antonio. 'Coloquio para una Estrategia' [Discussion for a Strategy], *Cuba Internacional*, IV, no. 36, August 1972, pp. 15–21.

Cortázar, Octavio. *Por Primera Vez* [For the First Time (film)], 1967.

Courbet, Gustave. *Realist Manifesto*, 1855.

C.R. 'Encuentro de Plástica Latinoamericana' [Meeting of Latin American Plastic Artists]. *Romances*, May 1972.

Craven, David. 'The Visual Arts Since the Cuban Revolution', *Third Text*, 6, no. 20, 1992, pp. 77–102.

——. *Art and Revolution in Latin America 1910–1990* (New Haven and London: Yale University Press, 2006).

Crimp, Douglas. 'Photographs at the End of Modernism', *On the Museum's Ruins* (Cambridge, MA: MIT Press, 1993), pp. 2–31.

——. 'This Is Not a Museum of Art', *On the Museum's Ruins* (Cambridge, MA: MIT Press, 1993), pp. 200–34.

——. 'The Art of Exhibition', *On the Museum's Ruins* (Cambridge, MA: MIT Press, 1993), pp. 236–81.

Cultural Policy Collective. *Beyond Social Inclusion: Towards Social Democracy* (Scotland: Cultural Policy Collective, 2004).

Dalton, Roque, Rene Depestre, Edmundo Desnoes, Roberto Fernández Retamar, Ambrosio Fornet and Carlos Maria Gutierrez. 'Diez Años de Revolución: El Intelectual y la Sociedad' [Ten Years of Revolution: The Intellectual and Society], *Casa de Las Américas*, X, no. 56, October 1969, pp. 7–48.

Daly, Macdonald. 'A Short History of Marxist Aesthetics', L. Baxandall and S. Morawski (eds.), *Karl Marx and Friedrich Engels on Literature and Art* (Nottingham: Critical, Cultural and Communications Press, 2006).

Danto, Arthur. *After the End of Art: Contemporary Art and the Pale of History* (Princeton, NJ: Princeton University Press, 1997).

Darke, Colin. 'Working-Class Culture and Artistic Autonomy', N. Kelly (ed.), *Art & Politics – The Imagination of Opposition in Europe* (Dublin: R4 Publishing, 2004), pp. 32–7.

Davies, Anthony, and Simon Ford. 'Art Capital', *Art Monthly*, 1998; 'Art Futures', *Art Monthly*, 1999; and 'Culture Clubs', *Mute*, 2000.

Davies, Catherine. 'Surviving (on) the Soup of Signs: Postmodernism, Politics, and Culture in Cuba', *Latin American Perspectives*, 27, no. 113, 2000, pp. 103–21.

De Feria, Lina. 'La Obra de Arte No Puede Estar Aparte de Todo Lo Que le Rodea' [The Work of Art Cannot Be Separate from that which Surrounds it: Interview with Canadian Painter/ Recording Artist, Richard Lacroix], *Juventud Rebelde*, 8 January 1968.

De Juan, Adelaida. *Del Silencio del Grito: Mujeres en las Artes Plásticas* [From the Silence of the Scream: Women in Plastic Arts] (Havana: Editorial Letras Cubanas, 2002).

———. 'Década iniciática' [Initial Decade], S. Maldonado (ed.), *Mirar a los 60: Antología de una Década* [Looking at the 60s: Anthology of a Decade] (Havana: Museo Nacional de Bellas Artes, 2004), pp. 21–3.

———. Interview with the author, 3 March 2010.

De Juan, Adelaida, Eugenio Darnet, Julio Le Parc, Carlos Granada and José Balmes. 'Puntos de Vista' [Points of View], *Cuba Internacional*, August 1972.

De la Fuente, Alejandro. *A Nation for All: Race, Inequality, and Politics in Twentieth-Century Cuba* (Chapel Hill and London: The University of North Carolina Press, 2001).

Del Duca, Gemma. 'Creativity and Revolution: Cultural Dimension of the New Cuba', J. Suchlicki (ed.), *Cuba, Castro and Revolution* (Coral Gables, FL: University of Miami, 1972), pp. 94–118.

Del Valle, Sandra. 'Cine y Revolución: La Política Cultural del ICAIC en los Sesenta' [Cinema and Revolution: The Cultural Policy of ICAIC in the Sixties], *Perfiles*, December 2002.

De Micheli, Mario. *Las Vanguardias Artísticas del Siglo XX* [The Artistic Vanguards of the Twentieth Century] (Havana: Ediciones UNIÓN, 1967).

Departamento de Estadística. *Estadística Educacional: final del curso 1962–63* [Educational Statistics: End of Year 1963–63] (Havana: Ministerio de Educación Dirección de Economía, 1963).

———. *Actividades Artístico-Culturales* [Artistic-Cultural Activities] (Havana: Ministerio de Cultura, 1985).

Departamento de Orientación Revolucionaria del Comité Central del Partido Comunista Cubano. *Constitución de la República de Cuba* [Constitution of the Republic of Cuba], 1976.

———. *Constitución de la República de Cuba* [Constitution of the Republic of Cuba], 1992.

Departamento de Planificación. *Plan de Actividades Educativas: Hasta el Curso 1964–65* [Plan of Activities: Until End of 1964–65] (Havana: Ministerio de Educación Dirección de Economía, 1964).

Department for Culture, Media and Sport (DCMS). *Creative Industries Mapping Document*, November 1998.

Department for Culture, Media and Sport. *Creative Industries Economic Estimates (Experimental Statistics)*, Full Statistical Release, 9 December 2010.

Department for Education and Skills. *Skills for Life: A National Needs and Impact Survey of Literacy, Numeracy and ICT Skills*, October 2003.

Department of Education [US]. *National Assessment of Adult Literacy*, 2009.

Desnoes, Edmundo. 'Las Armas Secretas' [The Secret Weapons], *Revolución y Cultura*, no. 4, 15 February 1968, pp. 46–8.

———. *Memories of Underdevelopment* (Middlesex: Penguin Books, 1971 [1968]).

De Tolentino, Marianne. 'Encuentro de Plástica Latinoamericana en Cuba' [Meeting of Latin American Plastic Artists in Cuba], *Listin Diario*, 27 May 1976.

———. 'Encuentro de Plástica Latinoamericana en Cuba' [Meeting of Latin American Plastic Artists in Cuba], *Listin Diario*, 28 May 1976.

Dill, Hans Otto. *El Ideario Literario y Estético de José Martí* [The Worldview and Aesthetics of José Martí] (Havana: Casa de las Américas, 1975).

Directorio Práctico Fiscal. *Impuestos sobre Compraventa* [Sales Tax], Segunda Época Primer Edición [Second Era First Edition], Vol. V (Havana: Directorio Práctico Fiscal, 1959).

Directors of ICAIC. '¿Qué Películas Debemos Ver?: Las Mejores' [Which Films Should We See? The Best], *Revolución*, 14 December 1963, reproduced in G. Pogolotti (ed.), *Polémicas Culturales de los 60* [Cultural Polemics of the 1960s] (Havana: Instituto Cubano del Libro, 2006), pp. 149–51.

Domínguez, Jorge I. *Cuba: Order and Revolution* (Cambridge, MA and London: Harvard University Press, 1978).

Domínguez, Jorge I., Omar Everleny Pérez Villanueva and Lorena Barberia (eds.). *The Cuban Economy at the Start of the Twenty-First Century* (Cambridge, MA and London: Harvard University Press, 2004).

Dopico Black, Georgina. 'The Limits of Expression: Intellectual Freedom in Postrevolutionary Cuba', *Cuban Studies*, no. 19, 1989, pp. 107–42.

Dorticós Torrado, Osvaldo. 'Speech at the First National Congress of Writers and Artists', *The Revolution and Cultural Problems in Cuba* (Havana: Ministry of Foreign Relations, 1962), pp. 68–76.

———. 'Clausura del Seminario Preparatorio al Congreso Cultural de la Habana', *Revolución y Cultura*, no. 3, 30 November 1967, pp. 4–16.

———. 'Discurso en el Seminario sobre el Congreso Cultural de la Habana' [Discourse in the Seminar on the Cultural Congress of Havana], *Pensamiento Crítico*, no. 11, December 1967, pp. 3–21.

———. 'Proclamamos la Necesidad de la Literature y el Arte en la Revolución' [We Proclaim the Necessity of Literature and Art to the Revolution], *El Mundo*, 5 January 1968.

———. 'Ante el Congreso' [Before the Congress], *Revolución y Cultura*, no. 4, 15 February 1968, pp. 2–9.

———. 'Inauguration of the Cultural Congress of Havana', 4 January 1968, reproduced in Instituto Cubano del Libro. *Cultural Congress of Havana: Meeting of Intellectuals from All the World on Problems of Asia, Africa and Latin America* (Havana: Instituto Cubano del Libro, 1968), unpaginated.

Dunayevskaya, Raya. *Marxism and Freedom: From 1776 until Today* (London: Pluto Press, 1975).

———. *The Power of Negativity: Selected Writings on the Dialectic in Hegel and Marx* (Lanham and Oxford: Lexington Books, 2002).

Eagleton, Terry. *Criticism and Ideology* (London: New Left Books, 1975).

———. *The Ideology of the Aesthetic* (Oxford: Basil Blackwell, 1990).

———. *Ideology: An Introduction* (London and New York: Verso, 1991).

Eckstein, Susan Eva. *Power and Popular Protest: Latin American Social Movements* (Berkeley: University of California Press, 1989).

———. *Back from the Future: Cuba under Castro* (Princeton, NJ: Princeton University Press, 1994).

Economic Intelligence Unit. *Cuba Country Report*, 1989, 1990, 1991, 1992, 1993 1988.

Eligio Fernández, Antonio. 'Tree of Many Beaches: Cuban Art in Motion (1980s–1990s)', *Contemporary Art from Cuba* (Arizona and New York: Arizona State University and Delano Greenidge Editions, 1999), pp. 39–66.

Ene, L. 'Plástica Latinoamericana' [Latin American Plastic Arts], *Bohemia*, 11 June 1976.

Escalante, Fabián. *Executive Action: 634 Ways to Kill Fidel Castro* (Melbourne: Ocean Press, 2006).

Espina Prieto, Mayra. 'Social Effects of Economic Adjustment: Equality, Inequality and Trends toward Greater Complexity in Cuban Society', *The Cuban Economy at the Start of the Twenty-First Century* (Cambridge, MA, and London: Harvard University Press, 2004).

———. 'Looking at Cuba Today: Four Assumptions and Six Intertwined Problems', *Socialism and Democracy*, 24, no. 1, March 2010, pp. 95–107.

Espinosa, Norge. 'Letter Signed Norge Espinosa' [by email], 2007.

Fagen, Richard. *The Transformation of Political Culture in Cuba* (Stanford, CA, 1969).

Fellini, Federico. *La Dolce Vita* (film), 1960.

Fanon, Frantz. *The Wretched of the Earth* (Middlesex: Penguin Books, 1976).

Farber, Samuel. *The Origins of the Cuban Revolution Reconsidered* (Chapel Hill: University of North Carolina Press, 2006).

Fernandes, Sujatha. *Cuba Represent!: Cuban Arts, State Power, and the Making of New Revolutionary Cultures* (Durham, NC: Duke University Press, 2007).

Fernández Retamar, Roberto. '¿Va a Enseñarse la Historia de la América Nuestra?' [You're Going to Teach Us the History of Our America?], *Cuba Defendida* [Cuba Defended] (Havana: Editorial Letras Cubanas, 2004 [1959]), pp. 47–9.

———. '1961: Cultura Cubana en Marcha' [1961: Cuban Culture in Progress], *Cuba Defendida* (Havana: Editorial Letras Cubanas, 2004 [1961]), pp. 66–73.

———. 'Para un Diálogo Inconcluso sobre "El Socialismo y el Hombre en Cuba"' [For an Inconclusive Dialogue on 'Socialism and Man in Cuba'], *Cuba Defendida* (Havana: Editorial Letras Cubanas, 2004 [1965]), pp. 178–91.

———. 'Algunas Veces el Che: Un Montón de Memorias' [Sometimes Che: A Mountain of Memories], *Cuba Defendida* (Havana: Editorial Letras Cubanas, 2004 [1965]), pp. 160–70.

———. 'Usted Tenía Razón, Tallet: Somos Hombres de Transición' [You Were Right, Tallet: We Are Men of Transition], poem which may be heard in the author's voice at: Palabravirtual.com.

———. 'Hacia una Intelectualidad Revolucionaria en Cuba' [Towards a Revolutionary Intelligentsia in Cuba], *Cuba Defendida* (Havana: Editorial Letras Cubanas, 2004 [1966]), pp. 265–90.

———. 'Hablar de la Responsabilidad' [Speaking of Responsibility], *Revolución y Cultura*, no. 5, 29 February 1968, pp. 38–40.

———. 'Un Nuevo Contenido de Solidaridad' [A New Content of Solidarity], *Revolución y Cultura*, no. 6, 15 March 1968, pp. 66–7.

———. 'Vanguardia Artística, Subdesarrollo y Revolución' [Artistic Vanguard, Underdevelopment and Revolution], *Estética y Marxismo* (Mexico: D.F.Era, 1970), pp. 333–42.

———. 'Caliban', *Caliban and Other Essays* (Minneapolis: University of Minnesota Press, 1989 [1971]), pp. 3–45.

———. 'Caliban Revisited', *Caliban and Other Essays* (Minneapolis: University of Minnesota Press, 1989 [1986]), pp. 46–55.

———. 'En los Treinta y Cinco Años de la UNEAC' [In the Thirty-Five Years of UNEAC]', *Recuerdo a* [I Remember To] (Havana: Ediciones UNIÓN, 2006 [1995]), pp. 272–4.

———. 'The Enormity of Cuba', *Boundary 2*, 23, no. 3, Autumn 1996, pp. 165–90.

———. 'Caliban en Esta Hora en Nuestra América' [Caliban in this Hour of Our America], *Todo Caliban* (Havana: Fondo Cultural del ALBA, 2000), pp. 117–45.

———. 'The Permanence of Haydée', *Haydée Santamaría* (Sydney: Ocean Press, 2003), pp. 73–85.

———. 'A Cuarenta Añcs de "Palabras a los Intelectuales"' [To Forty Years of 'Words to the Intellectuals'], *Cuba Defendida* (Havana: Editorial Letras Cubanas, 2004 [2001]), pp. 291–305.

———. 'Sobre la Revista *Casa de las Américas*' [On the *Casa de las Américas* Journal], *Casa de las Américas*, 2009.

Fernández-Santos, Francisco. 'Creación Artística y Creación Histórica' [Artistic Creation and Historic Creation], *Revolución y Cultura*, no. 6, 15 March 1968, pp. 87–8.

Fischer, Ernst. *The Necessity of Art: A Marxist Approach* (Middlesex: Penguin Books, 1963).

Fitzpatrick, Sheila (ed.). *Cultural Revolution in Russia 1928–1931* (Bloomington: Indiana University Press, undated).

Flo, Juan J. '¿Estética Antidogmática o Estética no Marxista?' [Antidogmatic Aesthetic or Non-Marxist Aesthetic?], *La Gaceta de Cuba*, III, no. 31, 10 January 1964, reproduced in G. Pogolotti (ed.), *Polémicas Culturales de los 60* [Cultural Polemics of the 1960s] (Havana: Instituto Cubano del Libro, 2006), pp. 102–10.

Florida, Richard. *The Rise of the Creative Class* (Cambridge, MA: Basic Books, 2002).

Foner, Philip S. 'Introduction', *On Art and Literature: Critical Writings* (New York and London: Monthly Review Press, 1982).

Font, Mauricio, and Alfonso W. Quiroz. *The Cuban Republic and José Martí: Reception and Use of a National Symbol* (Lanham and Oxford: Lexington Books, 2006).

Fornet, Ambrosio. 'Al Servicio de la Revolución' [In the Service of the Revolution], *Casa de Las Américas*, V, no. 33, December 1965, pp. 70–3.

———. 'El intelectual en la Revolución' [The Intellectual in the Revolution], *Revolución y Cultura*, no. 5, 29 February 1968.

———. 'La Década Prodigiosa: Un Testimonio Personal' [The Prodigious Decade: A Personal Testimony], S. Maldonado (ed.), *Mirar a los 60: Antología de una Década* [Looking at the 60s: Anthology of a Decade] (Havana: Museo Nacional de Bellas Artes, 2004), pp. 9–13.

———. *Las Trampas del Oficio: Apuntes sobre Cine y Sociedad* [Occupational Hazards: Notes on Film and Society] (Havana: Editorial José Martí, 2007).

———. 'El Quinquenio Gris: Revisitando el Término' [The Five Grey Years: Revisiting the Term], *Narrar la Nación: Ensayos en Blanco y Negro* [Narrating the Nation: Essays in White and Black] (Havana: Editorial Letras Cubanas, 2009), pp. 379–403.

Fornet, Ambrosio, Roberto Fernández Retamar, Roque Dalton, Rene Depestre, Edmundo Desnoes and Carlos Maria Gutierrez. 'Diez Años de Revolución: El Intelectual y la Sociedad' [Ten Years of Revolution: The Intellectual and Society], *Casa de Las Américas*, X, no. 56, October 1969, pp. 7–48.

Fornet, Jorge. *El 71: Anatomía de una Crisis* [In '71: Anatomy of a Crisis] (Havana: Editorial Letras Cubanas, 2013).

Foster, Hal. *The Return of the Real: The Avant-Garde at the End of the Twentieth Century* (Cambridge, MA: MIT Press, 1996).

Fraga, Jorge. '¿Cuántas Culturas?' [How Many Cultures? An open letter to Mirta Aguirre], *La Gaceta de Cuba*, II, no. 28, 18 October 1963, reproduced in G. Pogolotti (ed.), *Polémicas Culturales de los 60* [Cultural Polemics of the 1960s] (Havana: Instituto Cubano del Libro, 2006), pp. 72–85.

———. 'Ambigüedad de la Crítica y la Crítica de la Ambigüedad' [Ambiguity of the Critic and the Critique of Ambiguity], *La Gaceta de Cuba*, III, no. 31, 10 January 1964, reproduced in G. Pogolotti (ed.), *Polémicas Culturales de los 60* [Cultural Polemics of the 1960s] (Havana: Instituto Cubano del Libro, 2006), pp. 35–42.

Franqui, Carlos. *Family Portrait with Fidel* (London: Jonathan Cape, 1983).

Fraser, Andrea. 'From the Critique of Institutions to an Institution of Critique', *Artforum* 44, no. 1, September 2005, pp. 278–85.

Fromm, Erich. *Marx's Concept of Man* (New York: Continuum, 1988 [1961]).

Gabriel. '¿Que Hay de Nuevo?' [What's New?], *Juventud Rebelde*, 31 May 1972.

Gainza, Miguel A. 'Recorren el II Frente de los Artistas Latinoamericana' [Latin American Artists Travel to the Second Front], *Sierra Maestra*, 25 October 1973.

Galardy, Anubis. 'Se Celebran en Nuestro País el I Encuentro de Plástica Latinoamericana' [The Second Meeting of Latin American Plastic Artists Is Held in Our Country], *Granma: Órgano Oficial del Comité Central del Partido Comunista de Cuba*, 16 May 1972.

————. 'Inauguran el Proximo Martes el Segundo Encuentro de Plástica Latinoamericana' [Second Meeting of Latin American Plastic Artists Inaugurated Next Tuesday], *Granma: Órgano Oficial del Comité Central del Partido Comunista de Cuba*, 10 October 1973.

Galeano, Eduardo. *Open Veins of Latin America: Five Centuries of Pillage of a Continent* (New York: Monthly Review Press, 1973).

Gálvez, William. *Camilo: Señor de la Vanguardia* (Havana: Editorial De Ciencias Sociales, 1979).

Garaudy, Roger. *The Turning Point of Socialism* (London: Fontana Books, 1970 [1969]).

García Buchaca, Edith. 'Consideraciones sobre un Manifiesto' [Considerations on a Manifesto], *La Gaceta de Cuba*, II, no. 28, 18 October 1963, reproduced in G. Pogolotti (ed.), *Polémicas Culturales de los 60* [Cultural Polemics of the 1960s] (Havana: Instituto Cubano del Libro, 2006), pp. 26–34.

————. 'Intervención de Edith García Buchaca' [Intervention of Edith García Buchaca], presented at La Primera Plenaria Provincial de Cultura de La Habana [The First Provincial Cultura Plenary of Havana], Payret Theatre, Havana, 25 November 1963.

————. *La Teoría de la Superestructura: La Literatura y El Arte* [Theory of the Superstructure: Literature and Art] (Havana: Consejo Nacional de Cultura, 1961).

García Espinosa, Julio. *La Vivienda* [Housing], 1959.

————. *Sexto Aniversario* [Sixth anniversary (film)], 1959.

————. *Cuba Baila* [Cuba Dances (film)], 1959.

————. 'Vivir Bajo La Lluvia' [Living in the Rain], *La Gaceta de Cuba*, II, no. 15, 1 April 1963, reproduced in G. Pogolotti (ed.), *Polémicas Culturales de los 60* [Cultural Polemics of the 1960s] (Havana: Instituto Cubano del Libro, 2006), pp. 9–13.

————. 'Galgos y Podencos' [Greyhounds and Hounds], *La Gaceta de Cuba*, II, no. 29, 5 November 1963, reproduced in G. Pogolotti (ed.), *Polémicas Culturales de los 60* [Cultural Polemics of the 1960s] (Havana: Instituto Cubano del Libro, 2006), pp. 86–94.

————. *Las Aventuras de Juan Quin Quin* [The Adventures of Juan Quin Quin (film)], 1967.

García Espinosa, Julio, Nicolás Guillén, Tomás Gutiérrez Alea and Humberto Solás. 'Statement by Film-makers', *La Gaceta de Cuba*, II, no. 23, 3 August 1963, reproduced in G. Pogolotti (ed.), *Polémicas Culturales de los 60* [Cultural Polemics of the 1960s] (Havana: Instituto Cubano del Libro, 2006), pp. 17–22.

García Espinosa, Julio, Tomás Gutiérrez Alea and Jorge Fraga. 'Carta de Severino Puente y de Directores del ICAIC' [Severino Puente's Letter and That of the Directors of ICAIC], *Revolución*, 17 December 1963, reproduced in G. Pogolotti (ed.), *Polémicas Culturales de los 60* [Cultural Polemics of the 1960s] (Havana: Instituto Cubano del Libro, 2006), pp. 152–7.

García Incháustegui, Mario. 'Inaugurado la Exposición del Segundo Encuentro de Plástica Latinoamericana' [Exhibition of the Second Meeting of Latin American Plastic Artists Inaugurated], *Juventud Rebelde*, 28 October 1973.

Garrudo Marañón, Mercedes, and Armando Hart Dávalos. *Resolución No. 8/78: Resolución Que Crea el Sistema Nacional de Casas de Cultura* [Resolution No. 8/78: Resolution Creating the National System of Casas de Cultura] (Havana: Ministerio de Cultura, 1978).

George, Susan. 'Winning the War of Ideas', *Dissent*, Summer 1997.

Gilbert, Chris. Resignation statement, available at: Stretcher.org/features/chris_gilbert_resigns/

Gilman, Claudia. *Entre la Pluma y el Fusil: Debates y Dilemas del Escritor Revolucionario en América Latina* [Between the Quill and the Rifle: Debates and Dilemmas of the Revolutionary Writer in Latin America] (Buenos Aires: Siglo Veintiuno, 2003).

Gil, Silvia, Ana Cecilia Ruiz Lim and Chiki Salsamendi (eds.). *Haydée Santamaría* (Havana: Casa de las Américas, 2009).

Goldenberg, Boris. *The Cuban Revolution and Latin America* (New York: Frederick A. Praeger, 1965).

González, Ariel. 'Lunes de Revolución y la Ideostética del Compromiso' [*Lunes de Revolución* and the Ideo-Aesthetics of Commitment], *Temas*, September 2002.

González, Mike. *Che Guevara and the Cuban Revolution* (London: Bookmarks, 2004).

González, Reynaldo. 'Letter from Reynaldo González', January 2007.

Gordon-Nesbitt, Rebecca. 'Don't Look Back in Anger', M. Lind (ed.), *Cultural Policy in 2015* (Stockholm and Vienna: International Artists Studio Program in Sweden [IASPIS] and European Institute of Progressive Cultural Policy [EIPCP], 2006).

———. 'False Economies', B. Drabble and D. Richter (eds.), *Curating Critique* (Edinburgh: Edinburgh College of Art, 2007), pp. 116–21.

———. *Value, Measure, Sustainability: Ideas towards the Future of the Small-Scale Visual Arts Sector* (London: Common Practice, December 2010). http://www.commonpractice.org.uk/wp-content/uploads/2014/11/Common-Practice_Value_Measure_Sustainability.pdf.

———. 'Third Wave Privatisation of Cultural Provision in the UK', *ArtSceneTrondheim*, October 2011. http://www.trondheimkunsthall.com/news/ThirdWavePrivatisationofCulturalProvisionintheUK.

———. 'Misguided Loyalties', *Conflict, Community Culture: A Critical Analysis of Culture-Led Regeneration*, 2013. http://shiftyparadigms.org/misguided_loyalties.htm.

Gorky, Maxim. 'Soviet Literature', M. Gorky, K. Radek, N. Bukharin, A. Zhdanov et al, *Soviet Writers' Congress 1934: The Debate on Socialist Realism and Modernism in the Soviet Union* (London: Lawrence & Wishart, 1977), pp. 27–69.

Gorky, Maxim, Karl Radek, Nikolai Bukharin, Andrey Zhdanov et al. *Soviet Writers' Congress 1934: The Debate on Socialist Realism and Modernism in the Soviet Union* (London: Lawrence & Wishart, 1977 [1935]).

Gott, Richard. *Cuba: A New History* (New Haven and London: Yale University Press, 2004).

Gouldner, Alvin W. 'The Sociologist as Partisan: Sociology and the Welfare State', *The American Sociologist*, 3, no. 2, May 1968, pp. 103–16.

Graf, William. 'The State in the Third World', *Socialist Register* (London: Merlin Press, 1995).

Gramatges, Harold. 'La Sociedad Cultural Nuestro Tiempo' [The Nuestro Tiempo Cultural Society], R.L. Hernández Otero (ed.), *Sociedad Cultural Nuestro Tiempo* (Havana: Editorial Letras Cubanas, 2002), pp. 281–306.

Gramsci, Antonio. *Selections from Prison Notebooks* (New York: International Publishers, 1971).

———. *Selections from Cultural Writings* (Cambridge, MA: Harvard University Press, 1991).

Grasskamp, Walter. Molly Nesbit and Jon Bird, *Hans Haacke* (London: Phaidon, 2004).

Gray, Alexander Ian, Antoni Kapcia and John M. Kirk. *The Changing Dynamic of Cuban Civil Society* (Gainesville: University Press of Florida, 2008).

Guerra, Lillian. *The Myth of José Martí: Conflicting Nationalisms in Early Twentieth-Century Cuba* (Chapel Hill and London: The University of North Carolina Press, 2005).

Guevara, Alfredo. 'Sobre un Debate Entre Cineastas Cubanos' [On a Debate between Cuban Film-makers], *Cine Cubano*, no. 14–15, November 1963, reproduced in G. Pogolotti (ed.), *Polémicas Culturales de los 60* [Cultural Polemics of the 1960s] (Havana: Instituto Cubano del Libro, 2006), pp. 23–5.

———. 'Alfredo Guevara Responde a las Aclaraciones' [Alfredo Guevara Responds to the Clarifications], *Hoy*, 18 December 1963, reproduced in G. Pogolotti (ed.), *Polémicas*

Culturales de los 60 [Cultural Polemics of the 1960s] (Havana: Instituto Cubano del Libro, 2006), pp. 169–74.

————. 'Declaraciones de Alfredo Guevara' [Declarations of Alfredo Guevara], *Hoy*, 21 December 1963, reproduced in G. Pogolotti (ed.), *Polémicas Culturales de los 60* [Cultural Polemics of the 1960s] (Havana: Instituto Cubano del Libro, 2006), pp. 199–203.

————. 'Aclarando Aclaraciones' [Clarifying Clarifications], December 1963 [unpublished], reproduced in G. Pogolotti (ed.), *Polémicas Culturales de los 60* [Cultural Polemics of the 1960s] (Havana: Instituto Cubano del Libro, 2006), pp. 233–45.

————. *Tiempo de Fundación* (Madrid: Iberautor Promociones Culturales, 2003).

————. 'Palabras de Alfredo Guevara en la Inauguración de la 31 edición del Festival Internacional del Nuevo Cine Latinoamericano' [Alfredo Guevara's Inaugural Words to the 31st International Festival of New Latin American Film], *Diario del Festival*, 5 December 2009.

Guevara, Alfredo, and Leadro Estupiñán Zalvidar. 'El Peor Enemigo de La Revolución Es La Ignorancia' [The Worst Enemy of the Revolution Is Ignorance], *Revista Caliban*, May 2007.

Guevara, Ernesto. *Guerrilla Warfare* (Lincoln: University of Nebraska Press, 1998 [1961]).

————. 'El Socialismo y el Hombre en Cuba' [Socialism and Man in Cuba], *Marcha*, 12 March 1965.

Guillén, Nicolás. 'Report to the First National Congress of Writers and Artists' presented at the First National Congress of Writers and Artists, Havana, 19 August 1961, *The Revolution and Cultural Problems in Cuba* (Havana: Ministry of Foreign Relations, 1962), pp. 41–64.

Gutiérrez Alea, Tomás. 'Realidades del Cine en Cuba' [Realities of Film in Cuba], R.L. Hernández Otero (ed.), *Sociedad Cultural Nuestro Tiempo* (Havana: Editorial Letras Cubanas, 2002 [1954]), pp. 109–32.

————. *Las Doce Sillas* [Twelve Chairs (film)], 1962.

————. 'Notas sobre una Discusión de un Documento sobre una Discusión (de otros Documentos)' [Notes on a Discussion of a Document on a Discussion (of Other Documents)], *La Gaceta de Cuba*, II, no. 29, 5 November 1963, reproduced in G. Pogolotti (ed.), *Polémicas Culturales de los 60* [Cultural Polemics of the 1960s] (Havana: Instituto Cubano del Libro, 2006), pp. 95–101.

————. 'Donde Menos Se Piensa el Calzador... de Brutas' [Witch-hunters Where You Least Expect Them], *La Gaceta de Cuba*, III, no. 33, 20 March 1964, reproduced in G. Pogolotti (ed.), *Polémicas Culturales de los 60* [Cultural Polemics of the 1960s] (Havana: Instituto Cubano del Libro, 2006), pp. 111–25.

————. *La Muerte de un Burócrata* [The Death of a Bureaucrat (film)], 1966.

————. *Memorias del Subdesarrollo* [Memories of Underdevelopment], 1968.

Gutiérrez Alea, Tomás, Julio García Espinosa, Alfredo Guevara Valdés and José Massip. *El Mégano*, 1955.

Gutiérrez Alea, Tomás, and Julio García Espinosa. *Esta Tierra Nuestra* [This Land of Ours (film)], 1959.

Gutiérrez Alea, Tomás, Juan Carlos Tabío and Senel Paz. *Fresa y Chocolate* [Strawberry and Chocolate (film)], 1993.

Gwynne, Robert, and Cristóbal Kay. 'Views from the Periphery: Futures of Neoliberalism in Latin America', *Third World Quarterly*, 21, no. 1, 2000.

Haacke, Hans. *Framing and Being Framed: 7 Works 1970–75* (New York: New York University Press, 1976).

Halimi, Gisele. 'De la Cultura de Opresión a la Cultura de Emancipación' [From the Culture of Oppression to the Culture of Emancipation], *Revolución y Cultura*, no. 5, 29 February 1968, pp. 41–2.

Harnecker, Marta. *Fidel Castro's Political Strategy: From Moncada to Victory* (New York: Pathfinder Press, 1987).

Harnecker, Martin. *Cuba: Dictatorship or Democracy?* (Westport, CT: Lawrence Hill, 1975).

Hart Dávalos, Armando. *Resolución no. 32/78: Resolución Que Reglamenta las Actividades en las Casas de Cultura* [Resolution no. 32/78: Resolution Which Legislates for the Activities of the Casas de Cultura] (Havana: Ministerio de Cultura, 1979).

———. 'Hacia El Siglo XXI: Fuentes Necesarias' [Towards the Twenty-First Century: Required Sources], *Cuba Socialista*, no. 3, 1996, pp. 2–14.

Harvey, David. *The Condition of Postmodernity: An Enquiry into the Origins of Cultural Change* (Oxford: Blackwell, 1980).

———. *A Brief History of Neoliberalism* (Oxford: Oxford University Press, 2005).

Hegel, Georg Wilhelm Friedrich. *Introductory Lectures on Aesthetics* (London: Penguin Books, 2004).

Heras León, Eduardo. 'El Quinquenio Gris: Testimonio de una Lealtad' [The Five Grey Years: Testimony of a Loyalty', presented at Casa de las Americas as part of a cycle of events entitled 'The cultural policy of the revolutionary period: Memory and reflection'], 2007.

Hernández Otero, Ricardo Luis. *Sociedad Cultural Nuestro Tiempo: Resistencia y Acción* [Nuestro Tiempo Cultural Society: Resistance and Action] (Havana: Editorial Letras Cubanas, 2002).

Hernández Otero, Ricardo Luis, and Enrique Saínz. 'Nuestro Tiempo', R.L. Hernández Otero (ed.), *Sociedad Cultural Nuestro Tiempo* (Havana: Editorial Letras Cubanas, 2002), pp. 320–6.

Hernández, Rafael. *Looking at Cuba: Essays on Culture and Civil Society* (Gainesville: University Press of Florida, 2003.

Horowitz, Irving Louis. *Cuban Communism* (Brunswick, NJ: Transaction Inc., 1987).

Howe, Linda S. *Transgression and Conformity: Cuban Writers and Artists after the Revolution* (Madison: University of Wisconsin Press, 2004).

Hudis, Peter, and Kevin B. Anderson. 'Raya Dunayevskaya's Concept of the Dialectic', *The Power of Negativity: Selected Writings on the Dialectic in Hegel and Marx* (Lanham and Oxford: Lexington Books, 2002).

ICAIC. 'Declaración de los Cineastas Cubanos', *Cine Cubano*, 11, no. 69–70, May–July 1971.

Iglesias Leyva, Joel. *De la Sierra Maestra al Escambray* [From the Sierra Maestra to Escambray] (Havana: Editorial Letras Cubanas, 1979).

Instituto Cubano del Libro. *Cultural Congress of Havana: Meeting of Intellectuals from All the World on Problems of Asia, Africa and Latin America* (Havana: Instituto Cubano del Libro, 1968).

———. *Cuba '71: I Congreso Nacional de Educación y Cultura* [First Congress on Education and Culture] (Havana: Instituto Cubano del Libro/Editorial Ámbito, 1971).

Jalée, Pierre. 'Cultura y Explotación Económica' [Culture and Economic Exploitation], *Revolución y Cultura*, no. 4, 15 February 1968, pp. 13–14.

Jameson, Fredric. 'Foreword', *Calibán* (Minneapolis: University of Minnesota Press, 1989).

———. *Postmodernism, or, The Cultural Logic of Late Capitalism* (Durham, NC: Duke University Press, 1990).

Jouffroy, Alain. 'Formación Integral del Hombre' [Integral Development of Man], *Revolución y Cultura*, no. 4, 15 February 1968, pp. 24–6.

Kant, Immanuel. *The Critique of Judgement* (Oxford: Oxford University Press, 1790).

Kapcia, Antoni. 'Revolution, the Intellectual and a Cuban Identity: The Long Tradition', *Bulletin of Latin American Research*, 1, no. 2, May 1982, pp. 63–78.

———. *Cuba: Island of Dreams* (Oxford: Berg Publishers, 2000).

———. *Havana: The Making of Cuban Culture* (Oxford and New York: Berg, 2005).

———. *Cuba in Revolution: A History since the Fifties* (London: Reaktion Books, 2008).

———. *Leadership in the Cuban Revolution: The Unseen Story* (London: Zed Books, 2014).

Kapcia, Antoni, and Par Kumaraswami. *Literary Culture in Cuba: Revolution, Nation-Building and the Book* (Manchester: Manchester University Press, 2012).

Karol, K.S. *Guerrillas in Power: The Course of the Cuban Revolution* (London: Jonathan Cape, 1971).

Kirk, John M. 'Prologue', J.M. Kirk and L. Padura Fuentes (eds.), *Culture and the Cuban Revolution: Conversations in Havana* (Gainesville: University Press of Florida, 2001).

Kirk, John M., and Leonardo Padura Fuentes. *Culture and the Cuban Revolution: Conversations in Havana* (Gainesville: University Press of Florida, 2001).

Knell, John, and Matthew Taylor. *Arts Funding, Austerity and the Big Society: Remaking the Case for the Arts* (London: RSA, 2011).

Kronenberg, Clive W. 'Che and the Pre-Eminence of Culture in Revolutionary Cuba: The Pursuit of a Spontaneous, Inseparable Integrity', *Cultural Politics*, 7, no. 2, 2011, pp. 189–218.

Kumaraswami, Par. 'Cultural Policy and Cultural Politics in Revolutionary Cuba: Re-reading the Palabras a los Intelectuales (Words to the Intellectuals)', *Bulletin of Latin American Research*, 28, no. 4, 2009, pp. 527–41.

Lasch, Christopher. 'The Cultural Cold War: A Short History of the Congress for Cultural Freedom', B.J. Bernstein (ed.), *Towards a New Past: Dissenting Essays in American History* (London: Chatto and Windus, 1970), pp. 322–59.

Latin American Artists. 'Manifiesto de los Artistas Latinoamericanas' [Manifesto of Latin American Artists], Manifesto, Havana, May 1972.

Lenin, Vladimir I. *Imperialism: The Last Stage of Capitalism*, undated.

————. *On Socialist Culture and Ideology* (Moscow: Foreign Languages Publishing House, 1960 [1909, 1920]).

Levitas, Ruth, and Will Guy (eds.). *Interpreting Official Statistics* (London and New York: Routledge, 1996).

Libby, Gary R. *Cuba: A History in Art* (Daytona Beach, FL: Museum of Arts and Sciences, 1997).

Liebman, Marcel. 'Responsabilidad Real de un Intelectual de Izquierda Europeo hacia el Tercer Mundo' [Current Responsibility of an Intellectual from the European Left towards the Third World], *Revolución y Cultura*, no. 5, 29 February 1968, pp. 43–4.

Llanusa Gobel, José. 'Hay Cuestiones de Método Que Se Convierten en Cuestiones de Principios' [There Are Questions of Method Which Become Questions of Principle], *Granma: Órgano Oficial del Comité Central del Partido Comunista de Cuba*, 13 January 1968 (supplement edition).

Llanusa Gobel, José, and Osvaldo Dorticós Torrado. *Seminario Preparatorio del Congreso Cultural de la Habana* [Preparatory Seminar of the Cultural Congress of Havana] (Havana: Instituto Cubano del Libro, 1967).

Lockwood, Lee. *Castro's Cuba, Cuba's Fidel: An American Journalist's Inside Look at Today's Cuba in Text and Pictures* (Boulder, CO: Westview Press, 1990).

Loomis, John A. *Revolution of Forms: Cuba's Forgotten Art Schools* (New York: Princeton Architectural Press, 1999).

Lopez Morales, Eduardo, Orlando Yanes and José Antonio Portuondo. '¿Que Opina Su del Congreso?', *Verde Olivo*, 16 May 1971.

López-Nussa, Leonel. 'El Grito' [The Scream], *Hoy*, 18 December 1963, reproduced in G. Pogolotti (ed.), *Polémicas Culturales de los 60* [Cultural Polemics of the 1960s] (Havana: Instituto Cubano del Libro, 2006), pp. 175–7.

López Oliva, Manuel. 'El Proceso Didáctico de las Artes Plásticas en Cuba', *Granma*, 23 September 1969.

Luis, William (ed.). *Lunes de Revolución: Literatura y Cultura en los Primeros Años de la Revolución Cubana* [*Lunes de Revolución*: Literature and Culture in the Early Years of the Cuban Revolution] (Madrid: Editorial Verbum, 2003).

Lukov, Leonid. *The Great Life* (film), 1948.

Lumsden, C. Ian. 'The Ideology of the Revolution', R.E. Bonachea and N.P. Valdés (eds.), *Cuba in Revolution* (Garden City, NY: Doubleday & Company, 1972 [1969]).

Lutjens, Sheryl L. *The State, Bureaucracy, and the Cuban Schools* (Boulder, CO: Westview Press, 1996).

MacEwan, Arthur. *Neoliberalism or Democracy? Economic Strategy, Markets and Alternatives for the Twenty-First Century* (London: Zed Books, 1999).

Maclean, Betsy (ed.). *Haydée Santamaría* (Sydney: Ocean Press, 2003).

Makdissi, Antone. 'Revolución y Cultura' [Revolution and Culture], *Revolución y Cultura*, no. 4, 15 February 1968, pp. 21–4.

Maldonado, Sonia (ed.). *Mirar a los 60: Antología de una Década* [Looking at the 60s: Anthology of a Decade] (Havana: Museo Nacional de Bellas Artes, 2004).

Mao Zedong. *Selected Works*, Vol. III (Beijing: People's Publishing House, 1991).

Marcuse, Herbert. 'Preface', R. Dunayevskaya, *Marxism and Freedom: From 1776 until Today* (London: Pluto Press, 1975 [1958]).

———. 'Art in the One-Dimensional Society', *Arts Magazine*, 41, 7, May 1967, originally a lecture at the New York School of Visual Arts (8 March 1967), reprinted in L. Baxandall (ed.), *Marxism and Aesthetics: A Selective Annotated Bibliography* (New York: Humanities Press, 1968).

Martí, José. 'Our America', P.S. Foner (ed.), *Our America by José Martí: Writings on Latin America and the Struggle for Cuban Independence* (New York and London: Monthly Review Press, 1977 [1891]), pp. 84–94.

———. P.S. Foner (ed.), *On Art and Literature: Critical Writings* (New York and London: Monthly Review Press, 1982).

Martínez, Juan A. *Cuban Art & National Identity: The Vanguardia Painters, 1927–1950* (Gainesville: University Press of Florida, 1994).

Marx, Karl. 'Debating the Freedom of the Press', L. Baxandall and S. Morawski (eds.), *Karl Marx and Frederick Engels on Literature and Art* (Nottingham: Critical, Cultural and Communications Press, 2006 [1842]).

———. 'On the Jewish Question', R.C. Tucker (ed.), *The Marx-Engels Reader* (New York: W.W. Norton, 1978 [1844]), 26–52.

———. 'Economic and Philosophic Manuscripts of 1844', L. Baxandall and S. Morawski (eds.), *Karl Marx and Frederick Engels on Literature and Art* (Nottingham: Critical, Cultural and Communications Press, 2006 [1844]).

———. 'Theories of Surplus Value', L. Baxandall and S. Morawski (eds.), *Karl Marx and Frederick Engels on Literature and Art* (Nottingham: Critical, Cultural and Communications Press, 2006 [1861-2]).

———. *Grundrisse: Foundations of the Critique of Political Economy* (London: Penguin Books, 1973 [1857–61]).

Marx, Karl, and Frederick Engels. C.J. Arthur (ed.). *The German Ideology* (London: Lawrence and Wishart, 1970 [1846]).

Massia, Alejandro, and Julio Otero. 'The Cuban Revolution Reminds Him of Many Who Were Intellectuals and Who Are Not Now', *CubaNews*, November 2004.

Massip, José. 'Cincuenta Años de Nuestro Tiempo' [Fifty Years of Nuestro Tiempo], R.L. Hernández Otero (ed.), *Sociedad Cultural Nuestro Tiempo* (Havana: Editorial Letras Cubanas, 2002), pp. 327–31.

Mayakovsky, Vladimir. *How Are Verses Made?* (London: Cape Editions, 1970 [1926]).

McCracken, Grant. *The Long Interview* (London: Sage, 1988).

Mella, Julio Antonio. *Documentos y Artículos* [Documents and Articles] (Havana: Instituto Cubano del Libro, 1975).

Mena Chicuri, Abelardo G. *Cuba Avant-Garde: Contemporary Art from the Farber Collection* (Gainesville: University of Florida Press, 2007).

Mesa-Lago, Carmelo (ed.). *Revolutionary Change in Cuba* (Pittsburgh: University of Pittsburgh Press, 1971).

Miller, Maria. 'Testing Times: Fighting Culture's Corner in an Age of Austerity', 24 April 2013. https://www.gov.uk/government/speeches/testing-times-fighting-cultures-corner-in-an-age-of-austerity.

Miller, Nicola. *In the Shadow of the State: Intellectuals and the Quest for National Identity in Twentieth Century Spanish America* (London and New York: Verso, 1999).

———. 'A Revolutionary Modernity: The Cultural Policy of the Cuban Revolution', *Journal of Latin American Studies*, 40, Special Issue 04 (Cuba: 50 Years of Revolution), 2008, pp. 675–96.

———. *Reinventing Modernity in Latin America: Intellectuals Imagine the Future, 1900–1930* (New York and London: Palgrave Macmillan, 2008).

Mills, C. Wright. *Listen, Yankee: The Revolution in Cuba* (New York: Ballantine Books, 1960).

Ministerio de Cultura (MINCULT). *Personalidades Que Han Sobresalido por Su Actividad Artistica o Que Han Hecho un Aporte de Consideración al Desarrollo de la Cultura Nacional* (Havana: Ministerio de Cultura, 1976).

———. *Documentos Normativos para la Actividad de Capacitación y Superación* (Havana: Ministerio de Cultura, 1979).

———. *Plan Actual de Tareas Principales del Ministerio de Cultura 1979–* [Current Plan of Principal Tasks of the Ministry of Culture 1979-] (Havana: Ministerio de Cultura, 1979).

———. *Principales Leyes y Disposiciones Relacionades con la Cultura, les Artes y la Enseñanza Artistica* [Principal Laws and Dispositions Related to Culture, the Arts and Artistic Teaching] (Havana: Ministerio de Cultura, 1982).

———. *Directorio: Instituciones Culturales* [Directory: Cultural Institutions] (Havana: Ministerio de Cultura, 1983).

———. *La Campana Nacional por la Lectura Debe Entenderse como una Profundización de la Campaña Nacional por la Cultura* (Havana: Ministerio de Cultura, 1985).

———. *Algunos Datos Sobre la Gestion Cultural Actual* [Some Data on Current Cultural Development] (Havana: Ministerio de Cultura, 1991).

Ministerio de Educación (MINED). *Ley de la Propiedad Intelectual y Su Reglamento*, 1934.

———. *Cursos de Superación Para Maestros* [Improvement Courses for Teachers] (Havana: Editorial Nacional de Cuba/Editorial Ministerio de Educación, 1963).

———. *Algunos Datos sobre la Educación en Cuba* [Some Data on Education in Cuba] (Havana: Ministerio de Educación, 1975).

Ministerio de Relaciones Exteriores (MINREX). *Camilo Cienfuegos: People's Hero* (Havana: Ministerio de Relaciones Exteriores, 1962).

———. *The Revolution and Cultural Problems in Cuba* (Havana: Ministry of Foreign Relations, 1962). Available online at: http://www.walterlippmann.com/fc-06-30-1961.html

———. *Suplemento/Sumario: La Funcion Cultural-Educacional del Estado Socialista Cubano* [Supplement: The Cultural-Educational Function of the Cuban Socialist State] (Havana: Dirección de Prensa, Información y Relaciones Culturales, 1976).

Ministry of Industry (MININD). *Report of Cuba to the XIV Meeting of the General Conference of UNESCO* (Havana: Ministry of Industry, 1966).

Moore, Robin D. *Music and Revolution: Cultural Change in Socialist Cuba* (Berkeley: University of California Press, 2006).

Morris, Desmond. *The Naked Ape: A Zoologist's Study of the Human Animal* (London: Jonathan Cape, 1967).

———. *The Human Zoo* (St Albans: Triad Panther, 1969).

Morris Hargreaves McIntyre. *Taste Buds: How to Cultivate the Art Market* (London: Arts Council England, 2004).

Mosquera, Gerardo. 'Cuba 1950–1995', E.J. Sullivan (ed.), *Latin American Art in the Twentieth Century* (London: Phaidon Press, 1996).

———. 'Introduction', *Revolution of Forms: Cuba's Forgotten Art Schools* (New York: Princeton Architectural Press, 1999).

————. 'The Infinite Island: Introduction to New Cuban Art', *Contemporary Art from Cuba* (Arizona and New York: Arizona State University and Delano Greenidge Editions, 1999), pp. 23–37.

————. 'New Cuban Art Y2K', *Art Cuba: The New Generation* (New York: Harry n. Abrams Incorporated, 2001), pp. 13–6.

————. A. Erjavec (ed.), *Postmodernism and the Postsocialist Condition* (Berkeley: University of California Press, 2003).

————. 'Modernidad Y Africanía: Wifredo Lam in His Island' [Modernity and African-Ness], *Third Text*, 6, no. 20 (undated), pp. 43–68.

Mosquera, Gerardo, Antonio Eligio and Marilyn Zeitlin (eds.). *Contemporary Art from Cuba* (New York: Delano Greenidge Editions, 1999).

Murúa, Lautaro. *Alias Gardelito* (film), 1961.

Nahmias, Alysa, and Ben Murray. *Unfinished Spaces* (film), 2001.

Navarro, Desiderio. 'In Media Respublica' [In the Midst of the Public Sphere], *La Gaceta de Cuba*, no. 3, June 2001, pp. 40–5.

————. 'Introducción al Ciclo "La Política Cultural del Periodo Revolucionario: Memoria y Reflexion"' [Introduction to the Series 'The Cultural Policy of the Revolutionary Period: Memory and Reflection'], Havana, 2007.

————. 'Letter from Desiderio Navarro', January 2007.

Nussa, Ele. 'Encuentro de Plástica Latinoamericana' [Meeting of Latin American Plastic Artists in Cuba], *Bohemia*, 8 June 1979.

Oliver-Smith, Kerry, A.G. Mena Chicuri. 'Globalization and the Vanguard', *Cuba Avant-Garde: Contemporary Art from the Farber Collection* (Gainesville: University of Florida Press, 2007).

Otero, Lisandro. *Cultural Policy in Cuba* (Paris: UNESCO, 1972).

————. *Dissenters and Supporters in Cuba* (Havana: José Martí, 1987).

————. *Llover sobre Mojado: Una Reflexión Personal sobre la Historia* [To Rain on the Wet: A Personal Reflection on History] (Havana: Editorial Letras Cubanas, 1997).

Padilla, Heberto. Speech to UNEAC, 27 April 1971, available at: Marionoya.com/2011/03/29/padilla-ante-la-union-de-escritores-y-artistas-de-cuba-27-de-abril-de-1971/

Padura Fuentes, Leonardo. 'Living and Creating in Cuba: Risks and Challenges', *Culture and the Cuban Revolution: Conversations in Havana* (Gainesville: University Press of Florida, 2001).

Páez, Tubal. 'El Desarrollo de Cuba Se Ha Hecho Posible Gracias a la Sierra Maestra' [The Development of Cuba Has Been Made Possible Thanks to the Sierra Maestra: Interview with Pierre Jalee], *Granma: Órgano Oficial del Comité Central del Partido Comunista de Cuba*, 10 January 1968.

Palevitch, Esteban. 'Diego Rivera: El Artista de una Clase' [The Artist of a Class], *Amauta*, no. 5, January 1927, cited in David Craven, *Art and Revolution in Latin America 1910–1990* (New Haven, CT, and London: Yale University Press, 2006).

Panabière, Louis. 'Les Intellectuels et L'État au Mexique (1930–1940) – Le Cas de Dissidence des *Contemporáneos*' [Intellectuals and the State in Mexico (1930–1940) – the Case of Dissidence of *Contemporáneos*], *Intellectuels et État au Mexique* (GRAL Institut, undated), pp. 77–112.

Papastamatiu, Basilia. 'Sobre la Pintura Panameña' [On Panamanian Painting], *Juventud Rebelde*, 24 May 1976.

Pasolini, Pier Paolo. *Accattone* (film), 1961.

PCC Central Committee. *Information from the Central Committee of the Communist Party of Cuba on Microfaction Activity* (Havana: Instituto del Libro, 1968).

Pérez, Louis A. *Cuba: Between Reform and Revolution* (New York: Oxford University Press Inc, 1990).

————. *On Becoming Cuban: Identity, Nationality and Culture* (Chapel Hill: The University of North Carolina Press, 1999).

Pichardo, Hortensia. 'Constitución de la República de Cuba' [Constitution of the Republic of Cuba], *Documentos para la Historia de Cuba*, IV: Part 2, Editorial de Ciencias Sociales, La Habana, 1940, pp. 329–418.

Pindera, Agnieszka. 'Touring Culture', *Re-tooling Residencies* (Warsaw: Centre for Contemporary Art Ujazdowski Castle, 2011), pp. 140–57.

Piñeiro Loredo, Carlos. 'Artes Plásticas y Lucha Revolucionaria: Mesa Redonda' [Plastic Arts and Revolutionary Struggle: Round-Table], *Casa de las Américas*, XIII, no. 74, October 1972, pp. 151–9.

Plekhanov, G.V. *Art and Social Life* (Moscow: Progress Publishers, 1974).

Pogolotti, Graziella. 'Para una Cultura Revolucionaria: Nuevos y Viejos Valores' [For a Revolutionary Culture: New and Old Values], *Casa de las Américas*, XVIII, no. 104, October 1977, pp. 108–13.

————. *Experiencia de la Crítica* [Experience of the Critic] (Havana: Editorial Letras Cubanas, 2003).

————. 'Los Sesenta no Fueron Light' [The Sixties Weren't Light], S. Maldonado (ed.), *Mirar a los 60: Antología de una Década* [Looking at the 60s: Anthology of a Decade] (Havana: Museo Nacional de Bellas Artes, 2004), pp. 15–19.

————. *Polémicas Culturales de los 60* [Cultural Polemics of the 1960s] (Havana: Instituto Cubano del Libro, 2006).

————. Interview with the author, 9 March 2010.

Polanyi, Karl. *The Great Transformation* (New York: Octagon Books, 1944).

Portela, Ena Lucia. 'Letter to Reynaldo González' [by email], January 2007.

Portuondo, José Antonio. *Estética y Revolución* [Aesthetics and Revolution] (Havana: Ediciones UNIÓN, 1963).

————. 'Las Classes en el Proceso Cultural Cubano' [Classes in the Cuban Cultural Process], *Revolución y Cultura*, no. 6, 15 March 1968, pp. 40–5.

————. *Itinerio Estético de la Revolución Cubana* [Aesthetic Itinerary of the Cuban Revolution] (Havana: Letras Cubanas, 1979).

Power, Kevin. 'Cuba: One Story after Another', K. Power and P. Perez (eds.), *While Cuba Waits: Art from the Nineties* (Santa Monica, CA: Smart Art Press, 1999).

Pratt, Andy C. 'Creative Cities: Tensions within and between Social, Cultural and Economic Development A Critical Reading of the UK Experience', *City, Culture and Society*, no. 1, 2010, pp. 13–20.

Prieto Jiménez, Abel. 'La Cultura Cubana: Resistencia, Socialismo y Revolución' [Cuban Culture: Resistance, Socialism and Revolution], *Cuba Socialista*, no. 2, undated, pp. 2–11.

Provincia Holguín. *Datos de Interes en la Cultura* [Data of Relevance to Culture] (Holguín: Provincia Holguín, 1989).

Puente, Severino. 'Preguntas sobre Películas' [Questions on Films], *Hoy*, 12 December 1963, reproduced in G. Pogolotti (ed.), *Polémicas Culturales de los 60* [Cultural Polemics of the 1960s] (Havana: Instituto Cubano del Libro, 2006), pp. 145–8.

Quinn, Kate. 'Cuban Historiography in the 1960s: Revisionists, Revolutionaries and the Nationalist Past', *Bulletin of Latin American Research* 26, no. 3, July 2007, pp. 378–98.

Rafael. 'Un Arme de Combat' [A Weapon of Combat], *Verde Olivo*, 11 June 1972.

Rafael Rodríguez, Carlos. 'Las Instituciones Culturales y la Situación Cubana' [Cultural Institutions and the Cuban Situation], *Havana*, January 1958.

————. 'Problemas del Arte en la Revolución' [Problems of Art in the Revolution], *Revolución y Cultura*, no. 1, 1 October 1967, pp. 6–32, republished in *Revolución: Letras Artes*, (Havana: Letras Cubanas, 1980) pp. 49–85.

————. 'Cuba: Ejemplo de América; Informe de la Delegación de Cuba al Congreso de la CEPAL, Intervención del Presidente y Conferencia con la Prensa Mundial', Press Conference presented at the CEPAL, Lima, 17 April 1969.

————. *Cuba en el Tránsito al Socialismo, 1959–1963: Lenin y la Cuestión Colonial* [Cuba in Transition to Socialism 1959–63: Lenin and the Colonial Question] (Mexico City: Siglo Veintiuno, 1978).

————. 'Discurso en la Celebración de Su Trigésimo Aniversario' [Discourse in Celebration of Its Thirtieth Anniversary], R.L. Hernández Otero (ed.), *Sociedad Cultural Nuestro Tiempo* (Havana: Editorial Letras Cubanas, 2002), pp. 307–16.

————. 'Haydée: Fire and Light', B. Maclean (ed.), *Haydée Santamaría* (Sydney: Ocean Press, 2003), pp. 90–1.

Ramírez, Mari Carmen. 'Brokering Identities: Art Curators and the Politics of Cultural Representation', *Thinking about Exhibitions* (New York: Routledge, 1996), pp. 21–38.

Randall, Margaret. *Haydée Santamaría: She Led by Transgression* (Durham, NC: Duke University Press, 2015).

Rapoport, Anatol. 'Have the Intellectuals a Class Interest?', Hans Peter Dreitzel (ed.), *Recent Sociology*, no.1 (London: Macmillan, 1969).

Read, Herbert. 'What Is Revolutionary Art?', C. Harrison and P. Wood (eds.), *Art in Theory 1900–1990: An Anthology of Changing Ideas* (Oxford: Blackwell, 1992 [1935]), 502–6.

————. 'The Problems of Internationalism in Art', *The Magazine of the Institute of Contemporary Arts*, no. 7, October 1968, pp. 1–4.

Reyes, Arnoldo. 'Sobre El Movimiento de Aficionados' [On the Amateur Movement], *Revolución y Cultura*, no. 4, June 1972, pp. 2–9.

Ripoll, Carlos. 'Writers and Artists in Today's Cuba', I.L. Horowitz (ed.), *Cuban Communism* (Brunswick, NJ: Transaction Inc., 1987), pp. 456–70.

Robertson, Iain. *Understanding International Art Markets and Management* (London and New York: Routledge, 2005).

Roca Calderío, Blas. 'Declaraciones de Blas Roca' [Declarations of Blas Roca], *Hoy*, 24 December 1963, reproduced in G. Pogolotti (ed.), *Polémicas Culturales de los 60* [Cultural Polemics of the 1960s] (Havana: Instituto Cubano del Libro, 2006), p. 216.

————. 'Respuesta a Alfredo Guevara I' [Response to Alfredo Guevara I], *Hoy*, Aclaraciones [Clarifications], 19 December 1963, reproduced in G. Pogolotti (ed.), *Polémicas Culturales de los 60* [Cultural Polemics of the 1960s] (Havana: Instituto Cubano del Libro, 2006), pp. 178–82.

————. 'Respuesta a Alfredo Guevara II' [Response to Alfredo Guevara II], *Hoy*, Aclaraciones [Clarifications], 20 December 1963, reproduced in G. Pogolotti (ed.), *Polémicas Culturales de los 60* [Cultural Polemics of the 1960s] (Havana: Instituto Cubano del Libro, 2006), pp. 185–8.

————. 'Respuesta a Alfredo Guevara III' [Response to Alfredo Guevara III], *Hoy*, Aclaraciones [Clarifications], 21 December 1963, reproduced in G. Pogolotti (ed.), *Polémicas Culturales de los 60* [Cultural Polemics of the 1960s] (Havana: Instituto Cubano del Libro, 2006), pp. 195–8.

————. 'Respuesta a Alfredo Guevara IV' [Response to Alfredo Guevara IV], *Hoy*, Aclaraciones [Clarifications], 22 December 1963, reproduced in G. Pogolotti (ed.), *Polémicas Culturales de los 60* [Cultural Polemics of the 1960s] (Havana: Instituto Cubano del Libro, 2006), pp. 207–11.

————. 'Respuesta a Alfredo Guevara V' [Response to Alfredo Guevara V], *Hoy*, Aclaraciones [Clarifications], 24 December 1963, reproduced in G. Pogolotti (ed.), *Polémicas Culturales de los 60* [Cultural Polemics of the 1960s] (Havana: Instituto Cubano del Libro, 2006), pp. 212–5.

————. 'Respuesta a Alfredo Guevara Final' [Final Response to Alfredo Guevara], *Hoy*, Aclaraciones [Clarifications], 27 December 1963, reproduced in G. Pogolotti (ed.),

Polémicas Culturales de los 60 [Cultural Polemics of the 1960s] (Havana: Instituto Cubano del Libro, 2006), pp. 225–32.

Rock Around the Blockade. '50 Years of Cuban Socialism: Achievements of the Cuban Revolution', 14 February 2011, available at: ratb.org.uk.

Rodriguez, Andrea. *Intelectuales Cubanos Debaten Pasado y Futuro* [Cuban Intellectuals Debate the Past and Future], press release (Associated Press), Havana, January 2007.

Rodríguez Manso, Humberto (ed.). *45 Años Después: Memorias de los Congresos de la UNEAC* [Forty-Five Years Later: Memories of the Congress of UNEAC] (Havana: Ediciones UNIÓN, 2010).

Rojas, Marta. 'Es Deber del Intelectual Genuino Luchar Contra el Colonialismo y el Neocolonialismo' [To Struggle Against Colonialism and Neocolonialism Is the Duty of the Genuine Intellectual: Interview with Huynh Tu, Chief of the Delegation on South Vietnam], *Granma*, 10 January 1968.

Rojas Mix, Miguel. 'Hay una Cultura Latinoamericana, es la Lucha lo Que Nos Une' [There Is a Latin American Culture – It Is Struggle That Unites Us], *Juventud Rebelde*, 5 June 1972.

Roque Pujol, Roberto. 'Las Funciones Del Complejo de Dirección del Trabajo Cultural' [The Functions of the Complex of Directing Cultural Work], *Temas*, no. 6, 1985, pp. 17–35.

Rosendahl, Mona. *Inside the Revolution: Everyday Life in Socialist Cuba* (Ithaca and London: Cornell University Press, 1997).

Ruffin, Patricia. *Capitalism and Socialism in Cuba* (Hampshire: Macmillan, 1990).

Russell, Bertrand, Jean-Paul Sartre and Ernest Fischer. 'Saludos al Congreso' [Greetings to the Congress], *Granma: Órgano Oficial del Comité Central del Partido Comunista de Cuba*, 6 January 1968.

Salkey, Andrew. *Havana Journal* (London: Penguin Books, 1971).

Sanchez, Juan. 'Segundo Encuentro de Plástica Latinoamericana' [Second Meeting of Latin American Plastic Artists], *Bohemia*, 26 October 1973.

———. 'Arte de Combate Latinoamericano' [Art of Latin American Combat], *Bohemia*, 23 November 1973.

———. 'Interview with Armando Hart Dávalos', *Bohemia*, 20 October 1989.

Sánchez Vásquez, Adolfo. 'La Creación y la Abolición de las Relaciones Mercantiles' [The Creation and Abolition of Mercantile Relations], *Estética y Marxismo* (Mexico: D.F.Era, 1970), pp. 189–90.

———. *Art and Society: Essays in Marxist Aesthetics* (London: Merlin Press, 1973).

Santamaría, Haydée. *Haydée Habla del Moncada* [Haydée Speaks about Moncada] (Havana: Editorial De Ciencias Sociales, 1978).

Santamaría, Haydée, and Jaime Sarusky. 'Casa Is Our America, Our Culture, Our Revolution', B. Maclean (ed.), *Haydée Santamaría* (Sydney: Ocean Press, 2003), pp. 60–9.

Santana, Joaquín G. *Política Cultural de la Revolución Cubana: Documentos* [Cultural Policy of the Cuban Revolution: Documents] (Havana: Editorial Ciencias Sociales, 1977).

Sartre, Jean-Paul. 'Ideología y Revolución' [Ideology and Revolution], In *Sartre visita a Cuba* (Havana: Ediciones R., 1960).

Sarusky, Jaime. 'From the 200th, with Love, in a Leopard: Interview with Roberto Fernández Retamar', *The Black Scholar*, Autumn 2005 [1995].

Sarusky, Jaime, and Gerardo Mosquera. *The Cultural Policy of Cuba* (Paris: UNESCO, 1979).

Schwartz, Stephanie. 'Tania Bruguera: Between Histories', *Oxford Art Journal*, 35, no. 2, 2012, pp. 215–32.

Serguera, Jorge. 'El Intelectual y la Revolución' [The Intellectual and the Revolution], *Revolución y Cultura*, no. 2, 15 October 1967, pp. 6–17.

Sexto, Luis. 'Alfredo Guevara with Students', *Cuba's Socialist Renewal*, 8 May 2011. http://cubasocialistrenewal.blogspot.com/2011/05/translation-alfredo-guevara-dialogue.html.

Shakespeare, William. *The Tempest* (London: Penguin Books, 2001).

Sherman, Susan. 'El Arte como Criterio para la Educación del Nuevo Hombre' [Art as a Criterion for the Education of the New Man], *Revolución y Cultura*, no. 4, 15 February 1968, pp. 19–21.

———. *America's Child: A Woman's Journey through the Radical Sixties* (Willimantic, CT: Curbstone Press, 2007).

Shiner, Larry. *The Invention of Art: A Cultural History* (London: The University of Chicago Press, 2001).

Shulte-Sasse, Jochen. 'Foreword: Theory of Modernism versus Theory of the Avant-Garde', *Theory of the Avant-Garde* (Minneapolis: University of Minnesota Press, 1984), pp. vii–xxxix.

Silber, Irwin. *Voices of National Liberation: The Revolutionary Ideology of the 'Third World' as Expressed by Intellectuals and Artists at the Cultural Congress of Havana, January 1968* (Brooklyn: Central Book Company, 1970).

Sklair, Leslie. 'The Emancipatory Potential of Generic Globalization', *Globalizations*, 6, no. 4, December 2009, pp. 525–39.

Slater, Howard. 'The Art of Governance: On the Artist Placement Group 1966–1989', *Variant*, 2, no. 11, 2000, pp. 23–6.

Sochor, Zenovia A. *Revolution and Culture: The Bogdanov-Lenin Controversy* (Ithaca and London: Cornell University Press, 1988).

Solás, Humberto. *Cecilia* (film), 1982.

Stallabrass, Julian. *High Art Lite* (London: Verso, 1999).

Stimson, Blake, and Gregory Sholette. 'Introduction: Periodizing Collectivism', *Collectivism after Modernism* (Minneapolis: University of Minnesota Press, 2007), pp. 1–15.

Stonor-Saunders, Frances. *Who Paid the Piper? The CIA and the Cultural Cold War* (London: Granta, 1999).

Strange, Susan. *The Retreat of the State: Diffusion of Power in the World Economy* (Cambridge: Cambridge Studies in International Relations, 1996).

Suárrez, Adolfo. 'La Brigada de Escritores y Artistas Jovenes Sierra Maestra' [The Sierra Maestra Brigade of Young Writers and Artists], *Revolución y Cultura*, no. 3, April 1972, pp. 89–91.

Thomas, Hugh. *Cuba or the Pursuit of Freedom* (London: Eyre and Spottiswood, 1971).

Thomas-Woodard, Tiffany A. 'Towards the Gates of Eternity: Celia Sánchez Manduley and the Creation of Cuba's New Woman', *Cuban Studies*, 34, 2003, pp. 154–80.

Tismaneanu, Vladimir. 'Castroism and Marxist-Leninist Orthodoxy in Latin America', I.L. Horowitz (ed.), *Cuban Communism* (Brunswick, NJ: Transaction Inc., 1989), pp. 554–77.

Trejo Fuentes, Fausto. 'Si Deber de Todo Revolucionario Es Hacer la Revolución el Deber de Todo Intelectual Es Hacer Conciencia Revolucionaria' [If the Duty of Every Revolutionary Is to Make the Revolution, the Duty of Every Intellectual Is the Make Revolutionary Consciousness], *Juventud Rebelde*, 8 January 1968.

Trejo, Mario, Fausto Canel and José de la Colina. 'Eligen Críticos *El Ángel Exterminador* y *Viridiana*' [Critics Choose *The Exterminating Angel* and *Viridiana*], *Revolución*, 17 December 1963, reproduced in G. Pogolotti (ed.), *Polémicas Culturales de los 60* [Cultural Polemics of the 1960s] (Havana: Instituto Cubano del Libro, 2006), pp. 160–3.

Troise, Emilio. *Aníbal Ponce: Introducción al Estudio de sus Obras Fundamentales* [Aníbal Ponce: Introduction to the Study of his Fundamental Works] (Buenos Aires: Ediciones Sílaba, 1969).

Trotsky, Leon. *Literature and Revolution* (Chicago: Haymarket Books, 2005 [1924]).

———. 'Literature and Revolution', C. Harrison and P. Wood (eds.), *Art in Theory 1900–1990: An Anthology of Changing Ideas* (Oxford: Blackwell, 1992 [1924]), pp. 427–32.

Turton, Peter. *José Martí: Architect of Cuba's Freedom* (London: Zed Books, 1985).

Tvzi, Medin. *Cuba: The Shaping of Revolutionary Consciousness* (Boulder, CO: Lynne Rienner Publishers Inc, 1990).

UNESCO. Recommendation Concerning the Status of the Artist, 27 October 1980.

Unión de Escritores y Artistas de Cuba (UNEAC). J.A. Baragaño (ed.), *Memorias del Primer Congreso Nacional de Escritores y Artists de Cuba* (Havana: Ediciones UNIÓN, 1961).

Unruh, Vicky. *Latin American Vanguards: The Art of Contentious Encounters* (Berkeley: University of California Press, 1994).

Urrutia y Lleó, Manuel. *Ley Fundamental de la Republica* [Fundamental Law of the Republic], 1959.

———. *Solares Yermos* [Uninhabited Sites], 1959.

Valdés-Rodríguez, J.M. 'Unas Palabras sobre Tres Películas Discutidos' [Some Words on Three Discussed Films], *El Mundo*, 22 December 1963, reproduced in G. Pogolotti (ed.), *Polémicas Culturales de los 60* [Cultural Polemics of the 1960s] (Havana: Instituto Cubano del Libro, 2006), pp. 204-6.

Van Mourik Broekman, Pauline. 'Mute's 100% Cut by ACE – a Personal Consideration of Mute's Defunding', 31 March 2011. http://www.metamute.org/en/mute_100_per_cent_cut_by_ace.

Various. 'Towards a National Culture Serving the Revolution', 19 November 1960.

———. 'Carta Abierta a Pablo Neruda' [Open Letter to Pablo Neruda], 25 July 1966. http://www.neruda.uchile.cl/critica/cartaabierta.html.

———. 'Llamamiento de la Habana' [Appeal of Havana], *Granma: Órgano Oficial del Comité Central del Partido Comunista de Cuba*, 13 January 1968 (second supplement).

———. 'Letter to Fidel Castro', *Le Monde*, 10 April 1971; republished in *The New York Review of Books*, 6 May 1971.

Venegas, Cristina. *Digital Dilemmas: The State, the Individual, and Digital Media in Cuba* (Toronto: Rutgers University Press, 2012).

Wallerstein, Immanuel, and Terence K. Hopkins. *The Age of Transition: Trajectory of the World System 1945–2025* (London: Zed Books, 1996).

Ward, Frazer. 'The Haunted Museum: Institutional Critique and Publicity', *October*, 73, Summer 1995, pp. 71-89.

Warnock, Mary, and Mark Wallinger (eds.). *Art for All?: Their Policies and Our Culture* (London: Peer, 2000).

Weiss, Judith A. '*Casa de las Américas*: An Intellectual Review in the Cuban Revolution', thesis, Yale University, 1973.

———. *Casa de Las Americas: An Intellectual Review in the Cuban Revolution* (Chapel Hill, NC: Estudios de Hispanofila?, 1977).

Weiss, Rachel. 'Performing Revolution: Arte Calle, Grupo Provisional, and the Response to the Cuban National Crisis, 1986–1989', B. Stimson and G. Sholette (eds.), *Collectivism after Modernism* (Minneapolis: University of Minnesota Press, 2007), pp. 114-62.

Wesker, Arnold. 'Aie Cuba! Aie Cuba!', *Envoy*, November 1969, pp. 15-21.

Wilkinson, Stephen. *Detective Fiction in Cuban Society and Culture* (Bern: Verlag Peter Lang, 2006).

Williams, Raymond. 'Literature and Sociology', *Culture and Materialism* (London and New York: Verso, 2005 [1971]), pp. 11-30.

———. 'Base and Superstructure in Marxist Cultural Theory', *Culture and Materialism* (London and New York: Verso, 2005 [1973]), pp. 31-49.

———. 'Politics and Policies: The Case of the Arts Council' *Politics of Modernism: Against the New Conformists* (London and New York: Verso, 2007 [1981]), pp. 141-51.

Winchester, H.P.M. 'Interviews and Questionnaires as Mixed Methods in Population Geography: The Case of Lone Fathers in Newcastle, Australia', *Professional Geographer*, 51, no. 1, 1999, pp. 60-7.

Witts, Richard. *Artist Unknown: An Alternative History of the Arts Council* (London: Warner Books, 1998).

Wolff, Janet. *The Social Production of Art* (London: Macmillan, 1981).

Worsely, Peter. 'One World or Three? A Critique of the World-System Theory of Immanuel Wallerstein', *The Socialist Register 1980* (London: Lawrence and Wishart, 1980).

Wright, Ann. 'Intellectuals of the Unheroic Period of Cuban History, 1913–1923: The "Cuba Contemporanea Group"', *Bulletin of Latin American Research*, 7, no. 1, 1988, pp. 109–22.

Wu, Chin-tao. 'Embracing the Enterprise Culture: Art Institutions Since the 1980s', *New Left Review*, no. 230, 1998, pp. 28–57.

———. *Privatising Culture: Corporate Art Intervention since the 1980s* (London: Verso, 2002).

Yglesias, José. 'The Case of Heberto Padilla', *The New York Review of Books*, June 1971, pp. 3–8.

Yúdice, George. *The Expediency of Culture: Uses of Culture in the Global Era Post-Contemporary Interventions* (Durham, NC: Duke University Press, 2004).

Yúdice, George, Jean Franco and Juan Flores. *On Edge: The Crisis of Contemporary Latin American Culture* (Minneapolis: University of Minnesota Press, 1992).

Zeitlin, Maurice. *Revolutionary Politics and the Cuban Working Class* (Princeton, NJ: Princeton University Press, 1967).

Zhdanov, Andrey. 'Soviet Literature – The Richest in Ideas, the Most Advanced Literature', M. Gorky, K. Radek, N. Bukharin, A. Zhdanov et al, *Soviet Writers' Congress 1934: The Debate on Socialist Realism and Modernism in the Soviet Union* (London: Lawrence & Wishart, 1977 [1935]), pp. 15–24.

Zvorykin, A.A. 'Cultural Policy in the Union of Soviet Socialist Republics' (Paris: UNESCO, 1970).

Towards a National Culture Serving the Revolution

(English translation by the author, consistent with selected quotations appearing in Ministerio de Relaciones Exteriores [MINREX], 1962)

Cuban intellectuals, writers and artists hereby wish to affirm our public creative responsibility to the Revolution and the people of Cuba, in a period in which the profound sense is that of united struggle to achieve the complete independence of our country as a nation.

We are confident that the victory of the Revolution has created among us the essential conditions for the development of national culture, a liberating culture, capable of encouraging revolutionary progress.

It seems to us that the unity of purpose of contemporary Cuban intellectuals is obvious in their work as much as in their efforts to spread culture among the people throughout the revolutionary period opened up by the destruction of the tyranny as well as during the years of struggle that preceded it.

This means that, fully identifying with the transformative scope and the far-reaching influence of the Cuban Revolution, it seems to us urgent to define criteria and establish positions around which the unity and coordination of our efforts can be realised.

Here are the views we hold:

- Cuban culture, forged in the struggle against first colonialism and then imperialism, was attacked from the outside as much as it was ignored on our own soil. That culture was distorted in all its manifestations, denationalised and replaced by Yankee tastes and modes. Moreover, the backward character of the country's economy – due to various factors, ranging from sugar monoproduction, with a single market, to the semi-feudal structure of society – created miserable living conditions, which always negatively affected all the popular sectors, not forgetting artists and intellectuals.

The noblest of human activities were suppressed and impoverished by base commercialism. The alienation of numerous and crucial means of cultural dissemination – which were seized as private property by monopolistic impresarios, motivated by an eagerness for money – limited the independence of the intellectual, writer, artist. They were deprived of material elements as much as of freedom of spirit to develop their creative work and display and disseminate it.

- The creative establishment of Revolutionary Power of the People, to vindicate the full sovereignty of the country and overcome the conditions described above, opens our eyes to the fullest perspectives of creation. This gives us the means for consciously participating in the development of national and revolutionary culture. This is the revolution of the Cuban people, the artists, writers and intellectuals, as much as the workers and peasants: a revolution that frees us from all bondage.

- The Declaration of Havana is, in our opinion, the historical response of the Cuban people to our Revolution: said document becomes a record and programme of all the progressive forces in Latin America. Therefore, it has the greatest support and the strongest commitment of Cuban intellectuals, writers and artists. Our immediate agenda is as follows:

 a) Recovery and development of our cultural tradition, which is rich in human content and was wrested away from the people by the colonialists and imperialists. Culture should serve as a connection between our nineteenth century and our twentieth century.

 b) To preserve, encourage, purify and utilise our folklore, spiritual wealth of the Cuban people, which the Revolution is liberating and re-evaluating.

 c) We consider sincere and honest criticism indispensable to the work of artists and intellectuals.

 d) We should try to achieve full identification with the character of our works and the needs of our advancing revolution. The purpose is to bring the people close to the intellectual and the intellectual close to the people, which does not necessarily imply that the artistic quality of our work must thereby suffer.

 e) Exchange, contact and cooperation among Latin American writers, intellectuals and artists are vital for the destiny of our America.

 f) Mankind is one. Our national heritage is part of world culture, and world culture contributes to our national aspirations.

- The artist chooses the most effective way to express themselves.

- We hereby summon all Cuban artists, writers and intellectuals to a forthcoming National Congress which unites us in the work of culture, of serving the people and the Revolution.

- The fate of the revolution depends on the fate of Cuban culture. TO DEFEND THE REVOLUTION IS TO DEFEND CULTURE.

Timeline of Events Significant to Cultural Development in Cuba

1951

18 **February** Nuestro Tiempo [Our Time] cultural society is founded with a remit to narrow the gap between art and the people.

1952

10 **March** General Fulgencio Batista takes power and viciously eradicates the last traces of the constitutional democracy he had established during the 1940s. At this time, 80 percent of Cuban imports come from the US and $1 billion of US capital is invested on the island, creating a situation of virtual monopoly.

Diplomatic relations between Cuba and the USSR are severed.

The international sugar market begins to decline, which affects Cuba's monocultural economy. US investors withdraw from sugar and move into utilities and oil.

1953

28 **January** As an alternative to a biennial planned by Franco's government in Spain, to coincide with the birth centennial of José Martí, Cuba's writers and artists propose an International Martían Exhibition of Art, which quickly becomes known as the anti-biennial.

26 **July** A group of 110 insurgents, led by twenty-six-year-old Fidel Castro Ruz, attacks the Moncada army barracks (the second largest in the country, lying just outside the centre of Santiago de Cuba), while twenty-two troops simultaneously attack the barracks at Bayamo. This action – which ends in disaster, with sixty-one guerrillas killed either during the attack or in subsequent retaliation – nonetheless serves to destabilise the Batista regime, giving the revolutionary movement its name and bringing wide renown to its leader.

September	Fidel is put on trial in Santiago de Cuba. As a trained lawyer, he represents himself and more than 100 others, many of whom played no part in the attack.
16 October	Fidel delivers a legendary speech before court, which serves as his defence and an outline of his political programme. Reconstructed from memory afterwards, this becomes known as 'History Will Absolve Me', on account of its concluding remarks. Distributed in Cuba by Haydée Santamaría and her comrades, it effectively serves as the manifesto of the 26 July Movement, including five revolutionary laws – returning sovereignty to the people; transferring ownership of land to agricultural workers; granting workers in industry, mining etc. a 30 percent share of the profits; granting sugar planters the right to 55 percent participation of the yield; confiscating wealth from those misappropriating public funds. Alongside this, consideration is given to agrarian reform, internal reform of the education system and nationalisation of the electricity and telephone companies. Fidel is sentenced to fifteen years in prison. Twenty-six other prisoners are found guilty, including Fidel's younger brother, Raúl, who receives a thirteen-year sentence. The Castro brothers and their comrades are interned on the Isle of Pines (Haydée Santamaría and Melba Hernández are interned at the Guanajay women's prison in Pinar del Rio province), where many of them read extensively.

1954

February	Haydée Santamaría and Melba Hernández are released from prison to continue their involvement in the urban underground.
17 June	A conference, hosted by Nuestro Tiempo, provokes a treatise from Tomás Gutiérrez Alea on the realities of film-making in Cuba.

1955

15 May	Having served less than two years of their sentence, the Castro brothers are released by the recently restored Batista as the result of a massive civil rights campaign.
12 June	The 26 July Movement is officially established, and the National Committee (which includes Haydée Santamaría and Armando Hart) agrees a plan to prepare for armed rebellion.
7 July	Seeing no future in electoral politics, Fidel follows Raúl to Mexico. Within a week, Fidel is introduced by his brother to the twenty-seven-year-old Ernesto 'Che' Guevara (who has been living in Mexico since the previous September).
	From exile, Fidel assembles a guerrilla force which is trained by Alberto Bayo (who fought against Franco in the Spanish Civil War). He also foments a workers' movement in Cuba, centred on a Rebel Army of conscientious peasants, disenfranchised young professionals and workers. In Cuba, José Antonio Echeverría resuscitates the Revolutionary Directorate (established by students in the 1930s).

16 August	On the fourth anniversary of the death of Eduardo Chibás (founder of the Orthodox Party), Fidel publishes 50,000 copies of a manifesto which is distributed by Haydée in Cuba. This is followed by a second, with a print run of 100,000 copies, recommending insurrection and general strike.

1956

25 November	Eighty-two men board a small motor cruiser, *Granma*, at Tuxpan on the Mexican coast and sail towards Cuba.
30 November	An armed insurrection, timed to coincide with the landing of *Granma*, takes place at Santiago and Moncada, putting the authorities on high alert.
2 December	Delayed by weather conditions, *Granma* runs aground just off the coast at Playa las Coloradas.
3 December	Twenty-one members of the *Granma* expedition are captured as part of an air force bombardment at Alegría del Pío.
5–16 December	Twenty-one members of the expedition fall in combat as the result of an army attack.
16–27 December	Nineteen of the original expedition effect their escape while the remaining men regroup in the Sierra Maestra mountains. The number of survivors is usually given as a biblical twelve, but the actual figure is twenty-one.
1957	A prolonged and unforeseen period of guerrilla warfare, centred on the Sierra Maestra, presents itself as the only option for Fidel and his troops. This forms part of an integrated strategy with the urban network of the 26 July Movement, led by Frank País, Faustino Pérez Hernández and Haydée Santamaría.
13 March	A group of university students from the Revolutionary Directorate attack Batista's presidential palace, with forty-two people being killed, including their leader, Echeverría. The organisation becomes known as Revolutionary Directorate 13 March, and those killed are honoured on this date every year thenceforward.
12 July	The Sierra Manifesto details a course of action derived from the five revolutionary laws outlined in 'History Will Absolve Me'. It reiterates a need for agrarian reform, literacy and educational campaigns and serves as a call for unity. This document compels the blockage of any attempts by Batista to impose a provisional military junta, an embargo on arms being sent to the dictatorship by the US and the immediate creation of a civic-revolutionary front (Frente Cívico Revolucionario, which corresponds with the initials of Fidel Castro Ruz).
30 July	Urban coordinator of the 26 July Movement, Frank País, is gunned down in Santiago de Cuba, representing a serious blow to the movement.
August	Carlos Rafael Rodríguez contacts Haydée Santamaría to discuss the possibility of the PSP supporting the insurrection.

October	A pivotal meeting takes place between Fidel and Ursinio Rojas, former leader of the sugar workers' union and now a representative of the Popular Socialist Party (PSP), which leads to synergy between the two camps. But PSP hesitation to support the Revolution, combined with its former strategy of collaborating with the Batista regime, compromises its future role.

1958

15 March	Nuestro Tiempo signs a statement, authored by the Collective of Cuban Institutions, which demands the immediate renunciation of power by Batista.
9 April	Despite Fidel's misgivings, liberation day is announced, with a general strike planned which is expected to overthrow Batista. When the strike fails, Batista redoubles his efforts to dislodge the Rebel Army from the mountains, but a victory over his soldiers provides a much-needed boost for the revolutionary forces.
July	On behalf of the PSP, Carlos Rafael Rodríguez travels to the Sierra Maestra to negotiate with Fidel, becoming the first party member to join the 26 July Movement. Having consistently advocated mass struggle at the expense of armed struggle, the PSP publicly throws its weight behind Fidel. While the PSP operates its own sixty-five-strong guerrilla group, party members also have success within guerrilla columns led by Raúl and Che.
21 August	Che Guevara and Camilo Cienfuegos are chosen to lead two columns marching westward towards Havana (via the south and north, respectively).
December	Less than a month before revolutionary triumph, the PSP suggests the nationalisation of foreign utilities and agrarian reform.
	The US government steps up pressure on Batista to resign.
31 December	Batista flies from Havana to Santo Domingo (capital of the Dominican Republic) with his family and friends.

1959

1 January	The official triumph of the Revolution is declared.
2 January	From a balcony in Santiago, Fidel makes a victory speech. Camilo Cienfuegos enters Havana.
3 January	Che Guevara enters Havana
8 January	Fidel enters Havana after a one-week tour of the island.
	Lawyer and politician Manuel Urrutia Lleó is appointed President and chooses José Miró Cardona as his Prime Minister; Fidel acquires the title of Military Commander-in-Chief.
	Between 500 and 600 Batistianos are executed. Fidel will later describe this process as 'a mistake, but a mistake that was not motivated by hatred or cruelty. You try a man who's killed dozens of *campesinos*, but you try him in a courtroom where there are thousands of people, where repudiation of the murderer was universal'.[1]

16 February	Fidel replaces José Miró Cardona as Prime Minister.
March	An Urban Reform Law redistributes income by halving rents.
19 March	Fidel makes a speech about the democratisation of universities.
20 March	The Cuban Institute of Cinematographic Arts and Industries (ICAIC) is created by Law 169 under the directorship of Alfredo Guevara.
22 March	The revolutionary government makes racial discrimination illegal.
23 March	The first issue of *Lunes de Revolución* is published as the cultural supplement of the main 26 July Movement newspaper.
April	The Literacy Commission and the National Institute for Agrarian Reform begin a modest programme of literacy work alongside ongoing efforts in this area by the Rebel Army.
28 April	Casa de las Américas is founded, to initiate cultural dialogues throughout the Americas, with Haydée Santamaría at its head.
17 May	The revolutionary government institutes an Agrarian Reform Law which puts an end to all estates over 1,000 acres, dividing them into smaller, individual plots to be distributed among the landless and specifying that the land can only be owned by Cubans. The new law gives credence to the rumours that Fidel is a communist. The US responds by demanding compensation for US interests affected by the law; the US Ambassador to Cuba fails to have any influence at home, and the US Congress becomes more extreme in relation to Cuba. The CIA is authorised to take control of infiltration and sabotage, plotting to execute Fidel and other top officials and training exiles into a paramilitary force. Manuel Urrutia is forced to resign after a series of anti-communist comments; Dr. Osvaldo Dorticós Torrado is appointed President. US State Department policy towards Cuba hardens.
October	A Soviet intelligence agent meets Fidel and Che to talk about restoring diplomatic relations. Fidel advises that the people are not ready and requests that a Soviet cultural and technological exhibition – which had been touring Latin America throughout 1959 and is due to close in Mexico – be brought to Cuba.
December	A second Urban Reform Law regulates land use, fixes low prices and ends speculation.

1960

31 January –February	Anastas Mikoyan, Vice Premier of the USSR, visits Cuba, touring the island with Fidel for several weeks and opening the exhibition about Soviet technology and culture. This eventually leads to the signing of new trade agreements between Cuba and the USSR valued at $100 million.
February	A US plane packed with explosives blows up over the España sugar mill near Havana as the culmination of several damaging raids on Cuba's sugar industry.

March	Having delivered weapons and ammunition to Cuba from Belgium, the French ship *Le Coubre* explodes in Havana harbour – an act that is admitted to be consistent with US policy.
May	Diplomatic relations are restored between Cuba and the USSR. When 300,000 tons of Soviet crude oil arrive in Cuba, the government asks Shell, Standard Oil and Texaco (owners of the three refineries on the island) to process it for them. The companies are initially willing to obey the US government's objections, but they receive instructions not to comply from US Secretary of the Treasury Robert B. Anderson. The Cuban government confiscates US oil company assets, and Washington mobilises to protect US corporate interests.
July	The US government (under Eisenhower) dramatically reduces the quota of sugar imported from Cuba.
	Some of the US companies in Cuba stop fertilising land and planting new crops, leading to Washington's confident prediction of lower yields which are attributed to Cuban governmental inefficiency.
August	Cuban bishops make a general declaration against communism at seven o'clock mass, which, by nine o'clock mass, is being shouted down by congregations claiming that the real religion in Cuba is the Revolution.
6 August	Fidel announces the nationalisation of all foreign-owned properties, including thirty-six sugar mills (with adjacent plantations), oil refineries, electric power and telephone utilities. This leads to an exodus of US and Cuban capitalists.
15 August	At a session of the Organization of American States (OAS) in Costa Rica, the US condemns Cuban policy, declaring that 'totalitarian' states are incompatible with the continental system.
September	All US-owned banks on the island – including the National City Bank of New York, Chase Manhattan and the Bank of Boston – are confiscated by the revolutionary government.
2 September	As a reply to the OAS declaration, Fidel convenes a General Assembly of the Cuban people and, in front of a million people in Revolution Square, delivers the first Declaration of Havana.
26 September	In a speech to the United Nations General Assembly, Fidel announces Cuba's aim of eradicating illiteracy within a year.
28 September	Committees for the Defence of the Revolution (CDRs) are launched 'to promote urban reform, education, and public health programs by organizing neighbourhood meetings, distributing printed materials, and ringing doorbells. The large scope of the mobilization and the sense of popular participating in pursuit of a common goal led to a dynamic sense of popular participation in pursuit of a common goal that had a strong impact on the lives of many Cubans'.[2]
October	Eisenhower declares an economic embargo of Cuba. In the US presidential campaign, Kennedy and Nixon compete over who can be more hardline in relation to Cuba.

	A third Urban Reform Law transfers all housing titles to tenants. The First National Congress of Municipal Education Councils is held in Havana. The Literacy Commission becomes a national institution.
27–30 October	The First National Meeting of Poets and Artists is held in Camagüey.
19 November	As a result of the Camagüey meeting, Cuban artists and writers publish 'Towards a National Culture Serving the Revolution' (see Appendix A), which is referred to in an unsigned foreword of a MINREX publication as 'the beginning of the enthusiastic work of artists and writers to unite, to take a position, to play a specific role in the revolutionary process'.[3]
	Film posters begin to be produced in Cuba, initiating a new visual style.
1961	This is named 'Year of Education' on account of the massive literacy campaign, beginning in April, which is led by 250,000 (mostly teenage) teachers.
January	Just before John F. Kennedy is sworn in as US President, Eisenhower terminates all diplomatic relations with Cuba and prohibits all US exports to the island, excluding medical aid.
4 January	The National Council of Culture (CNC) is established under Armando Hart's Ministry of Education (MINED) with PSP activists as its most influential leaders, prominent among whom is Edith García Buchaca as President.
17 March	Eisenhower orders the creation of a Cuban exile army, which begins training with generous funding from the CIA.
14 April	A meeting of the organising committee of the First National Congress of Writers and Artists is held in Havana.
15 April	An air raid, launched from Nicaragua, alerts Cuba to an approaching invasion.
16 April	At the funeral for those killed in the air raid, Fidel makes explicit the socialist character of the Revolution.
17 April	US forces land at Playa Girón [Bay of Pigs].
20 April	The Bay of Pigs landing is defeated by a huge mobilisation of the Cuban people.
May	A film about Havana's nightlife, called *PM*, sponsored by the cultural periodical *Lunes de Revolución*, is screened on television.
12 May	*PM* is presented to the Commission for the Study and Classification of Films.
31 May	An evening meeting to discuss *PM* is convened at Casa de las Américas, and a decision to limit further distribution is ratified.
June	Khrushchev visits Cuba. A debate is held between various writers, including Heberto Padilla, Ambrosio Fornet, Virgilio Piñera and Jaime Sarusky, pondering how they can best serve the Revolution as men of letters.
20 June	A law is passed nationalising education.

16, 23 and 30 June	Meetings are held at the auditorium of the National Library in Havana, involving the most representative figures of the Cuban intelligentsia, including the *Lunes de Revolución* group and leading members of the PSP. Also present are President Dorticós, Fidel, Armando Hart, members of the CNC and other representatives of the government. Artists and writers have an opportunity to expound on different aspects of cultural activity and problems relating to creative work. In conclusion of the third meeting, Fidel delivers his 'Words to the Intellectuals'.
July	The PSP, led by Blas Roca Calderío, merges with Fidel's 26 July Movement and Faure Chomón's Revolutionary Directorate to form the Integrated Revolutionary Organisations (ORI), which Aníbal Escalante is charged with coordinating.
18–22 August	Originally scheduled for April but postponed because of the Bay of Pigs invasion, the First National Congress of Writers and Artists is held in Havana. As one of the stated aims of this conference, the National Union of Cuban Writers and Artists (UNEAC) is created, with Nicolás Guillén as President, the writers Alejo Carpentier, José Lezama Lima, José Antonio Portuondo and Guillermo Cabrera Infante and the ballerina Alicia Alonso as Vice Presidents, and the poet Roberto Fernández Retamar as Secretary.
	The Revolution becomes synonymous with the state.
October	Pablo Armando Fernández brings news from Edith García Buchaca that production of *Lunes de Revolución* is to cease. The reasons given are financial (specifically a lack of paper), but the editors retrospectively contend that the periodical was self-financing through subscriptions and sales.
6 November	In the aftermath of the *PM* debacle, *Lunes* ceases publication.
December	Fidel declares himself a Marxist-Leninist.
1962	
January	At an OAS meeting in Uruguay, the US pressures the other member states into voting for Cuba's expulsion – a move that is resisted only by Mexico.
	The US imposes an economic embargo on Cuba as a reaction to the nationalisation of US companies and Fidel's declared Marxist-Leninist affiliations. This policy is adopted by all the countries of the Americas except Mexico and Canada, costing Cuba an estimated $41 billion in the period 1962–96. According to the UN, the embargo is illegal because it violates Cuba's right to self-determination. It lacks international backing and has been a factor in decreasing US popularity. Under the embargo's travel restrictions, visitors to the island are subject to scrutiny and possible persecution by the US.
February	The National Art Schools (ENA) are established, and construction begins under architects Ricardo Porro, Vittorio Garatti and Roberto Gottardi.
4 February	The Second Declaration of Havana is made.

9 March	The National Directorate of the ORI is announced by Aníbal Escalante. Ten of its twenty-five members are from the PSP, fourteen from the 26 July Movement and only one from the Revolutionary Directorate.
22 March	A revised ORI leadership is announced, containing just Blas Roca from the PSP.
26 March	Fidel denounces a 'sectarian' tendency within the Revolution, which has seen the rise to dominance of old Marxist militants. The ORI is disbanded, replaced by the United Party of the Cuban Socialist Revolution (PURSC).
October	The discovery by the US of Soviet nuclear missiles on the island triggers a major international crisis. This is eventually resolved by the Soviet Union making a deal with the US without consulting Cuba, causing a cooling of Cuban-Soviet relations.
25 November	The CNC's interpretation of government policy coheres into a ten-point Preliminary Plan, which García Buchaca presents to a Provincial Assembly of Culture in Havana.
December	The Preliminary Plan is discussed at the First National Congress of Culture convened by the CNC.
1963	Another significant land reform limits private ownership of land to sixty-seven hectares, with the state retaining and farming some 60 percent of the island's land.
4, 5 and 6 May	Meetings take place between a group of film-makers in the Department of Artistic Programming at ICAIC, to discuss the problematic relationship between cultural policy and aesthetics.
18 July	Law 1117 confers greater autonomy upon the CNC by moving it from MINED to the jurisdiction of the Council of Ministers.
3 August	Cuba's film-makers publish a statement, derived from the May meetings, which provokes an exchange of opinion in the UNEAC journal, *La Gaceta de Cuba*.
October	Mirta Aguirre (the CNC's Director of Theatre and Dance) publishes a text called 'Notes on Literature and Art' in the journal *Cuba Socialista* [Socialist Cuba], which exposes the scholastic Marxism lurking at the heart of the cultural council.
November–December	The debate around culture evolves into a very public spat between Blas Roca in the PSP newspaper, *Hoy*, and Alfredo Guevara in the 26 July Movement newspaper, *Revolución*.
1964	Labour identification cards are introduced.
November	The Conference of Latin American Communist Parties is hosted in Havana; Cuba agrees to be moderate.
1965	
March	Che Guevara writes a letter, 'From Algiers', which becomes known as 'Socialism and Man in Cuba' and explicitly condemns socialist realism as a trope.
26 July	The ENA is opened in an incomplete state.

Che Guevara leaves Cuba to pursue armed insurrection in Africa, thereby reneging on the moderation agreed the previous November.

El Puente, the last publishing house with complete independence from the Cuban state, is closed down.

3 October | The governing party is renamed the Cuban Communist Party (PCC) with Armando Hart as its Secretary. It is noteworthy that this takes place after the most important reforms have been carried out under Fidel's personal jurisdiction, including the formation of pivotal cultural institutions such as ICAIC and Casa de las Américas.

19 October | Precipitated by the suspension of the homosexual dramatist, Vicente Revuelto, at Studio Theatre, a meeting is convened between Hart and various intellectuals, including Alea, Carpentier, Edmundo Desnoes, Julio García Espinosa, Ambrosio Fornet, Lisandro Otero and Roberto Fernández Retamar to discuss the role of intellectuals within the party.

November | Military Units to Aid Production (UMAP) are set up, and those who are discounted from military service on the grounds of educational level, religious belief and sexuality are recruited. The first draftees are treated so brutally that their commanders are court-martialled and charged with torture.

1966 | Lezama Lima's *Paradiso*, a novel with overt homosexual content, is published, despite objections from orthodox forces.

3–14 January | The Tricontinental Conference takes place in Havana, with Che sending a letter of support. A survey is conducted by intellectuals present at this conference, which gives rise to a theme for future exploration – the role of the intellectual in society.

Spring | Having suffered the worst drought on record during the previous year (which has diminished the sugar crop), torrential rains stifle the harvest, reducing it from a predicted 6.4 million to 4.45 million tonnes.

12 May | On US television, Robert Kennedy speaks of the inevitability of revolution in Latin America.

11–18 July | The XXXIV Congress of the PEN Club is held in New York. The previous meeting, presided over by Arthur Miller, had been held in Dubrovnik (the first to have taken place in Eastern Europe since the Second World War). That a congress of the world's intellectuals behind the Iron Curtain is being followed by one in the US signals an apparent desire for the thawing of relations between east and west, shared by the majority of the world's intelligentsia. In anticipation of the US event, it has been understood that, in order to qualify as a genuinely international meeting of intellectuals, Soviet and Cuban representatives will be granted visas to attend. However, visas are generally not forthcoming, with the notable exception of that issued to the Chilean communist poet Pablo Neruda.

25 July	An open letter is sent to Neruda, speculating upon the reasons for his visa authorisation and questioning his decision to participate.
31 July	The letter to Neruda is published in *Granma* and disseminated extensively.
10 August	A round-table discussion on the theme of the 'Intellectual Penetration of Yankee Imperialism' is conducted on Radio Havana (subsequently published in *Casa*), involving Retamar, Otero, Fornet and Desnoes. This finds that, as a consequence of the adhesion of the majority of intellectuals to the Cuban Revolution, the US has become preoccupied with the danger posed by the radicalisation of the continent's intellectuals and has put subtle methods of co-optation into practice.
	The novelist, Lisandro Otero, is appointed Vice President of CNC.
November	Che Guevara arrives in Bolivia.
1967	An international crisis erupts, centred on the UMAP camps to which large numbers of Cuban artists and writers have been sent. At a meeting of international writers, Julio Cortázar and Ángel Rama protest to Fidel about the monstrous persecution of homosexuals at UMAP. Within twenty-four hours, repressive measures cease.
5–8 January	The first meeting of the collaborative committee of *Casa de las Américas* takes place in Havana – attended by Retamar, Fornet, Desnoes, Graziella Pogolotti and others. This gives rise to a declaration, pondering the insertion of the intellectual in society, which is published in the journals *Casa*, *Marcha* and *Siempre!*.
16–22 January	A 'Meeting with Rubén Darío' takes place in Cuba, on the birth centennial of the Nicaraguan poet. Picking up on the theme elaborated at the Tricontinental Conference, those assembled decide on the urgent necessity of redefining the task of the intellectual in society. The meeting also decides that it would be beneficial to convene a conference of all the intellectuals of the continent.
February	A new magazine, *Pensamiento Crítico* [Critical Thought], is published by the Department of Philosophy at the University of Havana.
	Representatives from the Rubén Darío meeting take the idea of a cultural congress to Fidel, who greets the proposal enthusiastically. This will be manifested as the Cultural Congress of Havana and extended to intellectuals far beyond the Latin American continent, in January 1968.
29 April	At a graduation ceremony in Pinar del Río province, Fidel recommends the rejection of copyright for creative works.
May	Many of those involved in the 'Meeting with Rubén Darío' publish poems dedicated to Nicaraguan modernists in issue 42 of *Casa*.

	The Cuban Book Institute is formed, with thirteen different presses, and all publishing is taken over by the state.
26 July	Fidel opens the Conference of the Latin American Solidarity Organization (OLAS) by paraphrasing the *Communist Manifesto* to assert that the phantom of the conference stalking the continent will keep reactionaries and imperialists awake at night. To commemorate the anniversary of the Moncada attack, the Paris Salon – hailing the European avant-garde, involving 150 painters (including Picasso, Miró and Léger), sculptors, intellectuals and journalists – is brought to Havana by Wifredo Lam. In Havana, ninety artists and writers paint a giant mural, entitled *Collective Cuba*. Meetings between Cuban and European painters and a meeting of protest song is organised in Varadero.
31 July–10 August	The OLAS conference takes place in Havana with Haydée as its president and Che as its mascot.
5 October	A declaration, issued by Casa de las Américas, emphasises the importance of the role of intellectuals in the Revolution, which accounts for the North American interest in co-opting them.
9 October	Che Guevara is captured and executed in Bolivia. The Russians publish documents, including fragments from Che's diaries, seeming to question Fidel's revolutionary conceptions; Cuban–Soviet relations reach and all-time low.
25 October–2 November	A preparatory seminar for the Cultural Congress of Havana takes place, involving leading representatives from the fields of culture and science. Five main themes are decided, along with an organisational protocol involving a rotating presidency.
December	A Centre for Literary Research is founded, with Mario Benedetti as its first director.
1968	Named 'Year of the Heroic Guerrilla' on account of Che Guevara's recent death.
2 January	Fuel rations are introduced, with Fidel blaming the Soviet Union and declaring that the dignity of the Revolution would be compromised by asking for Soviet rations to be increased.
4–12 January	More than 600 intellectuals from all over the world take part in the Cultural Congress of Havana, with the aim of discussing the role of intellectuals in relation to underdevelopment. In closing the congress, Fidel disputes the Soviet notion of 'peaceful coexistence' with the US and notes that many supposedly revolutionary forces are adopting a retrograde position.
24, 25 and 26 January	A plenary session of the PCC Central Committee hears the case against Aníbal Escalante.
13 March	On the anniversary of the Revolutionary Directorate's attack on the presidential palace, Fidel announces that approximately 55,000 small businesses and private shops will be nationalised as part of the so-called Revolutionary Offensive.

The poet, Heberto Padilla, sends a letter to the literary journal, *El Caimán Barbudo* (the weekly supplement of *Juventud Rebelde*) criticising Lisandro Otero's novel, *Pasión del Urbino* [Passion of Urbino], recently published in Cuba and praising Guillermo Cabrera Infante's *Tres Tristes Tigres* [Three Sad Tigers]. In the process, Padilla brings the literary debate into the political domain by attacking the grey bureaucracy permeating the cultural field. This controversy leads to the resignation of the editorial board of *El Caimán Barbudo* and the removal of Padilla's permission to travel.

19 April Fidel dispels the myth that Cuba might be contemplating re-entering the OAS.

30 July Cabrera Infante decisively breaks with the Revolution in a letter to the Buenos Aires-based journal, *Primera Plana* [Front Page].

August During an interview from exile, Cabrera Infante is explicitly critical of the Revolution, denouncing the condition of writers within Cuba, which leaves Padilla in the dangerous position of having defended him.

15 August Cabrera Infante is expelled from UNEAC, together with the pianist Ivette Hernández – by the former's account 'as traitors to the revolutionary cause'.[4]

20–21 August Soviet troops invade Czechoslovakia.

23 August Fidel appears on television to analyse events. In failing to condemn the invasion, he revives the spectre of Stalinism within certain sectors of the intellectual community.

October Padilla is unanimously awarded the UNEAC prize by a panel of international judges for his *Fuera del Juego* [Out of the Game]. This collection of poems distances him from the Revolution without directly declaring himself against it, by alluding to bureaucratic socialism and exalting individualism in the face of collective demands. At the same time, Antón Arrufat receives three of five votes for his dramatic work, *Los Siete Contra Tebas* [Seven Against Thebes]. The English critic J.M. Cohen is accused of having acted unscrupulously in influencing his fellow jurors, by publicly alluding to his favoured candidate in the press, prompting the UNEAC president, Guillén, to remind him of his obligations. While the prizes are honoured and the books published and widely circulated, they are condemned as counterrevolutionary in a disclaimer inserted by the UNEAC executive committee.

6 October Following the award of the Casa de las Américas Prize to Norberto Fuentes, Haydée Santamaría goes before Cuban television cameras to defend the policy of internationally prestigious prizes at the institution and to define quality as the sole criterion of prize-winning works.

7 October For the first time in seven months, two Cubans are accused of being CIA spies and condemned to death.

17 October	Against a backdrop of civil unrest, 500 hippies are arrested by the police in the centre of Havana.
20 October	The annual meeting of writers, held in Cienfuegos, approves a declaration of principles which includes the following: 'the writer must contribute to the Revolution through his work and this involves conceiving of literature as a means of struggle, a weapon against weaknesses and problems which, directly or indirectly, could hinder this advance'.[5] In his closing speech to the meeting, Otero makes an allusion to Padilla and reclaims the validity of a genuinely Cuban vanguard, with its own contemporary language, giving rise to an art in which social justice is united with the most audacious formal advances. At the same time, he rejects the idea of writers acting as the conscience of society.
3 November	A number of weekly articles, signed by Leopoldo Ávila, begin to appear in the army magazine, *Verde Olivo* [Olive Green], the first of which is addressed to Cabrera Infante's rupture with the Revolution. Two subsequent articles are highly critical of Arrufat and Padilla. News agencies outside Cuba immediately echo the most forceful parts of Ávila's articles, causing consternation among foreign intellectuals.
	Haydée suggests that the juries of future UNEAC prizes should be restricted to Cuban authors – advice which is heeded from the following year.
28 December	A year and a half after Cabrera Infante's article appeared in *Primera Plana*, Padilla launches a polemic against him which lasts until the following month, revivifying his support for the Cuban process by stating that revolutionary writers are either with the Revolution or nothing. This has the effect of producing growing irritation with his attitude.

1969

4 January	ICAIC convenes a meeting to discuss the UNEAC prizes and the articles of Leopoldo Ávila, with Alfredo Guevara identifying *Verde Olivo* as the voice of the Revolution.
8, 9, 10 January	*Casa* convenes a meeting of its collaborative committee to discuss the discrepancies arising from the Padilla affair, emphasising that individual liberty should not be at odds with achieving social justice.
11 January	A manifesto is issued by *Casa* (published in issue 11 in March), drawn from the preceding meeting.
16 January	At a convocation of the jury of the Casa prize, Haydée announces that future jurors will be from Latin America.
13 March	On the anniversary of the Revolutionary Directorate's attack on the presidential palace, Fidel announces the nationalisation of Cuba's universities.
	UNEAC institutes the David literary prize.

2 May	A round-table discussion (including Retamar, Fornet, Desnoes, Dalton and Depestre) is convened by the *Casa* collaborative committee to commemorate the first ten years of the Revolution, taking as its theme the intellectual and society.
	Padilla writes a personal letter to Fidel and, a day later, receives a response asking him to choose which job he would like to take up at the University of Havana, which is taken as a sign of his rehabilitation. He also serves on the jury of UNEAC's David prize, but Cabrera Infante continues to petition against him.
June	Having declined an invitation to take part in the preparatory work of the Conference of Communist Parties in Moscow, Cuba sends a delegation of observers and disagrees that the principal task of anti-imperialist forces is that of preventing war.
19 July	Fidel announces the government's plan to achieve a ten million tonne sugar harvest, which 'represents a last desperate attempt to find a way out of a pressing situation and a tentative response to the dilemma of how to finance a revolution'.[6]
1970	
22 April	On the centenary of Lenin's birth, Fidel condemns the anti-Soviet sentiment present among certain intellectuals (particularly those who had discredited the Revolution) and mocks their presumed capacity to eradicate imperialism in two seconds with their words. Jorge Fornet finds in this speech the roots of Fidel's closing address to the First National Congress of Education and Culture to be held the following year.
19 May	The ten million tonne sugar harvest is declared a failure. Fidel explains that technical deficiencies resulted from fundamental political deficiencies, taking his share of responsibility for this.
	Fidel and the PCC decide that the 'push for Communism' would be a mistake without passing through socialism first, which goes against Che's ideas.
26 July	Fidel speaks of the price of ignorance in relation to the failed sugar harvest, admitting to his imperialist enemies that the construction of socialism is difficult.
September	A census is conducted, the first since 1959, revealing a population of 8.5 million (3.4 million of whom are sixteen or under). A law is passed against vagrancy and a process initiated to create identity cards.
October	A meeting is held with the aim of reconstituting the *Casa* collaborative committee by inviting new collaborators.
	Personal identification cards become universal.
1971	
15 January	As part of UNEAC's 'Literary Fridays' series, Padilla reads poems from his new book, entitled *Provocations*.
19 January	The collaborative committee of *Casa de las Américas* begins a three-day meeting including Mario Benedetti, Julio Cortázar and Mario Vargas Llosa.

22 January	The *Casa* collaborative committee signs a declaration agreeing, among other things, to expand the committee considerably.
21 February	Raúl Alonso Olivé, assistant of French engineer, René Dumont, is arrested on charges of spying, for possessing a black market price list.
27 February	Alfredo Guevara arrives in Chile to sign a cinematic trade agreement between the two countries.
March	*El Caimán Barbudo* publishes a ferocious critique of a book by one of its editors, Eduardo Heras León (which had received a mention from Casa de las Américas the previous year).
20 March	Padilla and his wife, Belkis Cuza Malé, are arrested and jailed.
22 March	Belkis Cuza Malé is released.
29 March	International press agencies report that, during an informal meeting with students at the University of Havana, Fidel had assumed responsibility for Padilla's detention.
2 April	On the same day that an exhibition of modern Soviet architecture is launched at the Museum of Fine Arts, a letter from the PEN Club of Mexico, published in the periodical *Excélsior*, is addressed to Fidel in relation to Padilla's detention.
5 April	From prison, Padilla writes a private letter to the revolutionary government, explaining his actions.
9 April	Padilla's arrest prompts a letter, addressed to Fidel. Authored by Julio Cortázar and the Spanish writer Juan Goytisolo, the letter is signed by fifty-four prominent intellectuals, including Europeans and Latin Americans who had previously been sympathetic to the Revolution, such as Jean-Paul Sartre and Gabriel García Márquez, and by Cuban émigrés now viscerally against the Revolution, including Carlos Franqui. The letter extrapolates from Padilla's arrest to raise suspicions about the political climate on the island.
10 April	The letter to Fidel from fifty-four intellectuals is published in *Le Monde*.
23 April	The First National Congress of Education is inaugurated in salons of the Habana Libre hotel.
25 April	Fidel's suggestion to add 'Culture' to the name of the congress is adopted.
26 April	Padilla's letter to the revolutionary government is published via Prensa Latina.
27 April	*Granma* announces the addition of 'Culture' to the name of the First National Congress of Education. Padilla is released and makes a self-critical 'confession' to an evening meeting of UNEAC intellectuals, claiming his many errors to be truly unforgivable, reprehensible and unqualifiable.
28 April	Fidel joins the commissions of the First National Congress of Education and Culture.
30 April	Fidel attends the plenary session of the First National Congress of Education and Culture and makes a closing speech.

May	*El Caimán Barbudo* announces that Eduardo Heras León has been removed from his post on the editorial board, on account of suspect tendencies demonstrated in his book, leading him to spend years in the literal and metaphorical wilderness.
1 May	In his speech to the CTC, Fidel reiterates the conclusions of the First National Congress of Education and Culture. Having invested in 15 million pesos' worth of computer equipment, he recognises that communism relies on the development not only of conscience but also of productive forces.
5 May	Vargas Llosa writes to Haydée, resigning his post on the *Casa* collaborative committee. Haydée replies that it had already been decided months earlier, in a declaration that Vargas Llosa had himself signed, to substitute the committee with a broader list of collaborators, observing that he had not hesitated in adding his voice to the choir of the most ferocious enemies of the Cuban Revolution.
6 May	FAR officer, Luis Pavón Tamayo, is made President of the CNC.
12 May	An interview with Padilla is published in *Le Monde*.
20 May	A second letter is sent to Fidel (published in *Le Monde* the following day), protesting Padilla's confession in increasingly inflamed language. This letter is signed by sixty-two intellectuals, with some notable defections (including Cortázar).
	By way of reply to the second letter, the official transcript of Padilla's confession is circulated by the Cuban government through Prensa Latina and printed in full by *Libre* and in *Casa* issue 65–66.
21 May	On the same day as the second letter to Fidel is published in *Le Monde*, a cycle of ten programmes about the First National Congress of Education and Culture begins on television and radio.
22–23 May	The FEU hosts its first national congress, endorsing the cultural policy established during the First National Congress of Education and Culture.
24 May	Padilla addresses a letter to the signatories of the second letter to Fidel, accusing them of launching poisoned darts against Cuba. A war-like situation results in which some of the principal intellectuals of Europe and America are alienated from the Revolution.
25 May	For the second programme of the extended television series about the First National Congress of Education and Culture, a discussion on the Padilla case is hosted by ICAIC, presided over by Alfredo Guevara.
27 May	Cuban film-makers make a declaration about the Padilla case.
3 June	Another letter to Fidel is dispatched from Paris, mainly signed by French intellectuals, protesting the detention of their countryman, Pierre Golendorf.

28 July	Casa de las Américas inaugurates an exhibition of Cuban and Chilean plastic arts.
1 August	The Chilean Chancellor, Clodomiro Almeyda, visits the Cuba–Chile exhibition at Casa de las Américas.
16 August	Almeyda receives a Cuban delegation, led by Raúl Roa.
18 August	*Juventud Rebelde* announces that Casa de las Américas will host a meeting of Latin American artists the following May, in collaboration with the Latin American Art Institute of the University of Chile.
20 September	During a speech in Pinar del Río, Fidel insists on the necessity of an art for the masses.
10 November	Fidel arrives in Chile, where he meets Allende the following day.
15 November	The First National Youth Salon of Plastic Arts is inaugurated at the National Museum of Fine Arts.
2 December	Fidel and Allende appear in conversation in front of 80,000 people.
9 December	Richard Nixon convenes a meeting with his opposite number in Brazil, Emílio Garrastazú Médici, to discuss the possibility of a joint attack on Cuba and Chile.
20 December	Dorticós travels to the USSR, where he meets Brezhnev on Christmas Day.
1972	'Besieged militarily, isolated in the political and diplomatic fields, hardened in the intellectual field, and in a difficult economic situation',[7] Cuba is inserted into the Council for Mutual Economic Assistance. 'a Soviet-inspired, parallel international market providing a "fair deal" to the countries of the socialist bloc in Europe, Cuba and later Vietnam'.[8] While Cuba never joined the Warsaw pact, this move 'strengthened its ties to "actually existing socialism"',[9] but 'did not serve to improve things'.[10]
11 November	Three US hijackers of a Southern Airways plane make an emergency landing in Cuba.
1973	
February	A brief extradition treaty is signed between Cuba and the US.
1974	
5 January	Law 1262 prohibits 'ideological diversionism', an idea first mooted by Raúl Castro two years earlier.
1975	A new Constitution is drafted and circulated to party cells and to factories and farms to replace the amended version of the 1940 Constitution that the revolutionary government had adopted.
December	Artistic and literary creation forms one of the topics of discussion at the First Congress of the PCC. The majority of commentators are agreed that the PCC congress and the subsequent opening of the Ministry of Culture (MINCULT) signal a thawing of relations between the revolutionary government and the intelligentsia. The CNC's strictures against homosexuality are reversed.

1976	A Ministry of Culture and Council of State for Education, Science and Culture are founded, to replace the CNC, with Armando Hart (former Minister of Education) appointed as Minister of Culture. Alongside several other moves aimed at loosening the institutional hold over creativity, the ban on copyright is lifted.
	The Higher Art Institute (ISA) is inaugurated.
February	In a referendum to ratify the Constitution, 98 percent of the population participates, with 97 percent voting in favour. The new Constitution provides a formal parliament and declares the republic a sovereign workers' state with the PCC as the ideological motor of the Revolution. Thus, the state is placed at the heart of a Soviet-inspired Constitution and the role of the PCC becomes that of leading Cuba to communism after a socialist phase. PCC representatives inhabit all sectors of society, leading change from within, with mass organisations set up to provide an outlet for popular participation. The amended Constitution includes a specific article on education and culture, containing a clause echoing 'Words to the Intellectuals' which states that 'artistic creation is free so long as its content is not contrary to the Revolution. Forms of expression in art are free'. Jorge I. Domínguez notes that 'a public critique of the political system, even if the critic had done nothing to attack the government in any other way, would be in itself unconstitutional.[11]
	A system of material rewards and incentives is implemented, in an antithesis of Che's ideas, linking government expenditure to productivity for the first time. Cuba witnesses an increase in standard of living and access to defence, medicines, life expectancy and literacy rates and a decrease in infant mortality.
1977	The de facto blacklist against artists and writers is ended.
	The centralised Cuban Book Institute is dismantled.
1979	Many 'transgressive' artists and writers are released from prison.

NOTES

1 Fidel Castro Ruz and Ignacio Ramonet, *My Life* (London: Penguin Books, 2008 [2006]), p. 222.

2 Sujatha Fernandes, *Cuba Represent!: Cuban Arts, State Power, and the Making of New Revolutionary Cultures* (Durham, NC: Duke University Press, 2007), p. 29.

3 Ministerio de Relaciones Exteriores (MINREX), *The Revolution and Cultural Problems in Cuba* (Havana: Ministerio de Relaciones Exteriores, 1962), p. 6.

4 Guillermo Cabrera Infante, 'Expulsión', *Mea Cuba* (London: Faber and Faber, 1994), p. 20.

5 Lourdes Casal, 'Literature and Society', *Revolutionary Change in Cuba* (Pittsburgh, PA: University of Pittsburgh Press, 1971), p. 460.

6 Jorge Fornet, *El 71: Anatomía de una Crisis* [In '71: Anatomy of a Crisis] (Havana: Editorial Letras Cubanas, 2013), p. 29.

7 Roberto Fernández Retamar, 'The Enormity of Cuba', *Boundary* 2, 23, no. 3, Autumn 1996, p. 181.

8 Antonio Carmona Báez, *State Resistance to Globalisation in Cuba* (London: Pluto Press, 2004), p. 79.
9 Fernández Retamar, 'The Enormity of Cuba', p. 181.
10 Roberto Fernández Retamar, 'A Cuarenta Años de "Palabras a los Intelectuales"' [To Forty Years of 'Words to the Intellectuals'], *Cuba Defendida* [Cuba Defended] (Havana: Editorial Letras Cubanas, 2004 [2001]), p. 303.
11 Jorge I. Domínguez, *Cuba: Order and Revolution* (Cambridge, MA, and London: Harvard University Press, 1978), p. 204.

About the Authors

Rebecca Gordon-Nesbitt has been engaging with the internal dynamics of the cultural field for two decades. In 1995, she wrote a history of the artist-run Transmission Gallery in Glasgow and extended this into a comparative study of artistic self-organisation to accompany the first major survey of the UK cultural scene, held at the Musée d'Art Moderne de la Ville de Paris the following year. In 1998, she co-founded salon3, a polyvalent arts organisation, in London. Two years later, she took up a post as a curator at the Nordic Institute for Contemporary Art in Helsinki, with a responsibility for stimulating art exhibitions, publications and events throughout the Nordic region and, latterly, the UK and Ireland. As the cultural field succumbed to the neoliberal consensus, she dedicated herself to exploring the politico-economic conditions underwriting artistic practice.

Increasingly deploying an investigative approach, Rebecca has scrutinised the devolution of cultural provision from local government to the private sector. As Researcher-in-Residence at the Centre for Contemporary Art Derry~Londonderry, she interrogated claims of culture-led regeneration being made in relation to the first incarnation of UK City of Culture. As Research Associate at Arts for Health, Manchester Metropolitan University, she compiled an international evidence base around the relationship between arts engagement and health, which tentatively demonstrated a positive association between attending arts events and longer lives better lived.

Rebecca began her journey to Cuba in 2008, in search of new ways of thinking about culture. She arrived there the following year and spent five months in the libraries and archives of Havana, gathering the material that forms the basis of this book. Entering the final editing stages, she set up the Centre for Cultural Change (cambiarcultura.org), an umbrella organisation that enables critical and creative researchers to explore alternatives to the current socio-cultural malaise.

Since 1994, **Jorge Fornet** has been director of the Centre for Literary Research at Casa de las Américas, where he also co-directs the eponymous journal with Roberto Fernández Retamar. He has written widely on Latin American literature, focusing on the projects and worldview of writers born towards the end of the 1950s. In 2005, Jorge obtained a research scholarship from the Latin American Studies Center at the University of Maryland, and spent a semester with graduate students there. This gave rise to an essay, titled "Los nuevos paradigmas. Prólogo narrativo al siglo XXI" [The New Paradigms: Narrative prologue to the 21st century], which won the prestigious Alejo Carpentier prize. His critical consideration of the grey years, *El 71. Anatomía de una crisis* [In '71: Anatomy of a Crisis], published in 2013, is referenced throughout this book.

Index

Page numbers in *italic* refer to illustrations. 'Passim' (literally 'scattered') indicates intermittent discussion of a topic over a cluster of pages.

FRIENDS OF PM PRESS

These are indisputably momentous times—the financial system is melting down globally and the Empire is stumbling. Now more than ever there is a vital need for radical ideas.

In the seven years since its founding—and on a mere shoestring—PM Press has risen to the formidable challenge of publishing and distributing knowledge and entertainment for the struggles ahead. With over 300 releases to date, we have published an impressive and stimulating array of literature, art, music, politics, and culture. Using every available medium, we've succeeded in connecting those hungry for ideas and information to those putting them into practice.

Friends of PM allows you to directly help impact, amplify, and revitalize the discourse and actions of radical writers, filmmakers, and artists. It provides us with a stable foundation from which we can build upon our early successes and provides a much-needed subsidy for the materials that can't necessarily pay their own way. You can help make that happen—and receive every new title automatically delivered to your door once a month—by joining as a Friend of PM Press. And, we'll throw in a free T-shirt when you sign up.

Here are your options:

- **$30 a month** Get all books and pamphlets plus 50% discount on all webstore purchases

- **$40 a month** Get all PM Press releases (including CDs and DVDs) plus 50% discount on all webstore purchases

- **$100 a month** Superstar—Everything plus PM merchandise, free downloads, and 50% discount on all webstore purchases

For those who can't afford $30 or more a month, we're introducing **Sustainer Rates** at $15, $10 and $5. Sustainers get a free PM Press T-shirt and a 50% discount on all purchases from our website.

Your Visa or Mastercard will be billed once a month, until you tell us to stop. Or until our efforts succeed in bringing the revolution around. Or the financial meltdown of Capital makes plastic redundant. Whichever comes first.

ABOUT PM PRESS

PM Press was founded at the end of 2007 by a small collection of folks with decades of publishing, media, and organizing experience. PM Press co-conspirators have published and distributed hundreds of books, pamphlets, CDs, and DVDs. Members of PM have founded enduring book fairs, spearheaded victorious tenant organizing campaigns, and worked closely with bookstores, academic conferences, and even rock bands to deliver political and challenging ideas to all walks of life. We're old enough to know what we're doing and young enough to know what's at stake.

We seek to create radical and stimulating fiction and non-fiction books, pamphlets, T-shirts, visual and audio materials to entertain, educate, and inspire you. We aim to distribute these through every available channel with every available technology—whether that means you are seeing anarchist classics at our bookfair stalls; reading our latest vegan cookbook at the café; downloading geeky fiction e-books; or digging new music and timely videos from our website.

PM Press is always on the lookout for talented and skilled volunteers, artists, activists, and writers to work with. If you have a great idea for a project or can contribute in some way, please get in touch.

PM Press
PO Box 23912
Oakland, CA 94623
www.pmpress.org